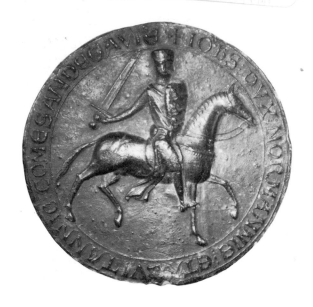

ENGLISH ROMANESQUE ART 1066–1200

Hayward Gallery, London 5 April–8 July 1984

Catalogue published in association with
the Arts Council of Great Britain

Weidenfeld and Nicolson · London

FRONT COVER Detail from a leaf related to the Winchester
Bible, 65
BACK COVER Doorknocker from the church of St John the
Baptist, Adel, Yorkshire, 264
PAGE 1 Seal of John, King of England 1199–1216, 335 (reverse)
OPPOSITE The Masters Plaque, 275

Catalogue edited by George Zarnecki, Janet Holt and
Tristram Holland
Photography research: Julia Baxter

Copyright © The Arts Council of Great Britain 1984
'The Historical Background' © Christopher Brooke 1984

Catalogue designed by Norman Ball
for George Weidenfeld and Nicolson Limited
91 Clapham High Street, London SW4 7TA

ISBN 0 297 78412 9 hard cover
ISBN 0 297 78433 1 soft cover

Set in Monophoto Sabon and printed
by BAS Printers Limited, Over Wallop, Hampshire
Colour separations by Newsele Litho Limited

Contents

Exhibition Staff

Exhibition organized by Janet Holt
assisted by Julia Baxter and Muriel Walker

Foreign Transport: Jeffery Watson
United Kingdom Transport: Roy Downer, Hilary Knowles-Brown,
 Vivien O'Toole
Installation: Norman McManus, Sidney Pottier
Gallery Superintendent: Leslie Kendall
Publicity: Joan Asquith
Publications: Tania Butler
Hayward Bookstall: Anna Sixsmith

Exhibition research assistant: Deborah Kahn
Exhibition promotion: Anne Binney
Exhibition design: Paul Williams
Exhibition design assistant: Hamish Muir
Graphic design: Philip Miles
Lighting: John Johnson
Special installation and object mounting: Peter Smith
Installation co-ordination: Roger Took
Audio-visual programme: production and photography by
Darryl Johnson and Roy Reed, Triangle Audio-visual
Partnership. Advisers: Richard Gem and Paul Williams
Sculpture conservation: Michael Eastham; Harrison Hill
Limited; John Larson; Peter Smith; Wojtek Sobczynski
Sculpture removal and packing: William Anelay Limited; John
A. Green; Anthony Snook
Paper conservation: Claire Gaskell

Exhibition Committee

Chairman: Professor George Zarnecki CBE
Dr Jonathan Alexander
Dr Thomas Cocke
Dr Richard Gem
Dr Margaret Gibson
Mr T.A. Heslop
Dr Deborah Kahn
Dr Michael Kauffmann
Professor Peter Lasko CBE
Mr Neil Stratford
Mr Paul Williams
Mr Paul Williamson

Arts Council:
Mrs Julia Baxter
Mr Andrew Dempsey
Miss Janet Holt

Advisory Committee

Mr Claude Blair
Professor Christopher Brooke
Mr Peter Burman
Mrs Shirley Bury
Professor Madeline H.Caviness
Professor Charles Reginald Dodwell
Miss Catherine Galbraith
Mme Marie-Madeleine Gauthier
Mr Donald King
Professor Lucien Musset
Professor Florentine Mütherich
Sir Walter Oakeshott
Mr Anthony Radcliffe
Mr Andrew Saunders
Professor Roberto Salvini
Dr Hanns Swarzenski
Mr Derek H.Turner

Preface

It is appropriate that in National Heritage Year the Arts Council of Great Britain should mount an exhibition of English Romanesque Art at the Hayward Gallery. The exhibition is the first of a series devoted to the presentation of English medieval art; it will be followed this autumn by *The Golden Age of Anglo-Saxon Art 966–1066* organized by the British Museum and British Library, and an exhibition of Gothic art at the Royal Academy in 1986.

The project was first suggested to Professor George Zarnecki in 1970 by Mr Alan Bowness, who was then a member of the Arts Council's Exhibitions Committee. In 1980, under Professor Zarnecki's skilful chairmanship an Exhibition Committee was formed to advise on the selection and realization of the exhibition. We have also benefited from the help of an Advisory Committee of scholars drawn from several countries. The Arts Council wishes to thank Professor Zarnecki for his untiring efforts on behalf of the exhibition and to express our gratitude to the members of both committees who are listed on page 7.

In 1959 the City Art Gallery in Manchester arranged an exhibition of Romanesque art, exhibiting works of British and Continental origin assembled from British and Irish collections. The scope of the present exhibition has been deliberately limited to works of English origin and is an attempt to show the art of England following the Norman Conquest. The victory of Duke William of Normandy at the Battle of Hastings in 1066 is imprinted on the memory of every schoolchild, and the establishment of his dynasty opened England to the political and cultural forces of Continental Europe. The artistic style known as 'Romanesque' was firmly established in Normandy, and it is the aim of this exhibition to show the fusion of the Romanesque and the indigenous Anglo-Saxon art to form a style which is quintessentially English; a celebration of the vigorous flowering of English art in Norman England.

At all stages in planning the Arts Council has received enthusiastic support. The Church was the great artistic patron in the 12th century and the Arts Council was honoured when the Archbishops of Canterbury and of York agreed to be Patrons of the exhibition. It would have been impossible to undertake this enterprise without the generous help of many Cathedral Chapters and Parochial Church Councils. The national museums and libraries, custodians of much of our medieval heritage, have aided us, and we warmly thank the Director of the British Museum: Dr David Wilson, the Victoria and Albert Museum: Sir Roy Strong, the Bodleian Library: Mr David Vaisey and the Director General of the British Library, Reference Division: Mr Alexander Wilson.

Our greatest debt is to the lenders through whose generous collaboration we have been able to assemble the most important surviving works of art of the period. This collection represents a small part of the riches of the period; the Dissolution of the Monasteries in 1539 and the despoiling of the majority of monastic foundations was followed, in the 17th century, by the iconoclasm of the Puritans which destroyed much of England's medieval heritage.

Some of the great buildings survive, for instance Durham Cathedral and the Tower of London, represented in the exhibition with other great building schemes undertaken by the Normans, in a specially commissioned audio-visual programme. Much sculpture, despite the ravages of centuries, is still *in situ*; detached fragments are exhibited here along with the finest manuscripts, stained glass, ivories, metalwork, seals, bookbindings, coins and ceramics. The final section of the exhibition is devoted to the strong tradition of antiquarian studies.

In preparing the exhibition we have received financial assistance from a number of sources. Charles Letts and Co. Ltd have generously sponsored the audio-visual programme. The extensive programme of sculpture conservation initiated by the Arts Council has received generous financial assistance from the Pilgrim Trust and Reading Area Museums Service and the help of the British Museum Conservation Department. The exhibition has also benefited from conservation work which was already in hand when the planning of the exhibition was begun: the Parochial Church Council of Castle Frome had already planned to conserve their splendid font and the Marc Fitch Fund joined with us in contributing to the costs of the work. The Department of the Environment has also been most generous in transporting sculpture from sites in its care and undertaking conservation work specially for the exhibition.

The Arts Council is indebted to many people in Europe and the USA for help and advice, who are listed on pages 10–11, but we particularly wish to thank the following for help in securing loans: in England, Sir Walter Oakeshott; in France, Dr Maylis Baylé and Madame Marie-Madeleine Gauthier; in the German Federal Republic, Professor Florentine Mütherich and in Italy, Professor Roberto Salvini. Mr R.W. Sanderson of the Institute of Geological Sciences has kindly analysed many samples of the stone sculpture, and we thank Mr Claude Blair, Dr Peter Bloch, Madame Gauthier, Dr Roswitha Neu-Kock and Dr Hanns Swarzenski for their advice on the objects of metalwork in the exhibition.

We particularly wish to thank all the contributors to the catalogue, who are listed on page 5. We are grateful also for the collaboration of Messrs Weidenfeld and Nicolson in the planning and preparation of this publication.

The installation of the exhibition at the Hayward Gallery presented many design and technical problems and we wish to thank Mr Paul Williams for the care and skill he has devoted to designing the presentation.

JOANNA DREW
Director of Art

Acknowledgements

The Arts Council would like to thank the following individuals and institutions who contributed in many different ways to the organization of the exhibition and the preparation of the catalogue.

Canon R.R. Acheson; Dr Aron Andersson – Curator, Statens Historiska Museum, Stockholm; Mrs Christie Arno – Medieval Field Study Centre, Coleford, Gloucestershire; Mr Don Bailey – Senior Research Assistant, Greek & Roman Antiquities, British Museum; The Very Reverend Dr Peter Baelz – Dean of Durham; Mrs E.M. Baker – Archaeological Field Officer, County Hall, Bedford; Mrs Katherine Barclay – Winchester Research Unit, Winchester City Museums; Mr Bruce Barker-Benfield – Assistant Librarian, Bodleian Library, Oxford; The Revd J.C.P. Barton – Malmesbury Abbey, Wilts; Mr P.M. Bartosch – Architect to St Mary's Church, Fownhope, Hereford; Mr Stephen Bate – Council for the Care of Churches, London; Dr Maylis Baylé – Centre National de la Recherche Scientifique, Paris; Dr B.S. Benedikz – Sub-Librarian, Special Collections, University of Birmingham Library; Miss Sarah Bevan – Editorial Assistant, Weidenfeld & Nicolson, London; Professor Martin Biddle – Fellow of Christ Church, Oxford University; Miss Birgul Biktimir – Keeper of Conservation, Verulamium Museum, St Albans, Herts; Mr E.G.W. Bill – Librarian, Lambeth Palace Library, London; Miss Mavis Bimson – Senior Scientific Officer, Research Laboratory, British Museum; The Revd David H. Bishop – Canon Residentiary, Norwich Cathedral; Mr Claude Blair – former Keeper of Metalwork, Victoria & Albert Museum, London; Professor Dr Peter Bloch – Direktor, Skulpturengalerie, Staatliche Museen, Preussischer Kulturbesitz, Berlin-Dahlen; Professor Jean Bony – Professor Emeritus, University of Berkeley, California; Mr Ralph Brasier – The Vesturer, Canterbury Cathedral; Canon P.A. Britton – Cathedral Librarian and Archivist, Winchester Cathedral; Mr David Brown – Assistant Keeper, Department of Antiquities, Ashmolean Museum, Oxford; Dr Roger Brownsword – Senior Lecturer in Materials, Materials & Energy Science Department, Coventry (Lanchester) Polytechnic; Professor Walter Cahn – Department of History of Art, Yale University, New Haven, Connecticut; Mr David Caldwell – Research Assistant, National Museum of Antiquities of Scotland, Edinburgh; Miss Marian Campbell – Research Assistant, Metalwork Department, Victoria & Albert Museum, London; Wing Commander Cartmell – Bursar, University College, Durham Castle; Mrs Martha Caute – Editor, Weidenfeld & Nicolson, London; L.F. Cave; Mr John Cherry – Deputy Keeper, Medieval and Later Antiquities, British Museum; Mlle Elisabeth Chirol – Conservateur en chef, Musées départementaux de la Seine-Maritime, Rouen; Mr John Clark – Senior Assistant Keeper, Medieval Department, Museum of London; Mr Christopher Clarkson – Conservation Officer, Bodleian Library, Oxford; Mr F.W. Cole – Stained Glass Studio, Canterbury Cathedral; Canon Ronald Coppin – Chapter Librarian, Durham Cathedral; Dr Paul Craddock – Principal Scientific Officer, Research Laboratory, British Museum; Professor Rosemary Cramp – Head of Department of Archaeology, University of Durham; Miss M.D. Cra'ster – Senior Assistant Curator, University Museum of Archaeology and Ethnology, Cambridge; Mr Robin Crighton – Keeper of Applied Arts, Fitzwilliam Museum, Cambridge; Miss Janey Cronyn – Lecturer in Conservation, Durham University; Mrs A Crown; Mr A.L. Cullen; The Very Revd A.H. Dammers – Dean of Bristol; Dr Michael Darby – Deputy Director and Keeper of Museum Services, Victoria & Albert Museum, London; Mr Gerald Deacon – Custodian of the Fabric, Bath Abbey; Canon A. Deedes – Master, The Hospital of St Cross, Winchester; Mrs Mary Denison – Associate Curator of Drawings & Prints, Pierpont Morgan Library, New York; Miss J. Dobie, Department of Ancient Monuments and Historic Buildings, Department of the Environment, London; Dr Saskia Durian-Ress – Bayerisches National Museum, Munich; Dr Elizabeth Eames; Mr G.P. Elphick; Mr Paul Everson – Royal Commission on Historic Monuments, Lincoln; Mr E.C. Fernie – Senior Lecturer, School of Fine Arts and Music, University of East Anglia; Miss Sylvia Finnemore – Secretary at the Courtauld Institute of Art, London; Mr G. Fisher – Conway Library, Courtauld Institute of Art, London; Mr Eric Franklin – Architect to Bristol Cathedral; Miss Jill Franklin; Mrs Irena Gabor Jatczak – Director, Polish Cultural Institute, London; Mme Danielle Gaborit-Chopin – Conservateur, Département des Objets d'Art, Musée du Louvre, Paris; Dr Jane Geddes; Monsieur Gérard Guillot-Chene – Musée d'Evreux, Evreux; Canon E. Gethyn Jones; Mr Peter Gibson – Superintendent and Secretary of York Glaziers Trust, York Minster; Mr Garth Hall – Research Assistant, Exhibitions, Victoria & Albert Museum, London; Mr Richard Halsey – Inspector, Department of Ancient Monuments and Historic Buildings, Department of the Environment, London; Mrs Elizabeth Hartley – Senior Keeper, Archaeology Department, The Yorkshire Museum, York; Mr John Higgitt – History of Art Department, University of Edinburgh; Mr David Hinton – Department of Archaeology, Southampton University; Sir Charles Hobhouse; The Very Revd Robert Holtby – Dean of Chichester; Mr John Hopkins – Librarian, Society of Antiquaries of London; Dr Michael Hughes – Principal Scientific Officer, Research Laboratory, British Museum; Mr Cyril Humphris; Mrs Gertrude Hunt; Miss Rebecca Hurst – Secretary at the Courtauld Institute of Art, London; Mrs M. Hutchinson – Senior Conservation Officer, Department of Ancient Monuments and Historic Buildings, Department of the Environment, London; The Very Revd J.M. Irvine – Provost and Rector of Southwell Minster; The Very Revd Ronald Jasper – Dean of York; The Revd A.A. Jones – Shipley Church, Horsham, West Sussex; Miss Rhiannon Jones – Secretary at the Courtauld Institute of Art, London; Miss S.M. Jones – Department of Manuscripts, British Library; Dr Rainer Kahsnitz – Germanisches Nationalmuseum, Nürnberg; Professor Lech Kalinowski – Krakow University, Poland; Mr Francis Kelly – Inspector, Department of Ancient Monuments and Historic Buildings, Department of the Environment, London; Mr and Mrs K.H. Kemp; The Venerable F.G. Kerr-Dineen – Archdeacon of Horsham; Mr Dafydd Kidd – Assistant Keeper, Medieval and Later Antiquities, British Museum; Dr Dietrich Kotzsche – Kunstgewerbemuseum, Schloss Charlottenburg, West Berlin; Mr James Lang – Lecturer, Nevills Cross College, Durham; Mrs Susan La Niece – Scientific Officer, Research Laboratory, British Museum; Miss Elizabeth Lewis – Curator, Winchester City Museum; Mr John Lewis – Assistant Keeper, Medieval and Later Archaeology, National Museum of Wales, Cardiff; Mr B.J. Le Mar – Clerk of Works, Canterbury Cathedral; Mr Fritze Lindahl – Nationalmuseet, Copenhagen, Denmark; The Hon. Thomas Lindsay; Dr Charles Little – Assistant Curator of Medieval Art, Metropolitan Museum of Art, New York; Mrs B. Lowe; Revd P.J. Markby – Church of St John the Baptist, Southover, Lewes, East Sussex; Dr Richard Marks – Keeper of the Burrell Collection and Assistant Director, Glasgow Museums and Art Galleries; Miss Fiona Marsden – Curator, Museum of Local History, Lewes, East Sussex; Mr Peter Marsh – Surveyor of the Cathedral Fabric, Canterbury Cathedral; Revd Brother Martin SSF, St Benet's Church, Cambridge; Mr E.J. Mason; Mr T.H. McK Clough – Keeper, Rutland County Museum; Brigadier K.J. Mears – Deputy Governor, H.M. Tower of London; Mr A.G. Mepsted – Ancient Monuments Administration, Department of the Environment, London; Mr Stephen Minnitt – Keeper of Archaeology, Somerset County Museum, Taunton; Mr Nicholas Moore – Executive Officer, Department of Ancient Monuments and Historic Buildings, Department of the Environment, London; Miss Jacqueline Moran – Personal Secretary, Medieval and Later Antiquities, British Museum; Miss Penelope Morgan – Hon. Librarian, Hereford Cathedral; Dr Richard Morris – Lecturer, History of Art Department, University of Warwick; Mr A.E.S. Musty – Inspector, Department of Ancient Monuments and Historic Buildings, Department of the Environment,

London; Mrs Nancy Netzer – Department of European Decorative Arts and Sculpture, Museum of Fine Arts, Boston; Mr and Mrs Newell; Dr P.A. Newton – Reader, Centre for Medieval Studies, University of York; Mrs M.D. Noles – Curator, Hedingham Castle, Halstead, Essex; Mr A.V.B. Norman – Master of the Armouries, H.M. Tower of London; Mr P.J. Norris – Chapter Agent, Canterbury Cathedral; Mr W.J. Norton – Assistant Keeper, Buttercross Museum, Ludlow; Canon J.S. Nurser – The Chancellor, Lincoln Cathedral; Miss Ann Oakley – Librarian, Canterbury Cathedral Library; Father Laurence O'Brien – St Mary's, Monmouth, Gwent; Mr Andrew Oddy – Head of Conservation Division, British Museum, London; Mr S. Omar – Organics Section, Conservation Division, British Museum, London; Miss Elizabeth Owles – Curator, Moyse's Hall Museum, Bury St Edmunds, Suffolk; Mr David Park; Canon Geoffrey Parks – Chichester Cathedral; Revd Arthur Parsons – Rector, Ludgvan Parish Church, Penzance, Cornwall; Mrs Helen Paterson – Finds Supervisor, St Albans Abbey Research Committee, St Albans Chapter House Excavation, St Albans; Mr Robin Peers – Churchwarden, St Michael's, Castle Frome, Hereford; Mr Hugh Perks – Surveyor to St Augustine's Foundation, Canterbury; Mrs Ann Poulet – Department of European Decorative Arts, Museum of Fine Arts, Boston; The Trustees of the Powis Estate – Powis Castle, Welshpool; Mr J.G.E. Price – Chief Conservation Officer, Department of Ancient Monuments and Historic Buildings, Department of the Environment, London; Mr Richard Randall – Director, The Walters Art Gallery, Baltimore, Maryland; M. Jean-Pierre Ravaux – Conservateur, Musée Garinet and Musée Municipal, Châlons-sur-Marne; Miss Elizabeth Real – Secretary at the Courtauld Institute of Art, London; Mr Roy Reed – Triangle Audio-Visual Partnership, London; Mr Stephen Rees-Jones – Head of Department of Conservation and Paintings, Courtauld Institute of Art, London; Mr P.R. Ritchie – formerly Inspector of Ancient Monuments, Scotland; Canon Joseph Robinson – The Master of the Temple, The Temple, London; M. Jean-Pierre Sainte-Marie – Conservateur, Musées de Troyes, Troyes; Dr E. Salthouse – Master, University College, Durham Castle; Mr R.W. Sanderson – Petrographical Department, Institute of Geological Sciences, London; Mr Peter Saunders – Curator, Salisbury and South Wiltshire Museum; Dr Walter Schulten – Director, Cathedral Treasury, Cologne; Dr Michael Sharratt – Librarian, Ushaw College, Durham; The Very Revd Allan Shaw – Dean of Ely; Mr C.A. Sizer – Director, Reading Museum and Art Gallery; Mr Joseph Smales – former Custodian, Fountains Abbey; Mr Michael Q. Smith – Senior Lecturer, Department of History of Art, University of Bristol; Professor Morton Smith – Department of History, Columbia University, New York; Mr Brian Spencer – Senior Keeper, Medieval Department, Museum of London; Mr Denys Spittle; Dr Roger Stalley – Trinity College, Dublin; Dr Felice Stampfle – Charles Engelhard Curator of Drawings & Prints, Pierpont Morgan Library, New York; The Very Revd Michael Stancliffe – Dean of Winchester; Mr Eric Stanford – Keeper of Art, Reading Museum and Art Gallery; Mr Patrick Strong – College Archivist, Eton College Library, Windsor; M. le Chanoine Jean-Marie Theurillat – Abbaye de St-Maurice (Valais) Switzerland; Mr F.H. Thompson – General Secretary, Society of Antiquaries of London; Mr J.C. Thorne – Department of Ancient Monuments and Historic Buildings, Department of the Environment, London; Dr Malcolm Thurlby – York University, Ontario; The Very Revd Hon. O.W. Twistleton-Wykeham-Fiennes – Dean of Lincoln; Mr David Vaisey – Keeper, Department of Western Manuscripts, Bodleian Library, Oxford; The Very Revd Victor de Waal – Dean of Canterbury; Mr Malcolm Watkins – Archaeology Director, Gloucester City Museum and Art Gallery; Mrs Leslie Webster – Assistant Keeper, Medieval and Later Antiquities, British Museum; Canon David Welander – Gloucester Cathedral; Mr Jeffrey West; Dr Hiltrud Westermann-Angerhausen; Dr William Wixom – Chairman of the Department of Medieval Art and The Cloisters, Metropolitan Museum of Art, New York.

The Arts Council and Publishers would like to thank Messrs George Allen & Unwin, Robert Hale Limited, Harvey Miller Publishers, and Penguin Books Limited for permission to use material for some of the entries in the Glossary.

Picture Acknowledgements

The colour photographs of objects in the exhibition in addition to those supplied by the lenders are by:

David Cripps 191, 212, 213, 216, 293, 368; Prudence Cuming Associates 551; Peter Gibson 89; Sonia Halliday and Laura Lushington 93; Harvest Studios, Northampton 499; Angelo Hornak 104, 127a, 128b, 135a, 137, 138, 139, 142, 163c, 164g, 176, 360; West Park Studios, Leeds 264

The black and white photographs of objects in the exhibition in addition to those supplied by the lenders are by:

Hallam Ashley; J. Bailey; Bildarchiv Foto Marburg; David Cripps; Courtauld Institute of Art; D.C. Cox; Prudence Cuming Associates; Department of the Environment, Ancient Monuments Laboratory; Documentation photographique de la Réunion des musées nationaux, Paris; Sonia Halliday Photographs; Angelo Hornak; C. Howard and Son; Rheinisches Bildarchiv, Cologne; Royal Commission on Historic Monuments, National Monuments Record; D.B. Sinclair; Neil Stratford; G. Zarnecki

We would also like to thank those who kindly made available the photographs on the following pages:

Courtauld Institute of Art 28 (left), 36; A.F. Kersting 19, 21 (bottom), 23 (bottom), 31, 33 (top), 35, 37, 38, 51; National Monuments Record 29; Phaidon Press Ltd. 27, 43 (top); Triangle Audio Visual Partnership 20, 21 (top), 28 (left), 30, 32, 33 (bottom), 39, 40, 50, 51 (top)

The plan on page 413 has been reproduced courtesy of Penguin Books Ltd.

Lenders to the Exhibition

UK *Aberdeen* University of Aberdeen 86
Adel Rector and Churchwardens of Adel Parish Church 264
Bath Rector and Churchwardens of Bath Abbey 116a, b, 166a, b
Bedford Bedford Museum, North Bedfordshire Borough Council 125, 479
Birmingham Erdington Abbey 490
Bristol
 The Dean and Chapter of Bristol Cathedral 96
 Wansdyke District Council 163a, b, c
Bury St Edmunds St Edmundbury Borough Council 118, 253, 300
Cambridge
 Master, Fellows and Scholars of Clare College, University of
 Cambridge, Diocese of Ely 10
 The Master and Fellows of Corpus Christi College 44
 The Syndics of the Fitzwilliam Museum 288
 The Master and Fellows of Pembroke College 21, 45
 The Master, Fellows and Scholars of St John's College 23, 43a, 66
 The Master and Fellows of Trinity College 11, 42, 62, 69, 83
 The Master and Fellows of Trinity Hall 70
 The Syndics of Cambridge University Library 30, 43
 Cambridge University Museum of Archaeology and
 Anthropology 230, 233, 236, 237
 Mr Christopher Methuen Campbell *et al* 337
Campsall Parochial Church Council, Campsall Parish Church 103
Canterbury
 The Dean and Chapter of Canterbury Cathedral 91, 92a, b, c, d, e,
 93, 94a, b, 164a, c–m, 324a, b, c, d, e, f, 493a, b
 The Royal Museum and Art Gallery 164b
 St Augustine's Foundation 107, 108, 159, 160, 171
 Mr Alban D.R. Caroe FSA, FRIBA 502
Castle Frome Churchwardens and Parochial Church Council of St
 Michael's 139
Chichester The Dean and Chapter of Chichester Cathedral 267, 272,
 314, 322a, b, 323a, b
 Mr Andrew Christie-Miller 155a–f
 The Croome Estate Trustees 546
Devizes Wiltshire Archaeology and Natural History Society 536
Dorchester Dorset Natural History and Archaeological Society,
 Dorset County Museum 210
Dormington Dormington Church 263
Durham
 The Dean and Chapter of Durham Cathedral 37, 77, 154a, b, 301,
 311, 312, 313, 333, 336, 339, 344, 355, 357, 366, 370, 474
 University of Durham 100
 Bishop Cosin's Library (University of Durham, in trust) 58
Edinburgh National Museum of Antiquities of Scotland 285, 298a, b
Ely The Dean and Chapter of Ely Cathedral 506
Exeter Devon Record Office, Exeter City Archives 338, 341, 378
 Mr Thomas Fenton 550
 Trustees of the Viscount Folkestone's 1963 Settlement 157a, b
Fownhope Fownhope Parochial Church Council, Hereford 138
Glasgow
 Glasgow Museums and Art Galleries, the Burrell Collection 234
 Glasgow University Library 32, 75
Glastonbury Bath and Wells Diocesan Trustees (Reg'd) 149a–g
Gloucester
 The Dean and Chapter of Gloucester Cathedral 243
 Gloucester City Museum and Art Gallery 133, 483
Hereford The Dean and Chapter of Hereford Cathedral 18, 26, 51,
 109a, b, c, d, e, f, 350, 352, 359
Horning Vicar and Parochial Church Council of St Benedict's 327
Ipswich
 Ipswich Museums and Galleries 478
 St Nicholas Parochial Church Council 121, 122

Kelloe Kelloe Parish Church 176
Lathbury The Rector of Newport Pagnell with Lathbury 104
Sir Berwick Lechmere 332
Lewes The Rector, Churchwardens and Parochial Church Council of
 St John the Baptist 145
Lincoln The Dean and Chapter of Lincoln Cathedral 12, 143, 360
Littleborough The Incumbent and Parochial Church Council of the
 Church of St Peter and St Paul, Littleborough, Nottingham 262
Little Hormead The Rector and Churchwardens of Great Hormead
 with Little Hormead and Wyddial 326
Liverpool Merseyside County Museums 219
London
 Bonaventure Books 551
 The British Library Board 1, 3, 7, 13, 14, 16, 24, 25, 38, 41, 46, 48,
 61, 71, 72, 80, 81, 82, 84, 187, 318, 328, 330, 331, 334, 340, 343,
 346, 347, 348, 358, 371, 372, 377, 473, 475, 510, 518
 The British Rail Superannuation Fund 292
 Trustees of the British Museum 117, 180, 184, 185, 189, 192a, b, 194,
 203, 211, 212, 217, 222, 223, 225, 231, 248, 249, 259, 261, 266, 271,
 276, 277a, b, 299, 310, 315, 316, 317, 319a–r, 320a–f, 321, 349, 368,
 379–466 (coins), 477, 480, 481, 485, 487, 489, 496, 497, 498, 500,
 511, 515, 527, 529, 530, 531, 537, 542
 City of London, Guildhall Library 503, 545
 The Courtauld Institute Galleries 544
 Department of the Environment, Directorate of Ancient Monuments
 and Historic Buildings 105a, b, c, d, e, f, 106, 146, 195, 260a, b
 Lambeth Palace Library 53
 The Museum of London 95, 200, 251, 257, 258, 467, 468, 484, 488
 The National Portrait Gallery 507, 519
 Public Record Office 342, 354, 361, 362, 471
 The Redundant Churches Fund 137, 245
 The Royal Hospital of St Bartholomew 353
 The Society of Antiquaries of London 469, 508, 509, 512, 513, 514,
 516, 520, 522, 523, 524, 535, 548, 551
 Victoria and Albert Museum 50, 136, 161, 162, 177, 178, 188, 191,
 196, 197, 199a, b, 202, 204, 205, 209, 213, 216, 220, 239, 247, 254,
 275, 279, 280, 287, 521, 534, 538, 543
 The Muniments of the Dean and Chapter of Westminster 110, 351,
 364, 367, 376
 The Archbishop of Westminster 491
Lower Halstow St Margaret's Church 244
Ludgvan Ludgvan Parish Church 240
Ludlow Ludlow Museum, Shropshire County Museum Service 238
Maidstone Maidstone Museum and Art Gallery 53a
Monmouth The Church of St Mary, and the Archbishop of
 Cardiff 241
Much Wenlock The Trustees of the Wenlock Abbey Estate 169a, b,
 170
Northampton
 St Peter's Parochial Church Council 142
 His Grace the Duke of Northumberland KG, PC, GCVO, FRS 256
Norwich
 Castle Museum, Norfolk Museums Service 476, 539
 The Dean and Chapter of Norwich Cathedral 126, 134a, b
 St Peter Mancroft Parochial Church Council 78
 University of East Anglia, Robert and Lisa Sainsbury Collection 120
Oxford
 Ashmolean Museum 224, 228, 486, 504, 525, 526, 540, 541
 Curators of the Bodleian Library 5, 8, 28, 31, 35, 36, 39, 40, 56, 59,
 60, 63, 63a, 67, 74, 356, 365, 472, 505
 The President and Fellows of Corpus Christi College 33, 55
 The President and Fellows of St John Baptist College 34
 University College 15
Preston Harris Museum and Art Gallery 528

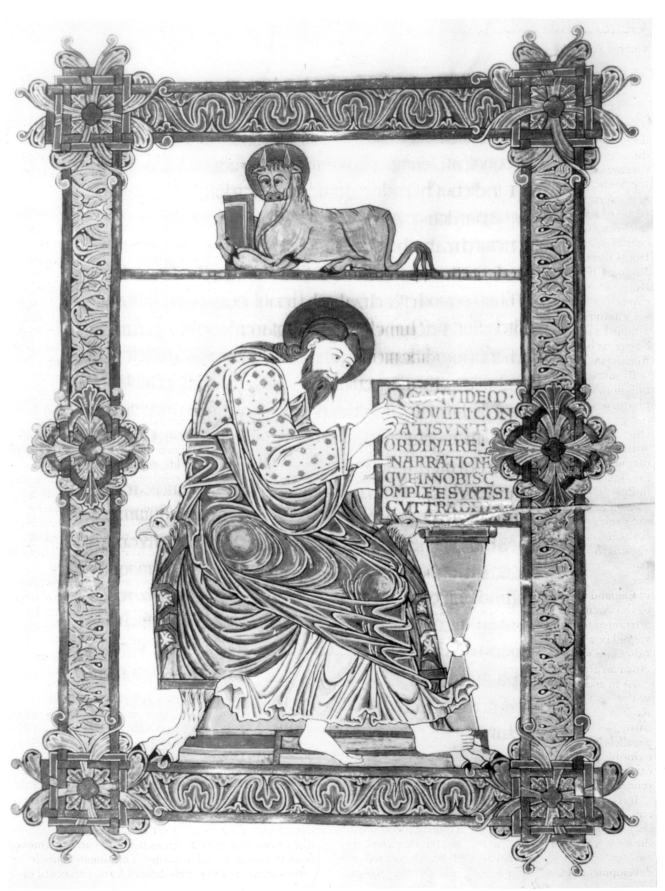

General Introduction

George Zarnecki

Romanesque art was born during one of the most decisive periods in European history. Following the disintegration of the Carolingian empire and the disastrous invasions of the Vikings, the Hungarians and the Arabs, civilized life almost ceased to exist. Recovery was at first slow but, by the 11th century, embraced all forms of activity – social, political, religious, economic, intellectual and artistic. Western Europe, full of optimism and self-confidence, was advancing on all fronts through territorial conquests, conversions to Roman Christianity and even by exploration. Romanesque art played its part in this revival and expansion. During the 12th century, when Romanesque art was at the height of its achievement, intellectual life attained a level unknown since classical times and this flowering became known as the Twelfth-century Renaissance.[1]

Romanesque art is probably best known through its buildings which are robust and monumental. To use the phrase of a contemporary chronicler, 'the whole earth . . . was clothing itself everywhere in the white robe of churches'[2]. Not since Roman times had places of worship been built in such a grand, ingenious and daring manner. It is not surprising that when early 19th-century antiquarians looked for a suitable term to describe these buildings, they decided on Romanesque (in French *roman*, in German *romanisch*, in Italian *romanico* and in Spanish *romànico*), thereby suggesting a link with the Roman style in the same way as the term Romance is applied to the languages and literatures derived from Latin. Although the term Romanesque, as a style, has been in use since 1819[3], by far the most popular name in England is Norman, since the introduction of the style to this country is generally, although not quite correctly, attributed to the Norman Conquest. This term, however, should be avoided for it is inaccurate and certainly ridiculous when used in such expressions as, for instance, Norman art in Burgundy!

As in architecture, so in the field of architectural sculpture, which virtually disappeared with the fall of the Roman Empire, there was an astonishing revival throughout Europe for which there are hardly any parallels before or since. The same can be said of painting, goldsmith's work, ivory carving and many other arts, all displaying wonderful technical skill and refined artistry.

It is not always appreciated that the English contribution to Romanesque art was enormous. Not only were Romanesque buildings in England amongst the largest and most daring in Europe, but they were also amongst the most influential and led directly towards the development of Gothic. In other media also the English

achievement was outstanding if often unrecognized. This is no doubt due to the great gaps in our knowledge because of historical circumstances. No other country has suffered greater losses to its medieval art treasures than England. The Dissolution of the Monasteries in 1539 caused the demolition of the great majority of monastic churches and the loss of their contents, while the despoiling of churches by the Puritans in the next century led to further destruction and defacements, especially of images. On reading medieval inventories, one becomes aware of how much has been lost. When Thomas Becket's shrine in Canterbury Cathedral was destroyed, 'the King's receiver confessed that gold and silver and precious stones and sacred vestments taken away from the shrine filled six-and-twenty carts'[4]. Only a fraction of what existed has come down to us, and the often mutilated state of the objects is an eloquent testimony to the fanaticism of the iconoclasts or to ignorant neglect. Because of this, our knowledge of English Romanesque art is imperfect. To piece together the full story from the existing evidence is a work of detection. There is still much to discover, such as wall-paintings hidden under whitewash, buried treasures and sculptures re-used as building material.

Romanesque art is closely linked with the emergence of feudalism and religious reform. Castle and church were the two centres which stimulated artistic life by providing generous patronage. There is some similarity between the structure of the feudal and ecclesiastical systems during this period and Romanesque buildings. In secular and church life there was a well-balanced hierarchy, with the peasant and humble monk and priest on the bottom rung of the ladder and the emperor, king or pope at the top, with the intervening steps filled by people of increasing importance and wealth, all bound together by ties of loyalty and mutual interest. A Romanesque building is also the sum of an intricate network of subordinate parts, forming a balanced, harmonious whole. A typical church consists of a succession of bays, repeating a rhythmical pattern of piers and columns leading from the entrance to the altar, the large arcades being surmounted by groups of smaller ones, with each bay crowned by a unit of vaulting. The whole design is composed of interdependent parts based on simple but rigid calculations. The sculpture and painting are closely linked to the architecture and often the awkward, irregular fields to be covered with carving or murals dictate the forms and proportions of the figures and of entire compositions. The resulting distortions and simplifications make this art far removed from the forms found in nature. The human figure is often treated as a flat, well-defined form, composed of

Portrait of St Matthew, his robes arranged in 'nested V-folds',
from the Dover Bible, 1150–60. Cambridge, Corpus Christi College,
MS3, f. 168ᵛ

usually triangular compartments, whose function is to
create a lively, decorative pattern rather than to make a
convincing anatomical statement. The principal means
of achieving this decorative aim is by arranging the
draperies of garments into groups known as 'nested V-
folds' and giving the hems of the robes lively meandering
designs.

At this time people were preoccupied with the afterlife
in heaven or hell, and thus the art of the period often
depicts God, his angels and his saints or else devils
inflicting horrible punishments on the sinful. Nature is
of little help in representing the deity, heaven,
miraculous happenings or devils and their underworld
kingdom, and this gave artists a wonderful opportunity
to put their imagination to the test. There were
numerous other situations which encouraged distortions,
exaggerations and inventiveness. One was the painting
of initials in books, where the shape of the letters dictates
the form of the human figures or of the animals to be
fitted in. Although the art of the 12th century is largely
devoted to biblical themes, it is also full of grotesque,
sometimes humorous subjects, occasionally bordering on
the obscene and vulgar. It was created for the
sophisticated and pious but also for the uneducated and
crude.

The dates in the title of the present exhibition, 1066–
1200, are only approximate. The Romanesque style had,
to a certain extent, influenced Anglo-Saxon art, but it
was the Norman Conquest of 1066 which opened the
gate to a stylistic invasion from the Continent where the
Romanesque style had already taken root. The year 1200
in the title may give the false impression that everything
before the end of the 12th century is Romanesque and
everything after is already Gothic. This is, of course, not
the case. The first entirely Gothic structure in England
was the choir of Canterbury Cathedral, rebuilt by a
French master mason after the fire of 1174. But in
painting, sculpture, metalwork and ivory carving, the
Gothic style was still to come, and the last quarter of the
12th century witnessed a short-lived style to which the
term Transitional is usually given. This Transitional art
abandons the Romanesque convention of decorative
surface patterns in favour of forms more closely related
to nature. This was not the result of a more intensive
observation of natural forms but rather an imitation of
models, chiefly classical and Byzantine, which are, by
comparison with the Romanesque style, far more
naturalistic. Just as there are some objects shown at the
beginning of this exhibition which are pre-Romanesque,
so at the end there are quite a few which depart
considerably from the canons of the Romanesque style.

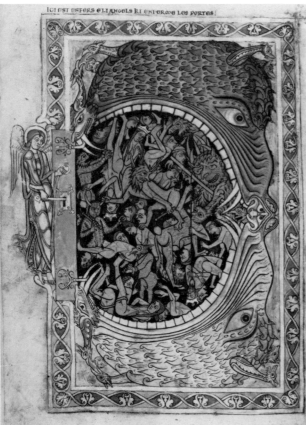

A vision of hell from the Winchester Psalter, c. 1150 (**61**).
British Library, MS Cotton, Nero C.IV, f. 139

The victory of Duke William of Normandy and his army in 1066 had similar consequences for English art and architecture as it had for political, social, economic and religious life. For some considerable time before the Conquest, the dukes of Normandy had turned away from their Viking past to become fervent supporters of church reform, and consequently, church building. Such abbey churches as Bernay and Jumièges were amongst the most advanced early Romanesque structures in Europe. In artistic matters, Normandy was in touch with the most creative regions of France, Italy, the Holy Roman Empire and Spain.

On the eve of the Norman Conquest, Anglo-Saxon England, having recovered from the recent ravages of the Vikings, was enjoying the peaceful reign of King Edward, himself half Norman. By appointing a number of foreign bishops to English sees, he had opened the door to Continental influences, especially from Flanders and the Empire and these, if allowed to continue, would undoubtedly have resulted in the eventual development of the Romanesque style in England. The royal abbey of Westminster, in which Edward was buried in January 1066, was already modelled on buildings in Normandy.

In the field of painting, Anglo-Saxon England continued to use the so-called Winchester School style, a misnomer since it was used not only in the capital city of Winchester but also in other monastic centres such as Glastonbury, Canterbury and Ely. The roots of this style are Carolingian but, in the course of time, the lively, light, dynamic, almost impressionistic forms gave way, towards the middle of the 11th century, to more solid silhouettes and heavier colours. This was clearly an evolution towards the Romanesque style, perhaps due to influences from across the English Channel.

The Normans had a great admiration for Anglo-Saxon book painting with its whole-page biblical scenes framed by rich borders of feather-like acanthus leaves. Robert, Abbot of Jumièges, appointed by King Edward to be Bishop of London in 1044 and subsequently Archbishop of Canterbury, made gifts of Anglo-Saxon books to his former abbey and this was certainly not an isolated occurrence. As a consequence of such gifts, the Winchester School style was well known in Normandy and had a strong influence on Norman painting and sculpture. But the dominant form of Norman book illumination, and the one which had a considerable impact outside Normandy, was the painted initial, which combined plant forms with human, animal and grotesque figures of arbitrary proportions and of great decorative inventiveness. Such initials became common

Miniature of St Andrew from a Troper, third quarter 11th century (3). The solid silhouette and heavy colours suggest Continental influences on English manuscript production shortly before the Norman Conquest. British Library, MS Cotton, Caligula A.XIV f. 30

William I in an initial of Norman inspiration from the *Chronicle of Battle Abbey*, early 12th century (13). British Library, MS Cotton, Domitian A.II, f.21

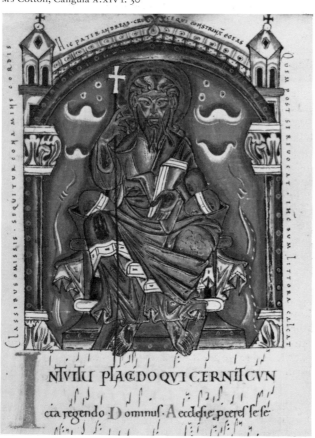

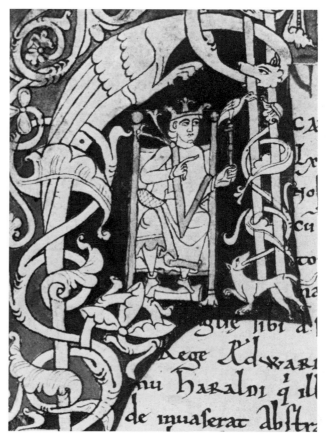

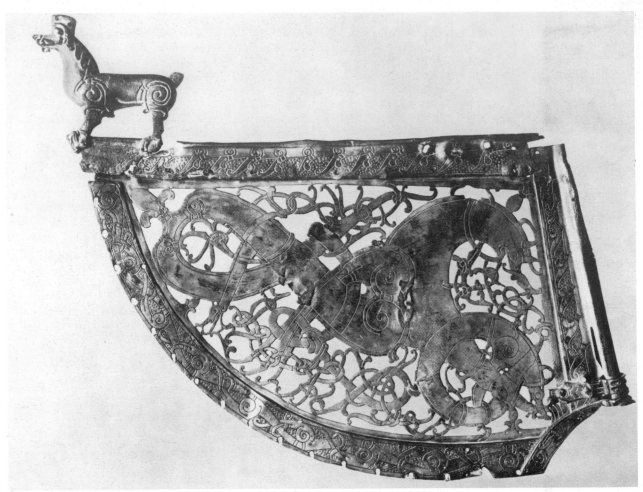

A weathervane in the Ringerike style from Heggen in Norway, late 10th century. Universitets Oldsaksamling, Oslo

in English book decoration after the Norman Conquest. Although the Winchester School style is best known in book illumination, it is also to be found in wall-painting, ivory carving, metalwork and even in large-scale stone sculpture.

There was, however, another artistic language in pre-Conquest England, but one with which the Normans were not familiar, namely the Ringerike. This was one of the Scandinavian animal styles which evolved towards the end of the 10th century. In it an animal, the so-called Great Beast, is interwoven with ribbon bands, creating a decorative pattern of great richness. The Ringerike uses foliage designs, a type of motif never previously found in Scandinavian art. The Viking settlers in England evidently came into contact with the Winchester School style in which foliage plays such an important role and incorporated it into their own art but, in the process, the Winchester acanthus is transformed into the thin stalks of a nondescript plant, terminating in small volutes. A Ringerike composition usually consists of the Great Beast and a snake entangled in asymmetrical, yet well-balanced foliage. This style gained some popularity in England, and not only in the regions of Viking

settlement, chiefly during the reign of Cnut, the King of Denmark and England (1017–35).

Thus, after their victory in 1066, when the Normans found themselves the sole patrons of the arts in England, they became heirs to complex artistic traditions. Their building activities are discussed elsewhere in this catalogue, but some comment must be made here on the decoration of buildings. On the exterior, sculpture was applied principally to doorways, corbel tables and string-courses, in the interior to capitals and to church fittings such as altars, roods, screens and fonts. While in earlier architecture a doorway is merely a rectangular or arched opening in the wall, a Romanesque doorway of any importance is recessed, with colonettes carrying capitals and crowned by moulded arches. These arches often enclose a tympanum, a semi-circular slab which offers an ideal field for sculptural decoration. No carved tympana existed in pre-Conquest England and those found in the 11th century are of Norman inspiration, usually decorated with modest, chip-carved geometric patterns. Geometric decoration, especially in sculpture, was extremely popular in Normandy and it was there that the chevron ornament was first applied to arches. It was

The sculptured doorway of Kilpeck Church, Herefordshire, c. 1140

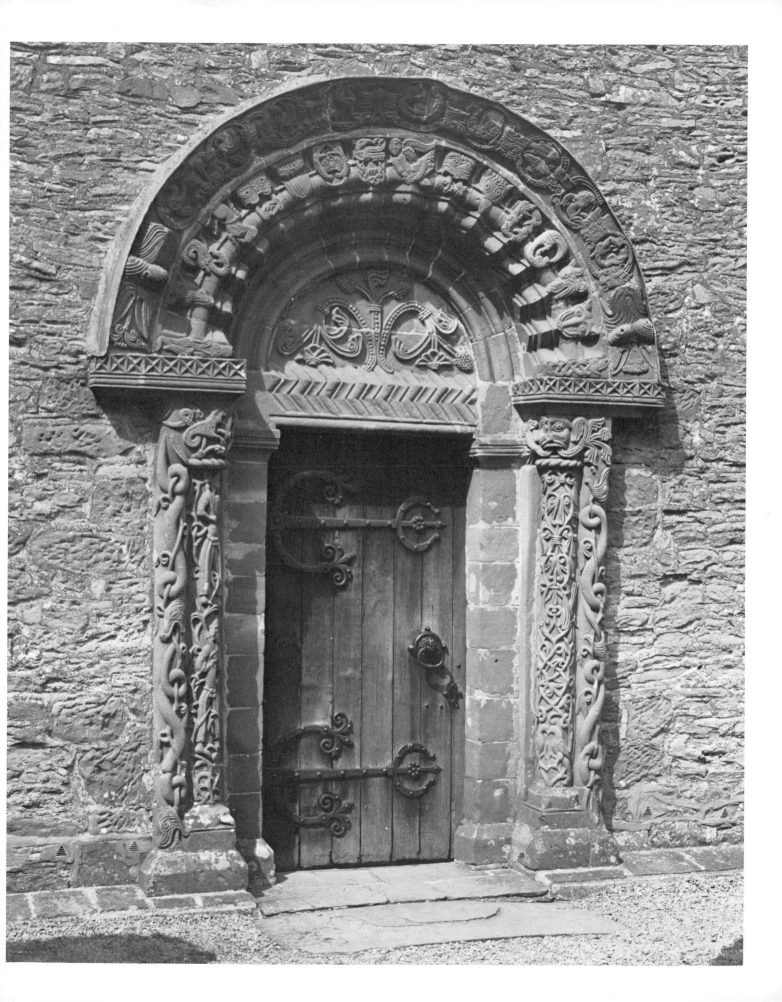

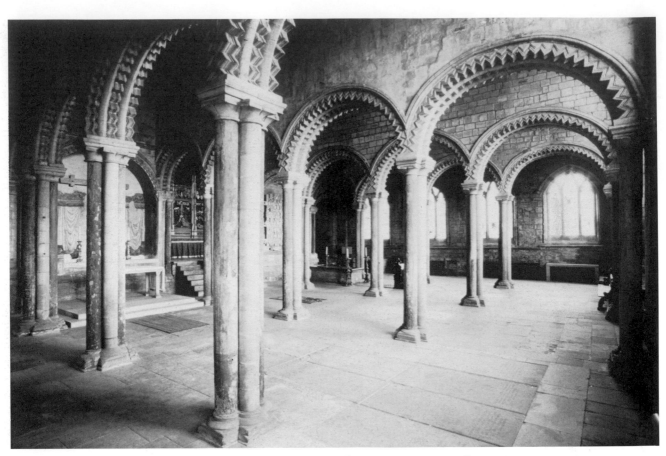

Chevron ornament on the arches of the Galilee Chapel at
Durham Cathedral, *c.* 1175

subsequently transmitted to England where it was used
throughout the Romanesque period and is found even in
early Gothic buildings.

The standard form of capital in Normandy at the time
of the Conquest was the simplified Corinthian, which
was frequently carved with geometric patterns, masks,
animals and even human figures, and similar capitals
were used soon after 1066 in a number of buildings in
this country. But by far the most popular form in
England was the cubic capital, unknown at that time in
Normandy and presumably introduced into England
from the Holy Roman Empire (**103**). It could be mass
produced and provided a convenient field for painting
and sculpture. Thus, almost from the start, the art
employed by the Normans in England differed in so
many ways from the art of Normandy, that the term
Anglo-Norman Romanesque is fully justified.

Every building of importance had glazed windows to
keep out the elements, and painted plaster on the internal
walls. These could be plain, but windows often
contained stained glass, walls were embellished with
murals and floors covered with tiles. No early
Romanesque windows survive in this country, no early
pavements and only a few murals which, for obvious
reasons, cannot be shown in this exhibition. The
examples of glass and tiles which are included are all

late. Romanesque wall-paintings are rare in any country,
for soot from candles and other dirt deposited on the
walls made their frequent cleaning or renewal a necessity
and, on the whole, only those re-plastered for subsequent
painting have survived. In England, the toll of
destruction at the time of the Reformation and later was
enormous. What remains, however, even in small rural
churches, is of a high quality. Some of the best-preserved
wall-paintings by English artists are abroad, one in
Normandy in the chapel built in 1160 at Petit-Quévilly
by Henry II, the other in the chapter house of the
Aragonese monastery of Sigena, founded in 1185 (**87**).
Murals covered not only the walls and the vaulting or
ceiling but also extended onto the sculpture. A few
fragments of sculpture in the exhibition (**152** and **171**),
which were buried in the 16th century or earlier, testify
to the vividness of the colours used.

The fittings in Romanesque churches were often
works of great beauty. The doors were enriched with
wrought-iron hinges and decorations, and a bronze
sanctuary doorknocker was sometimes attached. By
grasping it, a wrongdoer sought the protection of the
Church, accepting whatever penalty was imposed. The
altars were also lavishly decorated with frontals and
reredoses and there were crucifixes in stone, wood, ivory
or metal, not infrequently gold or silver, and studded
with precious stones. Nothing illustrates more
eloquently the losses suffered by English medieval art
than the lack of wooden crucifixes, of which there must

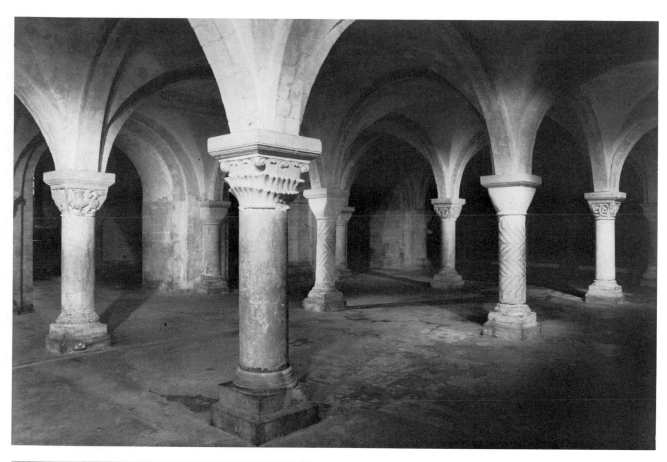

Corinthian and cubic capitals in Canterbury Cathedral, *c.* 1100

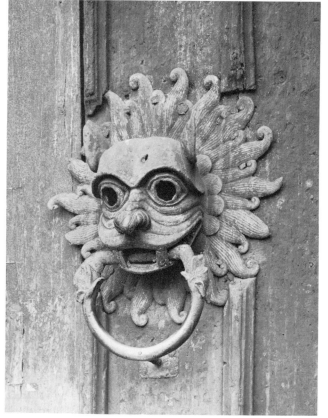

have been at least one in every church, but probably
many dozens in cathedrals and abbeys. Out of the
thousands of wooden crucifixes only one fragmentary
example survives (**115**). There were many other fittings
which were works of art – pictures painted on panels,
statues, carved or painted screens with large roods above
them, fonts, thrones and tombstones.

Little light filtered through the small windows filled
with stained glass and so the interior had to be lit by wax
candles. Large chandeliers and candlesticks, some of
wonderful workmanship, are mentioned in inventories
and the beautiful Gloucester Candlestick (**247**) is a small-
scale example of this type of object. A document tells us
of the seven-branched Easter candlestick of bronze at
Durham Cathedral which stretched the width of the
choir[5], and of several others, which were equally
impressive. The dim interior filled with incense, chanting
voices, loud prayer and ringing bells was more than just
a treasure house, it was a place of worship at a time
when faith, if not sophisticated, was intense and an
integral part of people's lives.

By far the most famous work of the early
Romanesque period is the embroidery, known as the
Bayeux Tapestry, commissioned by Bishop Odo of
Bayeux and made in Canterbury about 1070. Drawing

Bronze sanctuary doorknocker at Durham Cathedral, *c.* 1180

media – manuscript painting, ivory carving, metalwork and stone sculpture. In view of the Viking traditions in England, it is no wonder that the last two Viking animal styles, the Ringerike and the Urnes, found ready acceptance not only in a purely ornamental context, but also in religious art. The Urnes was the last of the native Scandinavian styles and had become firmly established by the middle of the 11th century. Its artistic vocabulary was, as in the Ringerike, linked to animal and plant forms interlacing in a complex and exciting way. The animal, often resembling a greyhound, is enmeshed in thin rope-like stalks of foliage, ending in minute leaves. Another favourite motif is a monster with a snake's body, but with a foreleg and a second leg taking the place of the tail. Both the Ringerike and the Urnes are represented in the exhibition by striking examples of stone sculpture from Ipswich, Norwich, Southwell and St Bees (121–4 and 126).

Apart from the secular narrative cycle which is displayed on the Bayeux Tapestry, early Romanesque art in England ignored story-telling and instead confined itself to decorative motifs, which included occasional figures. There is ample evidence that church leaders such as the two successive Archbishops of Canterbury, Lanfranc and Anselm, both scholars of great fame, were more interested in the texts of books than in their decoration. By the early 12th century there was, however, a marked change resulting in what one scholar has described as the 'revival of pictorial narrative'.[7] To some extent this could have been due to the influence of Cluny, that powerful mother-house of a vast monastic order which, during this period, led the way in elaborate liturgy, chant and prestigious church decoration. Since Henry I was one of the principal patrons of Cluny, the Cluniac way of life and the art of their monasteries must certainly have been known in this country, at least second-hand through the many Cluniac priories, such as Lewes and Much Wenlock. Reading Abbey, Henry's own foundation, was helped from its inception by Cluny. Knowledge of Continental Romanesque art, with its cycles of paintings and elaborate portals, must have been widespread as all the leading churchmen travelled frequently to Rome and visited each other for church consecrations or on Church business. The reconquest of the Holy Land by the Crusaders encouraged travel to the Near East, frequently through Byzantium. Pilgrimages to Jerusalem, Rome, Santiago de Compostela and numerous other places, which became so popular during the period, gave an added opportunity to a vast number of people to see churches and their decoration in many lands and sometimes on their return to try to emulate them.

The revival of the narrative in English Romanesque art is best seen in illustrated books, some of which clearly show a knowledge of contemporary painting in Flanders, Germany, France and Italy. With astonishing rapidity the fashion for luxurious Bibles, Psalters, the lives of saints, and other books became widespread, and some of the most important and beautiful illuminations

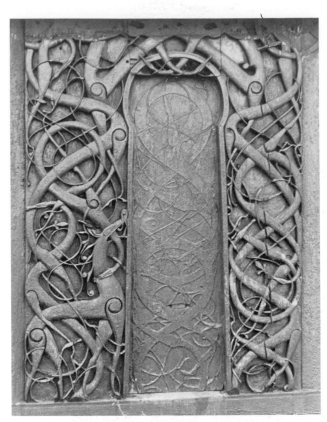

Wooden doorway of Urnes Church, Norway, mid-11th century. This church gave the name to the Urnes style

from both Norman and Anglo-Saxon traditions, it is an admirable example of some of the benefits of the Norman Conquest on artistic life, apart from being an important social and historical document. This epic, which has been rightly compared to the heroic contemporary epic poems known as *chansons de geste*,[6] is the only surviving narrative embroidery of the period, but it is known from documents that similar textiles depicting military exploits existed in Anglo-Saxon churches and houses. It is probably under the influence of such secular themes that the capitals in William Rufus' Westminster Hall were decorated with carvings which included the assault on a castle (105e).

There can be no doubt that the Norman aristocracy considered England a colony to be exploited but, in time, the position of the English population improved and its influence grew. The marriage in 1100 of Henry I to Edith, the sister of the King of the Scots, who through her mother was descended from the royal house of Wessex, encouraged the intermarriage of the two races and produced greater harmony. The English gradually filled many positions of influence and trust, the chronicler Eadmer being an early example of this, and their attachment to, and pride in, their English past must have helped the survival of many Anglo-Saxon artistic traditions during the 12th century. This is particularly noticeable in the use of the Winchester School style, notably the sketchy drawing technique and the characteristic acanthus leaves which are found in all

of Romanesque Europe were produced at that time in England. With very few exceptions, all these famous books are brought together in this exhibition. Biblical and secular narrative representations also became popular in other media such as metalwork, ivories and stone sculpture. In addition to traditional subjects new themes made their appearance, some inspired by liturgical dramas and mystery plays, others by the growing cult of the Virgin Mary, St George and other saints. In many cases such iconographic innovations were due to English artists and their ecclesiastical advisers and patrons, but England was also quick to adopt new themes from the Continent, such as, for instance, the Tree of Jesse.

These new artistic developments did not eclipse purely decorative motifs, for the English love of ornament was too deeply rooted to be suddenly abandoned. On the contrary pure decoration, whether grotesques, plant motifs or abstract interlaces, continued to be employed throughout the 12th century. In architectural decoration, the beak-head, that rather gruesome-looking enrichment of arches, was soon added to the already immensely popular chevron ornament.

During King Stephen's reign (1135–54), despite the civil war, Romanesque art blossomed into maturity. The hostilities must obviously have affected artistic activities, yet the works still in existence testify to the high standards in all media and to the lavish patronage. The king himself set an example by founding Faversham Abbey, like Henry's Reading, modelled in its observances on Cluny.

Beak-head ornament on the west doorway of Iffley Church, Oxfordshire, c. 1175

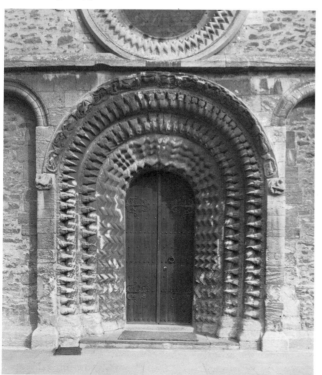

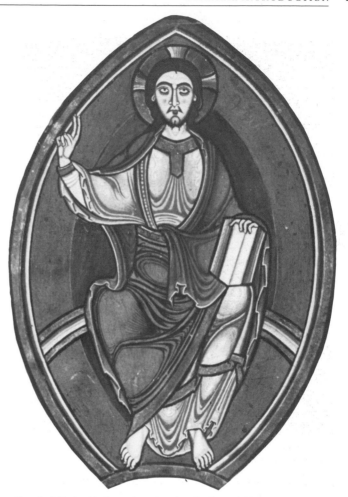

Detail of Christ, his draperies painted in the damp-fold style, from a miniature in the Bury Bible, c. 1135 (**44**). Cambridge, Corpus Christi College, MS2, f. 281ᵛ

In the early Romanesque period there were scarcely any stylistic differences between the art of various regions. This was the result of the wholesale importation of forms from Normandy to all parts of England. It was to take about two generations for regional styles to develop into something approaching French schools. But even then, family links, the travel of artists and many other factors made the exchange of ideas and the spread of new trends easy, with the result that very similar styles are found in widely separated places, such as Canterbury and Durham, Bury St Edmunds and St Albans, and Old Sarum and Lincoln. In many instances, regional styles affected only one medium but, in the majority of cases, the style found, for instance, in manuscript painting is also found in goldsmiths' work, stone sculpture, ivories and seals. If more wall-paintings had survived, they would, no doubt, reflect the contemporary styles in other media in the region. This close relationship between works in different materials was largely due to the practice, much more common than is realized, of the same artist being skilled in many techniques. The celebrated case of Master Hugo can be quoted in support of this observation. He was employed at Bury St Edmunds in the second quarter of the 12th century to

paint the Bible, one volume of which is in the exhibition (44), and he is recorded as the artist who made the bronze doors for the abbey and a wooden crucifix with the attending figures of St Mary and St John. He was thus an illuminator, bronze caster and carver and there is a strong likelihood that he also painted murals and carved reliefs in stone.

Master Hugo was an exponent of what is commonly called the 'damp-fold style'.[8] This is a method first used by the artists of classical antiquity, and was designed to show the correct form of the human body by clothing it with thin fabrics which cover its nudity and cling to it as if they were wet, revealing the body's form and movement. There are usually, in addition, some folds gathered into ridges which, while enlivening the surface, at the same time emphasize the roundness of the human figure. This subtle way of carving and painting was assimilated by Byzantine art and passed into Romanesque painting, first in Italy and then in the rest of Western Europe. Master Hugo was the first artist in England to use the damp-fold systematically and thereafter it is found in all media. It becomes, at times,

Byzantine-inspired Virgin from the Winchester Psalter, c. 1150 (61). British Library, MS Cotton, Nero C.IV, f. 30

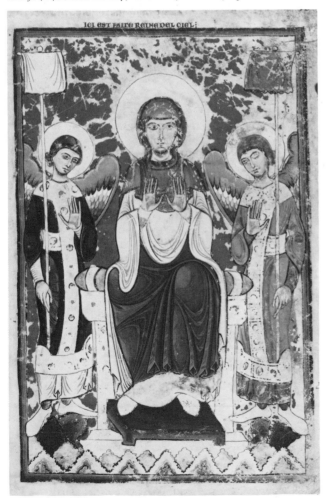

an almost riotous display of ridge patterns, giving the figure or scene a dynamic and expressive power, as in the Masters Plaque (275), and such manuscripts as the Winchester Psalter (61) and the Lambeth Bible (53).

The damp-fold was not the only debt Romanesque art owed to Byzantium for throughout the 12th century there were instances of Byzantine influences, either due to direct contact through travel or to the import of Byzantine objects. Such works of art as the relief of the *Virgin and Child* in York Minster (153) and the two Byzantine-inspired, whole-page miniatures in the otherwise entirely English Winchester Psalter are universally accepted as copies of Greek models, although views on when and how this came about differ. It will be seen subsequently that the Transitional style was also, to a great extent, indebted to Byzantine art.

Byzantine influences are only one aspect of the widespread contacts which England had with the Continent. Under Henry II's rule, England became part of the vast Plantagenet dominions stretching from the borders of Scotland to the Pyrenees. Not unnaturally, the artistic links with France became very close and England adopted a number of features which first evolved in French buildings. The screen-façade and doorway with radiating voussoirs became almost more popular in England than in Aquitaine from where they were derived. The use of column-figures in the doorways of St-Denis Abbey before 1140, although known to English sculptors, had a less enthusiastic reception, and this type of sculpture never really took root here. The reason for what almost amounts to hostility towards this monumental treatment of a doorway was the English preference for decorative, small-scale forms. The grand iconographic programmes of the French so-called royal portals made little impression on English patrons and artists for column-figures were only used in a few isolated cases. Although narrative sculpture did exist, it was not employed in the context of elaborate church doorways. To generalize is sometimes unwise, but it seems that the English love of decorative forms goes back to very ancient times, and this trait must have been reinforced by the influx of Viking settlers and the influence of Scandinavian art. The art of Normandy did nothing to change this for it was decorative rather than narrative. But even with the rise of pictorial narrative in the 12th century, purely decorative art continued to enjoy great popularity.

The screen-façade, so widely used in English Romanesque church architecture, did not encourage monumentality in decoration. Screen-façades in England, as in Italy and Aquitaine, employed multiple arches, niches, mouldings, occasional statues and reliefs, so that the overall effect was one of great richness. This was totally different from the treatment of façades in the Ile-de-France, such as St-Denis, where the stress was on monumental doorways.

The difference between English and French doorways is very revealing, though drawing general conclusions is made difficult since few Romanesque doorways survive

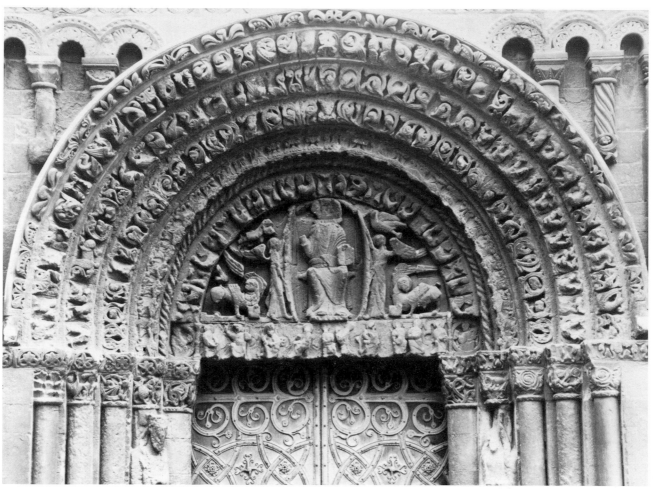

Radiating voussoirs on the west doorway of Rochester Cathedral, *c.* 1160

in English cathedrals and abbeys and, as a result, our knowledge is based largely on rural churches. Nevertheless, from the few examples in major buildings, it can be deduced that the main interest was in geometric or floral ornamentation and in grotesques. When large figures are employed, they are not in impressive rows such as in France, where they have a definite theological significance, but are used singly or in pairs. More frequently, however, the figures are small and carved in relief within medallions and resemble, in scale and delicacy, objects in ivory or metal.

The extravagant and dynamic damp-fold style, prevalent towards the end of Stephen's reign, gradually gave way to more restrained, gentler forms. The soft, flowing draperies envelop figures which are anatomically correct and whose movements are convincing and natural. Clearly, a new style was emerging to which, as has already been said, the name Transitional has been given. This style was derived from classical art, but it is generally accepted that the indebtedness is not direct, but through intermediaries, of which two are of great importance – Byzantine art, that heir to classical forms, and Mosan art, which is the art of the regions along the river Meuse where, since Carolingian times, the classical-inspired style had been endemic.

During the 12th century, Byzantium was accessible to Westerners who frequently travelled through on the way to the Crusading Kingdom. Byzantine art was also accessible in such centres as, for instance, Venice and Sicily. At that time Sicily, together with southern Italy, was ruled by Norman kings who, in the splendour of their art, emulated the Byzantine emperors of Constantinople, especially in commissioning Greek artists to execute mosaics in their churches and palaces. The links between England and Sicily in the 12th century were close, with a great number of Englishmen holding high office at court or in the Church. The culmination of these close ties was the marriage of the daughter of Henry II to King William II of Sicily in 1177. Contacts between England and the Mosan region were numerous and easy and artistic exchanges flowed in both directions. Mosan artists were famous for their goldsmiths' work, enamels, bronze casting and painting and the English readily absorbed their skills and style, adding to it their mastery of lavish decoration.

Mosan artists had adopted the dampfold style at the end of the 11th century and they continued to be receptive to Byzantine influences throughout the 12th. The region produced a number of talented artists whose

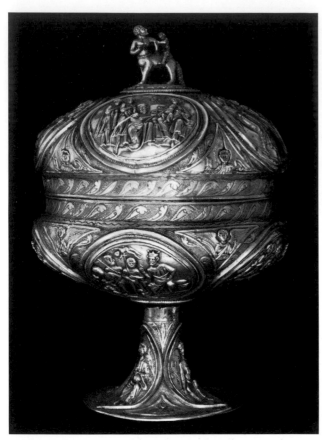

The St-Maurice d'Agaune ciborium, *c.* 1200–10 (**309**)

changes in many directions. An Anglo-Scandinavian nation became Anglo-Norman with a new language, institutions, culture and art. In the opinion of some modern scholars the Norman Conquest was an artistic disaster for it brought to an end the long and noble traditions of Anglo-Saxon art. However, this is not entirely true; many pre-Conquest art forms continued to flourish under the guise of the Romanesque style. Moreover the Conquest opened England to fresh and stimulating contacts with the Continent which resulted in a great blossoming of artistic life.

The monumentality of Anglo-Norman architecture, churches and castles alike, even in our age of technical miracles, is awe-inspiring. The skilful craftsmanship and artistry of the monks and lay artists produced masterpieces which, when they have not been subjected to deliberate damage or neglect, make us gasp with admiration over their technical perfection and beauty.

English Romanesque art was not only of local importance for it also exercised a considerable influence on the art of the Continent. As Normandy in the 11th century transmitted its artistic forms to England, so in the 12th the roles were reversed. But English artistic influences spread far beyond Normandy and, for instance, it has long been acknowledged that the splendid book illuminations of the Cistercian Order in Burgundy owe a great debt to English painting. Such instances of English influences on the art of the Continent can be multiplied. Most important is the emergence of Gothic architecture in France which is unthinkable wihout the daring experiments of Anglo-Norman architects.

The limitations imposed on this exhibition by what is available or what can safely be moved, mean that the picture it presents is incomplete. Nevertheless, the objects which are assembled will give a glimpse of the beauty of this distant and largely forgotten period. Ideally, a visit to the exhibition should be supplemented by visits to buildings, not only to the great cathedrals but also to small churches such as Kilpeck (p. 19) and Kempley (p. 51), the first for its sculpture, the other for its wall-paintings. There are still many Romanesque structures all over the country which will give enjoyment and enrich our experience. Enjoyment should, however, go hand in hand with greater care and better preservation of this precious heritage. Let us make this our aim.

names are recorded and whose works still survive. The greatest amongst them was Nicholas of Verdun, a metalworker who developed a very personal Transitional style.

English art of the late 12th century also produced some masterpieces which can be compared to the best on the Continent. The Winchester Bible (**61**) is undoubtedly the most famous but there are a number of other outstanding works, including the ciborium from St-Maurice d'Agaune (**309**), the ivory crosier of St Nicholas (**213**), some stone sculptures (**164** and **173**), stained glass from Canterbury and York (**88–94**), paintings from Sigena (**87**) and seals.

The time-span of this exhibition is just over 130 years, a period in English history which saw far-reaching

NOTES

 1. The term was first used in Haskins, 1927 (reprinted several times). See also Brooke, 1969

 2. This is a quotation from Raul Glaber (*c.* 985–*c.* 1046), a Cluniac monk and chronicler. The Latin text is given by V. Mortet, *Recueil de textes relatifs à histoire de l'architecture*, vol. I, Paris, 1911, p. 4. The English translation is given by E. G. Holt, *A Documentary History of Art*, vol. I, New York, 1957, p. 18

 3. W. Gunn, *An Inquiry into the Origin and Influence of Gothic Architecture*, London, 1819, p. 36 and p. 80

 4. A. Gasquet, *Henry VIII and the English Monasteries*, London, 1906, p. 409, note 3

 5. *Rites of Durham*, ed. Canon Fowler, *Surtees Society*, vol. CVII (1903), p. 10

 6. Dodwell, 1966, pp. 549–60: also Dodwell, 1982, pp. 134 ff

 7. Pächt, 1962

 8. Koehler, 1941, pp. 63–87

English Romanesque Architecture
Richard Gem

> With their arrival the Normans breathed new life into religious standards, which everywhere in England had been declining, so that now you may see in every village, town and city churches and monasteries rising in a new style of architecture.

So wrote the famous William, monk of Malmesbury Abbey, who was one of the greatest contemporary historians of the Anglo-Norman age – and one with a keen eye for architecture. William here rightly observed the coincidence of three events: the Norman Conquest of England; the 11th and 12th-century reform of the Church; and the development of Romanesque architecture. These three events were so interwoven in English history that it is easy to overlook their separate origins. But Romanesque architecture was indeed a distinct artistic episode in English culture, however much its development was facilitated by religious, economic and political factors.

The Conquest led to a prodigious outburst of building activity in England in the late 11th and early 12th centuries. Nearly every cathedral and abbey church in the land was rebuilt during these years (in addition to the great number of totally new castles). Then the arrival of the new religious orders and the construction for them of a new generation of great churches maintained the momentum into the second half of the 12th century. These buildings were on a lavish scale which still determines the size of most of our cathedrals, even where Gothic remodelling has replaced the original Romanesque work, and it was this scale which most impressed contemporary writers. On the other hand, we can observe for ourselves that English Romanesque architecture was more than an achievement of size and number. The surviving buildings display an originality and inventiveness of design (even deprived, as they are, of most of their essential coloured glass, wall-paintings and furnishings) which mark the period as one of the greatest in English architecture, and one where England can justly be seen in the forefront of European art. Yet the roots of this achievement are embedded in the Continent, and its continued fertilization also comes in part from across the Channel, so that if there is matter for pride herein it is not of an insular nature but rather a debt to a common European culture.

Romanesque architecture first appeared in Europe in the second quarter of the 11th century. It was not a single homogeneous style, but was constituted by several varying regional styles of which that in Normandy was an important representative. However, late Anglo-Saxon England in the main did not participate in the early development of Romanesque architecture, preferring its own pre-Romanesque traditions.

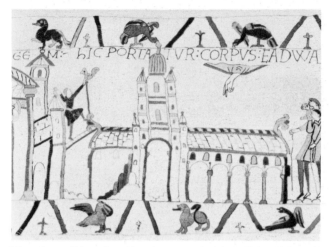

Westminster Abbey; the mid-11th-century church as seen in the Bayeux Tapestry

King Edward the Confessor's abbey church of Westminster (begun *c.* 1050) was the first building in the new style in England, but it did not represent the creation of an indigenous English version of Romanesque. Westminster drew directly upon the Early Romanesque style of Normandy – but transposed it onto a scale not paralleled in the duchy, and may in turn have influenced the great Norman abbey of Jumièges. In a sense, therefore, Anglo-Norman Romanesque had its beginnings before the Conquest; but at the time of the Conquest Normandy itself was turning from the Early to the High Romanesque style.

It was in two great buildings, at Caen and Canterbury, both under the rule of the famous Lanfranc, that the Anglo-Norman High Romanesque emerged. Lanfranc was a native of Pavia who became abbot of the learned Norman monastery of Bec; he was promoted to the new abbacy of Caen by Duke William, and then to the archbishopric of Canterbury by King William – now the Conqueror. The abbey church of St Stephen in Caen was begun in the early 1060s and its style was then adopted for the new metropolitan cathedral of Canterbury, *c.* 1070. Canterbury Cathedral, together with the famous abbey of St Augustine (begun *c.* 1070–73) in the same city, constituted the fountainhead of most English Romanesque architecture: but both buildings have been demolished (although the north-west tower of the cathedral survived into the 19th century, 548).

The two Canterbury churches and that at Caen epitomize the plan of a great 11th-century church (cf. p. 413). The *raison d'être* of the building was to house the high altar, perhaps with the associated shrine of a saint, and also the choir stalls for the community of clergy who

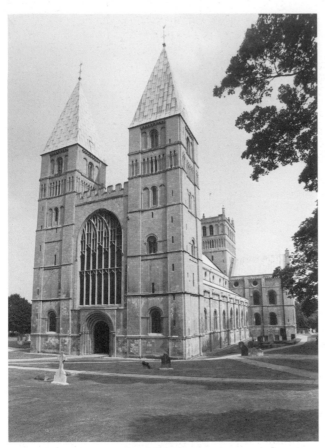

Southwell Minster; exterior from the south-west,
mid-12th century

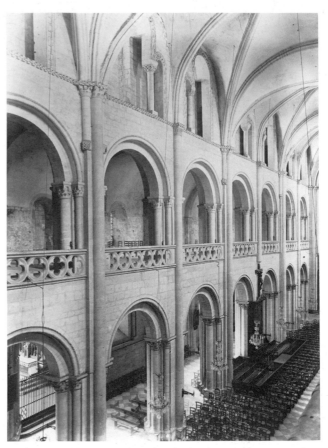

St Stephen's Abbey, Caen; nave, last third 11th century;
vault added mid-12th century

celebrated the liturgy. The altar and shrine were set in
an apse with an area for dignified ceremonial to the west
of it. Further west still were the choir stalls, over which
rose a lantern tower and flanking which were the
transepts. The transepts provided space for side chapels,
as did the aisles alongside the sanctuary. The aisles were
sometimes continued as an ambulatory around the main
apse and gave access to further radiating chapels (as at
St Augustine's). The nave was separated from the choir
by a screen, surmounted by a monumental crucifix and
by a gallery from which the Gospel was sung. The nave
and its aisles – which formed almost a distinct building
from the eastern parts of the church – would have been
unencumbered by seating and provided a clear area for
a standing congregation and for processions of clergy.
The main façade of the building was marked by a pair
of towers which provided a monumental accent in the
exterior silhouette, and balanced the crossing tower and
transepts in punctuating the long horizontal emphasis of
the main architectural mass. The exterior composition of
the building was a fairly conservative feature throughout
the period of Romanesque art, and the 12th-century
church of Southwell Minster still followed 11th-century
precedent.

It is not so much by plan and volume, however, that
the High Romanesque style is characterized, it is more
a matter of the composition of the internal elevations –

which may be seen in the surviving nave of Caen. There
is a three-storey elevation (aisles, galleries and clerestory
windows) built with massively thick walls, such that
passageways can run in their thickness. The nave is
divided along its length into bays by tall shafts rising up
the wall, and from bay to bay the design of the elevation
is repeated. Each of the main elements of the design is
itself built up from repeating units (similar columns,
capitals, mouldings, etc.), which in turn are constructed
with uniformly sized blocks of stone. The whole nave is
thus carefully articulated and depends upon the
principles of subordination and standardization both in
design and materials. These principles to some extent
reflect the technical advances and better professional
organization that developed with the Romanesque style.
The best stone quarries were being exploited carefully
and their products transported over long distances: for
example, for many buildings in England there came
shipments from the quarries at Caen. This trade must
have encouraged the preparation of the stone as much
as possible in advance to avoid unnecessary carriage, and
hence favoured standardization. The second factor is
that the increasing demand for buildings in the new style
created the opportunity for developing professionalism
in the mason's craft: skilled masons were constantly

St Albans Abbey (now Cathedral); north transept and crossing, c. 1080s

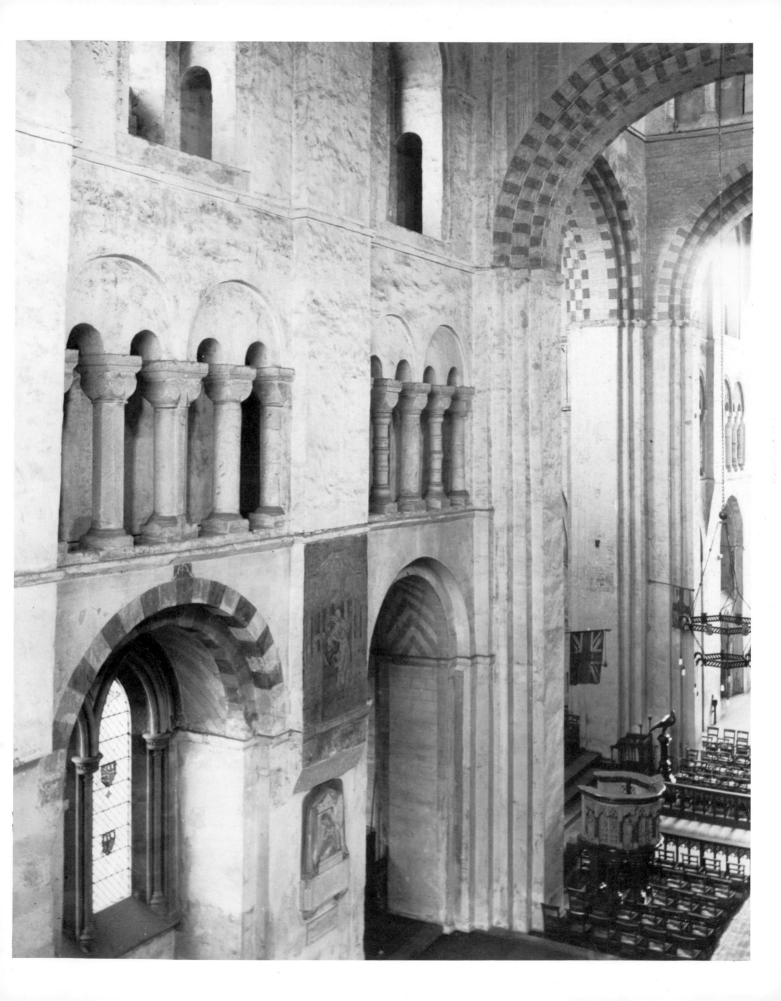

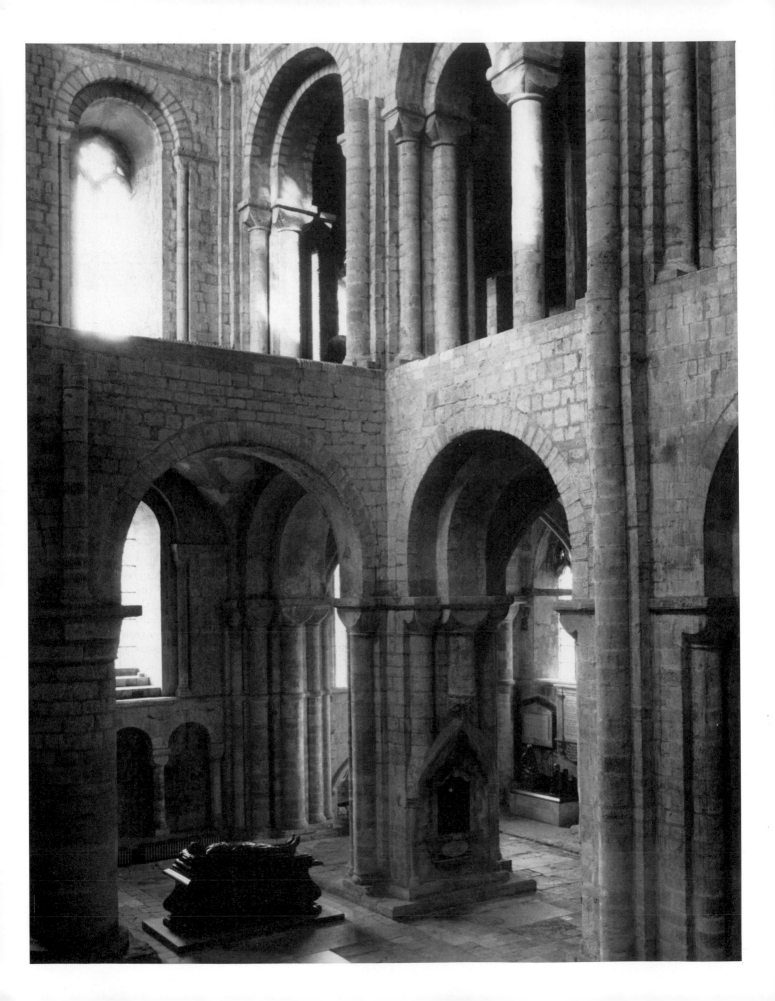

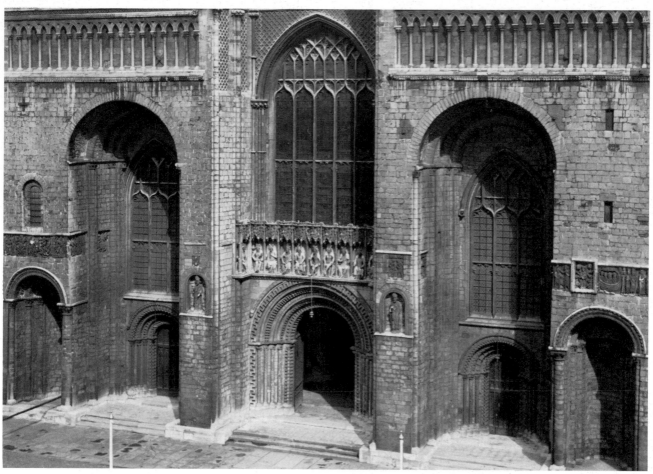

Lincoln Cathedral; the west front of *c.* 1090, incorporated in enlarged 13th-century façade

needed and could look forward to fairly secure employment where the greater their skills, the better their remuneration.

The names of some masons are recorded: Blithere at Canterbury, Robert at St Albans, Hugh at Winchester. These masons are the nearest equivalent to what we would call an architect, but they were essentially men with an applied craft training rather than a professional theoretical one. Design was not a process of preparing detailed scale drawings for a building in advance. The masons would determine the main dimensions according to mathematical and geometric rules of thumb handed down within the trade, and would lay out the plan therewith on site. Within this spatial framework the more detailed design would be evolved pragmatically following the master mason's guiding concept. Drawing of detail probably had only a limited role, although templates were designed and made for mouldings.

Of the numerous great churches begun in England in the 1070s and 1080s the most complete survivors are St Albans Abbey (p. 29) and the transepts of Winchester Cathedral, but neither is really typical of the lost

Canterbury Cathedral. St Albans (begun *c.* 1077 by Lanfranc's nephew, Abbot Paul) was built of stone but of brick salvaged from the ruins of the nearby Roman city, and this choice of a material, which did not offer the opportunity for cutting into elaborate mouldings or columns, imposed a sober rectilinearity on all the details of the design: the great crossing tower achieves through this quality a monumental gravity. St Albans illustrates one very important point about Romanesque architecture in England, as elsewhere, even at this early stage: the materials used for the construction, stone or in this case brick, were not intended to be left with their natural finish exposed. Brickwork or rubble stonework would be rendered with plaster, and both this and all dressed stonework would have been painted. Over large areas the painting might be no more than a white limewash with a masonry pattern drawn in red, but in some areas there was a richer use of colour – such as, presumably, in the lost painting that beautified the vault above the high altar of St Albans.

At Winchester (begun in 1079 by Bishop Walchelin) the design of the elevation is closer in style to Canterbury and Caen, but not the remarkably ambitious overall form of the building. In contrast to the comparatively modest dimensions of the earlier models, Winchester was planned to be one of the largest churches in Europe since

Winchester Cathedral; north transept, *c.* 1080s, with repairs of *c.* 1107

Roman antiquity and was intended to incorporate all the most elaborate features of contemporary Continental Romanesque architecture in France and in the German Empire (aisled transepts, a group of six or more towers, etc.). Behind the ambitious conception no doubt lay the drive of its patron, Bishop Walchelin. But were it Winchester or the less ambitious projects, it was the enormous scale of these new Romanesque churches in contrast with their Anglo-Saxon predecessors that made the most forcible impact on the imagination of contemporaries. Were we able to see Winchester complete we should no doubt be overwhelmed by the enormous spatial volumes and the dramatic towered silhouette: but only the transepts remain to give us an idea of this most telling expression of religious triumphalism.

Elsewhere in the late 11th century we can see a bishop with different preoccupations. Remi of Lincoln, obviously feeling a certain insecurity as part of the new Norman feudal establishment (he had taken part in person in the Battle of Hastings), decided to fortify his cathedral (begun in the 1070s, west front c. 1090?) to make it 'a strong church in a strong place, a beautiful church in a beautiful place: invincible to enemies as suited the times' (Henry of Huntingdon). His masons met this requirement by adapting existing traditions of church façade design in Normandy to more military

St John's Chapel, the Tower of London; c. 1070s

models and produced one of the most imposing designs of the period: a great screen of solid masonry, hollowed out in a series of monumental arches (p. 31).

The Conquest of 1066 had brought with it not only a new order in the Church but also a new military aristocracy which, to consolidate its hold, embarked upon a massive campaign of castle building aimed at providing strongpoints to control the population of both towns and countryside. William the Conqueror's own principal castle in London, the Tower (under construction in 1077), survives. With its magnificent chapel it shows, at its most elaborate, the form of great tower or *donjon* ('place of lordship') that was to become, in a simpler form, characteristic of the late 11th and 12th centuries. Such towers, however, were not places of normal everyday habitation and both castles and manors would be provided with more comfortable domestic quarters. At Richmond Castle (built before 1089) the domestic hall is set in one corner of the strongly defended site, while a later great tower rises over the gateway.

The great tower or *donjon* continued in importance through the reign of Henry I and several splendid examples survive. Of these, the still-roofed tower of Hedingham Castle conveys an idea of the increased architectural richness being brought to such buildings, helping to clothe the bare ruins of still grander monuments elsewhere. Among the latter is the lavish courtyard-plan palace at Sherborne Castle (**131**) built for the great Bishop Roger of Salisbury (1107–39) who was

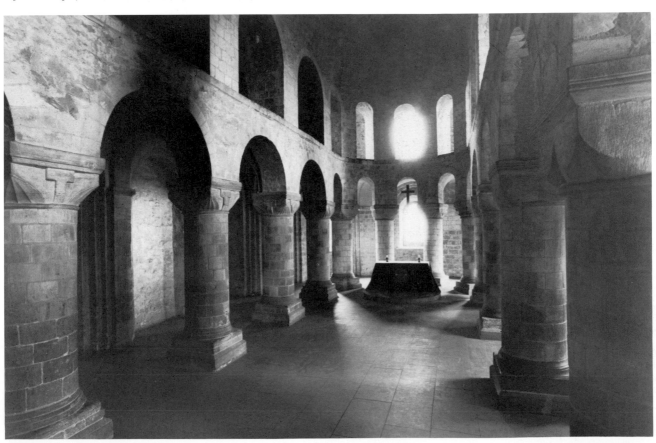

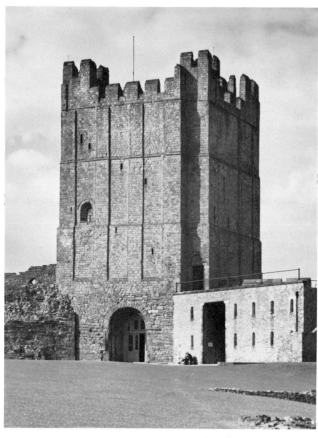

Richmond Castle; great tower, c. 1170

a minister of the Crown and one of the most powerful men in England.

It was in church architecture that the Anglo-Norman High Romanesque style reached its classic development with the extraordinarily prolific number of great buildings erected in the latter years of William II and during the reign of Henry I. The aesthetic aims of a major group of these buildings is well captured by William of Malmesbury's description of the new 'Glorious Choir' of Canterbury Cathedral, built c. 1095–1130:

> Nothing like it could be seen in England either for the light of its glass windows, the gleaming of its marble pavements, or the many-coloured paintings which led the wondering eyes to the panelled ceiling above.

It was an architecture not merely of volume and form but equally of texture and colour and light. This is difficult to appreciate today when so much has been destroyed: but in order to see Romanesque buildings as they were intended, visitors must be prepared to refurnish them in the imagination with wall-paintings and coloured glass, with sculpture and metalwork, with textiles and ceramics – otherwise they will see only a ghost of the original work of art.

The impact of this complex art form upon 12th-

Hedingham Castle; main hall, second quarter 12th century

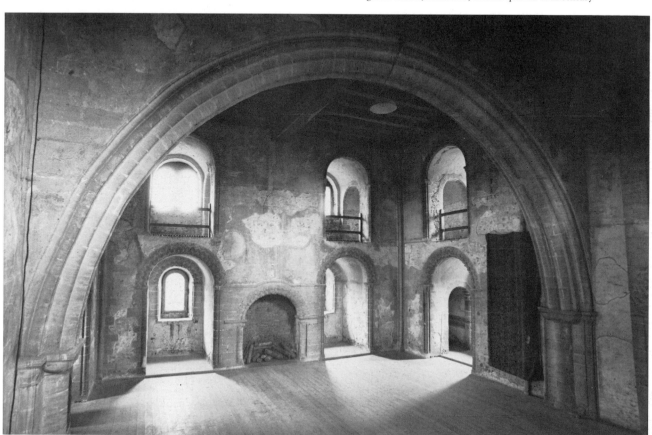

century contemporaries is indicated by William of Malmesbury's reactions to the paintings of Canterbury, to describe which he employs language that might be more expected in an amatory context:

> In the many-coloured pictures remarkable artistic skill, enticing the splendour of the pigments, quite carried the heart away; and the charm of beauty aroused the eyes towards the panelled ceiling.

Unfortunately little survives of the Glorious Choir except for the crypt (p. 21), dedicated to the Virgin Mary to whom devotion was growing fervently at Canterbury at this time. The architecture of the crypt achieves a delicacy of effect by means of the vistas of columns and vaults, subtly modulated by the shafts of light that fall erratically across them in the half darkness. The columns are provided with richly sculptured capitals that form an integrated counterpoint to the architecture. Some idea of the spatial effects of the lost upper choir may be conveyed by the elegant east arm of Peterborough Abbey (begun 1118) which may have been influenced by it. The Canterbury choir was begun in the archiepiscopate of St Anselm (though not directly by him) and was perhaps the quintessential work of art of the age of this great man, statesman and philosopher, theologian and saint, who left so significant a mark on the Europe of his day.

Although none of the original wall-paintings or glass remains at Canterbury, more or less complete contemporary schemes of painting survive perhaps associated with the Priory of Lewes which was the major house in England of the Cluniac monks – a reformed and influential congregation among the Benedictines. The Cluniacs became outstanding patrons and champions of Romanesque art and Lewes is likely to have been an important artistic centre (145). Unfortunately the priory itself does not survive, but in a group of smaller churches possibly decorated under its influence are to be found extensive series of frescoes. They are executed in natural earth colours, evocative of the soil to which these humble village churches stand so close, and show that even the more elaborate creations of Romanesque art were remarkably free from artificiality. At Hardam the subjects are principally biblical ones relating to the history of salvation, but there is also a series on the legend of St George reflecting the popular interest in this saint after his appearance to the Crusading army at the siege of Antioch in 1098. The paintings turn the church into a sacred theatre where the worshippers are imaginatively present amid the events of their redemption – while the same events are being commemorated sacramentally at the altar or the font. Within a larger, aisled, church the same participatory effect could not be created by paintings on the main walls, which were too far removed from the central area of activity. However, the enclosure screens round the choir – where the monks and canons sang the daily office which was at the heart of their life and of the building – seem to have been used in a comparable way for painted and sculptured narratives (the Durham Panels, 154a and b; and compare the cycles of narrative

Gloucester Abbey (now Cathedral); nave, c. 1100 and following; vault added in 13th century

paintings in Psalters that would have been used for the office, 17 and 61).

At Ely Cathedral only fragments of 12th-century painting remain, but the splendid 19th-century painted wooden ceiling gives a good idea of an otherwise lost class of work (though a 13th-century ceiling in the same tradition survives at Peterborough). Additionally Ely has a remarkable group of sculptured portals leading into the church from the cloister. Over the doorway of one of these is Christ seated in Majesty as judge of those who would enter Heaven, a subject which proclaims that the church building itself was intended to be seen as an image of heavenly realities. Nonetheless the Ely sculptures play a limited role in shaping the architecture of the building as a whole: they form, as it were, only an elaborate initial to the main text. This is no doubt so because it was the masons rather than the sculptors who were responsible for the main design. However, the masons' restraining influence on the role of sculpture should be seen in the context of the particular aesthetic effect they were aiming at through their own methods of design: at Ely a transformation of earlier Romanesque ideas was brought about through purely architectural means. The simple geometric shapes and unmoulded arches of the first style of the building (begun c. 1081 and deriving from Winchester whence came the Abbot, Simeon, brother of Bishop Walchelin) gave way in the transepts (c. 1090s) to more ambivalent geometric forms and to arches enlivened with delicate linear mouldings. It was a transformation perhaps meeting a particularly English taste and owing something to Anglo-Saxon precedents. Be that as it may, the new style created in the nave (c. 1100 ff.) one of the great works of English medieval architecture – dignified, yet full of liveliness, subtlety and gracefulness (p. 49).

Ely represents an elaborate variation upon the theme first established at Canterbury and it belongs recognizably to the same tradition. Elsewhere, however, the Canterbury theme was transformed, not merely in detail but in structure, to such a degree that a virtually new tradition was established. This was especially true in the West Midlands, first at Worcester Cathedral and then at the abbeys of Gloucester and Tewkesbury. At Gloucester (begun in 1089) the east arm retained the traditional aisle and gallery arrangement and combined this with stocky columnar piers at both levels. In the nave (c. 1100 ff.) the full galleries were abandoned and the great columnar piers were allowed to rise to a height commensurate with their girth – squeezing the middle storey of the elevation into a narrow band of decorative arcading. The whole design can be seen as tending to break away from the rather compartmentalized bay system in favour of treating the interior as a unified volume – an effect which must have been intensified when the building retained its 12th-century vaults.

Showing somewhat similar tendencies to Gloucester is the cathedral of Durham (begun in 1093, completed

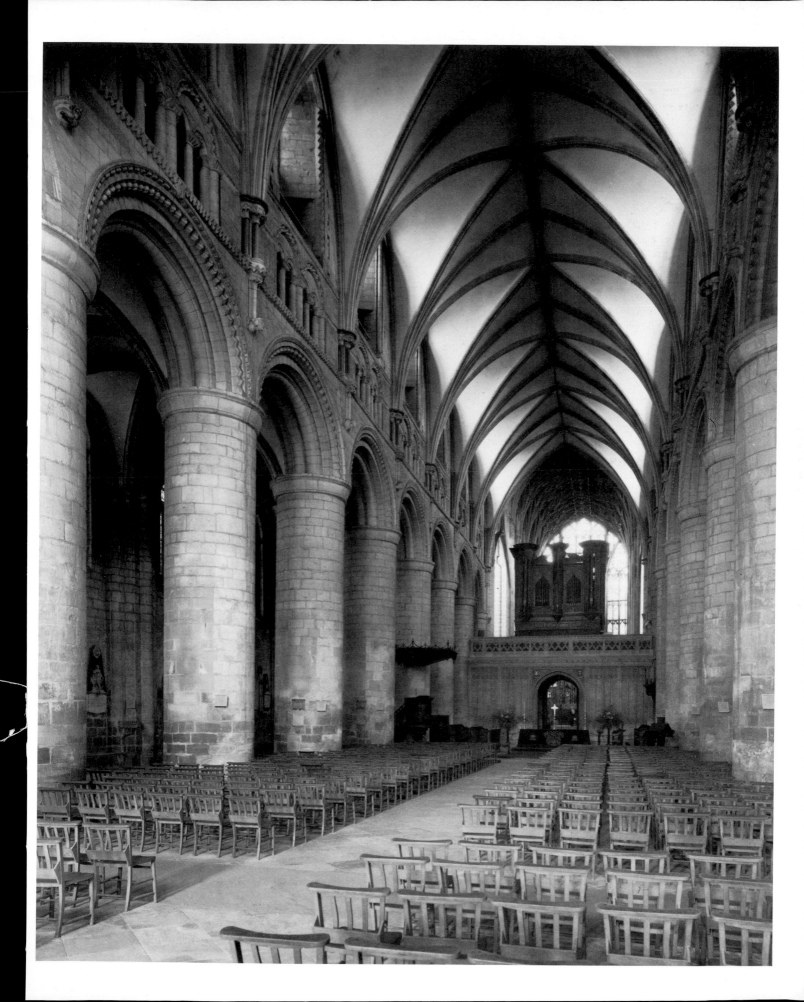

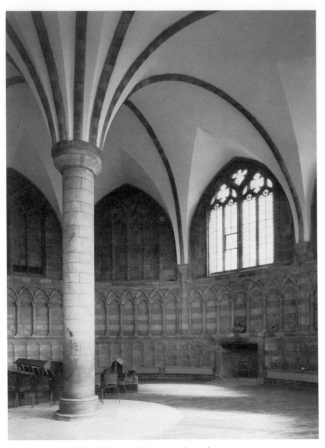

Worcester Cathedral; chapter house, early 12th century

c. 1130), though here the bay system was retained with alternating columnar and compound piers; the gallery also remained as a comparatively important element in the elevation (p. 50). Nonetheless, the columnar piers, with their surfaces sharply cut into by bold geometric patterns, create quite as much the effect of monumental gravity as do the piers at Gloucester. Durham is particularly remarkable, however, for the survival of its masonry vaults over the nave, transepts and aisles. Their historical position is difficult to evaluate because so much comparative material has been lost, yet they appear to represent one of the earliest attempts in Europe to cover a large building entirely with ribbed vaults. The diagonal ribs give the vaults a more pronounced role in the design than earlier vaults without such ribs, helping to integrate the vault with the two walls supporting it. The visual effect (whatever practical reasons, such as fire prevention, in addition to aesthetic reasons, may have occasioned the construction) is wholly different from that of the wooden-roofed tradition of Ely, and indicates a direction that was shortly to lead French designers to create the Gothic style. Not only in its main definition of volume and structure, however, does Durham contrast with Ely: the detailing also diverges, at least in the nave. Mouldings are not used to form a linear surface pattern, but to create a plastic fullness, penetrating the depth of the walls. The famous chevron ornament here,

as well as at Gloucester, should be seen in this context of a search for richer plastic effects, a search that also developed elsewhere in England as the 12th century progressed.

Durham has been regarded in modern times as the high point of English Romanesque architecture, not only for the technical achievement of its vaulting but also for its profoundly moving aesthetic quality. Given a superlative natural setting, the building rises above dark waters and verdant trees as the crown of a rocky and seemingly unapproachable eminence. The interior continues the mood with its heavy but dramatic masses of masonry and its tenebrous caverns of shadow, within the inmost recesses of which presides, from his resting place, the mighty St Cuthbert who takes us back to the womb of Christianity in northern England. It is a sublime experience which cannot fail to move the visitor. But at the same time we may wonder how far our modern reactions are conditioned by the Romantic movement and its legacy. We have no 12th-century accounts of the impression Durham made on contemporaries, but we do know that the architectural qualities which were most admired elsewhere were spaciousness, elegance, light and reverberant colour – not exactly the qualities of Durham, but pre-eminently embodied at Ely.

We should not seek examples of the architectural creativity of this period only in the churches, for the associated domestic buildings of the cathedrals and monasteries sometimes broke away from the constraints of the received pattern of straight ranges of buildings disposed around a rectangular though often richly decorated cloister court (**126, 127a-g, 134a** and **b** and **149**). Thus the early 12th-century chapter house of Worcester was built polygonal in plan and covered over by a vault carried on a central column – perhaps the moment of invention of this most picturesque form of English medieval building.

Many of the most important building projects of the reign of Henry I had been initiated before he came to the throne and continued into the 1120s and 1130s. These constituted such impressive and significant models that newer projects tended to conform to the general aesthetic that they had established, as, for instance, at Peterborough. This was why England failed to participate actively in the architectural current that *c.* 1140 was to transform the High Romanesque into the Early Gothic style in parts of France. Instead, there was an increasing elaboration upon Romanesque themes and this came to form a Late Romanesque style or, perhaps more accurately, a late phase of the High Romanesque style – there being no change in basic structural conceptions. Significant buildings marking the origin of this tendency to elaboration were probably Henry I's own great, Cluniac-inspired foundation of Reading Abbey (founded 1121; **127**), and the nearly contemporary eastern arm of Old Sarum Cathedral added under Bishop Roger (**130** and **135**), but neither of these buildings survives.

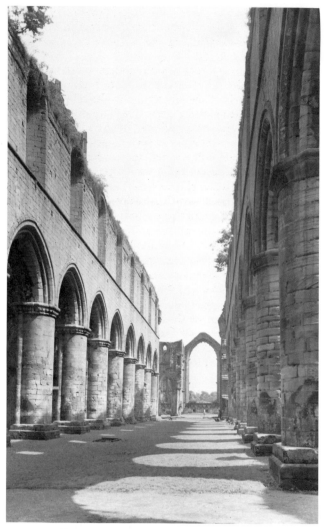

Fountains Abbey; nave, mid-12th century

Bishop Roger perhaps also started the rebuilding of Malmesbury Abbey church but only ruins survive of the earliest parts. The existing nave was probably erected under the French Cluniac Abbot Peter Moraunt (1141–c. 1158/9) and is one of the finest monuments of mid-12th-century English Romanesque. The basic structure does not diverge significantly from earlier English buildings except that it makes use of pointed arches – borrowed from Burgundian Romanesque architecture and not here significant of Gothic influence. The rich spread of decoration which clothes the building, on the other hand, is symptomatic of the new taste for increasing ornamental complexity. The range of forms is partly Anglo-Norman but includes many motifs introduced from Burgundy. The culmination of the sculpture is the south porch; parallels to its conception may be found in south-western France. But the biblical subject-matter of the sculptures derives in its iconographic treatment from Anglo-Saxon manuscripts, probably in the Abbey library.

The profusion of carved and painted decoration in major churches during the reign of King Stephen is to be found also in quite minor parish churches (for sculpture, see the Kilpeck doorway on p. 19 and 137–9). From one of these, at Kempley (p. 51) in Gloucestershire, an idea can be gained of polychrome treatment towards the middle of the 12th century. The chancel vault is painted in fresco with the vision of the Apocalypse, while other scenes appeared in the nave – a further reminder that the Romanesque church was seen by contemporaries as a representation of Heaven. At the same time the Kempley paintings show how the aesthetic impact of the architecture might be modified radically by polychrome treatment – both in the plain wall and vault surfaces and in the details such as chevron mouldings and capitals. In a context where architecture is an homogeneous natural colour, carved detail provides a richness of texture that stands out in contrast to the plain wall surfaces. In a polychromatic context, the unity of the carved detail is broken up and each element is related by its different colour to the wall surface where the same colour is repeated. The carving is thus integrated into a colouristic whole where differences of texture become accents rather than distinct passages in the composition.

A reaction against the increasing elaboration of Romanesque architecture can be traced back to the late 11th century but grew strong in the 12th century. The Anglo-Saxon Bishop Wulfstan of Worcester (1062–95) decried the new Romanesque style introduced to England in his lifetime on the grounds that it was vainglorious and that striving to erect such buildings led men to neglect God rather than serve him better: he preferred the simplicity of the saints of old. Wulfstan's ideas may have been symptomatic of a wider current of thought in England, but it was the new Cistercian Order of reformed monks, originating in Burgundy, that turned criticism into an organized programme. The Order legislated against 'frivolity', 'superfluousness', 'curiosity value' and 'variety' (perhaps often to be understood as polychromy) in the arts and it banished all figurative wall-paintings, glass and sculpture, as well as rich fittings, from its churches. Bitter denunciations of Romanesque art, especially that of the Cluniacs, were written by the great Cistercian theologians, such as the English monk Aelred of Rievaulx in a section of his *Mirror of Charity* based on St Augustine whom, however, he had failed to understand. The visual arts were a distraction from monastic contemplation and irreconcilable with monastic poverty; thus the Cistercian monk,

is happy enough to say his prayers in a little chapel of rough, unpolished stone, where there is nothing carved or painted to distract the eye; no fine hangings, no marble pavements, no murals that depict ancient history or even scenes from Holy Scripture; no blaze of candles, no glittering of golden vessels . . . and to be in a place where such things are will make him feel like one imprisoned in a dungeon of filth and squalor.

The Cistercians came to England from Burgundy in 1128 and their earliest churches were modest buildings

Orford Castle, begun 1165–6

where a virtue was made of a holy rusticity (cf. Eccles. VII. 16) such as suited the often remote places where they settled in search of a solitude where there would be no distractions from prayer and hard labour. But the enormous success of the new Order brought an influx of members, and with them the need for larger buildings. A considerable effort was made to retain, in the larger buildings, a severe simplicity of style, and this is well seen in the church of Fountains Abbey (c. 1145–60; p. 37). The elevation is of two storeys only; the piers are of plain columnar form; the arches and windows are without mouldings. Carved detail is restricted to the simplest capital forms. The interior was painted in plain white. The style of the building is a combination of basic Anglo-Norman traditions with ideas imported from Cistercian buildings in Burgundy (the plan, the pointed arcades) and as such makes a particularly telling contrast with the contemporary Malmesbury Abbey. Neither the religious nor secular establishment, however, was greatly moved by Cistercian views on art. The Abbot of Malmesbury must have been aware of the barbs aimed at the Cluniacs but chose to ignore them. Leading secular figures need not even have felt under attack – as, indeed, they were not, except very indirectly.

The more lavish secular buildings of the reign of King Stephen show a continuity with the early 12th century, as at Castle Rising, Norfolk, built for William de Albini following his marriage in 1138 to Queen Alice, the widow of Henry I. It followed closely a long-established tradition and was distinguished by little except its mid-12th-century detail. In castle architecture the great rectangular tower continued right through the reign of Henry II, even after the appearance of a new Continental influence shown in the polygonal tower of the royal castle at Orford, Suffolk (begun 1165–6). Distinct from such towers, the more domestic great hall also continued to follow earlier established patterns and was updated only in its decorative details, as in the sumptuous hall of Oakham Castle, Rutland (1180s or 1190s).

But the late 12th century saw a new phenomenon in domestic architecture: the construction of an increasing number of smaller stone houses for the wealthier merchants and members of the Jewish communities in the towns, for example at Lincoln. The bulk of housing in the towns and in the countryside must have continued to be of timber, however, and to have been of increasingly poor quality the further down the social scale its occupants were. Of 12th-century timber construction little remains standing except fragments; but there are some important exceptions to this generalization, such as the great barn for storing barley built for the Knights Templars at Cressing, Essex. The scale and sophisticated construction of this barn give some indication of the achievements of 12th-century carpenters – a group of craftsmen whose skills were

The Jew's House, Lincoln, late 12th century

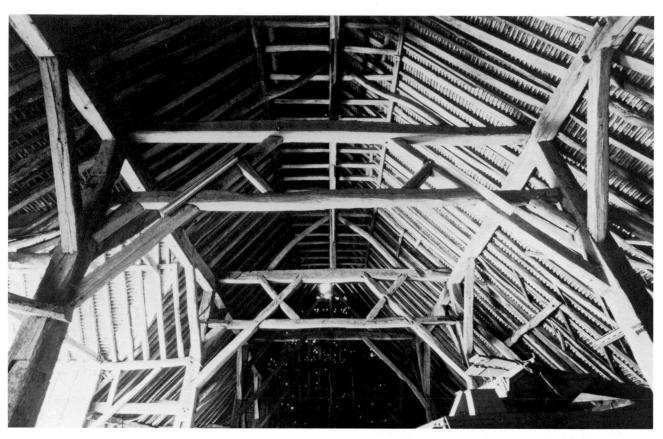

Cressing, Essex; barley barn, main posts and roof structure, probably 12th century

essential also in the erection and roofing of the great masonry buildings of the period.

The Templars were the patrons of one of the most important churches constructed in the reign of Henry II: the Temple Church in London (built *c.* 1161, dedicated 1185; p. 40). The building was a rotunda which, like other churches of the Order, was intended to imitate the Dome on the site of the Temple in Jerusalem (whence the Order, which was founded to help defend the Holy Land won during the First Crusade, took its name) and also the Church of the Holy Sepulchre (the focus of the Crusades). But though the Knights were first established under Cistercian influence, the London church is far from being a simple or rustic building: it is in fact highly elegant and one of the first churches in England that has some claim to be considered Gothic, despite its various Romanesque features. The main arcades with their quatrefoil marble piers, pointed arches and linear mouldings, together with the rib vaulting of the associated ambulatory, indicate the strong influence of northern French Gothic models.

Elsewhere in England in the 1160s and 1170s Gothic influences were starting to appear in the architecture of the religious orders (the Cistercians and the Victorines for instance, 163), and in architecture under episcopal patronage (for example, under Henry of Blois, Bishop of Winchester from 1129 to 1171, a noted connoisseur of

the arts; and under Roger of Pont l'Evêque, Archbishop of York from 1154 to 1181). But alongside these Transitional Gothic works there were others which remained more Romanesque in style while nonetheless sharing certain aesthetic concerns with the former. At Durham Henry of Blois' nephew Hugh, who was made Bishop in 1154, added a western Galilee Chapel (p. 20) to the cathedral and this, like the Temple Church, had elegant quatrefoil piers of polished Purbeck marble: yet the piers carried not Gothic arches but almost self-consciously Romanesque ones with elaborate chevron ornament. Around the altars were figurative paintings with a rich polychrome, including dark green, bright blue and purplish brown. Bishop Hugh also installed figurative stained-glass windows in the cathedral, but none survives (cf., however, the contemporary glass from York, 88–90).

The Late Romanesque was not a style confined to places far removed from possible Gothic influences deriving from the Continent, but was popular even in more metropolitan centres in the south of England. At Canterbury it enjoyed a flowering in the embellishment of the cathedral church and extension of the monastic buildings carried out under Prior Wibert (*c.* 1152–67) and shown in part in the famous drawing of Canterbury in Trinity College, Cambridge (MS R.17.1, 62). Like the Durham buildings, these were characterized by their richly carved ornament, by their use of polished marble and by the strong palette of the wall-paintings. The paintings in St Anselm's Chapel form part of a scheme

in which the comparatively plain masonry was enriched with polychrome decoration, and include a prominent scene (p. 51) in a style close to manuscript illumination, especially the Bury Bible (**44**). A comparable relationship to manuscripts is seen in the most sumptuous of all surviving Late Romanesque painted schemes in the Holy Sepulchre Chapel (*c.* 1175–85) at Winchester Cathedral, which relates to the work of the Morgan Master of the Winchester Bible (**64**; see also **64a** and **b**).

The great fire which destroyed a large part of Canterbury Cathedral in 1174 marked a turning point in English architecture. The monks of Canterbury felt that the loss of the Romanesque Glorious Choir was tantamount to being 'ejected from the land of promise, even from a paradise of delight' and they wished to see it restored as far as possible. But the rebuilding, which in the event almost wholly replaced the old work, was decisively Gothic in its architecture. This was not the first manifestation of Gothic in England, nor did it bring Romanesque to a sudden end: but its influence was significant in tipping the balance, so that, from *c.* 1180 onwards, the architecture of all the more important new projects was fully in the Early Gothic style. Nonetheless both Early Gothic and Late Romanesque were produced for patrons who, whatever their preferences in architectural style, shared common tastes in the other arts essential to the complete building. Thus in late 12th-century churches the sculpture, wall-painting and glazing often provide a unifying aesthetic theme that softens the architectural transition from Romanesque to Gothic.

Sculptures, panels of glass, metalwork and liturgical items, that formed an essential part of every Romanesque church, can be brought together in an exhibition; what cannot be transported is their architectural context. The designer of the exhibition has sought to capture some feeling of the monumental scale of major Romanesque buildings, yet the essential follow-up to the exhibition is a pilgrimage to some of the cathedrals and abbeys, parish churches and castles which survive from the 11th and 12th centuries. This pilgrimage is one with sure rewards, for the visitors will travel roads that lead to some of the most beautiful and inspiring buildings ever erected in this land. At the same time they will be exceptionally well prepared to understand the architecture when bearing in mind the images of colour and light, of texture and detail that form the central theme of the exhibition.

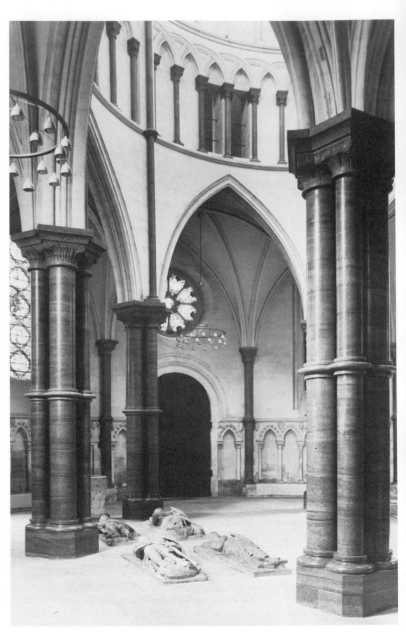

Temple Church, London; interior of rotunda, *c.* 1160

The Historical Background

Christoper Brooke

Do you see this ring?...
Do you see this square old yellow book, I toss
I'the air...?

Thus Robert Browning introduced the material evidence for the fascinating case of Count Guido Franceschini, the story of *The Ring and the Book*. In a similar spirit, though showing more care in the handling of books, our business is to evoke from rings and plaques and objects, small and large, from engravings, books and embroidery, the world which created English Romanesque, a part of the great cultural movement which we call the Twelfth-century Renaissance. The Bury Cross (206) and the Bury Bible (44) show us two elements of remarkable craftsmanship and art; the interior of Durham Cathedral (see p. 50) reminds us that for a while, in the 1120s and 1130s, the north of England was the centre of European fashion in the building of large churches.

The Twelfth-century Renaissance was a great movement of the human spirit in which religious values and secular tastes combined with learning and many of the arts in a revival in which were mingled ancient and distant inspirations – Roman, Byzantine and Islamic among them.[1] Yet the title is inexact. The renaissance began at the latest in the 11th century, and Romanesque art and architecture, our real concern, formed a part of it. In southern Europe it had no clear beginning and no end before the later Renaissance of the 15th century. So long as we grasp that the phrase has no precise meaning – yet represents a powerful movement nonetheless – we may look under its umbrella at some of the expressions of cultural revival of the age.

The word 'renaissance' was first coined for the revival of classical learning at the turn of the 11th and 12th centuries: the establishment of schools and incipient universities between 1050 and 1200 culminating, in England, in the foundation of Oxford University shortly before 1200 and of Cambridge soon after 1200. But the more closely this renaissance is studied the further it seems to reach; it affected many spheres of human culture and penetrated every corner of Western Christendom.

The English made their own contribution to Romanesque art and architecture, and English scholars and craftsmen played their part in historical writing, theology, law and letters. They included such representative figures as the great monastic chronicler Orderic Vitalis and John of Salisbury, humanist, letter writer, author and eventually bishop of Chartres.

The renaissance spread most obviously into religious life and flourished in a spectrum of new Orders. It blossomed in intellectual speculation, especially in theology and rising scholasticism; it bore fruit in secular literature – in the brilliant and original Latin lyrics of the 12th century, and the French, Provençal and German vernacular epics, lyrics and romances of the 12th and 13th centuries – and in building, sculpture, painting and all the minor arts. Its vigour is brilliantly symbolized by the men and animals which crawl all over the Gloucester Candlestick (247) – a rare survivor of early 12th-century English metalwork.

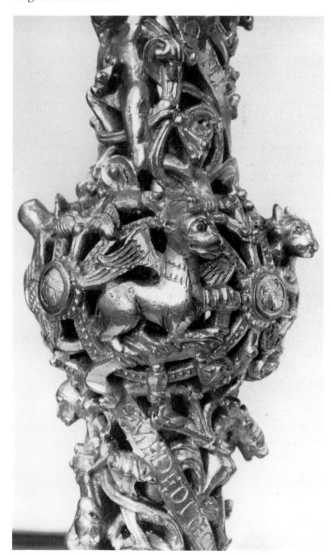

Detail of the Gloucester Candlestick, commissioned 1107–13 (247)

Romanesque is an element in all this. As a style it is described elsewhere; here we must place it in its setting – political, social, religious, and in the widest sense cultural, among the kings and bishops, monks and pilgrims, knights and serfs, of 11th and 12th-century England.

This exhibition has united objects usually scattered and can bring delight and instruction to us all, but it should also inspire us to become pilgrims to the churches and castles, spread over England and Normandy, which cannot be accommodated in an exhibition gallery; and it should take us to Bayeux to see the Tapestry.

The tapestry tells a story which is neither wholly 'Norman' nor wholly 'English' in outlook; it is embroidered in a style which reminds us that in drawing and design England and Normandy were one before 1066, and that in the artistic sphere the English had already 'conquered' Normandy. The tapestry was probably designed by an English craftsman working for a Norman patron (Odo, Bishop of Bayeux, the Conqueror's half-brother) which would explain its curious ambiguities and silences. Nevertheless, it is a masterpiece of narrative art and comes from a world of art and culture in which the Norman Conquest was only a ripple on a pool.

Stothard's engraving from the tapestry (551), copied with devoted care in the early 19th century, is hardly a substitute for the original. Yet, to the historian, this illustration is of greater value than the representation of the death of Harold in the tapestry at Bayeux, for the tapestry has been resewn since Stothard did his engraving, so his version shows the piece before it was restored – though we cannot be certain that Stothard saw the original rather than an earlier restoration. But if we inspect his vision of the tapestry we can see almost everything the most professional of historians knows about this decisive event.

The death of Harold from Stothard's engravings of the Bayeux Tapestry which were made before the 19th-century restoration and resewing of the tapestry (551).

On Saturday, 14 October 1066, Duke William's army advanced up the slope of the small hill on which Battle Abbey now stands.[2] Some of the battle's course is most vividly portrayed in the tapestry, especially its culmination in the death of Harold,[3] who had been anointed and crowned a few months before. Harold's death was one of the decisive moments in English history. It removed William's most powerful and dangerous rival, giving him a real chance not only of victory but also of successful conquest.

Once William I had conquered England, he settled Norman and other north French barons in almost all the major seats of power, as landlords, earls and sheriffs, and for the most part their protégés and friends were settled as bishops and abbots of the great monasteries. After his death in 1087, his realm was divided between his eldest son Robert, who held Normandy, and his second son William Rufus, who inherited England. After Rufus' death in 1100, Henry I, William I's youngest son, succeeded to England, and in 1106 he defeated his brother Robert – whom he kept a prisoner for the rest of his life – and so reunited the Norman empire of their father. Though it was in a certain sense hereditary, the English kingdom never passed to an eldest son or closest male relative between 1066 and 1189. When Henry I died it was one of his favourite nephews, Stephen of Blois, not (as he had hoped) his daughter Matilda, who succeeded; in 1154 the kingdom returned to Matilda's son Henry II; and in 1189 it passed to Henry II's eldest surviving son, Richard I, the Lionheart, the Crusader.

Henry of Blois, brother of Stephen, was another favourite nephew of Henry I, a man of cosmopolitan wealth and culture and one of the greatest art patrons of the Romanesque world.[4] Even though prince-bishops were rare in England in the Middle Ages, he is a symbol of that world: he united in his person the conventional devoutness of the great Burgundian abbey of Cluny, where he was nurtured, and the great house of Glastonbury, where he was Abbot; he enjoyed and enhanced the splendour of the richest bishopric in

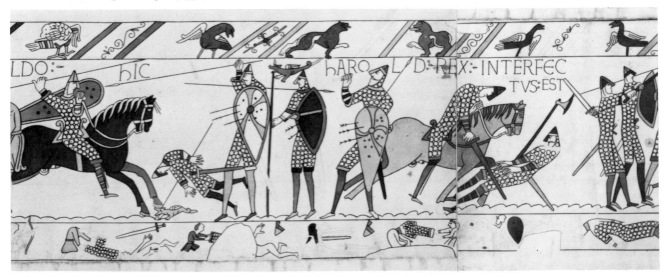

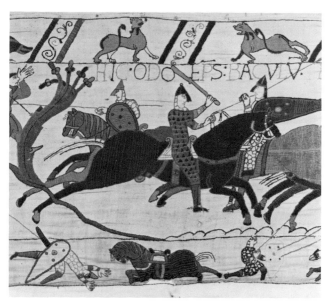

Odo, Bishop of Bayeux, fighting with a mace at the battle of Hastings, from the Bayeux Tapestry

England, that of Winchester; and he was a member of the Anglo-French dynasty which dominated half the Romanesque world (since Henry II sought to extend his empire right down into the south of France and even into Italy). He was deeply involved in the politics of King Stephen's reign, and able, by deploying the vast resources of his abbey at Glastonbury and his see at Winchester, to be a princely collector, a regal builder of castles and churches, and a noted benefactor to Cluny herself.

In his last years Henry of Blois became a peace-maker – uniting Stephen and Henry II in the treaty of Winchester of 1153, and attempting to reconcile Henry II and Thomas Becket in the 1160s. In earlier life he had been a warrior-bishop, notorious for destroying a large part of his own cathedral city. Yet he was far from being so secular a figure as the patron of the Bayeux Tapestry, Bishop Odo, the Conqueror's half-brother, who appears in the tapestry in full armour wielding a mace, however, rather than a sword, by a rare adherence to contemporary rules. The varied and shifting role of a medieval bishop is remarkably illustrated in the famous Lewis Chessmen (212) which represent English or Anglo-Scandinavian fashions in the mid-12th century. Chess was a war game and the pieces are a true representation of a social hierarchy which was military to the core, in which king, barons and knights were at once rulers and landowners, soldiers and cavalry officers.

To the role of king, the rituals by which kings were made, and the structure of kingship, the Norman Conquest made little difference at first, nor did it fundamentally alter the role of bishops and abbots. The most immediate change lay not in the offices but in the men: Normans and north French, and even a few from further afield, replaced all the leaders of English society; by the end of the Conqueror's reign only one English bishop and a tiny handful of secular leaders survived. In

human terms it was a mighty revolution. In an obvious sense England entered Europe: William brought links with northern France and a deep involvement with French politics which lasted for many generations. His barons brought a hierarchical structure of military service and a type of landholding which we call feudal (a word easier to utter than to define), which made the Norman aristocracy as visibly members of an Anglo-French social world as the dialect of French which they spoke. After the Conquest the Anglo-Norman social hierarchy united to foster new fashions – in ecclesiastical practice and reform spreading from Rome, and in church architecture. Also novel were their modes of military organization and technique, culminating in the building of great stone castles whose structures were developed equally on both sides of the Channel after 1066. We cannot build a castle or a church in an exhibition gallery, but we can show Cotman's vision of Castle Rising church (540, 541) and Girtin's of Colchester Castle (525), an immense monument of changing military needs and fashions of the 12th century; and we can show an engraving of the priory church of St Julian and St Botolph at Colchester (524; p. 44) to remind us of changing fashions in architecture and the religious life in the late 11th century.

Yet all was not new. For instance, the cult of St Botolph, an English saint, was fostered by both the newly-arrived Norman canons and their English colleagues.[5] Among the peasantry the Conquest made little difference, anyway at first; in the towns the English citizens continued to predominate – and the towns grew and flourished even if they had to accept some destruction to make way for Norman castles and

The west front of the church at Castle Rising; etching by John Sell Cotman, 1813 (541)

St Botolph's Priory, Colchester; engraving by
R.B. Godfrey, c. 1786 (524)

Norman overlords. But in the long run they prospered,
as did towns in every part of Europe in the 12th century:
the local changes brought by the Conquest were
swallowed up in the larger movement which we
sometimes call the urban renaissance, which affected the
cities and the economies of every land from Italy and
Spain to Scandinavia. So too with the peasantry: before
the Conquest the English peasantry knew more of
freedom and far more of slavery than their French
contemporaries; the Normans completed the freeing of
the slaves but reduced the great bulk of the population
to serfdom, that is tied them to the soil of their masters'
estates. They were subservient to a warrior aristocracy
which, if not different in its fundamental nature from
that of the Anglo-Saxons, was more highly organized for
war and oppression than the latter ever were.

Three great monarchies dominated northern Europe
in the 11th and 12th centuries: those of the German king-
emperors – rulers of the Holy Roman Empire (which
combined the kingdom of Germany with extensive
traditional authority in north and central Italy), the
French, and the English. None of these covered quite the
territory of their modern successors. Germany included
part of the Low Countries and Lorraine; south-eastern
France, east of the Rhône, lay in the Empire rather than
in France; and Germany's eastern frontier, in central

Europe, saw many fluctuations. From 1066 till after 1200
Normandy was commonly a part of the Anglo-Norman
empire, and from 1154 Henry II's realm stretched down
into Aquitaine, to the gates of Toulouse. The English
monarch also ruled part of Wales, laid claim (from the
mid-12th century) to Ireland and to some measure of
suzerainty over Scotland.

Elsewhere in Europe, there were kingdoms in Spain,
chief of them Castile – spring-board for the reconquest
of the Iberian peninsular from Islam; and from the 11th
century there was a Norman empire in southern Italy
and Sicily, remote in distance from its roots in
Normandy but often enjoying close links with
Normandy and England through family ties, trade and
the arts. City republics were also coming into being,
especially in northern and central Europe; and in the
heart of what we now call Switzerland the peasant
communes, from which the original forest cantons were
to spring, were already forming by 1200.

The summit of earthly authority was normally
reckoned to reside in kings, but in the 11th and 12th
centuries the old secular monarchies faced a formidable
rival in the new spiritual monarchy of the papacy.
Following the papal reform in the mid-11th century the
authority and influence of the popes widened and
deepened. In a sense it is paradoxical to call the papal
monarchy new: the papacy was far older than any
Western monarchy save perhaps the Holy Roman

Empire, whose roots could be found in the ancient empire of Rome. The Pope's claims were almost as old as the Christian Church; his Church looked to the promises of Jesus to St Peter for its foundation. Yet before the 11th century the papacy had been more truly a primacy than a monarchy. Now it became a universal spiritual monarchy, covering the whole of Western Christendom, its cosmopolitan character symbolized by the elevation to the papacy of Germans, Frenchmen and one Englishman, Nicholas Breakspear, Pope Adrian IV (1154–9). Papal reform brought no fundamentally new principles, no original theology into its wallet of authorities, and even in legal principles the reformers claimed to enforce and not to invent the law. Yet the attempt to realize the papal claims in their entirety, to shoulder all the burdens of universal spiritual monarchy, to use the Papal Curia as a base for the reform of Christendom – this was new. In the period from 1066 to 1200 relations between Rome and the English Church were determined far more by the changes in the structure of the papacy than by any changes in the English Church which resulted from the Norman Conquest. Over the years much practical compromise eased the relations between monarchies temporal and spiritual, but from time to time there was conflict. On various issues Anselm, Archbishop of Canterbury (1093–1109), found it difficult to agree with William II and Henry I and he spent many years in exile; so also did Thomas Becket whose conflict with Henry II came to a dramatic climax when four of Henry's vassals murdered Thomas in Canterbury Cathedral on 29 December 1170.

Fundamental to the culture of the British Isles in the late 11th and 12th centuries was a remarkable growth in the number and variety of monastic orders and houses. The traditional monasticism of Cluny and Glastonbury, which enshrined St Benedict's Rule enriched by the liturgy, music and colour of 10th-century monasticism, had grown, and was still growing, in the late 11th century; but by its side appeared a number of new models, all owing much to traditional monasticism, each adding its own colour to the spectrum.[6] Most famous of these was the Order of Cîteaux, one of whose founders was St Stephen Harding, monk of Sherborne, later third Abbot of Cîteaux herself, under whose inspiration even in that austere abbey charming book illuminations showing a marked English influence were to flourish. Less famous but also of much influence in England was the monastic reform, austere yet with an immediate appeal both to recruits and patrons, of Vitalis of Savigny. From Savigny grew such daughter houses as Furness Abbey, the great house in Cumbria founded by Count Stephen, later king, and the modest house of Buildwas by the Severn in Shropshire. Furness, Buildwas and all their sisters later joined the Cistercian Order.

Buildwas Abbey (529) is a piquant expression of many of the themes of this age. Originally a daughter of Savigny, almost all that we now see reflects the local version of Cistercian building of the mid and late 12th and early 13th centuries – universal in its mode, plain,

Buildwas Abbey; drawing by J.M.W. Turner, c. 1795 (529)

simple, but extremely solid. Built for eternity, it housed at most 20 choir monks and perhaps three times that number of lay brothers, illiterate folk who took monastic vows and performed most of the practical tasks of the community from farming to craftsmanship. Here we meet the aspiration of contemporary monasticism to solitude and self-sufficiency, the spirit of St Bernard of Clairvaux. We see also a sophisticated building programme designed to offer a plain, commodious setting for monastic worship free from the distraction of contemporary ornament, with arches deliberately lumpish and unadorned, solid, well-built rooms and an efficient water supply and drainage which marked, both in taste and technology, the most advanced practices of the mid-12th century.

In other religious orders the concern for solitude and plumbing was less pronounced. One of the main impulses of the 11th century was a return to the hermit ideal of the desert, and there were many hermits in England in the 12th century. But the Carthusian Order of organized hermits only impinged in the single house of Witham, celebrated more for bringing St Hugh of Avalon and Lincoln to England about 1180 than for its impact on Somerset or England in that age. The love of the desert could be satisfied by entering a Cistercian house, for to the romantic minds of the early Cistercians a quiet, lonely spot by a river was 'the desert'. As St Bernard himself said, 'you will find among the woods something you never found in books: stones and trees

will teach you a lesson you never heard from masters of the schools'.[7]

Even more popular with patrons, and equally so with recruits, were the orders of canons: the Augustinian, whose houses were often ancient churches converted to conventual uses, carrying large pastoral responsibilities with them; and the Premonstratensian, whose founder had been a German missionary and a friend of St Bernard, and whose Order became almost indistinguishable from the Cistercian in the impulse to solitude and way of life. The canons followed the rule of St Augustine, as the monks followed the rule of St Benedict; the canons were widely reckoned more practical folk, less inward-looking, more involved in pastoral work. But indeed the difference was often slight, and bewildered contemporaries as it bewilders us.

The Augustinians themselves embraced some variety. The church of the Holy Sepulchre at Cambridge was probably built for an ephemeral order of canons dedicated to crusading ideals – rapidly overtaken by the more prestigious Orders of Knights who represented the Church militant in its most extreme form in the heyday of the Crusades.[8] At the other extreme, houses like Llanthony, hidden away under the Black Mountain on the borders of Wales, was a site fit for any Cistercian; Shobdon, later Wigmore Abbey in Herefordshire was a daughter house of St-Victor in Paris and a link with one of the greatest centres of biblical scholarship of the day. St Frideswide's in Oxford is one of the most characteristic: a great town church in which citizens and canons met. Such too was St Botolph's at Colchester. In the mingling of layfolk and religious community was preserved for a time one of the fundamental impulses of traditional monasticism, which is the key to much that is most characteristic in Romanesque architecture.

Large Romanesque churches are of enormous size – with ground plans and length scarcely, if ever, surpassed in the history of church building – and largest of all are their naves. The Normans had conquered England by force and utter ruthlessness; but most of them seem sincerely to have believed that immense generosity of a material kind would be pleasing to God and help their souls on the difficult, almost desperate, journey to heaven. If we contemplate the grandiose ambitions and gargantuan sins of the Norman conquerors, or of the more worldly Norman bishops like Ranulf Flambard of Durham, we can understand why Winchester Cathedral came to be so long and Durham so spectacular. If we look deeper into the heart and see a sincere religious impulse to provide God, the saints, and the religious communities of these churches with fitting homes, we can learn more of their planning.[9] But, though God might be everywhere, he was especially upon the high altar in the presence of his body and blood in the Eucharist; if the saints were in heaven, their bones were in shrines and reliquaries, commonly behind the high altar, almost never in the nave; if the religious communities sometimes processed in the naves of their churches and found space there for minor altars, their

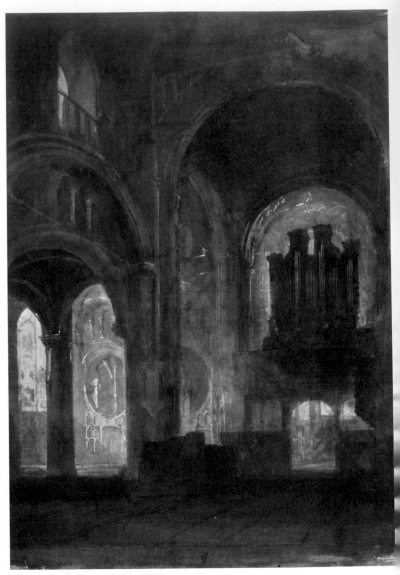

Interior of Christ Church Cathedral (formerly St Frideswide), Oxford; watercolour by J.M.W. Turner, c. 1800 (531)

home was in the stalls and at the altars of the choir and sanctuary. Why, then, the nave? Those who created these buildings would explain the purpose of the nave, no doubt, in various ways, but a major purpose must have been to house the laity: it gave them shelter in a world without other public buildings, a place for meetings, councils and gatherings of all kinds, even for playing games in wet weather, but above all it enabled throngs of visitors, especially layfolk, to join from time to time in the work and worship of the cathedral.

If we ask whether the laity liked to worship in large churches the answer must be no, or not normally, for the most characteristic types of Romanesque parish church, where most people worshipped most of the time, were small boxes, splendidly represented by the church at Barfreston (512), exceptionally ornate but modest in size. There were many larger parish churches or churches of modest religious communities, but in the domestic

intimacy of a small church most 12th-century English people met their priest and their creator. Yet on occasions – at Pentecost when their clergy led the faithful to the cathedral or another great church, on the festivals of the local saints, at times of rejoicing or of special danger – they flocked to the large church. The faithful of East Anglia gathered in Bury to see the relics of St Edmund, king and martyr, and be cured at his shrine, or of St Etheldreda, queen and abbess, at Ely. If we consider the drawing of the Romanesque screen in the nave of Ely (518), which is the only great English Romanesque screen whose form we know, and see in imagination the great shrine of the saint, we may learn much of popular devotion in the Romanesque world and understand why so grand and beautiful a nave (p. 49) was built as the culmination of an immensely ambitious building scheme on the island in the fens where Hereward the Wake had made his stand against the Norman conquerors.

'I Richard's body have interred new,' said Shakespeare's Henry v in expiation of his father's fault in usurping the English throne. So the builders of Ely and Winchester could say that they had given two of the most favoured Anglo-Saxon saints new homes and won from the saints their approval of the new regime. But the greatest of all the shrines in the late 12th century was in honour of a new cult: it commemorated the murder of Thomas Becket in his own cathedral at Canterbury. When the earliest surviving copy (72; p. 48) of John of Salisbury's narrative of the event was written and painted in the late 1170s preparations were already being made to rebuild the cathedral choir of Canterbury in a Gothic manner. Styles changed, but sentiments lived on.

Hubert's ring (324c) comes from the grave and the finger of Hubert Walter, Archbishop of Canterbury from 1193 to 1205, at various times chancellor and justiciar of the realm, and papal legate. Richard I being away from

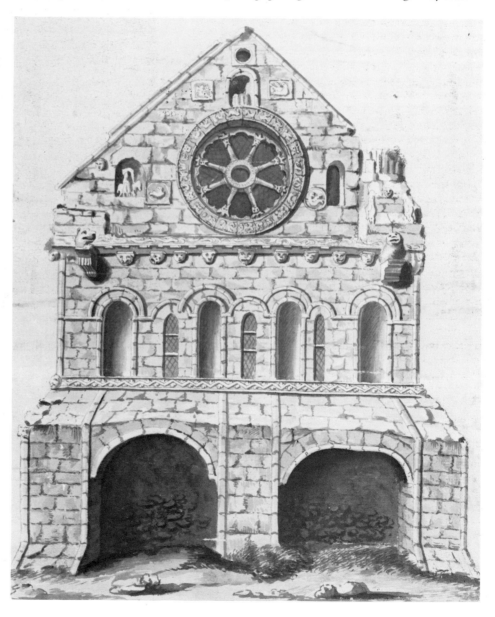

The east front of Barfreston Church from the 'Book of Drawings of Saxon Churches' compiled by Charles Lyttelton; pen and wash, 1749 (512)

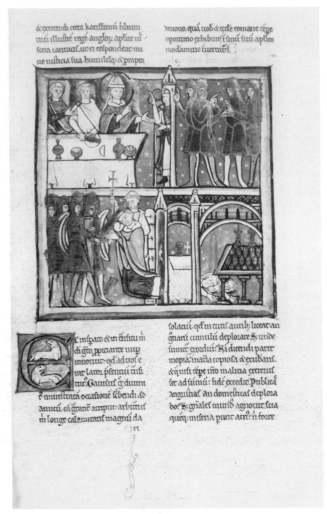

The earliest known representation of the murder of Thomas Becket, prefacing John of Salisbury's letter describing the martyrdom, *c.* 1180 (72). British Library, MS Cotton, Claudius B.II, f. 341

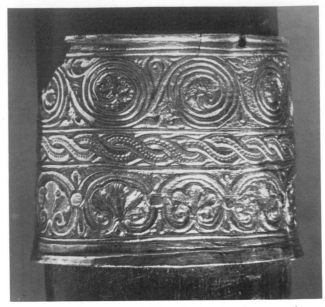

Crosier mount found at Bury St Edmunds, thought to have come from the tomb of Abbot Samson, last quarter 12th century (300)

the country for all but a few months of his reign in the 1190s, it was Hubert's singular achievement to restore and preserve effective government in the King's absence, to show that the developing central institutions could work if necessary without him. In 1199 Hubert presided over, and was responsible for, the effective succession of King John. He represents the government of church and kingdom more than any other man of the last years of the 12th century. His ring and his grave clothes evoke the end of our epoch, as the Bayeux Tapestry introduced it.

Yet to anyone acquainted with the contemporary literature of the English Church about 1200 there is one object even more evocative: a small mount from the crosier of Abbot Samson of Bury St Edmunds (300). Samson is the central figure in the vivid chronicle of Jocelin of Brakelond[10] which brings to life the ordinary humdrum world of monks and abbot in a great medieval religious house – not the heroic nor the deeply spiritual which we may meet in St Bernard or in his English disciples and especially in St Aelred at Rievaulx; but still the world of a notable man of unusual ability and average devoutness. Hubert Walter and Samson represent the worldly but conscientious men of affairs whose ability made possible the enormous achievement of English patrons and builders in the 12th century.

NOTES
1. Brooke, 1969; Haskins, 1927; Southern, 1960; Benson and Constable, 1982
2. Barlow, 1965; Loyn, 1962, 1967; Matthew, 1966; Brown, 1969a
3. Stenton, 1965; Brooks, Walker, 1979; Dodwell, 1966
4. Voss, 1932; Knowles, 1951; Stratford 1983
5. Brooke, Keir, 1975, pp. 144–6
6. Knowles, 1940, 1963; Knowles, Hadcock, 1971; Brooke, Swaan, 1974
7. St Bernard, *Epistola* 106, cited Knowles, 1940/1963, p. 221
8. Gervers, 1969, p. 363
9. Brooke, 1983
10. Butler, 1949

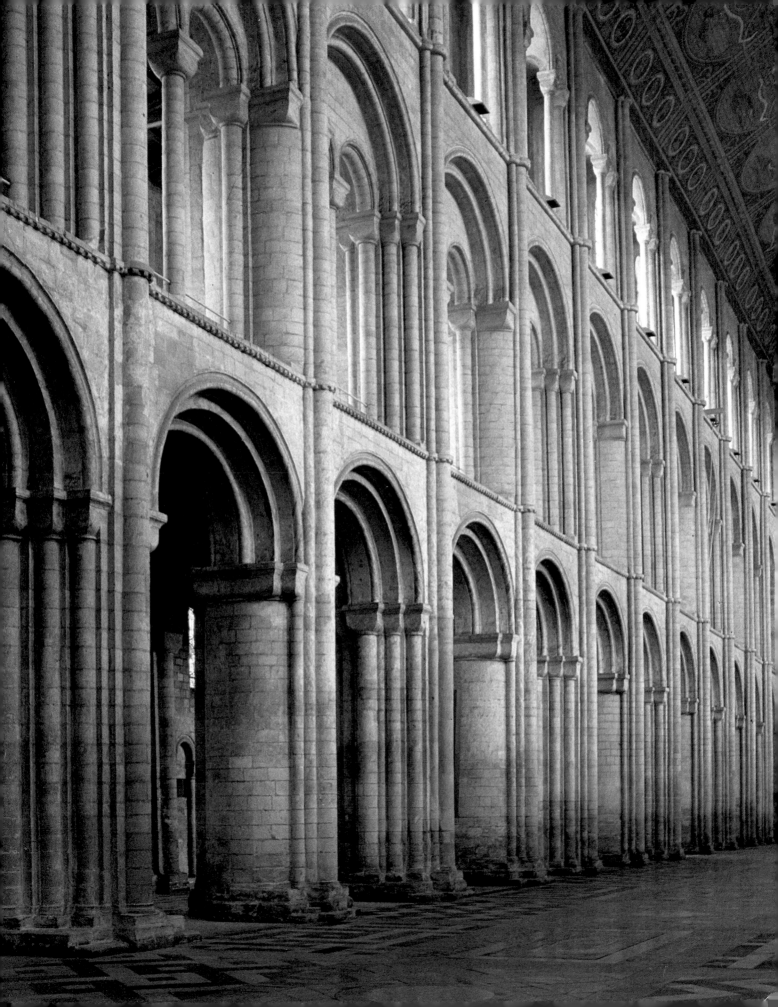

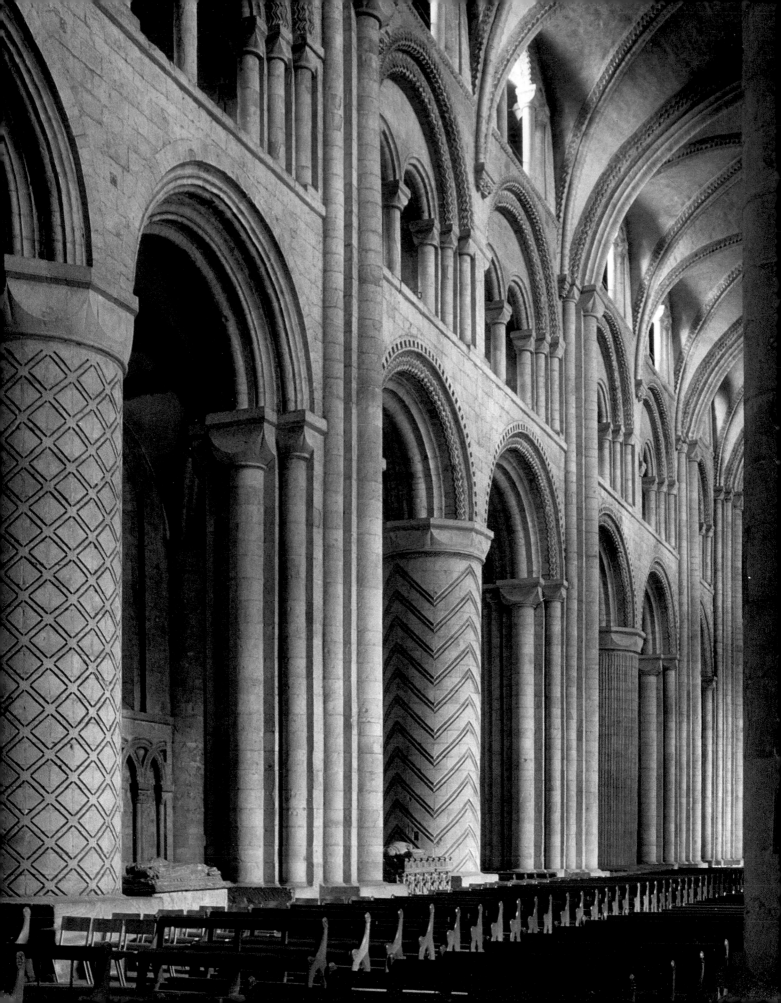

ABOVE Kempley Church,
mid-12th-century polychromy

RIGHT Christ Church Cathedral,
Canterbury, wall-painting of
St Paul and the Viper,
third quarter 12th century

LEFT Durham Cathedral,
the nave looking east,
first third 12th century

PAGE 49 Ely Cathedral,
the nave looking east,
c. 1100 and following

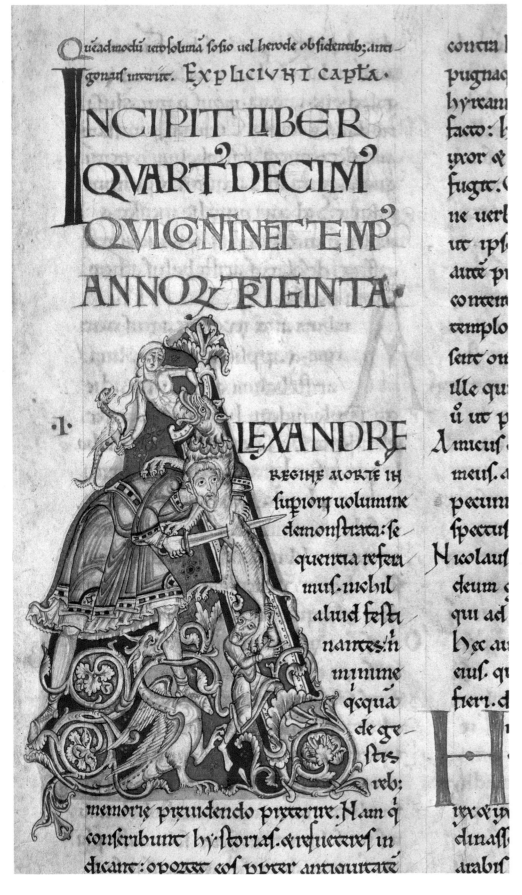

Queadmodū ierosolimā sosio uel hercle obsidentib; antī
igonare inuenire. EXPLICIVNT CAPTA.

INCIPIT LIBER
QVART⁹ DECIM⁹
QVI CONTINET TEMP
ANNO₂ TRIGINTA.

·I·

ALEXANDRE
REGINE MORTE IN
supiori uolumine
demonstrata: se
quentia referi
mus·nichil
aluid festi
nantes:in
minime
qequa
de ge
stis
reb;
memorie prouidendo preterire. Nam q
conscribunt hystorias. & requtres in
dicant: oportet eos uiter antiquitate

LEFT 43 Flavius Josephus,
Jewish Antiquities, c. 1130.
Decorated initial

RIGHT 44 The Bury Bible,
c. 1135, vol. I.
Frontispiece to Deuteronomy
showing Moses and Aaron

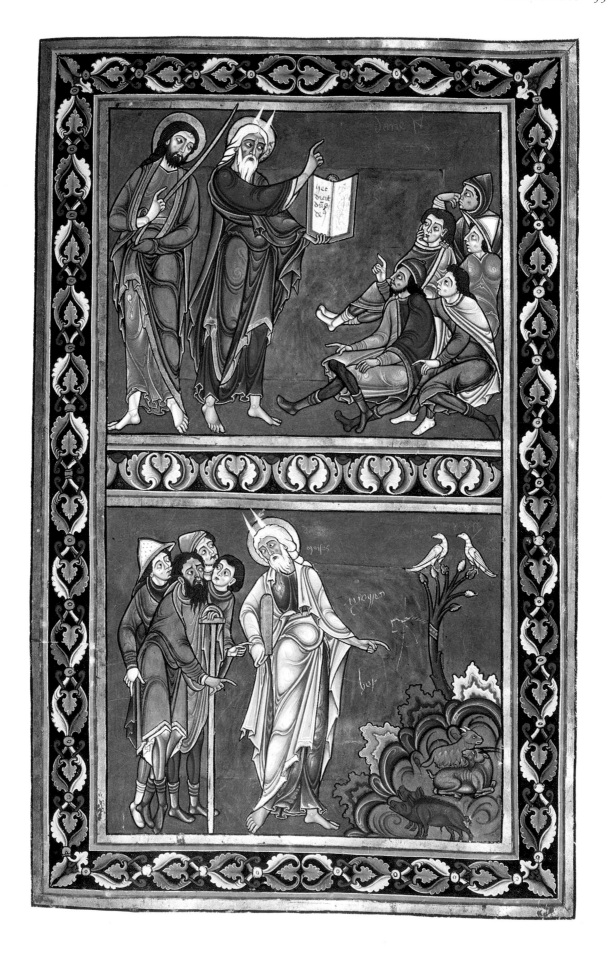

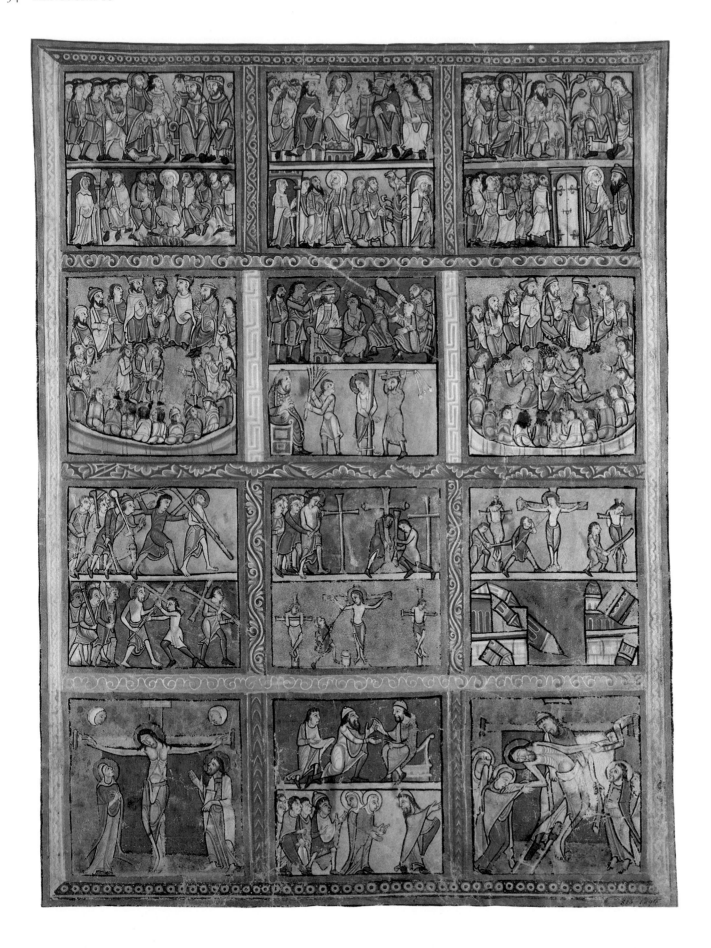

LEFT **50** Leaf from a Psalter, *c.* 1140. Scenes from the New Testament

RIGHT **61** The Winchester Psalter, *c.* 1150. *Christ's Betrayal and Flagellation*

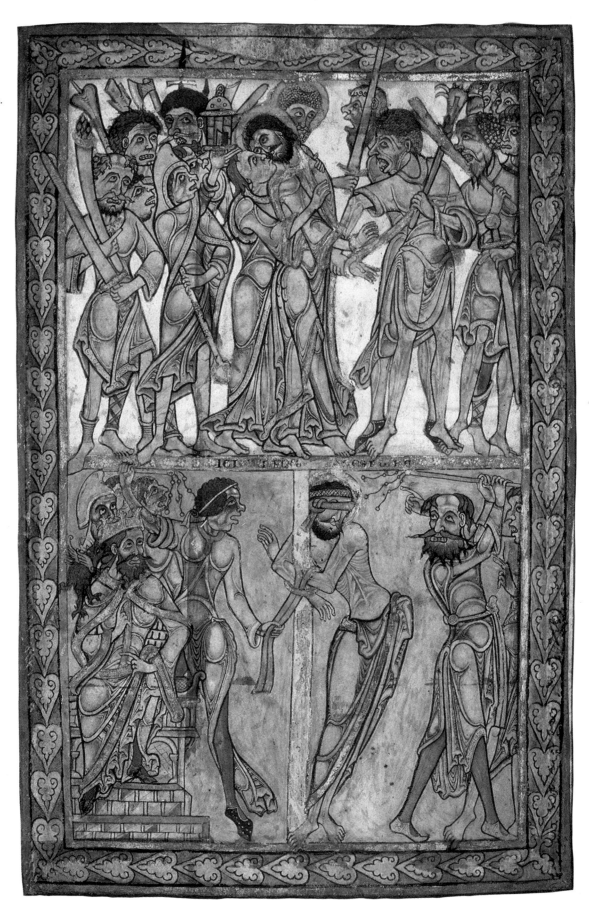

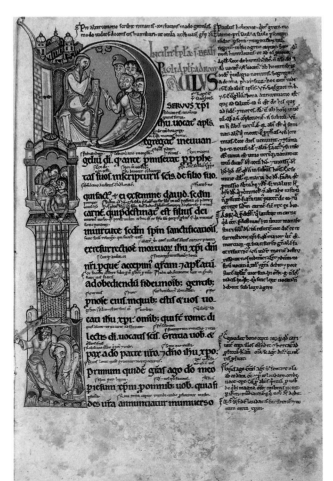

iniquitate.

Totadie iniustitiam cogitabit lingua tua sicut
 nouacula acuta fecisti dolum. Glosa.
Dilexisti malitiam sup benignitate iniquitatem.
Dilexisti omia uerba precipitationis lingua do
Propterea ds destruet te infinem euellet te et
 emigrabit te detabernaculo et radicem tuam
 deterra uiuentium. rem suum.

dei totadie.

Insidias cogitat lingua sua quasi nouacula
 acuta faciens dolum.
Dilexisti malum magisquam bonum mendaciu
Dilexisti omnia uerba addeuorandum lingua
 dolosa sed dr destruit te insempiturnum.
Terrebit et euellet te detabernaculu et eradica
 bit te deterra uiuentium.

ABOVE **64a** The Winchester Bible, vol. III c. 1155–60.
Opening initial Q to Psalm 51

LEFT **60** St Paul, Epistles, mid-12th century.
Opening initial showing scenes from the life of St Paul

RIGHT **65** Leaf related to the
Winchester Bible, c. 1160–80.
Verso: the story of David from
the Book of Samuel

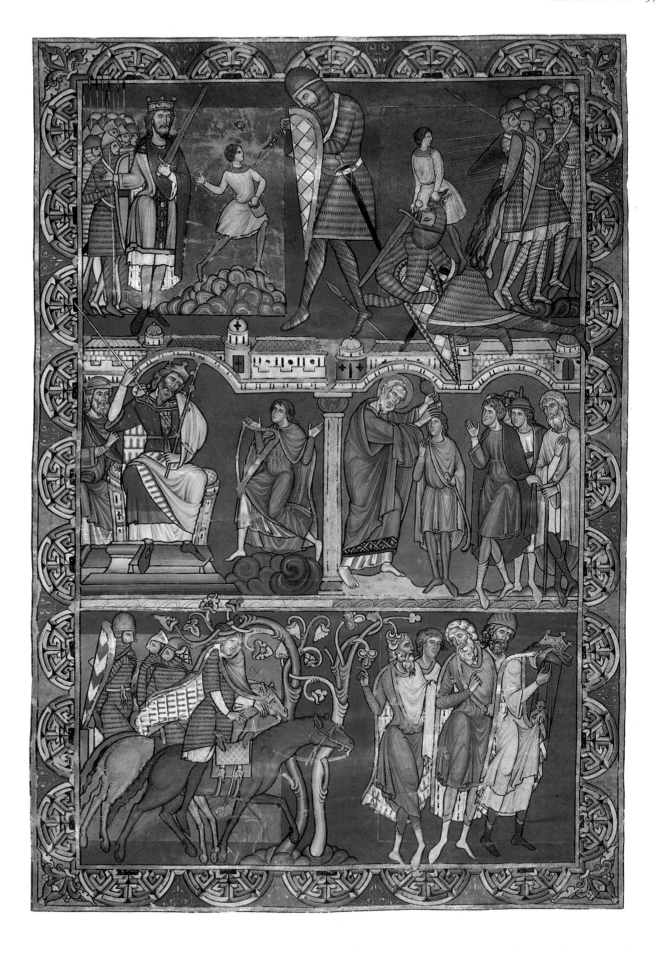

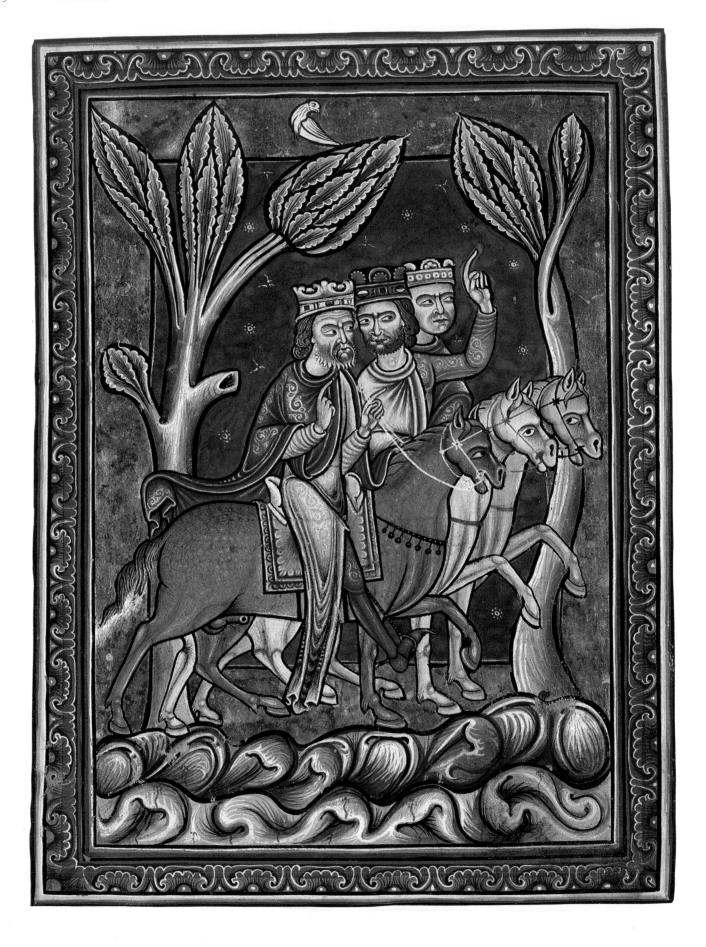

LEFT **76** Psalter,
c. 1170–5.
The Three Magi

RIGHT **75** Psalter,
c. 1170. *The Ascension*

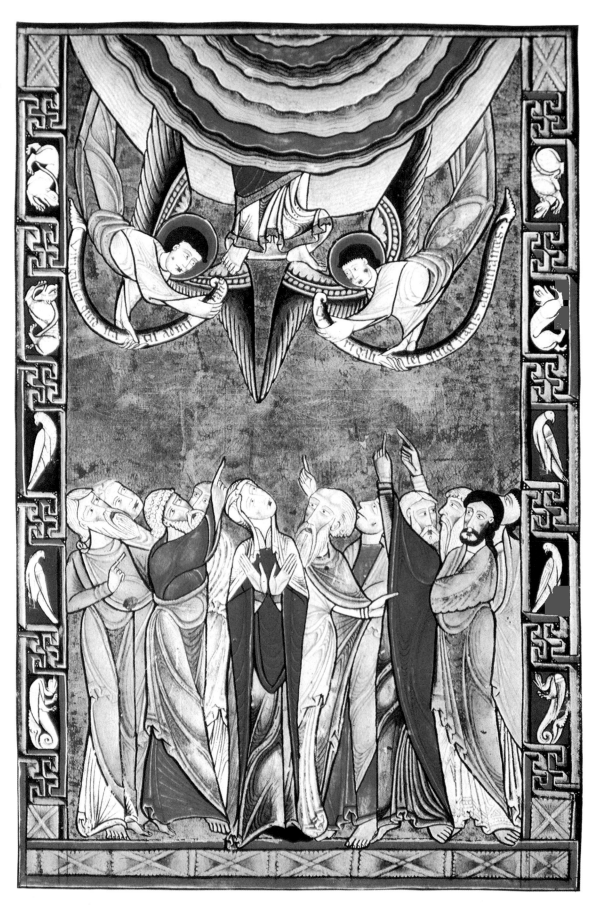

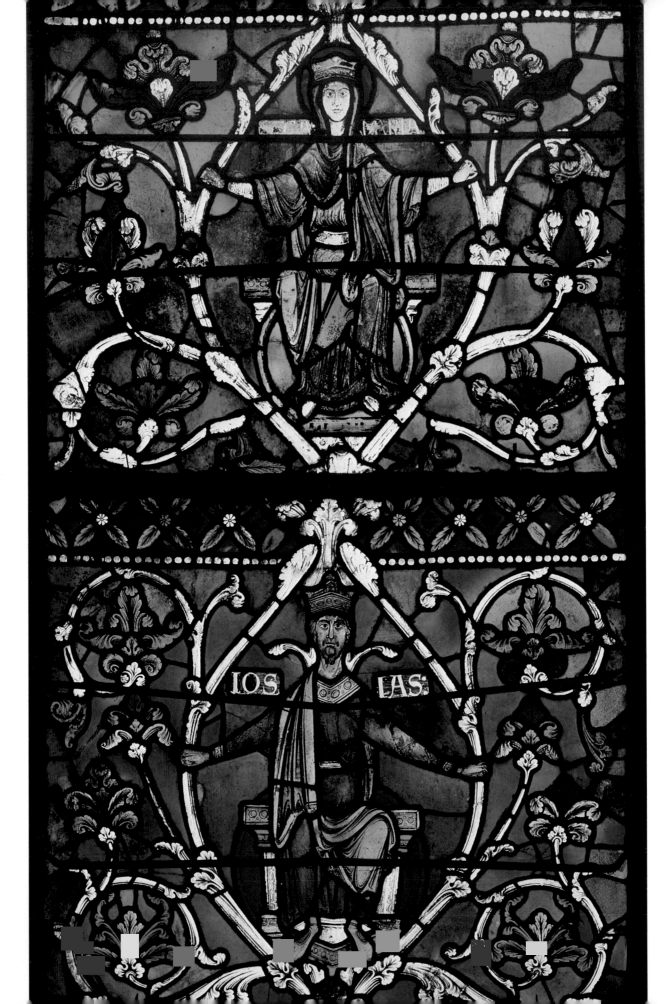

ABOVE 89 Scene from the *Legend of St Nicholas, c.* 1170–80. York Minster

LEFT 93 *King Josiah and the Virgin,* from a *Jesse Tree* window, *c.* 1200. Christ Church Cathedral, Canterbury

RIGHT ABOVE 104 Tympanum, 1090–1100. All Saints Church, Lathbury

RIGHT BELOW 135a Gable with lions from Old Sarum, 1130–40

LEFT 142 Tombstone, c. 1140. St Peter's Church, Northampton

TOP **138** Virgin and Child
tympanum, *c.* 1140.
St Mary's Church, Fownhope

RIGHT **127a** Capital from
cloister arcade,*c.* 1125.
Reading Abbey

RIGHT **139** Font, *c.* 1140.
St Michael's Church,
Castle Frome

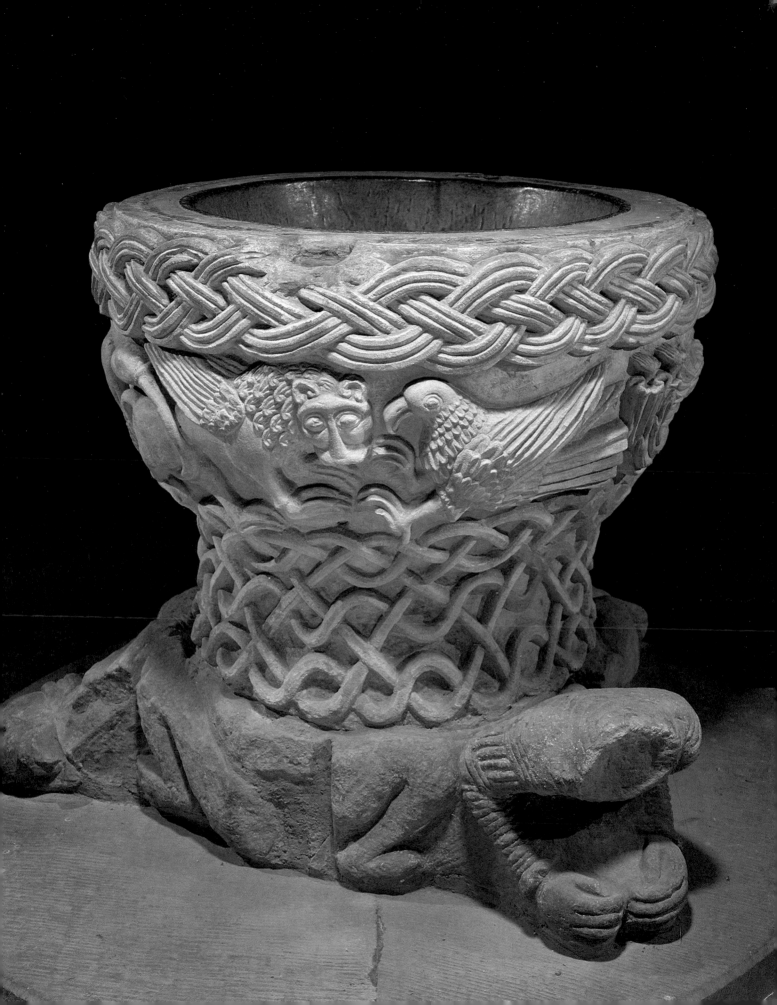

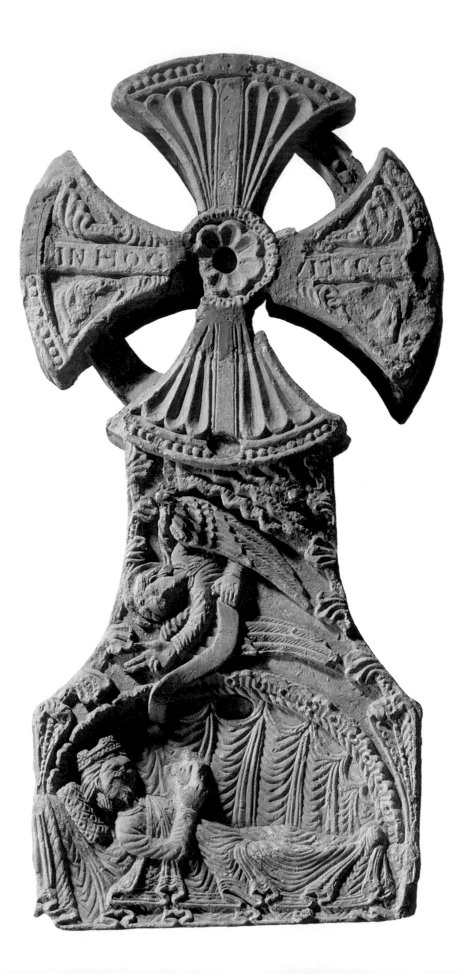

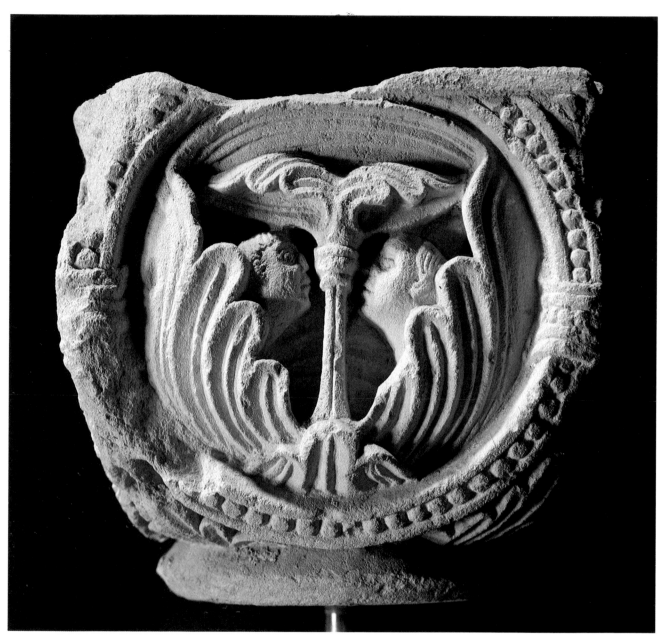

ABOVE **128b** Capital from Hyde Abbey, Winchester, 1125–30

LEFT **176** Detail of reliquary cross with scenes depicting
the legend of the *Invention of the True Cross, c.* 1200.
St Helen's Church, Kelloe

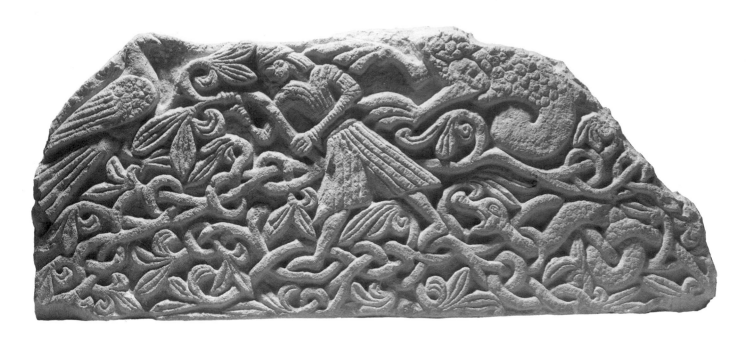

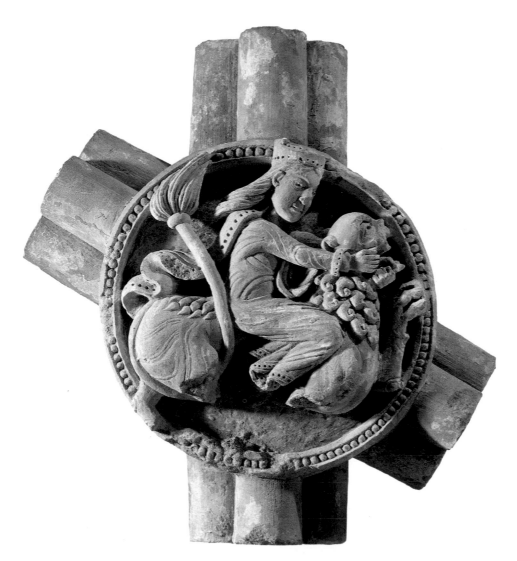

ABOVE **164g** Relief from decorative screen, 1180.
Christ Church Cathedral, Canterbury

LEFT ABOVE **137** Allegorical tympanum, *c.* 1140.
All Saints Church, Billesley, Warwickshire

LEFT BELOW **163c** Keystone from Keynsham Abbey,
Samson and the lion, *c.* 1170–80

RIGHT **216** Section of a
staff or handle showing
birds and beasts,
last quarter 12th century

FAR RIGHT ABOVE **213**
The St Nicholas Crosier,
1150–70

FAR RIGHT BELOW **191**
Oval box (pyx),
early 12th century

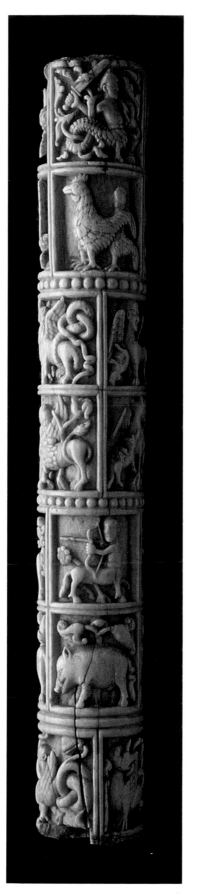

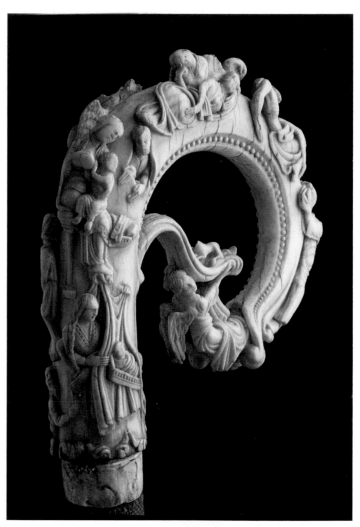

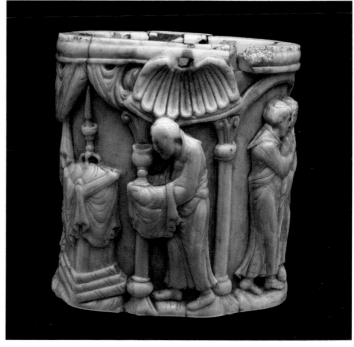

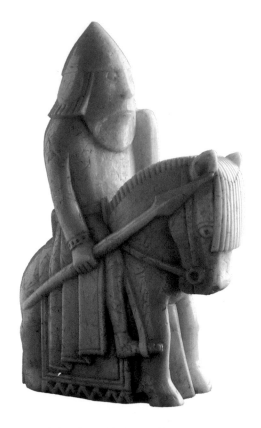

LEFT AND BELOW **212** The Lewis Chessmen: knight, queen and king, mid-12th century

RIGHT **247** The Gloucester Candlestick, commissioned 1107–13

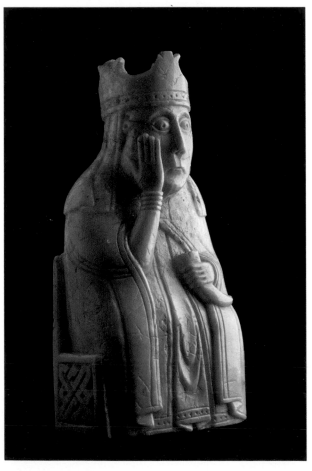

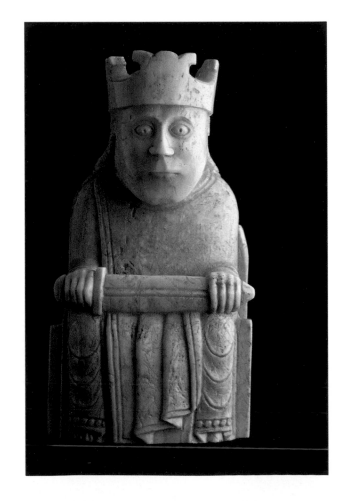

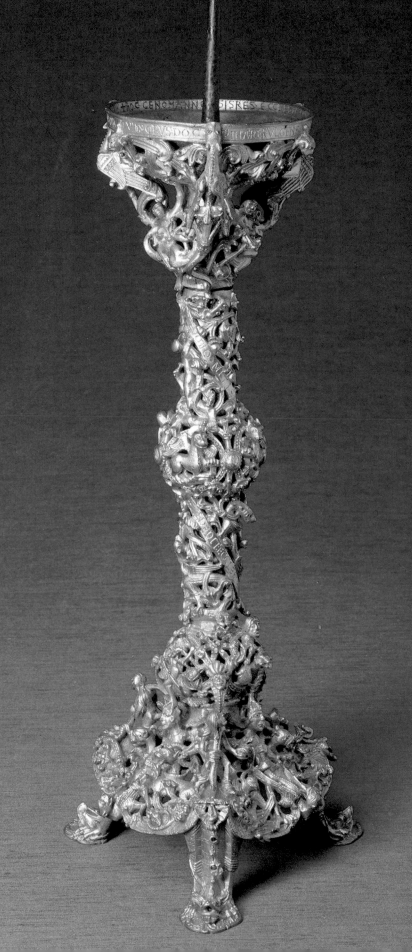

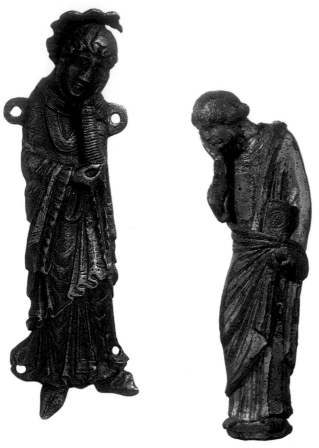

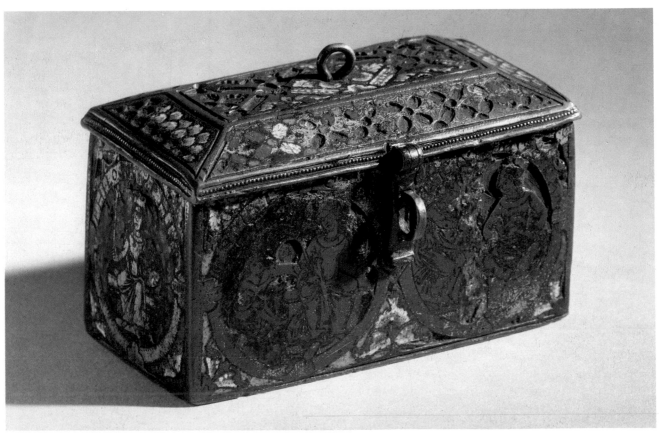

FAR LEFT 231 *The Mourning Virgin*, late 11th or early 12th century

LEFT 242 *St John mourning the Crucifixion, c.* 1180

BELOW 287 The Liberal Arts casket, *c.* 1180–1200

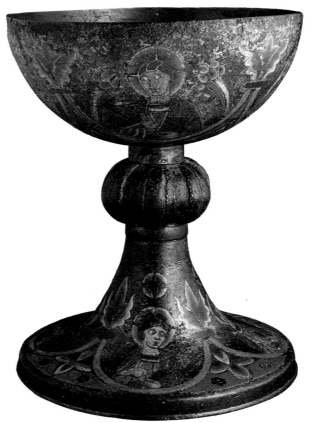

ABOVE 305 Drinking vessel from
'The Dune Treasure',
last quarter 12th century

RIGHT 293 Chalice, *c.* 1200

RIGHT 278 The Morgan Ciborium,
c. 1160–70

BELOW 280 The Warwick Ciborium,
third quarter 12th century

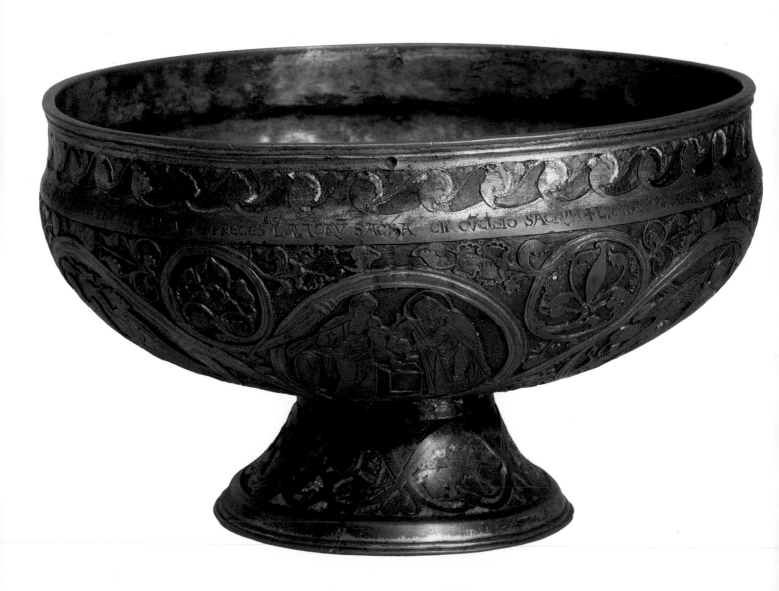

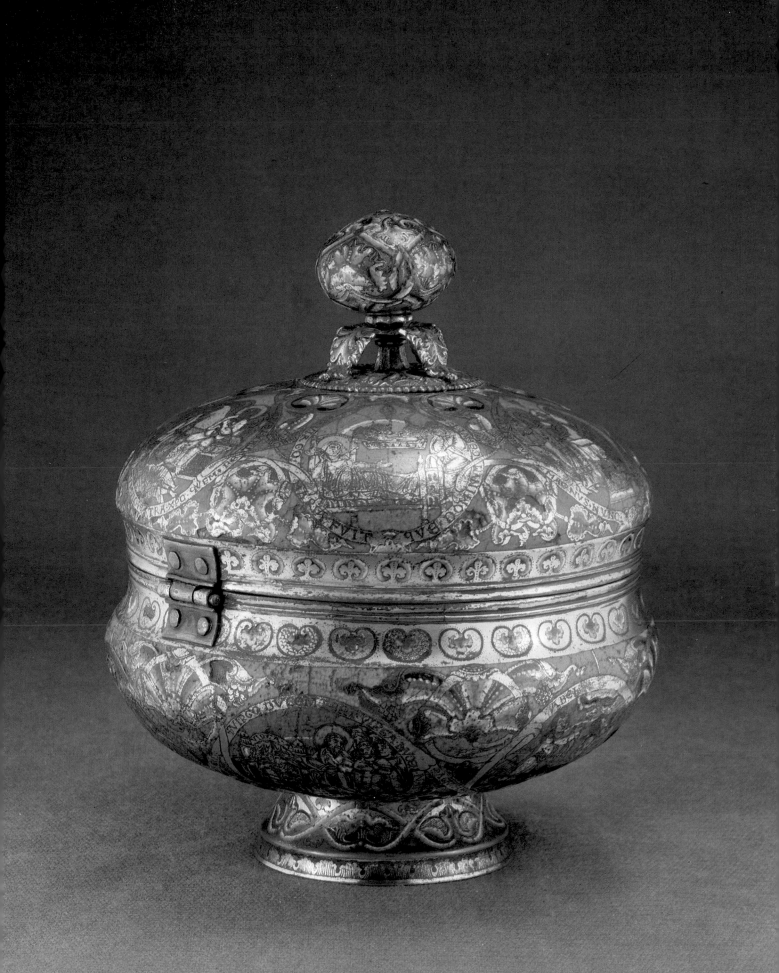

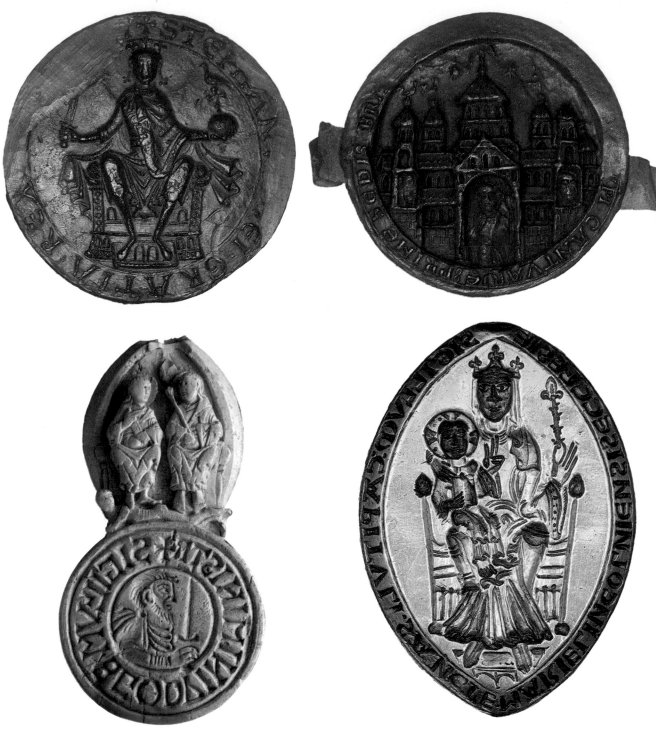

TOP LEFT **331** Stephen, King of England 1135–54, first seal (obverse), 1136

TOP RIGHT **358** Christ Church Cathedral, Canterbury, second seal (obverse), 1155–8

ABOVE LEFT **368** Matrix (obverse): Godwin the Thane, c. 1040–42

ABOVE RIGHT **360** Matrix (obverse): Lincoln Cathedral, 1150–60

RIGHT **499** Page from Sir Christopher Hatton's *Book of Seals*, 1640–1, showing a copy of a 12th-century charter recording a grant to Christ Church, Canterbury, by Bishop Odo of Bayeux

431

Odo baiocensis eps̄. Lanfranco archiepō. & Hammoni uicecomm̄. commib;
cantuariensib; regis fidelib; salute. Notum sit uobis. qd̄ego O. baiocensis
eps̄. & comes cantie nostre matri que in honore sc̄e trinitatis estructa
est cantuariensi ecc̄le: trado has quatuor dennas terre. uidelicet. Lossenha
mū & Adalardendenā. & Blaccecorā. & Aedenā. a dono Lanfranco archiepō
a omnib. successorib; ei ppetuo usu possidendas. p̄ redēptione domini mei
Guilelmi regis anglorum. & meā. & eox quoq̄ salute specialit̄ munctū
est michi p̄curare. & p̄ excābio xx & v. acrax terre que infra parcum
meum de Wicham continentur.

Odo þ͗ op baiuf. gret Landspane apceb. 7hammone scir 5r þegan. 7ealle þ͗es kinges þegenas on cænt fpeondlice
Sic op callu eud. Fie Odo þ op baiuf. 7 egit on cænt ge amin uße modes Þ iſ Xpeſ cinecan on cantpabe byþi3:
þof fupen dæne landeſ. þ iſ loßenham. 7Adalapdan dæne. 7 blaccecoran. 7 ile dæna. Spa þ͗ ſe lapond Landspane
apceb. 7 ealle hiſ æftep gangan. hi heom 3e agnian on ece yppe. þiſ ic do fop min ſe laponder alyſednerre
Willelmes kinges. 7 fop minre. 7 fap fpena manna a lypednesse. be þæna hala me ir ſindenlice 3ymene
7 fen 3e hpyxpe fiſ 7 þepentgpa acepan landeſ; þa liggað pið minan inniū deop ſalde æt Wicham.

432

Omnibz xp̄i fidelib; hoc sc̄ptu uisuris. Gl audituris. H. Di gr̄a Rex mannie et insulax. Salt
et̄na i d̄no. Iustū est. et oi iuris observaniū ut piissioris. et honesti petenciū postulacōnibus
regia auctoritas faacile p̄beat assensū. et p̄cipue sc̄e religioni annuere qd̄a iurisdicitone non
recedit. Inde ē qd̄ dm̄ abb̄i sup̄i. et eidem loci q̄uenc piis p̄c̄ib; idinati hoīsistā ipse signisi
cani. nos sub sima pace n̄ra et p̄rectoe recepisse naues sc̄i Abbis et monachoz et p̄sonastru
sentuiros qui religioses et bonū ipdeis nauib; exenū taq̄ bonū n̄ra̅p̄l. Rogantes q̄m cū per
uos ciuistepit ab omi molestia et giuāmine p̄gd̄eis sciēresq̄ gd̄ o eidem sc̄m siue siue i bono
siue i malo̅ nobis si reputabim̄. et si aqq̄ eis iuiriatū siut qd̄ absit. tanq̄ mur̄id n̄am
ppam dign̄ uletione uindicabimus. Salt.

433

Uenabili 7 dilecto pat̄ 7 d̄no. H. Winton epō. Higell de modbray. Sal̄ 7 fidelis seruitia. Noti siet
dilecte paturiti ipse me donasse. concessisse. 7 litteris mei sigñ 7̄ aff̄rmasse qd̄ ad ius mei aduoca
tione spectat de ecc̄la de benested Canonicis de sud̄wich p̄ d̄i Amore i ppetuā elemosinā salua
cpa uſm̄. p̄o misedia uſm̄ imploro exopanſ; petenſ sc̄m̄. 7 in consi̅pmatione 7 ecto qd̄ uſm̄
est ill misericordiæ si uob placuer̄it supplerentis. ualear kr̄na paturitas c̄pra.

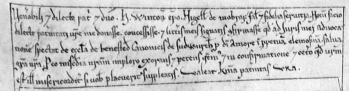

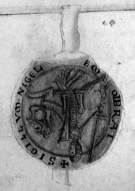

+ SIGILLVM NIGELLI · EQ... · DBRAI

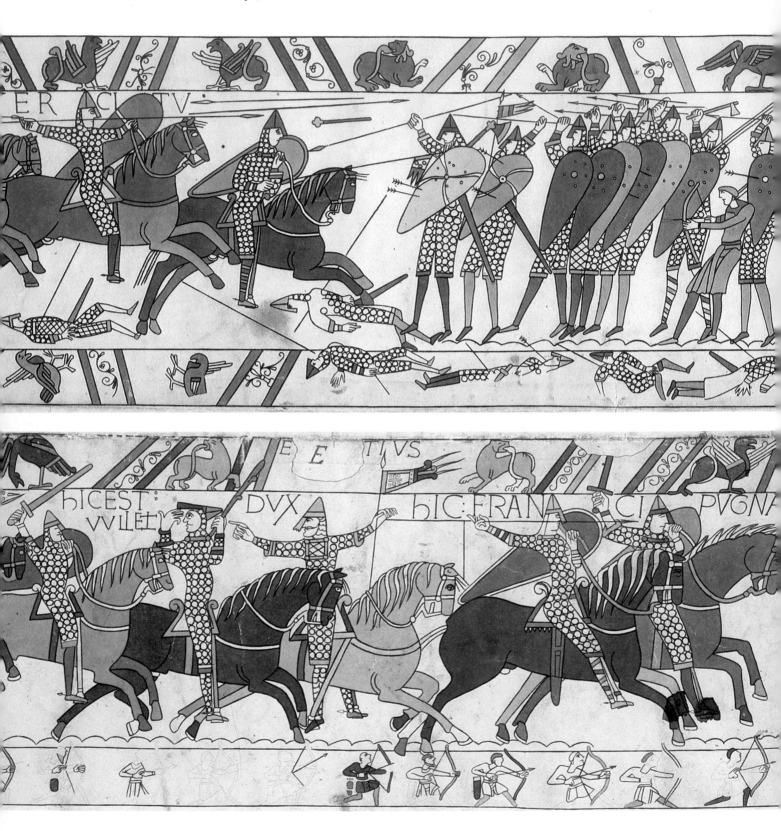

551 Scenes from the Bayeux Tapestry showing the battle of Hastings
from hand-coloured engravings by Charles Stothard, published 1819:
ABOVE Detail from pl. 14 showing Norman horsemen and English
footsoldiers
BELOW Detail from pl. 15 showing Duke William lifting his visor in
order to be recognized by his troops

THE CATALOGUE

Notes to readers

The information supplied in the entries has been drawn from published and unpublished sources, and most entries are initialled by the author, as follows:

J.J.G.A.	Dr Jonathan Alexander
M.M.A.	Miss Marion M. Archibald
M.B.	Dr Maylis Baylé
M.C.	Professor Madeline H. Caviness
B.C.	Mrs Bridget Cherry
J.C.	Mr John Cherry
T.C.	Dr Thomas Cocke
C.R.D.	Professor C.R. Dodwell
G.E.	Mr G. Elphick
M.F.	Mrs Mirjam Foot
J.G.	Dr Jane Geddes
T.A.H.	Mr T.A. Heslop
D.K.	Dr Deborah Kahn
C.M.K.	Dr Michael Kauffmann
D.B.K.	Mr Donald B. King
P.L.	Professor Peter Lasko
N.S.	Mr Neil Stratford
P.W.	Mr Paul Williamson
C.W.	Dr Christopher Wilson
G.Z.	Professor George Zarnecki

Where no initials are given, entries are by the author of the chapter introduction.

Dimensions are given in millimetres, except where metres are specified; h = height, w = width, d = depth, $diam$ = diameter. Other abbreviations are: p. = page, pl. = plate, no. = number, n. = note.

In the chapter on Manuscripts, the exhibited or illustrated page is usually indicated by its folio number, e.g. f. 19.

The date of an object is followed by its place of origin; a question mark indicates uncertainty. Where no Provenance is given, it is unknown.

All numbers in bold type (e.g. **247**) refer to other catalogue entries.

Bibliographical references are generally given in abbreviated form, e.g. Kauffmann, 1975. Full details are given in the Bibliography on pages 397–406. Specialized texts are given in full either in the catalogue entry or in the short Bibliographies at the end of each entry. All are listed in chronological order and, for works published in the same year, alphabetically by author.

A place followed by a date, e.g. New York, 1975, refers to a relevant exhibition, or to its catalogue. Full details are given on page 406.

The chapters on Coins and the Rediscovery of the Romanesque have their own Bibliographies, on pages 322–3 and 365–6 respectively, and are intra-referencing.

Periodicals are abbreviated as follows:

Antiq. J.	Antiquaries Journal
Archaeol. Cant.	Archaeologia Cantiana
Archaeol. J.	Archaeological Journal
Archit. Hist.	Architectural History
Art Bull.	Art Bulletin
Brit. Archaeol. Assoc. Conf.	British Archaeological Association Conference Transactions
Brit. Mus. Qu.	British Museum Quarterly
Bull. C.B.A. Churches	Bulletin of the Council for British Archaeology Churches Committee
Bull. Mon.	Bulletin Monumental
Burl. Mag.	Burlington Magazine
C.B.A.	Council for British Archaeology
Cahiers Civ. Med.	Cahiers de Civilisation Médiévale
Eng. Hist. Rev.	English Historical Review
J. Brit. Archaeol. Assoc.	Journal of the British Archaeological Association
J. Soc. Archit. Hist.	Journal of the Society of Architectural Historians
J. Warb. Court. Inst.	Journal of the Warburg and Courtauld Institutes
Med. Archaeol.	Medieval Archaeology
Proc. Battle Conf.	Proceedings of the Battle Conference in Anglo-Norman Studies
Proc. Brit. Acad.	Proceedings of the British Academy
Proc. Soc. Antiq.	Proceedings of the Society of Antiquaries
RCHM	Royal Commission on Historical Monuments
Trans. Royal Soc. Lit.	Transactions of the Royal Society of Literature
V and A Mus. Bull.	Victoria and Albert Museum Bulletin
Wall. Rich. J.	Wallraf-Richartz Jahrbuch

Technical or specialized terminology is explained in the Glossary on pages 413–6.

Manuscripts

The making of a manuscript

The production of a medieval manuscript was a complex, lengthy and expensive business. First the writing materials had to be manufactured or procured – the vellum or parchment for writing on and the ink, quill pens and knives for writing with. The scribe ruled the sheets, known as folios, for writing, leaving spaces for the artist to insert illustrations or decorations which might include the decorated initials typical of this period. If gold leaf was to be used it was applied first and after this came the painting with mineral and vegetable pigments. The last stage was the sewing together of the quires, that is groups of usually three to six bifolia (double-page sheets), and their protection by oak boards which were covered most commonly with leather (469–75). Precious metals, enamel, jewels or ivory carvings were also used to embellish the bindings in special cases, particularly for service-books.

Our information as to who did all this work, and how and why, is very incomplete. Many scribes of this period were certainly professed monks or nuns of Benedictine or other communities as we know from their signatures in often lengthy colophons. Thus Eadwin, who is described as 'Prince of Scribes' in the inscription accompanying his portrait in the Canterbury Psalter, is shown as a monk with tonsure and cowl (62); but we know also of non-monastic scribes such as the professionals employed by Abbot Simon of St Albans or Ralf of Pulleham, who worked alongside the Augustinian canons at Cirencester. Some of these men were presumably in religious orders since education came only via the Church at this time, and perhaps this is the reason why we hear of no professional woman scribes in England at this date, though nuns often wrote books.

Although we have few names and little information about the scribes, we can say even less for certain about the illuminators. In the monasteries some scribes were probably also responsible for decoration and illumination, but whereas a scribe might ask for the reader's prayers on completion of his or her work, artists are seldom named directly in the books. Hugo, the painter and illuminator (5), who was certainly a Norman monk, is exceptional in this, but significantly his self-portrait represents him as a scribe with knife and pen and is placed at the end of the text where a scribe normally signs. Professional artists, like professional scribes, are also attested. Another Hugo is the best-known artist in this period, though his name is discoverable only from the Bury St Edmunds Chronicle, not from any form of inscription or signature or portrait surviving in the Bible he illuminated for the abbey (44). Although the Chronicle calls him 'Magister' (Master) he was also skilled as a metalworker and sculptor. One may assume that such professional artists were employed by more than one centre and, indeed, there is evidence of itinerant illuminators working in both England and France (70 and 76).

Questions are often asked about the time a manuscript took to be produced and where in the monastery it was made. Although scribes in the later Middle Ages sometimes tell us how long a manuscript has taken them to write, I do not know of any similar inscriptions in 12th-century English manuscripts – which in itself suggests that in a monastic, non-commercial context time was not a main consideration. The word 'scriptorium' is used both of an institution, implying a scribal training and tradition, and of a place where books were copied. We can certainly see a scribal tradition exemplified in styles of layout and writing in certain monasteries such as St Albans. Some form of desk or writing surface must have been provided for the scribe and is often represented. There is some evidence both for special rooms being set aside and for desks placed in the cloister. J.J.G.A

The monastic library

The Norman invaders have been accused of destroying much of the wealth of Anglo-Saxon artefacts in gold, silver and cloth, but there is one area in which their record, in cultural terms, may be redeemed: the creation of monastic libraries to match the greatest of those on the Continent. Not that English pre-Conquest monasteries and cathedral priories were bereft of books, but their libraries were sparse and representative of early medieval culture, whereas under the influence of Norman abbots systematic libraries were established at the major centres – Canterbury (Christ Church and St Augustine's), Salisbury, Exeter, Durham, Worcester, St Albans and Bury St Edmunds – by 1100, and at all Benedictine houses of any significance by 1120–50. Once samples had been obtained, books were copied in the monastery either by monks or by professional scribes, usually clerics in minor orders, and money from specific rents or tithes would be set aside for the purpose. At St Albans, for instance, Abbot Paul of Caen allocated certain tithes for the manufacture of books. 'The Abbot had noble volumes copied for the church by expert scribes sought from afar,' the abbey chronicle informs us. Alternatively, books could be bought or acquired by gift (21 and 69) and this should serve as a warning that not every book in a monastic library was necessarily made there. Not surprisingly, the majority of the books exhibited here were produced in the dozen wealthiest monasteries, some of them, for example Bury St Edmunds which owned most of West Suffolk, among the largest landowners in the country.

There were three homes for books in the monastic community according to their various functions: in the church for service-books (Missals, Gospel books and Psalters); in the refectory for books to be read aloud at meal-times (Bibles); and in the general library for monks' private reading. Chapter 48 of St Benedict's Rule imposes the duty of 'sacred reading' at specific hours, and from the 12th century there was usually a library cupboard in the cloister. At Durham, for instance, it was in the glazed area on the north side of the cloister against the church door where the monks had their carrels (booths) for reading. As it was the custom to bind several texts together, even the larger libraries, such as Christ Church, Canterbury, with about 500–600 titles in c. 1170 (calculated from the fragmentary catalogue attached to 30), fitted into a relatively small cupboard space.

In an exhibition, where books are opened at a particular folio to show a splendid miniature or a decorated initial on a beautifully written page, it is all too easy to see these pages as

disembodied masterpieces and to forget the books of which they form part. For these books represent not only the art but the whole literary culture of 12th-century England. It is also worth remembering that, to judge from what survives, only about a fifth contained either illustrations or illuminated initials, but within the context of an art exhibition the attempt has been made to convey the breadth of texts available in the 12th century.

Given the monastic context, it is not surprising that Bibles and liturgical books form the largest group in the exhibition. The great Bibles, some of them accented for reading aloud in church and refectory (64, 64a and 64b), were illustrated with historiated initials or frontispieces to the individual books. The illustration of Gospels, on the other hand, was usually limited to portraits of the four Evangelists (2, 8, 9, 18, 22 and 54). In the history of book illustration and biblical imagery, however, the Psalter played the most important role. Containing a calendar and prayers as well as the Psalms, it was the central prayer-book of the period, divided into sections to be read through each week by monks and by the secular clergy, or for the private devotion of the laity. It was in Anglo-Saxon England that the practice originated of prefacing the Psalter text with a series of Old and New Testament pictures (1) and the great 12th-century Psalters inherited and extended this tradition (17, 25, 47–50, 61, 74–6, 79 and 82).

Biblical commentaries also form a considerable group (5, 6, 28, 42, 51, 60, 69, 70 and 78), but their illumination is usually limited to decorated or, occasionally, historiated initials. The same applies to the next group in the monastic library: the writings of the Western Church Fathers. Gregory (10, 45) and Augustine (4, 6, 28) were the most popular, followed by Jerome (4, 5, 42). The Eastern Church Fathers were known in Latin translations, but appear much more rarely in monastic libraries (26). Of the most popular medieval theologians, Hugh of St-Victor is not represented, but Richard of St-Victor's commentary on Ezekiel testifies the central importance of the great Parisian abbey in 12th-century theology. Of the authors most widely read in England, Bede and Anselm are represented by major illustrated manuscripts (15, 19, 59, 66 and 81). Another popular category of religious text was the martyrology or lives of saints (14) as well as the books devoted to single saints, such as Cuthbert, Edmund and Thomas Becket (15, 20, 72, 81) usually written and illustrated to emphasize the importance of the particular saint as protector of the monastic community from the depredations of its enemies.

Obviously the majority of the books in the monastic library, and hence in the exhibition, were religious, but it is essential to remember that in the 12th century the monasteries were still the principal repositories of much wider learning. A Canterbury manuscript of canon law with splendid decorated initials (41) represents the large category of legal books and a volume of Priscian (11) exemplifies the main textbook of Latin grammar, so crucial a feature of the 12th-century Renaissance. Of the great classical authors who were read at this period, including Virgil, Horace, Ovid and Cicero, only Terence, Pliny, Boethius and Prudentius are represented in the exhibition with illustrated texts (16, 30–2, 56–7). Furthermore, nearly all the science manuscripts – astrological, medical and herbal (34–40) – can trace their origins to classical antiquity. Of the histories and chronicles, Josephus (43) has only decorated initials, but there are politically significant illustrations in the Battle Abbey Chronicle (13) and in the chronicles ascribed to Florence of Worcester and Simeon of Durham (33 and 80).

Such a brief list of authors and titles can convey the wealth and variety of the literary culture with which we are dealing,

but one must be wary of presenting too static a picture. For the 12th century was a period of great economic expansion and social change throughout Western Europe and one of the results was a growth in literacy, which entailed the ability to read, if not always to write, in Latin. The output of books increased rapidly in the course of the century, an increase paralleled by the expanding production of written records, from charters relating to land transactions to letters from the royal chancery. The Sherborne Cartulary (46) is an early example of a collection of documents. The growing complexity of administrative, legal and commercial affairs, engendered by economic expansion and developing towns, necessitated a growth in the literate class, a need which expressed itself in the foundation of universities. This, in turn, gradually diminished the cultural importance of the monastery and its library in the period from about 1200. C.M.K

Stylistic development
(a) 1066–1100: the Anglo-Norman fusion

The text is obviously the primary determinant for the illustration and decoration of a manuscript. The pre-Conquest monasteries in England had produced sumptuous service and devotional books and also vernacular biblical texts with large numbers of illustrations in various techniques – fully painted, coloured drawings and ink drawings. The pre-Conquest monasteries in Normandy obviously had needed service-books and some, like the Sacramentary of Mont St-Michel, are fully illustrated, but they also evolved means of decorating the numerous patristic texts they copied with author portraits and with historiated and other initials (4 and 5). This decoration both served to stress the importance they attached to such texts and acted, by means of a hierarchy of decoration, as a way of directing the reader about the book. Thus there is certainly a different emphasis in Norman book production, and this emphasis was imposed by the Norman abbots and monks imported into England by William I on the houses they controlled.

In the last 30 years of the 11th century there is rather little to show of book illumination in England. This is probably not due merely to accidents of survival but is to be explained partly by the disruption of the English Church caused by the Conquest. At the same time immense and costly building projects at Winchester, Ely, Durham and elsewhere show that resources were available. Perhaps these projects were considered more urgent and used up all the available energy and money. Another explanation may be the lack in England of exemplars for the patristic texts which the Normans considered important. There is evidence that manuscripts were made in Normandy during this period and imported to Canterbury, Durham and Exeter (5).

The consequences of the Conquest for the development of illumination into the 12th century is a very complex subject, but three things need stressing. Firstly, the English monasteries must have been made aware of Continental stylistic developments through various political and religious links with the Continent in the reign of Edward the Confessor. The Leofric Gospels (8) illustrates the importation of Continental illumination and the Caligula Troper (3) the influence in England of such Continental styles. The Tiberius Psalter (1) also shows that Anglo-Saxon art at the mid-11th century was moving towards a more monumental, less Carolingian-derived style which prefigures later Romanesque art.

Secondly, pre-Conquest Norman illumination combines

Carolingian, Anglo-Saxon, northern-French and Flemish influences in significantly new ways. Twelfth-century Anglo-Norman artists had already been shown how to develop the Anglo-Saxon tradition in methods typical of 12th-century Romanesque manuscripts – for example, in terms of combining setting and framing (the architectural canopy) and of script and illustration (various forms of historiated, figure and 'clambering' initials). The Normans also imported an enriched vocabulary of foliage and flower forms.

Thirdly, not only did the imported Norman styles owe much to Anglo-Saxon art, but, as Wormald first showed, there was a survival of Anglo-Saxon drawing style in particular, as illustrated by the Durham *Life of St Cuthbert* (15) and other manuscripts. Thus the effect of the Conquest, even though in the short run there may have been disruption in the scriptoria as well as the documented loss of works of art taken to Normandy, was in the long run to enrich and revitalize English illumination. J.J.G.A

(b) The 12th century

Whereas the mutual influences of Anglo-Saxon and Norman styles in the course of the 11th century are complex and difficult to chart with precision, the difference between styles of book illumination in 1050 and 1130 is strikingly apparent. A sharply contrasting comparison can be drawn between two famous manuscripts in the exhibition – the mid-11th-century Psalter, British Library MS Cotton Tiberius C.VI (1), and the St Albans Psalter of *c.* 1120–30 (17). The Anglo-Saxon illustration, its style derived ultimately from the Carolingian school of Rheims, is typically an outline drawing lightly tinted in watercolour, executed in a delicate calligraphic technique of fine, nervous zigzag lines. Agitated draperies add considerably to the figures' movement. Space, in so far as it exists, is indicated by the hillock on which the figure stands.

The St Albans Psalter provides a complete contrast in almost every respect, and it is the contrast between Anglo-Saxon and Romanesque styles. Painted in strong, heavy colours, the contours are thick and straight or gently curving. The draperies are no longer made up of agitated zigzag lines, but are constructed in areas indicating, in a stylized way, the body beneath. Large eyes and gesturing hands lend expression to solemn hieratic figures. Nearly all indications of physical space have been abandoned as detracting from the religious drama portrayed. Sometimes perspective is built up in layers, as for the figures grouped together in the mouth of Hell. Apart from this, there are stylized vaults and towers, and different coloured panels forming a separate backcloth for different individual figures or groups.

This is the earliest extant manuscript with an extensive cycle of miniatures in a fully developed Romanesque style to be produced in England. The overriding purple colour, the panelled backgrounds and the solid, hieratic figures are linked with Ottonian illumination in Germany, particularly of the 11th-century school of Echternach, while the architectural backgrounds and, above all, the draperies, with their cobwebs of white highlights, betray the influence of Byzantine art. Some of the artist's own idiosyncrasies, in particular the profile with its straight line from brow to tip of nose and regular, curly black fringe, become a hallmark of his influence on later manuscripts (21).

The next landmark is the great Bible illuminated by Master Hugo for the Abbey of Bury St Edmunds in about 1135 (44). Many of the basic characteristics which differentiated the St Albans Psalter from its 11th-century predecessors are equally fundamental to the Bury Bible. Yet Master Hugo was also a great innovator. His faces are both more naturalistic and more sophisticated than those of the St Albans manuscript. This is due to their close adherence to Byzantine rules of facial contours and modelling. Dark facial shading in ochre and grey with greenish tints and white highlights, long flowing hair and awe-inspiring features are Byzantinizing even down to the 'U' convention between the eyebrows.

However, it is the disposition of the draperies, with their rhythmical, sinuous double-line folds, articulating the body beneath, that has become the hallmark of the Bury Bible style. Those clinging areas have been characterized as damp-folds, for they have the appearance of wet cloth stuck to the body whose main features – stomach, thigh, knee, leg – thus become clearly delineated. This is a Western adaptation of the Byzantine method of articulating the human figure, and it provides one of the international characteristics of Romanesque art. This concern with the rendering of the human body has been interpreted as the visual counterpart of 12th-century humanism, for the period witnessed an increasing stress on the importance of man's place in the universe and a confidence in his powers, as opposed to his sinful state in a totally hostile environment.

Master Hugo was the first to construct the damp-fold by a series of flowing S-shaped lines which have been dubbed 'clinging curvilinear drapery'. It is this particular form that characterizes the illumination of the finest English Romanesque manuscripts of *c.* 1140–70, such as the Lambeth Bible, the Winchester Psalter and the Winchester Bible (53, 61 and 64). The exhibited miniature of the Bury Bible, indeed, may be singled out as the epitome of English Romanesque art. All the emphasis is on the figures and the drama of the dialogue between them. This is conveyed by their intensely expressive eyes, their gestures emphasized by elongated index fingers, and by the drapery folds – which cover their surface with a rhythmic pattern. These draperies serve to reinforce postures and gestures in relating different figures and groups to each other. These are monumental figures, but the main emphasis is on the didactic content of their discourse.

A perfect foil to the solemnity of the illustrations is to be found in the uniquely inventive nature of the decoration. The inhabited scrolls of Anglo-Norman initials become filled with an ever-increasing variety of battling figures, grotesques and monsters. These are the 'ridiculous monsters . . . filthy monkeys, savage lions, monstrous centaurs, half human creatures' castigated by St Bernard as a purposeless distraction. These creatures were derived from different sources, such as Near-Eastern silks, astrological illustrations, calendar scenes and bestiaries. Their purpose was embellishment rather than illustration, though it may not be fanciful to seek psychological explanations for their irrational forms.

Meanwhile, the foliage itself was changing. From about 1120 there is an increasing emphasis on individualized flowers – as opposed to undifferentiated acanthus scrolls – which become the dominant motif at the centre of the foliage spirals. This type of decoration is discernible at Canterbury and elsewhere from about 1120 and reached its maturity in the Bury Bible with its luxuriant plant formations that extend in all directions like a fleshy octopus. Yet however luxuriant the blossoms and whatever the form of the inhabiting creatures, the foliage spirals are always rigorously controlled within the confines of the initial.

The inventiveness of English decoration in the second quarter and middle of the 12th century was never surpassed

either in this country or on the Continent, and there was no fundamental change until about 1170. When it came, this change was linked with a new type of book produced by the expanding workshops of Paris. These books are the biblical glosses of Peter Lombard, characterized by a complex page layout to accommodate the biblical text, the gloss and the scholarly apparatus of notes and sources. This new page layout embodies one of the most significant changes in Western education, from the spiritual exercise of the monastic reading to the close study of the text implicit in the new scholasticism (see **69**). These books required a profusion of small initials running parallel to the larger ones of the main text. To match the reduction in size, the foliage becomes thinner and the spirals more tightly and regularly wound, and the background is usually of burnished gold. The floral forms are also smaller and neater and usually circumscribed by a row of white dots. The principal animal decoration now consists of small white creatures which inhabit the scrolls in great profusion. The initial itself is usually placed on a framing panel of blue, red or gold. These initials are neater than their predecessors, but it may be felt that what has been gained in refinement has been lost in vigour and inventiveness. It is a decorative scheme that fits the regularized systems of knowledge current in the later Middle Ages.

At the same time, c. 1170, there was an equally striking change in figure style. It is characterized by the renewed influence of Byzantine art, particularly in the careful modelling of the faces in heavy ochres and greys, producing a more naturalistic effect. An early group of manuscripts with illuminations in the new style (**70**) is that associated with Abbot Simon of St Albans (1167–83), produced by one of several itinerant workshops active in France as well as England. The greater realism of the faces is accompanied by a new naturalism in the fall of the drapery, in which multiple folds gradually replace the abstract patterns formed by the damp-fold. Smaller and neater figures accord with the reduced size of most books, and the fine white outlines, usually considered a feature of Gothic illumination, make their first appearance at this date. Variants of this style occur in the last quarter of the century in manuscripts from Durham and elsewhere (**76–8**), but a distinction should be made with the style embodied in the later initials of the Winchester Bible (**64, 64a** and **b**). Here the Byzantine influence appears in a more direct form and it is likely that it reached England via Sicily, with which there were close political links through the Norman kings, Roger II (1101–54), builder of the Capella Palatina at Palermo, and William II (1166–89), builder of Monreale. This is the calm, classicizing Byzantinism which forms another aspect of the transition to Gothic art. C.M.K.

Note: The bibliography sections of the entries on illuminated manuscripts are limited to principal monographs and to recent literature. For full bibliographies, the reader is referred to the relevant volume of the *Survey of Manuscripts Illuminated in the British Isles*, i.e. Kauffmann, 1975; Temple, 1976; and Morgan, 1982; to which references are given in each case.

1

1 Psalter

248 × 146 mm; 129 ff.
c. 1050; Winchester
London, British Library, MS Cotton, Tiberius C. VI

The manuscript contains computistical material (ff. 2–7ᵛ), a series of full-page miniatures (ff. 8–16), the Ps. Jerome treatise on musical instruments (ff. 16ᵛ–18), prefatory material to the Psalter (ff. 19–27ᵛ), two homilies in Anglo-Saxon (ff. 28–30) and the Psalter proper in the so-called Gallican version with a gloss in Anglo-Saxon, ending incomplete in Psalm 113 (ff. 31–129ᵛ).

Coloured outline drawings relating to the computistical diagrams at the beginning of the manuscript include angels, a feasting scene (f. 5ᵛ), figures of Life and Death (*Vita et Mors*, f. 6ᵛ) which derive from those in the Leofric Missal made at Glastonbury before 979 (cf. Heimann, 1966), and a figure of God, Creator of the Universe (f. 7ᵛ). The picture cycle, also coloured outline drawings, begins with five scenes from the life of David (ff. 8–10) and continues with Gospel scenes from the life of Christ, beginning with the Temptation (f. 10ᵛ; exhibited) and ending with Pentecost (f. 15ᵛ) and St Michael fighting the dragon (f. 16). The Ps. Jerome text is illustrated with diagrams of instruments and a representation of David playing the

psaltery (f. 17ᵛ). The Psalter prefaces are preceded by a fully-painted miniature of Christ in Glory (f. 18ᵛ) and the Psalter itself by another showing David and his musicians (f. 30ᵛ). Before Psalms 51, 101 and 109 are coloured outline drawings of, probably, St Jerome, of Christ triumphant over the beasts and of the Trinity (ff. 71ᵛ, 114ᵛ, 126ᵛ). Finally, there are fully-painted initials with ornate frames with leaf decoration and rosettes for the prefaces (f. 19) and for Psalms 1, 51, 101 and 109 (ff. 31, 72, 115, 127). The initials for the liturgical division of the Psalter, though smaller, are also painted (ff. 48ᵛ, 60, 73, 85, 98ᵛ, 112).

The manuscript, damaged by the Cottonian Library fire, is still clearly a lavish product making use of the full repertoire of techniques of the period, though it is interesting that gold leaf is not used. It is the first surviving example of a Psalter with a prefatory series of scenes of Christ's life, though it has been conjectured that in this it copies an hypothetical earlier model of the later 10th century (Wormald, 1952a). Such Psalters become common in the 12th century (cf. **17a**). Script, text and the style of the initials suggest the Psalter was written at the New Minster, Winchester, during the reign of Edward the Confessor, probably *c.* 1050. It is not impossible that it was made for a highly placed ecclesiastic or royal personage rather than for use in the community. Wormald has emphasized the liturgical character of certain scenes such as the *Washing of the Disciples' feet* (f. 11ᵛ), and a number of comparisons can be made with the Winchester Benedictional of St Ethelwold of *c.* 971–80 (British Library, Add. MS 49598).

The scene exhibited (f. 10ᵛ) shows the Devil tempting Christ with the prestige possessions of the period (drinking-horn, gold torques). The scene opposite (f. 11) of the Entry to Jerusalem, known as the *Adventus Domini*, had been adapted in Early Christian art from the representations of the triumphal entry of the emperor in the antique period, and still had secular overtones.

The manuscript illustrates the high standards of Anglo-Saxon book production so much admired by contemporaries. The drawings show Romanesque tendencies in their strong outlines and angular patterning as opposed to an earlier lighter, more atmospheric style. J.J.G.A

PROVENANCE Signature of Thomas Cotton, son of Sir Robert Cotton, d. 1662, f. 2; Cottonian Library presented to the nation in 1700 and incorporated in the British Museum, 1753; manuscript damaged in the fire at Ashburnham House in 1731
BIBLIOGRAPHY Wormald, 1952a, pp. 50–3, pls. 30–2; Ker 1957, p. 262; Wormald, 1962, pp. 1–13, pls. 1–30; Heimann, 1966, p. 43 ff., pls. 9a, 10a, 12a; Temple, 1976, no. 98, pls. 297, 302–11, fig. 37

2 Four Gospels (*illustrated on p. 14*)

320 × 238 mm; 154 ff.
Before *c.* 1062–5
Rheims, Bibliothèque municipale, MS 9

The illumination consists of canon tables with gold-framed arches containing acanthus patterns on 10 pages (ff. 18–22ᵛ), and of framed portraits of the Evangelists with their symbols above them (ff. 23, 60, 88, 128). Each Evangelist is shown with a gold-framed plaque on which the opening words of his Gospel are written. The text is not repeated on the succeeding verso and there is no initial there, which is a very unusual if not unique arrangement. The colouring as seen on the illustrated page of St Luke (f. 88) is varied and includes much use of a particular blue-green blue.

It is not known where the Gospels was made, but the circumstances of its gift to St-Remi, as reconstructed by Hinkle, are of great interest, illustrating the way illuminated manuscripts might circulate in this period. Burchard, the son of Aelfgar, Earl of Mercia, had accompanied Archbishop Aldred of York and others to Rome in 1061 and had died on the journey. He was buried at St-Remi and as a consequence his father gave lands to the abbey, as is recorded in Domesday Book. Eighteenth-century records also mention verses inscribed on the precious-metal binding of a Gospels at St-Remi recording its donation by Aelfgar and his wife in memory of Burchard. This must have been the present manuscript, though the binding no longer survives. It showed the Crucifixion and the Lord in Majesty and must have closely resembled the extant Anglo-Saxon binding of the Gospels of Judith of Flanders (New York, Pierpont Morgan Library, MS 708). J.J.G.A.

PROVENANCE St-Remi, Rheims, inventory of 1549
EXHIBITION Rheims, 1967, no. 45
BIBLIOGRAPHY Hinkle, 1970, pp. 21–35, pls. VII–IX, fig. 1; Temple, 1976, no. 106, ill., p. 299

3 Troper (*illustrated on p. 17*)

218 × 135 mm; 36 ff.
Third quarter 11th century
London, British Library, MS Cotton, Caligula A. XIV

A Troper contains texts with music to be sung in the liturgical services of the Church. This manuscript, which starts incomplete at Christmas and ends incomplete at the dedication of a church (f. 36ᵛ), contains 11 scenes as full-page or smaller miniatures showing the Ascension (f. 18) and Sts Stephen (f. 3ᵛ), John the Baptist (f. 20ᵛ), Peter (f. 22), Lawrence (f. 25), Joachim and Joachim and Anna for the birth of the Baptist (ff. 26, 26ᵛ), Martin (f. 29), Andrew (f. 30ᵛ), All Saints (f. 31), and the Holy Virgins (f. 36). There is also a painted initial H on f. 2.

The exhibited scene (f. 22ʳ) shows St Peter's release from prison by the angel as narrated in Acts XII. Parts of this text are written around the miniature. As the angel leaves him at the bottom St Peter says 'thank you' ('*Grates*' written on his scroll)!

Neither the date nor the origin of the manuscript can be certainly established, though Canterbury has been suggested in the past on liturgical grounds and a date from the middle to the third quarter of the 11th century seems likely on stylistic grounds.

All the miniatures are fully painted with gold and silver also used, except the All Saints miniature which is a coloured drawing. The colours, olive-green shading to yellow and brown shading to orange, are unusual in Anglo-Saxon book painting. Parallels exist for the colouring, for the conventions of sharply corrugated drapery folds and for the curling hair in manuscripts made in northern France and Belgium (e.g., the *Life of St Bertin*, St-Omer 698). This suggests the possible influence of Continental styles on English manuscript production even before the Conquest. J.J.G.A.

PROVENANCE Sir Robert Cotton, Bt, d. 1631; Cottonian Library presented to the nation in 1700 and incorporated in the British Museum, 1753
BIBLIOGRAPHY Wormald, 1973, p. 253, ill. p. 256; Temple, 1976, p. 97, ills. pp. 293–5

4 Treatises by Jerome, Augustine and Ambrose
(*not illustrated*)

290 × 220 mm; 199 ff.
Mid 11th century; Mont St-Michel, Normandy
Avranches, Bibliothèque municipale, MS 72

Mont St-Michel was refounded as a reformed Benedictine community in 966 and like other Norman monasteries proceeded to build up an impressive library containing biblical commentaries and other works especially by the four Fathers of the Latin Church, Ambrose, Augustine, Jerome and Gregory the Great. Most of the texts copied here concern controversies with heretics in the 4th century, and they may have had special relevance in the context of contemporary disputes such as that between Lanfranc of Bec and Berengar of Tours concerning the Real Presence. Berengar's recantation is copied into another Mont St-Michel manuscript.

Miniatures on ff. 97 (exhibited) and 182ᵛ show respectively St Augustine seated disputing with the heretic Felicianus (exhibited) and St Ambrose writing the *De bono mortis* (*On the Good of Death*). Both fall into the category of author portraits established in antiquity and used above all for representations of the Evangelists at this time (2). The importance attached to the Fathers by the monks is suggested by this assimilation to Evangelist portrait types and also by the remarkable half-length blessing figure of God in the lunette above. This recalls the Byzantine Pantocrator type of which knowledge could have reached the abbey either through Norman pilgrimages to southern Italy, especially to the shrine of St Michael on Monte Gargano, or as a result of Abbot Radulphus' pilgrimage to Jerusalem on which he died, *c.* 1055–8.

The style of the miniatures shows clearly a debt to later 10th-century Anglo-Saxon book painting of which examples had reached Normandy by this date. At the same time there are features characteristic of Romanesque painting such as the emphasis on the flat coloured background and a planar space construction. The manuscript also contains a number of painted scroll initials, one with a figure fighting a lion, which are important precedents for 12th-century Anglo-Norman initials.

The manuscript is signed by the scribe '*Felix Frotmundus per secula frater amandus*' ('Happy Frotmund for ever a loving brother'; cf. Eadwin's colophon, **62**). J.J.G.A.

PROVENANCE Transferred to Avranches with other manuscripts from Mont St-Michel in 1791
EXHIBITIONS Paris, 1954, no. 187; Rouen, 1975, no. 17; Rouen, Caen, 1979, no. 117, repr.
BIBLIOGRAPHY Alexander, 1970, *passim* and pls. 3c, 11h, 12a, 13b, 22, 28; Delalonde, 1981, pp. 6, 14, pls.

5 Jerome, Commentary on Isaiah

371 × 260 mm; 291 ff.
Late 11th century; Normandy, (?) Jumièges
Oxford, Bodleian Library, MS Bodley 717

This is a good example of the care expended by Norman scriptoria on copies of patristic texts. The volume is large, finely written by three scribes, and decorated with two large frontispieces (exhibited), the first showing Isaiah with his prophecy 'Behold a virgin shall conceive' (f. vᵛ), the second showing St Jerome and Eustochius for whom he wrote the text (f. vi exhibited). There are also historiated initials for the preface showing a burial scene (f. viᵛ) and for the beginning of the text proper showing Isaiah preaching (f. 2, Isaiah II. 3), and decorated initials for each book. The burial scene also occurs in a Corbie manuscript of the same text and similar date (Paris,

5

Bibliothèque nationale, latin 13350) demonstrating the close links between northern French monastic communities at this time.

At the end of the text (f. 287ᵛ) is an illustrated colophon inscribed 'Image of Hugo painter and illuminator of this work'. Representations of illuminators are rare in the early Middle Ages and this has been called by Otto Pächt the first surviving signed self-portrait. Hugo represents himself not as artist but as scribe with knife and pen, thus aligning the image with the much more common type of scribe portrait. He was probably a monk of Jumièges for which he illustrated other manuscripts now in Rouen and Paris, the latter with a second self-portrait inscribed *Hugo levita* (Avril, 1975). The present manuscript may have been a gift to Exeter by the first post-Conquest Norman bishop, Osbern (1072–1103). J.J.G.A.

PROVENANCE Exeter Cathedral inventory of 1327; given to the Bodleian Library by the Dean and Chapter of Exeter Cathedral, 1602
EXHIBITION Rouen, 1975, pp. 43, 49; Rouen, Caen, 1979, no. 145
BIBLIOGRAPHY Pächt, 1950, pp. 96–103, pls. IVb, Vb, c, VIa; Dodwell, 1954, pp. 117–8, pl. 70e; Pächt, Alexander, 1966, no. 441, pl. XXXVI; de Merindol, 1976, I, pp. 381–3; Alexander, 1978, p. 107, pl. 19

6 Augustine, Commentary on the Gospel of St John

366 × 272 mm; 184 ff.
Late 11th century; St-Ouen, Rouen
Rouen, Bibliothèque municipale, MS A.85(467)

This is another example of a finely written and decorated
patristic manuscript made in Normandy. It contains over 117
ornamented initials, many historiated with Gospel scenes. The
style of drapery painted in bands of red and green perhaps
comes to Normandy from the north (cf. the Corbie Gospel
book, Amiens, Bibliothèque municipale, MS 24). The two-
volume Bible given to Durham by Bishop William of St Carilef
(d. 1096), probably on his return from exile in Normandy from
1088–91, is in a similar style and is probably by the same artist
(Avril, 1975). He was no doubt a monk of St-Ouen.

The drapery style is taken up in England, for example by the
artist of the historiated initials in the St Albans Psalter (**17**). The
illustrated initial showing the Last Supper (f. 121) is an early
example of the updating of the scene from the half-circle type
of table found in early Christian and Byzantine art to the
straight table presumably familiar to artists from their
contemporary experience. J.J.G.A.

PROVENANCE St-Ouen, Rouen
EXHIBITION Rouen, 1975, no. 33, repr.
BIBLIOGRAPHY Dodwell, 1954, pp. 11, 20, 115–17, pls. 9c, e, 71a, f, 72d; Pächt, Dodwell,
Wormald, 1960, p. 202, pl. 165c

6

7 Psalter with Anglo-Saxon gloss

306 × 192 mm; 149 ff.
c. 1080; Winchester (? New Minster)
London, British Library, MS Arundel 60

To judge from the saints listed in the calendar and Litany
(including Sts Grimbald and Swithun) this is a Winchester
manuscript. The Anglo-Saxon gloss suggests that most of it
was written before the Conquest and it contains drawings in
an Anglo-Saxon style, however part of it (ff. 47–52, 133–42�v)
is in an Anglo-Norman hand of the last quarter of the
century.

This imposing painting of the Crucifixion with the
Evangelist symbols at the corners of the frame is one of two
illuminated pages immediately following the later text (ff. 52�v,
53), and it also may be dated towards the end of the 11th
century. Most unusually for this period it is almost fully
Romanesque in character. The nervous calligraphy of Anglo-
Saxon art has given way to thick, firm outlines and contours
which stress the anatomy of Christ and delineate the abstract
pattern on the loincloth. The heavy colours dominated by deep

8

8 Four Gospels: Leofric Gospels

315 × 245 mm; 204 ff.
Late 9th or early 10th century; Landevennec, Brittany;
additions of the third quarter 11th century, northern France or
Flanders
Oxford, Bodleian Library, MS Auct. D.2.16

The original illumination consists of three Evangelist portraits
(ff. 28ᵛ, 71ᵛ and 101ᵛ; St John is missing) and initials for the
Gospel openings and for the prefaces. There are also rather
plain arches for the canon tables (ff. 23–8). The portraits drawn
in ink and coloured with washes of orange minium and yellow
are of the type known as 'beast-headed', that is they conflate
the human Evangelist with his symbol. This conflation perhaps
originates in the British Isles in the 8th century (Barberini and
Maeseyck Gospels) and is probably preserved in Brittany in the
9th century, where other examples occur, through the
connections between the Celtic and the Breton church. For a
later example see the Hereford Gospels (18). On ff. 72ᵛ
(exhibited) and 146 are portraits of Sts Mark and John fully
painted and in a very different style which finds its nearest
comparisons in manuscripts of the second half of the 11th
century from Liège in Belgium and the monastery of St-Bertin
near Boulogne-sur-mer. There must have originally been four
such portraits as we can tell from the late-11th-century
copy (9).

 At the end of the Gospels is a list of liturgical Gospel
readings including readings for the feasts of Sts Winwaloe and
Samson, suggesting the Gospels was made at Landevennec. The
community there fled from the Viking raids to Montreuil-sur-
mer about 924. It has been assumed that Leofric, who was
educated in Lotharingia, acquired the Gospels on the
Continent. However, many Breton manuscripts reached
England in the 10th century, particularly in the reign of King
Athelstan (924–39), and it is equally if not more probable that
Leofric acquired the manuscript in England (Hartzell, 1981). If
so he must have decided, perhaps for theological perhaps for
aesthetic reasons, that new portraits should be added and
presumably he therefore either sent to France or Flanders for
them, or had them inserted while he was there. J.J.G.A.

PROVENANCE Manuscript includes records in Latin and Anglo-Saxon of gifts to Exeter by
Leofric, bishop 1050–72 (ff. 1–2ᵛ, 6ᵛ–7)
BIBLIOGRAPHY Schilling, 1948, p. 312, pls.; Ker, 1957, p. 351; Pächt, Alexander, 1966, nos. 427,
433, pl. XXXV; Alexander, 1966, pp. 6–16, pls. 10–11; Wormald, Alexander, 1977, p. 14;
Hartzell, 1981, p. 89 n. 6

blue and green are also unlike those of Anglo-Saxon
illumination; only the unpainted background and the stylized
acanthus decoration overflowing the contours of the frame are
more Anglo-Saxon than Romanesque. Various comparisons
have been made with both Ottonian art and with Norman and
northern French manuscripts of the 11th century, and this
miniature serves to show that the Romanesque style was
imported into England from the Continent in the second half
of the 11th century.

 The trees on either side of the cross represent the two trees
of Paradise described in Genesis II.9: the tree of life and the tree
of knowledge of good and evil. On the opposite side, Psalm 51
(52 of the Authorized Version) opens with a decorated page
(*Quid gloriaris*, 'Why boastest thou', the opening words of the
Psalm), framed in the same manner as the *Crucifixion*. The
fleshy acanthus of Anglo-Saxon art has turned into a harder,
more tightly controlled form indicative of the transition to
Romanesque style. C.M.K.

PROVENANCE Thomas Howard, Earl of Arundel (1585–1646); presented by Henry Howard to
the Royal Society, 1681; bought by the British Museum in 1831
BIBLIOGRAPHY Kauffmann, 1975, no. 1

9

10

9 Four Gospels

245 × 170 mm; 132 ff.
Late 11th century; Exeter
Paris, Bibliothèque nationale, MS latin 14782

Each Gospel is preceded by an ornately framed portrait of the Evangelist with his symbol on a verso with initials similarly framed on the opposite rectos (ff. 16ᵛ–17, 52ᵛ–3 [exhibited], 74ᵛ–5, 108ᵛ–9). There are decorated canon tables with Evangelist symbols on 15 pages (ff. 9–16).

Though there is no indication of the manuscript's original provenance, the portraits of Mark and John are replicas of those added to the Leofric Gospels (8) and a textual error in the Leofric Gospels' canon tables is repeated. The manuscript was almost certainly made at Exeter, therefore, and the script is quite consonant with this too.

The manuscript is an interesting example of how an artist of this period on the one hand copied the Evangelists almost exactly, but on the other also made additions such as the frames. He also must have had a different model or models for his canon tables, either of the 8th or of the 10th–11th centuries. His Evangelist portraits are, in terms of a development towards a Romanesque spatial construction, more conservative than their models. J.J.G.A.

PROVENANCE Abbey of St-Victor, Paris, early 16th century, with pressmark and list of contents by the librarian, Claude de Granderue; not identifiable in the Exeter inventories of 1327 or 1506
BIBLIOGRAPHY Alexander, 1966, pp. 6–16, pls. 6, 7, 8, 12, 15, 16, 18, 20; Kauffmann, 1975, no. 2; De la Mare, 1983, pp. 79–88

10 Gregory the Great, Dialogues

322 × 205 mm; 207 ff.
Late 11th century; Worcester Cathedral Priory
Cambridge, Clare College, MS 30

The Worcester provenance is indicated by the 13th-century copies of four letters relating to the Priory on f.1ᵛ. This is one of five such splendid decorated initials in the manuscript. Its foliage spirals with palmettes and curling trumpet leaves, animal masks, human and animal profile terminals and large, winged dragons, all on a multi-coloured ground of red, green and pale purple, are typical of the ornamentation produced in England under Norman influence in the post-Conquest period. Although Worcester, during the bishopric of St Wulfstan, played an important part in maintaining Anglo-Saxon cultural and ecclesiastical traditions after the Norman Conquest, it was not an important centre of manuscript illumination. There are a few other manuscripts with initials of this type (Bodleian Library, Hatton 23; Lat. th. d. 33) and a handful of illustrations (see 23 and 33), but book illumination at Worcester is not comparable to that of Canterbury, Winchester, St Albans, Bury or Durham. C.M.K.

PROVENANCE Worcester Cathedral Priory
BIBLIOGRAPHY Kauffmann, 1975, no. 4; idem. in 'Medieval Art and Architecture at Worcester Cathedral', Brit. Archaeol. Assoc. Conf. 1, 1975 (1978), p. 45, pl. V

11 Priscian, Grammar (*not illustrated*)

150 × 217 mm; 160 ff.
c. 1070–1100; Canterbury, St Augustine's Abbey
Cambridge, Trinity College, MS O.2.51

The exhibited initial (f. 91) is one of 17 – one at the beginning of each book – decorating this manuscript. The figures clambering up the shaft of the initial, entwined in the foliage scrolls and engaged in mortal combat, epitomize these early Romanesque initials, developed in Normandy in the middle of the 11th century and perfected in England by about 1100. Yet the style of the figures, characterized by nervous, almost zigzag outlines, only lightly tinted, is very much in the Anglo-Saxon rather than the Norman tradition. This mirrors the conditions at St Augustine's, Canterbury, where the English monks took unkindly to Norman rule and refused to accept a Norman abbot in 1087; after two years of turbulence order was restored only when the community was dispersed and replaced by 23 monks from Christ Church. In another way this manuscript is typical of Canterbury illumination: the splendid initials are purely decorative and not illustrative. A grammar, indeed, is hard to illustrate, but narrative illustration is rare in Canterbury manuscripts in general, at least until the mid 12th century.

Priscian stood for Latin grammar in monastic libraries and, through his examples, for much of Latin literature. His renewed popularity at this period illustrates the meaning of the term 'Twelfth-century Renaissance'. C.M.K.

PROVENANCE Probably St Augustine's, Canterbury (cf. script of Bodleian, Ashmole 1431), subsequently (?) Christ Church, Canterbury; Dr Thomas Gale (1635/6–1702) Regius Professor of Greek; given to his college by his son Roger Gale, 1738
BIBLIOGRAPHY Kauffmann, 1975, no. 8; Lawrence, 1982, p. 103

12 Bible, vol. I, Genesis – Job (*not illustrated*)

480 × 318 mm; 235 ff.
c. 1100; Lincoln
Lincoln Cathedral Library, MS A.1.2

The Lincoln Bible, of which the second volume is in Trinity College, Cambridge (MS B.5.2), is the earliest illustrated English Romanesque Bible, though most of the twelve historiated initials are limited to single figures. This is the only initial (f.70^v) with two figures applied to the shaft and a narrative content, for it illustrates, however simply, the Lord's command to Joshua (Joshua 1.2–9). The construction of the initial with uncoloured foliage with curling leaf endings shown against a background of small areas of green, blue, red and yellow, is of Norman origin. Typical of Lincoln manuscripts of this period (Lincoln MSS A.3.17; B.3.5, B.2.3) are the thin figures with peculiarly long hands and fingers.

The fact that there is a group of related illuminated manuscripts in the cathedral library indicates that there was a local scriptorium at Lincoln. Even though there was no monastic priory attached to it, the cathedral remains the most likely home of this scriptorium. C.M.K.

PROVENANCE Given to Lincoln Cathedral Library by *Nicholaus Canonicus et archidiaconus*, probably to be identified with Nicholas, Archdeacon of Huntingdon (d. *c.* 1109)
BIBLIOGRAPHY Kauffmann, 1975, no. 13; Cahn, 1982, p. 260, no. 32

13 Chronicle of Battle Abbey (*illustrated on p. 17*)

210 × 160 mm; 22–130 ff.
Early 12th century; Battle Abbey
London, British Library, MS Cotton, Domitian A.II

No attempt was made to portray physical likeness at this period, but the crown and sceptre on f.21 show that the sitter was a king and he is identified in the opening words of the text: *Anno ab incarnatione Domini* MLXVI *Dux Normannorum nobilissimus Willelmus* . . . (In the year of our Lord 1066, William, most noble Duke of the Normans. . .). It goes on to narrate how William, about to commit himself to his first battle on English soil, swore that if he were successful he would found a monastery on the battlefield and would dedicate the site to God. As a result of this promise, the Abbey of St Martin at Battle was founded in the mid-1070s and dedicated in 1093, and the Chronicle of which this is the opening page gives an account of its history up to the 1180s. Its central theme is the Abbey's freedom 'from all subjection to and exaction of bishops' as promised by King William himself. The dispute with the Bishop of Chichester came to a head in a series of lawsuits in the 1150s which the Abbey won on the basis of forged charters. Eleanor Searle, the recent editor of the Chronicle, has dated the origin of the main text after 1155, perhaps *c.* 1170, with subsequent additions up to the 1180s.

However, a date *c.* 1170 is very difficult to reconcile with the style of the initial. The large, curling leaves, with stems loosely wrapped round the shafts, and the ochre colouring are closely linked with the Anglo-Norman tradition of the late 11th century. The dog pulling a stem round the shaft occurs in Norman manuscripts of this period (e.g. Avranches MS 89, *c.* 1070–95, Alexander, 1970, pl. 15d) and there are English comparisons of the early 12th century (e.g. Lambeth MS 62, Dodwell, 1954, pl. 7f.), while the figure of the Conqueror echoes that of King David in a Canterbury Psalter of *c.* 1070–1100 (Trinity, Cambridge, MS B.5.26). Early 12th century is therefore a reasonable date based on the style of the initial, but it is separated by over half a century from the historian's date.

There are various possible explanations for the dichotomy. It is conceivable that the initial was painted on to a blank sheet that remained unused for several years before the text was written. At any rate the letters spill over on to the colour which means that the initial was completed before the text was begun. Alternatively, perhaps the historical and palaeographical evidence for the late dating of the Chronicle is less conclusive than has been argued. The rubricated initials in the text could be about 1130–40 and possibly this could be a compromise date uniting the Conqueror's portrait and the body of the text. C.M.K.

PROVENANCE Battle Abbey until its dissolution (1538); Magdalen College, Oxford, 1614; Sir Robert Cotton, Bt, 1638/54; Cottonian Library, presented to the nation in 1700; incorporated in the British Museum, 1753
BIBLIOGRAPHY Searle, 1980

14

14 Passionale (lives of saints)

333 × 222 mm; 229 ff.
1100–20; Canterbury, St Augustine's Abbey
London, British Library, MS Arundel 91

The exhibited initial (f. 188) illustrates the life of St Caesarius, a deacon from Africa, who was martyred on 1 November 300 at Terracina in Italy for speaking out against the practice of human sacrifice. Above, the Saint watches a pagan sacrifice: Lucian, the victim, first sacrifices in the temple (left medallion) and then hurls himself from the mountain as a sacrifice in honour of Apollo; on the right spectators watch his suicide; below, St Caesarius is condemned for sorcery; in the last medallion he is sewn into a sack and thrown into the sea.

The figures are still drawn very much in an Anglo-Saxon style of flimsy, agitated pen outlines which survived at St Augustine's until well into the 12th century (see under 11). This is a very rare example of narrative scenes in a manuscript of the post-Conquest period. It demonstrates clearly that the lack of narrative illustrations in the period between 1066 and the early years of the 12th century was due not to lack of artistic skill, for here a complex sequence of pictures has been compressed with great ingenuity to fit within the confines of a small initial. It appears instead that the tradition of narrative illustration was interrupted by the Normans' unfamiliarity with it after the Conquest. C.M.K.

PROVENANCE Thomas Howard, Earl of Arundel (1585–1646); presented by Henry Howard to the Royal Society, 1681; bought by the British Museum, 1831
BIBLIOGRAPHY Kauffmann, 1975, no. 17, Lawrence, 1982, p. 105

15 Bede, Life of St Cuthbert

197 × 122 mm; 203 pp.
c. 1100; Durham Cathedral Priory
Oxford, University College, MS 165

Bede, who was two generations younger than St Cuthbert (d. 687), monk and Bishop of Lindisfarne, wrote this work in about 721, basing it on an anonymous *Life* of c. 699–705. Between 1083, the year of the foundation of the Benedictine priory at Durham, and about 1100, a group of seven other miracles was composed and added after Bede's text, and these are included in this manuscript. As it contains no mention of the key event of the translation of Cuthbert's relics to a new shrine in 1104, it was most probably written before that date. The style of these drawings is similar to that of the Hunterian medical manuscript (37), and of other Durham manuscripts of the early 12th century; the nervous zigzag lines at the hems of garments, and the very fact that they are outline drawings, relate them to Anglo-Saxon art of the previous century. Yet the figures have a new solidity characteristic of the Romanesque period.

This book, with its 55 pictures, is the earliest surviving post-Conquest manuscript with a cycle of religious narrative illustrations. There is a group of later Cuthbert cycles, which are closely related: Trinity College, Cambridge, MS O.1.64, 12th century (only two drawings completed); British Library Add. MS 39943 c. 1190–1200 (81); York Cathedral windows, early 15th century; Carlisle Cathedral choir stalls, late 15th century. The whole group is descended from an archetype, probably produced at Durham between 1083 and 1100.

The exhibited illustration (p. 14) shows St Cuthbert, still a layman, kneeling in prayer, and thereby saving the monks from shipwreck. He is watched by a group of mocking spectators, but the praying monks, who appear in the companion manuscript, are not shown here. C.M.K.

PROVENANCE Southwick Priory near Southampton (erased ex-libris ff. 1–2); given by William Rogers of Painswick, Gloucestershire to his college, after 1666
BIBLIOGRAPHY Kauffmann, 1975, no. 26; Baker, 1978, pp. 16–49

16

16 Prudentius, Psychomachia and other tracts

152 × 105 mm; 128 ff. (Prudentius ff. 1–35ᵛ)
c. 1120; St Albans Abbey
London, British Library, MS Cotton, Titus D.XVI

Dating from the 5th century, Prudentius' *Psychomachia* is a Christian poem written in the manner of a classical epic. It relates how virtues and vices, personified as female figures, battle for possession of the human soul. It was an immensely popular work in the early Middle Ages and some 20 illustrated manuscripts survive, most of them dating from the 9th to 11th centuries, all so closely related as to presuppose a common archetype. The archetype no longer exists, but, as several of the extant manuscripts are very classical in appearance, it is generally accepted that it was produced as early as the 5th century. Cotton, Titus D.XVI is one of the very last of the sequence and has only 46 out of the 90 illustrations in the complete manuscripts.

This opening (f. 15) shows *Superbia* (Pride) taking a fall – after charging *Humilitas* (Humility), illustrated on the previous pages – after which *Humilitas* cuts off her head. In the technique of lightly-tinted pen outline drawing, the artist has followed his Anglo-Saxon models, but the outlines have hardened and the actions and the figures are more realistically portrayed than in the pre-Conquest manuscripts. The elongated figures usually shown in profile are similar to those in the St Albans Psalter (17) which indicates the influence of the Alexis Master (see 17) on an artist working at St Albans in the older, calligraphic tradition. C.M.K.

PROVENANCE St Albans Abbey (inscriptions ff. 36ᵛ, 37) Egidius Watson, 16th century; Sir Robert Cotton, Bt (1571–1631); his library presented to the nation in 1700
BIBLIOGRAPHY Kauffmann, 1975, no. 30; Thomson, 1982, no. 19

17 Psalter: St Albans Psalter

276 × 194 mm; 418 pp.
c. 1120–30; St Albans Abbey
Hildesheim, Basilika St Godehard

This manuscript, with its 40 full-page framed miniatures – mostly of the New Testament – preceding the text, five tinted drawings and 211 historiated initials, is one of the most splendid and influential of the English 12th century. The evidence of the calendar and Litany indicates that it was assembled by Abbot Geoffrey (1119–47) for Christina, anchoress of Markyate. Although the date, c. 1119–23, proposed in the magisterial study of Pächt, Dodwell and Wormald, is open to doubt, even the revision c. 1120–30 proposed by Rodney Thomson and generally accepted means that the St Albans Psalter is the first extant English manuscript with a cycle of full-page miniatures (as opposed to tinted

drawings) since the early Winchester School in the 10th century. Nearly all the miniatures and drawings are by the hand of the Alexis Master, named for his drawing of the life of St Alexis.

The opening (pp. 48–9) shows the Entombment, with St Joseph of Arimathea supporting Christ's head and shoulders and the Virgin shown in an emotional embrace, and the Harrowing of Hell, the descent of Christ into limbo after the Resurrection as described in detail in the Apocryphal Gospel of Nicodemus. He treads on the gates of Hell and draws up the supplicating figures of Adam and Eve. The style is characterized by symmetrical compositions, with solemn, hieratic, elongated figures set against different coloured background panels to render space, and by an extensive use of purple, which betrays a considerable debt to Ottonian art. The figures have heavy contours and most of them are shown in profile, which is marked by an almost straight line from the brow to the tip of the nose. The clearly-delineated contours of Christ's thigh in the *Harrowing of Hell* represent an early stage of the damp-fold convention showing the body beneath the drapery. The practice of picking out the drapery surface in a series of fine, comb-like white highlights is Byzantine in origin. Iconographically, these pictures also show Byzantine influence, particularly in the case of the *Entombment*, while the tradition of showing Hell in the form of a dragon-mouth is of Anglo-Saxon origin. The cycle of illustrations is related to those in the Pembroke College New Testament and the four Psalter leaves (21 and 47–50). Other works by the Alexis Master and his assistants are nos. 17a–21 in the exhibition. C.M.K.

PROVENANCE Christina, anchoress of Markyate; still in England in the 16th century (under Henry VIII the word *pape* erased from the calendar); Benedictine Abbey of Lampspringe, near Hildesheim, by 1657; brought to St Godehard's, Hildesheim, when Lampspringe was suppressed in 1803
BIBLIOGRAPHY Pächt, Dodwell, Wormald, 1960; Kauffmann, 1975, no. 29; Thomson, 1982, no. 72

17

18

17a Leaf from the St Albans Psalter (*not illustrated*)

270 × 176 mm (cut down on three sides)
c. 1120–30; St Albans Abbey
Cologne, Schnütgen Museum

This leaf contains three of the 211 initials illustrating the
Psalms, Canticles, Collects and prayers in the St Albans Psalter.
They are painted by two followers of the Alexis Master who
worked in a somewhat less sophisticated version of his style,
but they show his typically elongated figures, characteristic
profiles and eloquent gestures. The leaf contains three Collects
and must, therefore, have followed p. 414 at the end of the
Psalter. There is a historiated initial to each of the Collects:
H (*ostium nostrorum quaesumus*. . . 'We beseech thee Oh
Lord to crush the pride of our enemies . . .') with Christ smiting
a monster; A(*nimabus quaesumus*. . . 'We beseech thee Oh Lord
to hear the prayer of your supplicating servants for the souls
of the departed . . .'), a prayer for the dead, with a bishop, two
naked figures, two monsters and Christ above; D (*eus qui es
sanctorum tuorum splendor*. . . 'God, which art the wonderful
light of Thy saints . . .') similar to the last. This literal method
of illustrating a single verse of text is typical of the initials of
the St Albans Psalter. C.M.K.

PROVENANCE In the collection of Dr Hans Lücker, Sürth-bei-Köln since 1918; identified by
Hermann Schnitzler before 1960; acquired by the Schnütgen Museum with the rest of the
collection in 1963
EXHIBITIONS Cologne, Schnütgen Museum, *Grosse Kunst des Mittelalters aus Privatbesitz*,
1960, no. 105; Brussels, 1973, no. 22
BIBLIOGRAPHY Pächt, Dodwell, Wormald, 1960, p. viii, supplementary pl.

18 Gospels

237 × 153 mm; 141 ff.
c. 1120–30; (?) St Albans Abbey
Hereford Cathedral Library, MS O.I.VIII

The style of both the decoration and of the figures in this
manuscript is very similar to the St Albans Psalter, and Pächt
attributed the illumination to the Alexis Master working with
an assistant. However, the script has been characterized as
'West Country' (Rodney Thomson) and it is not certain that
the manuscript was actually produced at St Albans.

There is a historiated initial at the beginning of St John, but
the page exhibited (f. 46) contains the only miniature. It shows
St Mark with the head of a lion, his symbol. Such a mixture
of Evangelist and his symbol occurs as early as the 8th century
(Gellone Sacramentary, Paris, Bibliothèque nationale, latin
12048), but this particular type, in which the animal-headed
Evangelist is seated, in the manner of an ordinary Evangelist
portrait, is rare, occurring for example in **21**. It remains a
curiously disconcerting image. C.M.K.

PROVENANCE Hereford Cathedral Library (inscribed with price f. 2; *De Concordia
evangeliorium prec.* XIIIs IIId)
BIBLIOGRAPHY Kauffmann, 1975, no. 33; Thomson, 1982, no. 78

19 St Anselm, Prayers and Meditations

265 × 180 mm; 106 ff.
c. 1130; (?) St Albans Abbey
Verdun, Bibliothèque municipale, MS 70

Anselm (1033–1109), monk and Abbot of Bec in Normandy
and then Archbishop of Canterbury, was one of the great
theologians of the Middle Ages who combined high office with
rare human warmth, shown in his many letters expressing
personal friendship. He wrote his *Prayers and Meditations* in
his early years, before he became Abbot of Bec in 1078. They
are the first examples of what was to become a vogue for fervid
and personal devotion, especially to the Virgin. As he wrote
them, he sent copies to his monastic friends or to ladies of
noble birth, from Adela, daughter of William the Conqueror,
the first recipient in 1071, to Mathilda, Countess of Tuscany,
the last in 1104. This manuscript is the earliest extant
illustrated text of the *Prayers and Meditations* but it is likely
that earlier illustrated texts existed.

The miniature exhibited (f. 68ᵛ) is the only one of the original
14 that remains. It illustrates the prayer to St Peter, showing
Christ handing the keys to St Peter combined with the
injunction 'Tend my sheep' (John XXI.16) in a composition very
similar to the small illustration of the same scene in Bodleian
MS Auct. D.2.6 of about 1150 (**59**). In style it is so close to the
St Albans Psalter (**17**) that it is attributed to the Alexis Master
himself, even though there are differences in the colours.
Rodney Thomson has identified the scribe as the main hand of
the St Albans Josephus manuscript in the British Library (Royal
13. D.vi–vii), but doubts whether this manuscript was actually
made at St Albans. As the leaves are pricked in both margins
and ruled in plummet, he suggests a date about 1130–40,
somewhat later than the Hereford manuscript (**18**) which is
ruled in the earlier technique of drypoint. Such a date is
supported by the floral decoration of the initials, for the
individual flowers are larger and more exuberant than in the
earlier St Albans manuscripts. C.M.K.

BIBLIOGRAPHY Kauffmann, 1975, no. 31; Thomson, 1982, p. 26, no. 79; on the text see R. W.
Southern, 1963, pp. 34–46; Anselm, St, 1973

20 Life and Miracles of St Edmund, King and Martyr

273 × 184 mm; 100 pp.
c. 1130; Bury St Edmunds Abbey
New York, Pierpont Morgan Library, M 736

Edmund was an obscure East Anglian king killed by the Danish
invaders in 869. Within 40 years he had come to be honoured
as a saint in East Anglia and the community that guarded his
relics at Bury was to become one of the most important
monasteries in the country. There are many manuscripts of his
life and miracles, but this is the only one, before the 15th
century, which is illustrated. Out of the 32 miniatures with
which this manuscript opens, the first 26 illustrate the text of
Abbo of Fleury's *Passio Sancti Edmundi* written before 998; the
remainder illustrate the collection of miracles.

The opening (pp. 36–7) shows one of the most gruesome
scenes in English Romanesque art. As Abbo of Fleury recounts,
eight thieves broke into the church to plunder St Edmund's
shrine. By the miraculous intervention of the saint they were
fixed motionless in the church until morning. The Bishop
ordered them to be hanged and in the miniature the execution
is being carried out. The blindfolded thieves hang in their death
agony, mouths open as they are asphyxiated. It is a graphic
warning to all who attempt to despoil the abbey of St Edmund.
This was of particular relevance in the late 11th and early 12th
centuries, a time when the Bishop of East Anglia attempted to

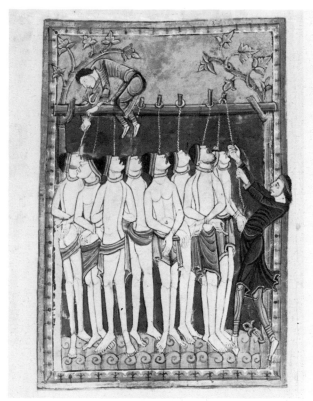

20

subvert the abbey's immunity from episcopal control and
Henry I collected all the abbey's income while keeping the
abbacy vacant (1102–21; see Abou-El-Haj, 1983). Nor would
it be lost upon contemporaries that it was the abbey's right to
hang thieves within its jurisdiction in West Suffolk.

The scene on the opposite page illustrates one of the miracles
described by Archdeacon Herman. During the period of Danish
invasions in about 1010–13, the monk Egelwin, guardian of St
Edmund's shrine, brought the saint's relics to London. The
house of a priest who had refused hospitality was miraculously
burnt to the ground.

In style, these miniatures are very similar to the St Albans
Psalter (17) and Pächt has attributed them to the Alexis Master
himself. However, the colours are brighter – royal blue and
green predominate – and the figures in the St Edmund
manuscript are less convincingly modelled than those in the
Psalter. Recently Thomson has put forward the view that the
Alexis Master drew the outlines and the paint was then more
crudely applied by a different hand.

In contrast to the miniatures, the initials are not in a St
Albans style but close to the Bury New Testament (21), and
E. McLachlan has identified the main scribe as one working on
contemporary Bury books. It appears, therefore, that the Alexis
Master or an assistant came to Bury to carry out the prefatory
miniatures for this manuscript, which is otherwise the work of
local scribes and illuminators. A date c. 1130, indicated by the
relationship with the St Albans Psalter, is supported by the
evidence of copies of letters from Henry I and Prior Talbot to
Abbot Anselm of Bury inserted at the beginning of the book.
C.M.K.

PROVENANCE Bury St Edmunds Abbey; George Roche, 16th century; W. Stonehouse; Robt.
Parker, 17th century; John Towneley, sale, 8 July 1814, lot 904, bought by Booth for £168;
R.S. Holford; Sir George Holford; Pierpont Morgan Library, 1927
BIBLIOGRAPHY Pächt, Dodwell, Wormald, 1960, pp. 118, 141 f., 167, pl. 139; Kauffmann, 1975,
no. 34; Bateman, 1978, pp. 19–26; McLachlan, 1978a, p. 333; Thomson, 1982, p. 26, no. 80

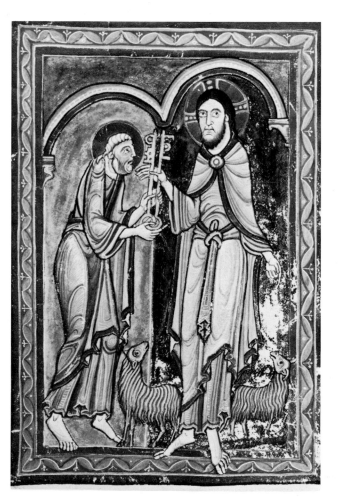

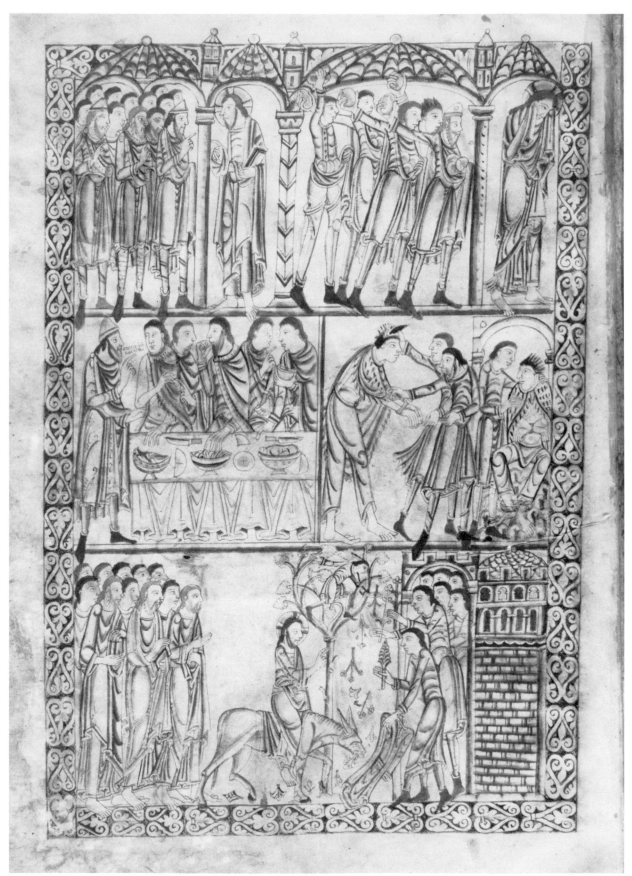

21 New Testament

416 × 270 mm; 182 ff.
Picture leaves, *c.* 1130; text *c.* 1140; (?) Bury St Edmunds
Abbey
Cambridge, Pembroke College, MS 120

The opening 12 pages, which were probably not originally part
of this manuscript, contain drawings, some of them tinted,
illustrating 40 scenes of the Ministry, Passion and Resurrection
of Christ. Pictures of the Nativity were probably lost. The
elongated, rather stiff, hieratic figures and characteristic
profiles are typical of the St Albans Psalter style (**17**). This was
known at Bury from about 1130 when the *Life of St Edmund*
(**20**) was produced there, and it is likely that these drawings
also originated at Bury at this period. On the other hand, the
bulk of the manuscript which contains five historiated and
about 40 decorated initials appears to date from the 1140s and
was, to judge from script and initials, probably produced
elsewhere.

The cycle of New Testament illustrations is related to those
of the St Albans Psalter and the four Psalter leaves (**47–50**), and
it is likely that it was also prefixed to a Psalter. These drawings
were probably bound with this manuscript at some date after
the 14th century when it entered the Bury Library.

Exhibited is f. 2ᵛ, showing the following scenes, starting top
left: Christ disputing with the Jews and the stoning of Christ;
the parable of the wedding garment in which the man
inadequately dressed is thrown out of the banquet; the Entry
into Jerusalem with the inhabitants laying down palms; and on
the right leaf: the Last Supper with Judas receiving the sop;
Christ washing the Disciples' Feet; and His Betrayal. The *Entry
into Jerusalem* is identical in the St Albans Psalter while the
two upper scenes on the right are very similar in the leaf in the
Morgan Library (M 521, **49**), which demonstrates the
common parentage, or at least kinship, of the three
manuscripts. Most unusual is the inscription of the king's
speech to the guest in the wedding garment scene: '"Friend,
how camest thou in hither not having a wedding garment?"
And he was speechless' (Matthew XXII. 12). This is very rare
in 12th-century illustrations, in which forceful gestures were
seen as sufficient to depict speech, and it has been suggested
that these written words served to stress the contrast with the
speechlessness of the guest (Camille, 1982). C.M.K.

PROVENANCE Given to the Abbey of Bury St Edmunds by the Sacrist Reginald of Durham, early
14th century (inscription f. 7); probably presented to Pembroke College by Edmund Boldero,
DD, Master of Jesus College, 1663–79
BIBLIOGRAPHY McLachlan, 1969; 1975; Kauffmann, 1975, no. 35; Bateman, 1978, pp. 19–26;
Henderson, 1981, p. 26 f.

22 Gospels

263 × 168 mm; 76 ff.
c. 1120
New York, Pierpont Morgan Library, M 777

Although the decorated initials are similar to those in early
12th-century Canterbury manuscripts they are insufficiently
close to warrant any firm localization.

Exhibited is the frontispiece to Luke (f. 37v), showing the
Evangelist seated on a bull, his symbol – one of four such
Evangelist portraits in the manuscript, all of them painted on
separate sheets of vellum and pasted on. They are highly
unusual, both for their close stylistic dependence on
Carolingian models and because of their being seated on their

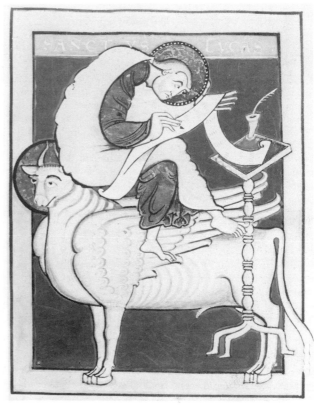

22

symbols. Stylistically, a close comparison can be made with the
9th-century Ebbo Gospels, from Rheims (Epernay,
Bibliothèque municipale MS 1). The outlines have become
harder, but the heads, facial types and postures are closely
similar.

However, such large Evangelist symbols do not appear in
Carolingian manuscripts, nor are they found in Gospels of the
late Anglo-Saxon period. Tselos convincingly compared these
Evangelist symbols, for their scale and general appearance,
with those in certain early 9th-century insular manuscripts,
such as the Canterbury Gospels (British Library, Royal 1. E.VI)
and the Book of Cerne (Cambridge Univeristy Library MS
LI.1.10). For the Evangelist seated upon his symbol, he drew
a parallel with illustrations of the four elements in a 12th-
century German astronomical manuscript (Vienna
Nationalbibliothek MS 12600, f. 30) in which the human
personifications of air, fire, earth and water are seated,
respectively, on an eagle, a lion, a centaur and a griffin. The
correlation between the four Evangelists and the four elements
– the four spiritual and the four physical constituents of the
universe – was discussed in medieval texts from the 9th century
and it may well be that the artist of the Morgan Gospels
adopted his 'riding Evangelists' from comparable illustrations
of the four elements. C.M.K.

PROVENANCE Stephen Batman (d. 1584), chaplain to Archbishop Matthew Parker; Sir Thomas
Mostyn, Bt, 1744 (f. 2); A. Chester Beatty, 1920; Pierpont Morgan Library, 1932
BIBLIOGRAPHY Tselos, 1952, pp. 257–77; W.M. Hinkle, *Aachener Kunstblätter*, 44, 1978,
p. 193; Kauffmann, 1975, no. 25

23 Calendar: St Isidore, Homilies etc.

330 × 202 mm; 136 ff.
c. 1120–40; (?) Worcester Cathedral Priory
Cambridge, St John's College, MS B 20

Calendars were habitually placed at the beginning of liturgical manuscripts and occasionally of other texts to record month by month the feasts and saints' days celebrated locally. In this instance, the saints listed indicate a probable Worcester origin.

The exhibited page (f. 2ᵛ) follows a series of tables and precedes the calendar text. At the top, the last of the tables concerns the phases of the moon. Below, linked pairs of roundels contain the signs of the Zodiac and illustrations of the occupations of the months: January, feasting, Janus seated holding a loaf and horn; February, warming, a man wrapped in a hairy cloak; March, digging; April, pruning; May, falconry; June, weeding; July, mowing; August, reaping; September, vintage; October, sowing; November, killing hogs; December, gathering wood.

These occupations follow a well-established pattern which is ultimately derived from classical models. Even so, such calendar illustrations are alone in the art of the period in providing an insight into the rhythm of rural life. The English cycles are similar to the French, but adapted to the colder climate: the pruning of vines is replaced by digging in March and appears in April instead; mowing, reaping and threshing occur a month later; the gap in June is filled by weeding, which does not appear in other countries.

The manuscript is unusual in showing the roundels grouped together on one page instead of distributed in their appropriate months in the calendar, but the occupations illustrated are very similar to those in the Shaftesbury Psalter (25). Among the other exhibited manuscripts with comparable calendar illustrations are the St Albans Psalter (17), the Bodley 614 astrological text (39), the Winchester Psalter (61) and the York Psalter (75). C.M.K.

PROVENANCE William Crashaw, Puritan divine; bought by Henry Wriothesley, Earl of Southampton, c. 1615; library given by Thomas Wriothesley, Earl of Southampton to St John's College, 1635
BIBLIOGRAPHY Kauffmann, 1975, no. 39

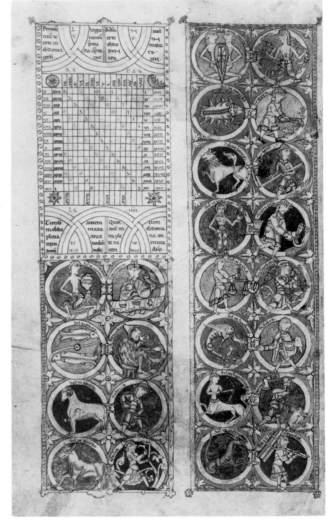

23

24 Bible, vol. II Joshua – Kings (not illustrated)

395 × 265 mm; 189 ff.
c. 1130; Rochester Cathedral Priory
London, British Library, MS Royal I.C.VII

Volumes I, III and IV of the Old Testament are lost but the New Testament volume survives in the Walters Art Gallery, Baltimore (MS 18). Although this Bible bears no Rochester inscription, its initials, characterized by their attenuated animals entwined in the shafts and by the rows of palmettes at the outlines, are typical of Rochester manuscripts at this period.

Apart from the Lincoln Bible, with its very tentative illustrations (12), this is the earliest of the great English Romanesque Bibles illustrated with narrative scenes. With only four historiated initials in this volume, the pictures are sparser than in the later Bibles, but the illustrative scheme, whereby one scene in a book is picked out and placed in the opening initial, is already firmly established.

Exhibited is the opening to 2 Kings (f. 154ᵛ; *Praevaricatus est autem Moab in Israel* . . . 'Then Moab rebelled against Israel . . .'), illustrated with the ascension of Elijah: 'There appeared a chariot of fire, and horses of fire . . . and Elijah went up by a whirlwind into heaven' (2 Kings II.11). This scene was already popular in Early Christian art because of its typological significance as a forerunner of the Ascension of Christ, and it is for this reason that it was selected for the initial to 2 Kings in almost every Western illustrated Bible from the 11th century (cf. the Lobbes Bible of 1084, Tournai Seminary MS 1). This initial is unusual in not including the figure of Elisha receiving the mantle, but the River Jordan, where the event took place, is depicted with great clarity. C.M.K.

PROVENANCE Rochester Cathedral Priory (1202 catalogue refers to a 5-volume Vulgate); entered the Royal Library at the Dissolution of the Monasteries, c. 1540; given to the British Museum by George II, 1757
BIBLIOGRAPHY Kauffmann, 1975, no. 45; Richards, 1981, pp. 59–67; Cahn, 1982, p. 261

25

25 Psalter with prayers: Shaftesbury Psalter

220 × 130 mm; 179 ff.
c. 1130–40: West Country
London, British Library, MS Lansdowne 383

This manuscript has long been attributed to the nunnery at
Shaftesbury. The inclusion of a kneeling nun in two of the
miniatures indicates that it was produced for a nunnery, and
the evidence of the saints invoked in the calendar and Litany
points to Shaftesbury, though Wilton is also a possibility.
However, two other manuscripts illuminated in the same style,
probably by the same artist (**26** and **31**) have no connection
with Shaftesbury and it may be that they were all produced at
one centre in the West Country, or by itinerant artists in the
area. This localization is supported by the striking similarity
with the ivory figure excavated at Milborne St Andrew (**210**).

In both style and iconography, the Shaftesbury Psalter is
related to the St Albans Psalter (**17**). It contains the
characteristic St Albans profiles and elongated figures, and the
composition of the *Marys at the Tomb*, the *Ascension* and
Pentecost miniatures is identical in the two manuscripts.
However, the frontal faces, characterized by their oblong
shape, curling hair and beard, long mandarin moustaches and
large, protruding eyes, are not of the St Albans Psalter type.
Nor are the parallel folds, which have been convincingly

compared with the Stephen Harding Bible (Dijon, MS 14)
produced at Cîteaux in about 1109. Recently, Sir Walter
Oakeshott has attributed these three manuscripts to the
'Entangled Figures Master' of the great Bodleian Bible (**63**). He
based his argument on the recurrence of a specific decorative
form, consisting of a profile head emerging from a curled-over
acanthus leaf (as it appears, for example, in the drawing
exhibited, **26**) as well as a comparison of the Shaftesbury
Psalter figure style with the Obadiah and Genesis initials of the
Bodleian Bible.

The exhibited opening (f. 12ᵛ) shows two of the six
miniatures preceding the Psalter text: God sending forth the
angel Gabriel for the Annunciation to the Virgin, and the
Marys at Christ's empty tomb after the Ascension. The gap
between the two scenes, from pre-Annunciation to post-
Crucifixion, perhaps indicates that some intervening
illustrations have been lost. The *God sending out Gabriel* is of
Byzantine origin; the only other 12th-century Western example
is in the Winchester Psalter (**61**) while the *Three Marys at the
Tomb* appears to be a direct copy of the St Albans Psalter (**17**).

The essence of Romanesque illustration, in which verbal
communication is indicated by stern expression – especially of
the eyes – and gestures, particularly the pointing index finger,
is most graphically displayed in the miniature of God and
Gabriel. God is envisaged in terms of a ruler portrait, with
crown and orb, while the index finger is extensive even by
12th-century standards. The vertically striped background in
the *Three Marys* shows the survival of the 11th-century
convention for rendering space as opposed to the oblong panels
that were used in the 12th century (e.g. **44**). C.M.K.

PROVENANCE Shaftesbury Abbey, Dorset; William Adlard, 1612; Dorothy Berington, 1627
(inscr. f. 2); William Petty, first Marquess of Lansdowne (1737–1805); library bought by
Parliament from his executors, 1807
BIBLIOGRAPHY Kauffmann, 1975, no. 48; Oakeshott, 1981, p. 99 ff; Heslop, 1982b, pp. 124–8;
Thomson, 1982, no. 85

26 St John Chrysostom, Commentaries and Homilies
(not illustrated)

272 × 170 mm; 148 ff.
c. 1140; West Country
Hereford Cathedral Library, MS O.5. XI

St John Chrysostom, Archbishop of Constantinople 398–403,
is honoured as one of the four Greek Doctors of the Church
and above all as a preacher. His sermons were read and
appreciated in Latin translation in the medieval West.

This drawing (f. 147) illustrates the *Life of St John
Chrysostom* which appears at the end of the book. It records
the vision of a holy man, Marcus, who saw the Saint in heaven
surrounded by cherubim. Beneath the Saint are the two monks,
Marcus and Macharias, who told the story. In style, it is closely
related and probably by the same hand as the Shaftesbury
Psalter and the Bodleian Boethius (**31**), but the more
naturalistically articulated draperies indicate a slightly later
date, probably in the 1140s. The unusual position of the angels,
who walk away from the mandorla they are holding but turn
their heads towards it, is peculiarly English, paralleled, for
example, on the tympanum of the Prior's doorway at Ely
(Zarnecki, 1958, fig. 40). The general compositional scheme,
with the monks squeezed into a narrow compartment below
the more important figures is reminiscent of Anglo-Saxon
dedication drawings, such as the one in the *Regularis
Concordia* (British Library, MS Cotton, Tiberius A.III). C.M.K.

PROVENANCE Hereford Cathedral Library, no record of other provenance
BIBLIOGRAPHY Kauffmann, 1975, no. 51; Oakeshott, 1981; Thomson, 1982, no. 84

27 New Testament and Psalter (*not illustrated*)

432 × 292 mm; 192 ff.
c. 1130–40; Winchcombe Abbey, Gloucestershire
Dublin, Trinity College, MS 53

The Winchcombe provenance, suggested by Abbot Richard's ownership of the manuscript, is confirmed by the existence of several contemporary manuscripts from Winchcombe with similar initials. The style of the figures has been compared with the historiated initials of the Bury *Life of St Edmund* (20), and both the figures and the large, luxuriant blossoms with the Shaftesbury Psalter (25) which suggests a date *c.* 1130–40.

 The exhibited page (f. 7ᵛ) shows the opening to Matthew with the Evangelist writing and the initial L containing the ancestors of Christ from Abraham to Jechonias as described in Matthew I.2–11. This is an unusual opening illustration for Matthew, but it does occur in earlier manuscripts, for example in an Anglo-Saxon Gospel book from St-Bertin (Boulogne, MS 11) where the ancestors are also ranged under arcades. More exceptionally, 22 of these figures are identified by attributes they hold or by inscriptions. At the top of the shaft are Abraham with the fire (Genesis XXII.6), Isaac with the ram and, in the centre, Jacob with a rod and a book, the father of twelve sons. The series concludes with the last king, Jechonias, who has taken off his crown and offered it to Christ as a footstool, a poignant symbolic gesture which demonstrates how far this artist has breathed new life into an established formula. C.M.K.

PROVENANCE Given by Richard of Kidderminster, Abbot of Winchcombe 1488–1525, to his monastery; James Usher, Archbishop of Armagh (1580–1656) whose books were acquired by Trinity College, Dublin
BIBLIOGRAPHY Heimann, 1965, pp. 86–109; Kauffmann, 1975, no. 53

28 St Augustine, Commentary on Psalms

420 × 275 mm; iii + 233 ff.
c. 1130–40; (?) Eynsham Abbey, Oxfordshire
Oxford, Bodleian Library, MS Bodley 269

The style of this impressive drawing (iii) is essentially Romanesque in its solid structure, its frontal, geometric composition, and the stern, hieratic expression of the Virgin. Yet it contains Anglo-Saxon components rare in manuscripts of this late date. The outline drawing technique is reminiscent of Anglo-Saxon drawings in general terms, and the head of the Child is remarkably similar to that of St Dunstan in the 11th-century *Regularis Concordia* manuscript (British Library, MS Cotton, Tiberius, A.III). The frontal Virgin and Child formula in which the Virgin holds the Child on her left arm is of Byzantine origin, while the double mandorla, the animal-head throne and the meander frame are derived from Carolingian and Ottonian art.

 As the knob at the bottom of the sceptre is irregular in shape and somewhat resembles a root, it has been interpreted as an allusion to the stem of Jesse, defined in the Messianic prophecy in Isaiah XI.1 ff. From an early date this stem (in Latin, *virga*) was seen as representing the ancestors of Christ and associated with the Virgin (*Virgo*), so that the root sceptre in this picture would have the double significance of a royal sceptre and a symbol of the Virgin.

 There is nothing strictly comparable to this drawing in 12th-century England, and it would be difficult to suggest a date were it not for the initial on the reverse which is very similar to those in the Winchcombe Psalter of *c.* 1130–40. Eynsham is quite near Winchcombe and although we cannot be sure that this manuscript was written at Eynsham, it was certainly there

28

in the 13th–14th centuries; the late Neil Ker said that the script might well indicate a West Country origin. However, as this drawing does not, strictly speaking, illustrate the text it precedes, its date may not be the same as that of the rest of the manuscript. C.M.K.

PROVENANCE Eynsham Abbey, Oxfordshire (pressmark B.III, 13th–14th centuries f. 1); given to the Bodleian Library by the Dean and Canons of Windsor, 1612
BIBLIOGRAPHY Kauffman, 1975, no. 52; Heslop 1981a, p. 57

29 Obituary roll of Vitalis, Abbot of Savigny (*not illustrated*)

225 × 950 mm; 15 ff.
1123; France and England
Paris, Archives nationales, AE.II–138 (1.966, no. 4)

Throughout the Middle Ages it was customary for religious communities to notify the death of members to a large number of other houses with which they were associated, for the purpose of soliciting prayers for the dead. When a prominent member died a messenger would take the ever-expanding obituary roll over a more or less prepared route from one monastery to the next. Each recipient recorded his arrival and added a note of condolence and pious sentiment.

 Vitalis, whose death is here announced, had been chaplain to Robert of Mortain, brother of William the Conqueror, and in about 1095 had renounced his canonry to become a hermit and itinerant preacher. In 1112, having attracted a considerable following, he obtained permission from Raoul de Fougères to establish a Benedictine monastery on his estate at Savigny, near

Avranches. When he died, as founder and first abbot, on 16 September 1122, the monks decided to announce his death in an obituary roll. The messenger left Savigny at the end of 1122 or early in 1123 and visited over 200 houses. Their names are not in order and the itinerary is difficult to trace with precision, but it appears that the roll was first taken round Normandy and France and then to England as far as York, returning via Norwich and Colchester, then to London and the West Country, taking in Gloucester, Tewkesbury, Evesham, Pershore and Worcester, and finally to Canterbury, Battle and the south coast before embarking at Bosham.

This roll, therefore, embodies the close connection between monasteries on both sides of the Channel which is of fundamental importance throughout the history of English Romanesque art. C.M.K.

PROVENANCE Savigny Abbey
EXHIBITION Rouen, Caen, 1979, no. 61, catalogue entry by J. Dufour with full bibliography
BIBLIOGRAPHY Delisle, 1866, no. 38, pp. 281–344

30 Boethius, De Musica, De Arithmetica
(not illustrated)

291 × 203 mm; 137 ff. (a list of books belonging to Christ Church is appended on ff. 135–7)
The Syndics of Cambridge University Library, MA. ii.3.12

Boethius was a key figure not only for philosophy but equally for early medieval learning. His work dominates the *Quadrivium*, the fourfold way, that is what was seen as the mathematical four of the seven liberal arts: arithmetric, geometry, astronomy and music.

The exhibited page (f. 61ᵛ) contains the frontispiece to the *De Musica*. It shows Boethius plucking a stringed instrument marked with the notes A to E, together with three philosophers who had influenced his text: Pythagoras above, on the right, and Plato and the neo-Platonist Nichomacus below. The frame is made up of quotations from the philosophers concerned. Like the text itself, this drawing is derived from earlier Boethius manuscripts, ultimately perhaps from a late classical model. There is a similar illustration, for example, in a 10th-century Boethius manuscript in Vienna (Nationalbibliothek, MS 51; Courcelle, pl. 5).

These are solid figures in what may be described as the first fully Romanesque illustration produced at Canterbury. C.M.K.

PROVENANCE Christ Church, Canterbury (inscription ff.2, 62); bequeathed to the Cambridge University Library by Richard Holdsworth, Master of Emmanuel College, 1664
BIBLIOGRAPHY Courcelle, 1967, pp. 67 f., 70 f., pl. 2; Kauffmann, 1975, no. 41; Gibson, 1981, p. 432

31 Boethius, The Consolation of Philosophy

192 × 117 mm; vii + 75 ff.
c. 1130–40; West Country
Oxford, Bodleian Library, MS Auct. F.6.5.

As well as a philosopher (see **30**) Boethius was minister to Theodoric, the Ostrogothic ruler of Italy, but he was suspected of siding with the Byzantine Emperor against the Ostrogoths and this led to his downfall. Between his condemnation and his execution in 524/5 he was imprisoned at Pavia, where he had sufficient freedom to write the *Consolation of Philosophy*. The exhibited miniature (f. 1ᵛ) showing Boethius in prison comforted by Philosophy and the Muses, illustrates the book's opening poem in which the author sets forth his change of fortune and explains that he is still accompanied by the Muses of Poetry:

> While I was quietly thinking these thoughts over to myself . . . I became aware of a woman standing over me. She was of awe-inspiring appearance, her eyes burning and keen beyond the usual power of men. . . . It was difficult to be sure of her height, for sometimes she was of average human size, while at other times she seemed to touch the sky with the top of her head. . . .

The earliest illustrations of this scene are German, 10th century, and by the 11th century it had become standard more or less as we see it here (cf. Paris, Bibliothèque nationale, latin 6401). Another 12th-century English example is in Cambridge (University Library MS Dd. 6.6., *c.* 1140), and the Glasgow manuscript (**32**) now mutilated, originally had an illustration of this scene. The exhibited miniature differs from the standard composition in underlining Boethius' sorrowful condition by placing a chain round his neck.

In style, this manuscript is closely related to and probably by the same hand as the Shaftesbury Psalter and the Hereford John Chrysostom (**25** and **26**) – Oakeshott has attributed this group to the 'Entangled Figures Master', the principal artist of the first volume of the great Bodleian Bible (**63**). C.M.K.

PROVENANCE Given to the Bodleian Library by William Harwood, Prebendary of Winchester, 1611
EXHIBITION Oxford, 1975, no. 124
BIBLIOGRAPHY Kauffmann, 1975, no. 49; Oxford, 1980, vii. 3; Oakeshott, 1981, p. 99.; Thomson, 1982, no. 87

31

32

32 Boethius, The Consolation of Philosophy, with gloss

255 × 385 mm; 65 ff.
c. 1120–40
Glasgow, University Library, MS Hunter U.5.19 (279)

Unfortunately, this little known manuscript has been sadly mutilated: it originally contained a drawing of Boethius in prison, presumably comparable to the one in the Bodleian manuscript (**31**), of which only a fragment survives, as well as large capitals at the beginning of each book, but only the D for book 5 still exists.

The exhibited drawing (f. 45ᵛ) shows Ulysses reaching safety even as the crew of the ship have been changed into animals by Circe. As Philosophy is explaining that a man who abandons goodness sinks to the level of an animal, she illustrates her meaning with a poem based on the Odyssey recounting how Ulysses is saved by Hermes from Circe's curse:

> For her new-come guests she mixes
> Cups she has touched with a spell;
> In various shapes they are changed . . .
> . . .
> But the winged Arcadian God
> Takes pity on his plight
> Saves him from Circe's curse.

The author of the gloss preserved in the manuscript discusses the significance of the Circe myth as an illustration of the principle of the relationship of all physical bodies, which enables one to be turned into another. This illustration is unique among extant Boethius manuscripts and it may well reflect the importance given to this incident by this unknown commentator.

The manuscript was apparently in Scotland by the middle of the 12th century, but there are no comparable illustrated books produced there at the time, and its original provenance remains unknown. The Scottish connection could be taken to suggest an origin in northern England and it is quite conceivable that this manuscript was produced in, for example, Durham some time after Bede's *Life of St Cuthbert* (**15**, cf. also Mynors, 1939, e.g. no. 68), but there is no firm evidence for such an attribution. C.M.K.

PROVENANCE Apparently in Scotland soon after it was written (inscription f. 3: *david dei gracia Rex scotorum*, 'David by the grace of God King of the Scots' – that is, David I 1123–53); Gregory Sharpe, sale, 8 April 1771, lot 1467; Dr William Hunter (1718–83), who left his museum to Glasgow University; at this time the manuscript was bound with two others, Cicero, *De Amicitia* and Martianus Capella, *Satyricon*, now Hunter U.5.18 and 20
EXHIBITION Edinburgh, 1982, B.21
BIBLIOGRAPHY J. Young and P. H. Aitken, *Catalogue of manuscripts in the Hunterian Museum, University of Glasgow*, 1908, no. 279; J. Beaumont in Gibson, 1981, p. 296 f.; N. R. Ker, *Wm. Hunter as a collector of medieval manuscripts*, Glasgow, 1983, p. 15

33 Florence and John of Worcester, Chronicle

325 × 237 mm; 398 pp.
c. 1130–40; Worcester Cathedral Priory
Oxford, Corpus Christi College, MS 157

The Worcester Chronicle, attributed to two monks, Florence and John, is one of the major works of historical writing in England. Down to 1095 it consists mainly of a translation into Latin of the Anglo-Saxon Chronicle grafted on to the world history of Marianus Scotus, a copy of which had been imported from Germany by Bishop Robert. Florence died in 1118 and hence it was John who was responsible for most of the account of contemporary events.

Exhibited are the visions of Henry I in Normandy, 1130, (pp. 382–3) when the king saw himself visited by infuriated peasants, armed and threatening knights and aggrieved prelates, all complaining of high taxation. In the last scene Henry is overwhelmed by a storm at sea which abates only when he promises to withhold the Danegeld for seven years and go on a pilgrimage to Bury St Edmunds.

John tells us that he was away at Winchcombe *c.* 1134–9. It was there that he learnt from the royal physician, Grimbald, of Henry I's dreams, and it is Grimbald who is shown seated on the left of each illustration explaining the visions. It appears that the bulk of the manuscript was written before about 1130 and the last entries, including those describing the visions, added in about 1140. A companion volume is in the Bodleian Library, MS Auct. F.1.9.

The peasants' faces are somewhat caricatured and appear similar to the monks in the Bodleian Terence (**56**), while the face of Grimbald resembles those of the Shaftesbury Psalter group (**25**). These scenes are among the earliest extant chronicle illustrations and certainly the earliest in England. The Bayeux Tapestry apart, narrative illustrations in chronicles are rare before the Matthew Paris manuscripts in the 13th century. C.M.K.

PROVENANCE Worcester Cathedral Priory; exchanged by Frater Thomas Straynsham with Thomas Powycke for a copy of Guido's *De Bello Trojano* (inscription p. 1), 1480; given to the College by Henry Parry, a fellow, 1618
BIBLIOGRAPHY Kauffmann, 1975, no. 55; Ayers, 1974a, p. 209; Brit. Archaeol. Assoc. Conf., 1978, pp. 6 ff., 46 f.; Camille, 1982

382. *Mariani*

34 Natural Science Text Book assembled by Byrhtferth

342 × 242 mm; 177 ff.
c. 1080–90; Ramsey Abbey
Oxford, St John's College, MS 17

Viking depredations in the 9th century had reduced Latin culture in England to a very low ebb and it was only with the monastic reform headed by Dunstan, Archbishop of Canterbury 960–88, that there was an intellectual revival. One of the outstanding English scholars of the period was Byrhtferth, monk of Ramsey, where he had been a pupil of Abbo of Fleury, a teacher of international repute. He assembled this collection of early medieval scientific texts principally by Bede, Isidore of Seville and Abbo of Fleury in the early 11th century, and this is the earliest surviving copy.

Exhibited is one of the splendid diagrams illustrating this book (f. 7ᵛ). Attributed to Byrhtferth himself, it shows the harmony of the 'physical and physiological fours' dominated by the four elements (*Terra, Aer, Ignis, Aqua* – earth, air, fire, water), the four seasons and the four points of the compass (*Oriens, Occidens, Aquilo, Meridiens* – east, west, north, south). It also includes a demonstration of the relationship between the four ages of man and the four humours under the influence of the signs of the Zodiac. The whole is a complex statement of medieval Christian cosmology, conveying in a perfectly ordered manner the microcosmic-macrocosmic harmony in the constitution of the universe. Such diagrammatic exposition is of particular interest for its relationship with the didactic layout of so much of Romanesque art in which the picture plane is divided into compartments. The Tree of Jesse picture in the Lambeth Bible (**53**) is an outstanding example of this type, but Byrhtferth's diagram and the others in this manuscript may be described as works of art in their own right. C.M.K.

PROVENANCE Thorney Abbey, *c.* 1100 (annals of the abbey added in margins of ff. 139–55); Robert Talbot, 16th century; Hugh Wickstead, early 17th century, who gave it to St John's College; borrowed by Sir John Cotton, Bt, *c.* 1623, who stole five leaves, now in British Library, Cotton, Nero C.VII
BIBLIOGRAPHY Kauffmann, 1975, no. 9; *R. W. Hunt Memorial Exhibition*, Bodleian Library, 1980, IV.5; P. S. Baker in *Anglo-Saxon England*, 10, 1981

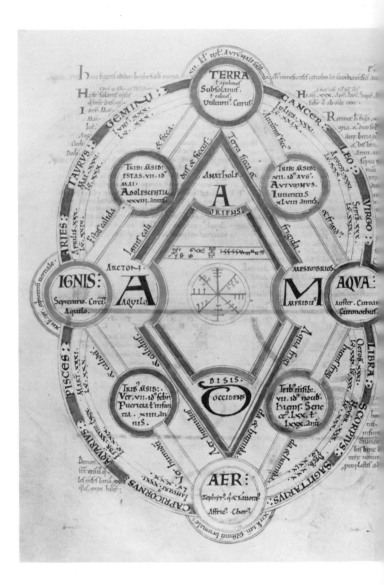

35 Herbal (*not illustrated*)

237 × 150 mm; 43 ff.
Last quarter 11th century; Canterbury, St Augustine's Abbey
Oxford, Bodleian Library, MS Ashmole 1431

The herbal, a medical manual containing descriptions of plants listing their medicinal qualities, can be traced back to ancient Greece. In the Middle Ages the most popular herbal was traditionally linked with the name of Dioscurides, a physician of the 1st century AD, and this text was combined with another selection of plants attributed for no known reason to 'Apuleius Barbarus', also known as 'Pseudo-Apuleius'. From the 9th century there is a proliferation of illustrated herbals; the plant drawings were copied from one manuscript to another and remained essentially schematic rather than naturalistic.

This manuscript contains about 150 drawings of plants; those exhibited (ff. 18ᵛ–19) are: *Herba Peristerion* (vervain), *Herba Brionia* (black bryony), *Herba Nymphea* (water lily), *Herba Chrision* (red clover) and *Herba Isatis* (woad). C.M.K.

PROVENANCE St Augustine's, Canterbury (ex-libris and pressmark, 15th century, f. iv)
BIBLIOGRAPHY Kauffmann, 1975, no. 10; Lawrence, 1982, p. 103

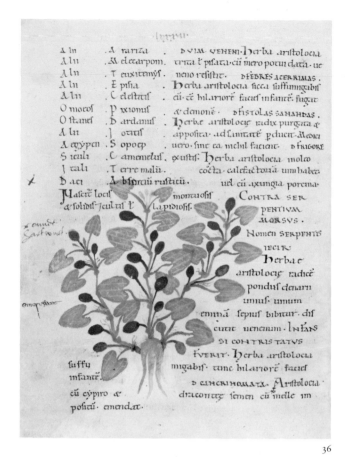

36

37

36 Herbal and Treatise on the medicinal qualities of animals attributed to 'Sextus Placitus'

244 × 180 mm; 95 ff.
c. 1100; (?) Bury St Edmunds Abbey
Oxford, Bodleian Library, MS Bodley 130

The 'Pseudo-Apuleius' text and the illustrations are related to MS Ashmole 1431 (see 35) but the execution of the drawings is here infinitely more sophisticated and lifelike. Indeed this manuscript is unique at this period in that several of its illustrations are convincing naturalistic studies, apparently painted with reference to actual plants rather than copies from earlier texts. Such an attempt to correct the transmitted tradition by consulting nature is not found again until the late 14th century in Italy.

 The exhibited pages (ff. 43ᵛ–44) show: *Herba Aristolocia* (smearwort) used to cure acute fevers and snakebite, *Herba Apollinaris* (glovewort) and *Herba Camemelon* (camomile) used for eye trouble. C.M.K.

PROVENANCE Bury St Edmunds Abbey (pressmark and inscription, 14th century, f. 1.) Sir Thomas Knyvett (d. 1594); Augustine Styward (inscription f. 1); given to the Bodleian Library by Dr Edward Tyson, 1706
EXHIBITION Oxford, 1975, no. 122
BIBLIOGRAPHY Kauffmann, 1975, no. 11

37 Medical and Astrological Treatises

170 × 122 mm; 124 ff.
c. 1100–20; Durham Cathedral Priory
Durham Cathedral Library, MS Hunter 100

The list of saints in the calendar at the beginning of the manuscript supports a Durham provenance; a reference to the death of William II (1100) fixes the earliest possible date while comparison with other Durham drawings, including those in Bede's *Cuthbert* (15) indicates a date in the early years of the 12th century. The illustrations of constellations (ff. 61ᵛ–64ᵛ) are not dissimilar to those in other English astrological manuscripts (38 and 40) though they belong to a different recension. Most of the medical texts (ff. 85–120) are not illustrated but at the end of the volume there are three pages of cautery illustration.

 The first of these is exhibited (f. 119): a surgeon is cauterizing a patient's forehead, while below an assistant heats the cautery irons. This is one of about twenty surviving medieval manuscripts with cautery illustrations; the earliest is southern Italian of the 9th century (Florence, Laurenziana, Plut. 73.41) and it contains a very similar treatment of a recumbent patient. The practice of placing such medical illustrations under elaborate arcades is also traditional at this date.

 Cautery was, together with bloodletting, one of the principal forms of medical treatment in the Middle Ages. Its use spread far beyond the cauterization of wounds. Cautery illustrations differ in detail but they all show figures on which the points where the iron is to be applied are clearly marked. C.M.K.

PROVENANCE Dr Christopher Hunter (1675–1757); bought by the Dean and Chapter of Durham, 1757
BIBLIOGRAPHY Mackinney, 1965, p. 120; Kauffmann, 1975, no. 27

38 Scientific and Astrological Treatises (*not illustrated*)

292 × 197 mm; 41 ff.
c. 1122; Peterborough Abbey
London, British Library, MS Cotton, Tiberius C.I

The second part of this manuscript (British Library, MS Harley 3667) contains the annals of Peterborough Abbey written in the same hand up to 1122, which gives us its approximate date. Apart from the astrological material, the text and diagrams belong to the tradition of St John's College (see **34**). The astrological drawings, on the other hand, are copied from a 9th-century manuscript, probably written at Fleury, of a Cicero text describing the constellations (British Library, MS Harley 647). Cicero had written a Latin verse version of a Greek poem on the constellations by Aratus. Further explanatory material was added to the text in the late classical period and this was written within the figures, which were left without outlines. Here, therefore, is a 12th-century copy of a Carolingian manuscript which had in turn been copied from a late classical original.

The opening (f. 24ᵛ) shows the constellations Aquarius and Capricornus with the points of the stars marked by red circles. The figures have outlines and the textual filling is in lower-case letters whereas Harley 647 had classical-looking rustic capitals and no outlines, but otherwise these illustrations are an accurate reflection of their late Roman originals. Indeed, it was through the survival of the classical tradition of astrological manuscripts (**40**) that the pictorial images of classical gods and mythical creatures remained known in the Middle Ages. C.M.K.

PROVENANCE Peterborough Abbey; Sir Robert Cotton, Bt (1571–1631), his library presented to the nation by his grandson, Sir John Cotton, Bt, 1700
BIBLIOGRAPHY Kauffmann, 1975, no. 37

39 Astrological Treatises and Marvels of the East

143 × 100 mm; 51 ff.
c. 1120–40
Oxford, Bodleian Library, MS Bodley 614

This combination of astrological texts and *Marvels of the East* occurs previously in an Anglo-Saxon manuscript of about 1000 (British Library, MS Cotton, Tiberius B.V), while the astrological illustrations are very similar to those in Digby 83 (**40**).

The *Marvels of the East* had their origin in ancient Greek descriptions of the fabulous peoples of India, which in turn were probably derived from Indian mythology. This actual text of the *Marvels*, which probably originated in the 4th century AD, is written in the form of a letter from a certain Fermes to the Emperor Hadrian, purporting to comment on a journey to the East. The earliest complete illustrated *Marvels of the East* manuscripts are the Anglo-Saxon ones of about 1000, of which two survive, and this manuscript is very closely related to the one not already mentioned (British Library, MS Cotton, Vitellius A.xv).

Its 50 illustrations include the Sciapodes, men with a single large foot; the Cynocephali, men with dog's heads; ants as big as dogs; and pygmies and giants of various kinds. On the exhibited page (f. 30) are small beasts called Lertices, with donkeys' ears, sheep's fleece and birds' feet. Even more fabulous and of distinctly surrealist appearance are the men without heads, who have their eyes and mouths in their chests. They are eight feet tall and eight feet broad, and inhabit an island on the river Brixontes. These particular creatures appear in Greek literature from the 4th century BC, and were

39

transmitted through Pliny's *Natural History* (VII.ii). In the Romanesque period the *Marvels of the East* illustrations were much used by painters and sculptors as a source of inspiration for decorative motifs. C.M.K.

PROVENANCE Ralph Hopwood, 16th century; acquired by the Bodleian Library, 1605–11
BIBLIOGRAPHY James, 1929; Kauffmann, 1975, no. 38; J.B. Friedman, *The Monstrous Races in Medieval Art and Thought*, 1981, p. 144

40 Astronomical Treatise

203 × 150 mm; 76 ff.
Mid 12th century
Oxford, Bodleian Library, MS Digby 83

Books I–III contain texts not found in Bodley 614 (**39**) but Book IV and all but a few of the illustrations are identical in the two manuscripts. Exhibited are ff. 51–52, showing, in bold pen outline drawings, the constellations Delfinus (Dolphin) and Equus (Pegasus). They are in the tradition of astronomical illustration derived from the Carolingian manuscript Harley 647, and here epitomized by Cotton, Tiberius C.I (**38**), differing only in that the textual infill has been omitted. Indeed, this is the last of the English astronomical picture cycles in this tradition and the last manuscript to contain the texts most in vogue before the large-scale penetration into Western Europe of Arabic and Greek science in the 12th century. C.M.K.

PROVENANCE Robert Colshill, 15th century (inscription f. iii); Sir Kenelm Digby (1603–65), who presented his library to the Bodleian, 1634
BIBLIOGRAPHY Saxl, 1957, p. 108 ff., pl. 61; Kauffmann, 1975, no. 74

41

41 Corpus of canon law

430 × 330 mm; 256 ff.
c. 1120; Canterbury, Christ Church
London, British Library, MS Cotton, Claudius E.V

Among the repertory of creatures contained in the 38 decorated initials of this manuscript is a variety of fish, birds, beasts and semi-human figures including men with animal heads and humans with horns. In many cases the outline of the initial itself is constructed with these creatures. The exhibited initial (f. 49) was compared by Zarnecki with carved capitals at Castor, Northamptonshire and at Canterbury itself as an example of the influence of Canterbury manuscripts on decorative sculpture. These capitals date from about 1120 and a similar approximate date for these illuminations may be inferred from copies of letters dated 1119–22 which have been added to the end of the manuscript. C.M.K.

PROVENANCE Sir Robert Cotton, Bt (1571–1631); his library presented to the nation by his grandson, Sir John Cotton, Bt, 1700
BIBLIOGRAPHY Zarnecki, 1951, pl. 40; Kauffmann, 1975, no. 21

42 St Jerome, Commentaries on the Old Testament

335 × 235 mm; 170 ff.
c. 1120; Rochester Cathedral Priory
Cambridge, Trinity College, MS O.4.7

Rochester Cathedral Priory was founded by Archbishop Lanfranc and modelled on Christ Church, Canterbury, and the links remained close even after Rochester became a flourishing centre in its own right with over 60 monks by 1108. Hence it is no surprise that this text is closely copied from a Christ Church manuscript of the same work (Trinity College, B.2.34) and the style of the initials is also very similar to Canterbury work.

Exhibited is one of a series of splendidly-decorated pen outline initials showing a man teaching a bear the ABC (f. 75). Michael Camille has recently shown that this refers to Jerome's texts on the Old Testament, which use an etymological method of translating lists of Hebrew names as a basis for spiritual interpretation. This initial precedes a long list of names beginning with A, and the teacher's efforts can be taken as an admonition to the reader to learn these names by rote. C.M.K.

PROVENANCE Rochester Cathedral Priory (ex-libris f. 1); Dr Thomas Gale (1635/6–1702); given to his college by his son Roger Gale, 1738
BIBLIOGRAPHY Kauffmann, 1975, no. 23; Camille, 1982, p. 13

42

43 Flavius Josephus, Jewish Antiquities, I–XIV
(*illustrated on p. 52*)

404 × 280 mm; 239 ff.
c. 1130; Canterbury, Christ Church
Cambridge University Library, MS Dd.1.4

Josephus (AD 37–*c.* 95), the celebrated historian of the Jews, was an eye-witness of many of the events he described and his work, written in Greek, was popular in Latin translation throughout the Middle Ages. Like most 12th-century Josephus texts, this manuscript is not profusely illustrated, though there are a few historiated initials. Its importance lies in its decorated initials which include some of the most splendid ever produced at Canterbury or, indeed, in English Romanesque art. They are the work of several artists, some producing initials with clambering figures as in earlier Canterbury manuscripts (e.g. 11). This manuscript is in two volumes, the other also exhibited here (43a).

The exhibited page (f. 220) shows a more fully-developed Romanesque initial with solid figures modelled by nested V-folds. The basic ingredients are the same as in earlier Anglo-Norman manuscripts: men fighting beasts, dragons fighting men and foliage engulfing both. However, this initial differs in two essentials from its predecessors. On the one hand, the foliage is more firmly controlled and no longer flows freely over the initial and beyond its confines, while large, luxuriant flowers appear in the centre of foliage spirals. This control and subordination of the parts to the whole is an essential characteristic of Romanesque art. On the other hand, this initial shows a new firmness, confidence and sophistication which sets it apart from its predecessors. C.M.K.

PROVENANCE Not recorded
BIBLIOGRAPHY Kauffmann, 1975, no. 43; T. A. Heslop, *Burl. Mag.*, April 1984

43a Flavius Josephus, Jewish Antiquities XV–XX; Jewish Wars (*not illustrated*)

382 × 270 mm; 249 ff.
c. 1130; Canterbury, Christ Church
Cambridge, St John's College, MS A.8

A different group of artists worked on this volume. The exhibited initial, with its dark blue background and opaque paint surface, is unusual for both volumes, though the decorative features are very similar.

This initial, opening Book XV of *Jewish Antiquities* (f. 1ᵛ), was always interpreted as Cain offering to God the fruits of the earth and Cain slaying Abel. Yet these events occur in Book I and not Book XV, and hence it was suggested that the initial had been mistakenly placed in this book. Recently, however, Naftali Deutsch has interpreted the scene as Herod executing his wife, Mariamne, who was accused of adultery with his brother Joseph, an event which does occur in Book XV (chapter 7). This is a convincing interpretation, though it remains true that the artist has based his illustration on a Cain and Abel composition. It is also clear that he laid greater stress on the decorative than on the illustrative elements of the initial. C.M.K.

PROVENANCE Christ Church, Canterbury (inscription f. 2); William Crashaw (1572–1626); Henry Wriothesley, Earl of Southampton, *c.* 1615; presented to St John's College by his son Thomas, 1635
BIBLIOGRAPHY Dodwell, 1954, *passim*; Kauffmann, 1975, no. 44; Mellinkoff, 1979, p. 24; Naftali G. Deutsch, *Iconographie de l'illustration de Flavius Josèphe au temps de Jean Fouquet*, unpublished dissertation, Jerusalem, 1978, describes comparative scenes

44 Bible: The Bury Bible, part I, Genesis–Job
(*illustrated on pp. 23 and 53*)

rebound in 3 vols of which this is vol. I, ff. 1–121
514 × 353 mm; 121 ff.
c. 1135; Bury St Edmunds Abbey
Cambridge, Corpus Christi College, MS 2

As long ago as 1912 M.R. James identified this Bible with the one described in the *Gesta Sacristarum* (sacrists' chronicle) of Bury St Edmunds Abbey: 'This Hervey, the sacrist, brother of Prior Talbot, commissioned a large Bible for his brother the Prior and had it beautifully illuminated by Master Hugo.'

Master Hugo was not only a renowned painter but also a sculptor and worker in metal, for he is recorded in Bury as casting the bronze doors for the west front of the abbey church, casting a great bell, and carving a cross in the choir and statues of the Virgin and St John. The Bible's patron, Sacrist Hervey, and his brother Prior Talbot served under Abbot Anselm (1121–48), and there is evidence to show that they had ceased to hold office by 1138, which helps to establish the latest possible date of the Bible.

The exhibited miniature – the second of six remaining in the Bury Bible – is the frontispiece to Deuteronomy (f. 94) showing Moses and Aaron expounding the law to the people of Israel and Moses expounding the law of the unclean beasts. It is one of the undisputed masterpieces of English 12th-century painting. Its style shows a certain debt to the Master of the St Albans Psalter (17) particularly for the monumental figures with their characteristic profiles, but it also marks Hugo as a great innovator. The very strong, rich colours – the prevalence of royal blue, magenta, bright red, purple and green – are unparalleled in earlier English illumination. The faces are both more naturalistic and more sophisticated than those of the St Albans manuscripts. This is due to their close adherence to Byzantine rules of facial contours and modelling, characterized by dark shading in ochre and grey with greenish tints and white highlights. It is the disposition of the draperies, with their sinuous double-line folds dividing the body beneath into clearly defined areas, that has become the hallmark of the Bury Bible figure style. This is the clinging, curvilinear variety of the damp-fold, a stylized version of the Byzantine method of articulating the human figure. Although these draperies can be seen as abstract patterns, they succeed in endowing the figures with a much greater degree of solid, recognizable humanity than had been prevalent in early medieval art. Master Hugo was probably the originator of this particular convention and, once it had been perfected, it can be found in nearly all the major English paintings between about 1140 and 1170. C.M.K.

PROVENANCE Abbey of Bury St Edmunds (pressmark B1, f. 2); bequeathed to his college by Matthew Parker, Archbishop of Canterbury (d. 1575)
BIBLIOGRAPHY Kauffmann, 1975, no. 56; Thomson, 1975, pp. 51–8; McLachlan, 1978a; Parker, 1981; Haney, 1982b; Cahn, 1982, pp. 160 ff., 259, no. 27

46

45 St Gregory the Great, Homilies on the Gospels
(*not illustrated*)

304 × 230 mm; 124 ff.
c. 1140–50; Bury St Edmunds Abbey
Cambridge, Pembroke College, MS 16

This is the most richly illuminated of the manuscripts produced at Bury under the influence of Master Hugo. Although it differs in colour, the style of both the figures and the decoration is dependent on the Bury Bible. The exhibited initial (f. 71ᵛ) illustrates Homily 39 on Mark XVI. 14–20, delivered on the Feast of the Ascension. The reading from Mark describes Christ's final address to the Apostles and His subsequent ascension. E. McLachlan has pointed out that the way in which Christ stands on the head of the dragon probably refers to the famous passage in Psalm 90 (91 in the Authorized Version) where the triumphant Saviour treads upon the lion and the dragon.

More than half the page, on the outer side, is occupied by the 12th-century gloss on Gregory's text. C.M.K.

PROVENANCE Abbey of Bury St Edmunds (inscription and pressmark f. 1); given to Pembroke College by William Smart, Portreeve of Ipswich, 1599
BIBLIOGRAPHY Kauffmann, 1975, no. 57; McLachlan, 1979, pp. 216–24

46 The Sherborne Cartulary

275 × 183 mm; 88 ff., bound in original oak covers
c. 1146; Sherborne Abbey
London, British Library, Add. MS 46487

Many of the manuscripts on display contain several different texts bound together, but few have such diverse material as the Sherborne Cartulary. On the one hand it contains documents relating to Sherborne Abbey including royal and papal charters, the latter in particular relating to a quarrel between the monks of Sherborne and Jocelin, Bishop of Salisbury, over the election of an abbot. This quarrel was won by the abbey in February 1146, when Pope Eugenius III wrote to Bishop Jocelin ordering him not to impede the election. The manuscript was probably written not long after that date. Secondly, there are liturgical texts, including narratives of the Passion from the four Gospels, for use at the altar during Holy Week.

A cartulary is essentially a collection of title deeds copied into a register for greater security, and in this particular case they were copied into a holy book for added protection against any future attempts at interference by the Bishop of Salisbury. The growing use of cartularies marks the increasing number of documents and memoranda produced and preserved in a period of expanding economy and growing literacy.

The exhibited figure of St John (f. 52ᵛ) is very similar to that of Moses in the Deuteronomy page of the Bury Bible (**44**) and it is probable that this example of the damp-fold drapery convention, and also the dark, Byzantinizing facial modelling, are derived from Master Hugo. The white crosshatching forming arrowhead patterns is most closely paralleled in the Shaftesbury Psalter (**25**). C.M.K.

PROVENANCE Sherborne Abbey, Dorset; Lord Digby, *c.* 1712; Thomas Lloyd, early 19th century, sold Sotheby's, 10 May 1828, lot 202, bought by Thorpe for Sir Thomas Phillipps of Cheltenham; bought by the British Museum, 1947
BIBLIOGRAPHY Kauffmann, 1975, no. 60; Clancy, 1979, pp. 62, 79 f.

47 Leaf from a Psalter

400 × 292 mm
c. 1140; Canterbury, (?) Christ Church
New York, Pierpont Morgan Library, M 724

This is the first of four leaves (see also **48**, **49** and **50**) with biblical scenes in twelve compartments per page.

Recto:

1. Pharaoh enthroned, two Israelite midwives, Shiprah and Puah before him; Jochebed holding Moses; Moses floating in the Nile.
2. Moses taken out of the Nile and given to Pharaoh's daughter; Pharaoh crowns the boy Moses; the boy steps on the crown.
3. Moses and the burning bush; his rod turned into a serpent; Moses and Aaron with the serpents, before Pharaoh.
4. Moses parts the Red Sea.
5. The Jews pass over the Red Sea.
6. (?) The camp of Israel.
7. Moses on Mount Sinai; Moses and the brazen serpent.
8. Joshua conquers a city (?Jericho).
9. Saul crowned.
10. David before Saul.
11. David fighting Goliath.
12. David beheads the fallen Goliath.

Verso (*not illustrated*):

13. David offered the crown of Judah.
14. (?) David entering Jerusalem.
15. (Larger compartment) Tree of Jesse with the Annunciation; the wedding of Mary and Joseph, and Zacharias swinging the censer.
16. Visitation.
17. Birth of John.
18. Naming of John.
19. Nativity.

In format, choice of subject, and composition of individual scenes, these leaves are closely similar to the prefatory cycle contained in Paris, Bibliothèque nationale, latin 8846, the last Psalter in the Utrecht Psalter tradition written at Canterbury c. 1180–90 (**73**). Consequently, it may be assumed that these four leaves belonged to another manuscript in the Utrecht Psalter tradition written at Canterbury.

This is the only one of the four leaves with Old Testament scenes, but as Paris latin 8846 has a Genesis cycle it is probable that a Genesis leaf is missing from the series. The Moses and David illustrations go into great detail; they include not only rare biblical scenes such as the midwives Shiprah and Puah with Pharaoh, but also a scene not in the Bible at all: Moses trampling on Pharaoh's crown, a Jewish legend popularized by Josephus (*Jewish Antiquities*, II, 9.7). The large Tree of Jesse containing the ancestors of Christ leads from the Old Testament to the New, and the page ends with the Nativity of Christ as foretold in Isaiah's messianic prophecy on which the Tree of Jesse is based (see **53**). C.M.K.

PROVENANCE All four leaves in the William Young Ottley sale, Sotheby's, 12 May 1838, lots 130–3; lot 130 bought by Tindall for £1; Holford collection, sold Sotheby's, 12 July 1927, lot 48, bought by the Morgan Library
BIBLIOGRAPHY Kauffmann, 1975, no. 66; Heimann, 1975, pp. 313–38

48 (recto)

48 Leaf from a Psalter

405 × 300 mm
c. 1140; Canterbury, (?) Christ Church
London, British Library, Add. MS 37472(1)

The second of four leaves (**47–50**).

Recto:

1. Annunciation to the shepherds.
2. The Magi follow the star.
3. The Magi before Herod.
4. The Jews before Herod.
5. The Magi ride to Bethlehem.
6. Adoration of the Magi.
7. The Magi are warned.
8. Presentation in the Temple.
9. Joseph is warned.
10. Flight into Egypt.
11. Massacre of the Innocents.
12. Herod's suicide.

Verso (*not illustrated*):

13. Baptism of Christ.
14. The wedding at Cana: Christ orders the wine.
15. Wine is brought.
16. First Temptation.
17. Second Temptation.
18. Third Temptation.
19. Healing the leper.
20. Peter's mother-in-law healed (wrongly depicted as a man).
21. Foxes have holes; Christ with Apostles.
22. The storm stilled; Christ cures the demoniac.
23. Curing the paralytic.
24. Jairus before Christ; Jairus' daughter healed. C.M.K.

PROVENANCE As **47**, 1838; David Mackintosh, sold Christies, 20 May 1857, lot 771, bought by the British Museum
BIBLIOGRAPHY As **47**

49 Leaf from a Psalter (*not illustrated*)

400 × 292 mm
c. 1140; Canterbury (?) Christ Church
New York, Pierpont Morgan Library, M 521

The third of four leaves (**47–50**).

Recto:
1. The two blind men healed.
2. Apostles plucking corn; Christ disputing with Pharisees.
3. The withered hand; the dumb man healed.
4. Feeding of the five thousand.
5. Christ prostrate; He walks on the water.
6. Christ and the woman of Canaan; the dogs eat crumbs that fall from the table.
7. Peter receives keys from Christ; the Transfiguration.
8. The unmerciful servant; the debtor led to prison.
9. Parable of the vineyard.
10. The woman taken in adultery.
11. Dives and Lazarus (four scenes).
12. The prodigal son.

Verso:
13. The wise and foolish virgins.
14. Parable of the talents.
15. Zacchaeus in the tree; he offers Christ a dish.
16. Simon the leper; at the feast Mary wipes Christ's feet with her hair.
17. Christ and the Samaritan woman at the well.
18. Christ in the house of Mary and Martha; a woman pours ointment on His head.
19. Mary and Martha greet Christ; the raising of Lazarus.
20. The apostles obtain the ass; the entry into Jerusalem.
21. Judas receives his money.
22. Christ with two apostles; the Last Supper.
23. The washing of feet; the agony in the garden.
24. The betrayal (two scenes). C.M.K.

PROVENANCE As **47**, lot 133 in the Ottley sale, 1838, bought by Payne for £2.8*s.*; Bateman sale, sold Sotheby's, 25 May etc. 1893, lot 1152, bought by the Morgan Library
BIBLIOGRAPHY As **47**

50 Leaf from a Psalter

400 × 300 mm
c. 1140; Canterbury, (?) Christ Church
London, Victoria and Albert Museum, MS 661 (no. 816–1894)

The fourth of four leaves (**47–50**).

Recto (*illustrated on p. 54*):
1. Christ before Annas; Peter's first denial.
2. The officer strikes Christ; Peter's second denial.
3. Christ led before Caiaphas; Peter's third denial.
4. Christ in the hall of judgment.
5. The mocking; the scourging.
6. The crown of thorns.
7. Christ carrying the cross; Simon of Cyrene takes the cross from Him.
8. The crosses erected; Christ and the thieves on the crosses.
9. Longinus pierces Christ's side while two men break the thieves' legs; the earthquake.
10. Crucifixion with Mary and John.
11. Joseph begs Pilate for the body.
12. The deposition.

Verso (*not illustrated*):
13. Three Jews ask Pilate for a guard; soldiers cast dice for the tunic.
14. The swathing of the body; the entombment.
15. Three Marys at the tomb; Peter and John at the tomb.
16. Mary Magdalen at the tomb; '*Noli me tangere*' ('touch me not').
17. Journey to Emmaus (two scenes).
18. Supper at Emmaus; Christ rises to leave.
19. Christ appears to the disciples.
20. Incredulity of Thomas; Thomas prostrate.
21. Christ appearing to the disciples on the shore of Tiberias; Christ eats bread and fish with the disciples (John XXI. 1–14).
22. The disciples touch Christ's arm; they give Him the fish and the honeycomb (Luke XXIV. 36–44).
23. The Ascension.
24. Pentecost.

These leaves contain by far the largest New Testament cycle produced in England or anywhere else in the 12th century. The Gospels are illustrated with about 150 scenes, and the cycle clearly belongs to the same family as the St Albans Psalter (**17**) and the New Testament in Pembroke College (**21**) with which it has many scenes in common. All three manuscripts were probably derived from a common model similar to the 11th-century Ottonian cycles from Echternach, which also contain several of the rare illustrations to the Parables and Miracles. However, the four leaves contain a greater profusion of scenes than any Ottonian manuscript and it is conceivable that they echo early Christian cycles of the kind contained in the 6th/7th-century Gospels in Corpus Christi College, Cambridge.

In comparison with the St Albans Psalter and the Pembroke College New Testament, the execution is cruder and several scenes have been abbreviated to fit into tiny compartments. One artist, whose style is characterized by profile figures of the St Albans Psalter type with the addition of damp-fold drapery, appears to have been responsible for the first three leaves and the upper half of the recto of the fourth. A different hand may be detected in the lower half of the recto and the whole of the verso of the Victoria and Albert leaf. This is a more sophisticated style, linked with the Lambeth Bible in the treatment of the faces, hair and beards and in the drapery folds. C.M.K.

PROVENANCE As **47**, lot 132 in the Ottley sale, 1838, bought by Lloyd for £2.2*s.*; N.P. Simes, sold Christie's, 9 July 1886, lot 1095; acquired by the Victoria and Albert Museum, 1894
BIBLIOGRAPHY As **47**; Park, 1983, p. 40 f.

51

51 Minor Prophets glossed, Jeremiah Lamentations glossed

287 × 186 mm; 189 ff; medieval binding with chain
Mid-12th century; (?) Hereford
Hereford Cathedral Library, MS P.4.III

The exhibited initial V (f. 3) shows the prophet Hosea before God. These figures, with their drooping moustaches, heavy cheekbones, large eyes, and their thin bodies with clinging draperies spread out in a fan at the feet, have long been linked with those carved on the chancel arch at Kilpeck Church and on the Castle Frome font (139). This connection with the Kilpeck sculpture, which probably had its source in Hereford, supports the Herefordshire provenance of this manuscript, but there is no evidence as to whether there was a scriptorium attached to the Cathedral. C.M.K.

PROVENANCE Hereford Cathedral Library (14th-century inscription, f. 1)
BIBLIOGRAPHY Kauffmann, 1975, no. 64

52 Bible, Genesis–Ruth

473 × 317 mm; 137 ff.
c. 1150; (?) Walsingham Priory
Dublin, Chester Beatty Library, MS 22

On account of its celebrated image of the Virgin, the Augustinian Priory of Walsingham in Norfolk was an important place of pilgrimage in the Middle Ages. This manuscript has been connected with Walsingham because the contemporary rental of the Priory was used as a flyleaf (f. 2). However, as the Priory was only founded in about 1153 and as nothing is known of its library, the manuscript's place of origin remains in doubt.

As far as one can tell from the single surviving volume with its six historiated initials, the Walsingham Bible was neither as fully illustrated nor as sumptuously produced as the more famous English 12th-century Bibles (e.g. 44 and 64). It is more akin to the slightly earlier Rochester Bible (24).

The exhibited page (f. 32ᵛ) contains the initial H to Exodus (*Hec sunt nomina duodecim filiorum Israel* – 'These are the names of the twelve children of Israel'). Moses is shown removing his shoes before the burning bush, placed at the top of the shaft, which contains the head of God (Exodus III.2). At the same time he grasps a serpent, a reference to the brazen serpent he was ordered to set up in Numbers XXI. 8–9. Rather curiously, the artist used the same composition, but without the burning bush, to illustrate the beginning of the book of Numbers (f. 67ᵛ). The profiles are reminiscent of some in the Dover Bible (Cambridge, Corpus Christi College, MS 4, ff. 58, 84ᵛ), but the distinctive striped and dotted drapery is not readily found elsewhere. A date in the 1140s is suggested by the decoration of the initials, but as one initial is on gold ground (f. 6ᵛ) it may be slightly later. C.M.K.

PROVENANCE Walsingham Priory; Sir Henry Spelman (1564?–1641), antiquary; Hon. Richard Bateman; John Jackson, FSA, 1774; Sir Thomas Phillipps, Cheltenham (1792–1872), MS 4769; bought by Sir A. Chester Beatty from the Phillipps Collection, 1921
BIBLIOGRAPHY Kauffmann, 1975, no. 59; Stones, 1978; Cahn, 1982, pp. 245, 260, no. 30

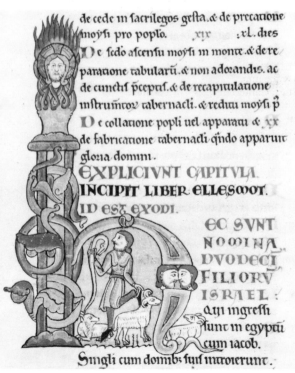

53 Bible: the Lambeth Bible, vol. I, Genesis–Job

578 × 353 mm; 328 ff.
c. 1150; (?) Canterbury, St Augustine's
London, Lambeth Palace Library MS 3

The illuminations of this great Bible are not in a Canterbury style nor is there any internal evidence for the original provenance, but Dodwell argued cogently that the ownership from 1538 by Kentish families with close Canterbury ties strongly suggested St Augustine's which was dissolved in that year. More recently arguments have been put forward for a Bury provenance (Denny) and, more plausibly, for St Albans (Thomson), but the evidence is inconclusive. In any case, the artist was an itinerant professional who also illuminated a Book of the Gospels for the abbey of Liessies in Hainault in 1146 (54; see also 55).

It can be seen from the exhibited *Tree of Jesse* page (f. 198), the frontispiece to Prophets, that the figure style is derived from that of the Bury Bible (44). The clinging curvilinear folds by which the body beneath the drapery is delineated are essentially the same, but it is a mannered version of the style which has come to dominate the composition. However, the link with Bury does not necessarily imply a direct dependence, for this drapery style appears elsewhere, for example in the Winchester Psalter and Bible (61 and 64a).

The miniature is a supreme example of the figured diagram, expressing a series of complex theological doctrines in clearly comprehensible form. Isaiah's 'And there shall come forth a shoot out of the stock of Jesse and a branch out of his roots shall bear fruit' was a famous prophecy of the coming of Christ. The Latin *virga* (rod or stem) was identified with *Virgo* (Virgin) (see also 28), and the pictorial image of the Tree of Jesse incorporating the ancestors of Christ originated in the 11th century. In this miniature the rod leads straight from Jesse through the Virgin to Christ who is surrounded by the seven gifts of the Holy Spirit (Isaiah XI.2) in the form of seven doves. In the upper roundels the Church Triumphant is flanked by two Apostles while on the right the veil – symbol of her blindness – is torn from the face of Synagogue, who is accompanied by Moses (horned) and another Old Testament elder.

In the lower roundels, at the Virgin's feet, four prophets point upwards towards Christ and in the middle roundels are personifications of the four virtues referred to in Psalm 84 (85 in the Authorized Version): 'Mercy and Truth are met together; Righteousness and Peace have kissed each other.' Mercy holds a vase and Justice her scales. According to Jerome's commentary on Psalm 84, Truth symbolizes the Jews and Mercy the Gentiles and hence this verse, like the illustration above, refers to the union of Jew and Gentile, Old and New Testament, which is the theme of the Tree of Jesse itself.

The second volume of this Bible is also exhibited (53a).

C.M.K.

PROVENANCE John Colyar of Lenham, near Maidstone, 1538; other references to Colyar, Hales and Pery families (inscription at end of Maidstone volume; Archbishop Bancroft; bequeathed to Lambeth Palace Library, 1610
BIBLIOGRAPHY Dodwell, 1954, p. 48 ff., p. 81 ff.; Dodwell, 1959; Kauffmann, 1975, no. 70; Denny, 1977, 51–64; Thomson, 1982, pp. 31–3, no. 81; Cahn, 1982, pp. 171, 180, 191, 261, no. 34

53a

53a Bible: the Lambeth Bible, vol. II, Psalms–Revelation

500 × 357 mm; 310 ff.
c. 1150; (?) Canterbury, St Augustine's
Maidstone Museum and Art Gallery

Most of the illuminated pages and initials of the second volume of the Lambeth Bible have been removed, but fortunately five historiated initials survive at the liturgical divisions of the Psalms. The Psalms had long been divided into eight sections for reading each week (one section each day and one for Vespers), but it was in England in the 12th century that these divisions were first illustrated.

Thus the exhibited initial D (f. 32ᵛ) (*Dixit Dominus . . .*) contains a literal illustration of the opening of Psalm 109 (110 in the Authorized Version): 'The Lord saith unto my Lord, Sit thou on my right hand until I make thine enemies thy footstool.'

The iconography is derived from scenes of the Trinity and of Christ trampling on His enemies, but this is one of the earliest examples of the subject in this context. It subsequently became the standard illustration to Psalm 109 in both English and French Psalters.

The first volume of this Bible is also exhibited (53). C.M.K.

PROVENANCE As 53; Maidstone Parochial Library; Maidstone Museum
BIBLIOGRAPHY As 53

54 Two leaves from a Gospel

355 × 240 mm
1146; French, illuminated by an English artist
Avesnes-sur-Helpe, Musée de la Société archéologique

The first leaf shows St Mark writing his Gospel, inspired by
the Holy Spirit. The creature at his feet, with the heads of a
lion, an ox, an eagle and a human, refers to the vision of
Ezekiel (Ezekiel 1.10) which is being expounded by the prophet
on the left. The four heads of this creature coincide with the
four beasts of St John's Apocalyptic vision, which in turn
became the symbols of the four Evangelists (see also 83). On
the right is the baptism of Christ and in the corner medallions
Bede – who had written a commentary on St Mark – and three
prophets. The second leaf shows St John surrounded by
medallions with scenes from his life. His inkhorn is held by
Wedric, Abbot of Liessies in Hainault, the patron of the
manuscript.

These leaves belonged to a Gospels formerly in the
Municipal Library at Metz (MS 1151) but destroyed in the last
war; this contained other illuminations in the same style. We
know from inscriptions that this manuscript was made for
Wedric in 1146.

From the style of these paintings it is clear that they are by
the artist of the Lambeth Bible (53), while the script on the back
indicates that the manuscript was written in France. The
Lambeth Bible Master must have worked in both countries but
his origin in England is suggested by the derivation of his style
from that of the Bury Bible. C.M.K.

PROVENANCE Abbey of Liessies, Hainault
BIBLIOGRAPHY Dodwell, 1959, pp. 16–19, pls. 7–8; McLachlan, 1975, p. 12; Henderson, 1980, p. 18

55 Two leaves (one bifolium) from a (?) Psalter
(*not illustrated*)

347 × 241 mm
Mid-12th century; St Albans Abbey
Oxford, Corpus Christi College, MS 2*

These 'shadowy masterpieces', as Boase called them, appear to
have been left unfinished, with only faint washes of colour
applied, and subsequently damaged by erasure or rubbing. A
13th-century map of Palestine drawn on the reverse extends
over both leaves, showing that the bifolium was used as a single
sheet at that date. The fact that the map is by Matthew Paris,
monk at St Albans, suggests that the miniatures also originated
at St Albans.

In style they are related to the Lambeth Bible (53). The
elongated figures, the round faces, treatment of the curls on
hair and beards and, as far as one can judge, the drapery folds,
are all paralleled in the Bible. The heads in medallions on the
frames, a type which originated in Ottonian illumination, also
occur in the Lambeth Bible and in the Avesnes leaves (53 and
54). Another St Albans manuscript (Bodley, Acut. D.2.6,
ff. 1–8) also contains illustrations in the Lambeth Bible style
which indicates that the Master of the Lambeth Bible himself,
or an assistant, worked at St Albans.

In the *Deposition*, Joseph of Arimethea holds Christ's body
while St John holds His hands in a gesture of sorrow and the
Virgin stands weeping on the left. Both this scene and the
Marys at the Sepulchre on the right are similar to their
counterparts in the St Albans Psalter (17). C.M.K.

BIBLIOGRAPHY Kauffmann, 1975, no. 72; Thomson, 1982, p. 31, no. 52

56 Terence, Comedies

282 × 220 mm; 174 ff.
Mid-12th century; (?) St Albans Abbey
Oxford, Bodleian Library, MS Auct. F.2.13

The six comedies of Terence (c. 194–159 BC) were enormously popular throughout the Roman period and their continued fame in the Middle Ages is evidenced by the survival of a considerable number of manuscripts, of which 13, dating from the 9th to the 12th centuries, are illustrated. The drawings in these manuscripts derive from a classical archetype and they reflect the appearance of actors on the Roman stage, with their masks and characteristically exaggerated gestures and expressions. The names of the characters have been written in red by the scribe above the drawings. The Bodleian Terence is one of the last manuscripts in this very classicizing tradition. Classical literature continued to be popular in succeeding centuries, but in the illustrations the Roman and Greek characters took on the guise of Gothic knights and ladies.

Exhibited here is the illustration to Act II, scene I of *Andria* (f. 13). Charinus, a devoted lover of Philumena, asks for a short delay of her marriage to Pamphilus and is therefore greeted with open arms by Pamphilus himself who is doing his utmost to avoid the match, as he loves Glycerium. Davus, on the left, is the rascally slave who is used to pass messages.

In composition, these illustrations hardly differ from their Carolingian forerunners, but compared to the sketchy treatment of the figures in the Carolingian manuscripts, they are characterized by much more solid Romanesque forms with firm outlines and stylized drapery folds. This hand has long been identified with the 'Master of the Apocrypha Drawings' of the Winchester Bible (64b), who appears to have been an itinerant artist working in northern France as well as in England. A 13th-century ex-libris (f. 1) is evidence of a St Albans provenance but it is uncertain whether it was written there (Thomson). C.M.K.

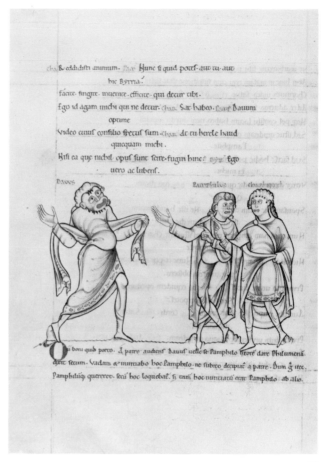

56

PROVENANCE St Albans Abbey; Roger Walle, Canon of Lichfield (d. 1488)
EXHIBITION Oxford, 1975, no. 127
BIBLIOGRAPHY Jones, Morey, 1931, pp. 69–93 (all drawings reproduced); Kauffmann, 1975, no. 73; Ayres 1974b, p. 220; Ayres, 1976; A.C. de la Mare, unpublished note in Bodleian Library, 1979; Oakeshott, 1981, pp. 53–7; Thomson, 1982, pp. 136–7, no. 42

57 Pliny, Natural History *(not illustrated)*

435 × 320 mm; 435 ff.
Mid-12th century; probably English
Le Mans, Bibliothèque municipale, MS 263

In the dedication miniature (f. 10ᵛ) Pliny is shown, above, writing; his sword, lance and shield hang on the wall; a servant holds a candle and inkwell; below, in armour dressed as a knight, he offers his book to the Emperor Vespasian. There are six decorated initials at the opening to the books (ff. 2, 11, 22ᵛ, 28ᵛ, 34, 162ᵛ).

The manuscript was recorded at the Abbey of St-Vincent at Le Mans in 1698 but there is no evidence that it was produced there. As long ago as 1954 Jean Porcher compared the initials with those of the Bodleian Auct. Bible (63) and suggested that it may have been brought to France from England. On the other hand the decorated, horizontal-striped background derives from French manuscripts of the 11th century (e.g. *Life of Ste-Radegonde*, Poitiers MS 250) and the drapery style is also linked with the western French tradition (see the Anglo-French comparisons in Ayres, 1974b).

Recently, the comparison with the Auct. Bible has been taken up again by Oakeshott (Oakeshott, 1981). Arguing that the human supporters of the initial are definitely by the same hand as the full-page miniature, he attributed them to the 'Entangled Figures Master' and subsequently (Oakeshott, *Burl. Mag.*, April 1984) to a different hand from the same workshop. Thomson drew attention to similarities with the Apocrypha Master's style, and argued that the script also indicated an English origin for this manuscript. This is supported by the textual recension which appears in two other English manuscripts (British Library, MS Arundel 98, 12th century; New College Oxford 274, 13th century). Pliny's *Natural History* was known in medieval England from the time of Bede, and this manuscript is a further example of classical texts copied for a monastic readership in the 12th century. C.M.K.

PROVENANCE Le Mans, Abbey of St-Vincent, 1698
EXHIBITION Paris, 1954, no. 231
BIBLIOGRAPHY Swarzenski, 1954, fig. 293 (?Le Mans); E. de Saint-Denis, 'Un manuscrit de Pline l'Ancien ignoré des philologues', *Revue de Philologie*, 3rd series, 34, 1960, pp. 31–50; Oakeshott, 1981, p. 103; Thomson, 1982, p. 135, n.76; Oakeshott, *Burl. Mag.*, April 1984

58

58 Laurence of Durham, Works

241 × 152 mm; 107 ff.
c. 1150–60; Durham Cathedral Priory
University of Durham, Bishop Cosin's Library, MS V.III.I

Laurence was Prior of Durham from 1149 to 1154 and this edition of his works was probably written at about this time. His principal text is a versified history of the Old and New Testaments (ff. 19ᵛ–92). The miniature of Prior Laurence (f. 22ᵛ), like all such author portraits, is derived from the traditional Evangelist portrait, though the manner in which the desk is joined to the chair is highly idiosyncratic. He seems to be writing in a bound book, but this is an artistic convention, for there is evidence to show that the scribe usually wrote on separate sheets which were bound after the work was completed. C.M.K.

PROVENANCE Durham Cathedral Priory (catalogues of 1391 and 1416); given by Nicholas Frevyle to George Davenport, Chaplain to Bishop John Cosin, 1670 (inscription f. ii); given by Davenport to Bishop Cosin's Library
BIBLIOGRAPHY Kauffmann, 1975, no. 76

59 St Anselm, Prayers and Meditations
(*not illustrated*)

241 × 155 mm; 156–200 ff. (bound with other texts)
c. 1150
Oxford, Bodleian Library, MS Auct. D.2.6

For a discussion of St Anselm's *Prayers and Meditations* see the entry on the Verdun manuscript with which this manuscript is related (**19**).

The miniature exhibited (f. 180ᵛ) opens the Prayer to St Nicholas and shows the Saint raising from the dead the three murdered youths. This legend was the most popular miracle of St Nicholas and hence chosen as a suitable illustration even though it does not figure in Anselm's text.

The evidence of the saints invoked in the prayers points to the house of Arrouaisian Augustine Canons at Dorchester, Oxfordshire, as the original home of the manuscript. However, this remains open to doubt as the Arrouaisian habit was black, whereas the figure depicted kneeling before St Peter on f. 184 of the manuscript is a white canon.

Stylistically, the facial types, in particular the characteristic profiles, descend from the St Albans Psalter tradition. But the drapery, with its complex damp-folds, and also the foliage decoration, belong to the post-Bury Bible period and indicate a mid-century date. C.M.K.

PROVENANCE By the early 13th century this text bound, as it still is, with a St Alban's calendar and a Psalter from Winchester and belonging to Adam Basset of Littlemore, Oxfordshire (inscription f. 155); given to the Bodleian by Richard Beswick, fellow of Exeter College, 1672
BIBLIOGRAPHY Pächt, 1956, pp. 68–83; Kauffmann, 1975, no. 75; Eleen, 1982, p. 20

60 St Paul, Epistles, with gloss 'Pro altercatione'
(*not illustrated*)

298 × 190 mm; 154 ff.
Mid 12th century; (?) Winchester
Oxford, Bodleian Library, MS Auct. D.1.13

This splendid opening (f. 1) initial shows St Paul teaching, at the top; in the centre he is being lowered down the walls of Damascus in a basket to escape the plot of the Jews against him (Acts IX.25; 2 Corinthians XI.33); and below he is beheaded.

The style of the figures, with their expressive, mask-like faces, is reminiscent of the St Albans Terence (**56**) and the Apocrypha drawings of the Winchester Bible (**64b**). The likelihood of a Winchester provenance is supported by the scrollwork initials which are similar to those in the Winchester Bible. In stressing the itinerant nature of the Apocrypha Master's workshop, Thomson has attributed this initial to an artist working on a Norman manuscript completed in 1158 (Avranches, Bibliothèque municipale, MS 159). The iconography recalls earlier versions of these scenes in the Carolingian Bible in Rome (San Paolo fuori le Mura). C.M.K.

PROVENANCE Exeter Cathedral (catalogue of 1506); given by the Dean and Chapter to the Bodleian Library, 1602
BIBLIOGRAPHY Kauffmann, 1975, no. 79; Oakeshott, 1981; Thomson, 1982, p. 136 n. 78; Eleen, 1982, p. 21, cf. figs. 162–71

61 Psalter: the Winchester Psalter
(*illustrated on pp. 16, 24 and 55*)

320 × 230 mm; 142 ff.
c. 1150; Winchester, (?) Cathedral Priory of St Swithun
London, British Library, MS Cotton, Nero C.IV

The 38 full-page miniatures preceding the Latin and Old French Psalter text of this famous manuscript are now on the

rectos only but were originally on the rectos and versos so that the pictures faced one another. It was presumably after the manuscript was damaged in the Cotton Library fire of 1731 that the leaves were split and the pictures mounted as rectos. However, it is likely that these miniatures were originally only lightly tinted and not, as has been thought, that the blue background was damaged by scraping.

Although it has been traditionally known as the St Swithun's Psalter from the evidence of the calendar and of the prayer addressed to St Swithun, the manuscript's original provenance remains in doubt. The link with Henry of Blois, Bishop of Winchester and brother of King Stephen, was always tenuous and Wormald drew attention to the possible connection with Hyde Abbey, Winchester and to the fact that the Litany is most typical of Abingdon. The Anglo-Norman French inscriptions round the miniatures, explaining their subject in the simplest terms, appear to be additions to the original manuscript (according to Haney) and cannot be used to help identify the original recipient.

The exhibited page (f. 21) shows Christ's Betrayal and Flagellation. The figures are articulated and their movement enhanced by the clinging curvilinear drapery convention of the Bury Bible (**44**) which is in a less mannered form here than in the Winchester Bible (**64a**). Characteristic of this manuscript are the caricatures, which are among the most expressive in the whole of English art. Two of the miniatures, the *Death of the Virgin* and the *Virgin Enthroned* (p. 24), are in a different style, closely copied from a Byzantine model, perhaps an icon. C.M.K.

PROVENANCE Shaftesbury Abbey (additions to the calendar), 13th century; Sir Robert Cotton, Bt (1571–1631); his library presented to the nation by Sir John Cotton, Bt., 1700; incorporated in the British Museum, 1753
BIBLIOGRAPHY Wormald, 1973 (all miniatures reproduced); Kauffmann, 1975, no. 78; M. R. Witzling, *Gesta*, XVII, 1978, p. 29; Haney, 1981, p. 149 ff.

62 Tripartite Psalter: the Eadwine Psalter

460 × 327 mm; 286 ff.
c. 1150–60; Canterbury, Christ Church
Cambridge, Trinity College Library, MS R.17.1

Each page of the text is divided into three columns corresponding to the three versions of the Psalms: *Hebraicum*, St Jerome's Latin version from the Hebrew; *Romanum*, St Jerome's Roman version; and *Gallicanum*, St Jerome's revision of his own *Romanum* text which became the Psalter generally used in Western churches. The last of these is in pride of place. In addition, an exegetical gloss accompanies the *Gallicanum* and an English and a French translation is interlined with the *Romanum* and the *Hebraicum* respectively. The errors in the text of the Old English version have been explained as the result of uncritical copying of an archaic text at a time when the language was no longer in current use.

The text of each Psalm is illustrated in a literal, line-by-line fashion by oblong drawings extending across the page. This is one of four extant Psalters illustrated in this way, the earliest of which is the 9th-century Psalter from Rheims now at Utrecht. The Utrecht Psalter was at Canterbury in the Middle Ages, where it was much copied: one copy, now in the British Library, MS Harley 603, is of c. 1000, unfinished, with later additions; a second is this exhibit, the Eadwine Psalter; and a third, now in Paris, Bibliothèque nationale, latin 8846, dating from c. 1180–90, is also exhibited here (**73**).

As well as these 156 tinted outline drawings, the Eadwine Psalter contains a most unusual architectural plan showing the waterworks at Christ Church installed by Prior Wibert c. 1160 (ff. 284ᵛ–86) and a portrait of the scribe, the monk Eadwine

62

(f. 283ᵛ) here exhibited. Inscribed *Scriptor: S[c]riptorum princeps ego nec obitura deinceps laus mea nec fama . . .* ('Scribe: the prince of scribes am I: neither my praises nor my fame shall ever die . . .'), this is one of the most monumental paintings to be produced in Canterbury and the only 12th-century picture in which the scribe is depicted in the posture, size and setting of an Evangelist portrait.

The date of the Eadwine Psalter has been placed in the 1140s, because of the description of a comet which appeared in 1145 (f. 10). Recently, George Zarnecki has proposed that the Eadwine portrait belongs to a later stylistic phase linked to the wall-painting of St Paul in the Anselm chapel of the Cathedral (c. 1163) and that it is an additional leaf, not part of the original Psalter. However, Sydney M. Cockerell, who has rebound the manuscript, is convinced that the portrait formed part of the original manuscript (unpublished letter to C.R. Dodwell).

A solution may perhaps be provided by the text. The script of the gloss closely resembles that of a Christ Church document of 1163–7 (Rental B). Palaeographical evidence of this kind is notoriously difficult to evaluate – a scribe's hand could remain the same over a lifetime – but there is support for a date c. 1160 from Margaret Gibson's suggestion (in a lecture) that the gloss may be related to Peter Lombard's (see **69**) which was not widely published until the late 1150s. However, a firmer date will have to await the study of the complete text by R.W. Pfaff. C.M.K.

PROVENANCE Christ Church Canterbury (Eastry's catalogue, 14th century); remained at Canterbury until presented to Trinity College by Thomas Nevile, Dean of Canterbury and Master of Trinity (1593–1615)
BIBLIOGRAPHY James, 1935; Kauffmann, 1975, no. 68; Heimann, 1975; Clark, 1976, pp. 1–33; Zarnecki, 1981, pp. 93–100

63 Bible, vol. I, Genesis–Job

525 × 360 mm; 315 ff.
c. 1160 and *c.* 1170–80; Winchester
Oxford, Bodleian Library, MS Auct. E. inf. 1

This initial V (f. 304) to the Book of Job (*Vir erat in terra* – 'There was a man in the land . . .') is the most inventive of all the 37 initials in this splendid volume. It shows the fully-developed Romanesque initial in its most luxuriant form: the figures are enmeshed in thick foliage scrolls, and battling with dragons and huge grotesque heads. A distinctive feature is the profile heads emerging from the petals of flowers which end in long curling spurs. This artist was originally characterized as the 'Master of the Entangled Figures' by Boase, and Oakeshott has recently attributed to him not only the initials in certain Winchester manuscripts (e.g. Bodley, MS Auct. D.2.4.) but also the Shaftesbury Psalter and related manuscripts (**25, 26** and **31**).

It was from this Bible that the text of the great Winchester Bible (**64**) was corrected, and three leaves added to it are by the scribe of the Bodleian Auct. Bible. Oakeshott has argued convincingly that it was this Bible and not, as had been thought, the Winchester Bible, that was sent by Henry II to St Hugh's foundation at Witham in Somerset after 1180. Subsequently, when St Hugh discovered that the Bible had been taken by the king from the monks at Winchester, he insisted that it should be returned to its rightful home.

Because of stylistic and textual links with St Albans, Oakeshott suggested that this manuscript was begun at St Albans and completed at Winchester, but his arguments were not accepted in Thomson's discussion of the St Albans scriptorium. It is likely that this manuscript was produced at Winchester, *c.* 1160; two initials in this volume (ff. 161ᵛ, 162ᵛ) and the majority of the initials in vol. II (also exhibited here: **63a**) were added in the 1170s. C.M.K.

PROVENANCE Given to the Bodleian Library by George Rives, Warden of New College and Canon of Winchester, 1601
BIBLIOGRAPHY Kauffmann, 1975, no. 82; Caviness, 1977, p. 54 f.; Oakeshott, 1981; Thomson, 1982, p. 34 f.; Cahn, 1982, no. 35

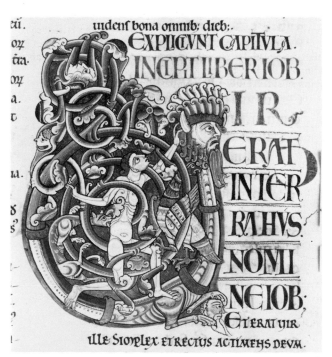

63

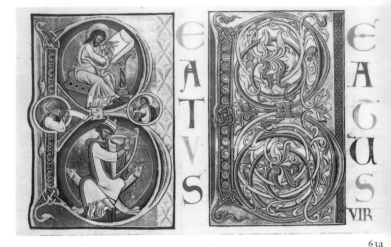

63a

63a Bible, vol. II, Psalms–Revelation

527 × 362 mm; 318 ff.
c. 1160 and *c.* 1170–80; Winchester
Oxford, Bodleian Library, MS Auct. E. inf. 2

The first volume of this Bible is also exhibited here (**63**).

The book is open at the beginning of the Psalms (f. 2) which are given in two versions: Jerome's Gallican translation, the standard text; and Jerome's Roman translation which it superseded. The opening (*Beatus vir* – 'Blessed is the man . . .') is the only historiated initial in this Bible. It shows David as the author of the Psalms and, below, the standard illustration of him as a king playing the harp, with prophets in the medallions. The second *Beatus* initial is decorated with tight spirals on gold ground.

In style they are in sharp contrast to most of the initials in vol. I: the figures are in the new Byzantinizing style of the last quarter of the century, with naturalistic, carefully modelled faces with greenish shading, and multiple-fold drapery quite different to the more abstract patterns of the mid-century. These figures are comparable to the work of the Master of the Morgan Leaf in the Winchester Bible (**64**) and, indeed, Oakeshott has attributed this initial to the Amalekite Master, another artist working on the Winchester Bible, *c.* 1170, in a Byzantinizing style. C.M.K.

PROVENANCE As 63
BIBLIOGRAPHY As 63

64 Bible: the Winchester Bible, vol II

583 × 369 mm; 129–214 ff.
c. 1155–60 and *c.* 1170–85; Winchester, Cathedral Priory of St Swithun
Winchester Cathedral Library

Its size and elaborate decoration make this the most ambitious of all English Romanesque Bibles. Originally in two volumes, it is now bound in four volumes of which three are exhibited here. The script is possibly by a single scribe (except for the two Isaiah supply leaves which are by the hand of the Bodleian Bible, (**63**), probably as early as 1155–60. However, the illumination is by at least five artists whose work covers more than 20 years, which indicates that the Bible remained for a long time unbound. The illumination was never completed, as can be seen by the numerous unfinished initials and blank

spaces in vols. III and IV. These artists were characterized by Walter Oakeshott many years ago, and both the analysis and his nomenclature have been widely accepted. The earliest, the Master of the Leaping Figures, is discussed in the next entry (64a). The Apocrypha Drawings Master (64b) also belongs to the earlier group, c. 1155–60, while the Master of the Morgan Leaf, the Master of the Genesis Initial and the Gothic Majesty Master belong to the period c. 1170–85.

This initial (f. 190), opening the Book of Daniel, has been traditionally interpreted as King Nebuchadnezzar eating, with the three Hebrew children in the foreground (Daniel I). However, comparison with Daniel illustrations both in the 11th-century Roda Bible (Paris, Bibliothèque nationale, latin 6) and on monumental sculpture (e.g. a capital at Vézelay), suggests that this scene represents Belshazzar's feast at the moment when the vessels from the Temple were brought to the King, just before the appearance of the writing on the wall (Daniel V). The artist is the Master of the Morgan Leaf, so named because of his work on the single leaf in the Morgan Library (65). Carefully modelled, bearded faces are in the classicizing, Byzantine manner common throughout Western art in the last quarter of the century. The draperies are also less patterned and more naturalistic than hitherto, and the background is gold rather than blue as it was in the earlier initials. The Morgan Master's Byzantinism was probably derived from the mosaics of the Capella Palatina in Palermo; there were close links between the two countries when one of Henry II's daughters married William II of Sicily. This is the artist whose workshop was probably responsible for the frescoes from Sigena, Catalonia (87). C.M.K.

PROVENANCE Probably at St Swithun's, Winchester, throughout the Middle Ages
BIBLIOGRAPHY Oakeshott, 1945; Kauffmann, 1975, no. 83; Oakeshott, 1981; Cahn, 1982, pp. 175, 240, no. 38

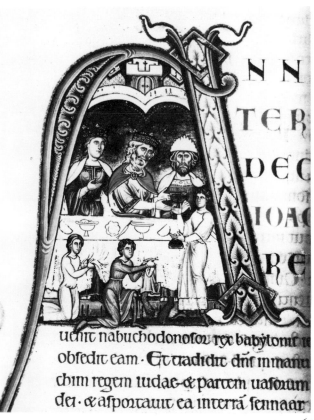

64

64a Bible: the Winchester Bible, vol. III

(*illustrated on p. 56*)

578 × 396 mm; 215–330 ff.
c. 1155–60 and c. 1170–85; Winchester, Cathedral Priory of St Swithun
Winchester Cathedral Library

The Psalms in the Winchester Bible contain three sets of initials at the tripartite divisions (Psalms 1, 51, 101) and at one of the five liturgical divisions (Psalm 109; see 53a). These two initials (f. 232), Q (*Quid gloriaris*, 'Why boastest thou?') to the Gallican and the Roman versions of the Psalms, illustrate Psalm 51 (52 of the Authorized Version) and show Doeg telling Saul that David has fled, and Doeg, at Saul's command, slaying the priests (1 Sam. XXII). The latter, which occurs also in the Lambeth Bible (53a), became the standard illustration for this Psalm.

Both initials were completed by the Master of the Leaping Figures, an artist working in the clinging curvilinear drapery convention of the Bury Bible and the Winchester Psalter (44 and 61), whose figures are constantly poised for movement. The decoration of the initials with large acanthus leaves and bunches of fruit is very similar to the Bury Bible. Working in a mid-century style, this is the principal of the earlier artists collaborating on the illumination of this Bible. He was responsible for the design of some 40 initials, though he only completed seven. Several of his unfinished initials were later coloured by different hands. C.M.K.

PROVENANCE As 64
BIBLIOGRAPHY As 64

64b Bible: the Winchester Bible, vol. IV (*not illustrated*)

583 × 396 mm; 331–468 ff.
c. 1155–60 and c. 1170–85; Winchester, Cathedral Priory of St Swithun
Winchester Cathedral Library

This drawing at the opening of Maccabees is one of two remaining full-page frontispieces in the Bible (f. 350ᵛ); the other is at the beginning of the Book of Judith. It is likely that they were added to the Bible as an afterthought to the original plan, and probable that they were intended to be coloured. In the upper register Antiochus is commanding the Jews to make sacrifices and Mattathias slays the Jew sacrificing at the pagan altar (I.44–52; II.24–5); in the middle register the battle of Adasa; Nicanor's head hung up beside Jerusalem (VII.43–7); in the lower register the battle of Eleasa; King Demetrius defeats Judas Maccabeus; burial of Judas Maccabeus (IX.17–19).

The Master of the Apocrypha Drawings has long been identified with the principal artist of the Bodleian Terence manuscript (56). Apart from similarities of the delicate pen drawing technique and the characteristic postures, Oakeshott has drawn attention to details, such as the fish-hook folds at the thigh which are identical in the two manuscripts. The Apocrypha Drawings, like the initials of the Leaping Figures Master, may be dated in the 1150s.

It is worth noting that full-page illustrations to Judith and Maccabees form the subject of the last two Old Testament illustrations of the Carolingian Bible at San Paolo fuori le Mura in Rome, and it is likely that the Winchester artist had recourse to full-page illustrations of this kind. C.M.K.

PROVENANCE As 64
BIBLIOGRAPHY As 64

65 Leaf related to the Winchester Bible

(illustrated on p. 57)

575 × 388 mm
c. 1160–80; Winchester, Cathedral Priory of St Swithun
New York, Pierpont Morgan Library, M.619

The recto contains chapter headings to 1 Samuel and miniatures on the right side and lower half: lower left, Hannah praying in the Temple; Hannah before Eli; top right, Hannah presenting Samuel in the Temple; Samuel before Eli and called by God; Saul meeting Samuel; Saul anointed by Samuel.

The verso is fully painted in three registers: top, Saul with army; David meets and kills Goliath; centre, Saul hurling javelin at David; Samuel anointing David; bottom, Joab kills Absalom caught in the tree; David sorrowing over Absalom's death.

This leaf has long been recognized as being closely linked with the Winchester Bible, and Oakeshott devised the name Master of the Morgan Leaf to describe one of the Bible's principal artists. The chapter headings on the recto begin at precisely the same place in the text as in the Winchester Bible, and, in all likelihood, this leaf was made as a frontispiece to 1 Samuel at the same time as the full-page illustrations to Judith and Maccabees. Oakeshott has shown that these full-page frontispieces were an afterthought to the original plan and this leaf was never inserted in the Bible.

Although the style of the painting is that of the Master of the Morgan Leaf (see **64**), there are clear signs, as Oakeshott has demonstrated, that the drawing beneath is by the Master of the Apocrypha Drawings (**64b**). Not only the characteristic cross-legged stance, but also details such as the boat-hook crease, are sure indications of this artist's work. The difference between the two sides has been explained as reflecting the Morgan Master closely following the under-drawing on the recto while completely obliterating the original contours on the verso.

Iconographically, the leaf is related to earlier illustrations to 1 Samuel, for example, in the Carolingian Bible at San Paolo fuori le Mura, Rome, and more strikingly, in the early 12th-century Bible of Stephen Harding, Abbot of Cîteaux (Dijon MS 14), and it is likely that such a cycle of illustrations to the Books of Samuel and Kings was available in 12th-century England. C.M.K.

PROVENANCE Bought by J. Pierpont Morgan from L. Olschki, 1912
BIBLIOGRAPHY Kauffmann, 1975, no. 84; Oakeshott, 1981, p. 58 ff; Cahn, 1982, p. 184 f.

66 Bede, Commentary on the Apocalypse

270 × 178 mm; iii + 213 ff.
c. 1160–70; (?) Ramsey Abbey, Essex
Cambridge, St John's College, MS H.6

This manuscript was at Ramsey Abbey in the later Middle Ages but there is no evidence to show whether it was produced there. The linear treatment of the folds has been compared with north German enamels of about 1170.

Two of the four full-page, framed pen drawings preceding the text are shown here: f. ii^v, St John, author of the Apocalypse, vested as a bishop with a monk, the scribe, kneeling at his feet (*scriptor libri veniam* – 'the scribe of this

66

book [begs] pardon'); f. iii, a vaulted building with seven towers representing the seven churches and a seven-branched candlestick (*septem ecclesie; septem candelabra*). This is an unusual illustration; the seven churches are normally shown as separate entities and the *septem candelabra* of Revelations I.20 are, strictly speaking, seven candlesticks which symbolize the seven churches. In telescoping them into one, the artist is depicting the seven-branched candlestick of the Jewish Temple which was described by Bede himself in his treatise on the Temple and which was illustrated in manuscripts describing Temple furnishings (e.g. Petrus Comestor, Cambridge, Trinity College MS B.15.4; Henderson, 1980, pl. I). Such candlesticks were made and used in the 11th and 12th centuries, presumably under the influence of ancient Jewish ritual. Large, seven-branched candlesticks still exist in Essen and Milan Cathedrals and they were recorded in Winchester, St Augustine's at Canterbury, Bury St Edmunds, Westminster, Lincoln, Hereford, York and Durham. C.M.K.

PROVENANCE Ramsey Abbey (15th- or 16th-century inscription, erased, f. 1); William Crashaw (1572–1626) Puritan divine; Henry Wriothesley, Earl of Southampton, *c.* 1615; presented to St John's College by his son, Thomas, 1635
BIBLIOGRAPHY Kauffmann, 1975, no. 86; Henderson, 1980, p. 20

67 Richard of St-Victor, Commentary on the vision of Ezekiel (*not illustrated*)

245 × 155 mm; 128–67 ff.
c. 1170
Oxford, Bodleian Library, MS Bodley 494

The Temple of Ezekiel's vision, which is described at considerable length in the Bible, shares essential features both with Solomon's Temple (1 Kings VI. 5–9; 2 Chronicles III. 1–7, 11) and with the second and third Jewish Temples in Jerusalem. It consisted of oblong buildings divided into three rooms flanked by storage chambers and surrounded by courtyards. The Temple of Jerusalem was frequently depicted in medieval art, but usually according to a conventional formula derived from the Church of the Holy Sepulchre.

As the exhibited section of a building shows (*Edificium vergens ad aquilonem*, the building situated to the north; f. 162ᵛ), the illustrations in Bodley 494 contrast sharply with this convention in having the appearance of real architectural drawings. The reason for this lies in the character and aims of the author of this commentary. Richard of St-Victor was a Scot who became Prior of the Abbey of St-Victor in Paris in 1162 and died there in 1173. He set out to explain the literal sense of Ezekiel's text, for which he needed diagrams. At the same time these architectural drawings help to interpret the buildings in terms of contemporary architecture. They have close affinities with sections of actual 12th-century castles, and they may be seen as the nearest approach we have to genuine architectural drawings of the period.

An English origin for Bodley 494, suggested by its provenance, is, as R. W. Hunt once said, attested by its script. It was presumably copied from a near-contemporary French manuscript closely similar to the one now in the Bibliothèque nationale, Paris (latin 14516). C.M.K.

PROVENANCE Bound up with other manuscripts given to Exeter Cathedral by Hugo, Archdeacon of Taunton, 1219–44 (inscription f. iii); Exeter Cathedral catalogues of 1327 and 1506; given to the Bodleian Library by the Dean and Chapter of Exeter, 1602
BIBLIOGRAPHY Kauffmann, 1975, no. 88; W. Cahn, 'Architectural draftsmanship in 12th-century Paris; the illustrations of Richard of St-Victor's Commentary on Ezekiel's Temple Vision', *Gesta*, 15, 1976, pp. 247–54; Rosenau, 1979

68 Psalter and Book of Hours

275 × 175 mm; 249 ff.
c. 1170–80; (?) Westminster Abbey
Paris, Bibliothèque nationale, MS latin 10433

This is an early example of a Psalter combined with a Book of Hours (Hours of the Virgin, ff. 226–46). From the prominence given to English saints in the calendar and Litany, the Abbé Leroquais (*Livres d'Heures*, 1927) decided that it was an English manuscript and he was the first to publish it as such. Subsequently he attributed it to Westminster, but a close comparison of the calendar with undoubted Westminster manuscripts, such as the Westminster Psalter (**82**), does not fully support this conclusion.

Although only the illustrations to Psalms 1 and 26 exist, the empty spaces at the beginning of Psalms, 38, 51, 68, 80 and 109 indicate that this manuscript was intended to be illuminated at all the liturgical divisions of the Psalter (see **53a**). Exhibited is the frontispiece to Psalm 1 (f. 9) showing the Last Judgement with the Fall below, and angels holding the instruments of the Passion above. Christ himself divides the saved on his right from the damned on his left; the relevant text from Matthew

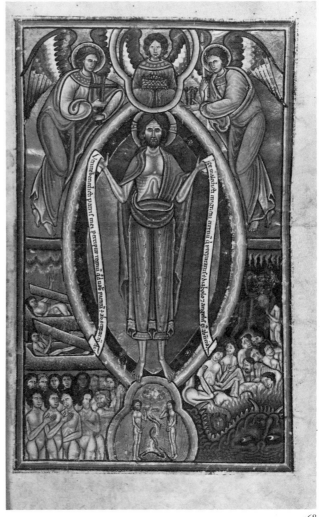

68

XXV.34 and 41 is inscribed on his speech-bands. The figures of Adam and Eve, always seen in the Harrowing of Hell and occasionally at the foot of the Crucifixion, are rare in the Last Judgement in medieval art. Occasionally, as in the Torcello apse mosaic and in the 12th-century *Hortus Deliciarum*, they appear praying for redemption in the Last Judgement. Here, however, the emphasis is on the Fall, which enables the miniature to encompass the story of salvation from beginning to end.

The style is Byzantinizing, the figures characterized by heavy, greenish facial shading and fierce expressions emphasized by furrowed brows. This dramatic Byzantinism provides a link with the later hands of the Winchester Bible, in particular with the Master of the Genesis Initial. However, the draperies in the Paris manuscript are organized into a pattern of ovoid folds less naturalistic than in the Winchester Bible and perhaps, therefore, slightly earlier. The absence of Thomas Becket in the original calendar may indicate a date before his martyrdom in 1173, though this cannot be taken as firm evidence for such an early date. C.M.K.

PROVENANCE Abbey of St-Pierre le Vif, diocese of Sens, 14th century (saints added to calendar); acquired by the Bibliothèque nationale, 1860
BIBLIOGRAPHY Kauffmann, 1975, no. 89

69 Peter Lombard, gloss on the Psalter, edited by Herbert of Bosham, vol. I

450 × 317 mm; 184 ff.
c. 1173–7; probably written in Paris by Herbert of Bosham
Cambridge, Trinity College, MS B.5.4

Peter Lombard, who came to France from Lombardy, lectured in Paris and died as Bishop of Paris in 1160, wrote his gloss on the Psalter and the Epistles of St Paul in the period 1135–48. Based on earlier glosses, in particular that of Anselm of Laon (d. 1117), it became the *magna glosatura*, the standard text of biblical exegesis used for theological teaching in the cathedral schools and new universities. However, Peter Lombard died before he could put it into its final form, and the earliest revised copies were produced by his followers in Paris in the 1160s. It was at this period that Thomas Becket asked his friend Herbert of Bosham to edit these texts, and the exhibited volume is one of four that Bosham produced during his exile in France. As Becket is referred to as 'saint' on f. 1, it may be dated after his canonization in 1173, while the volume's dedication to William, Archbishop of Sens dates it before 1177, for William was translated to Rheims in that year.

The carefully-structured layout of the exhibited pages (f. 15) is typical of these volumes. Text and glosses are arranged so as to facilitate study. For almost the first time in the history of glossed texts, each page is designed as a visual unit. The biblical text is written in a large bold script on every second line, covering less than one column width, while the gloss is written round it in a smaller script. Different-coloured inks are used for marginal comments and illuminated initials mark off new sections of text and gloss and even new sentences. Both for their page layout and their illumination, the Bosham books are splendid early examples of the typical glossed Bible text of the late 12th and 13th centuries. The decoration of the initials is characterized by tight spirals with small, neat flowers and small white lions among the foliage stems, usually with a gold background, the whole placed against a coloured panel. There are similar glossed books produced for Becket himself, and both these and the Bosham books were thought to have been produced at Pontigny, in the diocese of Sens, where Becket spent part of his exile. However, Christopher de Hamel has shown conclusively that these volumes belong to a new type of book that originated in Paris in response to new methods of study and teaching. He has attributed the writing of the Bosham books to Herbert himself and suggested that they were produced in Paris where he was working *c.* 1174–8.

Volume II of this work is in the Bodleian Library, MS Auct. E. inf. 7. C.M.K.

PROVENANCE Given by Herbert of Bosham to Christ Church, Canterbury (Eastry's catalogue early 14th century, no. 854); presented to Trinity College by Thomas Nevile, Dean of Canterbury and Master of Trinity (1593–1615)
BIBLIOGRAPHY James, 1900–4, I, p. 188; Dodwell, 1954, p. 104 ff; Pächt, Alexander, 1973, no. 201; Smalley, 1973, p. 82; de Hamel, 1980, p. 39 ff.; de Hamel, 1984

70 Ralph of Flaix: Commentary on Leviticus

453 × 283 mm; 182 ff.
1167–83; St Albans Abbey
Cambridge, Trinity Hall, MS 2

This manuscript was made for Abbot Simon (1167–83) whose abbacy marks the second high point of intellectual and spiritual life at St Albans in the 12th century. The *Gesta Abbatum* ('Deeds of the Abbots') stresses his love of books, and his interest in recent biblical commentaries, of which this is an example, is indicative of his concern to attract educated men to St Albans in face of competition from the cathedral schools and new universities. Ralph, a monk at Flaix in the diocese of Beauvais, wrote his commentary on Leviticus in about 1150. This manuscript is one of the earliest copies of what was to become a standard text.

The initial V to Book I (f. 3) shows God addressing Moses (the inscription on the scroll is a 14th-century addition). The figures are characterized by heavy, grey facial shading in the Byzantine manner; soft, naturalistic treatment of the drapery; and great solemnity. Five decorated initials are similar to those in the Bosham books (**69**). Both figures and decoration are typical of St Albans in the Abbot Simon period, and this artist has been dubbed the Simon Master. His work appears in several other St Albans manuscripts including the Corpus Christi College Bible (MS 48), the Stonyhurst College *Gregory the Great* (MS 10) and the St John's College Psalter (MS 68), as well as in manuscripts produced elsewhere such as the Copenhagen Psalter (**76**), and a great Bible in Paris (Bibliothèque nationale, latin 16743–6). The last was produced in Troyes and supplies evidence that the Simon Master and his workshop worked in France as well as in more than one English centre.

The Simon Master is not a major innovative artist, as was the Alexis Master at St Albans in the 1120s, but these volumes are of a uniformly high standard of book production. This particular initial was attributed to the Simon Master himself by Walter Cahn and to an assistant by Rodney Thomson. C.M.K.

PROVENANCE Made for Abbot Simon (inscription f. 1ᵛ); given to Trinity Hall by the Cambridge antiquary Robert Hare, 1603
BIBLIOGRAPHY Kauffmann, 1975, no. 90; Cahn, 1975, pp. 189, 211; Thomson, 1982, pp. 53, 60, no. 15; B. Smalley, *Studies in Medieval Thought and Learning*, 1982, pp. 49–96; de Hamel, 1984.

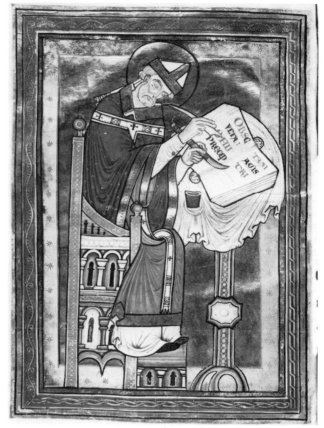

71

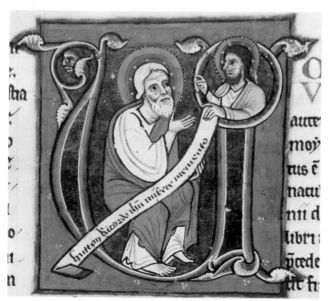

71 Commentary on the Rule of St Benedict ascribed to Smaragdus, Abbot of St Mihiel

245 × 176 mm; 156 ff.
c. 1170–80; Canterbury, Christ Church
London, British Library, MS Royal 10.A.XIII

The frontispiece miniature, now detached from the rest of the manuscript but originally f. 2, shows St Dunstan writing the Rule of St Benedict in a book inscribed with the opening words: *Obsculta, o fili, praecepta magistri* ('Hearken, my son, to the precepts of the master'). Dunstan, Abbot of Glastonbury and the leading reformer of English monasticism in the 10th century, was Archbishop of Canterbury under King Edgar from 960 until his death in 988. He was the principal agent of the revival of the Benedictine Rule in England after the depredation of the Viking invasions, and it is fitting that a Canterbury manuscript dealing with the Rule should contain his picture as a frontispiece. It is identified by the inscription, *Scs. Dunstanus*, above.

The gold background, multiple-fold drapery decorated with small red circles and heavy, Byzantinizing facial shading suggest a date not earlier than c. 1170, and in any case later than the Eadwine portrait. On the other hand, the figure still has an essentially Romanesque, hieratic quality and both the posture and the throne – decorated with registers of arcades – are reminiscent of the Eadwine picture. C.M.K.

PROVENANCE Christ Church, Canterbury (14th-century inscription, f. 1, and catalogue); Archbishop Thomas Cranmer (name on f. 3); John, Lord Lumley (d. 1609), whose library was bought by James I; Royal library given to the British Museum by George II in 1757
BIBLIOGRAPHY Kauffmann, 1975, no. 92

72 John of Salisbury, Life of St Thomas Becket; Letters Of St Thomas Becket (*illustrated on p. 48*)

328 × 215 mm; 356 ff.
c. 1180; Canterbury, Christ Church
London, British Library, MS Cotton, Claudius B.II

John of Salisbury (*c.* 1110/20–80), perhaps the most distinguished scholar and political thinker of 12th-century England, was a friend of Becket from the time they worked together in Archbishop Theobald's household in 1154. His Life of Becket is short and his account of the murder, which he witnessed, is a repetition of a letter he wrote in 1171, shortly after the event. Becket's letters, which form the bulk of this manuscript, were collected by Prior Alan, later Abbot of Tewkesbury. M.R. James identified this manuscript with the *Epistola Sancti Thome Alani Prioris* listed in Eastry's early 14th-century catalogue of the Christ Church library, and the attribution to Christ Church has been generally accepted. The style of the decorated initials and of the figures suggests a date *c.* 1180.

The miniature of Becket's martyrdom (f. 314ʳ) is placed before John of Salisbury's letter describing the event. Becket had been Henry II's own nominee to the post of Archbishop of Canterbury in 1162 but the two soon quarrelled over the respective rights of Church and State and Becket went into exile in 1164. He returned to England on 1 December 1170 and was murdered in Canterbury Cathedral by four knights of the King's household on 29 December. In the upper register of the miniature a servant announces the arrival of the four knights to Becket who is seated at table; the knights stand outside the door; lower register, the martyrdom; on the right the four knights in penitence at Becket's tomb.

It was an event that profoundly shook the Christian world: Becket was canonized in February 1173 and his cult at once became popular in the whole of Europe. Within two decades his martyrdom was illustrated in manuscripts, on reliquary caskets, stained-glass windows and seals (see Borenius, 1932, pls. 27, 29, 37).

The exhibited miniature is one of the earliest examples of what was to become the standard iconography: the knights approach from the left, one of them strikes the Archbishop, who is kneeling near the altar, while his crucifer, later identified as Edward Grim, stands on the right. Reginald Fitzurse, the leader of the knights who strikes the fatal blow, is distinguished by his armorial bearings, a bear rampant. C.M.K.

PROVENANCE Christ Church, Canterbury (probably no. 358 in Eastry's catalogue); Sir Robert Cotton, Bt (1571–1631); his library presented to the nation by his grandson, Sir John Cotton, Bt, 1700; incorporated in the British museum, 1753
BIBLIOGRAPHY M.R. James, *The Ancient Libraries of Canterbury and Dover*, 1903, pp. 52, no. 358, 525; Kauffmann, 1975, no. 93

73 Tripartite Psalter, Psalms 1–98

480 × 325 mm; 174 ff.
c. 1180–90; Canterbury, Christ Church
Paris, Bibliothèque nationale, MS latin 8846

This is the last of the three extant copies made at Canterbury of the Carolingian Utrecht Psalter (see 62). There are eight full-page miniatures, preceding the Psalms, containing scenes from the Old Testament and from the infancy and ministry of Christ; these are related to the four Psalter leaves of *c.* 1140–50 (47–50). The Psalms are illustrated by 96 framed miniatures: those to Psalms 1–39, 42–4, 48, 50 and 52 were carried out by an English artist of *c.* 1180–90 and follow the Utrecht Psalter tradition; the remainder, up to Psalm 98 when the text breaks off, are the work of a Catalan painter of the mid-14th century following a different prototype. Like the Eadwine Psalter (62), the text includes all three of Jerome's translations: the *Gallicanum*, the text of the Vulgate, in pride of place, the *Romanum* and the *Hebraicum*. The Gallican has an interlinear Latin gloss, the Hebrew a gloss in French and the Roman a few fragments of one in Anglo-Saxon. F. Michel, in *Le livre des Psaumes, ancienne traduction française*, 1876, has pointed out that there are differences in the French text between this copy and Eadwine, and Adelheid Heimann has shown that the illustrations were not derived directly from the Eadwine Psalter nor from the Utrecht Psalter but from a lost intermediary, also available to Eadwine.

As in the other manuscripts of the Utrecht Psalter recension, the pictures contain literal illustrations of each verse of the Psalms. The book is open at Psalm 22–23 in the Authorized Version, 'The Lord is my shepherd' – (f. 39). The Psalmist sits 'beside the still waters' (v. 2) which flow from a spring in the hillside. An angel behind the Psalmist hands him a staff and anoints him with oil (vv. 4, 5). In the middle of the picture is 'a table prepared for him' (v. 5) and on the right his enemies are shooting at him. On the left stands 'the house of the Lord', in which the Psalmist 'will dwell for ever' (v. 6). This is one of the examples used by Heimann to demonstrate crucial differences of detail with the Eadwine Psalter illustration (Heimann, 1975, figs. 4–6).

These pictures differ from the previous copies of the Utrecht Psalter in being fully-painted miniatures, with a burnished gold background, rather than tinted outline drawings. The faces and bodies are heavily modelled in the Byzantine manner and may be compared with those of the later hands of the Winchester Bible (64), as well as with the main artist of the volume II of the Bodleian Auct. Bible (68a) and the Westminster Psalter – Hours (68). In Canterbury, a close comparison can be made with the Old Testament figures in the earlier windows of the Cathedral. C.M.K.

PROVENANCE Christ Church, Canterbury; Catalonia, where the illumination was completed, early 14th century; came to the Bibliothèque nationale from the library of Napoleon
BIBLIOGRAPHY Omont, 1906; Heimann, 1975; Morgan, 1982, no. 1

73

74 Psalter (*not illustrated*)

260 × 171 mm; 139 ff.
Mid- or third quarter 12th century; northern England
Oxford, Bodleian Library, MS Douce 293

An origin in northern England is indicated by the
preponderance of northern saints in the calendar (Wilfrid,
Oswald, Paulinus, Kentigern). There are several northern
French and Flemish saints in the calendar, which may indicate
a link with a Continental model. The absence of Thomas
Becket suggests a date before his canonization in 1173.

Exhibited are two of the 16 full-page miniatures preceding
the Psalter text (ff. 13ᵛ–14): the *Entombment* and the
Harrowing of Hell (see 17 for a discussion of these scenes). The
style is strikingly primitive: lively but utterly lacking the usual
sophistication of Romanesque art. Enormous goggle eyes
dominate the faces while the figures are flat, with simple pleats
or chevron folds on the drapery. The appearance of liveliness
is accentuated by unusually bright colours, with a
preponderance of orange and red. The use of horizontal
painted bands for the backgrounds is an 11th-century feature,
not usually found in 12th-century illumination, and
may indicate that the artist used a Continental model of the 11th
century. C.M.K.

PROVENANCE Francis Douce (1757–1834), antiquarian, Keeper of Manuscripts in the British
Museum
BIBLIOGRAPHY Kauffmann, 1975, no. 94; E. Temple, unpublished dissertation, Oxford

75 Psalter (*illustrated on p. 59*)

290 × 184 mm; 210 ff.
c. 1170; northern England
Glasgow University Library, MS Hunter U. 3.2.

The inclusion of certain specifically northern saints in the
calendar and Litany (John of Beverley; Paulinus – Litany only)
suggests an origin in the north of England, possibly York, but
P. D. Stirnemann has argued that both this manuscript and the
Copenhagen Psalter (76) were probably produced at Lincoln

for Nottingham use. The fact that there is no entry for Thomas
Becket in the calendar suggests a date before his canonization
in 1173, but this cannot be taken as firm evidence.

Two of the 13 full-page miniatures preceding the text of the
Psalms are exhibited (ff.13ᵛ–14): the *Incredulity of Thomas*,
with *Christ saving St Peter upon the waters* below, and the
Ascension. This order of scenes is curious, for whereas the
Doubting Thomas is in its correct chronological position
following the Resurrection, the scene of Christ walking on the
waters should have preceded the Passion. Boase suggested that
these two incidents were combined because both of them deal
with the lack of faith on the part of an Apostle. In the upper
scene, St Peter holds the keys and the Virgin stands behind the
Apostles on the right. Below, a realistic touch is added by the
manner in which the expanse of the lake spreads over the
border of the frame; the rope rowlocks must reflect a
contemporary practice. R.P. Hancock has drawn attention to
a similar fitting in one of the small Viking boats in the Gokstad
find, AD 900, which has holes in the top strake for lashing the
oars against a projecting horn (A.W. Brøgger, H. Shetelig, *The
Viking Ships*, Oslo 1951, ill. p. 61). The *Ascension* follows a
peculiarly English type, for which there are precedents in
Anglo-Saxon art, in which Christ is shown disappearing into
the clouds.

The style of the figures represents a more rigid and stylized
version of the mid-century damp-fold convention. Elongated
and stiff with long faces and staring eyes, these figures are
silhouetted against a tooled gold background. Compared to the
figures in, for example, the Bury Bible and the Winchester
Bible, they are somewhat lacking in sophistication, and
yet they are among the most expressive in English Romanesque
art. C.M.K.

PROVENANCE Louis-Jean Gaignat, sale Paris, 10 April 1769, Lot 50; Dr William Hunter (1718–
83), who left his museum to Glasgow University
EXHIBITION *William Hunter Book Collector*, Glasgow University Library, 1983, no. 1
BIBLIOGRAPHY Boase, 1962; Kauffmann, 1975, no. 95; Stirnemann, 1976; N. R. Ker, *Wm.
Hunter as a collector of medieval manuscripts*, Glasgow, 1983, p. 14

76 Psalter (illustrated on p. 58)

286 × 198 mm; 199 ff.
c. 1170–5; northern England
Copenhagen, Royal Library, MS Thott 143.2°

The calendar and Litany are very similar to those of the Glasgow Psalter (75) and this, together with the stylistic similarity of the historiated initials in the two manuscripts, suggests that they were written in the same scriptorium.

There are 16 full-page miniatures of the New Testament preceding the Psalter text; the two exhibited here are of the Magi following the star and adoring the Christ Child (f. 10ᵛ–11). They are both by the principal artist of the manuscript, who is one of the great masters of the English 12th century. In the figure, the emphasis is on curves formed by the contours and by the softly indicated pear-shaped damp-folds, and accentuated by arabesques in white or light tones. This form of surface decoration on draperies had been a recurrent feature in English illumination since the 1130s, when it appeared in the Bury Bible (44) and it reached its apogee in the Copenhagen Psalter. The figures retain a Romanesque solidity and the draperies are still defined by damp-fold abstractions, but there is a neatness and grace in some of the figures which presages the Gothic style. Interest also attaches to the definition of space achieved by the depiction of the three horses, one behind the other. As a method of portraying groups, this is not new, but in its emphasis it marks a point where traditional Romanesque picture space, limited to the conventions of a stage set, becomes more convincingly naturalistic.

The decorated initials include some with the fleshy acanthus leaves and large luxuriant flowers of the mid-century, and others with the tight spirals and small white lions of the post-1170 period. It may, therefore, well be that the illumination was begun by *c.* 1170 and then completed by younger artists in the 1170s. Some of the historiated initials towards the end of the manuscript (e.g. ff. 163, 174, 178) are in the style of the Simon Master, an itinerant artist who worked at St Albans in the 1170s (see 70). A late 12th-century psalter in the Bodleian Library (MS Gough Liturg. 2; Kauffmann, 1975, no. 97) has a picture cycle which is iconographically almost identical. C.M.K.

PROVENANCE Augustinian house in northern England (calendar and Litany); Sweden, early 13th century, at a convent associated with 'Birger Jarl' – probably Birger Jarl Brosa of the Folkungar stock, d. 1202 (f. 16ᵛ); Count Otto Thott, 18th century; Royal Library, Copenhagen, 1786
BIBLIOGRAPHY Mackeprang, Madsen, Petersen, 1921, 32 ff. pls. 48–60; Kauffmann, 1975, no. 96; Stirnemann (see 75); Thomson, 1982, no. 100

77 Bible: the Puiset Bible, vol. I, Genesis – 2 Kings

465 × 312 mm; 224 ff.
c. 1170–80; Durham Cathedral Priory
Durham Cathedral Library, MS A.II. 1

Hugh du Puiset (*c.* 1125–95) became Archdeacon of Winchester in 1139 through the patronage of his powerful kinsman Henry of Blois, Bishop of Winchester, at whose instigation he went north and ultimately became Bishop of Durham in 1153. Less of a scholar than a connoisseur and patron, he gave some 75 books to the Priory Library. Of these, the four-volume Bible is incomparably the finest, though many of its initials have been cut out.

Exhibited is the only historiated initial remaining in vol. I (f. 173). It is the letter F opening the second book of Samuel (*Factum et autem postquam mortuus est Saul* – 'Now it came

77

to pass after the death of Saul . . .') and shows David seated, mourning the death of Saul and Jonathan who lie before him. This initial, the most accomplished in the Puiset Bible, is a sophisticated example of the Byzantinizing style of the 1170s. The draperies are carefully modelled with white highlights and the faces with shades of ochre, while David's sorrow is convincingly conveyed. The initials in the other volumes are all much cruder, if no less expressive. Of the decorated initials, the majority have the tight foliage spirals with small animals typical of the period after 1170.

The third volume of this Bible is exhibited among the bindings (474). C.M.K.

PROVENANCE Given to Durham Cathedral Priory by Hugh du Puiset, Bishop of Durham 1153–95 (inscription *Hugonis episcopi* on fly leaf)
BIBLIOGRAPHY Mynors, 1939, no. 146, pls. 49–53; Kauffmann, 1975, no. 98; Cahn, 1982, no. 31

78 Epistles of St Paul, with gloss of Peter Lombard
(*not illustrated*)

386 × 260 mm; 202 ff.
c. 1180; (?) Peterborough
Norwich, St Peter Mancroft

For their close reasoning and their wealth of material on doctrinal matters, the Epistles of St Paul played a central part in theological teaching from the early 12th century. They were glossed by Peter Lombard (d. 1166, see **69**), who apart from them glossed only one other biblical book: the Psalms. His gloss superseded all previous commentaries and became one of the most important text books in theological schools in the late 12th and early 13th centuries.

Typically of such manuscripts in the period after about 1170, each page contains a few lines of biblical text written on alternate lines, surrounded by commentary in a smaller hand. There are two initials at the opening of each Epistle, one for the text, another for the gloss. On the whole these initials contain less narrative illustration than the earlier Pauline manuscripts (e.g. **60**). The exhibited historiated initial P to 1 Thessalonians (f. 147), containing an author portrait of St Paul seated, is typical of late 12th-century Pauline Epistles, both in these glossed volumes and in complete Bibles.

The figure style, with heavy facial modelling and fine white striation on the draperies, is very similar to a glossed St Paul in Durham (MS A.II.9; Kauffmann, 1975, no. 100) and a northern provenance was proposed for this manuscript, too. However, Christopher de Hamel has identified its original owner as Robert de Noville, a member of the household of Abbot Benedict of Peterborough (1177–94) who is recorded in documents in 1177–82 and 1194, and the book is probably identical with a copy of *Epp. Pauli gl.* listed as acquired by Peterborough Abbey under Abbot Benedict. De Hamel suggests that the stylistic similarity with the Durham book could be explained if both were written by English scribes sent to Paris to copy examples of Peter Lombard's text, and possibly illuminated by a French artist. C.M.K.

PROVENANCE Robert de Noville (f. 1); Geoffrey Parishe (*c.* 1513–88), Vicar of Lilford, Northants, formerly a monk (f. 172); given to St Peter Mancroft by William and Alice Gargrave.
BIBLIOGRAPHY Kauffmann, 1975, no. 101; de Hamel, 1984, ch. 5

79 Psalter: the St Louis Psalter

242 × 175 mm; 185 ff.
c. 1190–1200; northern England
Leiden, University Library, MS lat. 76A

The saints commemorated in the calendar indicate an origin in an Augustinian house in northern England, perhaps York, and hence this manuscript follows in the tradition of luxury Psalters produced in the north, including those now in Glasgow (**75**), Copenhagen (**76**) and in the Bodleian Library (Gough liturg. 2). It appears to have been made for Geoffrey Plantagenet, illegitimate son of Henry II who was Archbishop of York 1191–1212 (recorded in calendar, 7 July). He spent some time in France and the manuscript passed to Blanche of Castile, wife of Louis VIII, King of France. Her son became Louis IX, and we are told in a 14th-century inscription (ff. 30ᵛ, 185): *Cist Psaultiers fuit mon seigneur saint Looys qui fu Roys du France, ouquel il aprist en s'enfance* ('This Psalter was my lord St Louis' who was King of France, from which he learned [to read] in his childhood').

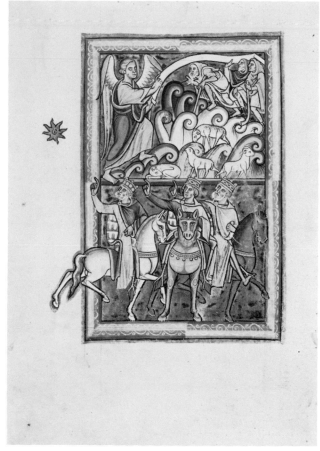

79

There are 23 pages of miniatures containing 14 Old Testament and 32 New Testament illustrations, mostly two per page. The opening shows the *Annunciation to the Shepherds*, with the *Journey of the Magi* (f. 16ᵛ) and the *Magi before Herod* with the *Adoration of the Magi* (f. 17). The miniatures are dominated by the burnished gold backgrounds and the thick outlines of the figures which are somewhat stiffly executed. Morgan has drawn attention to two further northern picture cycles (St Johns, Cambridge MS K. 30, and another in a private collection), to which these miniatures are closely similar in style and iconography. C.M.K.

PROVENANCE Geoffrey Plantagenet, Archbishop of York (1191–1212); Blanche of Castile, Queen of France (1200–52) (obit of her father Alfonso added to the calendar, 6 October); Louis IX, his daughter Agnes, wife of Robert, Duke of Burgundy; their daughter Jeanne (d. 1348), who married Philip of Valois, who gave it to his second wife, Blanche of Navarre, from whom it passsed to her grandson, Philip of Burgundy, 1398; thereafter it remained at the Burgundian court in Dijon (inventory of 1420) and then Bruges (Inventory of 1467); given to the University Library at Leiden by J. van den Bergh, curator of the University and Burgomaster, 1741
BIBLIOGRAPHY Omont, 1902; Morgan, 1982, no. 14

80 Simeon of Durham: Chronicle from the coming of the Saxons (bound with other historical treatises)

(*not illustrated*)

223 × 154 mm; ff. 28–43
Late 12th century; northern England
London, British Library, MS Cotton, Caligula A.VIII

Among Germanic peoples, the Anglo-Saxons alone handed down a number of royal genealogies and these were expounded at length in Nennius, *Historia Brittonum* (*c.* 830). It is possible that some of the early texts included figured genealogical tables, but no such illustrations have survived from before *c.* 1166, the date of the fragment added to a manuscript of Simeon of Durham's Chronicle (Durham Cathedral Library MS B.II.35; Mynors 1939, pl. 44). This shows the descent from Adam to Woden, the great Germanic god to whom all Anglo-Saxon kings traced their ancestry, with a bust of Adam at the top and one of Woden at the foot of the page. Woden surrounded by busts of his sons appears in the Simeon of Durham text from Sawley Abbey, Yorks. of *c.* 1190 (Cambridge, Corpus Christi College, 66; Kauffmann, 1975,

no. 102) and in an early 13th-century manuscript in Liège (University Library 369c; D'Ardenne, 1962, ill.). This contains the same text as Caligula A.VIII – an abridgement of Simeon of Durham's Chronicle up to the year 1119, itself based directly on the Florence of Worcester Chronicle (33), to which the genealogy has been joined.

An awe-inspiring Woden is shown in the centre of f. 29 surrounded by busts of six of his sons, the founders of the dynasties of the Anglo-Saxon kingdoms. These are, from left to right, Vectam (kings of Kent); Beldei (corrected to Bealdeah in the Liège MS; Wessex); Feothulgeat (Mercia); Beldei (Northumbria) and Wegdam (Sussex). The figure on the lower left, which lacks an inscription, may be identified from the Liège MS as Casere (East Anglia). Needless to say, these are mythical names; what mattered was the descent from Woden. C.M.K.

PROVENANCE Robert Cotton, Bt (1571–1631); his library presented to the nation by his grandson, Sir John Cotton, Bt, 1700
BIBLIOGRAPHY S.R.T.O. D'Ardenne, 'A neglected MS of British history', *English and medieval studies presented to J.R.R. Tolkien*, 1962, pp. 84–93, esp. 88ff; text printed in Thomas Arnold, *Symonis monachi opera omnia*, Rolls series, 1882–5, appx. I, pp. 365–84; on the attribution of the chronicle to Simeon of Durham see A. Gransden, *Historical Writing in England, c. 550 – c. 1307*, 1974, p. 148

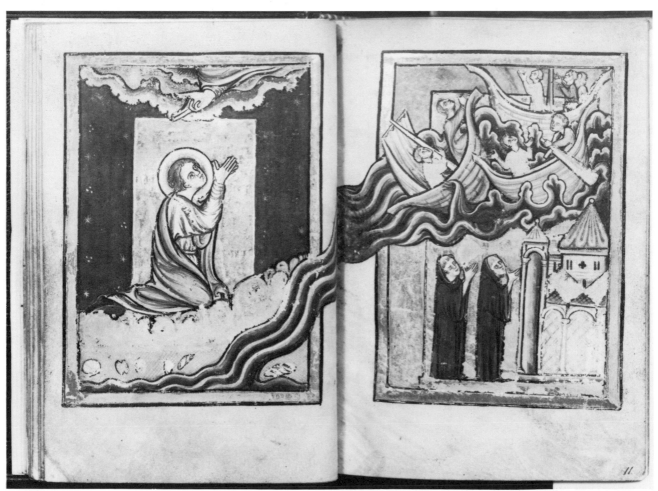

81 Bede, Life of St Cuthbert

135 × 98 mm; 150 ff.
c. 1190–1200; Durham Cathedral Priory
London, British Library, Yates Thompson MS 26 (Add. 39943)

The scene is the same as in the earlier manuscript (**15**), but the style and treatment are very different. Framed, fully-painted miniatures on gold or blue ground (ff. 10ᵛ–11) have replaced the earlier, lightly-tinted outline drawings. The brown facial modelling with dark shading, particularly around the eyes, is in the Byzantine manner, well absorbed into Western artistic vocabulary at the end of the Romanesque period. The naturalism of the drapery folds, and their neat white outlines, are features indicating the transition to the Gothic style.

In composition, the main change is that St Cuthbert himself has been detached from the narrative scene and placed on his own, almost as a self-contained devotional image. This icon-like treatment of the Saint reflects the Durham monks' use of St Cuthbert as their authority for past traditions in their battle for independence from the control of the bishop. In 1195 – at about the time when this manuscript was written – after a long series of disputes, Hugh du Puiset, Bishop of Durham, finally recognized their rights.

By a detailed comparison of the picture cycles, Malcolm Baker has shown that this manuscript was copied, not from University College MS 165, but from a lost intermediary, probably of the mid-12th century. This is borne out in the scene of the boats, for the British Library manuscript includes the praying monks, who appear in the York windows, and hence probably in the archetype, but are omitted in Univ. 165. C.M.K.

PROVENANCE Durham Cathedral Priory (inscription f. 2ᵛ); Lawson family, Brough Hall, 1906; sold by Sir John Lawson, bought by Henry Yates Thompson; bought by the British Museum, in 1920
BIBLIOGRAPHY Baker, 1978, esp. pp. 21, 27, 34 ff.; Morgan, 1982, no. 12a

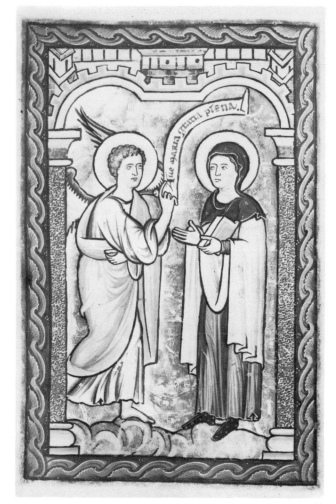

82

82 Psalter: the Westminster Psalter

230 × 158 mm; 224 ff.
c. 1200; Westminster Abbey (with later additions)
London, British Library, MS Royal 2.A.XXII

The saints appearing in the calendar and Litany and the special prayers to St Edward the Confessor and St Peter all point to an origin in the Benedictine Abbey of Westminster, where it is recorded in the later Middle Ages. The main artist painted the five full-page miniatures preceding the Psalter text; a different hand was responsible for the calendar roundels and most of the initials.

The book is open at the miniatures of the *Annunciation* and the *Visitation* (f. 12ᵛ). The figure style is similar to that of the later hands of the Winchester Bible, particularly the Gothic Majesty Master. It has also been linked with the Master of the Morgan Leaf (see **64**), but these figures lack the emotional force of that artist. Byzantine influence on the facial modelling is still much in evidence, but the colours are lighter and the expressions more gentle; a further stage has been reached in the development to the Gothic style.

It is generally agreed that the illuminated initials in the Gospels at Trinity College, Cambridge (**83**) are probably by the same artist. As this manuscript was written at St Albans, it is likely that he was an itinerant professional. C.M.K.

PROVENANCE Westminster Abbey (inventories of 1388 and 1540); John Theyer (1597–1673); bought for the Royal Collection *c.* 1678; passed to the British Museum, 1757
BIBLIOGRAPHY Thomson, 1982, p. 61; Morgan, 1982, no. 2

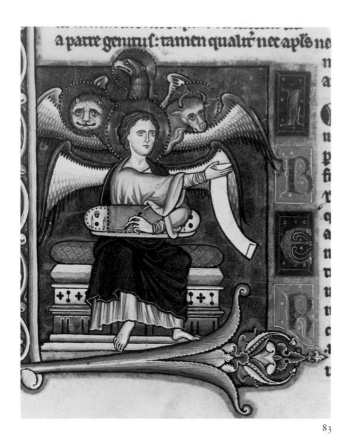

a patre genitus: tamen qualiter nec aptos ne

83

83 Glossed Gospels

410 × 315 mm; 236 ff.
c. 1190–1200; St Albans Abbey
Cambridge, Trinity College, MS B. 5.3.

An origin at St Albans, indicated by the 13th-century ex-libris,
is confirmed by the canon tables, which are virtually identical
with those in the St Albans Bible at Corpus Christi College,
Cambridge (MS 48), and by certain scribal idiosyncracies, such
as the flourished paragraph marks and quire numbers, which
Thomson has identified as typical of the St Albans scriptorium.

The splendid initial L to Matthew (f. 4ᵛ) (*Liber generationis*
. . . 'The book of the generation . . .') contains an unusual
representation of the Evangelist in the form of his symbol, a
Winged Man (compare **18**), incorporating the symbols of the
other Evangelists: a Lion, a Bull and an Eagle. The four are
combined in the form of a tetramorph described in Ezekiel's
vision (Ezekiel I. 5–10). These four heads coincide with St
John's vision in the Apocalypse (Revelation IV. 6–8), which, in
turn, were interpreted as a metaphor of the four Evangelists.
The initial to Luke (f. III ᵛ) also has the tetramorph and there
are earlier examples of this rare combination in the Pembroke
College New Testament (**21**) and on the St Mark leaf from the
Liessies Gospels (**54**).

It will be seen that the figure style is very close to that of
the Westminster Psalter (**82**), and it may well be by the same
hand. This exhibition provides a rare opportunity of seeing the
two manuscripts side by side. C.M.K.

PROVENANCE St Albans Abbey (ex-libris f. 2ᵛ); Thomas Nevile (1593–1615), Master of Trinity,
who gave it to his College.
BIBLIOGRAPHY McLachlan, 1975, p. 10; Thomson, 1982, p. 61, no. 12; Morgan, 1982, no. 3

84 Bestiary (*not illustrated*)

300 × 178 mm; 41 ff.
c. 1170
London, British Library, Add. MS 11283

The medieval bestiary was directly descended from the Greek
physiologus, a compilation in which fantastic descriptions of
real and fabulous animals and birds were used to illustrate
Christian allegories and moral lessons. The *physiologus* was
translated into Latin perhaps as early as the 5th century,
though there is no surviving manuscript until the 8th century.
There is no extant intermediary between the 8th – 10th-century
Latin *physiologus* and the 12th-century bestiaries whose
descendants they were. The earliest of them, Bodley, Laud.
Misc. 247, c. 1120, contains only 36 chapters, whereas the
'second family' of bestiaries to which Add. 11283 belongs
contains new textual material, follows a new system of
classification into beasts, birds and reptiles, and has an
additional 60 illustrations bringing the total to about 100.

Exhibited on f. 12 is a sheep (*ovis*), shown with bull's horns;
a wether (*cervex*) with small, tightly-curled horns; a polled
sheep (under the heading of *agnus*, lamb) with one foreleg bent
back under the body, inspired by the symbolic figure of the
Lamb of God; and a goat (*hircus*). Each of these is pricked for
transfer.

Although these animals are partly fanciful, they have a more
naturalistic appearance than those in the earlier 12th-century
bestiary, Laud. Misc. 247. Yet the importance of the bestiary
lies less in the degree of realism of its depictions than in
providing one of the main channels through which classical
representations of animals and fabulous beasts remained
known and could provide a fruitful source of decoration
throughout the Middle Ages. The English origin of this
manuscript is confirmed by its adherence to an English textual
tradition. C.M.K.

PROVENANCE P.H. Mainwaringe, 17th–18th centuries (inscription f. 1), bought by the British
Museum, 1837
BIBLIOGRAPHY McCulloch, 1960, p. 34; Kauffmann, 1975, no. 105; P.L. Armitage and J.A.
Goodall, 'Medieval horned and polled sheep: the archaeological and iconographical evidence',
Antiq. J., 57, 2, 1977, pp. 73–89

85 Bestiary (*not illustrated*)

216 × 165 mm; 120 ff.
c. 1185; (?) Lincoln
New York, Pierpont Morgan Library, M 81

Although this manuscript has the complete series of 105
miniatures and is, in appearance, indistinguishable from the
second-family bestiaries of c. 1200 (e.g. **86**), it does not contain
quite all the textual material of the fully-developed second-
family recension. It shares with the Cambridge bestiary
(University Library, MS Ii. 4.26) a Lincolnshire provenance, and
because the whole group is so closely related it has been
suggested that all these bestiaries were produced at one centre,
possibly at Lincoln, where there was an important cathedral
school.

The opening shows, on f. 36ᵛ, a griffin, described as having
the body of a lion and the head and wings of an eagle, carrying
off a pig; and, below, two boars. On f. 37 a bonacon, a
mythical creature like a lion with curling horns, is attacked by
men. C.M.K.

PROVENANCE Given, with other books, to the Augustinian Priory of Radford (now Worksop)
by Philip, Canon of Lincoln, 1187 (inscription f. Iᵛ); 10th Duke of Hamilton, 19th century;
Prussian Government 1882–9; bought by William Morris, 1889; Richard Bennett; J. Pierpont
Morgan, 1902
BIBLIOGRAPHY Kauffmann, 1975, no. 106; Muratova, 1977

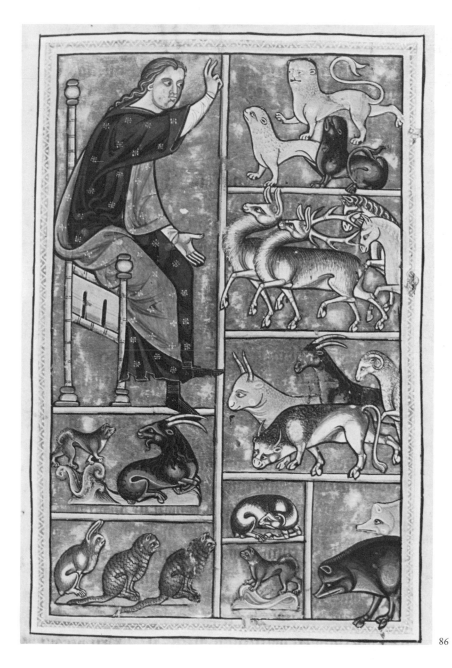

86

86 Bestiary

300 × 205 mm; 203 ff.
c. 1200
Aberdeen, University Library, MS 24

This manuscript contains 96 miniatures on burnished gold
grounds, including five scenes of the Creation at the beginning
with the text of Genesis I.I – II.I as well as illustrations to the
bestiary proper. It is the earliest luxury copy of the fully-
developed bestiary categorized by M. R. James as the second
family; the British Library copy (84) is an earlier member of
this group, but its illustrations are outline drawings only. The
Aberdeen Bestiary is a sister manuscript of Bodley, Ashmole
1511.

The opening shows a full-page *Christ in Majesty* (f. 5),
placed at the end of the Creation series; and *Adam naming the*
animals, with which the bestiary illustrations begin. This
accompanies a text by Isidore of Seville which deals with the
naming of animals. In biblical illustrations of this scene, for
example in the Byzantine Octateuchs, Adam is usually shown
naked, whereas here the fact that he is fully clothed serves to
underline the message of man's superiority to unreasoning
beasts. He not only gives them names, but allocates the roles
they are to play, a central indication of man's supremacy in the
world.

The style retains Byzantine features such as the dark facial
modelling. It does not have the linear elegance and neatness
that characterizes the early Gothic style of Ashmole 1511 and
is probably, therefore, somewhat earlier. C.M.K.

PROVENANCE From the Old Royal Library (1542 inventory no. 518), Thomas Reid, Secretary
to James I; given by him to Marischal College, Aberdeen 1624; incorporated in Aberdeen
University Library, 1860
BIBLIOGRAPHY Muratova, 1977; Morgan, 1982, no. 17

Wall-paintings

87 Prophets from the chapter house of Sigena

Fresco
Late 12th century
Barcelona, Museo d'Arte de Cataluñya

The chapter house of the royal monastery of Sigena in the
province of Huesca, Aragon, in northern Spain, was severely
damaged by fire in 1936. It was decorated with murals of
outstanding quality, which included New Testament scenes on
the walls, and an Old Testament cycle on the five transverse
arches, with busts of the prophets on the soffits of these arches.
As a result of the fire, the New Testament murals were
completely destroyed and the colours of the rest of the
paintings suffered greatly, so that the paintings are now
primarily monochrome. What survived was skilfully removed
to the museum in Barcelona.

The exhibited panels with prophets decorated the soffits of
the five arches. There were originally 70 busts (14 to each
soffit), three arches depicting the genealogy of Christ according
to St Luke (III. 23–38), starting with Adam, and two devoted
to the genealogy according to St Matthew (I. 1–25), starting
with Abraham.

The paintings were recognized by Pächt (1961) as English,
being particularly close in style to the Master of the Morgan
Leaf (65). Pächt concluded that the work was executed by a
travelling English artist who had recently studied Byzantine
mosaics in Sicily. Since then Oakeshott has devoted a
monograph to the paintings (Oakeshott, 1972a) in which he
suggested that two or even three artists who had previously
worked on the illuminations of the Winchester Bible (64) were
responsible for the Sigena paintings. He made the important
observation that the Sigena scenes were not copied directly
from Sicilian mosaics but were the progeny of the Winchester
Bible.

The Sigena paintings are also stylistically related to the 12th-
century murals in the Chapel of the Holy Sepulchre in
Winchester Cathedral, and to the Canterbury Psalter (73),
which strangely enough, found its way to Spain, for it was
completed there in the 14th century.

Winchester was, in the 12th century, an artistic centre of the
greatest importance and its artists were evidently held in high
esteem even in distant Spain. G.Z.

EXHIBITION New York, 1970, no. 238

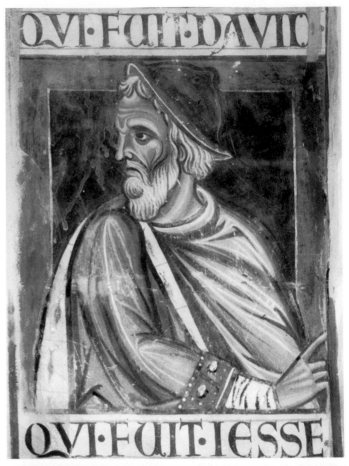

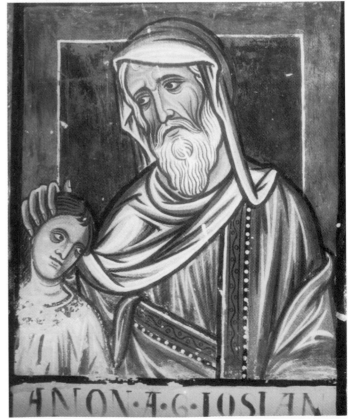

Stained Glass

In contrast to the rich legacy of sculpture, wall-paintings, ivory carvings, metalwork, and above all manuscript illumination of the periods before and after 1066, remnants of stained glass are so scarce in England that we cannot even evaluate the impact of the Norman Conquest in this field. It is only at the very end of the period that we call Romanesque, and into the Transitional phase, that significant amounts remain of two vast programmes of glazing, those of the cathedral choirs of the rival archiepiscopal sees of York and Canterbury.[1] The prelude to these great cycles can, however, be pieced together from documents and archaeological finds, which indicate that the art of painting on glass had been brought into England well before the late 12th century.

Window glass, which had been known in Roman times, seems to have been reintroduced into England in the 7th century; its use is documented in York about 670, when St Wilfrid replaced linen hangings and pierced transenna with glass, and its manufacture is recorded in Monkwearmouth in 674.[2] Excavated fragments from Monkwearmouth, Jarrow and Escomb in Northumbria are coloured but unpainted; they seem to have been leaded together in decorative compositions.[3] It remains uncertain when painted glass was introduced to England. A certain Osbernus Vitrearius witnessed charters in Ramsey between 1114 and 1160: the name suggests that he was a glassmaker, but it is equally possible that he was a glass-painter.[4] William of Malmesbury's reference of about 1125 to glass in the choir of Christ Church, Canterbury, is unclear: 'Nothing like it could be seen in England, whether for the brilliancy of its glass windows, the beauty of its marble pavements, or the many coloured pictures which lead the wandering eye to the very summit of the ceilings.'[5] Here 'brilliancy' may refer only to translucence, not colour. A figure of St Michael in All Saints Church, Dalbury in Derbyshire, however, is dated to the late 11th century by Peter Newton, and would thus provide valuable evidence of glass-painting in England before Anselm's choir was completed at Canterbury about 1110.[6] Certainly there was a long-standing tradition of painting on glass on the Continent before this date.[7] A few fragments were found in Carolingian levels in Mont St-Michel in Normandy, but most significant finds come from farther east. There are Carolingian fragments in Cologne and Lorsch, Ottonian glass from Schwarzach and Wissembourg is extant; and documents indicate that there was historiated glass in Rheims Cathedral in the 10th century.[8] The great figures of prophets in Augsburg Cathedral may be contemporary with Anselm's windows and, given the influences from the Empire that are evident in the architecture, they may be an indication of the kind of work that Malmesbury admired in the Canterbury choir.[9]

Early in the 12th century Theophilus, probably writing in German lands, acknowledged the pre-eminence of France in glass-painting.[10] However, by the second half of the 12th century English glass-painting, like manuscript illumination, seems to have gained considerable fame on the Continent. Henry II and Eleanor of Aquitaine gave the great east window to Poitiers Cathedral and are shown kneeling at the foot of the *Crucifixion* and *Ascension*; the date would have to be between 1162 and 1189[11]. The style, however, seems to represent a local variant of the damp-fold style rather than an English importation.[12] Glass formerly in Braine, near Soissons, has been said to have been sent by Eleanor, Queen of England, to her relative Agnes of Dreux;[13] Read cites this as a gift of Matilda in 1153, but this seems too early.[14] However, a stylistic connection with some of the Canterbury glass of the late 12th century gives some likelihood to the English association. At the same time, glass from the last quarter of the 12th century is widely distributed in France, from Strasbourg and Rheims in the east to Lyons and Clermont-Ferrand in the south to Angers and Le Mans in the west.[15] York and Canterbury formed other regional schools. Some of the glass at York seems to antedate the earliest at Canterbury, but developments in the two sites appear largely independent of each other.

In the north of England the arts throve at York and Durham. Hugh du Puiset had the windows around the altars of his cathedral at Durham filled with historiated glass at some time between 1153 and 1195, and left 75 manuscripts to the library there on his death.[16] His contemporary in York rebuilt and probably glazed the choir; in 1207 Pope Innocent III found York Minster far grander and more dignified than Notre-Dame in Paris.[17] In the south, great books were produced at Canterbury and Winchester while the choir of Christ Church Cathedral was being rebuilt in early Gothic style, and the manuscripts are related to the earliest styles in the glass.

The 12th-century glass in York Minster is one of the most tantalizing collections of the period. Panels from a very extensive series of windows were apparently salvaged from an earlier building in the 14th century when the nave was being rebuilt, and many of them were installed in the clerestory windows where they formed a band of intense colour between panels of grisaille, and were complemented by coloured heraldic panels.[18] Such 'belles-verrières' are not uncommon in Gothic buildings.[19] The figural panels were cut down, in most cases from circular or quatrefoil shapes that can still be read in the lead-lines, and decorative borders were put in the tracery lights. A few pieces seem to have been used also in the chapter house and the vestibule leading to it.[20] In this way, parts of eight or more iconographic series are preserved, and about 15 decorative border designs. Most of the figured panels, and a few of the borders, have recently been very sensitively restored by observing the lead-lines and eliminating stop-gaps so that the fragmentary scenes have regained some of their clarity.

The derivation of the York glass is both international and regional. Some of the designs, whether for borders or figure subjects, are related to glass made for the abbey church of St-Denis before 1144;[21] but the styles of execution have counterparts in north English sculpture and manuscript illumination later in the century, even if the origins of these styles are Mosan or north French.[22] The episcopacy of Roger of Pont-l'Evêque (1151–81), who rebuilt the choir of the Minster, is generally cited in conjunction with the glass.[23] This dating is confirmed by comparisons with other works, which suggest that a glazing campaign extended over at least a decade.

The borders, of which two lengths are exhibited (**90a** and **b**),

are generally more than 250 mm wide, a dimension that is comparable to Canterbury borders of the late 12th century (compare 92d and e).[24] Although 90a may derive from a design in the *Moses* window of St-Denis, there are differences:[25] for example, in the strapwork – elegantly curving on the St-Denis border, but bolder and more severely angular in the York design; and in the more varied and confident use of palmettes at York. The earlier work is on a miniature scale and would have been very time-consuming to produce.[26] Closer in feeling to some of the St-Denis glass are curled acanthus fronds from the corners of panels with inscribed quatrefoil figural compositions, and some palmettes with beaded centre veins;[27] but these types persist in the glass of the abbey church of St-Remi in Rheims in the latter part of the century.[28]

The second border exhibited (90b), with straps forming interlocking hoops filled with sideways-growing palmettes, is of a type seen late in the century at St-Remi, Canterbury and elsewhere.[29] The affinities, general though they are, seem to attest to exchanges with the glazing ateliers of northern France and the Rhineland rather than with Angevin sites (Le Mans and Angers) as Lethaby proposed.[30] The range of styles in the extant York ornament may indicate adjustments to the scale of upper and lower windows, as well as internal developments. The insistence on stylized and decorative forms contrasts with the astonishingly naturalistic leafy vegetation of the early Canterbury choir aisle borders of c. 1175–80.[31]

Over 40 early figured panels are preserved in York. Most of their subjects were ingeniously identified by Peter Newton in the course of advising on the recent restoration. He was able to recognize, with little more than the lead-lines and a few heads to go on, three subjects from the life of St Benedict which relate to compositions in an 11th-century manuscript from Monte Cassino.[32] An early cycle in glass was at St-Denis, though the remnants so far published do not overlap in subject or composition with the York scenes.[33] Clearly related in design to either St-Denis or Chartres, however, is the sole surviving panel of a king from a York *Jesse* window (88). The general position of the figure and distribution of the foliage correspond, but the execution of the drapery betrays the later date of the York figure; the high belt, the rope-like edge of the mantle, and the crisp, sweeping trace-lines, often clustered in threes, are reminiscent of metalwork of c. 1175–85, such as the reliquary of St Oswald from the Guelph treasure (of north English origin), now in Hildesheim Cathedral.[34] These features are also found in glass from Troyes which probably pre-dates a fire of 1188, and in related manuscripts.[35]

The St Nicholas panel (89) represents a different mode of depiction from the *Jesse Tree* king; asymmetry suits the narrative import of the scene, but it is also noticeable that there is a softer handling of the drapery, with more varied trace-lines. The magnificent head of the carter, with its furrowed brows, high cheek-bones, smooth beard and slightly ruffled hair, seems to belong to a phase that is more naturalistic.[36] Resemblance to well-preserved heads in Canterbury is marked (compare 92). Comparison with the head of Elkanah in the *Presentation of Samuel* (91), however, demonstrates the still-greater naturalism of the Methuselah Master's work at Canterbury. This extends to the spatial coherence of the Canterbury composition, in which the figures are not only plastically rendered but occupy space and generally recede one behind the other. In the York panel the foreground figure and the horses ambiguously positioned above interweave with the legs and feet of the carter. A precisely similar decorative effect is seen in the *Flight into Egypt* in a late-12th-century north English Psalter now in the Gough collection of the Bodleian Library.[37]

In fact it is with the group of northern manuscripts to which the Gough Psalter belongs that the closest analogues in painting can be found for the York glass. The Psalter has prefatory pages dominated by monumental figures, strongly outlined, at times clearly silhouetted and at others interwoven against two-coloured grounds; the manner of composing is very similar to that in the glass. Furthermore, most of the schemata used for drapery folds, such as those in the wide sleeves and the hems of mantles, or encircling the thighs, come from the same motif book; in the manuscript both triplets of fine lines and more dramatic two-tone modelling are found. Another book with related painting styles is the Bible of Hugh du Puiset (77).[38] A third book, to which the Gough Psalter is linked in iconography, is the Copenhagen Psalter (76), made for an Augustinian house in Yorkshire about 1170; its earlier date is suggested by compositions which are more coherent spatially, and by draperies that tend to cling in the damp-fold tradition, the highlights decorated with scrollwork.[39] In this book, the proportions and facial types of the female figures in the *Visitation* resemble the *Three Marys* in the York glass, and comparable fluttering scarves to theirs are found in the *Daniel* panel that is installed in the north transept; in fact the latter panel also shares some of the more elegant quality of the Copenhagen Psalter (for instance in the sweep of the angel's wing).[40]

These comparisons with manuscripts suggest c. 1170–80/95 as dates for the glass. Related sculpture, such as the four Evangelist symbols that were also salvaged from some earlier programme and placed above the great west window, two in the nave and two on the exterior, and the statues from the chapter house of St Mary's Abbey, York, can be placed in the same decades; but as George Zarnecki has pointed out, it is improbable that such work was done for the Minster during the decade that the see remained vacant after the death of Roger, nor in the disturbed archiepiscopacy of Geoffrey of Plantagenet (1191–1212), so the Minster sculpting and glazing should probably be limited to the decade before 1181.[41] There seems a clear association between the role played by Roger in the coronation of Henry the young King, son of Henry II and Eleanor of Aquitaine, in 1170, and the inclusion of a Tree of Jesse modelled on the St-Denis type in the Minster glass; if the type was not already known to Roger, it was certainly known to Eleanor who had attended the consecration of Suger's choir in 1144.[42] She may also be linked to the Canterbury *Jesse* window, which reproduces essentially the same design (93); the style would accord with a gift on her journey with Richard I when they paused in Canterbury in 1194 to give thanks for his release from prison.[43]

Most of the evidence weighed so far is consistent with the view that the early glass at York was made for Roger of Pont-l'Evêque's choir, about 1170–80. It is worth considering what the programme of glazing may have been, since the building plan has been uncovered.[44] The *Jesse Tree*, as Lethaby suggested, might have been in the flat east wall, but practice elsewhere would not support his suggestion of the central window; more likely it was the one to the north, as probably at St-Denis, Chartres and Canterbury.[45] Allowing for flanking prophets, as in those windows, and borders, the original window would have been about 2 m wide, which is the average for the earlier stonework of the north choir aisle of Canterbury and which could have been accommodated in the choir walls of York.[46] The Passion scenes, including the *Three Marys at the Tomb* and an *Emmaus* cycle, may have been in the central east window. Old Testament scenes, of which only *Daniel being fed by the Prophet Habbakuk in the Lions' Den* (based

on the Apocryphal book of Bel and the Dragon) remains, may have been types to New Testament scenes, or an independent narrative. Saints' lives may have occupied the chapel windows in the choir and in the undercroft, as at St-Denis; in addition to Benedict and Nicholas, they included Martin, and perhaps also Richarius. The St Nicholas series, evidently in pointed ellipses that were divided horizontally by a bar, would give the same dimensions as the *Jesse* window. Other scenes, in quatrefoils or circles, were probably paired in the window openings. In most cases there are indications that the armatures were of the straight bar type, since ornamental fill adheres to the edging lines of the figural fields.

An attempted reconstruction of the *Last Judgement*, of which 12 panels survive, raises the most interesting questions because the subject is rare in narrative lancets.[47] It might have been arranged as a series of paired circular panels, originally of over 1 m in diameter, but Peter and Paul on either side of the gates of Heaven seem to require a central position, perhaps between two pairs of trumpeting angels, and Christ should have figured between the two groups of seated Apostles. A window three panels wide would have been as large as the east window of Poitiers Cathedral, but it could have been accommodated between the towers of Roger's west work. A more logical setting, however, would be an oculus, like the ones at Canterbury, or even a rose of the type that appeared by 1180 in Laon; a series of oculi would also serve. The more strident colours of this group, with greater amounts of red and yellow and less of the purple, green and white prevalent in the other cycles, would suit a position well above floor level. In the absence of further archaeological evidence such reconstructions remain hypothetical.

For Canterbury the case is very different, both because all the window openings survive, some with glass *in situ*, and because there is early documentation for the programme. Anselm's choir was severely damaged by fire in 1174 and rebuilt, beginning from the western transept, by the architects William of Sens and 'the English' William; the contemporary Chronicle of Gervase indicates that the building was essentially complete, including an eastern extension of the Trinity Chapel, by 1184.[48] The second architect had taken over the work in 1179, after the first was injured in a fall; the new choir was put into use at Easter 1180, with a temporary partition behind the high altar closing off the building work to the east. The only mention of glazing in the Chronicle is of glass in three windows in this partition, but iconographic and other evidence indicates that the glass-painters followed closely behind the masons until the choir was ready for use, filling three stories of windows.[49] In the 12 lower windows of the choir aisles, eastern transepts and presbytery was placed a typological cycle, beginning at the west end of the north aisle with the Incarnation and ending in the facing aisle with the Passion.[50] Each Gospel scene was flanked by two or more types, many chosen from the Old Testament, and these had explanatory inscriptions (e.g. **91** and **92**). All the inscriptions and subjects were recorded in three medieval manuscripts which have recently been collated and translated. Only four windows of this series partially survive, and their panels have been gathered in two openings of the north choir aisle, corresponding to the second and third windows originally.

The short trefoil-headed windows which William of Sens used in the upper walls of the choir aisles to fill the section he added to their height seem to have been glazed with the lives of the Canterbury archbishop-saints, Dunstan and Alphage, whose relics were translated to altars in the presbytery in 1180.[51] The clerestory windows were filled with ancestors of

Christ, beginning with Adam in Luke's genealogy at the west end of the north wall and presumably ending with the Virgin and Christ in the facing window; a sufficient number of figures survive from various parts of the building to reconstruct the whole series, though none is now *in situ*. It seems that when the decision was taken, with English William in charge, to extend the Trinity Chapel, figures from Matthew's genealogy had to be selected to fill out the programme in the hemicycle; some of the figures from the east of the temporary screen may be considerably later than 1180, since delays were surely occasioned by financial and political problems, including the exile of the archbishop and monks from 1207 to 1213; the work may have been completed in time for the translation of the relics of Thomas Becket to the Trinity Chapel in 1220.[52]

The figures on exhibition, Aminadab and Naasson from Luke III.32–3 (**94a** and **b**), are from the first window beyond the partition on the north side; they were originally set in an armature, surviving *in situ*, which has a bowed configuration as a tentative departure from the straight bar type consistently used to the west.[53] The figures to the east are smaller in size, confined within varied geometric forms such as circles, quatrefoils or lozenges. The style of these two figures, and even the colour and quality of the glasses which have weathered less than most at Canterbury, serve to associate them with north French glass-painters rather than with others of the Canterbury hands.[54] Current research indicates that they may have been provided by an atelier that worked on the choir clerestory windows of St-Remi in Rheims in the early 1180s, and which went on to provide clerestory figures (with a genealogy of Christ based on Luke and Matthew) for the abbey church of St-Yved in Braine; the church there was completed, and perhaps already had its glass in position by 1208.[55] There may be some truth in the legend that the Queen of England provided the glass for Braine, if either Eleanor of Aquitaine on her visit to Canterbury in 1194 or earlier, or John's bride Isabella of Angoulême, who was crowned there in 1201, commissioned the glaziers to return to France; both were relatives of Agnes of Dreux.[56]

The lower windows of the Trinity Chapel at Canterbury, and of the axial chapel beyond it known as the Corona, were probably glazed slowly between about 1184 and 1220. The Corona may have been given priority, judging from the styles and programme; the east window took up themes already used in the last of the typological windows in the south choir aisle, completing the cycle with the Ascension and Pentecost. A *Jesse* window (**93**), probably originally placed immediately to the north, emphasized kingship in a way that had been avoided in the full genealogy of the clerestory.[57] Both the political climate that may be inferred from this iconography, and the style, which is close to that of the second Great Seal of Richard I of 1198, suggest that the window was not created until 1195–1200, and that it was perhaps a royal gift, as suggested above. The glass-painter seems to have worked in Canterbury before 1180, however, supplying figures in the north transept oculus, and he continued with glazing to the east of the screen, working alongside the French master of *Aminadab* and *Naasson*.[58]

The last phase of glazing in Canterbury is not represented in the exhibition. It belongs to the Gothic era, when marked influences from the Continent were assimilated, probably during the years of exile; the windows of the Trinity Chapel, with numerous scenes illustrating the posthumous miracles of Thomas Becket, are contemporary with the great cycles in the newly built French cathedrals of Bourges and Chartres, and it is with these rather than with local work that they show most affinity. M.C.

NOTES

* I acknowledge with thanks the financial support of the American Council of Learned Societies which enabled me to further research on this and related glass, and of the Arts Council of Great Britain. I am indebted to several colleagues: Sarah Brown of the National Monuments Record for help with photographs and the Corpus Vitrearum numbering of the York Minster windows; Peter Gibson of York Glaziers Trust for giving me access to glass in storage and in the Minster, and for information on its restoration; Peter Newton of the University of York; and David Connor of Manchester University.

1. The glass in Lincoln Cathedral is Transitional or Gothic. See Grodecki, Brisac, 1977, pp. 202–3; see also J. Lafond, 'The Stained Glass Decoration of Lincoln Cathedral in the Thirteenth Century,' *Archaeol. J.*, 103, 1946, pp. 119–56; and N.J. Morgan, *The Medieval Painted Glass of Lincoln Cathedral*, Corpus Vitrearum Medii Aevi, Great Britain: Occasional Paper III, 1983, pp. 44, 47, who places the earliest glass of the north rose in the first decade of the 13th century.

2. Gee, 1977, p. 112; O'Connor, Haselock, 1977, pp. 318–19.

3. R. Cramp, 'Decorated window-glass and millefiori from Monkwearmouth', *Antiq. J.*, 50, 1970, pp. 327–35; and 'The Window Glass', in M. Pocock and H. Wheeler, 'Excavations at Escomb Church, County Durham, 1968', *J. Brit. Archaeol. Assoc.*, 34, 1971, pp. 26–8.

4. Woodforde, 1954, p. 7.

5. William of Malmesbury, *De gestis pontificum Anglorum*, ed. N.E.S.A. Hamilton, 1870, p. 138; '*ut nichil tale possit in Anglia videri in vitrearum fenestrarum luce, in marmorei pavimenti nitore, in diversi coloribus picturis quae mirantes oculos trahunt ad fastigia lacunarim.*'

6. Briefly mentioned by Nelson, 1913, p. 68, who assigned a 13th-century date to it. Unfortunately it was not available for exhibition.

7. Excellent illustrated summaries of this period are in Grodecki, Brisac, 1977, pp. 37–56, and Frodl-Kraft, 1970, pp. 13–28.

8. F. Gerke, 'Das lorscher Glasfenster', in *Beiträge zur Kunst des Mittelalters: Vorträge der ersten deutschen Kunsthistorikertagung auf Schloss Brühl, 1948*, 1950, pp. 186–92; R. Becksmann, 'Das schwarzacher Köpfchen, ein ottonischer Glasmalereifund', *Kunstchronik*, 23, 1970, pp. 3–9; historiated windows in Rheims are credited to Archbishop Adalberon (969–89) in *Richeri Historiarum libri IIII* (*Scriptores rerum germanicarum*), ed. G.H. Pertz, 1839, p. 123.

9. For Augsburg see Grodecki, Brisac, 1977, pp. 50–4, colour pls. 36–9, fig. 40. For Ottonian influences in Canterbury see Woodman, 1981, pp. 50–1.

10. Theophilus, 1961, p. 4; 'Francia' would presumably refer to northern France.

11. Grodecki, Brisac, 1977, pp. 70–4, colour pl. 58, figs. 56, 57, and p. 286, no. 73, with bibliography.

12. The heavy trace-lines in the faces especially appear as a local feature. A work on the glass of Poitiers is in preparation by Virginia Raguin.

13. Charles-Louis Hugo, *Sacri et Canonici Ordinis Praemonstratensis Annales*, 1734, p. 395, says only that Agnes built a large church and put in it glass brought from England; Claude Carlier, *Histoire du duché de Valois*, II, 1764, p. 65, and Pierre LeVieil, *L'Art de la peinture sur verre et da la vitrerie*, 1774, p. 24, add that the glass was given by the queen. Carl Barnes, however, has pointed out to me that there may be a confusion with Soissons, where secondary sources dating before 1584 state that the queen gave glass to the cathedral. In neither case have primary sources been found.

14. Read, 1926, p. 35 n.2.

15. Grodecki, Brisac, 1977, pp. 57–90, 112–47, 187–97.

16. For the glass, the chronicle of Symeon the monk is cited by J. Haselock and D.E. O'Connor, 'The Medieval Stained Glass of Durham Cathedral', *Brit. Archaeol. Assoc. Conf.*, III, 1977, 1980, pp. 103 & 124 n.2. For the manuscripts see Kauffmann, 1975, p. 121.

17. A letter to King John is cited by Gee, 1977, p. 127: it is printed in *The Historical Works of Gervase of Canterbury*, II, ed. William Stubbs, 1880, p. lxxiii.

18. The building dates are summarized in Zarnecki, 1975b, p. 18, with bibliography. Torre described the clerestory in 1690, with the early panels already in position, and it is unlikely they had been placed there in the interim (Torre, 1690–1).

19. E.g. in Bourges, Chartres, Rouen, St-Germer-de-Fly, St-Remi of Rheims, Châlons-sur-Marne, Augsburg, to name but a few; see M.H. Caviness, 'De convenientia et cohaerentia antiqui et novi operis: Medieval conservation, restoration, pastiche, and forgery', in *Intuition und Kunstwissenschaft: Festschrift für Hanns Swarzenski*, 1973, p. 206.

20. *Daniel in the Lions' Den* is in one of the grisaille windows known as the 'Five Sisters' in the transept, and there is another, *Kings led by Demons*, in the chapter house, but it is questionable whether either panel was placed there in the Middle Ages. Ornament in the vestibule traceries, however, was probably incorporated in the 14th century; see French, 1971, p. 92, pl. xxa.

21. Westlake, 1881, p. 42, emphasizes the derivation from St-Denis, though he also notes analogues in local sculpture.

22. Zarnecki, 1975b, pp. 18–19, has similarly reassessed the extent of immediate French influence in the sculpture.

23. The argument is strongly made in Lethaby, 1915, pp. 37–46.

24. O'Connor, Haselock, 1977, p. 319, refers to 15 designs. I was able to see

examples of most in storage, and others are visible in the north nave clerestory and the crypt museum. The coloured plates in Browne, 1847, pls. CXIX, CXXIII, CXXVIII, are useful but not entirely accurate. See also Westlake, 1881, pls. XI h and i, XII m, XXIII.

25. Grodecki, 1976, type F, pp. 129–30, figs. 200–2; original pieces are in America: New York, 1982, p. 83, no. 24, colour pl. II.

26. The contrasts are very evident when four elements from the *Infancy* window of St-Denis, preserved in the Yorkshire Museum and currently in storage with the York Glaziers Trust, are viewed together with the Minster borders.

27. Browne, 1847, pl. CXXVII A, has combined the two, though there is no proof they belong together; cf. also the border he gives to the *Jesse* panel, pl. CXXIII and p. 145.

28. E.g. the type shown in New York, 1982, p. 111, no. 38 A.

29. Caviness, 1977, pp. 44–5; 1981, figs. 92, 257, 373–5. Cf. Grodecki, 1976, type E.

30. Lethaby, 1915, p. 47; his comments are restricted to composition, but the affinities cannot be carried further.

31. Caviness, 1981, pl. VII, figs. 148b, 172a, 176, 369.

32. Rome, Vatican Library, Cod. lat. 1202, published by D.M. Inguanez and D.M. Avery, *Miniature cassiniense del secolo XI illustranti la Vita di San Benedetto*, 1934; for the identifications see O'Connor, Haselock, 1977, p. 321.

33. Grodecki, 1976, pp. 108–14, figs. 145-63. Peter Gibson tells me, however, that a scene of St Benedict in the cave, comparable to that at York, and in the style of St-Denis, is in Raby Castle.

34. Swarzenski, 1954, p. 79, fig. 484, with a date of *c.* 1176; Geddes, 1980, pp. 143–6, pl. XXIIB, prefers a date after 1185 for historical reasons.

35. Grodecki, Brisac, 1977, pp. 140–7, 294–5, pls. 118–25, with bibliography.

36. The comparison with glass of *c.* 1190 in Le Mans Cathedral suggested by Jane Hayward in New York, 1970, I, p. 220, is not convincing; cf. Grodecki, Brisac, 1977, pl. 55.

37. Oxford, Bodleian Library, MS Gough Liturg. 2, f. 17; Kauffmann, 1975, pp. 120–1, fig. 270. Other similarities include the drawing of the neck and shoulder of the horse and donkey, and the hair, beard and facial modelling of the carter and Joseph.

38. Durham, Cathedral Library, MS A.II.1, in four volumes; Kauffmann, 1975, pp. 121–2, figs. 279–82, 285. Compare especially the *Esther* initial, vol. III, f. 109, with the trumpeting angels in York, and the drapery of the *Amos* initial, II, f. 109, with the *Jesse* king.

39. The affinity was noticed by Zarnecki, 1975b, p. 19. Copenhagen, Royal Library, MS Thott 143, 2°; Kauffman, 1975, pp. 118–20, figs. 272–6, colour frontispiece.

40. An excellent colour reproduction of the *Daniel* panel is in F. Harrison, *Treasures of Art: Stained Glass of York Minster, c.* 1959, pl. I. For the *Visitation* in the Psalter, see Zarnecki, 1975b, fig. 3.

41. Zarnecki, 1975b, p. 18; see also A. L. Poole, *From Domesday Book to Magna Carta, 1087–1216*, 1955, pp. 348, 356–7, 445.

42. Caviness, forthcoming. For the consecration see Erwin Panofsky, *Abbot Suger on the Abbey Church of St-Denis and its Art Treasures*, 2nd. edn., 1979, pp. 112–13.

43. Caviness, forthcoming; 1979, p. 49.

44. Gee, 1977, pp. 118 (plan), 121–7.

45. Lethaby, 1915, pp. 44–5. The St-Denis *Jesse Tree* has been reconstructed in the south window of the pair in the axial chapel, but remnants were in both windows prior to this, making the choice arbitrary.

46. Lethaby, 1915, pp. 39ff., allows only about 1.5 m. for the York windows. The Canterbury openings pre-date the fire, and survive from Anselm's choir.

47. Such a window may have existed, however, in Le Mans Cathedral *c.* 1160–70; see Grodecki, Brisac, 1977, pp. 62, 284, pl. 52. After 1200 a clerestory window of the apse hemicycle of Soissons Cathedral was filled with a *Last Judgement*, but only fragments remain.

48. W. Stubbs (ed.) *Gervasii Cantuariensis Opera Historica*, Rolls series, 73, I, 1879, pp. 3–29; English translation in Willis, 1842–63, *Canterbury*, 1845, pp. 36–62.

49. Caviness, 1982, pp. 46–55.

50. Fully described in Caviness, 1981, pp. 76–156.

51. Ibid., pp. 63–75.

52. The historical circumstances are outlined in Caviness, 1977, pp. 23–35.

53. Ibid., appendix fig. 5, window N.X.

54. Ibid., pp. 77–82, fig. 152, cf. fig. 154.

55. M.H. Caviness, 'Saint-Yved of Braine: primary sources for dating the Gothic church', *Speculum*, forthcoming (1984).

56. See n. 13 above. The queen's identity is discussed more fully in M. H. Caviness, 'Rediscovered Glass of about 1200 from the Abbey of St-Yved at Braine', *Corpus Vitrearum Colloquium*, 1982, forthcoming; a third candidate is Agnes' niece, Marguerite, who married Henry the young king.

57. Apart from the preponderance of patriarchs in the early genealogy, Abia and Achim, who are among the kings in Matthew, are shown without crowns or insignia in the clerestory. In St-Remi, on the other hand, Abiud and Eliachim were given crowns.

58. Caviness, in New York, 1975.

88

88 King of Judea from a Jesse Tree window

h 760 mm, *w* 730 mm
c. 1170–80; York Minster
North nave aisle, n. xxviii (formerly known as 37)
York, Dean and Chapter of York Minster

This panel, showing a frontal seated king with yellow crown and tunic and rose-purple mantle, his hands extended to grasp white branches with decorative foliage, may be identified as the sole survivor at York from a *Tree of Jesse* window comparable to earlier ones preserved in the abbey church of St-Denis and in the west façade of Chartres Cathedral. Such windows illustrate Isaiah's prophecy that from the root of Jesse will spring a stem that will bear a flower (Isaiah XI. 1–3). In this configuration Christ is seated at the top of a tree which springs from the loins of Jesse, asleep in the bottom of the window. The trunk of the tree is formed by a series of the kings of Judea, representing Christ's royal ancestors, and culminating with the Virgin. In St-Denis and Chartres, as apparently here, the kings are not identified by inscriptions or attributes, whereas these are given in later examples, such as the Canterbury panels (93 a and b). Both of the early examples in France also included prophets on either side of the kings, holding scrolls inscribed with their writings concerning the coming of Christ.

Traditions rooted in the 19th century have claimed a date of about 1150 for the York *Jesse* panel (Westlake, Harrison, Woodforde), but cogent arguments for a later date were made in 1915 by Lethaby, and later by Lafond and others.

This was the only king from the *Jesse* window described by Torre and Browne; they saw it in the nave clerestory (N.xxv, formerly C.28, on the north side) where it remained until 1950. The king's head was recorded in a drawing of 1840 with some loss due to breakage; Westlake later noted a stop-gap and paint loss; by 1950 it had lost all its paint, and shortly before the present exhibition the glass was replaced by a newly-painted head. The foliage has likewise lost most of its original paint, but the green, purple, red, yellow and white glasses are 12th-century; the outlines of the composition were confused by many mending-leads, some of which may have been added after the fire in the nave in 1840. M.C.

BIBLIOGRAPHY Torre, 1690–91, p. 36; York Minster Library, watercolour drawing, watermarked 1840; Browne, 1847, I, pl. CXXIII; II, pp. 85, 145; Westlake, 1881, I, pp. 41–2, pls. XIj, XXII; Nelson, 1913, p. 245; Lethaby, 1915, pp. 40–1, 45–6; John D. Le Couteur, *English Medieval Painted Glass*, 1926, pp. 66–7; F. Harrison, *The Painted Glass of York*, 1927, pp. 37–8, repr. facing p. 38; Arthur Watson, *The Early Iconography of the Tree of Jesse*, 1934, pp. 140–1; Woodforde, 1954, p. 1; Jean Lafond, Review of Woodforde, *Archaeol. J.*, CXI, 1954, p. 240; Caviness, in New York, 1975, p. 376, fig. 7; O'Connor, Haselock, 1977, p. 320; Grodecki, Brisac, 1977, pp. 200–1, 297–8 no. 117, fig. 175; Gibson, 1979, p. 16; Caviness, forthcoming

90a

89 Scene from the Legend of St Nicholas
(*illustrated on p. 61*)

h 750 mm, *w* 760 mm
c. 1170–80; York Minster
South nave aisle, s.xxix (formerly 26)
York, Dean and Chapter of York Minster

This narrative panel shows a bearded carter in a green tunic with a whip over his shoulder standing beside a pair of rose-purple and yellow horses; the brilliant yellow, white and blue wheel of the cart they pull runs over a prostrate figure with yellow shoes, red hose and green tunic. A tree and clouds indicate a landscape setting. The subject has been identified as one of the posthumous miracles of St Nicholas, Bishop of Myra (the prototype of Santa Claus) as recounted in the *Acta Sanctorum*: The man who is run over had falsely sworn that he had repaid a debt to a Jew; the moneylender vowed to become Christian if his debtor was restored to life, and this came about after prayers were offered to the saint.

The scene is rarely illustrated; a whole window in the 12th-century building at York must have been dedicated to this popular saint, and would surely have included more familiar scenes. One other fragment survives, with St Nicholas appearing to sailors to calm a storm. The larger panel appears to have been cut down from half a pointed vesica, presumably in the late Middle Ages when the red edging lines were added, and the spandrels were filled with palmettes cut down from elsewhere. Torre saw this panel in the south nave clerestory, S.xxv (C.31), where it remained until it was releaded and restored in 1969. The breakages and heavy mending-leads, however, result from earlier damage. There are several replacements, including old green fragments stopped into the tree, and modern glass used to fill out the back of the purple horse and the rim of the wheel. The original paint is well preserved in the head of the carter, parts of his tunic, and in the horse. In 1979 a 14th-century head that had been used as a stop-gap for the debtor was exchanged for a 12th-century one preserved in another clerestory window, and the panel was placed in an aisle window to allow its painted detail to be seen. M.C.

BIBLIOGRAPHY Torre, 1690–91, p. 40; Nelson, 1913, p. 245; New York, 1970, I, pp. 220–1 no. 224; Grodecki, Brisac, 1977, pp. 202, 298 no. 118, fig. 176; O'Connor, Haselock 1977, p. 322, fig. 88; Gibson, 1979, pp. 11, 19, pl. 12; (for the St Nicholas legend see C. de Smedt, G. van Hooff (eds.), *Analecta Bollandiana*, 1883, pp. 155–6; Jacobus de Voragine, *The Golden Legend*, transl. G. Ryan & H. Ripperger, 1941, I, p. 22.)

90a and b Pieces of borders (*b not illustrated*)

h 670 mm, *w* 260 mm (each)
c. 1170–80; York Minster
Tracery of south nave clerestory, S.xxii (C.34) and S.xxiii (C.33)
York, Dean and Chapter of York Minster

These panels, among the few fragments of early ornament to have been releaded during the current restoration, are splendid examples of the richly-painted type which is typical of York work. Their considerable width both confirms their early date and indicates the large size of the window openings. Also typical of the period are the red grounds outside the half-circles and lozenges described by the strapwork, with brilliant blue grounds inside, and the use of rose-purple, green and yellow in the palmettes.

The detailing in reserve on the bold geometric straps and the vigorous but abstracted curves of the leaves suggest that they

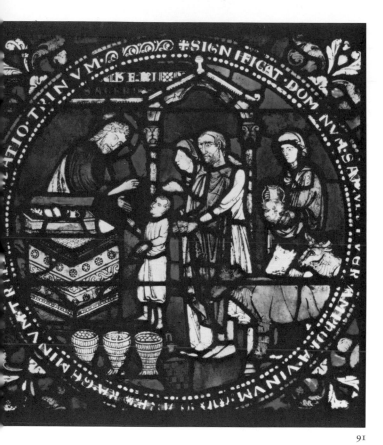

91

were intended to frame lower windows, and possibly that they were made early in the 12th-century campaign. The finely-modulated brush-strokes on the leaves, the highlighting that follows the lead-lines and the use of cross-hatching contribute to the vitality of the designs by accentuating contrasts of light and dark; the same techniques are used in the drapery of the king from the *Jesse* window (88).

All the glasses are pot-metal, that is they are coloured all through with metal oxides, and analysis has indicated that the composition of the purple and of the green glasses differs sufficiently to explain their different weathering properties: the purples, as also the blues, are scarcely corroded whereas the greens are severely pitted. M.C.

BIBLIOGRAPHY Browne, 1847, I, pl. CXXVIII; II, p. 84 (no. 90b); Westlake, 1881, I, p. 42, pl. XXIIIc (no. 90b); New York, 1970, pp. 218–20, nos. 222, 223, ills. 90a, b; R. Hedges and R.G. Newton, 'Use of the "Isoprobe" for studying the chemical composition of some 12th-century glass from York Minster', in R.G. Newton, *The Deterioration and Conservation of Painted Glass: A Critical Bibliography and Three Research Papers*, 1974, pp. 79–86, (no. 90a); O'Connor, Haselock, 1977 p. 324, fig. 90, nos. 91a & b

91 Presentation of Samuel in the Temple

h 690 mm, *w* 700 mm
c. 1175–80; Christ Church Cathedral, Canterbury
North choir aisle, second typological window, n.XV, 17
(Rackham II, 13)
Canterbury, Dean and Chapter of Canterbury Cathedral

This panel has remained *in situ*, next to its antetype, the *Presentation of the Christ Child in the Temple*; the other type was the *Offerings of Melchizedek*, but it is not preserved. Together they provided interpretations of the Gospel according to 12th-century exegesis: Samuel prefigured Christ, the offerings of wine and flour alluded to the Eucharist, and with the cattle symbolized the Trinity. The meanings were clarified in the inscription painted around the edge of the medallion: + SIGNIFICAT DOMINVM SAMVEL PVER AMPHORA VINVM [ARE]RA GEMINVM TRIPLEX OBBLATIO TRINVM (*are* is misplaced, and the word should be [*natu*]*ra*): 'The child Samuel signifies the Lord, the amphora, the wine; the threefold offering signifies the triune form of that which is by nature twofold.' On the left is an altar, with gold frontal and the open ark on it. Behind it stands the high priest Eli, nimbed, his name HELI SACERDOS inscribed on the temple roof above. He greets the boy Samuel as he approaches the altar from the right, followed by his parents, Hannah and Elkanah, and a maidservant with a flask. In the foreground are the offerings of three baskets of loaves and three cattle.

An illustration based on the text of 1 Samuel I.24 was sometimes included in Old Testament illumination (for instance the Stavelot Bible and the Morgan leaf from the Winchester Bible), and it was used as a type of the *Presentation of Christ* in 13th-century glass in Assisi, as well as in cycles related to Canterbury such as the typological window in the collegiate church of St-Quentin and in the Peterborough Psalter. Its significance was perpetuated in the Middle Ages in the monastic *oblatio* or offering of a son to a monastery, normally at the age of seven.

The panel is well preserved, apart from the replacement in this century of Eli and Samuel. The firmly-modelled figures with soft, clinging draperies and the subtle range of pink and purple glasses, used in conjunction with yellows, green and white, are typical of the earliest of the Canterbury painters. A fitting name for this artist is the 'Methuselah Master', for a figure he supplied in the clerestory of the choir. The contrast with the stiffer, more abstract style of the York painter of the Nicholas scene (89) has been pointed out (p. 136); it extends to the treatment of the anatomy of the beasts. The Methuselah Master was an outstanding draughtsman who, like Nicholas of Verdun, pursued naturalism through ancient and Byzantine models. His importance has only recently been recognized. M.C.

BIBLIOGRAPHY Cambridge, Corpus Christi College, MS 400, part IV, f. 121; Canterbury, Cathedral Archives and Library, MS C.246; Oxford, Corpus Christi College, MS 256, f. 185ᵛ; Williams, 1897, p. 9; James, 1901, pp. 14, 27; Nelson, 1913, pl. IV; Mason, 1925, p. 23; Rackham, 1949, p. 58, pl. I4a; L.M. Ayres, 'Studies on the Winchester Bible', Ph.D. thesis, Harvard University, 1970, p. 173; Caviness, 1977, pp. 94, 123, 134, fig. 60; Reiner Haussherr, 'Der typologische Zyklus der Chorfenster der Oberkirche von S. Francesco zu Assisi', in *Kunst als Bedeutungstrager: Gedenkschrift für Gunter Bandmann*, ed. W. Busch, R. Haussherr and E. Trier, 1978, p. 100; Alison Stones, Review of Lucy Freeman Sandler, *The Peterborough Psalter in Brussels*, in *Zeitschrift für Kunstgeschichte*, 43, 1980, p. 216; Caviness, 1981, pp. 97–98, pl. V, figs. 171, 171a (for an appreciation of the Methuselah Master, see L. Grodecki, 'A propos d'une étude sur les anciens vitraux de la cathédrale de Cantorbéry,' *Cahiers Civ Méd.*, XXIV, 1982, pp. 62–3)

92 a Three Righteous Men

h 660 mm, *w* 590 mm
North choir aisle, n.xv, 9i (Rackham II, 21)

92 b The Sower among Thorns and on Good Ground

h 690 mm, *w* 710 mm
North choir aisle, n.xv, 8 (Rackham II, 20)

92 c The Deceitfulness of Riches (Emperors Julian and Maurice)

h 660 mm, *w* 590 mm
North choir aisle, n.xv, 7 (Rackham II, 19)

92 d and e Border panels

h 760 mm, *w* 220 mm
Corona n.III, 4 and 6

c. 1175–80; Christ Church Cathedral, Canterbury
Canterbury, Dean and Chapter of Canterbury Cathedral

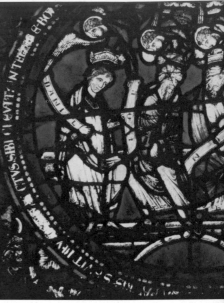

92e

As indicated in the medieval manuscripts that record the titles and inscriptions, these figured panels were originally in the sixth typological window of the series of 12. The armature that they would fit is still in place in the north face of the north-east transept (n.xi); its rectilinear panels of irregular size describe a great cross, and evidently semicircles were inscribed in some of them, as in **a** and **c** here. Christ teaching was shown in the summit of the window, followed by the parables of the Sower, the Three Measures of Meal, the Net and the Harvest, each juxtaposed with symbolic scenes that provide a commentary; the overall theme was that of Judgement, with the saved placed to the right of Christ (our left) and the damned to His left.

In this case the good ground, represented by the open furrows in the central scene (**b**), is illustrated by three Old Testament patriarchs, Daniel, Job and Noah, who are being crowned by angels (**a**). The inscription around the edge has been cut down and some stop-gaps inserted, but it can be reconstructed as: VERBA PATRIS SEVIT DEV[S HIIS FRV] CTVS SIBI CREVIT: IN TELLVRE BON [A TRIPLEX SVA CVIQUE CORONA] ('God sowed the words of the Father; from these His fruit increased on the good ground threefold; His own crown was given to each'). The thorns which choked out some of the seedlings are shown in clumps in the foreground of the sower panel, and are illustrated by crowned figures, labelled IVLIANVS and MAVRICIVS, with a treasure of gold (**c**). The inscription can be reconstructed: [ISTI SPINOSI LOCVPLETES] DELICIOSI. NIL FRVCTVS REFERVNT QVO [NIAM] TERRESTRIA QVERVNT ('These thorny ones are the rich and extravagant. They bear no fruit since they seek earthly things'). The choice of these two Emperors is rather esoteric. Gregory the Great had likened his contemporary, Mauricius Tiberius, to Julian the Apostate because he forbade his soldiers to enter

92b

92c

92d

the monastic life. Julian himself had forced his soldiers to
sacrifice to pagan gods, and according to some legends was
struck down by the agency of the Virgin; he is also said to have
boasted about leaving the Christian faith.

The compositions, colours and draughtsmanship of these
panels are distinctive; their creator may aptly be named the
Master of the Parable of the Sower. The scenes are clear and
uncluttered, ordered by repetitive elements such as the arcade
in **c** or the angels in **a**. The principal figures are boldly
silhouetted and named on hands or scrolls (the inscription
above the sower is misplaced). Their postures are active and
they turn in space. The layered depth and diagonal recession
of the landscape with the sower is remarkable. The figures are
taller and more dynamic than those of the Methuselah Master
(compare **91**) and the colours more saturated and brilliant,
including a deep red in the ornament and a streaky orange-red
in the draperies. This Master also supplied glass in the
clerestory before 1180. Analogous styles are found in the Great
Canterbury Psalter in Paris (Bibliothèque nationale, MS latin
8846, **73**), and the Balfour ciborium in the Victoria and Albert
Museum (**279**).

Replacements in the figured panels are few. They include the
head of Daniel in **a** and those of the attendants in **c**.

The two border panels have been installed since 1953 in the
corona with the *Jesse Tree* panels (**93**), but there is a strong
probability that they came from the sixth typological window,
in which Hasted saw borders in 1800 after the figured panels
had been removed to the north choir aisle. The bold, colourful
design and strong modelling are in keeping with the panels
known to come from the transept window, and the trefoil
leaves are repeated in the corner of panel **a**. The complexity
of the design, with interwoven stems forming vesica shapes

against red and blue grounds, and delicate foliage with berries,
is typical of the earliest glass at Canterbury (for instance the
border of the second typological window, n.XV). The emphasis
on organic forms, such as the leaf rings below the shoots on
the white stems, contrasts with the abstract, geometrically
controlled forms of the York borders (**90a** and **b**). M.C.

BIBLIOGRAPHY Cambridge, Corpus Christi College, MS 400, part IV, f.125; Canterbury,
Cathedral Archives and Library, MS 246; Oxford, Corpus Christi College, MS 256, f. 186ᵛ;
E. Hasted, *The History and Topographical Survey of the County of Kent*, 2nd edn., XI, 1800,
p. 380; Canterbury, Cathedral Archives and Library, Emily Williams Collection, drawings nos.
13, 15, 19; Williams, 1897, p. 11; James, 1901, pp. 18, 30; Nelson, 1913, pl. IV; Mason, 1925,
pp. 24–5; Read, 1926, pl. I; Rackham, 1949, p. 59, pls. 17 d, e, f; J. Baker, *English Stained
Glass*, 1960, p. 48, pl. V; Frodl-Kraft, 1970, p. 80, pl. XIII; Caviness, 1977, pp. 63–4, 97, 118–19,
128–30, pl. II; figs. 95, 97; Caviness, 1979, pp. 44–6, fig. 18; Caviness, 1981, pp. 117–18, 122–4,
172, figs, 193, 194, 203–05a

93 King Josiah and the Virgin from a Jesse Tree window (*illustrated on p. 60*)

h 760 mm, *w* 840 mm (each panel)
c. 1200; Christ Church Cathedral, Canterbury
Corona, n.III, 5 and 8
Canterbury, Dean and Chapter of Canterbury Cathedral

These two crowned figures, inscribed with their names: IOSIAS and SCA MARIA, are all that survive from a *Jesse* window in Canterbury. The composition was evidently similar to that used in St-Denis and York (88); there the seated figures are severely frontal, their hands outstretched to grasp white branches which bend to form a vesica shape and which bear brilliantly-coloured foliage. Here they are seated on thrones and orbs.

The unusual amethyst robe and cool green mantle of the Virgin form a subtle contrast with the warmer purple and green of the king's draperies. Despite the red and yellow in the ornament, the colours are less strident than those of the Master of the Parable of the Sower, and they are dominated by limpid blue grounds. The painting is subtle, with one tone of modelling applied to the outer surface, and the Jesse Tree Master has carefully rendered the minutiae of folds in the lap of the king. One of the models he used may have been the new Great Seal made for Richard I on his return from the Crusades in 1198, which shows a similar conception of the figure. The allusion may be conscious if, as suggested above, the window was connected with the royal visit of 1194.

Both panels are exceptionally well preserved. They were not releaded until 1953, and the original lead cames are preserved in the Cathedral Restoration Studio. Tracings and watercolour drawings made by Joyce and Hudson in the 1840s indicate that they were then in the east window of the corona, where they had replaced broken panels in a typological *Passion* window; they were copied by George Austin in the 1860s in a full *Jesse* window which he placed next to the *Passion* (n.II), and he presumably removed them from the Cathedral when he completed the *Passion* at that time. In 1908 they were sold by his successor in glass restoration, Samuel Caldwell Jr, to Philip Nelson and on his death in 1953 his executor John Hunt returned them to the Cathedral, together with the borders exhibited here (**92d** and **e**). M.C.

BIBLIOGRAPHY London, Victoria and Albert Museum, Department of Prints, 93.H.29: J.G. Joyce, *Specimens of the Ancient Stained Glass in Canterbury Cathedral drawn for Thomas Willement*, 1841, 4513.29; London, Victoria and Albert Museum, Department of Prints, O. Hudson, watercolour tracings, 1848, 4154.1 and 9; Canterbury Cathedral Archives and Library, tracing attributed to Austin, among Caldwell's papers; C. Winston, 'An account of the Painted Glass in Lincoln Cathedral and Southwell Minster', *Proceedings of the Archaeological Institute*, 1850, p. 91; Westlake, 1881, p. 41; L.D. Day, *Windows: A Book about Stained and Painted Glass*, 1909, fig. 250; L. Day, *Stained Glass*, Victoria and Albert Museum Handbooks, 1913, figs. 14, 16; Rackham, 1949, pp. 116–17, pl. B.b; B. Rackham, *The Stained Glass Windows of Canterbury Cathedral*, 1957, pp. 44–5, pl. 4; Jean Lafond, *Le Vitrail*, 1966, p. 103; Caviness, in New York, 1975, pp. 373–98; Caviness, 1977, pp. 17, 20, 26, 42, 71–5, 89, 102, 105, figs. 133, 134; Caviness, 1979, p. 49; Caviness, 1981, pp. 172–4, pl. X, figs. 233–7a; Caviness, forthcoming

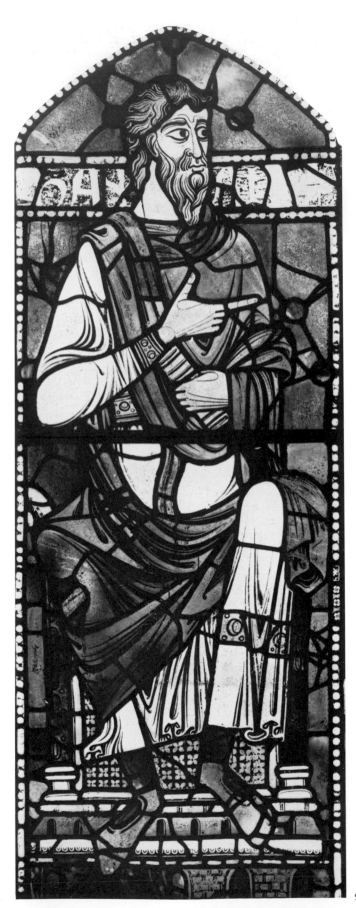

94a

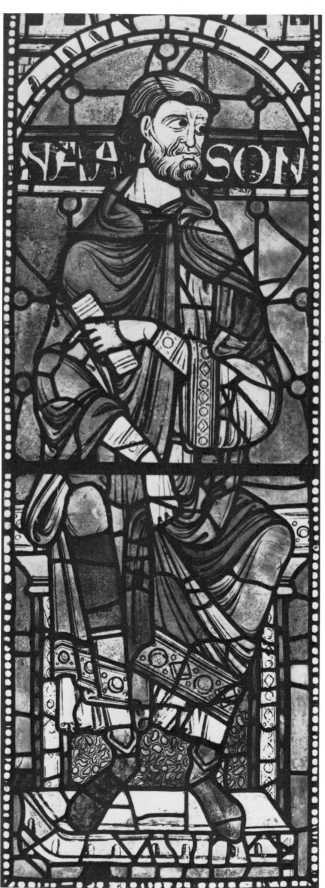

94b

94a and b Ancestors of Christ: Aminadab and Naasson

h 1.40 m, *w* 510 mm (each)
c. 1180–1205; Christ Church Cathedral, Canterbury
West window, w.f. 2 & w.b. 2
Canterbury, Dean and Chapter of Canterbury Cathedral

These two figures, with their names inscribed: [AMI] NAD[AB] (the first letters, s HA misplaced) and NAASON, are from the genealogy of Christ enumerated in Luke (see p. 137). These two, originally placed so that the canopy over Naasson provides a daïs for Aminadab as in the exhibition, were cut down at the sides when they were moved to the west window in the 18th century. The heads have a number 16 scratched on them, which corresponds to Gostling's label for Trinity Chapel clerestory N.X., evidently their original position.

The style has been discussed above; it appears to belong to the same phase as the *Jesse Tree*, but the patterning of the thrones, the somewhat mannered gestures, and especially the brilliant purple streaky glasses used in combination with cold white, identify another artist, known as the Petronella Master from his work in the Trinity Chapel ambulatory window below. He seems to have trained in France and to have been active in Canterbury at some time between 1180 when this part of the building was closed off from the presbytery by a temporary screen, and 1207 when glazing was interrupted by the exile of the monks. A date for these figures in the 1190s or about 1200 would accord with the chronology of work by the same atelier in France. M.C.

BIBLIOGRAPHY W. Gostling, *A Walk in and about the City of Canterbury*, 2nd edn., 1777, p. 327; Rackham, 1949, pp. 36–7; Caviness, 1977, pp. 48, 77–80, 98, 99, figs. 151, 152; M.H. Caviness, 'New observations on the Channel School: A French glass painter in Canterbury', *Akten des 10. Internationalen Colloquiums des Corpus Vitrearum Medii Aevi*, ed. Rüdiger Becksmann, 1977, pp. 30–1; Caviness, 1981, pp. 9, 16, 36–7, pl. IV, figs. 53–7

Sculpture

The importance of the Romanesque period in the development of architectural sculpture in Europe cannot be overestimated. During the turbulent times which had gone before, carving was practically banished from buildings, for there was neither the will nor the resources to indulge in enriching churches with sculpture. It was only in the more settled conditions of the 11th century that a modest revival of sculptural decoration, chiefly by carving capitals, took place. Once under way, this activity increased with great rapidity, soon involving not only capitals but doorways and, at times, entire façades, and it became ever more ambitious and daring as the years went by. By the beginning of the 12th century, there was a general blossoming of sculpture which spread to all parts of continental Europe.

The development of sculpture in England followed a somewhat different path. Here, the ancient tradition of high crosses and gravestones, carved with both figures and ornaments, and of stone roods inside churches, survived the period of Viking devastations, but was quite out of step with the new architectural sculpture evolving on the Continent. Some Anglo-Saxon works produced in the 11th century were of a very high quality, but they were entirely based on the art of the past and were largely independent of architectural forms. Anglo-Saxon reliefs were pinned to the wall as flowers or jewels would be to a dress, without being an integral part of it. The strength of Romanesque sculpture, on the other hand, was its unity with buildings which were clearly the result of a close collaboration between the mason and the sculptor, who were, at times, one and the same person. This art, although borrowing from the art of the past, had great inventiveness and originality.

Two reliefs illustrate particularly well the high artistic quality of pre-Conquest stone sculpture and its non-architectural character. One, from London, which formed part of a sarcophagus (95), is in a style of Scandinavian origin, the Ringerike, the other, a coffin lid from Bristol (96), is a good example of the Winchester School style. Both these artistic traditions exercised their influence on Romanesque sculpture in England. Although it is arguable that, even without the Norman Conquest, Romanesque sculpture would have eventually developed in England, in the event, it was an importation from Normandy.

The rebirth of architectural sculpture in Normandy during the 11th century was inspired by the example of Italy, Germany and the two regions of France where early Romanesque sculpture was particularly outstanding, Burgundy and the Loire Valley. Anglo-Saxon manuscript painting of the Winchester School style also had some influence, as is demonstrated by the capitals from Jumièges Abbey (98). By far the most popular type of capital in Normandy just before 1066 was the simplified Corinthian type which sometimes incorporated geometric or figural motifs, usually a mask or a human head (99).

Most of the sculpture produced during the Romanesque period was in stone, since so much of it was made for the adornment of buildings. There were, of course, a number of timber churches and the majority of houses were built of wood or partly so, but none survives and their embellishments perished with them. Wooden sculpture was also used in stone churches, for instance for furniture, but most frequently for crucifixes. Contemporary documents praise certain wooden sculpture in such terms that it was obviously not regarded as inferior to sculpture in stone. For example, two fragments of a crucifix (115), which is all that survives of Romanesque wooden crucifixes in this country, are of very high quality, even though made for a modest village church. They give us a glimpse of that branch of sculpture of which we are otherwise almost entirely ignorant. The largest number of Romanesque wood carvings survives in Scandinavian countries, and it is often said that some of the most beautiful amongst them show a strong stylistic influence from England. It is a great loss that the English works of art in this medium have been almost totally destroyed.

Those who are not familiar with English Romanesque sculpture and its history, may feel disappointed that so much is fragmentary, weathered and at times deliberately mutilated, the human face having been the favourite target of the iconoclast's or vandal's hammer. To understand the development of Romanesque sculpture in England, it is necessary to see not only the surviving fragmentary sculpture, now often found in museums, but also to travel to major buildings where the sculpture still survives as an integral part of a building's decoration.

The damaged state of the sculpture is due mainly to the demolition of monastic houses in the 16th century when entire buildings were destroyed, as, for example, the royal abbeys, Battle of William the Conqueror, Reading of Henry I and Faversham of Stephen. In the relatively few cases when an abbey also served as a cathedral, for instance Canterbury and Durham, they were left standing. It was not only monastic houses which were destroyed or damaged during the Reformation, for cathedrals served by canons and even parish churches also suffered severely. For example in 1540 at Lincoln Cathedral, which was not monastic, Henry VIII confiscated the treasury, including two shrines. This was followed in 1548 by a second plunder by the reformist bishop and the dean who 'pulled down and defaced most of the beautiful Tombs in this Church; and broke all the Figures of the Saints round about this Building; and pulled down those of our Saviour, the Virgin, and the Crucifix; so that at the End of the Year 1548, there was scarcely a whole Figure or Tomb remaining.'[1]

During the Civil War in the next century much destruction was inflicted on religious art by the Puritans and, to use the same example, Lincoln Cathedral, the building was attacked in 1644 and 1648, when much stained glass was broken. John Evelyn, who visited the building in 1654, noted in his *Diary*: 'The soldiers had lately knocked off most of the brasses from the gravestones, so as few inscriptions were left; they told us that these men went in with axes and hammers, and shut themselves in, till they had rent and torn off some barge-loads of metal, not sparing even the monuments of the dead.'[2] No wonder the only Romanesque figure sculpture surviving in Lincoln is the unique frieze, too high on the west front to be reached without a scaffold or a long ladder, though even here, many heads were deliberately broken off (p. 31).

Changing artistic tastes, and the resulting replacement of

Romanesque sculpture by something more in keeping with contemporary fashion, further depleted the number of works from the period. In quite a few cases the discarded sculpture was re-used as building material and was recovered in modern times. Such pieces tend to be very damaged.

It is well known that in England the Normans frequently used stone imported from the ducal quarries near Caen, which is a fine-grained limestone, ideal for sculpture. The sculpture from Reading Abbey (113 and 127) is of Caen stone, which must have been brought in barges across the Channel and up the Thames. Not everybody had the resources of King Henry I, so local materials were used on a vast scale. Masons and sculptors probably often had workshops near quarries; it is helpful to have a proper identification of the source of the stone, a task at present being carried out by Mr R. W. Sanderson of the Institute of Geological Sciences. Most Romanesque sculpture, like the classical before it, was painted but certain stones were valued for their intrinsic colour and polish and these were left plain. A stone which enjoyed great popularity during the 12th century was black Tournai marble, exported from what is today Belgium to many countries bordering the English Channel and the North Sea. In most instances, this took the form of mass-produced fonts and tombstones but, in some cases, the stone was not carved until it reached its destination (145). Purbeck marble was a local substitute for Tournai marble (146), and there were other stones which were employed for their ability to take a fine polish (149, 169 and 170).

Little is known about the sculptors of this period in England. Some undoubtedly started as masons and, if they acquired skill in carving, probably turned exclusively to sculpture. Some inscribed their work with their signature (107), and a certain Richard not only carved his name in runic script on a font at Bridekirk in Cumbria, but also depicted himself holding a chisel and mallet and carving the foliage on the font. No tools survive from this period, but the tool-marks left on sculpture prove that a wide range of chisels were employed and that the drill came increasingly into use.

It is unlikely that the ordinary sculptor knew Latin, even if he had learned to write his name in that language, but there was a class of sculptor of a different kind, who undoubtedly did. Such were the artists who practised several techniques with equal competence, namely book-painting, wall-painting, goldsmith's work, ivory carving and stone sculpture. Hugo of Bury St Edmunds is the best example of this kind of artist, but there were others. The carved capitals of the crypt in Canterbury Cathedral, c. 1100, are so close in their style and subject matter to the initials painted in contemporary Canterbury manuscripts, that they must have been created by the same artists. There are objects in other materials which must also be attributed to them and these include ivories (199), metalwork (247) and objects in wood. The great revival of sculpture in all Western Europe during the late 11th century was due to the fact that artists who had previously specialized in refined, small-scale luxury objects for church treasuries and libraries started to work in stone in co-operation with the mason-sculptors.

The Norman Conquest of England occurred on the eve of this sculptural revolution and, with a slight delay, England followed the same path of development. When the Normans took control of a country so much larger and richer than their own duchy, they embarked almost immediately on an immense building programme. There were clearly not enough sculptors available to do the work required, if all capitals were to be carved, as was by then the custom. They therefore resorted to the expediency of using cubic (or cushion) capitals, for these could be mass produced and then embellished with paint. By the end of the 11th century cubic capitals had started to be occasionally carved, as in the crypt of Canterbury Cathedral (p. 21). A delightful example from Campsall in Yorkshire is also of this type (103).

Cubic capitals were sometimes used side by side with the Corinthian form, the type which was very popular in Normandy, and such Corinthian capitals were frequently enriched with human or animal heads (101 and 102). Narrative subjects on capitals in 11th-century Normandy were rare, and so it is all the more remarkable to find carved in William Rufus' Westminster Hall an extensive series of secular subjects (105), which present a striking parallel with the borders of the Bayeux Tapestry. The fragment of a relief from Winchester (97), whatever its date, seems to belong to this type of secular art.

In comparison with pre-Conquest sculpture the kind of decoration introduced from Normandy was, to say the least, modest but, being closely bound with architecture, it had a certain massiveness and strength which it shared with early Romanesque buildings. One of the most popular forms of Norman decoration was geometric and this was transplanted to England from the outset. The earliest carved tympanum surviving in England, on the keep of Chepstow Castle, c. 1070, is of that type. Adopted from Islamic art, the chevron or zigzag was first applied to arches in Normandy in the last quarter of the 11th century and made an early appearance in England. This ornament became almost inseparable from Romanesque architecture (e.g. p. 35) and continued to be used throughout the 12th century (171).

During the peaceful reign of Henry I Romanesque sculpture came of age. Contacts with many artistic centres on the Continent, especially Lombardy, became widespread, and the marriage of the King's daughter Matilda to the Emperor Henry V strengthened the influence of German art. Henry's own foundation, Reading Abbey, was lavishly decorated with sculpture, the best remnants of which are from the cloister and the chapter house (127). The patronage of Henry was imitated by his chancellor, the rich and powerful Roger, Bishop of Salisbury, who not only enlarged and enriched with sculpture his cathedral of Old Sarum (135), but also his castles and especially Sherborne (131). But while foreign influences on English sculpture were widespread, the local pre-Conquest traditions were still alive, producing works inspired both by the Winchester School style (109) and the Scandinavian Ringerike and Urnes (121–4 and 126).

Large-scale narrative sculpture applied to doorways, especially to their tympana, to friezes and to church furnishings such as screens, was rare in England where small-scale intricate forms were clearly preferred. Our view of this may be, to some extent, distorted by the destruction of religious art in the 16th and 17th centuries when purely decorative art had more chance of surviving than religious scenes. Judging by what is preserved in other countries, it is safe to assume that some of the most artistically important works of sculpture were church fittings such as screens, retables, altar-frontals, crucifixes, shrines, tombs and fonts, but, with the exception of fonts, nothing survives save a few fragments.

The turbulent years which followed Henry's death in 1135 witnessed the emergence of several regional schools of sculpture, for example in Yorkshire (140 and 141) and Northamptonshire (142). The remarkable font from Castle Frome (139) is typical of the school which came into being in Herefordshire in the 1130s and produced such outstanding schemes of decoration as Shobdon and Kilpeck (p. 19). Other

sculptures of this school include the tympanum from Fownhope (**138**) and another, recently discovered, at Billesley (**137**). This school of sculpture arose through the influence of a sculptor who must have been taken on a pilgrimage to Santiago de Compostela in Spain by Oliver de Merlimond, the founder of Shobdon Church, and who evidently studied and made sketches of sculpture in churches on the road to Santiago and especially those in Poitou and Saintonge. On his return to Herefordshire his sketches clearly became models for the decoration of a large number of buildings in the area.

Pilgrimages were of considerable importance during this period and there were a large number of people of all classes who made sometimes long journeys to holy places, especially Jerusalem, Rome and Santiago. Such travel had, in some instances, important artistic consequences by giving artists and patrons an opportunity to see the art of other countries or regions, and this resulted in the spread of artistic ideas. Pilgrimages were only one of the reasons for travel; in fact, the people of the period crossed frontiers with ease and frequently.

The reign of Stephen produced some of the most outstanding works of English Romanesque sculpture. From the King's own foundation, Faversham Abbey, only one Purbeck marble capital survives (**146**). The King's brother, the Cluny-educated Henry of Blois, Bishop of Winchester and Abbot of Glastonbury, was a discriminating patron who built up a collection of antique sculpture which he had bought in Rome. Two capitals from Winchester with centaurs and other creatures based on classical models (**150** and **151**) could well have been inspired by Roman reliefs in this collection. In all probability it was due to his patronage that Tournai marble was introduced into England.

One of the greatest patrons of the arts during this period was Abbot Suger of St-Denis, whose architectural and sculptural innovations changed the course of artistic development in Europe. The choir of the church which he caused to be erected between 1140 and 1144 was the first Gothic structure ever built and the west front, which was consecrated in 1140, included three portals lavishly decorated with tympana, intricately carved colonnettes and 20 column-figures, that is statues attached to responds. Such statues, representing the royal ancestors of Christ, became a standard feature of Gothic façades. Many English ecclesiastics tried to emulate Suger and it appears that Henry of Blois was one of them. Another was Anselm, the Abbot of Bury St Edmunds, who commissioned Master Hugo to cast bronze doors for his abbey, depicting scenes from the Passion, in clear imitation of Suger's bronze doors at St-Denis which also had narrative reliefs. Roger of Salisbury's two nephews were also great patrons of the arts. Alexander 'the Magnificent', Bishop of Lincoln, rebuilt his cathedral and inserted into the 11th-century façade three doorways and a frieze (p. 31) which combine elements derived from Italy with those from St-Denis (**143**). The impact of the St-Denis sculpture can also be found in York (**144**).

The north of England, laid waste by William the Conqueror, had by the second half of the 12th century completely recovered from this savage devastation and produced some outstanding

works of sculpture, for example the *Virgin and Child* in York Minster (**153**), strongly Byzantine in character, which was probably inspired by Italo-Greek works brought back from Sicily by Archbishop William Fitzherbert, the nephew of Henry of Blois. The screen panels in Durham Cathedral (**154**) illustrate a different aspect of Byzantine influence, the damp-fold style.

With the accession of Henry II England was brought into even closer artistic contact with the Continent and especially with the Plantagenet dominions. The major decorative schemes of the period are fortunately still *in situ*, the porch sculpture of Malmesbury Abbey and the façade of Rochester Cathedral (p. 25), but important fragments of sculpture from the early years of Henry's reign also survive: fragments from the King's favourite palace at Clarendon (**155**), the remarkable statuettes from St Albans Abbey (**152**) and two figures from Ivychurch Priory (**157**).

During the later years of his reign stylistic changes inspired by Mosan and Byzantine art led to the emergence of the Transitional style. This new, more naturalistic trend is well illustrated by a number of sculptures of a high order, found in many parts of the country. In the south the most important are the reliefs from the screen erected in 1180 in Canterbury Cathedral (**164**). In the north there are the strongly classical statues from St Mary's Abbey at York (**173**, **174** and **175**) and the charming and unusual reliquary cross from Kelloe (**176**). The west of the country has the delicate doorways, still *in situ*, in the ruins of the Lady Chapel of Glastonbury Abbey, the remarkable lavabo and lectern from the Cluniac priory at Much Wenlock (**169** and **170**) and the recently-discovered keystones from Keynsham Abbey (**163**). Some of these works date to the reign of King Richard and one or two may even be a little later.

When compared to the works produced soon after 1066, the sculpture of the second half of the 12th century shows that quite a dramatic change had taken place. What had been a flat relief, often in two planes, became three-dimensional, fully exploiting the play of light and shade. The often oddly-proportioned figures gave way to an anatomically correct rendering of forms. The stress on geometric and ornamental patterns had largely disappeared. What was dynamic and expressive became relaxed, gentle and almost classical. It would be foolish to say that during those hundred or so years, sculpture made progress, for such a notion should not be applied to art. In one respect there was an obvious improvement, namely in the technique of carving, with a resulting greater mastery over the material. There was also a considerable change in the presentation of a story. The simple scene, almost in shorthand, developed into a complex narrative often involving many figures in well-presented compositions. Even the religious content altered somewhat and the earlier preoccupation with hell and the struggle with evil became less frightening and morbid. The greater humanism and naturalism which affected all the arts, including sculpture, were the principal achievements of the late Romanesque period and a worthy equivalent of the intellectual Twelfth-century Renaissance. G.Z.

NOTES

1. H.F. Kendrick, *The Cathedral Church of Lincoln*, 1899, p. 37
2. Kendrick, op. cit., pp. 39–40

95

95 Relief from a sarcophagus

Oolitic limestone; broken into four pieces, but otherwise well
preserved; traces of original paint on a gesso base; *h* 470 mm,
w 570 mm (at top), 540 mm (at base), *d* 200 ɯɯ
Anglo-Scandinavian; *c*. 1030
London, Museum of London, no. 4075

This relief has been called 'the finest Viking antiquity in the
country' (Kendrick, 1949, p. 99). On the left edge a two-line
Scandinavian runic inscription reads: *k[i]na : let : lekia : st/in :
pensi : auk : tuki :* ('Ginna and Toki had this stone set up'). On
the main face, carved in two planes, is the combat between the
lion and the serpent in a typically Ringerike style, in which the
Scandinavian animal design is enriched by the addition of the
Winchester School acanthus, transformed into long tendrils
with tightly curling ends. There is a remarkable unity in the
composition, with repetitive spirals incised on the animal's
hips, echoed by similar forms of foliage, the whole expressing
boundless energy. The lack of any religious symbols well
illustrates how superficial was the Christianity of the Vikings
in England during the reign of King Cnut (d. 1035). G.Z.

PROVENANCE Excavated in St Paul's Churchyard, London, 1852
EXHIBITIONS *The Vikings in England and their Danish Homeland*, Copenhagen, 1981; Århus,
1981; York, 1982, no. 199
BIBLIOGRAPHY Kendrick, 1949, pp. 99–100; Stone, 1955, p. 38, pl. 23; J. Graham-Campbell and
D. Kidd, *The Vikings*, 1980, pp. 168–73

95

96

96 The Harrowing of Hell coffin lid

Sandstone; broken in two and repaired, many details damaged, conservation work carried out by M.R. Eastham, 1983; *h* 1.70 m, *w* 650 mm (at top), 765 mm (at base), *d* 150–240 mm
Anglo-Saxon; *c.* 1050; St Augustine's, Bristol
Bristol, Dean and Chapter of Bristol Cathedral

Christ giving the benediction with His right hand, holds the cross in His left, to which the two small nude figures of Adam and Eve are clinging. Christ is trampling on the bound Devil emerging from the mouth of Hell. The Harrowing of Hell, based on the Apocryphal Gospel of Nicodemus (Romilly Allen, 1887, pp. 278–81), was a popular subject in medieval art and drama (see **109a**). The relief stands out strongly against the rough surface of a deeply-scooped background and the folds are marked by shallow grooves. Except for the circular line on Christ's shoulder, the draperies are logical, with two groups of nested V-folds, such as are frequently found in the manuscripts and ivories of the Winchester School style. Particularly close is the Christ in the mid-11th-century Psalter in the British Library

(1; MS Cotton, Tiberius C.VI, ff. 10ᵛ and 14ʳ) and an ivory of the same date in a private collection in Paris (Saxl, Wittkower, 1948, no. 23; Beckwith, 1972, no. 14). The dates proposed for the relief range from 1000 (Rice, 1960, p. 167) to 1100 (Saxl, Wittkower, 1948, no. 23) and even later (C.E. Keyser in *Archaeologia*, vol. 47, 1883, p. 172), but the stylistic similarities mentioned above and, even more relevantly, between the relief and the Hereford Gospels in Cambridge (Pembroke College MS 302) of *c.* 1050 (Temple, 1976, no. 96), make it likely that the relief is of a similar date.

The Augustinian abbey, now Bristol Cathedral, was founded about 1140 (Dickinson, 1976, pp. 109–36) on a site which, as Dickinson argues, was visited in 603 by St Augustine, the apostle of the English. The relief was found in 1832 under the chapter house floor, serving as a coffin lid. It was one of twelve coffins and Dickinson may be right in thinking that there was an Anglo-Saxon cemetery on the site. He hints that the relief could have been made in the 11th century for the tomb of a certain Jordan, who was believed to have been a companion of St Augustine. As the relief tapers, it was in all probability made as a coffin lid, and the subject of leading souls to salvation is therefore very appropriate. G.Z.

BIBLIOGRAPHY Saxl, Wittkower, 1948, nos. 4, 23; Stone, 1955, pl. 24; J.C. Dickinson, 'The Origins of St Augustine's, Bristol', *Bristol and Gloucestershire Archeol. Soc.*, vol. C, 1976, pp. 109–26

97 The so-called Sigmund relief

Box Ground Oolite, from the neighbourhood of Bath;
h 695 mm, *w* 520 mm, *d* 270 mm
1016–1035 or Romanesque; Winchester Old Minster
Winchester City Museum; Winchester Research Unit,
CG.WS.98

The scenes carved on this severely damaged relief originally extended in all four directions and illustrate two stories. In the first, a figure in a mail shirt and with a broad-bladed sword is walking to the left. The upper part of the body and the feet are missing. The second scene involves a figure with long hair lying on its back, its raised arms and neck bound together with a rope. Above is a dog or a wolf whose fore-paw and tongue touch the face of the bound figure. Most of the human figure and that of the animal are missing.

This fragment was excavated by Biddle in 1965 on the site of the eastern crypt of the Old Minster (cathedral) at Winchester where it had been thrown as rubble when the Anglo-Saxon church was demolished in 1093–4, to make room for the Romanesque cathedral. Biddle (1966) put forward an ingenious interpretation of the meaning and purpose of the relief. He identified the figure lying on its back as Sigmund, a hero from the Volsunga Saga, who, together with his nine brothers, was taken prisoner. All of them were put into stocks and abandoned in a forest to die. Night after night a she-wolf killed one of the brothers but on the tenth night a servant sent by their sister smeared honey on Sigmund's face and in his mouth. The wolf put her tongue into Sigmund's mouth to taste the honey and Sigmund bit it and, in the struggle the stocks were split open and the wolf died.

Some episodes of the Volsunga Saga were carved in Sweden, Norway and England but no representation of the Sigmund and the wolf story exists. Biddle believes that the relief was part of an extensive interior or exterior frieze over 20 m long, commissioned for the Anglo-Saxon cathedral by King Cnut, to commemorate the common ancestry of the English and Danish royal houses, which included Sigmund and his son Helgi.

97

This attractive hypothesis rests on many assumptions. No alternative solution is offered but several points can be usefully examined.

Biddle noted the similarity of the armour used on the relief to that found on the Bayeux Tapestry of *c.* 1070, and on the other hand the lack of any Anglo-Saxon works in a style which can be compared to the Winchester panel. In the opinion of the author of this entry the solid, round forms with well-defined contours are Romanesque rather than Anglo-Saxon.

The identification of the relief as the story of Sigmund rests on the assumption that the bound figure is a man, but the relief is too damaged for one to be certain of this. On the Romanesque apse of the collegiate church at Königslutter in Lower Saxony there is a relief depicting a man bound by two rabbits, and themes of that kind, part humorous, part moral, often inspired by Aesop's fables, are frequently found in Romanesque art, including the Bayeux Tapestry. On the very large and extensive Romanesque frieze on the façade of Andlau church in Alsace, there are several such subjects, as well as episodes taken from epic stories, including some of Scandinavian origin (R. Will, *Alsace romane*, Zodiac series, 1970, p. 262, pls. 103–11).

If the relief does indeed represent the story of Sigmund, could it be that it is a Romanesque copy of a subject which was depicted at Winchester on an embroidered hanging presented by Cnut and which served as a prototype for the Bayeux Tapestry?

These and many other problems raised by this unusual sculpture deserve investigation. G.Z.

EXHIBITIONS Winchester, 1972, no. 16; 1973, no. 18; Copenhagen, 1981; Århus, 1981; York, 1982, no. J1
BIBLIOGRAPHY Biddle, 1966, pp. 329–32

98a and b Two respond capitals (*not illustrated*)

Limestone; both in good condition, but necking and one angle of (**b**) damaged; **a** *h* 480 mm, *l* 550 mm, *w* 280 mm; **b** *h* 370 mm, *l* 360 mm, *w* 360 mm
c. 1040–52; Jumièges Abbey of Notre-Dame
Jumièges, the Abbey Museum, République française, Ministère de la culture

98a The design consists of a central rosette from which spring scrolls of foliage, forming circular frames, the upper two of which enclose confronted birds, their heads turned back. The motifs are in low relief but stand out clearly against the background. The modelling is achieved by means of sharp incisions and grooves. The capital comes from the transept of the abbey church and its dimensions suggest that it was part of the double arcading under the tribunes.

This capital, as well as several others in a similar style, was found *c.* 1852 by the founder of the Jumièges Museum, A. Lepel-Cointet. Apart from the related capitals in the Museum, of which (**b**) is one, there are others, still *in situ*.

The style of all these capitals is closely related to the ornamentation of manuscripts of the Winchester School style and especially those of the first quarter of the 11th century from Christ Church, Canterbury (e.g. Cambridge, Trinity College B.10.4 and British Library, Royal MS 1 D IX).

The peculiar shape of the central motif and the flexible stems around it very often occur in the ornamental borders of such manuscripts. It must be recalled that Robert Champart, Abbot of Jumièges (1037–44), then counsellor to King Edward the Confessor, Bishop of London (1044–51), and Archbishop of Canterbury (1051–2), sent gifts to his former abbey (among which was the *Sacramentary of Robert of Jumièges*, Rouen MSY.6). In his time, Jumièges must have been in close relations with England.

The Jumièges capitals are among the first examples of an important trend of architectural sculpture in England, Normandy and northern France, where carved ornamentation in low relief on the whole surface of the block is closely related to manuscript illumination and ivory carvings (Bibury, Gloucestershire *c.* 1050, St-Ouen in Rouen *c.* 1070, Goult *c.* 1090, Fécamp *c.* 1106, Montivilliers *c.* 1115 (sculptures destroyed *c.* 1830), Canterbury Cathedral crypt *c.* 1100, St-Bertin Abbey *c.* 110, Worcester Cathedral *c.* 1120).

98b Carved on three sides with foliage organized in three different compositions, this capital belongs to the same group of sculptures as (**a**) and was found nearby. It came originally either from the transept, or more likely from the choir of the abbey church. M.B.

BIBLIOGRAPHY L. Jouen, G. Lanfry, J. Lafond, *Jumièges, à travers l'histoire, à travers les ruines*, Rouen, 1954, pp. 160 and 185–6; L. Grodecki, 'Les débuts de la sculpture romane en Normandie: les chapiteaux de Bernay', in *Bull. Mon.* CVIII, 1950, p. 64 and fig. 26; G. Zarnecki, 'The Winchester Acanthus in Romanesque Sculpture', *Wallraf Richartz Jahrbuch*, XVII, 1954, pp. 211–14; J. Taralon, *Jumièges*, Paris, 1962, pp. 22 and 37, 2nd ed. 1979, pp. 31 and 58; Zarnecki, 1966, pp. 93–4 and pl. VIIA; R. Liess, *Der frühromanische Kirchenbau in der Normandie*, Munich, 1967, pp. 233–5; L. Grodecki, *Le siècle de l'an mil*, Paris, 1973, p. 82; L. Musset, *Normandie romane* II, La Pierre-qui-vire (Zodiaque) 1974, pp. 108–9 and pl. 34; G. Zarnecki, 'Romanesque sculpture in Normandy and England in the eleventh century', in *Proc. Battle Conference*, I, 1978, pp. 174–6; Rouen, Caen, 1979, no. 197; M. Baylé, 'La sculpture romane en Normandie. Le décor inspiré des enluminures et des ivoires', in *Archaeologia* (Dijon) No. 144, July 1980, pp. 44–8; 'La sculpture du XI siècle à Jumièges et sa place dans le décor architectural des abbayes normandes', in *Aspects du Monachisme en Normandie, Actes du Colloque Scientifique de l'Année des Abbayes Normandes* (1979), Paris, 1982, pp. 75–80

99 Respond capital

Limestone, lower part of capital damaged; necking and one
volute missing; *h* 360 mm, *l* 590 mm, *w* 590 mm
c. 1063
Rouen, Cathédrale de Rouen, République française, Ministère
de la culture

This capital was found during the excavations of 1945–55, re-
used in the foundations of the fourth southern pier of the
Gothic nave, and is now kept in the crypt.

Amongst the six capitals then discovered, four, including this
one, were respond capitals and two were free-standing. All six
are of a very similar type with simple geometric decoration and
one with a mask. They all come from the building erected
under Archbishop Maurilius and dedicated in 1063.

Such capitals with crudely carved masks and prominent
volutes in the upper register and with a lower row of plain
leaves, are very common in Romanesque Normandy, especially
between 1050 and 1080: the nearest parallels to the Rouen
capital are found in the crypt of Bayeux Cathedral (*c.* 1050),
in Thaon old church (*c.* 1060), in the nave of the Trinity abbey
church in Caen (*c.* 1070) and in St-Etienne, Caen. Later
examples do not preserve such a powerful monumentality of
the block.

Although this type did not spread as widely in England as
in Normandy, it may be found, with some differences, in
Gloucester Cathedral crypt (*c.* 1089), in Blyth Priory church
(*c.* 1080) and in Stogursey parish church, a former priory of
Lonlay-l'Abbaye. It may also be compared to capitals from
York Minster, the richer composition of which depends on
more complex origins (see 101). M.B.

BIBLIOGRAPHY G. Lanfry, *La cathédrale de Rouen du XI siècle. Chapiteaux retrouvés dans le
fouilles* in *Bulletin de la Commission des Antiquités de la Seine Mme*, XXII, 1953–9, pp. 294–5;
La cathédrale dans la cité Romaine et la Normandie Ducale, Cahiers de N.D. de Rouen, Rouen,
1956, pp. 33–7 (3 pl.); J. Verrier, *Fouilles et découvertes* in *Les Monuments Historiques de
la France*, 1956, pp. 93–100; R. Liess, *Der frühromanische Kirchenbau in der Normandie*,
Munich, 1967, p. 163; A.M. Carment-Lanfry, *La cathédrale Notre-Dame de Rouen*, Rouen,
1977, pp. 21–3; M. Baylé, *La Trinité de Caen*, Paris-Genève, 1979, pp. 83–9 and fig. 95

99

100

100 Corinthian capital

Medium-grained buff-yellow sandstone; one face of this free-
standing capital cut away, presumably when re-used as
building material, otherwise in good condition; *h* 235 mm
c. 1075; (?) Durham Castle
The University of Durham

The capital has prominent angle volutes, between which are
arched fields, two enclosing plant motifs hanging down from
the apex; below, a leaf ending in a volute and a trefoil plant.
The third arch contains a human head, with an upright leaf
below. Additional upright leaves are carved under the angle
volutes. The damaged necking is in the form of a plain roll.

This is a typical Norman-inspired capital closely related to
those in the crypt of the chapel in Durham Castle, founded in
1072 by William the Conqueror 'as a stronghold for the bishop
through whom he hoped to govern this turbulent part of the
country' (Colvin, 1963, p. 21). The original location of this
capital is unknown but its similarity to the castle capitals
(Zarnecki, 1951, especially pl. 3) suggests that it too was made
for the castle. (For Durham Castle chapel, see G. Baldwin
Brown, 'Saxon and Norman Sculpture in Durham', *Antiquity*,
vol. V, 1931, pp. 438–40.) G.Z.

PROVENANCE Found in a builder's yard, North Road, Durham

101 Respond capital

Limestone; worn and damaged through re-use, but still
preserving traces of red paint and a black ground; *h* 480 mm
c. 1080; York Minster
York, Dean and Chapter of York Minster

This is the better preserved of two similar capitals discovered
in the 1972 excavations at York Minster. They were originally
part of the building erected by the first Norman Archbishop,
Thomas of Bayeux (1070–1100). The shape of the capitals at
their base suggests that they crowned twin shafts and therefore

101

103

probably came from the crossing. The capital is in two
registers, the lower consisting of roughly-shaped, upright
acanthus leaves springing from a cable-moulded necking. The
tips of the acanthus are broken off. In the centre of the upper
zone is a damaged human head with bulging eyes, and at the
angle are prominent volutes from which spring four stalks, two
on each adjoining face of the capital, each pair forming a
circular frame from which emerge trefoil leaves which end in
curly tips.

While capitals with masks are common enough in early
Anglo-Norman buildings, the combination of masks with
acanthus leaves of the type found in York is not. Such capitals
are rare even in Normandy, the closest parallels existing in the
crypt of Bayeux Cathedral (mid-11th century). The type
originated in the Loire Valley and there are similar but finer
capitals at the Abbey of St-Benoît-sur-Loire (G. Chenesseau,
L'Abbaye de Fleury, Paris, 1931, no. 20, pl. 29a). G.Z.

102 Capital decorated with a mask and foliage

Unknown stone; *h* 210 mm, *w* 230 mm, *d* 305 mm
c. 1090–1100; St Mary's Abbey, York
York, The Yorkshire Museum

This capital comes from a nook-shaft about 150 mm in
diameter and was probably set into a window jamb. It was
discovered in 1955 during excavations at the west end of the
nave of St Mary's Abbey. A mask-like human face on the
corner is flanked by symmetrical leaf sprays and long stalks.
The latter may have ended as a projecting volute.

The piece has scarcity value since it is the only decorative
carving known to have survived from the abbey church whose
foundation stone was laid by King William II in 1089. Together
with Durham Cathedral Priory, St Mary's, York was the
North's most important monastic house, and its 11th-century
church was architecturally far more ambitious than that begun
at York Minster about a decade earlier.

Capitals with single, simply carved masks occur in
11th-century Normandy (e.g. **99**) and in several first-generation
Anglo-Norman buildings such as Durham Castle chapel, Blyth
Priory and Gloucester Cathedral crypt. All these examples have
a face set in the middle of each side, but the St Mary's design
could have been suggested by a capital such as the one in
Durham Castle whose corners are supported by atlantes with
outsized heads. C.W.

103 Cubic capital

Limestone; in good condition, cleaned by Dr S. Rees-Jones,
1983; *h* 180 mm, *w* 200mm (at top), *d* 200 mm (at top), *diam*
(of column) 150 mm, *l* (total, of block) 305 mm
c. 1090; St Mary's Church, Campsall, Yorkshire
The Parochial Church Council, Campsall Parish Church

The small size of this respond capital suggests that it was used
in a window or wall arcade rather than in a doorway or chancel
arch. Only two out of three sides are carved, that on the right
with a seven-petalled demi-rosette, the middle one with a lion
entangled in foliage. The shallow relief is in two planes, almost
like the Ringerike sarcophagus from St Paul's, London (**95**).
The motif of an animal entangled in foliage as if struggling
with it is clearly derived from Viking art, of which there are
numerous examples in Yorkshire. Even more markedly
Scandinavian capitals are found in the windows of another
Yorkshire church, Kirkburn Priory (Kendrick, 1949, p. 120,
pl. LXXXIV). G.Z.

102

104 Tympanum (*illustrated on p. 63*)

Limestone of local origin; *h* 390 mm, *w* 920 mm, *d* 130 mm
1090–1100; All Saints Church, Lathbury, Buckinghamshire
The Rector of Newport Pagnell with Lathbury

This tympanum was removed in 1983 for conservation by
Harrison Hill Ltd. The Romanesque church of which it formed
part has been almost entirely rebuilt and it is unknown from
which doorway the tympanum came. The stone was broken
into many pieces and these have now been joined together. In
some earlier restoration the missing left upper corner was
repaired, and in 1983 the bottom right corner was similarly
completed. Originally the tympanum continued upwards at
least 90 mm so that the carved design was enclosed by a
semicircle which had a radius of 475 mm.

Tympana usually consist of one or more stones shaped to
make a semicircular field for sculpture. In a few cases in
England a rectangular stone was used on which a semicircular
field was marked for carving. This expediency is found only in
rural churches of the late 11th century (Keyser, 1927, figs. 11,
13).

The relief of the Lathbury tympanum is very flat, with hardly
any modelling. The composition is divided in two by a central
stem of interlaced beaded bands, presumably symbolizing the
Tree of Life, from which issues a scroll of foliage with leaves,
filling the top left portion of the tympanum. One beaded band
continues upwards towards the missing top. The stem is
flanked by two animals, on the right a lion with a stylized
mane, the tail passing between its hind legs and emerging high
up with a leaf terminal. The head is damaged and it is not clear
whether the lion is showing its tongue, as do so many of the
lions on the borders of the Bayeux Tapestry, or is biting
foliage. To the left of the stem is a similar animal but without
a mane, perhaps a lioness, her head turned back to bite the
beaded body of a serpent, whose half-hidden head is biting the
lioness's neck. A similar, but damaged, serpent's head is seen
behind the lion's hind legs and it seems that the serpent's body
is transformed into foliage, which fills the upper right part of
the tympanum. This serpent-foliage is distantly related,
perhaps derived, from such Anglo-Viking works as the relief
from a sarcophagus found in London (95).

The meaning of the tympanum is fairly clear but it is
significant that instead of a straightforward Christian subject
concerning sin and salvation, the village carver preferred
symbolism involving the struggle of animals, which he based
on Scandinavian traditions, evidently still very much
alive. G.Z.

BIBLIOGRAPHY RCHM, *Buckinghamshire*, vol. II, 1913, p. 161, pl. p. 14; Keyser, 1927, p. 30, fig. 39

105b

105c

105a–f Six respond capitals (*a not illustrated*)

Limestone; *h* 240–250 mm
c. 1090; Westminster Hall
Department of the Environment, Directorate of Ancient
Monuments and Historic Buildings (Jewel Tower,
Westminster)

Westminster Hall was a royal palace, the largest in England
and probably in Europe, completed in 1099 (Colvin, 1963,
p. 45). In 1835 ten carved capitals and one abacus were found,
re-used in the 14th century for refacing the walls, and these
were drawn by Smirke and published in *Archaeologia*
(vol. XXVI, 1836, pls. XLIII–XLIX). Of these only nine capitals
survive, eight respond capitals normally exhibited in the Jewel
Tower and one free-standing capital in the Museum of
London (106). Most of them are badly damaged through re-
use. The respond capitals are all block-shaped and their small
size suggests that they probably decorated the blind arcades of
the interior walls. The subjects carved are either decorative or
narrative. To the first category belong three capitals (and one
drawn by Smirke, but now missing).

105a An animal (lion?) encircled by foliage (one face of the
capital survives).

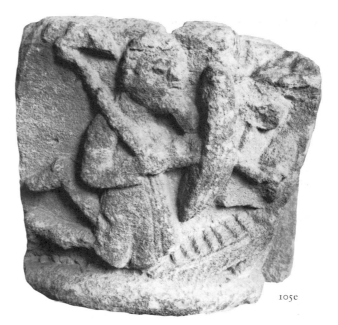

105e

105f

105b A dragon seen from above, with a beaded spine and foliate tail and forming a circle. The tail of another animal at the angle suggests that a similar composition existed on the adjoining face.

105c A lion with a foliate tail facing an eagle preening its breast.

The narrative subjects include the following:

105d A warrior in a short tunic and carrying a round shield charges forward. A branch of foliage emerges between his feet. Judging by the remnants of feet and foliage on the right face, he was facing an adversary, now obliterated.

105e The assault on a castle. On the right face is a tower on stilts, similar to that at Dinan as represented on the *Bayeux Tapestry* (Brown, 1970, p. 34, pls. 10 and 13). The heads of two defenders appear between the crenellations. On the left face is a kneeling soldier in a short tunic, an axe in one hand and a round shield in the other. This is how the English infantry is shown on the *Bayeux Tapestry*. In front of the soldier, steps lead up to the castle gate which swings back behind a third defender whose long sword pierces the attacker's shield and enters his mouth. This explains his kneeling, collapsing position.

105f Smirke identified the subject of this capital as the fable of the ass. The animal's head is seen in the upper right-hand corner of the left side of the capital, watching his master playing with a dog, who reaches up to lick his master's face. On the other side the ass attempts to imitate the dog by putting his front hoofs on his master's shoulders to lick his face but the master turns away in disgust, while one of the servants punishes the ass with a club.

Of the two capitals in the Jewel Tower, not in this exhibition because of their damaged condition, one depicts the hunting of a stag, the other the fable of the wolf and the lamb.

The subjects represented on this series of capitals are very suitable for a secular building, although fables based on Phaedrus and Aesop were also used in churches and monastic buildings for their didactic value (Mâle, 1978, pp. 337–40). Numerous fables are illustrated on the borders of the *Bayeux Tapestry*, to which the capitals in Westminster Hall have close similarities in style and iconography. G.Z.

BIBLIOGRAPHY Grant, 1976, with full bibliog.

106 Free-standing capital (*not illustrated*)

Limestone; *h* 180 mm
c. 1090; Westminster Hall
Department of the Environment, Directorate of Ancient
Monuments and Historic Buildings, on loan to the Museum of
London

The capital is very damaged, one side being almost obliterated
and the base broken off. It belongs to a well-known type in
early Romanesque art in which eight upright lions are arranged
in pairs, paw to paw, in the centre of each face. The lions'
heads are turned back and merge with the heads of their
neighbours and bite one of their own forepaws. The parallels
for such capitals are many, from León in Spain to Toulouse,
St-Benoît-sur-Loire and Rucqueville in Normandy. The
sculptor of this capital must have been in touch with the
developments in Continental sculpture at that time.

Although the capital is different in shape, type of decoration
and style from the previous capitals (105), it is likely that it is
contemporary with them. One side is carved more carefully and
with more detail, and was clearly the principal side for
viewing. G.Z.

BIBLIOGRAPHY Grant, 1976, p. 4

108

107 Fragment of a voussoir

Caen stone; re-used as rubble, much abraded and chipped;
h 100 mm, *l* 200 mm
c. 1100; St Augustine's Abbey, Canterbury
Property of St Augustine's Foundation, Canterbury, on deposit
at Dover Castle. Department of the Environment, Directorate
of Ancient Monuments and Historic Buildings, 78203129

St Augustine's Abbey, Canterbury, one of the most eminent
religious houses in the country, had the distinction of being the
first Benedictine monastery founded in England. Unfortunately,
after 1538 the great abbey was systematically destroyed and
consequently much less is known about its sculptural
decoration than about its neighbour and rival, Christ Church
Cathedral. What does remain, however, suggests that the
carving was closely related to that of the cathedral. This point
is borne out by the manuscripts produced at both houses, the
styles of which are often indistinguishable.

This piece is unusual for the Romanesque period in England
in that it is signed by the artist: *Robertus me fecit* ('Robert
made me'). Beneath this inscription is a male half-figure
flanked by two grotesques tugging at his beard, while he in turn
holds their tails. The figures are composed of simple, smooth
geometric shapes and incised lines. The piece is slightly curved
and the inscription suggests that it formed the keystone of an
arch.

The dynamic style of the carving is reminiscent of the famous
capitals in the crypt of Canterbury Cathedral. It also presents
close parallels with contemporary manuscript initials from
both St Augustine's Abbey and Christ Church Cathedral,
notably the Josephus, Cambridge, St John's College MS8, f. 219
(Zarnecki, 1950b). D.K.

BIBLIOGRAPHY Zarnecki, 1950b, p. 75; Zarnecki, 1951, no. 58; Kahn, 1982, p. 50

108 Foliage capital

Caen stone; despite surface chipping, traces of vivid pigment
survive, dark brown in background and light blue and pink on
leaves; *h* 220 mm, *l* 190 mm
c. 1100; St Augustine's Abbey, Canterbury
Property of St Augustine's Foundation, Canterbury, on deposit
at Dover Castle. Department of the Environment, Directorate
of Ancient Monuments and Historic Buildings, 743172

The capital is carved with symmetrically arranged, supple
stalks of foliage, terminating in leaves. This motif is closely
related to manuscript initials of the late 11th and early 12th
centuries produced at Canterbury, notably in a St Augustine's
Passionale (see 14) in the British Library, MS Arundel 91,
f. 206ᵛ, initial B. The style of the carving is also related to that
on the east face of the apse capital in St Gabriel's chapel, in
the crypt of Canterbury Cathedral. D.K.

BIBLIOGRAPHY For St Augustine's Abbey see 107; Kahn, 1982, p. 51; Geddes, 1983, p. 95

109a–f Narrative capitals (*c, d and e not illustrated*)

Shelly oolitic limestone; some damage to the surface and two
capitals broken; *h* 250 mm
c. 1100–10; Hereford Cathedral
Hereford, Dean and Chapter of Hereford Cathedral

Until 1842 these capitals were part of the main apse arch but
L. Cottingham, who was restoring the church in that year,
replaced them, rather pointlessly, by copies. The capitals
crowned the respond columns and alternated with scalloped
capitals, which crowned square responds. The outer and
middle capitals on either side of the arch are small, each of the
two carved faces being 250 × 250 mm, while the inner capitals
are of the same height but have one short (250 mm) and one
long (440 mm) face.

109a The Harrowing of Hell. Christ with a banner and
dressed as a priest, the hand of God above Him, takes Adam's
hand. There are other nude figures emerging from the mouth
of Hell, which is depicted upside-down; and the devil, his
hands bound, is at the bottom. On the other face another devil,
with bat-like wings and a bird's head and a tail ending in a
similar head, holds instruments of torture. This capital was the
northernmost of the arch.

109b There are two nimbed figures, one standing and
displaying an open book, the other seated in a pose of
submission. This could be the Annunciation, but the standing
figure has no wings. A similar nimbed messenger brings news
to a bearded, also nimbed man holding a long cross. Perhaps
this is the angel appearing to Joseph (Matthew 1.20). This was
the middle capital on the north side.

109c The short face, which was towards the congregation, is
carved with the symmetrical interlace of two stalks of foliage,
emerging from a palmette base. On the long face, a nude devil
with only a long cloak fluttering behind it is astride a lion with
a tail ending in a head. The devil holds the reins which come
from the lion's mouth. This capital was the inner one, on the
north side.

109d From the head of a fierce animal, placed at the angle,
branches of foliage emerge and end in large leaves. This was
the southernmost capital.

109e On each of the two faces is an irregular arch under
which is a seated, nimbed figure with arms raised. One figure
has a beard. The identity of the figures is obscure. This capital
was in the middle of the southern half of the arch.

109f On the short face is a crouching, bearded figure with
wings, holding an object which looks like a stole. On the long
face is a flying angel holding a cross. This was the southern
capital of the inner arch.

This series includes some of the earliest narrative capitals in the
country (other than those from Westminster Hall, *c.* 1090, **105**),
though not all the subjects are readily identifiable. There is an
undoubted coarseness in the execution – the disproportionately
large hands, bulging eyes and roughly-carved draperies – and
yet the work has character and power. The relief is quite high
and is in great contrast to the flat, linear style hitherto
employed in England. The figure style owes something to
Anglo-Saxon sculpture (compare capital **a** and the *Harrowing
of Hell* in Bristol, **96**), but the robust carving of animal motifs
is of Norman and perhaps ultimately Italian inspiration. G.Z.

BIBLIOGRAPHY Sir Gilbert Scott, 'Hereford Cathedral', *Archaeol. J*, vol. 34, 1877, p. 317; Prior,
Gardner, 1912, p. 162, fig. 139; RCHM, *Herefordshire*, vol. I, 1931, pp. 90–120; Zarnecki, 1951,
p. 18, pp. 29–30, pls. 27, 28

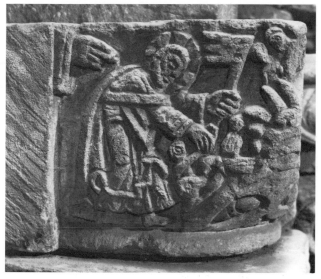

109a

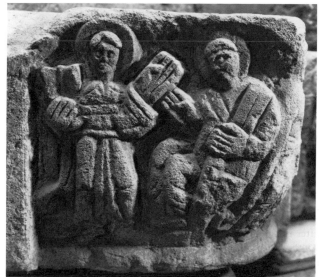

109b

109f

110

110 The Judgement of Solomon capital

Caen stone; at some stage used as building material and
sculpture chiselled off on two faces, also broken into many
pieces and subsequently repaired; *h* 300 mm
c. 1120; Westminster Abbey
London, Muniments of the Dean and Chapter of Westminster

The story, taken from the Book of Kings (III.16–28), is told in
three episodes. In the first scene two women, one standing, one
kneeling, are putting their case to Solomon who is seated on
the right, attended by a servant. The next scene, to the left,
includes five figures, Solomon enthroned, a servant by his side,
and a soldier with a sword raised. On the extreme left, one
woman is standing while another is prostrate, touching
Solomon's feet. The scene continues on the next face, much better
preserved, to the left, where a servant turns to the false mother
holding the child, to announce the king's order that the child
is to be divided with the sword. Behind the woman is a gabled
building, presumably Solomon's palace. The next scene, the
best preserved, shows Solomon with a crown and sceptre, his
legs crossed to emphasize his role as a judge, attended by two
servants and addressing the women. The true mother, a smile

III

on her face, is holding her child. The false mother is shown as
a half-figure, pleading with an expression of sorrow.

The capital is block-shaped and each face is treated as a
separate composition. The proportions of the figures are squat,
but their movements natural. The well-preserved figure of
Solomon is carved with great attention to detail. All the
participants have large, expressive eyes, some with drilled
pupils. In all probability the capital was in the cloister arcade.
The scene of this royal judgement would have been particularly
appropriate in a royal abbey. G.Z.

BIBLIOGRAPHY Prior, Gardner, 1912, p. 162, fig. 138; Lethaby, 1925, p. 35, fig. 17; Zarnecki,
1953a, pp. 8, 53, pl. 1; Stone, 1955, p. 50, pl. 32b

111 Narrative capital

Limestone; surface weathered and many details lost, especially
legs of people and branches of trees, which were completely
detached from background; *h* 255 mm
c. 1120; Lewes Priory
London, Trustees of the British Museum, 39.10.29.43

The block-shaped capital was free-standing, each face being
carved with a separate episode or motif. The scenes should be
viewed anti-clockwise.

1. A boat, built of planks, floats on waves depicted as
concentric strands. There are two men in the boat, simply
dressed, their hair cut in straight fringes. One is holding an oar
and both are pulling out of the water a net with indistinctly
carved fishes in it. This clearly illustrates Matthew IV.18–19,
in which Christ sees Peter and Andrew fishing and calls them to
follow Him.

2. This scene, the Calling of St Peter, illustrates
Matthew IV.20, in which Peter and Andrew 'left their nets, and
followed Him'. A nimbed figure of Christ is separated from the
two figures by a tree, now largely broken. Peter and Andrew
are dressed in cloaks with hoods, presumably the standard
dress for fishermen in the 12th century and essentially like that
of today.

3. Here the nimbed Peter, holding a large key, his symbol,
lifts the lame man whom he has just healed at the gate of the
Temple (Acts III.1–17). The man's crutches are damaged but
unmistakable.

4. This depicts a church built with diagonal ashlar and with
arcades, while on the tiled roof was a cross (now broken). It
illustrates Matthew XVI.18: '. . . thou art Peter, and upon this
rock I will build my Church'.

The subject of this capital was particularly appropriate for
a Cluniac house such as Lewes, since Cluny had a very special
relationship with the papacy, and the popes always emphasized
their succession to St Peter, the first Bishop of Rome. Cluny
Abbey was dedicated to St Peter. The Calling of St Peter is also
found on the lavabo in the Cluniac priory at Much Wenlock
(**169b**). There was yet another, more topical reason for showing
scenes connected with St Peter, and by implication with the
Church itself: the conflict over the lay investiture of bishops
and abbots, which the papacy bitterly opposed. In England, the
conflict first came into the open under Archbishop Anselm
who, returning from Rome in 1100, refused to pay homage to
the new King, Henry I. Seventy years later this conflict led to
the murder of Thomas Becket.

Stylistically the capital is somewhat hesitant and shows a
similar attempt at narrative sculpture to that in the *Judgement
of Solomon* capital in Westminster Abbey (**110**). G.Z.

PROVENANCE Lewes Priory; bought from Dr Gideon Mantell, 1839
BIBLIOGRAPHY Kitzinger, 1940, p. 85, pl. 40; Zarnecki, 1951, pp. 37–8, pl. 71; Stone, 1955,
p. 71, pl. 49b; Lockett, 1971, p. 53, pl. XIV(5) with bibliog.

112

113

112 Aquarius relief

Limestone; weathered, but in fairly good condition; *h* 255 mm,
w 330 mm
c. 1120–30; Wallingford Castle, Oxfordshire
Reading Museum and Art Gallery

This small relief was found in the castle grounds and
presumably formed part of the decoration of the building,
which was already in existence in 1071. However, it is unlikely
that the relief is earlier than *c.* 1120.

The subject is the constellation Aquarius, the water-carrier,
which is usually represented as a semi-nude figure pouring
water from a container. Constellations, or the Signs of the
Zodiac, are often represented side by side with the respective
occupations of the months: Aquarius is matched by the
occupation for January, which is feasting. Medieval calendars,
which contained the Signs of the Zodiac and the Labours of
the Months, were ultimately derived from classical models.
The peculiarity of the Wallingford relief is that the figure's legs
end in hooves, the head is that of a dog and in addition to
carrying bags of water thrown over a hooked stick, the creature
holds an axe in one of its over-long hands, while looking
backwards. There is a carved font at Hook Norton in
Oxfordshire by the same sculptor and on it two signs are
carved, Sagittarius and Aquarius, the latter in a reversed
position to that on the Wallingford relief and with a human
head, but otherwise practically identical, with bags and the
axe. The human figure with the head of a dog, the
cynocephalus, is found in medieval bestiaries and the *Marvels
of the East*. Almost identical to that on the Wallingford relief
is the *cynocephalus* in a Canterbury initial of *c.* 1120–30
(British Library, MS Cotton, Claudius E.V, f.4ᵛ, **41**).

It is likely that the relief formed part of a complete cycle of
the Signs of the Zodiac which decorated the castle hall. G.Z.

BIBLIOGRAPHY C.E. Keyser in *Proceedings of the Society of the Antiquaries*, 2nd series, vol. XXI,
1907, pp. 118–21

113 Coronation of the Virgin capital

Caen stone; unfinished, probably abandoned and used as
building material in cloister, two sides completely obliterated;
h 190 mm, *w* 300 mm, *diam* (of column) 170 mm
c. 1125; Reading Abbey
Reading Museum and Art Gallery

The face which was completed, although it is now severely
damaged, is carved with the oldest known representation of the
Coronation of the Virgin, a subject which subsequently became
highly popular in European art. The scene shows Christ and
Mary sitting on an elaborate throne. He, holding a book in one
hand, places a crown, of which only the bottom portion
survives, on the Virgin's head with the other. The Virgin's pose
and gesture express humility. The adjoining face of the capital
is unfinished and also damaged and has only one recognizable
figure, an angel, its feet pointing towards the left. Across the
body of this angel is the damaged wing of another; this suggests
that the unfinished scene was perhaps the Dormition of the
Virgin, a precursor of the subject on the famous doorway at
Senlis Cathedral, in which the body of the Virgin is on a bed
surrounded by joyful angels who are about to take her to
Heaven. The scenes on the capital were framed by elaborate
arcades, and the necking was cable-moulded, as on many capitals
from the cloister (**127**).

Iconographically, this is an important work, reflecting the
growing cult of the Virgin; England was in the forefront of this
movement. There is a possibility that Reading Abbey, which
was dedicated to the Virgin, had a tympanum carved with the
Coronation of the Virgin of which the tympanum at
Quennington in Gloucestershire, only 20 miles from Reading,
is a slightly later copy. G.Z.

PROVENANCE Excavated at Borough Marsh, Berkshire, 1949
BIBLIOGRAPHY Zarnecki, 1949, p. 524; 1950, pp. 1–12

114

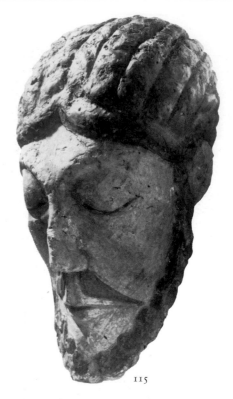

115

114 Head of Christ relief

Sandstone; re-used as building material, badly weathered;
h 280 mm, w 350 mm, d 290 mm, relief projects 160 mm
1120–30; Old Sarum Cathedral
Salisbury, Council of the Salisbury and South Wiltshire
Museum

Although this fragment was found in Salisbury where it had
been re-used, it must originally have come from Old Sarum.
The top and bottom of the stone is cut smooth and bears the
original chisel-marks, suggesting that it was part of a large
relief, carved on many separate pieces of stone, arranged in
horizontal courses and thus comparable to the reliefs from the
screen at Chichester Cathedral.

The relief shows the head of Christ with a solemn expression
which makes it very reminiscent of the heads on the Chichester
reliefs. These works, as well as the fine crucifix fragment from
South Cerney (**115**), show the influence of contemporary and
earlier German art.

Two fragments of draperies in the South Wiltshire Museum
may be from this relief: if so, they are far more linear than the
drapery on the Chichester panels and cannot be by the same
sculptor. This drapery, as well as the type of head on the
fragment, has much in common with the figures in the Psalter
attributed to Shaftesbury or Wilton (**25**) dated to 1130–40. The
Psalter is closely related to the St Albans Psalter (**17**) which
itself presents stylistic analogies with the Chichester reliefs. The
ivory Magus found in Dorset (**210**), has a head similar to that
of the Christ on the Old Sarum relief, although it is necessary
to be cautious when comparing objects so different in size.
Nevertheless, all these similarities suggest the existence in the
1130s of a regional style with Old Sarum as a likely centre. The
fragment with the head of Christ was part of a large
composition which, if similar to the Chichester reliefs, must
have consisted of six courses and was about 1.68 m high. It
could not have been part of the screen, however, for a panel
from the Old Sarum screen survives re-used in the 13th-century
screen in Salisbury Cathedral and it is not made up of small
courses of stone, but is monolithic. G.Z.

PROVENANCE Found in the North Canonry, Salisbury
BIBLIOGRAPHY Zarnecki, 1953b; 1979, XII, pp. 117 and 120

115 Two fragments of a crucifix

Wood, covered in gesso and paint, restored by the British
Museum, most recently in 1983–4; h (of head) 145 mm, (of
foot) 120 mm, (of entire crucifix, when complete) approx
800 mm
c. 1130; All Hallows, South Cerney, Gloucestershire
The Vicar and Parochial Church Council of All Hallows, South
Cerney

These two fragments of what was once a crucified Christ were
found in 1915 concealed in the north-east wall of the nave. The
crucifix was probably hidden at the time of the Reformation,
and it has disintegrated due to the humid condition of the
cavity. The two fragments have survived as shells, kept
together by gesso and paint, and subsequently they were filled
with sawdust and glue. The nose was restored by the British
Museum laboratory in 1960.

The head shows Christ already dead, with closed eyes and
an expression of tranquillity. It is an elongated face, with a
drooping triangular moustache, a beard with short, highly
stylized locks and hair arranged in rope-like strands. When
viewed from one side, the head has a more dramatic
appearance, chiefly because of the huge eyeballs and the
downward line of the mouth. Seen thus in profile, the head to
some extent resembles the 11th-century bronze crucifix at
Werden. The foot is also an object of touching beauty: the
forms are angular and the toes bent as if in anguish.

The work has been considered Spanish (Stone, 1955), but its
inspiration is more likely to have been German, presenting
some analogy with such German-inspired sculptures as the
Chichester reliefs (Zarnecki, 1953b) and the Old Sarum head
of Christ (**114**). The fragments are particularly precious since
they are all that survives of a type of wooden sculpture of
which there must have been many thousands in the country,
with every church having a crucifix. G.Z.

EXHIBITION Barcelona, 1961, no. 554
BIBLIOGRAPHY W.R. Lethaby in *Proc. Soc. Antiq.*, XXVIII, 1915–16, p. 17; Zarnecki, 1953b,
p. 117, pl. 26b; Stone, 1955, p. 65

116a

116b

116a and b Two martyrdom capitals

Limestone; damaged through re-use and exposure; *h* 600 mm
c. 1130; probably made for Bath Abbey
Bath, The Rector and Churchwardens of Bath Abbey

These are respond capitals, carved on two sides only. Their
proportions are unusual in being narrow but tall; most likely
they came from a compound pier of the interior rather than
from a doorway. The two capitals are decorated with scenes
which are identified conventionally, but probably wrongly, as
the Martyrdom of St Lawrence and the Martyrdom of St
Bartholomew.

116a On this capital a nude saint is standing along the angle,
facing his tormentor carved on the right face, who binds his
hands. A second torturer stands behind, raising the scourge.
One of the tormentors is bald and both wear short tunics with
nested V-folds. The saint is nude and has shoulder-length hair,
a short beard and a moustache. The scene is based on the
Flagellation of Christ, but Christ is never represented entirely
nude, as here. It could well be the scourging of St Vincent, a
scene depicted for instance on a relief in Basel Münster in
Switzerland (H. Beenken, *Romanische Skulptur in
Deutschland*, Leipzig, 1924, p. 253).

116b Here the nude saint is shown on a rack being tortured
by two men in short tunics, one pressing large, sharp nails into
the saint's legs, the other, who turns his head back, about to
inflict a blow with a spear (damaged). At the top, an angel, the
head missing, is hovering to receive the soul of the martyr. The
mechanism of the rack is shown in considerable detail. The
scene probably represents the martyrdom of St Vincent.

There were, presumably, other capitals adjoining, on which
there could have been other episodes from the lives of St
Vincent and other saints. The cult of St Vincent in England was
widespread and there were altars and even churches dedicated
to him. Many churches had his relics, for instance
Glastonbury. G.Z.

PROVENANCE Found re-used in a mill at Batheaston, 1867

doorways. This style spread from Como, Milan and Pavia to other parts of Italy and beyond the Alps, as far as Hungary, Poland, the Scandinavian countries and England. The doorways of Ely Cathedral (*c.* 1130) testify to the enthusiastic reception of this style in England. The Italian influence on stone sculpture at Bury has been noted (Zarnecki, 1967, p. 407 ff.), but this came from a later stage of development in Italian sculpture, best represented by the art of Niccolò. The closest parallels for the Bury capital exist amongst the capitals of Sant'Eufemia in Piacenza, dating to between 1107 and 1125 (C. Verzár Bornstein, 'The capitals of the porch of Sant'Eufemia in Piacenza', *Gesta*, vol. XIII/1, 1974, pp. 15–26), which show a mixture of the *corrente comasca* and the early style of Niccolò. It will be remembered that the abbot of Bury between 1121–48 was Anselm, an Italian. G.Z.

BIBLIOGRAPHY *Brit. Archaeol. Assoc.*, vol. I, 1846, p. 244, with ill.

118 Head in profile

Limestone; very weathered; *h* 110 mm, *d* 60 mm
c. 1130; Bury St Edmunds Abbey
Bury St Edmunds, St Edmundbury Borough Council

The small head has been broken off a capital or relief. This weathered but important fragment is modelled with great sensitivity. It presents a close stylistic analogy with the heads in the *Life and Miracles of St Edmund* (**20**), and should therefore be dated to *c.* 1130, before the Bury Bible (**44**). G.Z.

PROVENANCE Excavated on site of crypt, mid-1960s; subsequently stolen; recovered 1983
EXHIBITION *Church Treasures of West Suffolk*, Ickworth, 1967, no. 6
BIBLIOGRAPHY Zarnecki, 1967, p. 410; Gilyard-Beer, 1970, pp. 256–62

118

117

117 The Dragon Slayer capital

Limestone; surface weathered, horizontal crack across upper part, but otherwise in good condition; *h* 390 mm, *diam* 260 mm (at base)
c. 1130; Bury St Edmunds Abbey
London, Trustees of the British Museum

This is a respond capital carved on two sides only, probably originally part of a doorway. The man wears a short tunic and, standing astride the dragon's tail, grips its neck with his left hand and thrusts a spear into the creature's breast with a huge right arm, the size of which gives the impression of superhuman power and strength. The dragon, its mouth open and tongue protruding, has a beaded band decorating the entire length of its body. The composition is so devised that the monster's head is in the spot where, on a Corinthian capital, a volute is normally found, while the wing and the spear form a V shape. The subject is one of the most popular in Romanesque art, being an allegory of the human struggle with evil. The style of the capital is unmistakably of northern Italian inspiration. The school of sculpture which had developed in Lombardy in the late 11th century, and is known as the *corrente comasca*, a style originated at Como, is characterized by rich, decorative subjects applied chiefly to capital-friezes and

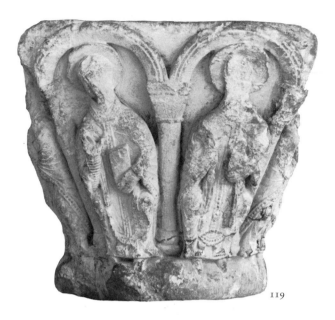

119

119 Capital with figures under arcades

Limestone; top of the capital broken and plain necking
damaged, complete arches survive on only one face, but all
heads destroyed; *h* 190 mm
1130–40; probably made for Winchester Cathedral
Winchester City Museum, 834

This free-standing capital is carved with eight seated figures
under arcades, two to each face. The capitals of the arcades
are plain, while the arches and bases are moulded. The rather
stocky seated figures fill the space under the arcades so
completely that there is no room to show what they are sitting
on, and they are repeated without any significant variations.
They have haloes and wear chasubles enriched with beaded
borders and central decorative strips. The fringed ends of their
stoles are shown emerging below the chasubles. All this is
evidence that they are saintly priests, perhaps the Apostles.
They all hold books and raise their right hands as if in prayer,
while their feet rest on the necking. The sleeves of the raised
arms have segmented folds but on the chasubles and on the
limbs there are sharply incised plate-folds. There is an
undoubted similarity between these delicately-carved figures
and the fragments thought to have been part of the shrine of
St Luidger at Werden, dating from *c.* 1070 (R. Wesenberg,
Frühe mittelalterliche Bildwerke, Düsseldorf, 1972, p. 54 ff.).
Works such as this shrine most probably had a strong influence
on the style of the sculpture at Cluny. If it is remembered that
Henry of Blois, Bishop of Winchester from 1129 till his death
in 1171, was brought up at Cluny and remained in contact with
the abbey throughout his life, it is possible that this capital
distantly reflects the early sculpture of Cluny. G.Z.

BIBLIOGRAPHY Zarnecki, 1951, p. 38, pl. 75

120 Head

Limestone; nose damaged and numerous minor chippings;
h 171 mm
Second quarter 12th century
Norwich, University of East Anglia, Robert and Lisa Sainsbury
Collection

The back of the head is uncarved. The angle of the neck with
a small section of a decorated collar suggests that originally this
was not a standing figure. The large hole at the back is
probably not original.

The head is of a man with a solemn expression and so has
been identified as Christ, but the half-baldness is
uncharacteristic. The sculptor employed exaggerated,
geometric forms, for instance the drilled eyes are bulging, the
nostrils are flared, the long moustache is rigidly triangular and
the grooved beard, where it joins the ears, is arranged into
almost a chevron pattern. The hair falls at the back in rope-like
strands.

Kauffman (Manchester, 1959, no. 59) compared the head to
the reliefs from the screen in Chichester Cathedral, both of
which are works of great emotional intensity. The sculpture
seems to belong to the group of works influenced by German
art, such as the St Albans Psalter (**17**), the Chichester reliefs
(Zarnecki, 1953b) and the head of Christ from Old Sarum
(**114**). G.Z.

EXHIBITION Manchester, 1959, no. 59

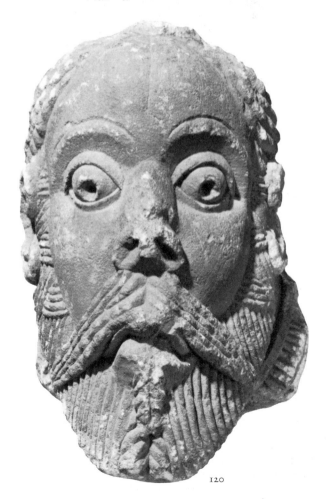

120

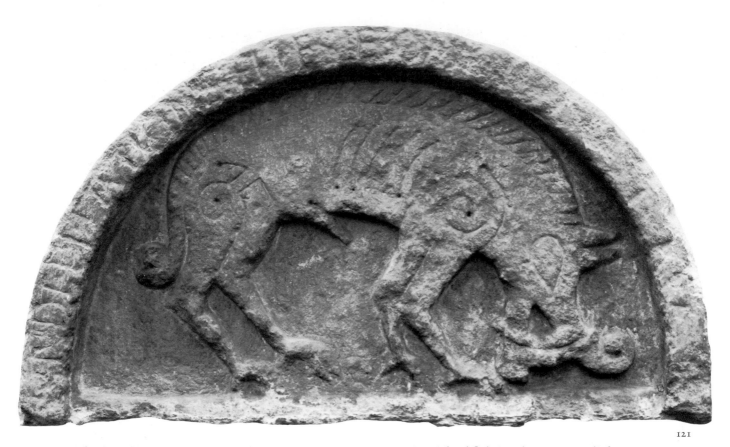

121

121 The Boar tympanum

Barnack limestone; weathered but otherwise in good
condition; *h* 560 mm, *w* 1.00 m (at base), *d* 160 mm
c. 1120; St Nicholas's Church, Ipswich
Ipswich, St Nicholas Parochial Church Council

When this tympanum was taken from its previous, but not
original, position inside the church in 1966, it was discovered
that it is carved on both sides, which is extremely rare. The
main face bears an inscription on the semicircular border: IN
DEDICATIONE ECLESIE OMNIUM SANCTORUM ('Dedicated to
the Church of All Saints'). To which church this refers is
unknown, but there can be no doubt that the tympanum was
carved by the same sculptor who executed 122. The relief is in
two planes with the boar conforming in shape to the
semicircular field. It has many features in common with the
dragon on 122: the snout, ears, eye, hip spirals and drilled holes
used as a decorative device. Galbraith (1973, pp. 68–74)
speculates that, since the boar is phallic, it was used here to
denote fertility and as a protection from evil. Be this as it may,
the boar is frequently found in Scandinavian mythology and
art. In the Romanesque period, it was carved within a
semicircular arch on two Gotland churches at Väte and
Grötlingbo. The Ipswich relief still harks back to such
Ringerike works as the relief from St Paul's, London (95).

The splayed cross on the verso has its arms split and
interlaced as if made of leather, making a spurious swastika in
the centre. At the end of the splits there are deep holes. A
similar cross is found on a tympanum at Salford in Oxfordshire
(Keyser, 1927, fig. 24), and on a Danish tomb at Århus, both
of the 12th century. G.Z.

BIBLIOGRAPHY Galbraith, 1968, pp. 173–6; *idem* (1973), pp. 68–74

122 St Michael fighting the Dragon relief

Caen limestone; broken in two and repaired, weathered, and
face, hands and one foot of the archangel broken off;
h 550 mm, *w* 890 mm, *d* 80 mm
c. 1120; probably made for former Church of St Michael,
Ipswich
Ipswich, St Nicholas Parochial Church Council

There was a Church of St Michael at Ipswich in 1086 of which
this relief probably formed a part, but how it was used is
uncertain. It was recorded in 1764 as being built into the outer
wall of the present church. It was moved to the interior in 1848
but was taken out again in 1966 for cleaning and repair, and
is now displayed alongside 121 inside the chancel.

St Michael is shown with his wings high above his head, with
a kite-shaped shield with a boss in one hand and a sword in
the other. He wears herring-bone mail and a long robe with
pleats decorated with the chevron and ending in a wide hem
in the form of a series of arrowheads. The dragon's body is
covered with scales and has a spiral on the hip-joint. The legs
have only two toes each. The head has a large eye and a long
snout from which issues a three-arrowed tongue. The tail
forms a figure-of-eight pattern. The uneven background was
covered by inscriptions but it is now legible only at the bottom.
It is in Old English and reads: HER :SCE// MIHAEL :FEHTꝐIꝰ/
/ꝰANE :DRACA: ('Here St Michael fought the dragon'). There
are numerous shallow drill-holes on this relief, some placed at
random. The style is strongly influenced by the Ringerike (see
95) and is one of a whole series of post-Conquest sculptures
in the Viking manner. G.Z.

BIBLIOGRAPHY Galbraith, 1968, pp. 173–6

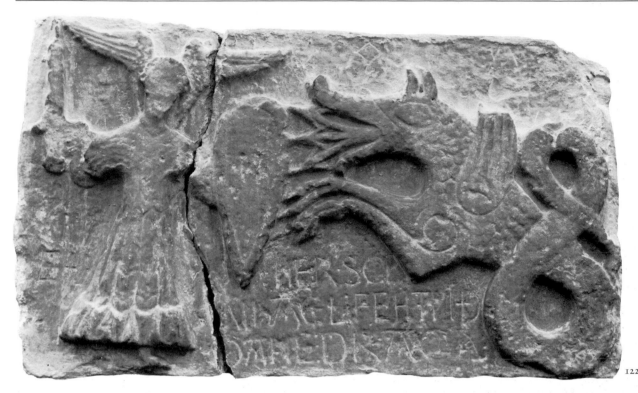

122

123 St Michael fighting the Dragon and David rescuing the lamb, tympanum

Limestone; broken into four pieces; *h* 520 mm (at apex),
d 230 mm, *l* 1.500 m (at base)
c. 1120; Southwell Minster, Nottinghamshire
The Provost and Chapter of Southwell Minster

This lintel was set, probably in the 19th century, over the staircase doorway in the north transept. Broken through settlement, it was removed in 1983 for repair by Harrison Hill Ltd. It is of a somewhat irregular shape and was evidently cut on the left-hand side to fit into its present position. Since all the Romanesque doorways of the church still exist, this lintel must have come from elsewhere, perhaps from the original chapter house. St Michael in the centre, wings outstretched, a round shield with a boss in one hand and a raised sword in the other, confronts the dragon whose body is covered with scales. Around the twisted tail twines thin foliage which also forms a collar round the neck of the beast. The dragon shows a strong connection with the last of the Scandinavian animal

styles, the Urnes (see p. 22), and this also applies to a related tympanum at nearby Hoveringham. On the left David, kneeling on one knee, wrenches open the lion's jaws, while the lamb is shown above. Apart from the lion's tail which interlaces with the hind legs, there is nothing Viking in the style of this group. (For a similar subject on a lintel from St Bees, see **124**.)

The soffit (under-side) is carved with acanthus, interlace, cable and irregular foliage. The recent removal of the lintel revealed further soffit carvings at both ends, on the left a large plant and on the right a grotesque figure with a human head, wings and the hindquarters of an animal with the legs sticking up. The carvings of the soffit were damaged by a rebate for a door 970 mm wide.

The flat relief, the lack of modelling, the folds and other features marked by engraved lines and the occasional use of drilled holes make this tympanum very close to the narrative capitals of the crossing of Southwell, also dating to *c.* 1120. G.Z.

BIBLIOGRAPHY Keyser, 1927, fig. 142; Clapham, 1930, pp. 135–6; Kendrick, 1949, pp. 121–2; Stone, 1955, p. 48, pl. 29a; Kelly, 1971; Lang, 1982, pp. 57–9

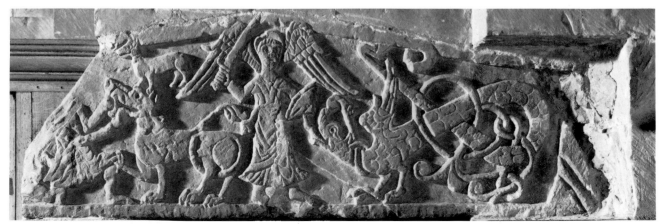

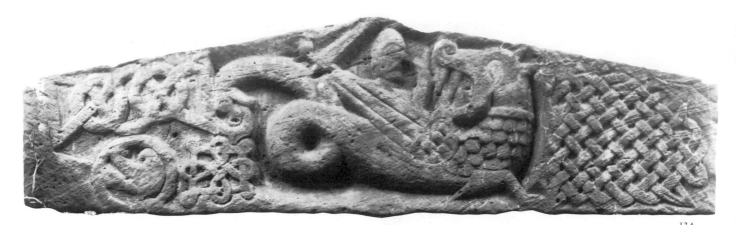

124

124 Gabled lintel

Red sandstone; considerably weathered; *h* 470 mm (max),
w 1.650 m (at base), *d* 240 mm, *w* (of rebate at back for doors)
1.220 m
c. 1120; St Bees Priory Church, Cumbria
The Vicar and Warden of St Bees Priory Church

In the centre is a large dragon, its head turned with a wide-open
mouth and sharp teeth. The twisted tail ends in a small head.
Partly concealed by the body and wing of the dragon is St
Michael with a conical helmet and a round shield with a central
boss; his right arm is stretched back and holds a sword. To
the right of the dragon is a tightly-knit interlace of diagonal
bands. To the left the decoration is in two horizontal registers.

The top one consists of two circles joined by two wavy bands,
one of which emerges from the terminal of the dragon's tail.
Below is a preening dove in a circle and an interlace.

This is one of the many Romanesque representations in
England of St Michael fighting the dragon, applied to doorways
(see **122** and **123**). In Western iconography, St Michael is
usually shown piercing the dragon with a spear (Alexander,
1970, pp. 85–100), but in England and in the Scandinavian
countries, he is often armed with a sword, like the hero of the
Norse saga, the dragon-slayer Sigurd (Lang, 1982, p. 59).
Cumbria was settled by Norsemen from Ireland in the 10th
century: the interlace decoration on the lintel has close
parallels with Irish art (Collingwood, 1927, pp. 120 ff.). G.Z.

BIBLIOGRAPHY Keyser, 1927, p. 47, fig. 135

125

125 Corbel

Grey, shell-fragmental limestone, closely comparable with the
Jurassic, Alwalton 'Marble' from near Peterborough;
numerous deep cracks, top left corner broken off, traces of
white and pink pigments, probably not original; *h* 260 mm
c. 1120
Bedford Museum, North Bedfordshire Borough Council

This corbel is carved in the form of a male head with large,
staring eyes, a broad nose with prominent nostrils and a
drooping moustache ending in small curls. Below a small
mouth, a double curve is incised. Small locks of hair extend
from one ear to another, but below the ears the hair forms
corkscrew locks. The stylized ears have a shell-like, concave
form. The head and neck emerge from a pyramidal base.

The linear stylization of the head brings to mind Insular
illumination, for instance the St Chad's Gospel (Lichfield
Cathedral Library). It is likely that a similar manuscript
inspired this unusual work. Kauffmann (Manchester, 1959,
p. 31) suggests that the corbel was used to support a tympanum
as in the prior's doorway, Ely. G.Z.

PROVENANCE Found re-used in St Mary's, Bedford
EXHIBITION Manchester, 1959, no. 57
BIBLIOGRAPHY Zarnecki, 1959, pp. 452–6, pls. 53, 54

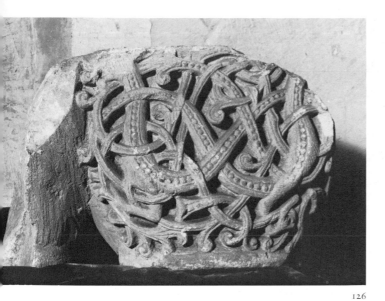

126

126 Cloister capital

Caen stone; *h* 200 mm
c. 1130; Norwich Cathedral
Norwich, Dean and Chapter of Norwich Cathedral

This is one of 14 double capitals from the Romanesque cloister which was replaced in the 14th century. The carved stones of the original structure were re-used as building material and, in the process, the most projecting portions were chiselled off. The carvings were recovered in a restoration of 1900. Two further double capitals are exhibited as **134**. The double capitals consisted of a plain cubic capital which must have faced the garth, while the adjoining capital was carved on three sides and must have faced the cloister walk. When the Romanesque cloister was built is unknown. The bishopric was moved from Thetford, and the new cathedral in Norwich was started in 1096. The date of *c.* 1130 proposed here is somewhat later than that of 1110–20 put forward by Franklin (1983).

The decoration of the capital consists of two wingless dragons on each face, intertwining with each other, their snake-like tails terminating in thin foliage with numerous leaves forming volutes. The dragons have only one leg each; their lip-lappets and pointed ears, as well as the interlace, are typical of the Urnes style. A close parallel for this decoration is provided by the Viking brooch from Pitney (**225**). The taste for Scandinavian decoration in Norwich at such a late date is understandable in view of the Viking settlements in East Anglia. G.Z.

EXHIBITIONS Norwich, 1980, no. 3; Copenhagen, 1981, cat. I.9
BIBLIOGRAPHY Zarnecki, 1955b, p. 176; Stone, 1955, pl. 49a; Franklin, 1983, pp. 56–70

127a–s Sculptures from Reading Abbey
(*a* illustrated on p. 64; *f*, *g*, *h*, *i*, *j*, *l* and *m* not illustrated)
c. 1125
Reading Museum and Art Gallery

Henry I was a great patron of Cluny Abbey: when he founded Reading Abbey in 1121 he entrusted it to Cluniac monks, although there was no official affiliation to Cluny. By the time Henry died in 1135 the choir was ready, and the King was buried in front of the high altar in a tomb with an effigy. The church was consecrated in 1164 by Archbishop Thomas Becket in the presence of Henry II. The founder's daughter, the Empress Matilda, gave rich gifts to the abbey, and so did his wife Adeliza, who was also buried in the abbey.

The monastic buildings were completed in five years (Victoria County History, Berkshire, vol. II, 1907, p. 62), and thus it is safe to date the remains of the cloister to *c.* 1125. It must have been an exceptionally lavish building, worthy of the patron and following the Cluniac tradition. Some time after the dissolution of the abbey in 1539 stones from the cloister, and perhaps other buildings, were taken in barges to Borough Marsh and re-used as building material. Some carved capitals were moved in modern times to Sonning and in 1912 they entered the Museum. In 1949 numerous further carved stones were excavated at Borough Marsh by the Courtauld Institute; these were deposited at the Victoria and Albert Museum and finally given to Reading Museum in 1975. Most of the sculpture exhibited was cleaned in 1983 by Michael Eastham.

Capitals of the cloister arcade
Caen stone; *h* 310 mm (average)

The Reading Abbey cloister consisted of figural and foliage capitals which alternated with trefoil capitals, the former being supported by round columns, the latter by octagonal ones. The arches of the cloister had carved voussoirs (discussed below) but no bases survive. The capitals, which are basically of cubic shape, are peculiar in that their abaci are carved from the same block of stone as the capital. Normally a capital is carved from a block of stone of the appropriate size and the abacus, which projects considerably in all four directions, is carved from a separate slab. The method employed at Reading is wasteful of stone and suggests that no expense was spared in this enterprise. Some capitals have one side of the abacus either plain or simpler than the other three, a clear indication that the plain side was facing the garth, and the opposite side the cloister walk. Here the sides of the capitals are designated F for front, L for left, R for right and B for the back face.

127a–f Figural and foliage capitals

127a Unfortunately, the F side is badly weathered, but it shows, as do all the other three, two S-shaped dragons, their tails forming volutes at the top, their wings meeting in the centre and their heads at the bottom, biting their own legs. The best preserved, but simplest, is the B face. The carving is crisp and elegant. The decoration of the abacus (except for B which is plain) is almost classical, with two rows of upright leaves. The necking is cable-moulded.

127b This is a cubic capital but with animals' heads at the angles from whose mouths emerge beaded bands, marking the borders of the shields and ending in leaves, some of which are trefoil 'Byzantine blossoms'. All four sides of the abacus are carved with leaf motifs in triangular frames with drilled holes used as an ornament, and the necking is carved with horizontal leaves. The F face of this capital is the richest, but the B is most

revealing, for it clearly shows that, in this case, the source was a manuscript similar to the Winchcombe Psalter (Cambridge, University Library, MS Ff. I.23) of between 1030 and 1050, whose initials, especially on f. 5, are markedly Scandinavian in character (Temple, 1976, no. 80).

127c The capital was found broken and since then the lower third has been lost. The photographs used in this catalogue show the state of the capital in the 1940s. The necking had a band of beading. The abacus is richly decorated on all four sides, so that it is difficult to determine which was the F side. In all probability it was the very damaged face with scrolls within which there are two figures facing each other. The abacus of this face is carved with an irregular interlace in the Scandinavian fashion. The remaining three faces of the abacus are each carved with a different leaf motif, and so is the capital itself. The L face has two elaborate leaves with circular stalks passing under and over them. The other two faces have 'Byzantine blossoms' encircled by stalks. The initials in a manuscript painted by the Master of the St Albans Psalter (Cambridge, King's College, MS 19, f. 80ᵛ) are remarkably similar.

127d It is broken vertically in two and repaired, and face B is badly damaged. The abacus is carved on three sides with the beaded guilloche ornament. On the F face are two seated figures enclosed by beaded mandorlas. Both are nimbed and have wings emerging from behind their haloes and forming a scallop design. The two figures are beardless; one is blessing while the other is holding a crosier. The identity of those figures is obscure; a winged figure should be an angel, but an angel should not be in a mandorla, for this was reserved for Christ. The celebrated choir capitals of Cluny Abbey use mandorla-shaped backgrounds for allegorical subjects, and so perhaps there is some echo of this arrangement here. The eyes of the two figures are disproportionately large, but there is a great deal of delicate detail in the carving, for instance the hatching of haloes and wings; yet the draperies are marked by parallel grooves and their folds, especially on the limbs, are arbitrary. The L and R faces contain highly stylized 'Byzantine blossoms'. The B face has two beaded stalks forming circles which are joined by a mask and within the circles are addorsed, rampant, dog-like creatures, their heads turned back. In the St Albans manuscript of *c.* 1120–30 (British Library, Royal, MS 13. D. VI–VII), there are numerous intitials which present striking parallels to this capital (e.g. VI. f.77ᵛ). The necking is cable-moulded.

127b

12

127e There is considerable damage to the necking and the B face. The abacus is carved on all sides with stylized leaves in semicircles and triangles, and the necking has horizontal mouldings. There are similar angle heads on another capital, not exhibited, but the heads at the back lack hair and have pointed ears. The stalks here emerge from masks and from the necking, forming a V design on each side ending in trumpet leaves and two loops which emerge from the necking and disappear into the mouths of the masks.

127f The abacus is decorated with a row of leaves which make loops around a horizontal band, and the necking has a tightly-knit interlace. On all four faces of the capital a similar composition is carved, repeated with minor variations. Two

<p align="center">127d</p>

<p align="right">127k</p>

<p align="center">127e</p>

127g–k Trefoil capitals

Caen stone; *h* 320–330, *diam* (of column) 170 mm

Nine capitals of this type were found by Keyser at Sonning and of these, five are in the exhibition. The trefoil capital is a more elaborate variant of the cubic type and, in the crypt of Canterbury Cathedral (*c.* 1100), where the earliest trefoil capitals are found, two out of three such capitals are of the simple cubic form with the trefoils incised on the semicircular shields. The third is a true trefoil capital with conical corners providing a harmonious link between the four faces.

The Reading series has sunken trefoils with moulded and, in most cases, also beaded frames. The space between the trefoils is filled by a variety of leaves with bands of ornament, while below the trefoils are fluted enrichments. Only two neckings are carved with bands of beading, and one also with the chevron ornament. All the abaci are plain. The angle leaves have prominent, overhanging tips. One capital (**k**) is decorated not with semicircular trefoils but with a 'stepped' variety, and here the angle leaves are overhanging in a very original way.

W.R. Lethaby (1925, pp. 32–5, figs. 16–19) compared these Reading capitals to those from the cloister of Westminster Abbey, where trefoil and figural capitals probably also alternated (see **110**), as they did at Reading.

winged dragons with a herring-bone pattern and a beaded band above the spine are back-to-back, their tails and necks interlacing. These dragons also intertwine with the dragons from the neighbouring faces. Their heads turn back, and their tongues are being pulled out by the half-figures of youths who emerge from the dragons' tails. In addition, there are semicircular bands, one on each face, which spring from the necking and interlace with the dragons' tails. An attempt has been made to interpret the decoration of this capital as illustrating the Norse Volsunga Saga (E. Ettlinger, 'A Romanesque Capital from Reading Abbey', *Berkshire Archaeol. Journal*, vol. 68, 1975–6, pp. 71–5), but this is too far-fetched and unacceptable. The subject is purely decorative, and is precisely what St Bernard had in mind when complaining about fantastic subjects carved in cloisters.

127n

1270

127l–n Springers
Caen stone; *h* 300–320 mm

A springer is a rectangular stone with a gabled top which crowns the abacus to support two arches, going in opposite directions. A large number of springers survive from the cloister arcade and these can be divided into two groups: springers with figurative and ornamental motifs and springers with beak-heads. The latter are badly damaged. Two examples from the first group are exhibited and they indicate that carving was applied not only to the face which was seen from the cloister walk, but also to the soffits of the arches. The face towards the garth was plain, with only a roll moulding along the soffit. In addition, one springer from the corner of the cloister arcade is also shown.

127l A springer with dragons and foliage. The snake-like dragons are very similar to those on capital **f**, and it is likely that this springer was originally on top of that capital. The foliage, by analogy, probably emerged from the dragons' tails.

127m This extremely weathered springer is decorated with a circle and semicircular bands ending in trefoil leaves, which interlace with each other and with the circle, creating a complex decorative whole.

127n A corner springer. At each corner where the arcade changed direction, the Reading cloister had a triple capital supported by three columns, and on top of this cluster of capitals were corner springers, much larger and heavier than those described above, for they were designed to support two arcades at right angles to each other. One such corner springer, too damaged to warrant inclusion in this exhibition, is decorated with the beak-head ornament. The one shown here has a badly weathered animal in foliage on one face and a bird entangled in foliage and preening its breast on the other. This subject brings to mind the pelican who, according to the bestiaries, killed her young and, three days later, opened a wound in her own side and revived the offspring with her own blood. This was the type of Christ. However, since there are no young on the springer the representation is likely to be merely decorative, as on a capital from Canterbury at Chartham, recently acquired by the Royal Museum and Art Gallery at Canterbury (Zarnecki, 1979c, pp. 1–6). The arch adjoining this face is carved with bands of beaded chevron.

127o–r Voussoirs
Caen stone; *h* 320 mm (average)

The arches of the cloister arcades were as rich as the capitals and springers. Some of them were decorated with beak-heads (see **129**), others with rosettes carved in high relief, and yet another group with animals and humans amid foliage. These last voussoirs are of an unusual shape, projecting like bosses from the arch-face. One voussoir of this type is carved from a single piece of stone; in all other cases, two stones were used for one composition, but of these unfortunately only half-compositions survive. The condition of the voussoirs is bad, owing to exposure and mutilation.

127o This voussoir is the only one which was not made from two halves. It is decorated with a pair of lions joined together by strands of foliage protruding from their mouths. The drilled pupils of the eyes are so placed that they direct the animals' gaze towards each other.

127p

127q

127r

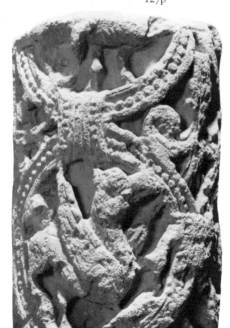

127s

127p This is the left half of a voussoir which, when complete, consisted of two animals' heads with foliage issuing from them.

127q In this case only the right-hand half survives, carved with a bird whose body is bound by a strand of foliage.

127r On this, the left-hand half of a voussoir, a man in a short tunic and bulbous cap, walks encircled by foliage and holds what looks like a staff with a hook. The surface of this stone is severely weathered.

While the voussoirs with rosettes can be compared to some arches in the cloister of St-Aubin at Angers (*c.* 1130), embossed voussoirs made of two halves appear to be unique. Perhaps a distant echo of them, although made of single stones, is found on a doorway of Dalmeny Church in Scotland.

127s Column from a doorway
Caen stone; *h* 500 mm, *diam* 240 mm

The fragment is very damaged.

This was a respond column, carved on only about two-thirds of its surface, the side hidden from view having been left plain. The decoration consisted of two vertical rows of beaded medallions joined by clasps, the spandrels being filled with floral motifs. Within the medallions there are figural subjects but the only two still identifiable are griffins, one in each complete medallion, placed head to head. This motif is derived from precious oriental silks, much admired and copied during the period. It is likely that the column was used in the cloister at the entrance to the chapter house. G.Z.

BIBLIOGRAPHY Zarnecki, 1951, pp. 35–6, pls. 59, 61–3; Stone, 1955, pp. 59–61, pls. 36b–37

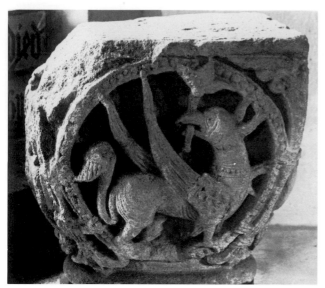

128a(1)

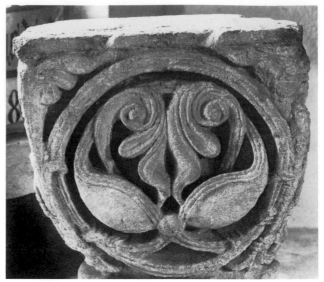

128a(4)

128 a–e Capitals from Hyde Abbey, Winchester
(b illustrated on p. 67)

Oolitic limestone; five capitals without their abaci and
considerably damaged; *h* 260–270 mm
1125–30
Winchester, St Bartholomew's Church, Hyde

Hyde Abbey was the successor to the New Minster, a
Benedictine monastery which stood beside the Cathedral of St
Swithun. The friction between the two neighbours was so
unbearable that, with the King's approval, a new church was
built for the monks of New Minster on a site outside the city
walls at Hyde Mead. In 1110, the monks solemnly moved the
relics and the much-venerated bodies of King Alfred the Great
and his family from the old to the new church, which must
have been sufficiently advanced to make this possible. The new
church was set on fire in 1141 on the orders of Bishop Henry
of Blois during his siege of the Empress Matilda and her
supporters.

The capitals clearly pre-date this unhappy event, but by how
long is a matter of conjecture. Judging from their small size and
the fact that they were free-standing, it is safe to assume that
they came from the cloister arcade. It was reported (W.
Dugdale, *Monasticon Anglicanum*, new ed., 1823, vol. II,
p. 432) that 'many capitals of columns, heads and other
ornaments, which have been dug out of the ruins of Hyde, are
to be seen in different parts of the city', but they have since
gradually disappeared. The five capitals, all block-shaped and
with plain neckings, fall into two groups, though the style of
their decoration is uniform. Three of them have medallions on
each face, mostly beaded, and these contain figural or floral
motifs, while the spandrels between the medallions are filled
with leaves. The remaining two capitals have no frames of any
kind. The motifs carved on the capitals are as follows:

128d(3)

128a 1. A griffin with a beaded collar on its neck and a flower
in its beak. 2. A griffin, head turned back. 3. As a1. 4. Two
leaves springing from a pod.

128b 1. Two leaves from which a pair of youthful heads
emerge, one with short, the other with shoulder-length hair. In
the centre is a plant with an open pod at the top. 2. Similar
leaves to b1, but with two flowers. 3. Two pods, two trumpet-
like leaves and a central leaf with beading. 4. Similar to b1,
but the central leaf is different and one head is half-bald.

128c 1. A griffin biting the frame and its tail twining around
it. 2. An elaborate acanthus leaf with beading. 3. A leaf
similar to that on b2, but upside-down. Similar to c2.

128c(2)

128c(3)

128c(1)

128d 1–3. Two heads cupped in leaves, eating fruit growing from the central stalk, flanked by more leaves and fruit. 4. Large leaves with fruit.

128e 1. A dragon biting its own wing; a band of beading runs along its entire length and the tail ends in a very elaborate plant with leaves of which one is of the 'Byzantine blossom' type. 2. A dragon very similar to that on e1, but bending in the opposite direction. 3. Similar to e1 but very damaged. 4. An animal's head, upside-down, from which issues foliage with large leaves.

The relief is quite deeply undercut and executed with great skill and attention to delicate detail. The range of motifs is limited and the sculptor tried to introduce some variety by repeating a motif already used on one face but in reverse, or upside-down, on the next, so that a mirror image is produced. The weakness of the whole series lies in the inability of the sculptor to bring all four sides of the capital into a unified composition. Instead, each face is treated as an independent unit, a method which is reminiscent of the separate pages of an illuminated book. Nevertheless, this is sculpture of a very high quality, executed by an artist who was familiar with, and probably also practised, book-painting, ivory-carving and metalwork.

In a recent article, the Hyde Abbey capitals were compared to those at Norwich (**126** and **134**) for which a date in the second decade of the 12th century was proposed; by implication the same date should apply to the Hyde Abbey capitals (Franklin, 1983, p. 58, pls. XV–XVII). However, such an early date for Norwich is unlikely, and although the similarity of some details to the Hyde Abbey capitals is undeniable, the general appearance is not. The closest parallels for the Hyde Abbey capitals are found in manuscripts, such as British Library Harley 624, dating to between 1120 and 1130, and even more relevant is their dependence on the sculpture of Reading Abbey (Zarnecki, 1950b, pp. 124–37, pls. 49a, b, 51a, d, 53b, c). If it is remembered that Reading was King Henry's own foundation, and that the building of Hyde Abbey was chiefly at the King's expense, a close co-operation between the two building sites would be quite understandable. The Hyde Abbey capitals are more three-dimensional than those from Reading, and are somewhat later. G.Z.

EXHIBITIONS Manchester, 1959, no. 59 (capital b); Winchester, 1973, nos. 89–91
BIBLIOGRAPHY J. Milner, *The History Civil and Ecclesiastical and Survey of the Antiquities of Winchester*, vol. II, 1798; Cave, 1945, p. 79

129

131

129, 130 and 131 Beak-heads (*130 not illustrated*)

129 Caen stone; *h* 260 mm
c. 1125; Reading Abbey
Reading Museum and Art Gallery

130 Sandstone; *h* 200 mm, *w* 145 mm, *l* 200 mm
c. 1130–40; Old Sarum Cathedral
Salisbury, Council of the Salisbury and South Wiltshire
Museum

131 Ham Hill stone; *h* 190 mm, *w* 100 mm, *l* 420 mm
c. 1130–40; Sherborne Castle
Private collection

The beak-head is an architectural enrichment which takes the form of the head of a bird, beast, or monster, the beak or jaw of which appears to grip the moulding on which it is carved. Occasionally, a human head is used, its tongue or beard extending on to the moulding. This decoration originated in western France, where the motif of human heads was applied radially to arches of doorways; the method spread to Anjou, Normandy, England, Ireland and Scotland. A bird's head is found predominantly in England and Normandy, but it also appears in northern France and northern Spain and single examples are even found in southern Italy and Portugal. There are over 160 sites with beak-heads in England, with two areas of particular concentration, Yorkshire and Oxfordshire-Berkshire. There is reason to believe that the motif was first used in England in the cloister of Reading Abbey, *c.* 1125, and spread from there with great rapidity. The Reading beak-heads, with large eyes and numerous drilled holes, are particularly savage-looking and were undoubtedly influenced by Anglo-Saxon works, for example the animal label-stops at Deerhurst.

It is not surprising that beak-heads are found in the buildings of Bishop Roger of Salisbury, for he clearly emulated Henry I's foundation at Reading. The beak-head from Old Sarum has a smooth surface and only the pupils are drilled; it is the work of the sculptor who carved some of the corbels and label-stops there (**135**). Like the Reading example, the Old Sarum beak-head is superimposed on a roll moulding. The former was part of the cloister arcade, the latter of a doorway. The beak-heads excavated at Sherborne Castle, one of the three castles built by Bishop Roger (his fourth, at Old Sarum, was given to him by King Henry), are a different type, for they came from the rib-vaulting of the chapel or the hall. Each segment of the rib is decorated with two beak-heads facing each other, their completely detached beaks resting on the central roll of the rib. Two such segments are in the museum at Sherborne, one is in a private collection and seven came to light in recent excavations. In many ways, they are very close to those at Reading, but their closest parallel is found at Avington in Berkshire, where double beak-heads are applied to the voussoirs of the chancel arch and the rib-vaulting. Avington is only 20 miles from Reading and it probably reflects the type of decoration which existed there, perhaps in the chapter house of the Abbey. Double beak-heads were also used in the south doorway of Lincoln Cathedral, which was made *c.* 1145 during the reign of Bishop Alexander, Roger's nephew. G.Z.

BIBLIOGRAPHY Henry, Zarnecki, 1957–8, reprinted in Zarnecki, 1979, VII, pp. 19–35; Stalley, 1971, p. 62 ff.

134b

132 and 133 Two label-stops (not illustrated)

A label-stop is the terminal of a projecting semicircular moulding, protecting a doorway from rainwater.

132 Limestone; fairly good condition; h 210 mm
c. 1130
Winchester City Museum, 840

The grotesque head has concentric grooves and ridges on the forehead, on the cheeks and around the eyes, which have drilled pupils. This fragment, found in 1975, is a typical but modest example of a traditional English label-stop.

133 Limestone; good condition, still attached to projecting part which would have been embedded in the fabric of the church and not visible; l 410 mm
1130–40; St Oswald's Church, Gloucester
Gloucester City Museum and Art Gallery, 41/75 W.S. 78

This elongated animal's head is a very typical rural, rather than urban, example of a label-stop from the west of England. Such heads had actually been used at Deerhurst Priory, probably at the time of the Conquest, and appeared subsequently in many Romanesque churches, the most elaborate and extravagant being in Malmesbury Abbey and Elkstone in Gloucestershire. This example has, in an elementary form, all the features found at Malmesbury: the elongated shape, the grooved forms following the shape of the large mouth, the oval eyes and the long, pointed ears. G.Z.

BIBLIOGRAPHY Zarnecki, 1953a, pp. 22 ff., pls. 47, 48

134a and b Cloister capitals (a not illustrated)

Caen stone
c. 1130; Norwich Cathedral
Norwich, Dean and Chapter of Norwich Cathedral

For a general discussion of the Norwich capitals see **126**.

134a Damaged in the same way as **126**; h 205 mm

All three sides are carved with graceful symmetrical foliage. On the left face a figure in a short tunic grips branches and is astride the stems joined by a clasp. The foliage encloses four flowers. This relief has similarities to decorated initials, ivories (**189**) and metalwork (**247**). On the central face there is foliage and the head of a man with outstretched arms. A strikingly similar motif is found on the vestry doorway of Ely Cathedral, c. 1130. Sculpture at Ely has much in common with the Norwich capitals and it has even been suggested that they are the work of the same sculptor. On the right face only foliage with flowers is carved.

134b Badly mutilated at top; h 200 mm

On the left face a man in a long robe, holding what appears to be a holy-water bucket in one hand and a long-handled aspergillum in the other, is being approached by a bearded man wearing a short tunic and a cloak, who makes a gesture of reverence and submission. This unusual scene may be an act of exorcism performed by one of the Apostles. A striking similarity between the figure on the left and that of the Virgin Mary in the Crucifixion scene on a whalebone portable altar (**203**), has been observed by Franklin (1983, p. 58). The main face shows two men fighting; the one on the left has fired an arrow at his opponent who holds a round shield and a sword. On the right face, a man rides a donkey, his hood hanging down his back; he is carrying what is probably a pig on a pole over his shoulder, the dead animal's head pointing downwards.

It is difficult to understand why these particular scenes are depicted. Combat was a popular subject in Romanesque art, often symbolizing the vice of anger (Ira), while carrying a dead animal is occasionally intended to refer to a humorous story, for instance on the south doorway at Barfreston where an ape seated on a goat's back has a dead rabbit slung over its shoulder. G.Z.

EXHIBITION Norwich, 1980, nos. 1, 2
BIBLIOGRAPHY Zarnecki, 1958, pp. 33 ff; Franklin, 1983, pp. 56 ff.

135c

135d

135a–g Architectural sculpture from Old Sarum Cathedral (*a illustrated on p. 63; b, e, f and g not illustrated*)

Sandstone
1130–40
Salisbury, Council of the Salisbury and South Wiltshire Museum

This is only a selection of pieces from the rich collection of Romanesque sculpture from Old Sarum. The pieces come from the eastern extension of the cathedral executed by Bishop Roger (1102–39), the faithful servant of Henry I as his steward and then chancellor and justiciar. Arrested by Stephen in 1139, he forfeited his castles at Old Sarum, Sherborne, Devizes and Malmesbury, and died soon afterwards. His nephews Alexander, Bishop of Lincoln and Nigel, Bishop of Ely, were like himself great builders. In his heyday he was powerful and rich, and liked lavish decoration, in which respect he was probably imitating his royal patron's enterprise at Reading Abbey. Roger's extension at Old Sarum lasted little more than 100 years, for it was gradually dismantled on the removal of the cathedral to a new site at Salisbury. The carved stones are now found in the site museum at Old Sarum and in Salisbury. No doubt further stones will be found from time to time in demolished buildings, for the abandoned cathedral served as a quarry for the expanding town of Salisbury.

135a Gable with lions

Very weathered, legs of one lion broken off; *h* 410 mm, *w* 400 mm, thickness 260 mm

The beasts crouch on a steeply-pointed, moulded gable, their mouths touching a sphere or ball finial. The heads have a rather humorous expression. Their tails pass between their hind legs and their manes are formed by curly tufts extending down their spines. The gable was probably used externally over a porch or projecting doorway. A similar lion, but shown as a half-figure, is depicted in a gable-like arrangement on f.15ᵛ of the Shaftesbury Psalter (**25**) which could have been inspired by the Old Sarum gable. The stylistic connection between this manuscript and another sculpture from Old Sarum has been discussed above (**114**). Animals were carved on the roofs of Canterbury Cathedral (as illustrated on the plan bound with the Eadwine Psalter, **62**), and some still exist on the roof of Oakham Hall; but the most spectacular examples are found on some cathedrals and churches in the Rhineland.

BIBLIOGRAPHY Springer, 1981, p. 110

135b Corbel with a trumpeter

Considerably weathered; *h* 220 mm, *w* 250 mm, *l* 380 mm

Corbels under the eaves of roofs frequently display a great freedom in the choice of subjects, which often include comic or even obscene motifs. This trumpeter could have been intended to symbolize watchfulness (as on the *Adoration* ivory in the Victoria and Albert Museum; Beckwith, 1972, no. 63), but equally its purpose could have been pure entertainment.

135c Corbel with a youthful head

Weathered, minor damage; *h* 180 mm, *w* 180 mm

The face has a sad expression. The large, mournful eyes have drilled pupils. The hair is carved with smooth grooves and the straight nose has well-shaped nostrils.

135 d Corbel with a lion's head

h 235 mm, *w* 200 mm, *l* 200 mm

The head is powerfully modelled, with the eyes emphasized by concentric lines for eyebrows, and the forehead sunken in the middle. The small ears are upright and the crooked nose has wide nostrils from which emerges a roll-shaped moustache. In the wide mouth there is the hint of a tongue, but no teeth. The head is encircled by the tufts of a mane. The eyes have the usual drilled pupils.

This corbel and the label-stop, **e**, below, were widely imitated and for quite a considerable length of time.

135 e Label-stop with a lion's head

h 230 mm, *w* 260 mm

This is very similar to corbel **d** but with large, square, widely spaced teeth and, instead of a moustache, there are parallel grooves starting from the nostrils and running along the upper lip. A very similar, but later, head is found in Malmesbury Abbey. Bishop Roger had a castle practically next to the abbey, and it is likely that such heads existed in the castle and influenced those in the abbey.

BIBLIOGRAPHY Zarnecki, 1953a, p. 22, pls. 45, 46

135 f Voussoir with a head with a fluted tongue

h 480 mm, *w* 280 mm (max), 200 mm (min)

This and the next voussoir, **g**, came from the arch of a doorway. Although the head is superficially similar to corbel **d** and label-stop **e** it is clearly by a less talented sculptor whose chisel was less assured, and the forms are consequently hesitant and flat. The chevron pattern on the nose is unexpected, as is the straight horizontal moustache. The hand of this sculptor can be recognized in Lincoln Cathedral, where he carved the only surviving corbel supporting the ribs of the nave built by Bishop Alexander, nephew of Roger (Zarnecki, Kidson, 1976, pl. 28).

BIBLIOGRAPHY Zarnecki, 1953a, p. 7, pl. 43

135 g Voussoir with a woman trying to open the mouth of a monster

h 480 mm, *w* 270 mm (max), 210 mm (min)

This voussoir was obviously carved by the same sculptor as the previous example, **f**, and it must have belonged to the same arch. The work is not particularly distinguished, but is amusing in the contrast between the elegantly and fashionably dressed woman in a horizontal position, with a belt and wide sleeve-cuffs and a beaded hem to her dress, her legs bent uncomfortably back, and the monster's head dominated by two rows of fierce teeth. Both this and the previous voussoir are roll-moulded, the heads superimposed on the mouldings. It is strange that the heads, when in position, must have been upside down.

Another Sarum voussoir with a beak-head is discussed separately (**130**). G.Z.

BIBLIOGRAPHY Zarnecki, 1953a, pp. 22, 56, pls. 42, 43, 45

136 Corbel (*not illustrated*)

Sandstone; *h* 368 mm, *w* 222 mm, *d* 660 mm
c. 1140; south-western England
London, Victoria and Albert Museum, A.4-1946

The corbel is carved as the head of a grotesque figure with drilled eyes, its mouth stretched open with its hands. On the left side are four decorative curling scrolls, one above the other, on the right two curling scrolls addorsed. Its condition is fair, although there are a number of surface abrasions.

There is a corbel showing the same type of figure on the outside of the south transept of Winchester Cathedral (Zarnecki, 1951, pl. 33), and there are two similar examples at Kilpeck (G.R. Lewis, *Illustrations of Kilpeck Church, Herefordshire*, London, 1842, pls. 6, 9). The corbel is not as early as those at Winchester (soon after 1107) but is likely to date before the Kilpeck sculptures of around 1150. Close in type is a beak-head from the Cathedral of Old Sarum, of about 1140 (**130**). Unfortunately, it has not been possible to associate the corbel with any known site: in view of the above, an origin in south-west England seems most likely. P.W.

PROVENANCE Original provenance unknown; bought from J. Hunt, 1946
BIBLIOGRAPHY Williamson, 1983, no. 40, ill.

137 Allegorical tympanum (*illustrated on p. 68*)

Oolitic limestone, probably from the north Cotswolds; originally a semicircular tympanum, *l* about 1.14 m (at base), *h* 570 mm, re-used and plastered over in 17th-century wall of vestry, found 1980, taken out and cleaned by Professor Baker, 1983; present *l* 1.060 m (at base), *h* 457 mm, *d* 165 mm
c. 1140; All Saints Church, Billesley, Warwickshire
London, the Redundant Churches Fund

In his article on the tympanum Dr Morris (1983) rightly attributes it to the Herefordshire School. Amid tightly interlaced stalks of foliage with leaves are a man, a snake, a dove and a dragon, now headless. The man wears the characteristic trousered dress found so frequently in the works of the school, for instance on the Eardisley font and the Monmouth Museum slab. The meaning of the sculpture is fairly obvious: a man is pursued by evil forces, personified by a snake and a dragon, and he strives to escape towards a dove, the symbol of purity.

A fragment of another tympanum, now built into the external wall of the vestry of Billesley Church, is part of a *Harrowing of Hell*, its message of the hope of salvation through Christ, complementing the subject of the first tympanum. The Harrowing of Hell was the subject carved on one of the two tympana at Shobdon, the earliest work of the Herefordshire School, *c.* 1130–35. The discovery of these works at Billesley, so far from the region in which the workshop was active, testifies to the high esteem it must have enjoyed. G.Z.

BIBLIOGRAPHY Morris, 1983, pp. 198–201

138 Virgin and Child tympanum (illustrated on p. 64)

Red sandstone of local origin; both ends broken off at the base, otherwise in good condition; *l* 1.780 m (at base, originally about 1.90 m), *h* 760 mm
c. 1140; St Mary's Church, Fownhope, Herefordshire
Hereford, Fownhope Parochial Church Council

The tympanum comes from a Romanesque church of which only the tower survives. In the middle of the last century it was built into the exterior west wall of the nave (*Bristol and Gloucestershire Archaeol. Soc. Trans.*, vol. 56, p. 40), but since then it has been moved inside the church. It represents the patron saint of the church, the Virgin Mary, with an unusually large Child seated frontally and blessing, a scroll in His other hand. The Virgin displays a small round object in the fingers of her right hand and wears a cap. She has bulging eyes and prominent ears. There is a certain ambiguity about the mandorla-like form behind her. At first sight it appears to be her long hair, but it is more likely to be the back of the throne on which she is sitting. The oval form is continued by the left arm of the Virgin and the right of the Child. The parallel folds of the robes and wrinkled sleeves are characteristic of the Herefordshire School, of which this tympanum is a well-known example. On both sides of the central group are long stalks with sparse leaves, and in the left bottom corner, a single bunch of grapes, partly broken off, probably symbolizes the Tree of Life. The stalks form loops which enclose a winged lion and a bird, perhaps the symbols of St Mark and St John. On another tympanum of the Herefordshire School, at Aston, there are also only two symbols of the Evangelists, those of St John and St Luke. There are other anomalies in the iconography used by Herefordshire sculptors; for example the nimbus of the Virgin at Fownhope is cruciform. As at Shobdon, Kilpeck and Brinsop, the Fownhope tympanum would have been part of a doorway with carved arches, capitals and columns.

The hieratic, frontal position of both the figures and the position of the Virgin's feet, so wide apart, suggests the influence of wooden images of a type known as *sedes Sapientiae* ('Throne of Wisdom'), particularly popular in central France (Forsyth, 1972), and which must have come to the notice of the principal sculptor of the Herefordshire School on his pilgrimage to Santiago (see p. 148). G.Z.

BIBLIOGRAPHY Prior, Gardner, 1912, p. 171, fig. 153; Keyser, 1927, pp. 20–1, with earlier bibliog; Baltrusaitis, 1931, p. 44; Boase, 1953, p. 83; Zarnecki, 1953a, pp. 9–18; Stone, 1955, p. 70

139 Font (illustrated on p. 65)

Old Red Sandstone; *h* (of bowl) 770 mm, *h* (of base) 210 mm, *diam* 1.400 m
c. 1140; St Michael's, Castle Frome, Herefordshire
Castle Frome, Churchwardens and Parochial Church Council of St Michael's

The bowl is in good condition, but a few details are missing, e.g. the head of the dove of the Holy Spirit (a recent act of vandalism) and the hand of St Matthew. The base was originally carved from three pieces of stone, but these are now broken in numerous fragments and many of these are missing, notably two heads of supporting figures. The font has been recently (1983) cleaned and the Victorian restoration in cement removed. The only head, broken in two, has been re-set in a correct position. The work was carried out by Harrison Hill Ltd. The whitish coat of lime on the bowl is not original, neither is the lead lining.

The font is chalice-shaped and rests on a base formed by three crouching figures. It is decorated with three-stranded plaiting along the rim and an irregular interlace on the stem. On the bowl is, appropriately, the Baptism of Christ whose nude figure is half-immersed in a round pool with four fishes, while the nimbed John the Baptist is shown as a priest, blessing and wearing a maniple, incorrectly, across his right arm. Above Christ are the Hand of God and the dove of the Holy Spirit, suggesting the Trinity. To the right is a pair of doves, perhaps symbolizing purity after baptism, while the figures on the base may signify sin. Also present on the bowl are the four symbols of the Evangelists, the Bull of St Luke, the Lion of St Mark, the Eagle of St John, and St Matthew shown as a Winged Man.

This is one of the outstanding works of the Herefordshire School of sculpture (see **137** and **138**). There are related fonts at Shobdon and Eardisley in Herefordshire, Chaddesley Corbett in Worcestershire and Stottesdon in Shropshire. The style is a mixture of local and western French elements but the base suggests a knowledge of Italian art. G.Z.

BIBLIOGRAPHY Bond, 1908, *passim*, pls. p. 52; Prior, Gardner, 1912, p. 167; Zarnecki, 1953a, pp. 9–15; Stone, 1955, pl. 47b; Pevsner, *Herefordshire*, 1963, pp. 99–100

140 Three sections of a label decorated with Signs of the Zodiac in roundels

Magnesian limestone; *h* 292 mm (average), *w* 168 mm (average), radius (to inner edge) approx 1.130 m
c. 1140
York, The Yorkshire Museum

The label to which these pieces belonged enclosed the semicircular arch of a doorway; hence the slight surface weathering. Uniquely in Yorkshire, the figures were placed perpendicularly rather than radially (but cf. Malmesbury, *c.* 1150–60). The Virgo roundel was high up on the right side, which suggests that there was a full Zodiac cycle beginning with Aquarius. The backgrounds are cut away unusually deeply leaving the figures as a kind of plateau on which details are indicated by a technique that is more surface engraving than relief carving. Only the faces of the human figures occupy oblique planes. Taurus' ponderous form is well conveyed in the massive neck and the folds of flesh hanging from the forelegs. Gemini is a pair of embracing youths, the left one cloaked and holding a leaf (?) in his right hand. Virgo wears a long-cuffed gown and carries a leaf (?) in her right hand. Her free hand rests on her hip, and both index fingers are extended. All three pieces were found on the south side of Pavement, York, together with two voussoirs and two capitals (not exhibited) apparently from the same door. Their provenance is not known, but a possible source is All Saints, Pavement (RCHM, 1975, p. xlv, pl. 28). Like most other York parish churches, All Saints was almost wholly rebuilt during the late Middle Ages.

One of the earliest Zodiac cycles on a Romanesque portal is at Vézelay in Burgundy, on the central west portal of *c.* 1125, and the York Zodiac signs resemble Vézelay in being set in roundels arranged as a continuous band enclosing a door arch. Vézelay is not the source of the iconography, but at Avallon, 13 km east of Vézelay, the main west portal of *c.* 1160 has a Virgo roundel so similar to the York Virgo as to suggest that both derive from some early 12th-century Burgundian portal which has now disappeared. Further examples of Burgundian-inspired mid-12th-century York sculpture are some foliage voussoirs from other dismembered parish church doors (see entry for **141**). Doors carved with Zodiac signs enjoyed a great vogue in mid-12th-century England, and in York there survives

140

141

an ambitious door from St Nicholas' Hospital (now at St Margaret's) which has roundels with Zodiac signs and other animal motifs, not only on the label but on the voussoirs, as on many Yorkshire doors of *c*. 1150–60 (e.g. **141**).

The roundels from Pavement may be dated as early as *c*. 1140 for three reasons. First, the door from St Nicholas' Hospital (founded by 1151–61) has foliage voussoirs which look like misunderstood versions of those found with the Pavement label pieces. Second, the prior's and monks' doors at Ely Cathedral (*c*. 1130–40) are extremely similar in their technique to the Pavement pieces, and the monks' door has foliage voussoirs very like those from Pavement. Third, the overall design of the label is closer to those inside the nave doors at Durham Cathedral (*c*. 1125) than to any Yorkshire doors (except for a virtually identical fragment in St Martin-le-Grand, York). If, as seems likely, the Yorkshire School of Romanesque sculpture owed its inception to the fire which in 1137 damaged or destroyed at least 40 of York's churches, the Zodiac roundels from Pavement must be counted among the very earliest products of this school. C.W.

141 Ten voussoirs decorated with beasts and foliage

Magnesian limestone; dimensions taken from complete voussoirs: (inner) *h* 154 mm, *w* 236 mm, (middle) *h* 175 mm, *w* 234 mm, (outer) *h* 140–175 mm, *w* 230 mm
c. 1145–50; (?) St Wilfrid's or St Leonard's Hospital, York
York, The Yorkshire Museum

These pieces came from three archivolts of a doorway with a clear span of about 1.40 m. The voussoirs from the innermost archivolt have a dog and dragon enmeshed in stems which they are about to bite. The backs of these stones are flat so as to fit against a wooden door for, as in all Yorkshire School doorways, there was no tympanum. The middle archivolt is devoted to foliage and triple-strand stems plaited into complicated patterns. As on the other archivolts, the decoration spills onto the roll moulding at the front angle.

From the outer archivolt there remain six voussoirs, three of them deeper than the rest. The deeper voussoirs have larger roundels attached to plaited foliage; on the shallower pieces the roundels are not attached to the foliage designs. The soffits of all six voussoirs from the outer archivolt have a saltire cross between areas of fluting. In descending order, the roundels contain: a monster with a twisted tail; a long-legged, bare-necked bird pecking at the ground; a pig-like creature entwined in foliage and biting a stem; a symmetrical spray of three leaves; a dog leaping through foliage and biting a stem; a griffin. Nine voussoirs were found in 1941 during work on the foundations of the York Assembly Rooms and a tenth (outer archivolt, top) was recovered from a rockery in Blossom St, York, some time before 1933. The parish church which stood nearest the Assembly Rooms was St Wilfrid's, demolished in the mid-16th century. Another possible source is St Leonard's Hospital, the largest hospital in the north. St Leonard's was refounded and its church rebuilt by King Stephen between 1137 and 1154.

The re-use of these voussoirs as building material after the Reformation has preserved them from the weathering and air pollution that have gravely damaged the three Romanesque doors still standing in York. But despite the difficulty of comparing these pieces to their counterparts at St Margaret's, St Lawrence's and St Denys', there is no doubt that their quality is exceptionally high. The drawing of the animals is bold but concise, their modelling neat and rounded; the plaited foliage, especially on the middle archivolt, is executed with unusual precision. Individual elements of this foliage occur in many Yorkshire School works, but the designs as a whole are closest to the capitals of *c*. 1155 in the York Minster crypt (Zarnecki, 1953a, p. 59). The ultimate origins of this type of foliage carving may be in Burgundy, for there are in the Yorkshire Museum and St Martin-le-Grand, York, voussoirs in which the characteristic motifs are arranged to form a design that practically duplicates one on a pillar from the Abbey of Souvigny. The design of the long-snouted beasts on the inner archivolt can be matched on the roughly contemporary door at St Lawrence, York. Influence from Viking Age art in Yorkshire has been suggested (Stone, 1955, p. 79), although the animal carvings show no sign of the general tendency of Scandinavian animal art to disintegrate into abstract pattern. C.W.

142 Tombstone (*illustrated on p. 62*)

Yellow, fine-grained limestone with scattered sand grains and
abundant fossil shell debris, similar to some of the rather
variable Jurassic, Great Oolite limestones from
Northamptonshire (R.W. Sanderson); slab trimmed along top
right-hand edge by approx 50 mm, but otherwise in good
condition; *l* 1.370 m, *w* 450 mm (at top), 420 mm (at base),
d 160 mm
c. 1140; St Peter's Church, Northampton
Northampton, St Peter's Parochial Church Council

The central motif is a male head; stalks with leaves and flowers
issue from its mouth. The stalks form two loops, one enclosing
a quadruped biting its own tail, the other a winged monster
seen from above and also biting its tail. Below is a stag being
attacked by a dog. All these creatures are upside-down in
relation to the human head, indicating that the slab was placed
horizontally and could be viewed from both ends. Above the
head are two medallions, one containing a grimacing lion, the
other an interlace.

The exuberant decoration makes no allusion to the deceased,
nor does it use any Christian symbols. Perhaps this was the lid
from a sarcophagus with carved sides on which there was an
inscription and some sacred images. Some traces of carved
foliage survive on the left edge of the slab, and this confirms
that the sides of the tombstone were originally exposed to view.

The sculptor of this relief also carved some capitals in
St Peter's. He was influenced by the north Italian sculptural
style known as the *corrente comasca*. G.Z.

BIBLIOGRAPHY Zarnecki, 1953a, pp. 18–19, 54, pl. 18; Maguire, 1970, pp. 11–25

143 Christ in Majesty and St Paul reliefs

Oolitic limestone of local origin; both reliefs badly damaged,
Christ fragment headless and body assembled from six separate
pieces; (Christ) *h* 890 mm, (St Paul) *h* 1.40 m
1140–45; Lincoln Cathedral
Lincoln, Dean and Chapter of Lincoln Cathedral

When complete, the composition presumably also included
St Peter on Christ's right and the subject would therefore have
been the *Traditio legis*, Christ confiding the scroll of the Law
to St Peter in the presence of St Paul. The identification of
St Paul rests on the balding head. The figure has been
compared (Zarnecki, 1979a, XV, p. 11, pls. 9a and b) to the
column-figures of St-Denis Abbey, that prestigious royal
foundation to which Abbot Suger added a new façade which
was completed in 1140. St Paul is carved, like many of the St-
Denis column-figures, cross-legged, and covered with delicate
fan-pleated drapery. On the slab showing St Paul there is part
of a mandorla, which is studded with stars and which encloses
part of the rainbow and the cushion on which Christ was
sitting. The surface of the stone above the cushion was left
rough and there is a drilled hole for a dowel which probably
fixed a gilded sheet of metal, as a background to Christ's figure.
In the upper spandrel is an eagle, the symbol of St John, and
in the lower a bull's head with wings, the symbol of St Luke.
Christ is holding an open book and His raised arm was
presumably handing a scroll or the keys to St Peter. The folds
of His robe and His cloak are carved with great precision and
include nested V-folds, pleats and damp-folds.

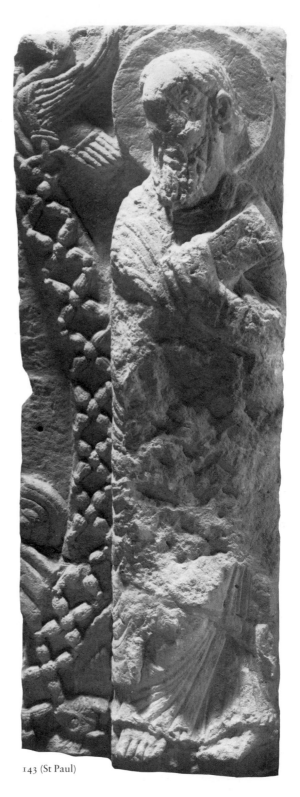

143 (St Paul)

The reliefs were probably used as a reredos over an altar or
were part of the screen which Bishop Alexander (1123–48)
must have erected when he rebuilt the nave of the
Cathedral. G.Z.

EXHIBITION London, 1930, where St Paul was exhibited as St John the Evangelist, no. 14
BIBLIOGRAPHY Prior, Gardner, 1912, pp. 141, 211, fig. 125; Stone, 1955, pp. 73–4; Zarnecki,
1963, p. 153, pl. LIII, 2; Zarnecki, 1970, pp. 10–13, pls. 18, 19a, 28

144 Fragment of an unbearded male head

c. 1145–55; probably York
York, The Yorkshire Museum

Magnesian limestone; *h* 250 mm, *w* 170 mm, *d* 210 mm
This fragment consists of rather over half an almost life-sized
head carved in the round. The intended viewpoint was frontal,
as shown by incompletely-worked parts of the hair. The overall
proportions are elongated, the brow receding and the chin
protuberant and rounded. The thin, unexpressive lips pout and
the large eyes bulge from shallow sockets, leaving little space
between eyelids and brow. The hair is arranged in twisted locks
radiating from the crown.

There is a striking resemblance between this piece and some
heads in the Louvre which come from the archivolts and
tympanum of the central west door at St-Denis Abbey (*c.* 1137–
40); the bulbous eyeballs and the treatment of the eyelids
are especially close. Whether or not this enigmatic fragment
belonged to a proto-Gothic column-figure of the type pioneered
at St-Denis, it shows that York was receptive to advanced
Continental influences in the very period when it was the centre
of a major regional school of English sculpture (e.g. **140** and
141). York sculptors probably contributed to the west portal
sculpture at Lincoln Cathedral, for it combines motifs from St-
Denis with others common in the Yorkshire School. Unlike
Lincoln, York maintained contact in the late 12th century with
advanced French sculpture (see **158**, **173** and **174**). The increase
in naturalism during the period *c.* 1150–80 can be gauged by
comparison with **173b**. C.W.

144

145 Gundrada's tombstone (*illustrated on p. 182*)

Black limestone (Tournai marble); narrower end is a 19th-
century restoration, with no attempt to complete the
inscription; *l* 1.935 m, *w* 620 mm (at top), 485 mm (at bottom)
c. 1145; Priory of St Pancras, Lewes
Lewes, the Rector, Churchwardens and Parochial Church
Council of St John the Baptist, Southover

Gundrada was the wife of William de Warenne, Earl of Surrey,
both of whom, as the result of a visit to Cluny in the 1070s
founded the Cluniac Priory of St Pancras at Lewes. She died in
childbirth in 1085 and was buried with her husband, who died
four years later, in the chapter house of the monastery. The
church and the monastic buildings were subsequently rebuilt
and consecrated *c.* 1145, when the bones of the founders were
placed in lead cists and new tombstones provided. After the
Dissolution of the Monasteries, Gundrada's tombstone was
moved to Isfield Church and incorporated into a tomb of 1550.
In 1774 it was removed to St John the Baptist Church,
Southover. The lead cists were accidentally discovered in 1845;
two years later they were placed, together with Gundrada's
tombstone, in a chapel built for the purpose.

The tombstone is framed by strips of inscription with an
additional strip dividing the slab lengthwise. The inscription
reads:

STIRPS GUNDRADA DUCU[M] DEC[US] EVI NOBILE GERMEN
INTULIT ECCLESIIS ANGLORUM BALSAMA MORU[M]
MARTH[A]
[lines missing]
[FUI]T MISERIS FUIT EX PIETATE MARIA
PARS OBIIT MARTHE SUPEREST PARS MAGNA MARIE
O PIE PANCRATI TES[TIS] [PIETA]TIS ET EQUI –
TE FACIT HEREDE[M] TU CLEMENS SUSCIPE MATREM
SEXTA KALENDARU[M] IUNII LUX OBVIA CARNIS
FREGIT ALABSTRU[M] [words missing]

Gundrada was the stem of a noble line, a noble sprig herself;
to the churches of England she brought the precious
ointments of her goodness, a Martha . . . to the wretched, in
her piety a Mary. The Martha in her died; Mary, the greater
part, survives. O pious Pancras, witness of piety and justice,
she makes you her heir; do you of your kindness take her
as your mother. The 27th of May saw her die, breaking the
alabaster vase. . . .

Professor Christopher Brooke, who made this translation,
adds:

To understand this it is necessary to recall that Martha
symbolized the active life, Mary the contemplative (and here,
eternal); that Mary was identified with Mary Magdalene and
the woman who broke the alabaster vase and poured the
unguentum over Jesus' head (Mark XIV.3) and also that
St Pancras was the patron saint of Lewes.

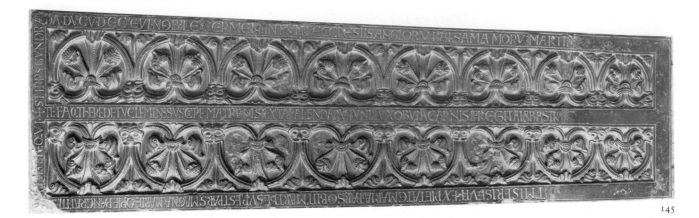

145

The ancient tradition that Gundrada was the daughter of William I is not accepted by modern historians, who believe that she was Flemish. Nevertheless, it is intriguing that the strips of the inscription on her tomb are evidently modelled on those of Queen Matilda's tomb in La Trinité, Caen. Matilda, the wife of William the Conqueror, died in 1083.

The decoration of the Lewes tombstone consists of 16 units of palmette-like plant motifs, of which four are restorations. They are joined together by lions' heads, shown full-face except the terminal ones which are in profile. Three different forms of leaves are used, including leaves enclosing berries and leaves with a band isolating their tops, the so-called 'island' leaves. Leaves of the same design are never placed next to each other. The leaves are enriched by beading and a minute raised chevron ornament. The lions' eyebrows and their ears are delicately engraved.

There is a striking similarity between the decoration of this tombstone and of the capitals from the cloister of Glastonbury Abbey (149), executed in local stone. If it is remembered that the builder of the monastic buildings at Glastonbury was Henry of Blois, the Abbot and also Bishop of Winchester, who was trained at Cluny and a friend of the Cluniac Priory of Lewes, this similarity must clearly be attributed to him. He was the man who imported the Tournai font for Winchester and it was presumably he who recommended this material to the monks of Lewes. But the stone was carved in England by a sculptor who was, it seems, in the service of Henry and who, shortly after carving Gundrada's tombstone, went to work at Glastonbury. G.Z.

BIBLIOGRAPHY Gough, 1786, pp. 8–9; W.H. Godfrey, *The Church of St John the Baptist, Southover, Lewes*, 1927, pp. 4–11; Lockett, 1971, p. 54; Turquet, 1974

146 Decorative capital

Purbeck marble; chipped and eroded; *h* 250 mm, *w* (of front face) 210 mm, (of side face) 370 mm
c. 1150; Faversham Abbey, Kent
Department of the Environment, Directorate of Ancient Monuments and Historic Buildings (The Maison Dieu, Ospringe)

The capital is unusually shaped with small steps linking the three main faces. *In situ* it probably crowned a respond, the back keyed into the wall. The decoration consists of foliage, including trefoil leaves with cap-like enclosures ('island' leaves), and human heads on the small steps adjoining the front of the capital. The heads are particularly fine, the almost naturalistic features contrasting with the schematically rendered hair.

Purbeck marble was rarely used at this date, but the material's popularity grew in the later 12th century, as the shiny, jewel-like appearance which the stone adopts when polished became fashionable.

St Saviour, Faversham, was a royal foundation of 1148. In establishing it Stephen followed William the Conqueror, founder of Battle Abbey, and Henry I, founder of Reading Abbey (see 113 and 127). Faversham Abbey was of special importance to Stephen and his queen, having been conceived and built as their mausoleum. The destruction of the abbey with its royal chapel and tombs deprives us of a most sumptuous royal building. As one of the few carved Romanesque survivals, this capital is of great importance. D.K.

BIBLIOGRAPHY Kahn, 1982, 54–6; (for other fragments) Philp, 1968

146

147b

147a

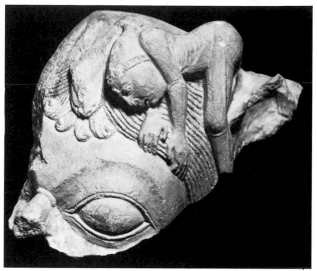

148

147 a–c Fragments of door jambs (*c not illustrated*)

Caen stone; very damaged; **a** *h* 580 mm; **b** *h* 430 mm;
c *h* 240 mm
1140–50; Wolvesey Palace, Winchester
Winchester City Museum, 841.1 and 2; Winchester Research
Unit, WP.WS.203

Wolvesey Palace was the residence of Bishop Henry of Blois.

The three fragments obviously came from one doorway, **a**
and **b** from one jamb, **c** from another. Their decoration consists
of medallions (beaded on **a** and **b**, moulded on **c**), enclosing
figural subjects, which include mermaids and harpies.
Intertwining with the medallions are branches of foliage which
spring from them and terminate in a great variety of leaves
which include pod-leaves and leaves with berries. These leaves
are very close to those used on a walrus-ivory arm from a stool
in the Museo Nazionale in Florence, which Beckwith (1972,
no. 93) attributed to Winchester and dated *c.* 1150. Such leaves
also occur profusely in the Winchester Psalter (**61**) of similar
date.

Although the motifs of these door jambs can be paralleled
in English manuscripts and ivories, the general character of the
decoration brings to mind the colonnettes of St-Denis Abbey.
Henry of Blois must have admired the new façade of Abbot
Suger's church (consecrated in 1140) and there are echoes of
this celebrated façade in other works with which Henry was
associated (see **148** and **149**). G.Z.

PROVENANCE **a** excavated in Wolvesey Palace, Room 14, 1965; **b**, **c** not recorded, Winchester
City Museum
EXHIBITIONS Winchester, 1972, no. 59 (only **a** and **b**); 1975, no. 93, pl. VII
BIBLIOGRAPHY Biddle, p. 327, pl. LXIV, b, c; Turquet, 1974

148 Fragment of a head

Caen stone; small fragment but in good condition, traces of
pigments preserved – red eye, black eyebrow and hair; *h* 155 mm
1140–50; Wolvesey Palace, Winchester
Winchester City Museum; Winchester Research Unit,
WP.WS.609

The top of the head is uncarved, presumably because the
sculpture was placed high up and that part of it was out of
sight. The fragment includes only the upper part of the nose,
the left eye and hair, which is parted in the centre but with a
few tufts forming a fringe. Perched on the hair is a small figure
with its hands holding the hair as if to prevent it from falling
into the eye. The little figure is round-headed with puffy cheeks
and delicate features. It wears a conical cap with a beaded
band. At first sight, the figure appears to be nude, the ribs
clearly visible under the skin, but a damp-fold is carved on the
legs, as if to imply a thin, tightly fitting dress.

This sculpture, so tantalizingly fragmentary, has been
compared to the works of the Master of the Leaping Figures
in the Winchester Bible (**64**), which suggests a date not earlier
than *c.* 1150. The head is so similar to the sculptures from
St-Denis Abbey that it is possible that it was part of a column-
figure, modelled on those which were on the west front of
St-Denis, and that it came from the same doorway as that of
which **147** was also part. Bishop Henry of Blois, who built
Wolvesey Palace, was a patron who would aspire to equal the
stature of Abbot Suger of St-Denis. G.Z.

EXHIBITION Winchester, 1972, no. 60; 1973, no. 94, pl. VIIIa
BIBLIOGRAPHY Turquet, 1974

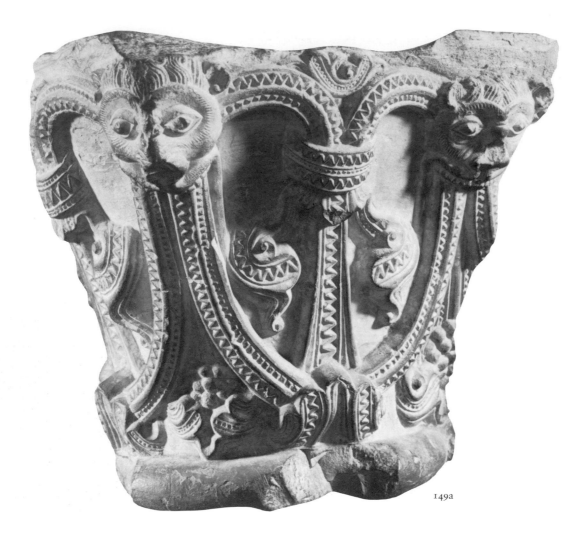

149a

149a–g Cloister sculpture from Glastonbury Abbey

(*b, e, f, and g not illustrated*)

Blue Lias limestone; a *h* 230 mm, b *h* 230 mm, c *h* 160 mm, d *h* 140 mm, e *h* 140 mm, f *h* 70 mm, g *h* 80 mm
c. 1150
a Salisbury, Council of the Salisbury and South Wiltshire Museum; b–g Glastonbury, Bath and Wells Diocesan Trustees (Reg'd)

149a This was originally a free-standing double capital supported by two colonnettes, but only half of the capital survives. It is decorated with stalks of foliage passing through lions' heads, and forms a heart-shaped design joined by clasps and enclosing trefoiled leaves, with additional leaves above and leaves and berries (or grapes) in the spandrels. The lions' heads have almond-shaped, bulging eyes, with eyebrows and whiskers marked by engraved lines while their mouths, with fierce teeth, are wide open. The foliage is delicately enriched by the raised chevron ornament and diminutive nail-heads.

The capital has no known provenance, but the material from which it is made is the same as that used for the cloister fragments from Glastonbury (b–g) and the style is also identical, so it is safe to assume that this fine capital also comes from Glastonbury.

BIBLIOGRAPHY Boase, 1953, pp. 118 and 220, pl. 436; Zarnecki, 1953a, pp. 17–18, pl. 40 (in both these works the capital is wrongly attributed to Flemish workmanship on the basis of an erroneous identification of the stone as Tournai marble); Turquet, 1974

149b A capital which was, in 1826, the property of J.F. Reeves of Abbey House, Glastonbury, and was drawn by L.C. Buckler (R. Warner, *History of the Abbey of Glastonbury*, 1826, pl. XIII). Although it is mutilated, the resemblance to capital a is striking. It is the same height and was, presumably, also half of a double capital supported by two colonnettes.

149c The fragment of a single free-standing capital which is decorated with leaves enriched by the raised chevron ornament, diminutive nail-heads, beading and berries.

149d The fragment of a single, free-standing capital which is carved with leaves enclosing berries at the angles and heart-shaped, beaded stalks, enclosing downward-pointing 'orchid' leaves.

149e The fragment of a base with a lion's head which has two beaded bands passing through it. The head is carved in higher relief than the small heads on capital a. The enrichment of bases with human or animal heads was particularly popular in Italy. In England, a remarkable series exists at Shobdon in Herefordshire, *c.* 1130–5.

149f The small head of a beardless youth with wavy hair, probably part of a capital.

149g The lower part of a human figure with delicate draperies, also presumably broken from a capital.

149c

149d

All these fragments display a rich, ornamental style. The stone, when highly polished, is like marble and is very similar in appearance to Tournai limestone. There is a significant stylistic resemblance between this group of sculptures and reliefs in Tournai marble such as, for instance, a fragment of a cloister fountain (Godfrey, p. 95 ff.) and the Gundrada tombstone (145), both from Lewes Priory. Further similarities can be found between the Glastonbury fragments and stone sculpture (147) and ivories (Beckwith, 1972, no. 93) from Winchester. The link between all these works was, in all probability, Henry of Blois, younger brother of King Stephen. He was educated at Cluny and was Abbot of Glastonbury from 1126 till his death in 1171. Appointed Bishop of Winchester in 1129, he retained Glastonbury in plurality, but resided in his palace at Winchester, being represented at Glastonbury by Robert, a monk of Lewes, who later became Bishop of Bath. Henry rebuilt the monastic buildings at Glastonbury, including the cloister, but these were all damaged by a devastating fire in 1184 and were demolished. Remnants from the cloister have been coming to light over the years, most of them in excavations.

Henry of Blois must have been influential in popularizing Tournai marble in England. The most splendid font in this black material is preserved in Winchester Cathedral, and there were also marble shafts there which are now lost. Henry was a collector of antique sculpture which he was purchasing in Rome and he probably liked Tournai marble for its fine finish, which he must have associated with some of his Roman pieces. In all probability it was Henry's example that made the Cluniac monks of Lewes use Tournai marble in their cloister and for the tombs of their founders. It has been argued that the Tournai marble tombstones at Old Sarum, Lincoln and Ely were commissioned by Alexander, Bishop of Lincoln, some time between 1140 and 1148 (Schwarzbaum, 1981, pp. 89–97), and this was probably done in emulation of Henry of Blois. When building the cloister at Glastonbury, a local substitute was found for the Tournai marble, making the work cheaper. There are superficial similarities between the sculpture from Glastonbury and works in Tournai marble, for instance the capitals in Tournai Cathedral; but the chief inspiration came from such works as the Bury Bible (44), transmitted through the artistic centre created by Henry of Blois at Winchester. Some similarities exist between the foliage motifs of the Glastonbury fragments and those on the colonnettes from the west front of St-Denis Abbey, dating to 1137–40 (New York, 1981, nos. 2a, b, c), which must have been known to Henry of Blois. G.Z.

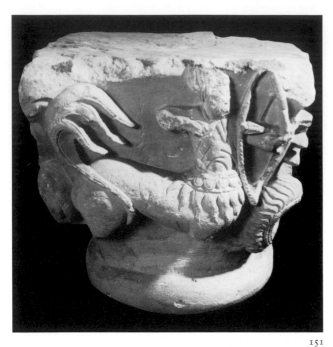

151

150 Capital with centaurs (*not illustrated*)

Limestone; originally a free-standing capital carved on four sides, subsequently cut vertically, about one-third missing, badly weathered through long exposure, necking disintegrated; *h* 295 mm
c. 1150
Winchester City Museum, 838

On the complete face is a centaur holding branches of foliage which entangle it tightly. On the neighbouring faces are similar reliefs, to the right another centaur, on the left a man. This must have once been a beautiful work, very similar in its decorative virtuosity to the initials in such local manuscripts as the Oxford, Bodleian Library MS Auct. E. inf. 1 (63). G.Z.

151 Capital with fighting monsters

Oolitic limestone; one corner cut away and filled with plaster, lower part missing, the necking is a modern restoration; *h* 265 mm, (with modern necking) 295 mm
1150–55; Winchester Cathedral
Winchester, Dean and Chapter of Winchester Cathedral

This is a free-standing capital carved on all four sides, the boundaries between the faces being marked by the sharp edge of the angle leaf, its top curving downwards. On the two opposite faces are centaurs; one, now badly mutilated, its human half turned back, has discharged an arrow which is seen protruding from the breast of a griffin carved on the adjoining face to the right. The bow is depicted with great care. The arm holding it displays the wide sleeve worn during this period by fashionable women, so presumably this is a female centaur. The male centaur on the opposite face is about to discharge an arrow at a winged monster with a snake-like tail and a bird's head with a large beak, in which one arrow is already lodged. In its outstretched arm the monster is holding a three-pronged spear aimed at its adversary. The centaur has a bushy beard and hair, and wears a decorated belt below which are long tufts of hair. Both centaurs have long tails with flame-like ends.

The sculpture is in high relief. The smooth, round forms have grace and dignity in sharp contrast to the violent deeds of the adversaries. Subjects such as these are of classical origin, but they were completely assimilated by Romanesque art, chiefly through the influence of the bestiaries (Mâle, 1978, p. 333 ff.; J. Adhémar, *Influences antiques dans l'art du Moyen Age français*, 1939, p. 179 ff.). However, there is something so genuinely classical in the elegant forms and the vigorous modelling of this capital that there is a strong possibility that the collection of classical sculpture purchased in 1151 by Bishop Henry of Blois in Rome exercised some influence in this case. If so, the capital would have to be later than 1151. G.Z.

EXHIBITION London, 1930, no. 15; Manchester, 1959, no. 54; Winchester, 1973, no. 92
BIBLIOGRAPHY Zarnecki, 1951, p. 38, pls. 73–4; Gardner, 1951, p. 69, fig. 117; Stone, 1955, p. 71, pl. 51b

152a–e Figural fragments (*d not illustrated*)

Totternhoe stone; chipped with some larger pieces broken off, but little weathered; pigment remains on some pieces
c. 1155–65; St Albans Abbey
St Albans, the Cathedral and Abbey Church of St Albans (on deposit at Verulamium Museum)

Stylistically the fragments are akin to other sculpture which was discovered *in situ* in the abbey's Romanesque chapter house built by Abbot Robert of Gorham (1151–66). The fragments may originally have been used in the decoration of that building. The preservation of pigment on some of the fragments results from their later re-use face down, lining a tomb. This group of fragments is of the finest quality. As a result of their discovery in 1978, St Albans emerges as a major centre not only of Romanesque book-illumination and metalwork, but of stone sculpture as well.

152a Male torso

Broken into two, traces of pigment on lower fragment – red background, blue and olive-green drapery; *h* 180 mm

Despite its fragmentary condition, this figure expresses a remarkable vitality and movement, with its hips and shoulders pivoted. The figure is unusual in the Romanesque period in being carved nearly in the round. The drapery hangs in segmental folds on the chest, with damp-fold patches on the shoulders and buttocks. The figure's surviving hand holds a drapery swag. Stylistically the torso resembles figures in the Terence manuscript (Oxford, Bodleian MS Auct. F.2.13, f. 47; 56), which was produced at St Albans in the mid-12th century.

152b Standing male figure

Fragmentary, broken into three pieces; traces of pigment indicate that the cloak was white, the ground red, with black or brown near the feet and a blue moulding; *h* 190 mm, original *diam* of base approx 140 mm

The figure holds a book in its left hand and the mantle in its right. The garment is arranged with crisp nested V-folds on the chest and triangular, tear-drop-shaped damp-fold enclosures. It is carved with great delicacy. Against the left shoulder are traces of a second figure. Fragments (not shown in this exhibition) confirm that this figure was flanked by others in similar poses. The figure stands on a curved base with a flat bottom, and was possibly part of a small shaft, or of a piece of church furniture.

152a

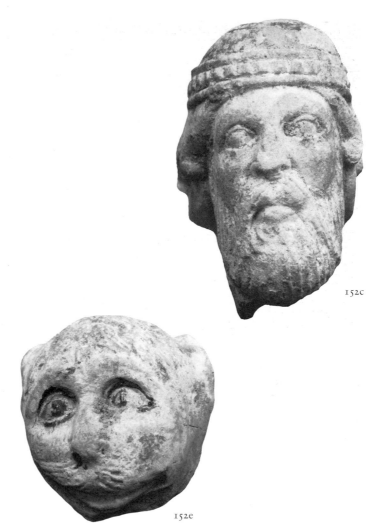

152c

152b

152e

152c Head of a prophet

Traces of brown pigment on cap, red on cheeks; *h* 55 mm

The head has a drooping moustache, short beard and a diadem or cap from under which emerge strands of hair. The expression is serene. The delicate execution of this and the other fragments suggests that the artist was familiar with ivory-carving techniques.

152d Head of a king

Traces of brown pigment on eyes, red on lips; *h* 55 mm

This crowned head has bobbed, shoulder-length hair and a grooved beard. The mouth and nose are small, and the large eyes are further accentuated and the lips highlighted by the use of paint.

152e Lion or cat head

Originally painted white, with brown eyes and nostrils, red cheeks and pink tongue; *h* 55 mm

The handlebar moustache and stuck-out tongue give this animal a comic appearance. The hair and moustache are modelled, but the cheeks have tiny grooved incisions. D.K.

EXHIBITION St Albans Abbey chapter house, 1982
BIBLIOGRAPHY Biddle, 1979; Biddle, 1980, pp. 17–32; Kahn, 1983, pp. 71–89

153

form, is placed diagonally across the Virgin's legs. The silhouette of the main figure is not entirely symmetrical, for a drapery on one side is shown as if blown by a slight breeze. The Child's hand and feet are modelled with considerable feeling for volume. The work is Romanesque in every detail, but is nevertheless strongly Byzantine in character. In fact the closest stylistic parallel for the relief is found in the Winchester Psalter (p. 24) of *c.* 1150, where two miniatures of the Virgin are believed to have been copied from a Greek diptych (Wormald, 1973, p. 90). It has been argued (Zarnecki, 1953a, pp. 29ff.) that the link between the Winchester Psalter and the York Virgin is to be found in the person of William (later St William), elected Archbishop of York in 1142 but summoned to Rome and deposed by the Pope in 1147. He visited his kinsman Roger, King of Sicily and was subsequently given refuge by his uncle Henry of Blois at Winchester. He was reinstated in 1153 and returned to York the following year but died soon afterwards, and was venerated as a saint almost immediately. He was clearly in a good position to give Byzantine or Italo-Byzantine objects as gifts to Winchester and York, and these could have provided the models for the two 'Byzantine' miniatures in the Winchester Psalter and the York Virgin. If this speculation is correct, the date of the relief is soon after 1154. It was probably used as a reredos over an altar.

Those who favour a pre-Conquest date for the relief point to the inscription at the top, SCA MARIA, as evidence because the square form of the C and an A with a loop, at the end of the inscription, are claimed to be early. However, an authority on Anglo-Saxon epigraphy concluded that 'the York Virgin is probably to be dated post-Conquest on artistic evidence, despite Clapham's attempt to prove a pre-Conquest date by reference to the script' (E. Okasha, 'The Non-Runic Scripts of Anglo-Saxon Inscriptions', *Transactions of the Cambridge Bibliographical Society*, vol. IV, 1968, p. 331). G.Z.

EXHIBITION London, 1930, no. 18
BIBLIOGRAPHY Clapham, 1948, pp. 6–13; Zarnecki, 1953a, pp. 29–31, pl. 64; Saxl, 1954, pp. 23–32; Stone, 1955, p. 75, pl. 55

153 Virgin and Child relief

Pale cream dolomitic limestone, probably obtained from the Magnesian Limestone outcrop on the west side of the Vale of York (R.W. Sanderson); mutilated, with Virgin's head and upper part of Child's body broken off, traces of red pigment on background; *h* 840 mm, *w* 382 mm (at top), 370 mm (at base)
c. 1155; York Minster
York, Dean and Chapter of York Minster

The slab bearing this relief was re-used in the 14th century, face downwards, in the east wall of the Minster, which accounts both for the damage and for the survival of some pigment. It was discovered after the fire of 1829.

The Virgin is seated on a cushion and rug, which extends down to cover a second cushion under her feet. The blessing Christ Child is not sitting on His mother's knee, as is usual, but is supported by her right hand, a convention derived from Byzantine art (see also 227). The relief is of exquisite quality, executed with assurance and great precision. The majority of the folds are composed of slight ridges and these are repeated rhythmically, covering the robes of both figures with curving patterns. Another type of fold, much bolder and tubular in

154a and b Reliefs with scenes from the life of Christ
(a not illustrated)

Sandstone: two slabs, each with two scenes, found re-used as building material in the precincts, probably deliberately mutilated, all heads missing and considerable other damage; *h* 830 mm, *w* 530 mm, *d* 180 mm
c. 1155; Durham Cathedral
Durham, Dean and Chapter of Durham Cathedral

These panels were identified (Clapham, 1934, p. 149) as forming part of the original rood-screen, the partition wall which separated the choir from the nave – that is to say the clergy, in this case the monks, from the congregation. In the *Rites of Durham*, written in 1593, the screen is described in some detail and there is the following sentence: 'Also there was . . . the whole storie & passion of our Lord wrowghte in stone most curiously & most fynely gilte . . . also . . . the whole storie & pictures of the XII apostles . . . also above . . . the most goodly & famous Roode [crucifix]. . . .' In addition, there were the images of 16 kings who were benefactors of Durham, and 16 bishops.

The panels have ridges on the back for fixing them in position, and one of them has a frame on the left side.

154a The two scenes illustrate the Transfiguration as described by St Matthew (XVII. 1–13) with Christ between

154b

both of whom were trained in the Byzantine damp-fold tradition but one was more restrained in its use than the other. Saxl and Swarzenski (Saxl 1954, p. 66) convincingly compared the style of the panels to the two ways figures are represented in the Winchester Psalter (**61**). The last of the bishops among the images mentioned in the *Rites of Durham* as decorating the screen was Hugh du Puiset, who became Bishop of Durham in 1153, having been previously Archdeacon of Winchester. He obtained the services of a team of sculptors from the south of England to execute the screen, which is likely to have been put in hand soon after his consecration.　G.Z.

EXHIBITION London, 1930, nos. 16–17
BIBLIOGRAPHY Prior, Gardner, 1912, pp. 219–20, figs 202, 203; Zarnecki, 1953a, pp. 32–3, 58, pl. 67; Saxl, 1954, p. 66; Stone, 1955, pp. 82–3, pl. 64

155 a–f Six fragments of figures and grotesques
(*not illustrated*)

Chilmark limestone; damaged through re-use as building material but virtually unweathered
c. 1155–60; Clarendon Palace, Wiltshire
Mr Andrew Christie Miller (on deposit at the Salisbury and South Wiltshire Museum)

The remains of Clarendon Palace are on a hill a few miles outside Salisbury. Originally a hunting lodge, in a forest, Clarendon became one of Henry II's favourite residences, and he made improvements to it almost annually, beginning in the second year of his reign.

The original use and location of the carved fragments is unknown. They were discovered in 1934 beneath a 14th-century floor, laid during the reign of Edward III, when the palace was extensively restored (Borenius, Charlton, 1936, p. 67). Borenius has suggested that the fragments are the remains of historiated capitals.

The dearth of domestic architecture and its decoration leaves a great gap in the knowledge of Romanesque art. There are only scattered survivals, notably the capitals from Westminster Hall (**105**) of *c.* 1090 and Oakham Hall of roughly a century later. But the murals, tapestries, pavements, carvings and other enrichments must on the whole be left to the imagination. Documents give some small insight into the splendour of Clarendon Palace. Herbert of Bosham described Clarendon as *nobilis et praeclara regis propria mansio quae ex re nomen habuit Clarendune* ('The King's own noble and illustrious mansion which was called Clarendon after him'; Colvin, 1963). The buildings included an aisled hall and the King's chamber and chapel. Documents refer to the panelling and painting of the King's chamber and to marble columns which were used somewhere in the building. The carved fragments, although so mutilated, are of the greatest importance. They bear witness to the quality of the art which adorned important secular buildings.

155a Upper part of a male torso holding a sword
Broken in two; *h* 120 mm

The sword is held vertically in the right hand. The left hand was also raised. The robes fall in graceful curved pleats on the arms and shoulders. The garment is edged with beading. The drapery is similar to that of the Apostles on a capital from Winchester City Museum (**119**) of *c.* 1140.

Moses and Elijah at the top, and the three disciples, Peter, James and John, below. They 'fell on their face, and were sore afraid. And Jesus came and touched them, and said, Arise, and be not afraid.'

154b Christ appears to Mary Magdalene after the Resurrection saying 'Touch me not' (John XX. 17); beneath is His appearance to the two Marys during which 'they came and held him by the feet, and worshipped him' (Matthew XXVIII. 9).

Even in their bad state of preservation, the panels show a remarkable clarity in their composition, and great nobility in the gestures and poses. There is a considerable difference in the details between the two panels. The Transfiguration scenes are carved in smooth, round forms without any ornament, while those showing Christ's appearances after the Resurrection use, almost excessively, the damp-fold convention and beaded hems on the robes. In panel **a**, the background is quite plain, but in the scenes on panel **b**, there are stylized trees, their branches interlacing. On panel **a**, Christ's halo is plain, on **b** it is cruciform. These differences imply the work of two sculptors,

155b Half-figure in profile

h 140 mm

This figure has a raised left arm, bent at the elbow, and drapery with similar arc-shaped folds and beading to that described above.

155c Legs of a seated figure

h 100 mm

The figure is seated as seen in profile. Borenius (p. 67) suggested that it may have represented the Christ Child seated on the Virgin's knee.

155d Head of a monster

h 70 mm

This fierce-looking grotesque head has an even row of square teeth and a face creased with wrinkles following the line of the upper jaw. The small almond-shaped eyes protrude slightly and the ears are raised.

155e Harpy

Legs, tail, head and one arm broken off; *h* 150 mm

This, the most complete figure in the series, is an eloquent testimony to the elegance and delicacy of the original carvings at Clarendon Palace. The lower, 'bird' half of the figure is decorated with small scale-like feathers. The human torso rises from a beaded waistband. The surviving arm is covered in a wide, fashionable sleeve. The figure is carved as if in motion, with slightly pivoted shoulders.

155f Figure seated on a (?) throne

h 110 mm

The figure is seen in profile facing left. It is not certain that the seat is intended as a throne. D.K.

BIBLIOGRAPHY Borenius, Charlton, 1936, pp. 55–84

156 Swan's head *(not illustrated)*

Limestone; small fragment, but in good condition; *l* 110 mm
Third quarter 12th century; Wolvesey Palace, Winchester
Winchester City Museum; Winchester Research Unit,
WP.WS.548

The head and neck are seen pointing towards the right; the back is plain. The feathers are stylized and resemble a scale pattern.

This is a rare survival of a very small-scale stone sculpture, probably broken from a capital or a piece of indoor fitting in some rich interior. Only fragments from Glastonbury Abbey (**149**) and Clarendon Palace (**155**) can be compared to this fragment in scale and delicacy of detail. G.Z.

157a

157a and b St Peter and St Paul reliefs

Portland stone (cream-coloured Oolitic limestone from the Isle of Portland, Dorset – R.W. Sanderson)
c. 1160; Ivychurch Priory, Wiltshire
Trustees of the Viscount Folkestone's 1963 settlement

These sculptures are from the Augustinian priory at Ivychurch, which in all likelihood was founded by King Stephen. The two reliefs were inserted in 1889 (see **510**) in the wall of Ivychurch House, the post-Dissolution successor to the priory, which will be discussed in the forthcoming volume of the RCHM, *The Churches of South-East Wiltshire*. They were taken out in 1982 for conservation, carried out by W. Sobczynski.

157a St Peter

Nose broken, considerable damage across legs, part of crosier missing, overall weathering; *h* 820 mm, *w* 400 mm, *d* 170 mm, (of relief) 120 mm

St Peter was carved from a slab on the other side of which is a shallow cross with splayed arms, interlacing with a 'wheel'

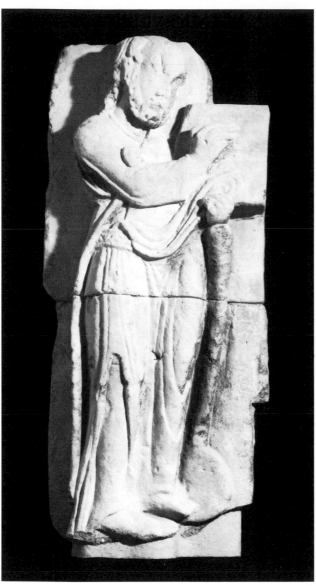

157b

157b St Paul

Damage across the legs similar to that on **a**, general weathering; *h* 830 mm, *w* 350 mm, *d* 180 mm, (of relief) 120 mm

This figure is so evidently half-bald that it can safely be identified as St Paul. The sculpture was made from two well-fitting pieces of stone (top piece *h* 440 mm, bottom *h* 390 mm). The figure is nimbed and stands in three-quarter view in front of a lectern with a round base and an open book resting on top. St Paul holds a pen and is writing in the book. He is dressed in a long robe with a slit and a belt; he holds two large folds of his cloak, one with the elbow of the right arm and the other in his left hand. There are delicate folds on the sleeve, vertical folds on one leg and oval ones on the other. The hair at the back of his head and the beard are arranged in small curls. The thin, drooping moustache adds to the solemn expression of the face.

The two reliefs clearly belonged to one decorative scheme, although there are important differences between them. St Peter is hieratic and ostentatious in the way he displays the symbols of his power. St Paul is represented as a writer, an air of gravity and concentration on his face. He is based on the representations of Paul as a scribe sometimes painted at the beginning of the Epistles, though there he is shown seated and not standing, as here (Eleen, 1982, pp. 43 ff.).

It is impossible to guess how the reliefs were used: were they part of the screen or perhaps they were placed on the piers of the cloister, of which there are many remnants on the site? Stylistically they belong to the 1160s, when the Romanesque style had reached its maturity and while there were still no traces of the naturalism of the Transitional style. G.Z.

158 Fragment of a statue of the Virgin and Child
(*not illustrated*)

Magnesian limestone; *h* 400 mm, *w* 500 mm, *d* 280 mm
c. 1160; St Mary's Abbey, York
York, The Yorkshire Museum

Almost certainly this fragment was found in 1829 somewhere on the site of St Mary's Abbey, York. Since both figures are broken off below waist level, it is unclear whether the Virgin sat or stood. The weathering and the roughly finished back suggest that this was an external niche figure (like one from Jedburgh Abbey and others on the west front of Rochester Cathedral, *c.* 1160).

This piece is of exceptional interest on account of its stylistic likeness to the column-figures on the Portail Royal at Chartres, *c.* 1145–55, especially as regards the long plaits, the tight creased tunic and the delicate carving of the folds. The frontally fastened cloak is usual in Romanesque representations of the Virgin and Child, and the fastening itself, with its long flying laces, is paralleled on jamb figures from the St-Anne portal of Notre-Dame, Paris, the south portal at Bourges and the west portal at Angers Cathedral, all *c.* 1160. A general comparison may be made with the slightly later standing Virgin from Minster-in-Sheppey (**161**), although the York piece is of much finer quality. C.W.

(compare a similar motif on the Kelloe reliquary cross, **176**). The work was evidently abandoned and the stone reversed and used for the relief of St Peter. The saint is shown standing full face, holding two large keys in his right hand while blessing, and a crosier in his left; from this arm a maniple with tassels hangs down. He is dressed as an archbishop with a pallium, a chasuble with a highly decorated collar and beaded borders, a long stole with tassels, an alb with splits at the sides and beaded sleeves. From underneath the alb protrudes one foot in a sandal; the other is broken off. On his head is a triangular mitre, which came into fashion after *c.* 1150. The face has a smooth surface with a line marking the beard. There are concentric folds on the chasuble. The figure, full of dignity and decorum, projects from a flat background.

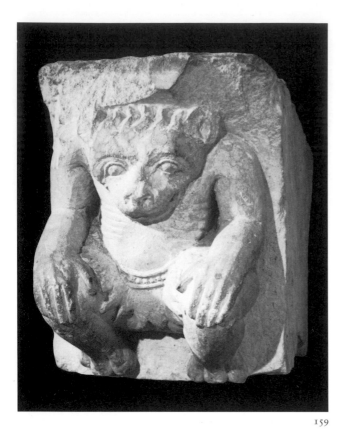

159

159 Double capital with a grotesque

Caen stone; *h* 210 mm, *l* 470 mm (at top), 200 mm (at bottom)
c. 1160–70; St Augustine's Abbey, Canterbury
Property of St Augustine's Foundation, Canterbury, on deposit
at Dover Castle. Department of the Environment, Directorate
of Ancient Monuments and Historic Buildings, LM.83.7820134

One side of the capital is carved with a seated grotesque,
hunched and resting its hands on its knees as if, like an atlas,
to support a weight above. It wears a fringed skirt with a
beaded belt and its bare torso displays prominent ribs. The
other side of the capital is carved with two simple scallops with
pronounced cones, terminating in balls. This double capital
may originally have been used as a support in a tower window,
with the grotesque facing outward. D.K.

BIBLIOGRAPHY Kahn, 1982, p. 118; Geddes, 1983, p. 95 (for St Augustine's Abbey see 107)

160 Segment of an arch carved with a dragon

Caen stone; chipped, but otherwise in good condition;
h 190 mm, *l* 470 mm (at top), 320 mm (at bottom)
c. 1170; St Augustine's Abbey, Canterbury
Property of St Augustine's Foundation, Canterbury, on deposit
at Dover Castle. Department of the Enviroment, Directorate of
Ancient Monuments and Historic Buildings, LM.172 or
SAM.237

The piece, a segment of a crescent, is unusually shaped. It may
have formed the right-hand side of a segmental tympanum over
a doorway. Similar examples exist elsewhere in Kent, notably
the priests' doorways at St Mary, Brabourne and St Nicholas,
Barfreston, and beyond the county at St Michael, Stewkley in
Buckinghamshire or a fragment found in Coventry, now in the
Herbert Art Gallery and Museum, Coventry (Woodfield, 1963,
pp. 293–4).

The motif of a dragon-like grotesque with a coiled tail is
common in Kentish Romanesque sculpture, perhaps owing to
its frequent use in local manuscripts. The piece has been dated
to the early 12th century (Zarnecki, 1950b, p. 76) and
compared with manuscript illuminations, notably Cambridge,
Trinity College MS B.4.9, f. 1. The prominent relief of the
carving, however, suggests a date later in the century, and this
would seem to be confirmed by the similarity of the motif to
the dragons decorating the south doorway of the nearby parish
church of St Mary, Patrixbourne. D.K.

BIBLIOGRAPHY Zarnecki, 1950b, p. 76; Kahn, 1982, pp. 119–20 (for St Augustine's Abbey, see
107)

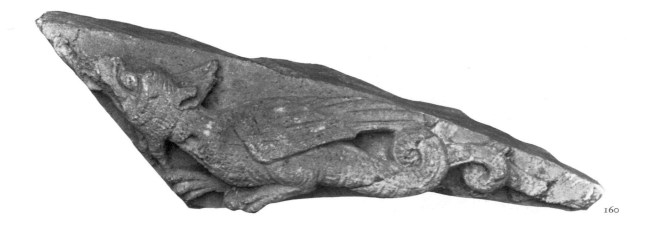

160

162

161 The Virgin and Child (*not illustrated*)

Caen stone; broken in two, badly damaged with both heads,
Virgin's right hand and Christ Child's left hand missing,
microscopic traces of red paint, almost certainly original,
recently discovered on Virgin's robe; *h* (of lower fragment)
640 mm, (of upper fragment) 200 mm
c. 1170–80; Church of Sts Mary and Sexburgha, Minster-in-
Sheppey, Kent
London, Victoria and Albert Museum, A.17-1973

The back of the sculpture is flat; Zarnecki (1972a)
reconstructed its original setting as on a screen, next to a figure
of Saint Sexburgha. This type of standing Virgin was unknown
in English Romanesque art before the figure's discovery and
was probably transmitted through northern France: the only
other 12th-century column-figure of the same subject is one at
Vermenton in Burgundy, of about 1160. Recently, Malcolm
Thurlby (1982a, pp. 215–23) has associated the Sheppey Virgin
with sculpture at Lewes and Barfreston, and has dated the
group in the 1160s. P.W.

PROVENANCE Bought from the Vicar, Churchwardens and Parochial Church Council of Sts
Mary and Sexburgha, Minster-in-Sheppey
BIBLIOGRAPHY Zarnecki, 1972a; Williamson, 1983, no. 42, with ill. and bibliog.

162 Fragment of a statuette

Magnesian limestone; in two parts, joined together, from the
lower half of a standing figure; *h* 190 mm, *w* 88 mm (max)
c. 1170–80; Bridlington Priory, Yorkshire
London, Victoria and Albert Museum, A.26-1950

The statuette is carved in the round but the back is left plain,
indicating that it was originally placed against a background,
probably a niche. Zarnecki (1953a, pp. 47–8, 62) suggested that
the figure formed part of a group, possibly an *Annunciation* or
a *Visitation*, and convincingly related it to two illustrated
Psalters, now in Glasgow and Copenhagen (**75** and **76**). These
Psalters must be attributed to an Augustinian house in
Yorkshire because of peculiarities in their calendars, and may
be dated to about 1170. Bridlington, an Augustinian Priory of
importance, cannot be ruled out as their place of origin. P.W.

PROVENANCE Found by Dr G. Zarnecki at Bridlington; given by him to the Museum, 1950
EXHIBITION New York, 1970, no. 29
BIBLIOGRAPHY Williamson, 1983, no. 41, with ill. and bibliog.

163a–c Three keystones from Keynsham Abbey, Somerset (*c illustrated on p. 68*)

Limestone; a *diam* 360 mm, *d* 310 mm, **b** *diam* 320 mm,
d 330 mm, **c** *diam* 370 mm, *d* 330 mm
c. 1170–80
Bristol, Wansdyke District Council

Keynsham Abbey was founded *c.* 1167 by William, Earl of
Gloucester, as a house for Augustinian canons, following the
rule of St-Victor of Paris. The site of the abbey has been
excavated on various occasions during the last hundred years
and many carvings, some of a very high quality, have come to
light, as well as several hundred tiles.

The three keystones, judging from their large size, were used
in the vaulting of the church itself or in another important
building, perhaps the chapter house. Since the ribs intersect at
an obtuse angle, the bays which they were vaulting were not
square but rectangular. The ribs are of three rolls, without a
keel.

163a The decoration of this keystone consists of six flowers
with berries, deeply undercut and forming a regular circular
design. Two holes are pierced in it to take ropes or chains for
the raising and lowering of a candelabrum.

163b Four masks with drilled eyes and schematized curls have
the ribs issuing from their mouths. This was a traditional
decoration for early keystones.

163c This is the richest of the three, having a beaded border
on a raised frame and within it, Samson and the lion. Samson
has a diadem on his hair and wears a long robe and a cloak
thrown over one shoulder; this hangs in wavy folds behind his
back. The border of his cloak, the diadem, the sleeves and the
hem of his dress have patterns of drilled holes. The eyes also
have drilled pupils. Samson is astride the lion and is wrenching
open its jaws. The ferocious beast oversteps the limits of the
beaded frame with its paws and bushy tail, as if to express
boundless strength. There are damp-folds on the dress of
Samson and rather surprisingly, also on the hindquarters of the
lion. In the symbolism of the period the lion often signified hell,
and Samson, wrenching open the lion's jaws typifies Christ,
who broke the gates of hell. The subject seems to have been
popular on keystones, for it is found in the next century at
Hailes Abbey in Gloucestershire (Gardner, 1951, p. 117,
fig. 216). G.Z.

BIBLIOGRAPHY W. Dugdale, *Monasticon Anglicanum*, London, 1830, vol. VI, part I, pp. 451–2;
B.J. Lowe, *Medieval Floor Tiles of Keynsham Abbey* (printed privately, no date), with a brief
history of the Abbey and a bibliog.

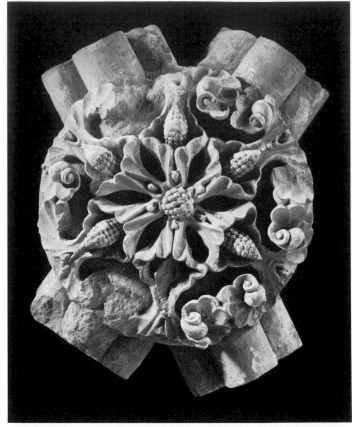

163a

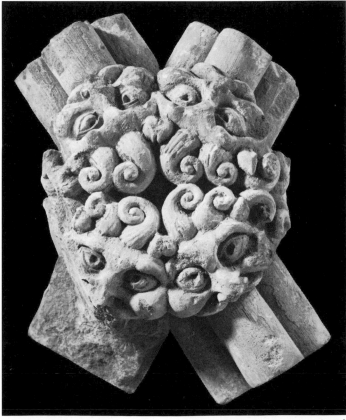

163b

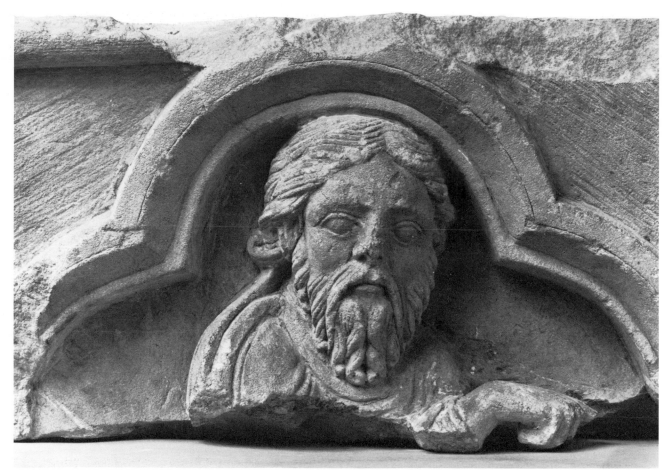

164c

164 a–m Reliefs from a screen

(g illustrated on p. 69; a, b, d, f, h, j, and m not illustrated)

Caen stone
1180; Christ Church Cathedral, Canterbury
a, c–m Canterbury, Dean and Chapter of Canterbury
Cathedral
b Canterbury, Royal Museum and Art Gallery

The reliefs were found in various places: **b** was in the collection of an 18th-century Kentish antiquary, B. Faucett, who believed that it represented King Cnut. Two others, including **a**, were found in the precincts of Christ Church; but the majority came to light during the recent restoration of the cloister where they had been re-used as masonry, with the carved side inwards. All the reliefs must have been part of one decorative scheme and this was, in all probability, the screen erected in 1180 which the chronicler Gervase, who was a local monk, mentions as the work of William the Englishman. The reliefs fall into four groups: fragments of statues (not in the exhibition), quatrefoils, roundels and architectural fragments.

164a–d Quatrefoils

h 345 mm (when complete), *w* 220 mm
Of the five surviving quatrefoils, four are exhibited. Judging from the best preserved, they were all rectangular stones with two corners at the base chamfered to make the reliefs fit between some kind of gables. The horizontal moulding at the top suggests that they were all in a row at the top of the screen. Two stones, **a** and **b**, have their original shape, but three were

trimmed at the bottom to be re-used as ashlar in the cloister. The quatrefoil frames are moulded but otherwise plain. In one relief, **b**, the frame has been removed, though traces of it survive. The surface outside the frame clearly shows diagonal chisel-marks. Within each frame of **a** and **b** is the half-figure of a king; **c** and **d** each have a half-figure probably of a prophet; and in another, not exhibited, is a woman, her face broken off. Since it was customary to have a crucifix over the centre of a screen, it is likely that these were the Virgin Mary and the ancestors of Christ, such as Jesse, David and Solomon, for during this period much stress was laid on the royal ancestry of Christ. The Tree of Jesse, as such genealogy was called, was painted at this time at Canterbury in the Paris Psalter (73) with half-figures in roundels, which include St Peter and St Paul. Thus, the woman in one screen quatrefoil is probably Mary, the two Kings David and Solomon, and the remaining two either prophets or the Apostles. There is a great deal of naturalism in the modelling of the faces, each being different although all are solemn and tense. Their cloaks are logically arranged, the folds falling in softly curving forms. There is a deliberate classicism in the coats fastened on the shoulder, in the loose garment thrown over the arm (**a**), in the arm hidden behind the mantle with only the fingers showing, and in the features of one of the kings (**b**). Three of the figures point in one direction, probably towards the crucifix. These small reliefs have their closest parallels in painting and metalwork and owe more to Mosan than to contemporary French art. They are no longer Romanesque but Transitional.

BIBLIOGRAPHY Courtauld, 1978

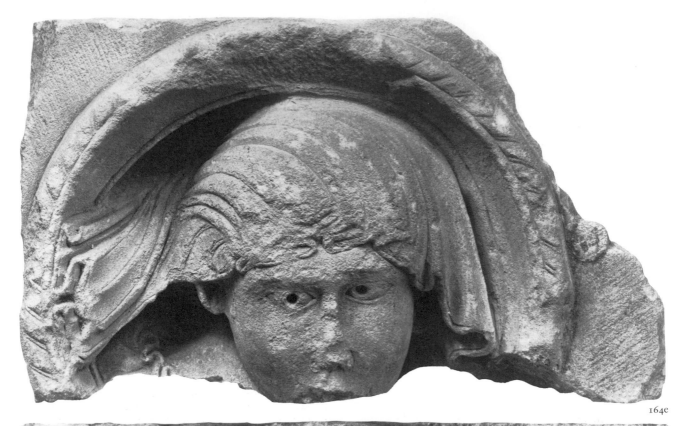

164e

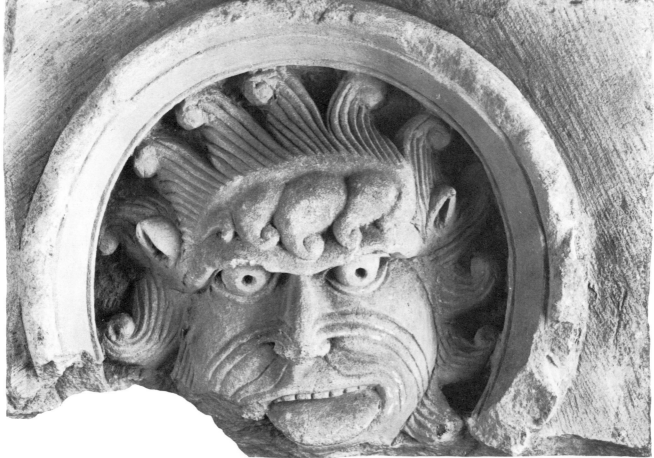

164i

164k

164 e–i Roundels

diam 300 mm (when complete)

These are rectangular stones of different sizes, all badly
damaged and none in a complete state. They have moulded,
round, projecting frames and the surface of the stone outside
the frames bears the clear traces of diagonal chisel-marks, as
on the quatrefoils. One frame (**f**) is entirely broken off; one,
although moulded, is plain (**i**); one has a cable moulding (**e**);
but two (**g** and **h**) have a very significant enrichment: a faint
chevron, produced by the rocking movement of a chisel, a
technique used in metalwork. The pupils of the eyes in all the
heads are drilled, and some have two curving lines across each
eye, to suggest the iris. It is difficult to guess how these reliefs
were used on the screen: **e** could well have been on the main
face towards the nave, but the others are more likely to have
been placed on those sections of the screen which separated the
choir from the aisles. The subjects within the roundels are as
follows:

164e The head of a young woman with a veil or scarf placed
asymmetrically over her head. The lines of the folds disappear
and reappear in a subtle way, suggesting depth and showing
an observation of nature. This, like the quatrefoils, is a
Transitional work, quite advanced for its date. The sad,
downward gaze of the woman suggests that she was a
personification of the Moon, so often, together with the Sun,
associated with the Crucifixion, or it could even be the
Synagogue, in which case there should also have been the
Church.

164f The head of a youth with a diadem is very damaged, but
even in its present state, it is a work full of character, with the
wide nose and one deeply undercut ear, the other hidden under
locks of hair.

164g This outstanding head with its flame-like beard, long
moustache and large, protruding ears, has the type of cap
which, in the Middle Ages, was associated with Old Testament
characters, so this head may have been intended to represent
a Jew. The similarity of this head in some details to the devils
in roundels **h** and **i** may well reflect the widespread anti-
semitism of the period.

164h This is clearly the head of a devil with horns, animal's
ears, flame-like hair and a beard. The mouth shows large teeth,
and there are sinister-looking wrinkles on the forehead and
round the nose.

164i A similar head to **h** but without horns, with strange
forms on the forehead and a protruding tongue.

These last two roundels seem still to be very much in the
Romanesque tradition and are influenced by such works as the
crypt capitals of Christ Church Cathedral (*c.* 1100, p. 21) and
works at Old Sarum (1130–40, **135**).

164 j–m Architectural fragments

These miscellaneous pieces, found in the restoration of the
cloister, include miniature columns, abaci, string-courses and
other features which decorated the screen and its doorways.
Those selected for the exhibition are:

164j This section of an arch (*l* 290 mm), decorated with the
billet ornament and stylized acanthus leaves, has a label-stop
at the junction with the neighbouring arch in the form of a
calf's head showing a protruding tongue.

Two other label-stops are included, but they are broken off
their arches.

164k A label-stop (*h* 105mm) in the form of a devil's head
with an enormously long, crooked nose and an open mouth
displaying large teeth.

164l

164l A label-stop (*h* 85 mm) showing a lion's head with a tiny human head in its mouth. This striking sculpture bears a strong similarity to the celebrated bronze doorknocker of Durham Cathedral (see p. 21; Geddes, 1982, pp. 126–7) with which it is roughly contemporary. The small human head in the mouth of the Canterbury lion is a feature not found in Durham, but it is used on other metal doorknockers, for instance at Adel and Luborzyca (**264** and **265**). There is no direct link between these objects, but the similarities point to metalwork as a medium with which the Canterbury fragments have much in common.

164m The string-courses, or imposts, found in the cloister still have traces of colour and suggest a lavish decoration. They are carved with orchid-type leaves, for which the Paris Psalter, painted in Canterbury at this time (**73**), provides close parallels. The curvature of one piece implies a three-dimensional treatment of the surface (*h* 145 mm, *l* 420 mm, *d* 265 mm). G.Z.

BIBLIOGRAPHY Reliefs illustrated in full in Zarnecki, 1978b

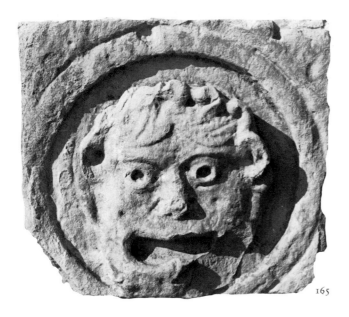

165

165 Roundel with grotesque mask

Limestone; surface badly eroded, corners and right-hand side of head broken; *h* 310 mm, *w* 345 mm
c. 1180; Rochester Cathedral
Rochester, Dean and Chapter of Rochester Cathedral

The round frame encloses a grotesque head with curly hair, drilled eyes and ears and a fierce, open mouth, all carved in deep relief. The roundel may be directly derived from a classical mask (Higgitt, 1972), and recalls such characters as are depicted in the various Terence manuscripts, particularly Oxford, Bodleian MS Auct. F.2.13 (**56**). It is closely related to the roundels containing grotesques from the screen erected by William the Englishman in 1180 at Christ Church Cathedral, Canterbury (**164**).

The stone's original use is not certain, though its weathered condition suggests an external rather than an internal position. An album in Rochester Cathedral Library contains a pre-1939 photograph showing this roundel together with a virtual twin, which has since vanished. D.K.

BIBLIOGRAPHY Higgitt, 1972, pp. 42–3; Kahn, 1982, p. 178

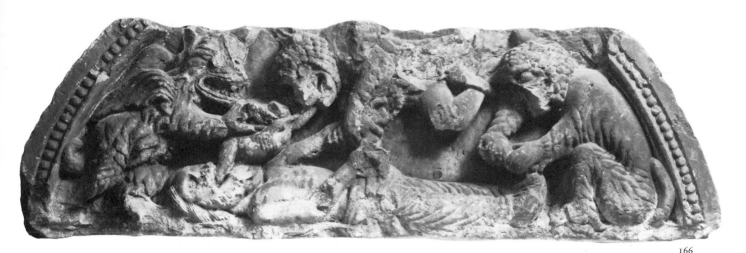

166

166 Section of a lunette with the death of a sinner

Magnesian limestone; *h* 350 mm, *w* 1.120 m
c. 1170–80; (?) York Minster
York, The Yorkshire Museum

The subject is probably the parable of Dives (the rich man) and
Lazarus in Luke XVI.19–31. The freshly-dead corpse lies along
the lower edge and the remainder of the space is occupied by
grotesque devils. The left-hand devil wrenches back the head
of the little anthropomorphized soul which has just left the
dead man's mouth. In the centre an airborne devil bites the
soul's left hand while tugging at the left arm of the corpse. Why
the right arm should also be raised is unclear, but a devil
crouched at the feet may be pulling from it some object now
broken away. The sides are part of a pointed-arched frame.
The fact that none of the figures continued on to another block
suggests that there were separate scenes above and below. It
is possible that the setting was a recess housing tiered scenes,
as at Moissac (Prior, Gardner, 1912, p. 212). This piece was
found in 1814 or 1817 re-used in the late medieval entrance
range of the archiepiscopal palace which adjoined York
Minster at its north-west corner. The didactic import of the
subject would make it appropriate for a position near the main
entrance to the Minster (as at Lincoln and Moissac). The
iconography may derive ultimately from Moissac, but the deep
cutting and the careful portrayal of anatomical details show an
awareness of northern French sculpture of *c.* 1170. Stylistically,
the closest local parallel is the *Doom* slab found nearby in 1905
and now in the crypt of the Minster (cf. Saxl, 1954, p.67). C.W.

167 Capital with scenes of men and monsters in combat (*not illustrated*)

Magnesian limestone; *h* 230 mm, *w* 520 mm
c. 1170–80; (?) York
York, The Yorkshire Museum

The capital has five faces, two on each side devoted to a single
subject. In the left-hand scene a club-wielding man attempts to
ward off two serpentine monsters, one of which bites his scalp
while the other prepares to bite his right thigh. His long tunic
is pulled tight round his outstretched legs. In the less well-
preserved right-hand scene a naked man straddling a lion falls
head-first behind the lion and towards a vulture-like bird which
pecks at his head. With his left arm he thrusts away the bird's

neck. The lion's tail is wound round the man's neck before
crossing its own thigh. The capital has been set on triple shafts
whose profile is incised on the underside. A York provenance
is likely though not certain.

This is one of the most accomplished English examples of
a favourite theme in Romanesque art and it is also one of the
latest. The full modelling, bold undercutting and relative
absence of stylization all suggest the period *c.* 1170–80, but the
carving is markedly more assured than most late-12th-century
York sculpture (e.g. **166**). The design skilfully reinforces the
architectural format of the capital. In the upper half of each
scene the densely-packed forms continue the planes of the
narrow upper margin whereas in the lower half sparser forms
recede towards the necking. The supporting elements rest on
the furthest-projecting parts of the necking so as to leave
hollows that complemented the recessions between the shafts
that stood underneath. The angles of the polygon are marked
in the left-hand scene by the vertical foreparts of the left-hand
monster, and in the right-hand scene by the angled
arrangement of the bird's wings. The composition of the right-
hand scene is impaired by the loss of the man's raised and
crooked left arm, an element originally emphasized by being
undercut and set in front of the hollow of the bird's wing.

It is probable that the original setting of this piece was a
secular building, for sculptural fantasy is almost completely
absent from the Cistercian-dominated church architecture of
late-12th-century northern England. The format of the capital
suggests that it was one of a pair supporting the hood of a
chimney-piece: the profile of the jambs recalls fireplaces of
c. 1160–70 at Conisborough Castle and Rievaulx Abbey, and
the division of the carving into two short friezes set at an angle
seems intended to exploit the most characteristic viewpoints of
a fireplace set in one of the long walls of a rectangular room.
The building in York most likely to have housed such an
exceptionally elaborate fireplace was the luxurious palace built
north of the Minster by Archbishop Roger of Pont-l'Evêque
(1154–81). C.W.

168 Fragment of a nook-shaft with foliage decoration

Magnesian limestone; *h* 342 mm, *diam* 125 mm
c. 1180; York
York, The Yorkshire Museum

Two foliage designs fill compartments generated by an all-over
pattern of interlocking diamonds and ovals. When the shaft
was in position the uncarved strip would have been concealed.
The unfinished lower corners of the carved area suggest that
the original location was a window jamb where these areas
would have been virtually invisible from ground level. The
recovery of this piece in 1920 from a site on the north side of
Pavement, York, has led to its association with parts of a mid-
12th-century door (140) found on the opposite side of the same
street (RCHM, *York*, 1975, p. xlv, pl. 28). A rather later date is
clear from the similarity of the foliage to the simplest designs
in the chapter house of St Mary's Abbey, York, *c.*1180–5. C.W.

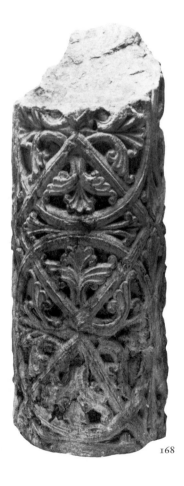

168

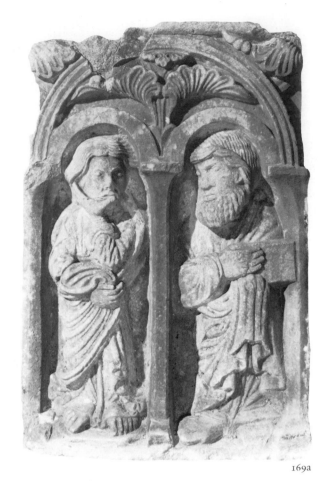

169a

169a–c Lavabo

Limestone ('Wenlock marble'); **a** *h* 770 mm, *w* 510 mm,
d 110 mm (at top) 150 mm (at base), **b** *h* 770 mm, *w* 650 mm,
d 135 mm (at top) 150 mm (at base), **c** *h* 550 mm
c. 1180; Much Wenlock Priory, Shropshire
The Trustees of the Wenlock Abbey Estate

These are fragments from what was once a substantial lavabo
or laver, a structure in which the monks could wash. The stone
has been identified by Mr R.W. Sanderson as coarse-grained
fossiliferous limestone, Silurian Wenlock limestone of local
origin, known in the district as 'Wenlock marble' because it can
be highly polished.

There were two successive churches on the site, first a 7th-
century nunnery where the future St Milburga was Abbess,
followed by an establishment of secular canons founded before
the Conquest. Roger, Earl of Shrewsbury, a trusted friend of
William the Conqueror, refounded the house between 1079 and
1082 as a Cluniac priory, dependent on La Charité-sur-Loire.

Within the ruins of the priory, on the south side of the
cloister garth, a mound was removed in 1878 and in it were
discovered the remnants of the lavabo, which included two
panels with figural reliefs and many pieces of carved foliage.
Soon after the discovery, the carved stones were drawn by
H. Langford Warren and eventually published (*Architectural
Review*, vol. I, 1891), and from these drawings it appears that
some foliage fragments have since disappeared. The surviving
carved stones were brought to London in 1982–3 by the kind
permission of the owners and have undergone conservation
and cleaning in the laboratory of the Department of the

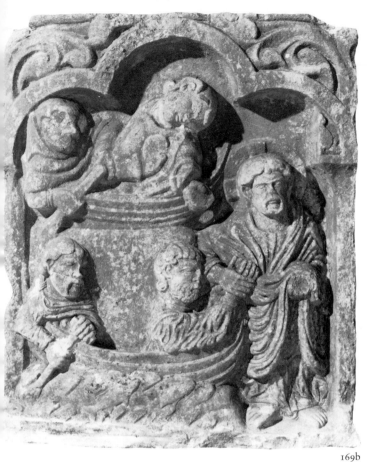

169b

Environment by Mr J. Price and his staff. The drawings reproduced here were made with great skill by Mr J. Thorn.

The Wenlock lavabo was situated close to the refectory, as was the general custom, so that the monks could wash before meals. It was an octagonal building with open arcades carrying a roof which provided shelter for the central structure of three storeys. The lowest was a circular wall supporting the trough with plugholes for draining the water through a pipe. This wall was faced with several plain and two carved slabs (**a** and **b** below). The trough was supplied with water from a cistern above which was smaller in diameter and made of one piece of stone. There were 32 lobes on the exterior and the same number of flutings inside the cistern. The water came from 16 spouts and fell into the trough below, so that 16 monks could wash simultaneously. There was yet another smaller construction above from which water fell into the cistern, but its form is unknown.

The carved panels are as follows:

169a Two Apostles

They stand under twin arches crowned by a large arch enclosing two leaves, which continue on the spandrels above. The figures are short and heavy. One is bearded and has a fringe of plaited hair. He holds a book in one hand which is covered, in reverence, by a cloak, but at the same time he touches this book with the other hand, which is bare. Heslop rightly points out that the Wenlock reliefs are related to the ivory flabellum handle in the British Museum (**217**) and, indeed, one of the figures at the top of the flabellum holds the book in an identical manner. The other figure on the stone

relief is beardless; he holds a swag of his cloak in one hand and places the other under his chin. This gesture of sorrow is often found in representations of St John in the Crucifixion scene. Thus, the figures are likely to be St John and another Apostle (but not St Paul as suggested by Langford Warren, for he is usually shown half-bald, as in **143** and **157b**).

169b Christ calling St Peter

The scene, hitherto wrongly identified as Christ walking on the water (Matthew XIV.22–31), is framed by a trilobed arch with spandrels filled with large leaves which spring from the capitals below the arch. Christ, identified by the cruciform nimbus, holds the ample folds of His cloak in one hand. He does not stand on the water, for this stops short of His feet. There are two boats in the water, each with an oarsman at the stern. The second man in the lower boat lifts his hands and Christ is touching them as if to illustrate Matthew IV.18–20, in which Christ calls Peter and Andrew, who are fishing in the Sea of Galilee, to follow Him. The other boat also has a second occupant, a youthful figure, making a gesture of submission, who must be John. In the same account, IV.21–2, Christ calls James and John, who are in another boat, and they also follow Him. The choice of subject for these two panels seems obscure, though it must be remembered that St Peter was particularly venerated at Cluny, the abbey having been dedicated to him. The power over the Church given by Christ to St Peter and thus to his successors, the popes, was frequently stressed during this period. It is no accident that the same subject was carved on a capital in another Cluniac priory, at Lewes (**111**).

169c Cistern (*illustrated on p. 202*)

The foliage on the cistern almost entirely covered the 32 lobes and was arranged in two rows. Each pair of adjoining lobes had the same motif repeated four times, two in the upper and two in the lower rows. Sixteen heads projected from the clefts between every second lobe at the bottom of the cistern, water issuing from their mouths, which had drilled holes for the purpose. The foliage is carved with great delicacy and precision, and when the stone was fresh and highly polished it must have been a work which well deserved to be called 'a gem of Romanesque design and workmanship' (Godfrey, p. 95).

Comparisons have been made between the style of the panels and Cluniac sculpture in Burgundy (Prior, Gardner, 1912, p. 120), and the head of Christ was thought to have been based on a classical dramatic mask transmitted by an illustrated Terence manuscript such as **56** (Stone, 1955, p. 100). But an explanation of the style should be sought in Mosan metalwork of the last quarter of the 12th century, for it is there that such abundant draperies are found, and such large, expressive heads. The metallic appearance of the foliage further points in that direction. G.Z.

BIBLIOGRAPHY H. Langford Warren in *Architectural Review*, vol. I, 1891, Boston, pp. 1–4, pls. VI–VIII; Prior, Gardner, 1912, p. 76, figs. 129, 130; D.H.S. Cranage, 'The Monastery of St Milburge at Much Wenlock, Shropshire', *Archaeologia*, vol. LXXII, 1922, p. 105; Zarnecki, 1953a, pp. 47, 62, pls. 113, 114; Lockett, 1971, pp. 59–60

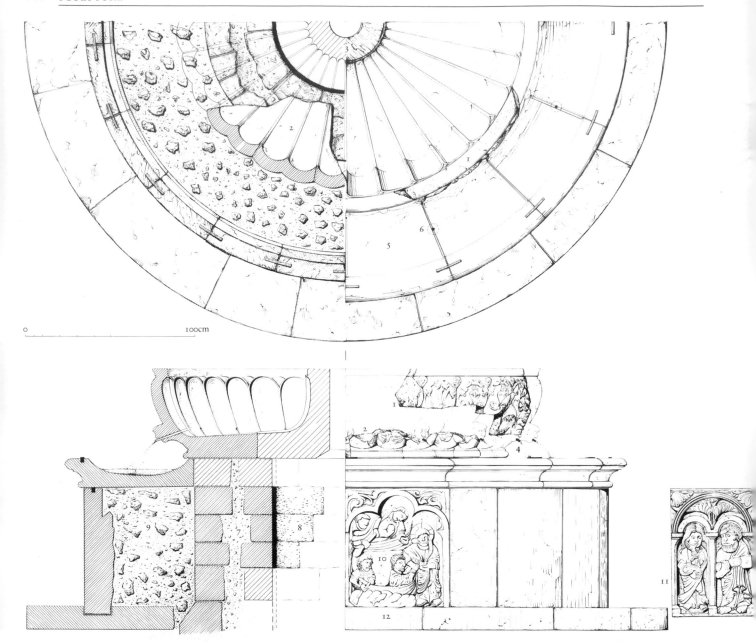

0 100cm

The drawing above is a reconstruction of the Much Wenlock Lavabo. It shows two basic views from the eastern side in plan and elevation with the left side used as a section in both cases.

The basin rim fragment (1) is placed in relation to the fluted base (2) which met a column (3) now lost, including the superstructure which probably contained a series of spouts which discharged into the basin. The basin was of one piece of stone with decoration of 32 ribs, with the motifs in pairs. Between each pair was an anthropomorphic spout, making a total of 16, 3 of which survive (4). These discharge into a trough (5) which had an iron clamped rim with probable sink-holes (6).

The basin was supported on an ashlar wellhead (7) which shows a thick lime concretion on the interior (8), and the trough was supported by a rubble core (9) confined by stone panels which originally contained the decorative panels (10, 11), of which there were three. These were set into a groove which partly concealed them, and fastened with iron clamps at the top. This also formed the step (12). JAMES COPLAND THORN

169c

169c

170

170 Lectern

Limestone ('Wenlock marble'); *h* 310 mm, *w* 580 mm (front
and back), 590 mm (sides), 470 × 470 mm (base)
c. 1180; Much Wenlock Priory, Shropshire
The Trustees of the Wenlock Abbey Estate

The Wenlock lectern was supported by a square capital and
column or pillar, but these have not survived. It was found in
the ruins of the priory. Only three 12th-century lecterns survive
in England, the others being at Norton (from Evesham Abbey)
and Crowle, both in Worcestershire. The Wenlock lectern is
the earliest.

The sloping top is surrounded by a rim on three sides and
has a ledge to hold the book at the bottom. There are two
knobs at the corners of the rim at the top, the purpose of which
is presumably purely decorative. On the ledge were two
projecting lions' heads, one of which is broken off. The three
remaining sides of the lectern are carved in high relief with
foliage issuing from inverted masks.

While marble lecterns are frequent on Italian Romanesque
pulpits, north of the Alps they were usually made of wood or
metal. The three examples in England are clearly the result of
a local fashion. G.Z.

BIBLIOGRAPHY Houghton, 1913, p. 4

171 Three voussoirs from a rib (*not illustrated*)

Caen stone; chipped, some large pieces broken off, traces of
vivid red and black paint remain; *h* 210 mm, *l* 170 mm (at top),
150 mm (at bottom)
Last quarter 12th century; St Augustine's Abbey, Canterbury
Property of St Augustine's Foundation, Canterbury, on deposit
at Dover Castle. Department of the Environment, Directorate
of Ancient Monuments and Historic Buildings, 775.775/6/7

The profile of the voussoirs suggests that they are rib segments.
On each a slim, central roll is flanked by an elegant dogtooth
ornament on one side, and by chevron with sharply-pointed
V-shaped teeth overhanging the central roll on the other. The
voussoirs are painted with black and red stripes, and in the
centre of each V is a three-lobed black and red rosette.

As has been noted (Miscampbell, 1981, Geddes, 1983), the
similarity of the profile of these voussoirs to that of the vault
ribs of the choir aisles, constructed between 1174 and 1180,
suggests that the two series cannot be far removed from one
another in date. But what makes these pieces remarkable is the

survival of pigment, which gives some idea of the lively painted
decoration which embellished most Romanesque architectural
mouldings. D.K.

BIBLIOGRAPHY Miscampbell, 1981, pp. 63–5; Kahn, 1982, p. 118; Geddes, 1983, p. 95 (for St
Augustine's Abbey see 107)

172 Gaming piece

Boxwood; smoothed by frequent handling, some crenellations
broken off; *h* 65 mm
Late 12th century
Boston, Museum of Fine Arts, 54.931, Helen and Alice Colburn
Fund

The piece is rectangular, with bevelled edges and a hollow
interior. On the top are carved two addorsed knights wearing
mail, surrounded by crenellations. On the sides chevron and
beading separate four scenes: a standing animal playing a
bagpipe; a seated man with pipes and with a bird at his feet;
a standing animal with a tail playing a tambourine, with two
cubs; and a seated animal playing a harp.

The hollow interior has led to the suggestion that the piece
may have been part of a precentor's staff. However, this seems
unlikely in view of the secular nature of the scenes represented.
The wear through frequent handling also suggests that the
piece was used for a board game. The scenes represented on
the piece are similar to those used on the south doorway of St
Nicholas, Barfreston, a parish church with sculpture derived
from Christ Church Cathedral, Canterbury. D.K.

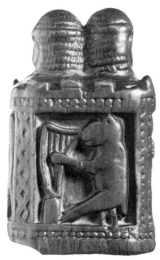

172

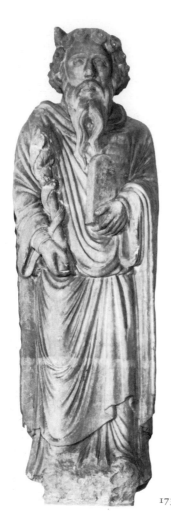

173a

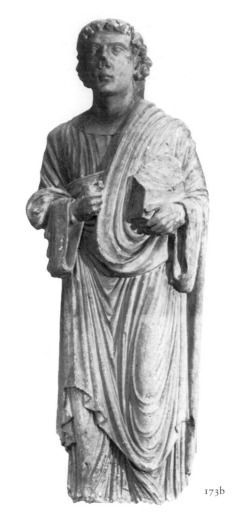

173b

173 a–d Four life-sized statues from a series of prophets, typological figures and Apostles

Magnesian limestone
c. 1180–85; St Mary's Abbey, York
York, The Yorkshire Museum

173a Moses

h 1.730 m, *w* 560 mm, *d* 400 mm

The prophet carries in his left hand the tables of the Law and supports with his right hand the end of a short staff around which twists the brazen serpent. Horns protrude from the crown, in accordance with St Jerome's mistranslation of Exodus XXXIV. 29. The hair is arranged in large ringlets and the beard is long and forked. The calf-length cloak, secured with a button-like fastening on the right shoulder, descends as a series of U-folds before being caught up over the left arm. Under the cloak is a wide-sleeved overtunic, its belt concealed by overlapping looped folds. The lower part of the overtunic is pulled up so as to generate vertical folds on the left and looped drapery flattened out against the right thigh and shin. The folds of the undertunic, interrupted by the emerging feet, oversail the base at the sides. The cuffs of the undertunic sleeves appear within the wider sleeves of the overtunic. Above the flat back a shaft extends from the shoulders to the top of the head. The overtunic retains traces of blue paint.

173b (?) St John the Evangelist

h 1.730 m, *w* 600 mm, *d* 360 mm

The prominent clean-shaven chin and short curly hair give this figure a youthful appearance appropriate to St John the Evangelist. The index finger of the clenched right hand points towards the book carried in the crook of the left arm. The cloak covers the left shoulder and arm, between which parallel folds hang in a roughly U-shaped formation. The front edge of the cloak emerges from under the right arm and is pulled horizontally across the lower chest, leaving the remainder hanging to calf level. Some of the hanging material is pulled up over the right forearm, where it forms a knot. Above and below the knee of the relaxed left leg the hanging loops of drapery are pressed smooth. Nested V-folds hang between the legs. The tunic, which has an undecorated round collar, fans out immediately above the feet and has overhung the base. Base and feet are broken away. The back is treated as in **a**.

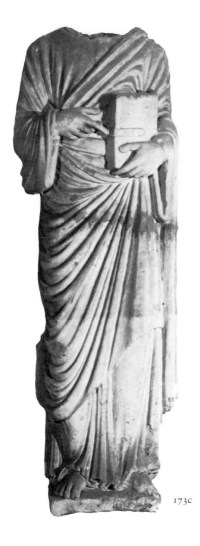

173c

173d

173c (?) An Apostle

h 1.500 m, *w* 500 mm, *d* 450 mm

The head is missing but there is otherwise little damage. The right hand is held against the upper chest and its index finger points down towards the book held upright in the left hand. The cloak covers the left shoulder and arm, is pulled down across the chest and disappears under the right armpit. The other end of the cloak reappears below the right elbow and is drawn across the front of the figure before being caught up behind the left hand and the book. Most of the relaxed right leg is covered by a very prominent series of loosely-looped folds. The tunic fits quite smoothly against the chest and the lower legs, although the latter are divided by fanned-out folds and flanked by others continuing the vertical lines of the cloak. The bare feet stand on a rectangular block at roughly 60 and 30 degrees to the front edge. The back is approximately right-angled, with traces of a shaft emerging at shoulder level.

173d (?) An Apostle

h 1.490 m

The head, feet and much of the upper right portion have been broken away. The left forearm supports the remains of a book set at an angle. On the upper half of the body the drapery seems to have been similar to that of **b** except that the cloak cannot have been pulled across the front, as there remain traces of the overlapping looped folds of the overtunic hanging in front of and concealing a belt (compare **a**). The general design of the lower part recalls **a**, although the relaxed leg flattens more of the overtunic drapery and the undertunic fans out at the bottom much as in **b**. The back is treated as in **a**.

These four figures and three others were found in 1829 buried in the ruined late-13th-century nave of St Mary's Abbey, York. A further four statues, apparently from the same series, have since been recovered from other sites in York. The original size and composition of the series is unknown. Only Moses (**a**), St John the Baptist and St James (not exhibited) can be identified beyond doubt. Seven figures, including **b**, **c** and **d** have generally been identified as Apostles by the books they carry and because the bare feet of four, including **c**, are the usual medieval means of denoting Apostles. However, this convention and the one by which prophets are shown shod and holding scrolls were not strictly adhered to outside France

during the late 12th century. If Moses' feet had survived and been shod, it would have been almost certain that the barefoot figures were Apostles. As it is, b, c and d could equally well be prophets, in which case the clean-shaven figure usually identified as St John the Evangelist (b) might be Daniel. The brazen serpent held by Moses betrays an awareness of a kind of figure cycle pioneered c. 1170 at Senlis, whose members all carry attributes referring typologically to Christ. (The brazen serpent is a type for the Cross.) Of the other figures preserved only St John the Baptist would fit into such a cycle, a fact which suggests that typological figures were always in a minority here. It is possible that the Apostles were distinguished from prophets and typological figures partly by having shorter beards, a method which would divide the survivors into four Apostles, including b and c, four prophets and typological figures, including a, and two figures without evidence of beard length, including d.

The St Mary's Abbey figures are not column-figures in the same sense as the sculptures on the jambs of major Ile-de-France portals, since their backing columns or shafts emerge only at shoulder level instead of extending the whole length of the figure. However, there are many French jamb figures outside the Ile-de-France which are related to their shafts in the same way as the York figures. The presence of shafts and the stylistic debt to France have given rise to the theory that the original setting was on the jambs of a portal or portals, an interpretation which can be challenged on two main counts. First, the figures were reported at the time of their finding to be brilliantly painted and gilded, which they are unlikely to have been if their setting had been outdoors. Second, the backs are of two different shapes, flat (e.g. a and b) and wedge-shaped (e.g. c and d), a variation not matched in any late-12th-century French portal. Recent research has shown that the chapter house of St Mary's, the Abbey's only richly decorated building contemporary with the statues, had a five-bay rib vault whose supports included shafts of the same diameter (180 mm) as those behind the heads of the statues (RCHM, York, 1975, pp. xlii–xliii, pls. 12b, 23a, 24a; Wilson, 1983, pp. 104, 113). Moreover, the number of these supports (12) was that needed to include a full Apostle series. The flat-backed figures would have stood between the lateral windows, and the figures with wedge-shaped backs would have fitted into the corners of the room. The chapter house vestibule was too low ever to have housed life-sized statues, so it appears that all the figures were in the main room. The most likely arrangement would be two tiers: Apostles representing the New Law above prophets and typological figures representing the Old Law. The nearest parallel for such a scheme is the Fürstenportal at Bamberg (c. 1235) whose jambs have 12 Apostles standing on the shoulders of 12 prophets. Although no exact parallels now exist for life-sized figures incorporated into the vault shafts of a chapter house, it is quite possible that the idea developed from the series of relatively small atlas figures which substitute for vault-shafts in the chapter house at Durham Cathedral, built c. 1133–41. Another possibility is that the York scheme was anticipated in one or more of the many French chapter houses destroyed during the 18th century.

a, b and c are variations on a type of standing figure which originated in Mosan metalwork and book-painting of c. 1100–60 and was adopted c. 1175–90 by French sculptors, notably on the west portals at Mantes and the north-west portal at Sens. The distinguishing features of the type are straight hanging folds that hide the leg carrying the weight and looped draperies pulled taut over the relaxed leg. Virtually every detail of the drapery on these three figures has been traced to the Mantes and Sens portals (Sauerländer, 1959, pp. 64–80), but parallels can also be drawn with the Virgin from the west front of Noyon Cathedral (compare the 'windswept' drapery on the left leg of b) and a column-figure of Dialectic in the Sens Municipal Museum (compare the small overlapping loops immediately below the waist of a and d). c also reflects the Mosan-derived type, but the drapery on the relaxed leg, instead of being pulled taut, hangs against the thigh and calf as a continuous yet carefully varied series of loops. In France this motif first appears on the central north transept portal at Chartres (c. 1205–10), was developed with increasing elaboration and emphasis at Rheims from c. 1220, and was eventually transformed into one of the stock features of mid- and late-13th-century French sculpture. Late-12th-century parallels for this drapery pattern probably existed among the many French jamb figures of this period which have been destroyed.

The St Mary's Abbey figures are the work of three artists. The sculptor of a, and of two other figures not exhibited, favours a rather top-heavy physique, perhaps in an attempt to compensate for the foreshortening that distorts figure sculpture placed high up. His drapery tends to fall in repetitive tubular loops, and his cutting is often perfunctory. The contrasted loops and folds of the lower draperies are for him primarily a surface pattern to enliven the almost straight-legged stance of his figures and not, as they were for most late-12th-century French sculptors, a way of emphasizing the contrast between relaxed and straight legs (Sauerländer, 1959, p. 61). In the other statues exhibited the purpose of this drapery pattern is fully understood, and the relaxed leg is shown projecting well in advance of the weight-bearing leg. The sculptor of c avoids the unwieldy proportions of a, but his cutting is also rather lacking in animation (see the folds on the left leg). The most skilled artist of the three was the one who carved b and d. His drawing is graceful and inventive and his cutting crisp and varied. The looped and twisted drapery on the right leg of d is perhaps the finest passage of carving on any of the St Mary's statues.

The formal, motionless impression created by the frontal stance and blocky contours of the St Mary's figures has been condemned and ascribed to a failure to employ the French technique of cutting into the block from the edges (Sauerländer, 1959, p. 69). However, these peculiarities are arguably due not to limited skill but to a concern that the sculptures should reflect the verticality of the vault shafts into which they fitted. Confirmation that the St Mary's figures were 'immobilized' so as to achieve harmony with their architectural setting is provided by some contemporary figures at York Minster which combine a lack of shafts with a sense of movement reminiscent of Nicholas of Verdun's prophets on the Three Kings Shrine at Cologne. C.W.

174 c,g,a

174 a–g Seven voussoirs with scenes from the life of Christ (*b, e and f not illustrated*)

Magnesian limestone
c. 1180; St Mary's Abbey, York
York, The Yorkshire Museum

174a The Visitation

h 450 mm, *w* 220 mm, *d* 200 mm

Mary, on the left, moves forward to embrace the stooping Elizabeth. Part of Elizabeth's right hand behind Mary's neck remains, but the undercut near arms of both figures are broken away. Parts of Mary's tunic originally obscured by the near arms are left unfinished.

174b Christ in the manger

h 420 mm, *w* 220 mm, *d* 400 mm

The swaddled infant Christ lies on a structure resembling a settle with a bowed front. Gathered drapery covers the back, over which peer the ox and the ass.

174c Herod orders the Massacre of the Innocents

h 630 mm, *w* 220 mm, *d* 360 mm

The seated king turns left and raises his right arm in a gesture of command. To his left are two helmeted and mail-clad soldiers, one with an unsheathed sword looking at Herod and pointing towards the next scene, as if verifying his orders. A column supporting a pair of turreted and crenellated arches divides Herod from his soldiers. As in **d** and **e**, there is a marked disparity in scale between seated and standing figures.

174d The Magi before Herod

h 460 mm, *w* 220 mm, *d* 560 mm

The centrally-placed Magus leans forward and converses with the seated Herod. The right-hand of the two Magi standing further back turns slightly towards his colleague.

174e Adoration of the Magi

h 440 mm, *w* 220 mm, *d* 520 mm

Christ is seated on the Virgin's left knee and raises His right hand in blessing as a Magus kneels to present a gift. Another stands beside the Virgin, and the head of the third appears between them. At some time during the Middle Ages the Virgin's head has been broken off and dowelled back on again.

174f Christ turns water into wine at the Marriage in Cana

h 530 mm, *w* 220 mm, *d* 370 mm

Christ, who carries a book, turns towards a servant pouring from an upturned vessel. Above the latter is the head of another servant and a round open-necked vessel. Behind Christ stands the Virgin, her left hand raised (in a gesture of surprise?). Despite its projection, the figure of Christ has been nimbed.

174g The raising of Lazarus

h 420 mm, *w* 220 mm, *d* 400 mm

The shrouded Lazarus rises from a tub-like sarcophagus behind which stands Christ and Lazarus' sisters, Mary and Martha. The left-hand sister looks towards Christ, and the other sister extends her left arm above Lazarus' head.

174d

Voussoirs **a, c, f** and **g** were found in 1829 in the ruins of St Mary's Abbey, York (exact find spot unknown); **b, d** and **e** were found in 1963 re-used in post-medieval masonry on the site of the east wall of the chapter house of the abbey. Measurement of the radii shows that **a–f** belonged to an arch of about 1.33 m clear width, apparently one of two flanking the slightly wider arch that incorporated **g**. The three arches probably had two archivolts each and a total of around 60 voussoirs, enough for a fairly detailed cycle of the life of Christ. The under-side of the base of **a** is a canopy, which proves there was another voussoir below. This was no doubt the Annunciation and the first scene of the cycle. There are anomalies in the arrangement of the scenes in the archivolt to which **a** and **e** belonged. *Christ in the manger* would almost certainly have been supplemented by figures of Mary and Joseph in the outer archivolt, contrary to the general sequence (but compare the south portal at Le Mans Cathedral, *c.* 1155). *Herod ordering the Massacre of the Innocents* and the now-lost *Massacre* itself occupied the apex of the archivolt instead of following the *Adoration* (but compare the great prominence of this episode at Le Mans and Glastonbury, 1184–6).

The two-arched structure in **c** has been compared to the *Massacre of the Innocents* in a northern English Psalter of *c.* 1180 (Oxford, Bodleian Library, MS Gough Liturg. 2, f. 19; Zarnecki, 1953a, p. 63, fig. 127). From the sculptor's point of view the main importance of this feature was as a 'filler' to prevent the figures from appearing almost horizontal on account of their position near the apex of the arch. The repertory of forms is essentially that of the large figures from St Mary's (**173**), although there is far greater variety of pose here. In most cases the disposition of the figures echoes the half-cylindrical plan of the base-cum-canopies. The degree of finish is not as high as in contemporary French voussoir sculpture, although most of the best-preserved heads are those worked less carefully because they were originally less prominent. The foliage under the base of **a** is closely related to a large capital from a vault-shaft in the chapter house (not exhibited), and the simpler design under **b** is common in mid-12th-century York decorative sculpture.

It has naturally been assumed that these pieces came from a portal (Prior, Gardner, 1912, p. 217). However, the recovery of three of them from the site of the east wall of the St Mary's chapter house suggests that they might have decorated large east windows lighting that building. The east wall was far thicker than the other walls, an anomaly which could have been due to the inclusion of unusually deep window recesses. In northern France windows with figural archivolts were apparently unknown until *c.* 1200 (Laon Cathedral, west front), but the English penchant for unconventional applications of the elements of French portal sculpture (e.g. **161** and **173**) makes it difficult to discount the possibility that the setting was one not paralleled in 12th-century France. The dimensions of these voussoirs do not correspond to those of the portals of the chapter house and its vestibule. C.W.

175 Foliage capital from a respond incorporating three shafts (*not illustrated*)

Magnesian limestone; *h* 350 mm, *w* 600 mm, *d* 770 mm
c. 1180–85; St Mary's Abbey, York
York, The Yorkshire Museum

Above the neckings three crown-like formations of leaves fan out into thick curling sprays forming a frieze under the semicircular upper edge. The sprays are grouped in five symmetrical pairs echoing the five projecting elements at the lower edge. This capital, found at St Mary's Abbey, York in 1829, appears to have belonged to a series of 12 supporting the chapter house vault and incorporating the well-known column-figures, **173** (Wilson, 1983, pp. 104, 113). From the same series survive a smaller corner capital and a fragment of another identical in format to the exhibited capital but of higher quality. The basic motif of the exhibited capital, the multi-lobed leaf with a central groove, appears on the jambs of the chapter house entrance. Nearly all the individual motifs of the chapter house foliage carving derive from capitals installed during 1177 and 1178 in the choir of Canterbury Cathedral. This influence from capitals in the most advanced French style, and probably carved by Frenchmen, raised the possibility that the French influences on the column-figures were also transmitted via Canterbury. Except for a dismantled doorway at Kirk Ella parish church (North Humberside), no other northern building has foliage carving in this style. C.W.

176 Reliquary cross (*illustrated on p. 66*)

Grey sandstone; broken and repaired; *h* 1.860 m, *w* 420 mm,
d 145 mm
c. 1200; St Helen's Church, Kelloe, County Durham
Kelloe Parish Church

The cross was found in 1854 built into the south wall of the chancel, three of its arms broken, sections of the 'wheel' missing and the shaft broken in two. It was crudely repaired and set in the north wall of the chancel at floor level. It was taken out in 1894 by William Anelay Ltd for conservation.

The top of the shaft narrows and is crowned by a perforated, splayed cross, its arms once joined by a 'wheel'. J.T. Lang, who devoted a detailed study to the cross (1977) draws convincing parallels between the iconography of the three scenes carved

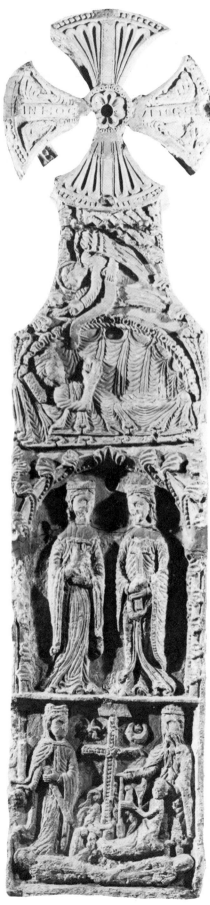

176

on the cross and that of Mosan metalwork. These scenes depict the legend of the Invention of the True Cross, in which the patroness of the church, St Helen or Helena, played the central role. In medieval times she was believed, quite wrongly, to have been a native of England.

The story begins with the lowest relief, which conflates several episodes. St Helena is shown with a drawn sword to compel the Jew Judas (the future St Cyriacus) to dig in search of the Cross. Judas is depicted with a very long beard and a cap, which in medieval art denotes a Jew (compare **164g**). He holds a spade with which he has dug up an old cemetery, discovering corpses and three crosses. The True Cross was identified by its bringing a dead body, about to be buried, to life; this is the small nude figure shown next to Judas. The two other crosses were burnt in the fire, symbolized by flame-like forms at Helena's feet. The True Cross is in the centre with a label on top on which there was perhaps a painted inscription identifying it: (?) *Lignum Domini* ('the Lord's wood'). It is flanked by the Sun and the Moon, taken from the iconography of the Crucifixion.

The next relief shows two figures in long robes and with diadems on their heads. One is holding a cross, the other a small sword (Lang, 1977, p. 113). Most scholars agree that the first is St Helena but opinions vary as to the identity of the other, who is thought to be the Church (Saxl, 1954, p. 68); Sheba (Boase, 1953, pp. 233–4); and even Constantine, Helena's son (Lang, p. 113), although they both appear to be women.

The third scene represents the Dream of Constantine, the first Christian emperor, in which an angel appeared to him and, pointing to a cross, said: 'In this sign you will conquer.' In the relief these words, somewhat abridged, are inscribed on the horizontal arms of the cross: IN HOC VINCES.

The figure style of the reliefs is characterized by rounded faces with placid expressions, and turbulent, flowing draperies. There is a great deal of ornamental detail: delicate leaves, beading and fluting on the vertical arms of the cross. The carved edge at the left of the cross is covered with a beaded leaf design. The right edge and the back of the cross are plain.

There is a round cavity in the centre of the cross-head deep enough to contain a small relic, which would have been covered by a transparent crystal, probably set in gold. There are numerous other oval settings for glass, crystal or semi-precious stones. When painted and studded with these jewel-like adornments, the cross must have looked rich and impressive. The most likely relic to have been in this unusual reliquary was a fragment of what was, at that time, thought to be the True Cross.

The two carved faces suggest that the cross originally stood against the south wall of the chancel, where it was found in 1854. The main carved side was no doubt facing the congregation, the edge carved with foliage, towards the altar. The iron hoops just below the cross-head were no doubt for the insertion of candle-holders, the candle light illuminating the focal point, the relic in its rich setting. G.Z.

BIBLIOGRAPHY Lang, 1977, pp. 105–19, pls. V–VI

Ivory Carvings

Ivory has always been a luxury material. Throughout the Middle Ages the supply of elephant tusks from Africa and from India was erratic. It is clear that in Britain and the rest of northern Europe it was in very short supply during the 12th century because virtually all the surviving pieces are made of what has been called 'morse' ivory – the ivory of the tusks of walrus or, more unusually, of whalebone. Although morse ivory lacks the fine grain and the much-prized, almost pure white colour of elephant ivory, it compensates for this by being of a rich buttery colour with a translucent surface, which in addition takes a most marvellous polish, especially when much handled.

Chroniclers tell us that walrus and even whales were hunted by Scandinavians since King Alfred's time and by the Basques of northern Spain since at least the 10th century. The 'Colloquium' written by Aelfric, who was Abbot of Eynsham at the time, gives us a rare glimpse of the luxury trade in the late 10th or early 11th centuries. It was written as an amusing and instructive reading book designed to help young scholars to understand Latin correctly. Among the descriptions of daily life – so rare in the early Middle Ages – a conversation between a scholar and a merchant is given: 'What kind of things do you bring us?' asks the scholar, and the merchant replies, 'Purple and silk, precious stones and gold, various sorts of clothing, pigments, wine and oil, ivory, copper, brass and tin, sulphur and glass and the like.' A little later he admits, 'I wish to sell dearer here than I bought there, that I may gain some profits to keep myself and my wife and son.'[1]

Ivory comes at the end of the luxury items in this list, purple and silk apparently being thought the most valuable, even more so than precious stones and gold; it is prized only a little more highly than the much more utilitarian copper and brass. This impression is supported by an analysis of the documentary evidence where, among the ivory objects mentioned, utilitarian objects like combs outnumber the more valuable objects like shrines or images many times over. The three combs shown in this exhibition (**184**, **197** and **198**), although objects of utility, are nevertheless very spectacular. The earlier, very large double-sided comb may be the only piece of elephant ivory of the Romanesque period as yet found in this country. It is highly decorated and bears a pious inscription. It may have been made for religious use, either during Mass or the ceremony of the consecration of bishops:[2] the pontifical of the Roman Curia still prescribes the use of an ivory comb after the annointing of a bishop-elect today. The other two combs, decorated with rather cramped figure scenes, also suggest liturgical rather than secular use. Of the more precious objects, ivory seems most often to have been used to make pyxes, the small containers in which to keep the reserved host.

The relatively few ivory carvings of the English Romanesque period that have come down to us represent only a very small proportion of those originally carved. Nevertheless, they give us a somewhat more complete picture than, for example, the work of gold- or silversmiths, whose intrinsically far more valuable material could easily be melted down to make coin in times of financial difficulty or be refashioned into a more up-to-date work of art. This was a frequent occurrence in the Middle Ages when people had the self-confidence to believe they could always improve on the work of an earlier time. But even ivory carvings fall short of the more complete history that can be traced in the far more numerous illuminated manuscripts to have come down to us. It is, therefore, frequently necessary to relate ivories to more accurately datable manuscripts and to books that can be localized by their contents to particular centres of production. Moreover it is natural to relate the style of ivories to illuminated books because, although it may only rarely be true that they were carved by the same craftsmen who painted miniatures, there can be no doubt that book-covers, which were often decorated with ivory carvings, must have been made in the same monasteries as books. Certainly this was still the case in the 12th century, although by the end of the Romanesque period secular workshops in the larger towns and cities may have increasingly taken over the production of such luxury books and their covers.

The dating of ivories and their attribution to centres of production are frequently controversial. Indeed, even the attribution to an English rather than a Continental origin is often a matter of dispute. Thus the famous large whalebone panel with the *Adoration of the Magi* in the Victoria and Albert Museum, long believed to be of Anglo-Saxon date and origin, later was thought to be English Romanesque and is now generally agreed to be of Spanish – or perhaps southern French – craftsmanship. It was therefore considered to be inappropriate to include that particular masterpiece in the exhibition. The *Deposition* panel, also in the Victoria and Albert Museum, which has been attributed by some scholars to a West Country workshop closely related to the Herefordshire School, has, for example, also been omitted from our selection for this exhibition. Other important pieces, although of undoubted English origin, like those in the Bargello Museum in Florence, which would have added much to our ability to demonstrate the high quality of ivories carved in the second half of the twelfth century, were unfortunately not lent by their owners.

One might have thought that provenance could be established when an ivory was found either accidentally, or better still, in controlled archaeological excavations at a particular place, and yet there is no certainty that such pieces were made there. Thus both the pierced decorative panel found at St Albans in 1920 (**189**) and the crosier fragment in an excavation at Battle Abbey in 1979 (**195**) find their closest stylistic parallels not at St Albans or at Battle, but at Canterbury. It is generally agreed that the provenance of ivory can be better established by stylistic links with manuscript illumination, which can be securely attributed to centres of production based on liturgical or historical evidence. The two double-sided combs already mentioned, for example, **197** and **198**, can be attributed to St Albans (or possibly to Bury St Edmunds) where a very similar figure style is seen in manuscript illuminations. The cache of 48 chessmen found on Lewis in the Outer Hebrides were certainly not local products, but probably among the goods of a merchant whose ships traded along the seaboard of the British Isles, across the North Sea and beyond. Not only are ivories always likely to have travelled easily, but skilled craftsmen also must often have worked both in Britain and on the Continent, especially at

centres linked by traditional ties in Flanders or northern France, as well as in Scandinavia.

None of the surviving ivories is dated by external evidence. In dating them, and especially those in the earlier part of our period during the formative years of the Romanesque style, much depends on one's understanding of the effect of the Norman Conquest. In ivory carving, as indeed in the other figurative arts, some scholars believe that the Conquest resulted in the ruin of the fine flowering of Anglo-Saxon art, and therefore tend to attribute any ivories of quality to a period well into the 12th century. Others affirm that the Conquest brought England into the mainstream of European development. Like most historical judgements, the truth lies somewhere in the middle. Some Anglo-Saxon characteristics, especially the free, sketchy drawing of the Winchester style, continued in use well after the Conquest. It was not only natural that indigenous artists should continue their craft after the Norman take over, but it was surely all the more to be expected, because the Duchy of Normandy, as well as the bordering Flemish regions, had themselves been under strong Anglo-Saxon influence throughout the first half of the 11th century. The so-called pen-case in the British Museum (185) still shows strong Anglo-Saxon stylistic traits on its lid and on some of the side panels – such as the one showing two men tilling the soil; whereas other panels, like the one with the large figure attacked by lions, show a sculptural quality of strong and simplified three-dimensional forms which indicate an understanding of Romanesque sculptural concepts one would not expect to find in England until well after the Conquest. If the date attributed to the pen-case can be accepted, it further strengthens the argument in favour of a strong Anglo-Saxon survival after the Conquest, which has frequently been recognized in pieces like the double-sided comb found in Wales (184) and the fragmentary corpus of a crucifix now in the London Museum (200) which can so convincingly be compared to another corpus fragment, certainly of late Saxon date, found in the excavations at Winchester.[3]

But as well as such continuity of Anglo-Saxon characteristics, the new and close contact with northern Europe established by the Normans can perhaps be better shown in ivory carving than in any other field – with the possible exception of architecture, where not only Norman planning, but such obviously Flemish, or possibly Rhenish, details like the ubiquitous cushion capital shows a similar familiarity with Continental practice.

A whole group of carvings can be attributed to the late 11th and early 12th centuries, which can only be explained by being derived from the Low Countries, and through them, from the traditions of the classical revival of the Carolingian and Ottonian periods. The two kings (192) and the small reliquary cross on loan to the British Museum (193) are of very high quality, and give us the first evidence, in figurative art, of such close ties with Flanders. Here we see the refinement and delicacy of style, as well as an astonishingly subtle naturalism, which can only be part of the classicizing traditions of the Low Countries. The self-conscious imitation of the antique, so long established there, is an essential ingredient of this style and, indeed, of the Early Romanesque and nowhere can it be better seen than in this small group of ivory carvings. Close to them,

and showing the same kind of elegance and refined form, is the oval pyx in the Victoria and Albert Museum (191) and the triangular piece with two flying angels from Winchester, so closely related to it (190). Both owe something to the same Flemish classicism, but also reveal a much stronger dependence on Anglo-Saxon traditions and it is not surprising that they have long been attributed to the Anglo-Saxon period. But their fully modelled three-dimensional treatment, the angels deeply set into their flat frame in the Winchester panel, and the elaborate architectural setting of the pyx, must make an early 12th century date far more likely. Support for such a date is given by the famous two-volume bible, written in 1095–7, in Stavelot Abbey and now in the British Library (MS Add. 28106–7). Here are found delicacy and subtlety of drawing, as well as elongated and thin figures very like the two kings. With these ivories the foundations are laid for the appearance of a masterpiece, equally strongly linked with the traditions of the Low Countries early in the second quarter of the 12th century: the great altar cross now in New York and the compelling Oslo corpus, which was probably always part of it (206–208). Without such earlier experiments it would be difficult to account for the creation of this great cross. With the New York cross, 12th-century ivory carving reached its climax. Even at a time when such objects were very much more common than their very rare survival today suggests, this cross, with its wealth of figure carving and its rich and remarkable liturgical meaning, must have been an outstanding work of art. Surrounded as it was, by the gold and silver furnishings of an early medieval altar and lit by the flickering light of candles, its impact must have been truly astonishing.

The Lewis Chessmen (212) were carved towards the middle of the century, either in eastern England or possibly in Scandinavia where pieces with a similar decorative vocabulary have been found. With them a much older indigenous insular tradition, in which animals are interlaced with foliate scrolls, comes again into its own. The same style is even more developed in the splendid large walrus tusk (211) which may be the remains of a magnificent ivory throne. If it is, and it can be compared in scale and form with the legs of surviving early medieval Scandinavian wooden chairs, it might have rivalled the great ivory throne of Maximianus in Ravenna carved in the 6th century or the Carolingian throne of St Peter's in Rome, a wooden structure richly decorated with ivory, made at the court of Charles the Bald.

The small ivory, carved almost in the round and now in the Metropolitan Museum in New York shows the *Flight into Egypt* (214). It proves that work produced later in the century could achieve remarkable quality – and that in ivory carving, as in the other figurative arts, the so-called 'Transitional' style of the late 12th century saw a fusion of stylistic elements, both formal and naturalistic, that was able to create work of great expressive power. But ivory carving, although still of very high quality, was about to decline in quantity if not in quality. Perhaps the material became less plentiful than it had been earlier in the century. Certainly walrus ivory is only very rarely found after the late 12th century. At the end of the 13th and early in the 14th centuries, when ivories were again to play an important role in European Gothic art, elephant ivory was the only material used. P.L.

NOTES

1. E. Lipson, *The Economic History of England*, vol. I, 1959, p. 513
2. Durandus, *Rationale Divinorum Officiorum*, 4th book, chap. 3
3. Winchester, 1973, no. 19

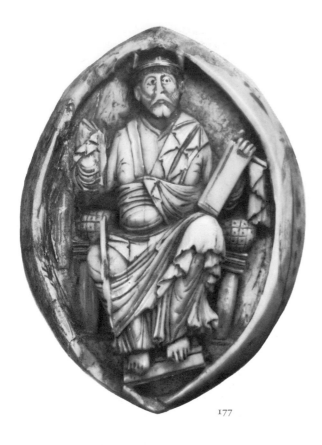

177

177 Christ in Majesty

Walrus ivory; *h* 95 mm
Anglo-Saxon; first half 11th century
London, Victoria and Albert Museum, A.32-1928

Part of the left side has broken and has been restored with plaster; Christ's right hand is missing. It is likely that the background was once gold plated.

It has been suggested that this relief and **178** are companion pieces and may have come from a book-cover (Beckwith, 1972, p. 126). There are two objections to this hypothesis: the first is that they are made differently (the border of the *Virgin and Child* relief is grooved and has pin-holes to hold a gold-plated band) which suggests that they come from different objects; the second is that the depth of carving on the reliefs would have made them unsuitable for a book-cover. A portable altar or reliquary shrine would seem a more likely setting.

The two reliefs fit comfortably into the stylistic *milieu* of the first half of the 11th century. The agitated, zigzagging draperies are very close to those seen in a number of manuscripts produced from the late 10th century right up to the Conquest: especially close to the *Christ in Majesty* is the same figure in a manuscript of about 1020 – Trinity College, Cambridge, MS B.10.4 (see Rice, 1952, pl. 62). This very distinctive style, derived from the Carolingian Utrecht Psalter, is first seen in England in the Benedictional of St Aethelwold, a manuscript produced at Winchester in around 980. The style had spread to Canterbury and elsewhere by the beginning of the 11th century. P.W.

PROVENANCE Purchased from Durlacher, London, 1928
EXHIBITION London, 1974, no. 24, repr.
BIBLIOGRAPHY Beckwith, 1972, no. 39, ill. 76 (with bibliog.); Williamson, 1982, p. 32, p. 15a

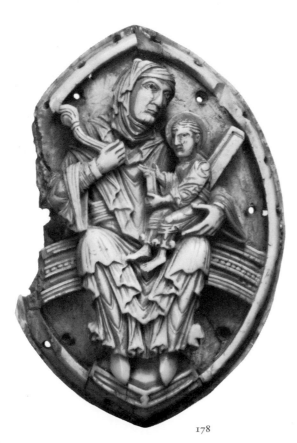

178

178 The Virgin and Child

Walrus ivory; *h* 100 mm, *w* 67 mm
Anglo-Saxon; first half 11th century
London, Victoria and Albert Museum A.5-1935

The Virgin is seated on a rainbow within a mandorla, supporting the Child on her left knee. She holds a sceptre in the form of a branch in her right hand and a book between the Child and her left arm. The border and background are pierced with pin-holes and a portion of the left side is broken away. The grooved border would have contained a gold band and the background would almost certainly have been gold plated. See notes on **177**. P.W.

PROVENANCE Demotte, Paris, presented by Alphonse Kann, 1935
EXHIBITION London, 1974, no. 25, repr.
BIBLIOGRAPHY Beckwith, 1972, no. 40, ill. 75 (with bibliog.); Williamson, 1982, p. 32, pl. 15b

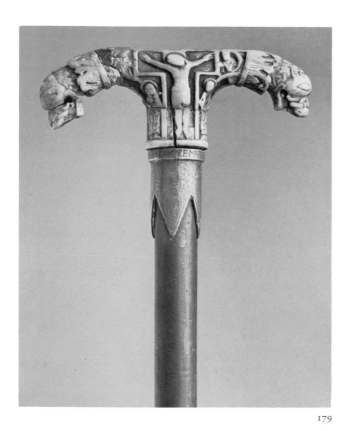

179

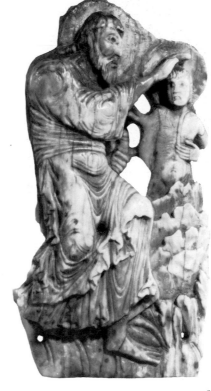

180

179 The Heribert crosier

Walrus ivory; *h* 55 mm, *w* 145 mm
Anglo-Saxon; first half 11th century
Cologne, Hohe Domkirche

The tau-cross-shaped crosier is much rubbed and is mounted over a ferrule of silver engraved with the Three Marys at the Tomb and the Harrowing of Hell in the Anglo-Saxon drawing style of the first half of the 11th century; the ring above is engraved RELIQVIE · SCE · MARIE · ET · SCI CHRISTOFORI · The relics of these saints were no doubt housed in the staff.

The crosier is carved with terminals of powerful lion heads issuing from a ring of acanthus leaves. On one side, there is a Crucifixion in a frame-like cross with sun and moon, the Hand of God the Father above and the Virgin and St John on each side. On the opposite side, two flying angels hold a mandorla with Christ in Majesty.

Originally from Deutz parish church, the crosier is linked by tradition with the Archbishop of Cologne, Heribert of Deutz (999–1021). Although it is not impossible that it belonged to the Archbishop and that he gave it to Deutz, a date for the crosier nearer the middle of the 11th century may seem more appropriate. Certainly the small reliquary cross (193) and the two flying angels from Winchester (190) suggest the continuity well into the 12th century of the Anglo-Saxon tradition, as seen in this crosier. P.L.

BIBLIOGRAPHY Beckwith, 1972, no. 30

180 Baptism of Christ

Walrus ivory; *h* 93 mm, *w* 45 mm
Anglo-Saxon; mid-11th century
London, Trustees of the British Museum, 1974, 10-2, 1

A large, bearded figure of St John the Baptist baptises the smaller figure of Christ. The agitated, linear style is typical of Anglo-Saxon drawing of the late 10th and 11th centuries, but the weight and volume of the figures and the directional pull of drapery approaches the monumental style of the *Harrowing of Hell* from Bristol (96) rather than the delicate but more superficial network of lines of the *Christ in Majesty* and *Virgin and Child* (177 and 178). P.L.

PROVENANCE Stanislas Baron Collection in the 19th century; Martin-le-Roy Collection; private collection, France; acquired 1974
EXHIBITION London, 1974, no. 10
BIBLIOGRAPHY Beckwith, 1972, no. 14

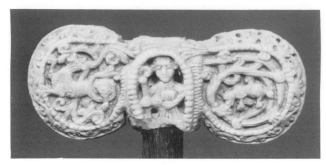

181

181 Head of a tau-cross crosier

Walrus ivory; *h* 50 mm, *w* 115 mm
Norman; mid-11th century
Rouen, Musée départemental des Antiquités

Each side is carved with foliage inhabited by quadrupeds and
framed by a border of foliate tendrils. This vigorous carving
is related to the capitals at Jumièges (**98**) and initials in Norman
manuscripts of the 11th century. In the centre of one face is a
man with a crosier and a book, and on the other is a mermaid,
both under arches. This is the earliest of the type of tau-cross
crosier heads represented by **188** and **205**, and is distinct from
the more delicate, thin-necked, dragon-headed crosiers of the
Anglo-Saxon tradition (**179**). P.L.

PROVENANCE Found at Jumièges, recorded by Abbot Cochet, 1868
EXHIBITION Rouen, Caen, 1979, no. 269
BIBLIOGRAPHY Gaborit-Chopin, 1978, pp. 94, 195, no. 120

182 Christ in Majesty

Walrus ivory; *h* 155 mm, *w* 65 mm
Flemish or English; late 11th century
New York, The Metropolitan Museum of Art, gift of
J. Pierpont Morgan, 1917 (B.27) (17.190.217)

On the front, a Christ in Majesty blessing and, on the back,
an Agnus Dei in a diamond frame against acanthus foliage and
two Evangelist symbols with eyes inlaid with black beads,
reminiscent of the reliquary cross in the British Museum (**193**)
on which the Evangelist symbol of St Luke is somewhat
similarly twisted to look upward towards the Lamb of God.
Moreover, it is rare to have the Bull of St Luke at the base
where the Winged Man of St Matthew is more normally
placed. It is clear that two pieces of ivory were originally
attached to each side to complete the composition with two
more Evangelist symbols.

 The style shows strong Anglo-Saxon influence, but the large
head and the broad, flat treatment of drapery are both
paralleled in the Gospels in the Royal Library in Brussels (MS II,
175; Cologne, 1972, f. 23, p. 229), probably from St-Bertin in
St-Omer. The fact that the ivory was in a Flemish collection
supports an attribution to Flanders but, if this is the case, it
was carved under very strong English influence. P.L.

PROVENANCE Quenson Collection, St-Omer and Arras, in the 19th century; acquired 1917
EXHIBITION London, 1974, no. 22
BIBLIOGRAPHY Beckwith, 1972, no. 27; Gaborit-Chopin, 1978, nos. 141 and 142

183 St John of Beverley crosier (*illustrated on p. 70*)

Walrus ivory; *h* 96 mm, *w* (of volute) 68 mm, *diam* 23 mm
Late 11th century
Private collection, on deposit at the British Museum

The stem is decorated with an inhabited foliate scroll, closely
related in style to manuscript illuminations of the late 11th and
early 12th centuries of the Anglo-Norman tradition. The same
is true of the figure style. In the volute, which has been broken
and restored opposite the stem, two figure scenes are shown,
explained by inscriptions partially surviving on the volute. On
the left of the stem St John of Beverley, Bishop of Hexham
(d. 721), carrying a cross, is seen healing the dumb youth,
attended by a second figure, perhaps his biographer the Deacon
Berthun, but more probably the doctor asked by St John to
assist in the healing of the youth's afflictions – the 'many scabs
and scales on his scalp' as the historian Bede put it. On the
other side are St Peter with his key and St John the Evangelist
curing a cripple in the temple (Acts III. 1–7), a miracle quoted
by Bede as comparison, ending his account with the words: 'So
the youth obtained a clear complexion, readiness of speech and
a beautiful head of hair, whereas he had formerly been
deformed destitute and dumb. In his joy at his recovery he
declined an offer from the bishop of a permanent place in his
household preferring to return to his own home.' P.L.

EXHIBITION London, 1974, no. 28
BIBLIOGRAPHY Beckwith, 1972, no. 44; Bede, *A History of the English Church and People*, ed.
L. Sherley-Price, 1982, pp. 272–3

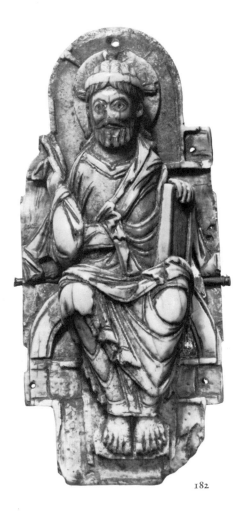

182

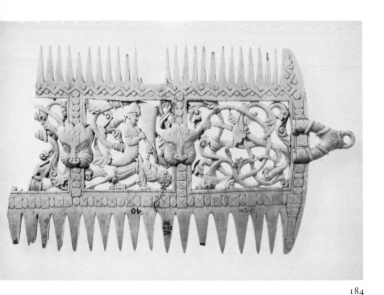

184

184 Liturgical comb

(?) Ivory; *l* 220 mm, *w* 130 mm
Late 11th century
London, Trustees of the British Museum, 56.6–23, 29

Highly decorated double-sided combs are known to have been used ceremonially during Mass and the ceremony of anointing bishops.

The comb has a suspension loop at one end and is decorated by three panels of pierced ornament, half of the third being broken away. An early break into two pieces has been mended. The decorative panels are separated by frames carved with lion masks and simple and irregular interlace. The inscription along one side is fragmentary and has not been satisfactorily read. The central panel is decorated with a half-figure of a helmeted warrior with shield issuing from the scroll, his unarmed opponent grasping his shield and lance.

The ornamental vocabulary can in general be paralleled by Canterbury initials of the end of the 11th century from both Christ Church and St Augustine's. The curious and very unusual vase-like decoration flanked by two leaves can be found in a late-11th-century manuscript from the borders of Normandy and Flanders: Gregory the Great's *Moralia in Job* in Arras (Bibl. mun., M 17, f. 64ᵛ). The warrior's helmet with a nasal and kite-shaped shield can be compared to the 'Temple Pyx' (234) and the Bayeux Tapestry and was introduced to Britain by the Normans. P.L.

PROVENANCE Said to have been found in Wales; acquired with the Maskell Collection, 1856
EXHIBITION London, 1974, no. 31
BIBLIOGRAPHY Beckwith, 1972, no. 47

185 So-called pen-case

Walrus ivory; *l* 23 mm, *w* 38 mm (top end), *h* 30 mm (top end)
Late 11th century
London, Trustees of the British Museum, 70.8–11, 1

The box has a sliding lid decreasing in size towards the end, a shape that reminds one of a pen-case although there is no evidence to support this. At the larger end it is undecorated but cuts show that a metal lock was fixed there. Under the lid three spring-like bronze fittings of the lock remain riveted to the ivory. Metal bands also covered the central join of the two pieces of ivory used to make the box.

The lid is decorated with pairs of beasts and birds placed symmetrically to each side of the central foliate stem, with a large mask at the end. The sides of the box are divided into four delicately-carved decorative panels in a flat, plain frame, with the head of an open-mouthed monster with two small lions in his teeth at the smaller end. Three of these panels show hunting scenes, one with a mounted man with a lance attacking dragons, the second with a man mauled by two lions and the third with two archers aiming at birds in a tree. The fourth panel shows two men digging to each side of a tree, with a large bird at the other end, the centre of this composition having been lost by damage.

Although there are strong reminiscences of Anglo-Saxon ornament – especially in the lid with its centrally-stemmed acanthus foliage and square-jawed birds and beasts – the much more solidly constructed figures, such as the man being attacked by lions, show really well-developed volumes foreshadowing the mature Romanesque style. A date towards the end of the 11th century may be the most acceptable. P.L.

PROVENANCE Found in the City of London
EXHIBITION London, 1974, no. 30
BIBLIOGRAPHY Beckwith, 1972, no. 46; Gaborit-Chopin, 1978, pp. 107, 198, no. 150

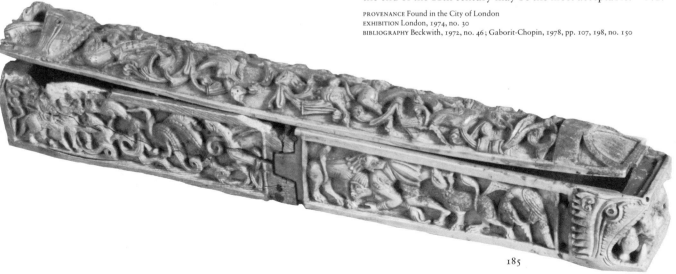

185

186 Dragon's head (*not illustrated*)

Walrus ivory; *l* 26 mm
Late 11th century
Winchester, Dean and Chapter of Winchester Cathedral, B.54

It has been suggested that the tomb this was found in was that
of William Rufus (d. 1100) or of Bishop Henry of Blois
(d. 1171). The style of the small finial certainly suggests a date
towards the end of the 11th century. It is too small to be the
kind of finial found on such furniture as folding stools and one
can only speculate whether it might once have decorated a pin
or a small knife, perhaps a pen-knife, or, as was suggested
when it was found, a small sceptre. P.L.

PROVENANCE Found in a tomb in front of the high altar, Winchester Cathedral, 1868
BIBLIOGRAPHY J.G. Joyce, 'On the opening and removal of a tomb in Winchester Cathedral
reputed to be that of King William Rufus', *Archaeologia*, XLII, 1869, pp. 309–21; Beckwith,
1972, no. 54

187 Crucifixion

Ivory; *h* 127 mm, *w* 85 mm
Late 11th century
London, British Library Board, MS Harley 2820

The carving decorates the cover of a Gospel book written and
illuminated in Cologne, *c.* 1070–80. The manuscript was
rebound in the British Museum in the 19th century, but the
ivory may well have decorated its original cover. Nothing is
known of the history of the book before its acquisition by the
Harley family in the first half of the 18th century.

It shows the figure of Christ, in a short loincloth and
standing triumphant and alive on a solid *suppedaneum* within
a cross with expanding arms. Above, the Hand of God issues
from a cloud, and the four winged and nimbed Evangelist
symbols carrying books are shown surrounding the cross, their
eyes inlaid with black beads (partly missing) as is very common
with English ivories of this period.

Although the ivory may have been carved in the Rhineland,
it is quite closely related to the late Saxon Crucifixion panel
in the Fitzwilliam Museum, Cambridge (Beckwith, 1972,
no. 38); however, in that somewhat smaller panel, the cross is
surrounded by half-figures of two angels and the Virgin and St
John instead of the symbols of the Evangelists. The fact that
the panel is not made of morse ivory further supports a
Continental origin, and, like the manuscript itself, it may have
originated in Cologne. The craftsman who carved it, however,
may have been trained either in the Low Countries or in
England, and perhaps followed English models. The date of the
ivory is certainly in harmony with the manuscript itself. P.L.

BIBLIOGRAPHY Dalton, 1909, no. 56; Goldschmidt, 1918, no. 68; P. Bloch and H. Schnitzler,
Die Ottonische Kölner Malerschule, Band I, 1967, no. XVIII, pp. 106–10 and 502

188 Head of a tau-cross (*not illustrated*)

Walrus ivory; *h* 45 mm, *w* 145 mm
c. 1100
London, Victoria and Albert Museum, 372-1871

On one side, two men are entangled in foliated scrolls; on the
other, two winged griffins in similar scrolls. The centre
portions, the knop at the top and the ends are missing, and the
whole outer edge has been cut down for a later metal mount.
In all probability the centre portions contained roundels with
figures, as seen on the Alcester tau-cross (Beckwith, 1972,
ills. 65–6) of the early 11th century and two tau-crosses of the
12th century (**194** and **205**).

This head of a tau-cross may be dated by comparison
with manuscripts produced at the end of the 11th century at
Canterbury and elsewhere (for an example, see Swarzenski,
1954, fig. 303). It is so close in style to the pierced plaque in
the British Museum (**189**) that it has been suggested they were
made by the same hand. P.W.

PROVENANCE Collection of Mgr. de Clermont at Le Mans in 1806; purchased from Webb, 1871
EXHIBITION London, 1974, no. 34, repr.
BIBLIOGRAPHY Beckwith, 1972, no. 59, ills. 109–10 (with bibliog.)

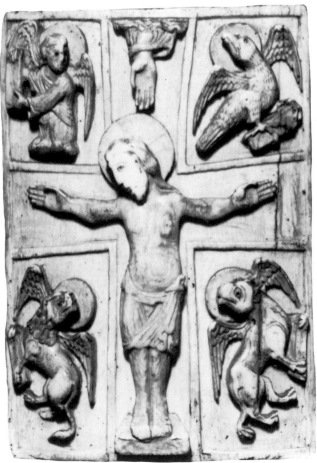

187

189 Fragment of a decorative panel

Walrus ivory; *h* 58 mm, *w* 60 mm
c. 1100
London, Trustees of the British Museum, 1921, 6–8, 1

The right-hand end of a decorative panel of pierced ivory,
almost certainly originally backed by colour, or, more
probably, by gilt-bronze or gold. The figure of a man in a short
tunic is enmeshed in a foliate scroll, with a border of egg-and-
dart ornament at the base. It is close in style to the tau-cross
crosier in the Victoria and Albert Museum (**188**), but the larger
flowers and the more emphatic linear treatment of both the
tendrils and the figure suggest a date just a little earlier, and
perhaps closer to the Anglo-Norman tradition. There is
certainly no sign of a stylistic link with any manuscript
attributable to St Albans, in spite of its having been found
there, but rather with initials in Canterbury manuscripts, the
Gloucester Candlestick (**247**) and with the cloister capitals at
Norwich (**134**).　P.L.

PROVENANCE Found on the site of the abbey of St Albans, 1920
BIBLIOGRAPHY Beckwith, 1972, no. 58; Norwich, 1980, p. 9

190

189

190 Two angels

Walrus ivory; *h* 75 mm, *w* 50 mm
Early 12th century
Winchester, City Museum (817)

This delicate carving is said to have been found in a garden
near St Cross, Winchester. Two flying angels are set deep
within a flat, triangular frame. Whether they are descending or
ascending with their open hands outstretched would depend on
the composition of which they originally formed a part. It
seems most likely, however, that they had descended onto the
end of a small hipped roof of a rectangular casket, or possibly
the roof of a hexagonal box – perhaps a pyx in which the
reserved Host was kept, the sides of which were decorated with
the Crucifixion or a Christ in Majesty, both of which were
often accompanied by flying angels.

It has long been accepted as Anglo-Saxon, of late 10th-
century date, and related to the large flying angels sculpted in
very low, very linear relief on the east wall of the nave of the
church of Bradford-on-Avon in Wiltshire. But the recent
convincing attribution (Heslop, 1981b) to the early 12th
century of the small oval pyx in the Victoria and Albert
Museum with the *Visitatio Sepulchri* (**191**) means that this
piece must also be reconsidered. The full modelling and large,
smooth areas of thighs and arms and the broad heads are all
close in style to the pyx and very different from the rich, broken
surface of zigzagging folds so typical of pre-Conquest ivories
(**177** and **178**). An early 12th-century date is far more
convincing.　P.L.

EXHIBITION London, 1974, no. 13
BIBLIOGRAPHY Beckwith, 1972, no. 16

191 Oval box (pyx) *(illustrated on p. 71)*

Walrus ivory; box rather worn, small piece of the upper rim
broken away; lid and mounts missing; *h* 65 mm, *w* 60 mm
(?) Early 12th century
London, Victoria and Albert Museum, 268-1867

It has been suggested that the scenes depicted on the box refer
to a miracle of St Lawrence (Beckwith, 1972, no. 19) – an
uneasy reading as the most important parts of that story are
not shown. An alternative interpretation, put forward by
Heslop (1981b, pp. 157–60), is that the scenes are from the
medieval drama of the *Visitatio Sepulchri*, an annually-
performed play based on the visit of the holy women to the
sepulchre; in this case, the parts of the holy women are played
by monks. We know that certain ivory *pyxides* were used
specifically to hold the Host between Good Friday and Easter
Sunday as one is referred to in the inventory of the gifts of
Bishop Henry of Blois (1129–71) to Winchester Cathedral:
'*Pixis eburnea in qua ponitur Corpus Domini in Parasceve*'
(Lehmann-Brockhaus, 1955, II, item 4767, p. 670). Scenes from
the *Visitatio Sepulchri* would have been eminently suitable for
such a pyx.
 The date of this pyx is rather problematic. Beckwith dated
it to the beginning of the 11th century, but Peter Lasko has
pointed out that the capitals on the architectural canopy can
hardly be before the Conquest (*Burl. Mag.*, CXVI, 1974, p. 429).
A date at the beginning of the 12th century, as first suggested
by Longhurst (1926, p. 94), seems most likely. P.W.

PROVENANCE Purchased from Webb, 1867
EXHIBITION London, 1974, no. 15, repr.
BIBLIOGRAPHY Beckwith, 1972, no. 19; ills. 25, 42–45 (with bibliog.); Heslop, 1981b;
Williamson, 1982, p. 32, pl. 16

192a

192b

192a and b Two kings

Walrus ivory; **a** *h* 108 mm, *w* 38 mm; **b** *h* 92 mm, *w* 36 mm
Early 12th century
London, Trustees of the British Museum; **a** 85,8-4,5;
b 1975,3-1,1

These two pieces were originally a pair. Both show bearded
kings with drilled eyes; in the more damaged figure the eyes
are still set with black beads. They turn gently towards each
other with their palms outstretched and flowered sceptres in the
opposite hands. They both wear short tunics, cloaks somewhat
longer than the tunics, ankle-length boots and crowns made of
a rim with two strips crossing each other over the top of their
heads.
 The figures show remarkable refinement of detail, subtly
modelled heads and delicate limbs, in marked contrast to the
simplicity – almost crudity – of architectural detail, with a flat
arch, simple capitals and bases. Under the foot of the complete
king is carved a heavily-ribbed acanthus leaf of obvious
Winchester School style derivation and most closely paralleled
in the Carilef Bible group of manuscripts (Durham Cathedral
Library, MS A II.4).
 The two kings once formed part of the decoration of the side
of a portable altar (compare 203) or a reliquary such as the
silver-gilt reliquary of St Oswald, now in the Cathedral
Treasury of Hildesheim, which also shows eight crowned
English royal saints, two of whom have no halo.

 The early date suggested here is based on stylistic links with
Flemish manuscripts such as the Stavelot Bible in the British
Library in which a king is shown with a similar cloak, longer
than his tunic, thin legs and wearing identical ankle-length
boots (MS Add. 28107, f. 93ᵛ). The refinement of the heads,
which show a surprising degree of naturalism for such an early
date, is also found in the initial P in the first volume of the same
Bible, written in 1095–7 (MS Add. 28106, f. 84ᵛ). The crowns
are also of an early type, as difficult to find represented in the
later 12th century as is the 'Winchester' leaf on which the
complete king stands (see also, 206, 207 and 208). P.L.

PROVENANCE a Acquired from Rohde Hawkins Collection, 1885
b Rohde Hawkins Collection or Kenyon family, Shropshire, in the 19th century; Lichfield
Cathedral, The Dean and Chapter; acquired 1975
EXHIBITION London, 1974, nos. 39 and 40
BIBLIOGRAPHY Beckwith, 1972, nos. 68, and 69; Lasko, 1972a, p. 167; Stratford, 1977

193 Reliquary cross

Walrus ivory; *h* 72 mm, *w* 66 mm, *d* 25 mm
Early 12th century
Private collection, on deposit at the British Museum

The cross is made in two halves hollowed out to contain a relic, probably of the True Cross. At the end of the right arm there was a metal hinge fixed with four nails. Internally there was a locking device housed in the left arm, and in the lower part the scars of an earlier mounting, perhaps for a metal foot, like the 11th-century cross in the Guelph Treasure, now in Berlin.

On the front, under the Hand of God, the figure of Christ, with a sensitively modelled head and finely drawn loincloth dropping to below his left knee, is set within a deep frame. Foliate scrolls issue from two of the corners of the cross. The reverse has an Agnus Dei in a quatrefoil surrounded by four Evangelist symbols, their eyes set with black beads. Two of the symbols are shown without wings, which is unusual, and the Bull of St Luke is very awkwardly placed.

The fine modelling of the head of Christ and the gentle fall of the loincloth link this reliquary with the two kings in the British Museum (**192a** and **b**). The deep framing might be compared to the two angels from Winchester (**190**) and perhaps more closely with the Heribert crosier in Cologne (**179**). The Lion of St Mark compares well with the same symbol on the reverse of the *Christ in Majesty* in New York (**182**). For the relationship of this whole group of carvings with the New York altar cross, see entries **206**, **207** and **208**. P.L.

PROVENANCE Formerly in the collection of Count Bernstorff Gyldensteen, Denmark
EXHIBITION London, 1974, no. 64
BIBLIOGRAPHY Beckwith, 1972, no. 108; Lasko, 1972a, p. 167, fig. 175; H. Langberg, *Gunhild's Cross and Medieval Court Art in Denmark*, 1982, p. 73, fig. 60; D. Koetzsche, *Der Welfenschatz*, 1973, no. 1

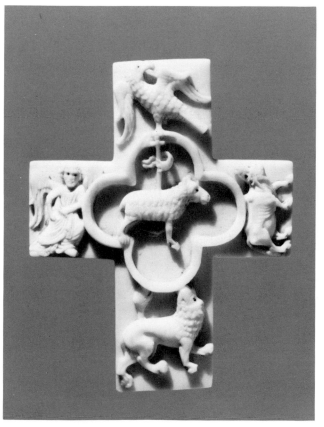

193

194

94 Fragment of a tau-cross crosier

Walrus ivory; *h* 46 mm, *w* 72 mm, *d* 24 mm
Early 12th century
London, Trustees of the British Museum, 74, 3–2, 3

This fragment is severely rubbed and both volutes are lost. The ivory has been stained red with madder (a dye from the root of the madder plant), a practice described by Theophilus in his *De Diversis Artibus* (*The Various Arts*), a craftsmen's handbook written in the early 12th century.

On each side is a central medallion in which there is a half-length figure of an angel with the right hand raised in blessing; the frames were originally set with glass pastes, one of which survives and is coloured blue. The remaining parts of the volutes show acanthus foliage with pearled veins exactly similar to the fragment found at Battle Abbey (**195**) which may be compared with the two ivory book-covers in the Victoria and Albert Museum (**199a** and **b**) and the capitals in the crypt of Canterbury Cathedral. P.L.

PROVENANCE Collection of Sir Augustus W. Franks; acquired 1874
BIBLIOGRAPHY Beckwith, 1972, no. 92; Theophilus, 1961, p. 168; Heslop, Zarnecki, 1980, pp. 341–2

195 Fragment of a tau-cross crosier (*not illustrated*)

Walrus ivory; *h* 27 mm, *l* 49 mm, *d* 22 mm
Early 12th century
London, Department of the Environment, Directorate of Ancient Monuments and Historic Buildings (on deposit at the British Museum)

It is clear that the crosier was thrown away, broken, after the dissolution of the monastery at Battle Abbey. It is the shoulder fragment of a double-volute crosier, like the one of which a middle fragment is in the British Museum (**194**). It is similar not only in shape but also in design. On both a border of acanthus leaves with heavily pearled veins is edged by a strip of rather debased egg-and-dart ornament. The acanthus is a somewhat more delicate and more flatly displayed version of very similar foliage found in the two pierced ivory book-covers in the Victoria and Albert Museum (**199a** and **b**) which can, in their turn, be closely related to the foliate capitals in the crypt at Canterbury dating from the end of the 11th century. P.L.

PROVENANCE Excavated at Battle Abbey on the site north of the reredorter range in a layer dated after 1538
BIBLIOGRAPHY Heslop, Zarnecki, 1980, pp. 341–2

196

197

197 Liturgical comb

Ivory; *h* 85 mm, *w* 115 mm
c. 1120; St Albans
London, Victoria and Albert Museum, A.27-1977

The comb is in excellent condition, with only a number of the smaller teeth broken. It shows on one side the Nativity, the Flight into Egypt, the Washing of the Feet of the Disciples, the Last Supper, the Betrayal, the Crucifixion and the Entombment; on the other side are the Massacre of the Innocents, the Adoration of the Magi, the Dream of the Magi and the Annunciation to the Shepherds. The ends of the comb show a continuation of the Annunciation to the Shepherds and the Soldiers on guard at the Sepulchre. The rather stiff figures – often in profile – and the crowded compositions are closely comparable to the illuminations in the St Albans Psalter (**17**), which is datable to *c*. 1120–30. P.W.

PROVENANCE Collection of Mrs T.L. Barwick-Baker (Hardwicke Court, Gloucestershire) before 1861; Miss Olive Lloyd-Baker, who placed it on loan to the Victoria and Albert Museum; accepted in lieu of capital transfer tax 1977
EXHIBITIONS Barcelona, 1961, no. 563; London, 1974, no. 38, repr.
BIBLIOGRAPHY Beckwith, 1972, no 65, ills. 128, 129 (with bibliog.); Lasko, 1972a, p. 235; Tcherikover, 1979, pp. 7–21; Park, 1981, pp. 29–30; Williamson, 1982, p. 37, pl. 19

196 The Crucifixion

Walrus ivory; *h* 105 mm, *w* 60 mm
(?) Early 12th century
London, Victoria and Albert Museum, A.3-1961

Christ is shown crucified between Longinus, on the left, and Stephaton, on the right; above are personifications of the Sun and Moon and the Hand of God. It was probably originally a pectoral cross: small holes around the edge of the cross indicate that it was formerly framed with a gold strip and the three larger holes around the body of Christ may have served to hold nails which affixed the back of the cross (probably of precious metal) to the front. There are two small cavities in the back of the cross, presumably containers for relics. The cross is worn, and the head of Longinus and the right foot of Stephaton are missing.

Assigned by Beckwith to the late 10th or early 11th centuries, the present cross is, however, markedly different in style from other Anglo-Saxon pectoral crosses and is probably to be dated after the Conquest although it is dependent on the earlier crosses for its format. The faces of the figures are closest to those of the small figures on the Gloucester Candlestick (**247**), dated between 1104–13, and it is perhaps best placed in the years around 1100. Although the cross was found in Norwich its place of origin is a matter of conjecture. P.W.

PROVENANCE Found at Tombland, outside Norwich Cathedral Close on the west side of the Cathedral, 1878; private collection; acquired 1961
BIBLIOGRAPHY Beckwith, 1961, pp. 434–7; Beckwith, 1972, no. 34, ill. 71

198

199b

199a and b Two pierced reliefs (a not illustrated)

Whalebone; a h 225 mm, w 135 mm; b h 215 mm, w 130 mm
First quarter 12th century; (?) Canterbury
London, Victoria and Albert Museum, 8461A and B-1863

In the centre of relief **a** is a circle containing a lion; in the corners four other lions, each in a segment of a circle connected with the central medallion by diagonals in which are bands of bead-and-reel ornament; the intervening spaces are filled with large foliage scrolls. The other leaf **b** is filled with a large design of foliage branching from a central stem. Both reliefs are in good condition.

The panels originally would have formed the front and back covers of a manuscript; it is possible that a gold or silver background highlighted the designs. The type of foliage ornament and the prancing lions have their closest parallels in the crypt capitals at Canterbury Cathedral (see especially those illustrated in Zarnecki, 1951, pl. 49, and 1979a, II, pl. 10). P.W.

PROVENANCE Formerly mounted on the covers of a Bible printed in Paris in 1552 (now in Victoria and Albert Museum Library); acquired 1863
EXHIBITION London, 1974, no. 50, repr.
BIBLIOGRAPHY Beckwith, 1972, no. 89, ills. 155–6 (with bibliog.)

200 Fragmentary crucifix figure (not illustrated)

Walrus ivory; h 135 mm
c. 1120–30
London, Museum of London, 4980

Little remains of the figure but it is enough to establish the very high quality of the carving. The detailed drawing of the torso and loincloth with its decorated hem show an unusual delicacy and subtlety of handling. Something of the sharpness of drawing and restrained outline is reminiscent of late-11th-century work such as the Norman Crucifixion in the British Library Psalter (MS Arundel 60, f. 52ᵛ, 7). Comparison has also been made with the Crucifixion in the Florence of Worcester Chronicle of 1130 (33) and, although the modelling in the 12th-century illumination is softer and more three-dimensional and the ivory is more tense, linear and hard, a date of c. 1120–30 may be the most likely. P.L.

PROVENANCE Found in Worship Street in the City of London
EXHIBITION London, 1974, no. 60
BIBLIOGRAPHY Beckwith, 1972, no. 103; Gaborit-Chopin, 1978, no. 154

198 Liturgical comb

Ivory; h 85 mm, w 118 mm
c. 1120; St Albans
Verdun, Musée de la Princerie

The comb is in excellent condition, with only a number of the smaller teeth broken. On one side are the Last Supper, the Betrayal and the Flagellation with above, two angels, one holding a soul, and, below, Judas and two figures, one holding a book and the other pointing to the text. On the other side are the Entombment and sleeping soldiers and the Marys at the Sepulchre with, above, an angel swinging a thurible and, below, Christ appearing to St Mary Magdalene. On the ends are two dragons. In style, iconography and composition the comb is very close to the London comb (197) and is most probably a product of the same workshop, almost certainly based in St Albans. P.W.

PROVENANCE Recorded at Abbey of St-Vannes, Verdun, in inventories of 1745 and 1773 as comb of Henry II, who was supposed to have presented it to Abbot Richard (1004–46); Cathedral of Verdun, 1792–1857
EXHIBITIONS Cleveland, 1967, no. II/6, repr.; London, 1974, no. 36, repr.
BIBLIOGRAPHY Beckwith, 1972, no. 66, ills. 132, 133 (with bibliog); Lasko, 1972a, p. 235; Tcherikover, 1979, pp. 7–21

201

201 Crosier

Walrus ivory; *h* 150 mm
c. 1120–30
Paris, Musée des Thermes et de l'Hôtel de Cluny, Inv. CL.
13066

The pierced crosier head is decorated with a winged eagle on
one side and a lion, perhaps also once winged, on the other;
both are in foliate scrolls, the volute itself ending in a fierce
dragon's head with eyes set with black beads. The two beasts
may be intended to be two of the four Evangelist symbols. The
stem is richly carved with foliage ornament, separated by two
vertical strips with egg-and-dart ornament originally set at
intervals with beads. The large knop is decorated with an
inhabited foliate scroll.

The shape of the crosier and the pierced ornament is
technically close to the St John of Beverley crosier (**183**) and
the ornament is of the kind characteristic of Canterbury
manuscripts made between 1120 and 1130 as well as related
ivories such as the tau-cross crosier in the Victoria and Albert
Museum (**205**). P.L.

PROVENANCE Formerly in the Carrand Collection, Florence; and Spitzer Collection, Paris
EXHIBITION London, 1974, no. 53
BIBLIOGRAPHY Beckwith, 1972, no. 94

202 Oval box (*not illustrated*)

Walrus ivory with (later) silver mounts; *h* 75 mm, *w* 65 mm,
d 35 mm
c. 1130; (?) St Albans
London, Victoria and Albert Museum, 208–1874

On the front of the box are two men seated on lions, holding
scourges and bending backwards to bow to one another; on
the other side are two centaurs with drawn bows, aiming away
from one another. At each end is a flowering tree and on the
lid are foliage sprays in four compartments.

The imagery and style of the carving has been compared
with the illuminations in the St Albans Psalter (**17**) and the Bury
Bible (**44**), so that a date between the execution of these two
manuscripts, in around 1130, would seem most likely for the
box. Katherine Bateman has attempted to explain the
iconography as 'an allegorical statement of man's unending
inner struggle, his fight against evil in the human soul', with
the centaurs symbolizing the two sides of man, those of good
and evil, shooting arrows of temptation towards their victims.
P.W.

PROVENANCE Collection of M. Le Carpentier (Sale, Paris, 23 May 1866, no. 193); purchased
from Webb, 1874
EXHIBITIONS Barcelona, 1961, no. 561, repr.; London, 1974, no. 37, repr.
BIBLIOGRAPHY Beckwith, 1972, no. 64, ills. 124–6 (with bibliog.); Katherine R. Bateman, *St
Albans: its ivory and manuscript workshops: a solution to the St Albans/Bury St Edmunds
dilemma*, Ph.D dissertation, University of Michigan, 1976, pp. 55–9

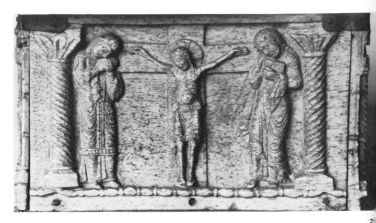

203 Portable altar

Whalebone; *l* 225 mm, *w* 150 mm, *h* 83 mm
c. 1130–40
London, Trustees of the British Museum, 1963, 11–7.1.

Two of the four panels have rebates showing that they were
once fitted together to form a box, but the top and base have
not survived. Originally it was either a reliquary or a portable
altar, and if the latter the only example to survive in Britain.
A keyhole on one of the larger sides indicates that it was
originally made to be locked, like so many of the portable
altars that survive on the Continent.

The two long sides show the twelve Apostles under an
arcade carried on elaborately decorated columns. On the
shorter sides there is the Crucifixion with rather oversize
figures of the Virgin and St John, and at the other end a Christ
in Majesty in a mandorla supported by the four Evangelist
symbols. The sequence of these symbols, beginning with St
Mark's Lion, is unique and almost certainly the result of
copying a vertical model which started with the Eagle of St
John top left, followed by Matthew, Mark and Luke. This

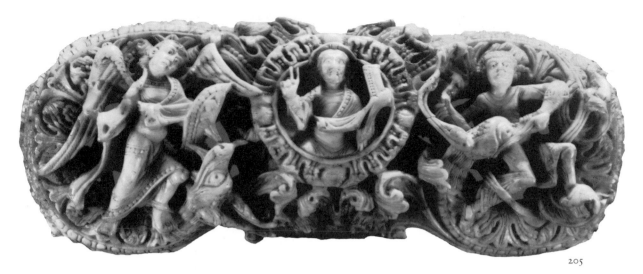

205

would also explain why the Winged Man of St Matthew appears lying on his back: in the model he would have been upright.

The canopies, especially the domed individual ones at one end of each of the long sides, which are pierced by circles, suggest that the carver had seen Byzantine ivories of the 10th and 11th centuries in which such canopies are very popular.

The figure style relates to the sculptured frieze added to the west front of Lincoln Cathedral at the time of Bishop Alexander between 1123 and 1146. The simple broad drapery folds of the Apostles also look like the double capitals carved for the Romanesque cloisters of Norwich Cathedral, of which only fragments remain (134b; Franklin). P.L.

PROVENANCE Collection of Lord Vernon, Sudbury Hall, Derbyshire before 1870
EXHIBITIONS London, 1974, no. 42; Norwich, 1980, nos. 8 and 17
BIBLIOGRAPHY Lasko, 1964, pp. 489–95; Beckwith, 1972, no. 81; Lasko, 1972a, p. 236

204 Ceremonial Staff

Narwhal horn; h 1·170 m
Second quarter 12th century
London, Victoria and Albert Museum, A.79-1936

The horn is carved on the lower portion with straight bands of scrolls – naked human figures among foliage alternating with bands of grotesque beasts. On the upper part the bands of ornament follow the spiral twist of the horn and the designs show plain leaf-scrolls and scrolls with birds and animals among foliage. The horn was originally longer and has been broken and repaired in two places. The pin-holes on the plain surfaces between the bands of ornament suggest that these spaces were originally covered with metal strips, possibly of gilded copper.

Fritz Saxl was the first to draw attention to the close similarity between the decoration of the staff and that of a column to the right of the central portal at the west end of Lincoln Cathedral (Saxl, 1954, figs. 22, 25, and p. 73 n. 24): this portal is to be dated around 1145, its columns strongly influenced by similar examples at St-Denis (cf. Zarnecki, 1964, 1970, p. 17). The presence of similar motifs does not, however, allow precise localization for the staff. Beckwith has noted the existence of another staff of the same type, the whereabouts of which are now unknown. P.W.

PROVENANCE Purchased from T. C. Cutt under the Bequest of Capt. H. B. Murray, 1936
EXHIBITION London, 1974, no. 43, repr.
BIBLIOGRAPHY Beckwith, 1972, no. 82, ill. 198 (with bibliog.)

205 Head of a tau-cross

Walrus ivory; h 55 mm, w 165 mm
c. 1140–50; (?) Winchester
London, Victoria and Albert Museum, 371-1871

One one side is the Virgin and Child between two men struggling with serpents. On the other side, Christ is shown blessing with his right hand and holding a book in his left; St Michael subdues a dragon to Christ's left, and to the right another man struggles to free himself from the jaws of a serpent. There are minor surface losses, the most important being the right arm of the archangel.

The fleshy, luxuriant foliage on the tau-cross has been compared with that found on Winchester manuscripts of the mid-12th century (Swarzenski, 1954, pls. 136–7: for the Winchester Bible see 64). Two other tau-cross fragments, one in the British Museum (194), the other excavated at Battle Abbey (195), illustrate the development of this type of foliage on tau-crosses from the beginning to the middle of the century. P.W.

PROVENANCE Said to have been in cathedral at Liège; collections of M. Piot and Baron de Crassier of Liège before 1715; purchased from Webb, 1871
EXHIBITIONS Barcelona, 1961, no. 559, repr.; London, 1974, no. 51, repr.; Brussels, 1979, no. 85
BIBLIOGRAPHY Beckwith, 1972, no. 91, ills. 163–5, and 167 (with bibliog.); Heslop, Zarnecki, 1980, pp. 341–2; Williamson, 1982, p. 38, pl. 21

206 Altar cross (*illustrated also on p. 70*)

Walrus ivory; *h* 577 mm, *w* 362 mm
Second quarter 12th century
New York, The Metropolitan Museum of Art, The Cloisters
Collection, No. 63, 12

See **208**

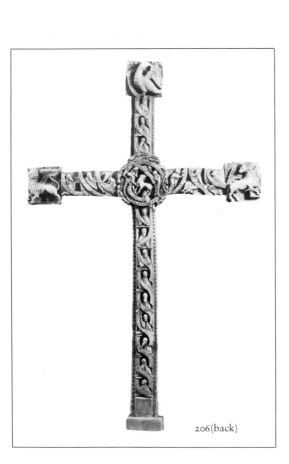

206(back)

206(front)

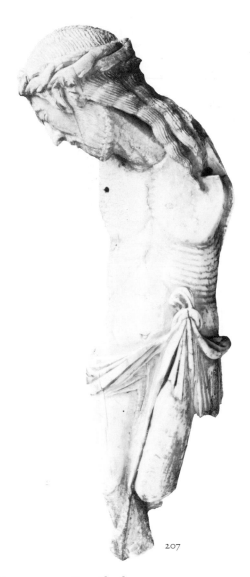

207

207 Fragmentary Crucifix figure

Walrus ivory; *h* 190 mm
Second quarter 12th century
Oslo, Museum of Applied Art, no. 10314

See **208**

208 Christ before Pilate (*not illustrated*)

Ivory plaque; 57 × 54 mm
Second quarter 12th century
New York, The Metropolitan Museum of Art, The Cloisters
Collection, 1963, 63, 127

The cross is assembled from seven pieces of morse ivory, the
longest of them showing the marked curve of the tusk. On the
front the cross is carved as a *lignum vitae* – the Tree of Life –
with its branches severed. Three areas of damage show where
the corpus was originally attached and the Oslo figure (**207**)
may well be the one missing from the cross.

At the square ends of each arm of the cross there is the
Deposition on the right, the Three Marys at the Tomb on the

left and the Ascension of Christ at the top. The carving
originally at the base is lost. In the centre a richly-carved
medallion shows St Peter, St John, Isaiah and Moses with the
Brazen Serpent – a symbolic prefiguration of the Crucifixion –
displayed in a forked stick. Below the top scene there are the
High Priest Caiaphas and Pontius Pilate.

The back is carved with twelve busts of prophets – a
thirteenth at the base being missing – with six more shown full
length on the cross arms, all bearing scrolls with quotations
from the Old Testament. In the centre medallion, supported by
four flying angels, there is the Agnus Dei, pierced in the breast
by a spear brandished by the figure of Synagogue, with St John
behind, appropriately in the pose in which he is usually shown
by the side of the Crucifixion. On the other side an archangel
holds a scroll with a text from the Apocalypse referring to the
slain Lamb of God. Three of the four Evangelist symbols are
at the ends of the arms of the cross, with the Winged Man of
St Matthew missing at the base.

When **208**, which is the same size as the ends of the cross,
was discovered it was thought it might have been cut from the
missing square block which originally had the St Matthew
symbol on its back; but the green staining of the back of this
plaque suggests long contact with bronze, and it seems possible
that it was originally mounted on a bronze base made for the
cross. Also the style of this panel is not identical with the rest
of the cross. Its drawing is finer, more linear and elegant. It is
more likely to have been a later addition, made nearer the end
of the 12th century. Moreover the subject of the scene, Christ
before Pontius Pilate, does not fit appropriately with the three
surviving scenes which all refer to events after the Crucifixion.
(It has been suggested that the Harrowing of Hell would have
been the most likely to occupy the base of the cross.)

All the imagery and the numerous inscriptions carried on the
scrolls comment on the theme of the Passion, with strong
emphasis on the prefiguration of the events in the New
Testament by those in the Old – a theme of increasing interest
during the 12th century.

In the corpus the magnificent bearded head of Christ is
turned to His right in an expression of deep suffering, crowned
with thorns and with long hair falling on to his left shoulder
and back. The emaciated body is drawn with linear precision
and the loincloth is drawn up into a large knot on his left hip.

It has been suggested that a hole in the back of the figure
may be aligned to another on the cross and that both are the
remains of a dowel fixture; it has been shown that such a
position on the cross would enable the arms and legs to be
restored with reasonable proportions.

The date of the cross and its corpus has been the subject of
much debate. The literary evidence of the major inscriptions
written in capitals on the sides and the front of the cross have
been said to point to a knowledge of Continental sources
towards the middle of the 12th century, but it is generally
agreed that in the absence of direct historical evidence, style
criticism will have to be the major determining factor.

There is general agreement that there is a relationship
between some of the small figures and the damp-fold pattern
that was so popular in England after being introduced by the
Bury Bible of *c.* 1135 (**44**), and it has led scholars to attribute
the cross to Bury St Edmunds, and even to the hand of Master
Hugo, who painted the Bury Bible itself. Others do not see such
a close relationship with Bury, but believe that the cross shows
the kind of gentle naturalism that developed later in the 12th
century, *c.* 1180.

But although touches of damp-fold can be detected here and
there – especially on one or two of the full-length figures of

prophets on the arms of the back of the cross – it seems by no means fully developed, but rather to show an incipient form of the style, and might therefore be dated to some years before *c*. 1135. The Oslo corpus could well support such an early date, although often dated later in the century, perhaps mainly because of its remarkably high quality and expressive intensity which suggests high naturalism. Such an analysis is, however, misleading. The head is not unlike the wooden head found at South Cerney, Gloucestershire (**115**), usually dated to *c*. 1125, with its large closed eyes and tightly curled and geometrically precise beard. The crown of thorns is agreed to have appeared at least as early as the beginning of the 11th century in England and possibly considerably earlier. The drawing of the emaciated body retains the use of repetitive lines which is to be found earlier rather than later in the century. Finally the loincloth has triangular folds nesting in one another that remind one most vividly of the *Christ in Majesty* in the Stavelot Bible of 1095–7, and on the right side a long fold is carved which is interrupted by a short, sharp line across the fold, a characteristic of the work of Roger of Helmarshausen which is dated to *c*. 1100; his style is influential in the first half of the 12th century, as for example at Canterbury in the Boethius manuscript of *c*. 1130 (**30**).

It would seem convincing to date the corpus and the cross to the second quarter of the 12th century, only a little later than the small group of ivories in the British Museum – the two kings and the reliquary cross (**192** and **193**) – and therefore early rather than late in that quarter. P.L.

PROVENANCE **206** Appeared in Topić-Mimara Collection after Second World War; acquired 1963. **208** Panel with 'Christ before Pilate' acquired separately, but at same time; now mounted on base of cross in conjectural restoration. **207** Collection of Professor Emil Hannover, Copenhagen, 1884
EXHIBITIONS New York, 1970, nos. 60 and 61; London, 1974, nos. 61 and 62
BIBLIOGRAPHY Beckwith, 1972, nos. 104 and 105; Gaborit-Chopin, 1978, nos. 6–8 and 194–5; Lasko, 1972a, pp. 167 ff.

209 Virgin and Child (*illustrated on p. 70*)

Walrus ivory; *h* 135 mm, *w* 635 mm
Second quarter 12th century; (?) Shaftesbury
London, Victoria and Albert Museum, A.25-1933. Purchased under the Bequest of Francis Reubell Bryan

The piece is cracked and has flaked in many places, the most noticeable loss being the Virgin's right shoulder. The holes pierced in the eyes would probably have been filled with jet or glass beads, and the piece has been stained a grey-purple colour. The back is plain.

The *Virgin and Child* originally formed part of an *Adoration of the Magi* group; a magus in the Dorset County Museum (**210**) almost certainly belonged to this group also. Details such as the treatment of the eyes, hands and hair are closely comparable in both ivories: confirming the connection are the similar measurements of the two pieces and the unusual feature of staining – no other English ivories are so treated. The proportions and poses of both pieces can be paralleled in the illuminations on the Shaftesbury Psalter (**25**), dated between 1130 and 1140, and a Shaftesbury origin for the two pieces cannot be ruled out, especially as the magus was found in Milborne St Andrews, barely twenty miles from Shaftesbury Abbey. Like the Shaftesbury Psalter, the *Virgin and Child* and the magus represent a slightly later manifestation of the style first developed in the St Albans Psalter (**17**). P.W.

PROVENANCE Formerly in private collection in Yorkshire; acquired 1933
EXHIBITION London, 1974, no. 44, repr.
BIBLIOGRAPHY Beckwith, 1972, no. 83, ill. 147 (with bibliog.); Gaborit-Chopin, 1978, p. 108, pl. 153; Williamson, 1982, p. 38, pl. 22

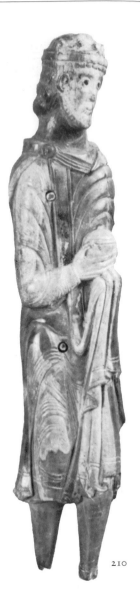

210

210 One of three Magi

Walrus ivory; *h* 130 mm
Second quarter 12th century; (?) Shaftesbury
Dorchester, Dorset Natural History and Archaeological Society, Dorset County Museum

The eyes are drilled in the same way as those of the *Virgin and Child* (**209**), and the jet or glass beads are missing. The figure has been stained the same colour as the *Virgin and Child*, although the stain has not been applied properly to the back which has been left uncarved. The figure was attached to a separate background by means of two ivory pins, the holes for which are seen on the right side of the figure. It is in good condition, although both feet are missing: the top of the left boot is still visible. P.W.

PROVENANCE Found at Milborne St Andrews, near Dorchester, probably in the first half of the 19th century; Mr C. Hall of Anstey, near Milborne, and heirs; purchased *c*. 1906
EXHIBITIONS London, 1930, no. 84; London, 1939, no. 145; Manchester, 1959, no. 31; Barcelona, 1961, no. 560; London, 1974, no. 45, repr.
BIBLIOGRAPHY Beckwith, 1972, no. 84, ill. 146 (with bibliog.); Lasko, 1972a, pp. 236–7

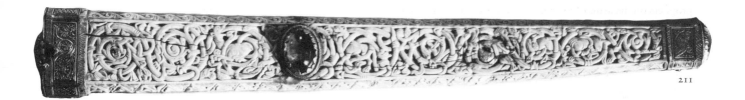

211

211 Fragment of a throne

Walrus ivory; *l* 447 mm, *w* 58 mm (top end), *d* 32 mm
Mid-12th century
London, Trustees of the British Museum, 1959, 12-2,1

This fragment consists of a whole walrus tusk hollowed out at
the larger end and mounted in bronze-gilt in the 14th century;
the hinged lid, locked with a pin, is set with a hog-back crystal.
The other end is also mounted and set with a crystal, another
being fixed in the centre. The mounts may have been added to
convert the piece into a reliquary. The tusk shows green stains,
some 20 mm wide, at each end – the signs of an earlier need
to wrap copper round the piece to strengthen its ends, both
having split probably before the 14th-century mounts were
added.

The tusk has chamfered corners and is richly decorated with
inhabited scrolls on all four sides. The ornamental vocabulary
can best be compared to the Lewis Chessmen (**212**) and other
pieces found in Scandinavia, and a date towards the middle of
the century is most likely. It is difficult to be sure what its use
was before the mounts were added, but size and shape make
it very possible that it served as the leg of an ivory chair or
throne. The reconstruction of the back legs of a chair found
at Lund dating from the 11th century (Roesdahl) shows how
well suited this piece would be to form part of an exceptional
piece of furniture such as a bishop's throne. The splits in the
material suggest the reason why it may have been put to a new
and less demanding use in the 14th century. Later medieval
chairs of carved wood are evidence of a tradition of highly
decorated furniture in Scandinavia. P.L.

PROVENANCE Said to have been in French private collections (Gaborit-Chopin) before 1953
BIBLIOGRAPHY Lasko, 1960–1, pp. 12–16; Lasko, 1972a, p. 236–7; Gaborit-Chopin, 1978,
no. 164; E. Roesdahl, *Viking Age Denmark*, 1982, p. 117, fig. 29

212 The Lewis chessmen *(illustrated also on p. 72)*

Walrus ivory
Kings Dalton, nos. 78 and 79, *h* 99 mm, *w* 57 mm
Queen Dalton, no. 84, *h* 93 mm, *w* 50 mm
Bishop Dalton, no. 93, *h* 93 mm, *w* 48 mm
Knight Dalton, no. 115, *h* 102 mm, *w* 33 mm
Warder (Rook) Dalton, no. 119, *h* 91 mm, *w* 41 mm
Pawn Dalton, no. 127, *h* 51 mm, *w* 27 mm
Mid-12th century
London, Trustees of the British Museum, 78–144 (counters),
145 (Buckle)

A hoard of 78 pieces was found in 1831 in the parish of Uig
on the Isle of Lewis in the Outer Hebrides in what was
described as a 'subterranean' chamber. Eleven pieces from the
same find are in the National Museum of Antiquities of Scotland
in Edinburgh. From the pieces it is clear that the hoard was not
made up of a number of complete sets, and as none of the
carving is incomplete, a workshop hoard is most unlikely.

Perhaps they formed part of the stock of a merchant ship
wrecked on the shores of the island, subsequently hidden and
not recovered. The pieces show virtually no signs of wear.

The form of the chessmen and the decoration on the back
of the thrones on which the kings, queens and some of the
bishops are seated, have led to the pieces being dated from the
middle to the end of the 12th century and to their being
attributed to either Britain or Scandinavia. It is difficult to find
a parallel for the figure style, except in other gaming pieces, and
even amongst these the Lewis pieces are more stylized and rigid
than any others that survive. It is unlikely that they were carved
later than the middle of the century, unless they were produced
in a very remote centre, but their very high quality and
especially the subtlety of their decorative carving would not
support this. They belong to a group of carvings (see also **211**)
whose style is found in both Scandinavia and East Anglia: at,
for example, Lund Cathedral and Ely Abbey, regions that were
linked by trading and by political and close ecclesiastical
contacts. The actual carving of such pieces of walrus ivory
could have been carried out on either side of the North
Sea. P.L.

PROVENANCE Acquired 1831
BIBLIOGRAPHY Beckwith, 1972, no. 166; Dalton, 1909, pp. 63–73; Lasko, 1972a, pp. 236–7;
Gaborit-Chopin, 1978, no. 168; M. Taylor, *The Lewis Chessmen*, 1978

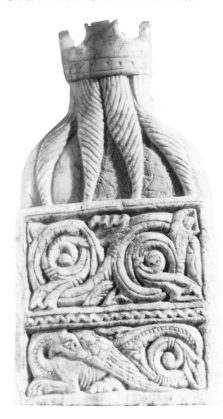

212

213 The St Nicholas crosier (*illustrated also on p. 71*)

Ivory; *h* 120 mm, *w* 110 mm
1150–70; (?) Winchester
London, Victoria and Albert Museum, 218–1865

The crosier shows two scenes from the Life of Christ, the
Nativity and the Annunciation to the Shepherds, and the Agnus
Dei, and three episodes from the life of St Nicholas: his birth,
the infant saint's abstinence from his mother's milk on fast
days, and the saint giving money to the impoverished nobleman
of Myra for his three dowerless daughters. It is in good
condition, apart from losses to the upper part of the Agnus Dei,
the head of the middle daughter of the nobleman and the right
hand of St Nicholas: on the stem are several cracks.

William Dale was the first to associate the scenes on the
crosier with St Nicholas and he compared them with stained
glass and sculpture (roof bosses) at Canterbury of around 1180
(Dale, 1956). It is probable that the crosier is slightly earlier
than 1180: its closest stylistic parallels may be found in the
unfinished illuminations of the 'Master of the Apocrypha
Drawings', in the Winchester Bible (**64**; see Swarzenski, 1954,
figs. 310–14) which are usually dated in the 1150s. The original
provenance of the crosier is still far from clear, although it
would seem reasonable to assume that it was made either for
the head of an institution consecrated to St Nicholas or for an
abbot or bishop of that name. That St Nicholas was a popular
saint in England in the third quarter of the 12th century is
indicated by two fonts carved with scenes from his life at
Brighton and Winchester (for these, see Zarnecki, 1953a,
pls. 38–9, 70). P.W.

PROVENANCE Purchased from Webb, 1865
EXHIBITIONS New York, 1970, no. 59, repr.; London, 1974, no. 55, repr.
BIBLIOGRAPHY Sauerländer, 1971, p. 512; Beckwith, 1972, no. 98, ills. 180–2 (with bibliog.);
Gaborit-Chopin, 1978, pp. 108–11 and 199, figs. 155–7; Williamson, 1982, p. 41, pl. 24

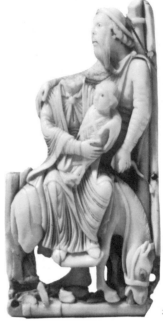

214

214 The Flight into Egypt

Walrus ivory; *h* 78 mm, *w* 39 mm
Third quarter 12th century
New York, The Metropolitan Museum of Art, Dodge Fund
1940, B100 (40.62)

Parts of the relief are lost, but it may originally have been a
rectangular panel or, if the curve of the frame behind the head
of Joseph were followed, the panel may have had a semi-
circular head. The Virgin is seated on the ass with the Christ
Child firmly bound in swaddling clothes. The eyes are inlaid
with black beads. The rich, multilinear parallel folds drawn in
soft curves and the intricate interplay of rounded forms
throughout the composition suggest a date well advanced into
the second half of the 12th century. Certainly this little carving
is later than the Apostle reliefs of the Malmesbury Porch of
soon after the mid-century.

It is difficult to suggest the original use of the piece but it
must have formed part of a sequence of scenes from the
Childhood of Christ or the Life of the Virgin. The
exceptionally deep relief makes it unlikely that a book-cover
or reliquary was decorated by this panel. P.L.

PROVENANCE Appeared in 1911 at exhibition in Tournai, Belgium; collection of E. Théodore,
Lille
EXHIBITIONS New York, 1970, no. 62; London, 1974, no. 57
BIBLIOGRAPHY Beckwith, 1972, no. 100; Gaborit-Chopin, 1978, no. 191

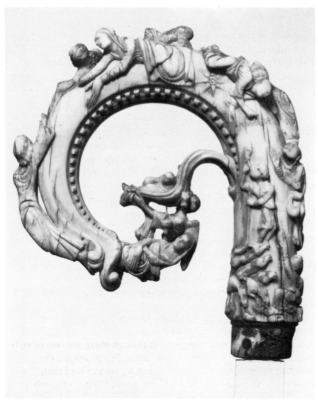

213

215

217

218

215 Section of a staff or handle showing Christ in Majesty, the Virgin and Child enthroned, angels and other figures

(?) Ivory; *h* 286 mm, *w* 26 mm
Last quarter 12th century
New York, The Metropolitan Museum of Art, The Cloisters Collection, 1981.1
See note on **218** below

PROVENANCE Karl Ferdinand von Nagler, Berlin; Kaiser Friedrich Museum 1835–1936; Homberg Collection, Paris, 1949; J. Hunt, Dublin; acquired 1981
BIBLIOGRAPHY Goldschmidt, 1926, no. 64; The Metropolitan Museum of Art, *Notable Acquisitions 1980–1*, p. 21–2; Dalton, 1909, p. 61

216 Section of a staff or handle showing birds and beasts (*illustrated on p. 71*)

Ivory; *h* 155 mm, *w* 19 mm
Last quarter 12th century
London, Victoria and Albert Museum, 373–1871
See note on **218** below

PROVENANCE Purchased from Webb, 1871
BIBLIOGRAPHY Goldschmidt, 1926, no. 65; Beckwith, 1972, no. 62; Longhurst, 1927, p. 83; Dalton, 1909, p. 61

217 Section of a staff or handle showing twelve Apostles and four Evangelist symbols

Ivory; *h* 203 mm, *w* 22 mm
Last quarter 12th century
London, Trustees of the British Museum
See note on **218** below

BIBLIOGRAPHY Dalton, 1909, p. 61; Goldschmidt, 1926, no. 66

218 Section of a staff or handle with foliage in the form of stylized trees

(?) Ivory; *h* 133 mm, *w* 21 mm
Last quarter 12th century
Paris, Musée du Louvre, département des Objets d'Art

BIBLIOGRAPHY Goldschmidt, 1926, no. 67; Beckwith, 1972, no. 96; Dalton, 1909, p. 61; Emile Molinier, '*Quelques ivoires récémment acquis par le Louvre*', *Gazette des Beaux-Arts* XX, 1898, p. 487

This group of four ivory staff or flabellum (liturgical fan) handles, with a fifth now in Florence (Goldschmidt 1926, 62), seems to be the work of one artist: for example, **215**, **217** and **218** use complex, dense leafwork (as opposed to scrolls) with prominent veining. Both **215**, around Mary's mandorla, and **217**, on the rim below the top register, have a series of rosettes alternating with vertical rows of dots. The Lion of St Mark on **217** and the bestiary lion on **216** have identical faces and manes. Furthermore, the condition of **215** and the Florence staff is also similar in that both are unfinished. Some draperies, such as the bishop's at the bottom of **215**, and of the figures round the top of the Florence staff, lack the fine trough folds so noticeable on **217**. Unfinished faces have bulbous eyes with no lids, whereas finished ones are small and naturalistic.

Goldschmidt attributed all five ivories (with another that does not belong) to England or France around 1200, and it is hard to improve on his suggestion though there are one or two indications that England is more likely. For example, the peculiar capitals supporting the arcades on **217** find their closest antecedents in 'Mercian' art around 800 on the reliefs with figures at Castor (Stone, 1955, pl. 15) and Breedon

on the Hill (Kendrick, 1938, pl. LXXIII). An ivory discovered at Kirkstall Abbey in Yorkshire (Beckwith, 1972, no. 163) has rosettes separated by framed beading similar to that already mentioned as appearing on 215. In terms of style both the figures and the foliage find parallels on the lavabo fragments from Much Wenlock (169) so that one might suggest, as a hypothesis for further exploration, that the ivories originated in the Midlands or the north of England. Another feature indicating a northern origin is the Scandinavian lip-lappet of the winged 'dog' with a serpent's tail on 216 (cf. Wilson, Klindt Jensen, 1966, pl. LXXI).

The survival of a homogeneous group of as many as five ivories suggests that they all come from a single source, for example a church treasury. Although it is unlikely that they are all part of one object they may have formed part of a set of, say, processional staffs. The iconography has, as yet, proved of little use in assessing their function or provenance. On 215 there is a seated bishop having a mitre placed on his head by an angel while in the act of blessing a kneeling figure. He is accompanied by two haloed ecclesiastics, but the precise subject is unknown. Equally, the Byzantine-derived garb and attributes of the angels on the middle two registers of 215 raise more questions than they answer. The 'encyclopedic' subject matter of the Florence staff and 216 also merits further investigation. The Florence staff includes what may be a group of the Liberal Arts, but shown as male practitioners rather than female personifications (see Evans, 1978); and also a set of Labours of the Months containing Spinario which appears only in Italy (Webster, 1938, esp. no. 32). However, some such cycle was known in England by about 1200 since Labours, including Spinario, form the basis of some of the figured capitals in the south transept at Wells Cathedral. The Bestiary subjects on 216 are even more unexpected. The taxonomy represented by the different registers – birds (with one exception), winged beasts, beasts and animals with serpents' tails – suggests a progression from airborne creatures to those that go on their bellies (perhaps a lower section of the handle, now missing, contained fish). This classification is very unusual and may be unique.

Apart from the stylistic comparison with Much Wenlock, the dating of these ivories is suggested by their contents. The mitre, placed on the bishop's head on 215, is of a form which was unknown until about 1150 and became common only in subsequent decades. In general the range of subjects and the orderliness of their arrangement indicates a period when such themes as the Bestiary and the Labours of the Months had been assimilated into the intellectual and visual repertoire, and that too implies the second half of the 12th century. The refinement of the carving on such a small scale, particularly on 216, is reminiscent of the love of minuteness evident elsewhere after about 1170, for example in the initials of manuscripts. T.A.H.

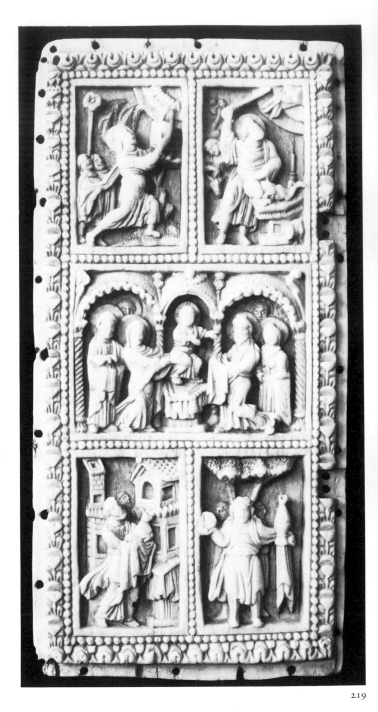

219

219 Panel

Whalebone; *h* 203 mm, *w* 98 mm
Last quarter 12th century
Liverpool, Merseyside County Museums, M8016

The panel has thin tenons extending the full length of all four sides beyond the decorated border. It was probably originally set within an ivory frame held by ivory pins, the holes of which are seen all round the edge; the cuts intended to accommodate two hinges on the right side suggest that it formed the back cover of a manuscript, perhaps a sacramentary.

Four scenes of biblical sacrifice and offering from the Old Testament surround the central scene from the New Testament and are prefigurations of it: they are Moses receiving the Tables of the Law and the Sacrifice of Isaac above; the Offering of the Paschal Lamb and the Priest Melchisidech offering Bread and Wine below; and the Presentation of Christ in the Temple in the larger central panel.

The short, rather squat figures are clearly related both to the flabellum handle in the British Museum (217), on which the heavy pearled borders are also found, and to the Much Wenlock lavabo in the cloister (169). P.L.

PROVENANCE Féjerváry Collection in 1856 (Pulszky); Collection Joseph Mayer F.S.A.; presented to City of Liverpool, 1867
EXHIBITION London, 1974, no. 59
BIBLIOGRAPHY F. Pulszky, *Catalogue of the Féjerváry Ivories*, 1856; Beckwith, 1972, no. 102

220

220 Judas at the Last Supper

Walrus ivory; *h* 85 mm, *w* 70 mm, *d* 45 mm
1200–10
London, Victoria and Albert Museum, A.34-1949

Judas is shown at the front of the table, being given the sop
from the hand of Christ who is now largely missing. Christ's
right arm is being restrained by the left hand of an Apostle who
would have been sitting in front of him. The fragment is carved
at each side and would not, therefore, have been any wider
than it is now. The back is plain and is pierced with three
circular holes for fixing to a background; the shelf carved into
the back, running right across the width of the piece, facilitated
the fixing of a separate piece or pieces of walrus ivory for the
flanking Apostles.

 The original appearance of the piece can be illustrated by
referring to a scene of the Last Supper in a northern English
Psalter of around 1200 (Bodleian Library, Oxford, Gough.
Liturg.2, f. 25): here Judas is shown facing to the left, but his
pose and that of Christ and the Apostle are similar, as is the
depiction of the drapery. Dean Porter has noted similarities
with the sculptures of the Much Wenlock washing fountain
(**169**), of around 1190, in the thickness of the drapery folds and
the squat proportions of the figures (1974, pp. 37–44). The
Judas at the Last Supper fragment is closely related to the
Deposition (**221**) and probably came from the same
altarpiece. P.W.

PROVENANCE Presented by Dr W.L. Hildburgh, 1949
EXHIBITION New York, 1970, no. 65, repr.
BIBLIOGRAPHY Porter, 1974, no. 9

221 The Deposition

Walrus ivory; *h* 182 mm, *w* 68 mm, *d* 33 mm
1200–10
Private collection, on deposit at the Victoria and Albert
Museum

The dead Christ is shown supported by Joseph of Arimathea.
Only the lower part of the cross survives, of a type similar to
the Cloisters cross (**206**). The back is flat and uncarved and has
three circular holes for mounting: like the *Judas at the Last
Supper* fragment (**220**), it has a shelf carved into the back near

the top – in this case probably for fixing the horizontal arm
of the cross. The *Deposition* is intimately related to the *Judas
at the Last Supper* fragment in construction, style and material
and it is probable that they belonged to the same ensemble,
possibly an altarpiece showing scenes from Christ's
passion. P.W.

EXHIBITION New York, 1970, no. 56, repr.
BIBLIOGRAPHY Sauerländer, 1971, p. 512; Porter, 1974, pp. 37–44 and no. 8

221

Metalwork

What survives of English Romanesque metalwork represents only a tiny fraction of the original total production. The wholesale dispersal, sacking and melting-down of church treasures in England began with the Dissolution of the Monasteries and was completed with total ruthlessness by the iconoclasts of the Cromwellian period. No other European country has experienced such thorough destruction of its liturgical vessels and shrines. As a result, England does not even boast one great medieval church treasury such as has occasionally survived elsewhere, for example at Aachen, Agaune, Conques, Essen, Sens. Horrific accounts of the butchering of the great shrines are legion. In the brutal assault on St Swithun's shrine at Winchester in 1538 the royal agents took most of one long night to rip off the sheets of precious metal, nearly two thousand marks of silver. In 1401 a great emerald, the glory of St Cuthbert's shrine at Durham, was valued together with five rings and silver chains at £3336.13s.4d. Not surprisingly, the stone was the principal object of the onslaught on the shrine in 1537.

It was not only during these particularly destructive periods that precious items were lost. Throughout the Middle Ages jewels and plate represented the accumulated capital of laity and church alike. As such they were permanently at risk, for instance under William Rufus, who faced the great churches with crippling levies which could only be met out of liturgical plate. Thus, over and over again great works of the goldsmith's art must have been destroyed for purely economic reasons. On one of the 'Henry of Blois' plaques (277) is a famous inscription: *Ars auro gemmisque prior . . .* ('Art comes before gold and gems'). This represents the personal credo of a great 12th-century patron for whom workmanship was all-important, the value of the materials secondary. Yet everything conspires to suggest that necessity or greed nearly always triumphed over artistic considerations. The verse reads almost as a plea from Henry of Blois to succeeding generations to leave his donation well alone.

In view of the scattered and haphazard nature of the survivals, whether in precious or base metals, it is hardly surprising that this is the first exhibition ever to assemble most of the remaining pieces of English Romanesque metalwork. Their small number only increases their historical, artistic and technical interest.

The Anglo-Saxon tradition of working metal is known through a wealth of documents which allude to spectacular objects: shrines and altars, crosses and reliquaries, plate and furniture both ecclesiastical and secular, now virtually all destroyed. The last hundred years of Anglo-Saxon England were evidently a period of outstanding artistic achievement not only in the field of sculpture, manuscript illumination and calligraphy but also and perhaps supremely in metalwork. Certainly contemporary writers infer the supremacy of the metalworker, but now only a few survivals hint at lost glories.

Although this age is not the main theme of the present exhibition, some examples of pre-Conquest metalwork are exhibited to provide a summary of the various styles and techniques current from the late 10th century up to the Conquest: the late Viking Ringerike (222) and Urnes (225)

styles, the so-called 'Winchester School' style (223, 226 and 229), casting and hammering of metal, niello inlay (223) and *champlevé* enamel (224).

The Conquest was no stylistic watershed. Artistic traditions do not conveniently disappear in the face of political events. The Viking legacy to English Romanesque art can be seen with the Pitney brooch (225), whose animal ornament in the Urnes style could still be relevant to a sculptor at Norwich *c.* 1130 (see 126). The Winchester School style, too, survived or was revived in metal, as in all the arts, during the reign of Henry I, though always with a harder line; the exuberance of the hemlines favoured by a great late Winchester School draughtsman of *c.* 1050, such as the author of the engraved figures on the Lundø crucifix (229), becomes contained within the silhouette, as a more reserved, inward-looking calm invades such figures as the Ushaw Virgin (231) or the Holderness Christ (232). A bold simplification of the drapery patterns has already been achieved with the Christ of the Sandford reliquary (228), an early 'Romanesque' object, enigmatic in style as in date (*c.* 1050?) and on the remarkable early Christ of *c.* 1080 in Cambridge (230), so close in spirit to the second *Crucifixion* miniature in the Arundel Psalter (7). The Christ of the Lundø cross raises the problem of the nature and extent of England's debt to Ottonian art in the mid-11th century. Such an effect is noticeable in English coinage, which became 'German' from *c.* 1050 onwards (see 381 and 391). Some German metalworkers were recorded in the Domesday Book (or at least their names are German), and Edward the Confessor already had Germans about his court before the Conquest. The Norman contribution to late-11th-century metalwork is even harder to assess. There are no survivals either side of the Channel. Perhaps it was never a major force. Only the winged dragons on the little belt-fitting from Winchester (246) form a counterpart in metal to the Anglo-Norman initial styles of this period (see 11 and 13).

The Gloucester Candlestick (247) is the one firmly-dated piece of English metalwork of the 12th century. Its inscription tells us that it was made for Abbot Peter and the monks of Gloucester within the period 1107–13. The motifs which decorate the candlestick are intimately related to contemporary Canterbury manuscripts. Here is the world of the inhabited initial, where monsters and little men fight or are caught up with each other in long foliage tendrils. The great artist who made the candlestick had a remarkable technical repertoire, for he not only modelled in wax (for the metal-casting process) but also engraved the metal, employed glass insets and inlaid niello on silver, as well as fire-gilding this intricate object.

The comparison with Canterbury illumination raises important questions as to the range of activities which belonged to the 'goldsmith' in 12th-century England. Presumably his role varied to some degree according to his talent. Anketyl of St Albans, who is known only from documents in the second quarter of the century, was a specialist metalworker, his only other activity being that he was at one time moneyer to the king of Denmark. On the other hand, his contemporary Master Hugo of Bury St Edmunds not only cast bronze doors and possibly a bell, but also carved a rood and

illuminated a Bible (44). Of the Simon who signed the Dune drinking-cup (305), which is the only metal object in the exhibition with a signature, nothing is known; but it is hard to believe that he was exclusively a metalworker, so intimately does his drawing style relate to works of the 1180s in stone and on vellum. Indeed many of the attributions of the metalwork in the exhibition depend on its similarity to works in other media, better localized and dated. Such similarities imply that this was by no means a period of universal technical specialization, rather a period of transition. For instance, the Gloucester Candlestick might reasonably be thought the work of an itinerant professional artist, responding to individual commissions in various media, not tied to a single community, or at least not through religious vows: in other words, a lay professional. There seems to have been a decline during the 12th century in the monastic tradition of the monk-artist, and a corresponding rise of the lay professional. This phenomenon is increasingly apparent in all the arts, and not only in England. On the other hand, a symptom of the expanding market for metalwork as a specialized craft is the first appearance of an unofficial guild of London goldsmiths in 1179–80. In Genoa by the early 13th century a small colony of English residents was made up largely of metalworkers, whose craft was presumably appreciated by the Genoese.

As to the social status of the goldsmith, little can be deduced. Anketyl of St Albans was a monk, but this may have been exceptional or he may have learned his trade before entering the cloister. In any case, to become a monk implies a certain social status: we find a goldsmith, Henry, witnessing a charter of Christ Church, Canterbury, in 1158. In the absence of all firm evidence the conclusion may be that after as before the Conquest the goldsmith was the most prestigious of artists, enjoying a certain standing; he was after all entrusted with stocks of precious metal.

Whether or not there was a large production of metalwork in the style of the Gloucester Candlestick it is impossible to say. Only the earliest of the Chichester crosiers (267) is in any way related. But in the first half of the 12th century a few other isolated objects can be compared to contemporary pen drawing styles: the bronze dish (259), the group of sleeping soldiers at the Holy Sepulchre (234). Again, from the second quarter of the century, there is a small but important series of cast images of Christ from crucifixes or Deposition groups (233 and 235–8). Given the notoriously conservative approach to the Crucifixion by Christian artists of all periods, it is always rewarding to compare a set of variations on this theme. Outstandingly beautiful are the Christ in Cambridge (233) and the Christ which once belonged to Pugin (235), both related in style to figures from the region of Anjou-Maine. The walrus ivory figure found in London (200) also makes a telling comparison with the Cambridge figure. Another Christ in Cambridge (236) is remarkable for its dynamic and sharply-angled silhouette, which can be paralleled in contemporary manuscripts. But the principal survival of this period is the exquisite little silver nielloed bottle at St-Maurice d'Agaune (296), whose winged dragons with foliate tails return us once again to the world of exotic beasts so frequently encountered not only in manuscripts but in sculpture (42 and 128e). The bottle, perhaps for perfume, was presumably hung from a belt. At a more everyday level, a few small cast 'bronzes' are all that survive of the practical utensils of the well-to-do. The animal heads and winged beasts which decorate them were the artistic currency of this period, when carved doorways in various parts of the country were being given 'beak-heads' as decoration (129–33). There are writing instruments (250 and 251), a needle (252), belt-fittings (246 and 256), a spout (253), a domestic lamp (258), and what may be a dog-leash swivel (248), all with strictly practical functions and all with animal decoration.

The English tradition of cast lead fonts is represented here by three major loans (243, 244 and 245) out of the 16 which are known to survive. The art of the blacksmith is demonstrated by the decorative ironwork on two doorways and a chest (325, 326 and 327). And if any doubts remain about the command of casting techniques in England during the period, the large-scale beast-head doorknockers are here to remove them. A doorknocker was a major technical challenge. They were probably cast in sand or clay moulds. To assure the correct flow of the copper alloy requires experience and judgement. To produce works of art of the force of the great Durham knocker (see p. 21) speaks of something more: a native monumental casting tradition worthy to stand beside the greatest German and Mosan achievements of the 12th century. The knocker from Dormington (263), related to Herefordshire School sculpture (e.g. Kilpeck) is unique among European knockers both in style and type. The Adel knocker (264), one of a group in Yorkshire, is claimed here as Romanesque and English (others have dated it far later and placed it in a German tradition). With it is exhibited the knocker (265) which comes from a most unlikely source – from Luborzyca in Poland, made by the same English workshop. Such works, with the lead fonts and 'bronzes' such as the Gloucester Candlestick, give substance to the claim that England in the Romanesque period was a major centre of metal-casting. Yet so much of the evidence has vanished. Of the giant seven-branched candlesticks, 12 of which are known to have existed in England between the early 11th and the late 13th centuries, not one remains. They were certainly not all imports, as we know from the case of a candlestick which was made at St Albans in the 1240s. A drawing in a manuscript (66) shows us how they might have looked.

To search for a metalwork production which corresponds to the most splendid manuscripts of the mid-12th century is now fruitless. Presumably the loss of the objects in precious metal must be blamed for this imbalance. Only the Masters plaque (275) exhibits that extreme manifestation of the love of pattern-making, two-dimensional and utterly schematized, which forces the draperies into 'damp-folds' and 'nested V-folds', as for instance in the Lambeth Bible (53). But as the human figure beneath the draperies begins to reassert its presence around 1160–70, the style of a manuscript like the Copenhagen Psalter (76) can be paralleled in the remarkable pewter crucifix figure from Ludgvan in Cornwall (240). As to the censer-cover (261), a masterpiece of intricate wax-casting, it is a puzzling object. Its date and pedigree have never been firmly established, but it is possible to argue for an English origin by comparing it with the ivory tau-cross (205).

The technique of firing powdered glass at a very high temperature so that it adheres to a base-metal surface (usually pure copper), which has first been cut out into fields to receive it (champlevé), has a long pre-Romanesque history and indeed never seems to have become wholly extinct in northern Europe during the so-called Dark Ages. The Brasenose disc (224) is a late Anglo-Saxon champlevé enamel, simple in that different-coloured glasses are not fired within the same field, but nevertheless decorative in design and in the distribution of colours. In the second quarter of the 12th century there was a phenomenal revival of copper champlevé in the Mosan region and in parts of Germany. Around the middle of the century, in northern Spain and south-western France, there arose another, equally vigorous new champlevé tradition which

contemporaries called 'Limoges work'. It seems that the *champlevé* technique was reintroduced to England from these European sources, for there is no clear continuity from the Anglo-Saxon enamels. If a few pieces are excepted as being without obvious European inspiration, such as the Masters plaque and two other enamels (274 and 276), the technical influence of the Mosan workshops is manifest, for example in 278–80 and 290.

The difficulties inherent in any attribution of a particular piece of metalwork to England in the 12th century are compounded by two factors: that much fine metalwork must have been imported and that some foreign craftsmen undoubtedly established themselves here. Romanesque England was not a region cut off from the main European artistic centres. With manuscripts which often contain evidence of their place of origin, and even more with monuments which do not move, it is sometimes possible to isolate a degree of stylistic influence from one or other of these foreign regions. But with the peripatetic metalwork such an exercise is much more hazardous. Is one piece a German import? Is another executed in England by a Mosan craftsman? The Cologne merchants had their own guild hall in London by some date in the reign of Henry II, and there were both German and Flemish colonies in London by the late 11th century.

With this in mind, some works of art exhibited here are attributed to foreign artists working in England. Thus the enamel plaques made before 1171 for Henry of Blois (277) seem to be the work of a Mosan goldsmith, for an English patron and, presumably, an English setting. The exquisite little silver nielloed Becket reliquary (302) has close connections with Rhenish art of the third quarter of the 12th century. Becket was murdered in 1170 and canonized three years later, so that there is every likelihood that the artist made the reliquary in England only just after that date. The little 'bronze' St John from Rattlesden (242) may or may not have been made in England, a measure of the difficulty of attribution to one or another side of the Channel on stylistic grounds alone in the period *c*. 1180. The same doubt must exist for other objects such as the *vernis brun* fragments from Battle Abbey (260), unique survivals of that technique in England at this period, as well as for certain pieces of early 'Limoges': the Rusper chalice (293), dug up in Sussex and so like a plaque in Rouen (294), and the Nuremberg Christ (291), which is perhaps a linear English transcription of a Limoges Christ. But then the whole vexed question of how the 'Limoges' production was launched and, above all, where it was centred in the early period, is probably not susceptible of a satisfactory solution, in the near-total absence of documents. The town of Limoges, first mentioned in connection with enamelling around 1170, was politically within the domains of Henry II and Richard I, from the time of Henry's marriage to Eleanor of Aquitaine in 1152. Was the earliest known Limoges Becket *châsse* (292) in England by 1200? And what of the apeing of Limoges patterns and designs by a group of silversmiths who made one of the Dune cups (306), the New York cup (308) and part of the 1178 Cologne precentor's staff (307)? They may well have been active within the Plantagenet domains.

Equally intriguing is the knot of connections between the metalwork of England and of Lower Saxony in the second half of the century. Again the political connections are there to explain these links: the family alliance of Henry II and Duke Henry the Lion, and Duke Henry's enforced exile in England in the 1180s. But is it justifiable to employ the few historical facts which have been recorded in order to explain the few works of art which happen to survive? In this case historians have been lured by Duke Henry's prestige into explaining artistic phenomena which are susceptible to quite other explanations. There are obvious similarities between metalwork in Lower Saxony and a group of objects in this exhibition, the nielloed silver book-clasps in Durham (301), the Pevensey silver spoon (299) and the crosier mount from Bury St Edmunds (300), as well as the mutilated reverse of the Chapter Seal of Lincoln (360) whose first use can be securely dated between 1148 and 1160, earlier than is customarily assigned to the German objects which are decorated with the same spiralling foliage patterns. A German artist or artists in England? An English artist or artists in Lower Saxony? Or indirect influence from one area to the other?

Six out of a set of seven surviving enamel plaques from a large-scale altarpiece or shrine have been brought together in this exhibition (290). Their subject-matter is concerned with episodes relating to Sts Peter and Paul but their original function remains unknown. Damaged as several of them are, the direct and monumental quality of their drawing is still apparent, and their coloured glasses strike an unusual resonance, with deep green, turquoise, azure blue and purple dominant. Here again the source is undoubtedly the Mosan region, but such a style was equally at home in English manuscripts (see 66).

The second major group of enamels (278–89) is one of the glories of the exhibition. Never before have all these pieces been brought together. Ranging in date from *c*. 1160 to 1200, and including ciboria, crosiers and boxes, they have enough in common technically to allow attribution to one group of metalworkers, yet they vary widely in style. Compare the corresponding scenes on the Morgan and Balfour ciboria (278 and 279), close if not identical in both style and iconography, and then compare these with the same scene on the Warwick ciborium (280), again with almost the same iconography but vastly different in style – the former drawn with a vigorous English line and enriched with large blossoms, the latter in a solemn, monumental Mosan style. It seems likely that a Mosan artist was working in England within an English workshop tradition. And what is improbable about that? Particularly interesting for an understanding of the English art of the 12th century is a Worcester manuscript (281) in which a poem was copied which includes all the Latin inscriptions found on the three ciboria. The poem corresponds to verses once painted in the Worcester chapter house as inscriptions commenting on a cycle of wall-paintings. Although the date of these lost paintings is unknown, it is tempting to see in the ciborium scenes a monumental painting in miniature. Certainly the three ciboria more than any other objects in the exhibition give the lie to the condescending phrase 'The Minor Arts' as it used so often to be applied to anything small-scale in metal; here scenes from the Old and New Testaments are drawn with monumental assurance and clearly reflect monumental prototypes. At the time the Romanesque 'precious arts' were more highly valued than any monumental painting or sculpture. Perhaps with historical hindsight we should think of the three ciboria as the highest expression of contemporary patronage, and of the lost wall-paintings as executed perhaps by artists who could work in several media, even in metal, but here operating at a lower scale of artistic enterprise.

The technical assurance and beauty of these enamels is not restricted to the ciboria. The David scenes on the knop of the 'Chartres crosier' (282) are fully as remarkable, and no foliage in the exhibition surpasses that of the enamelled blossoms on the lid of the Boston casket (284). The rich blossoms favoured by this group of enamellers are remarkably varied and call for

the finest gradations of palette. The big cast 'orchids' pinned through the crook of the Whithorn crosier (285) are one of the most exotic manifestations of the English love of fantastic blossoms. But it is the heavily-damaged casket with the Liberal Arts (287) which speaks most for the extraordinary level of achievement of this English enamel workshop. It was executed towards the end of the century, from 20 to 40 years after the ciboria and in a thoroughly avant-garde style: the refinement of the drawing of this artist places him among the best European artists of his time. The Virtues and Vices of the Troyes casket (283) are earlier in date (c. 1170) and drawn in a vigorous, sketchy style, the frenzy of combat powerfully communicated. Once again with this workshop comparison is possible between similar scenes, for the Virtue and Vice groups of the 'Chartres crosier' are nearly though never quite the same as those on the Troyes box. It seems likely that these little enamelled caskets were for secular use, perhaps as jewel-boxes, for writing-instruments or for some other domestic purpose.

A special effort has been made to assemble objects which were made for secular use. Historically the Church has always had a keener motive for preserving its treasures than the laity, for whom fashion tends to be all-consuming. So little has survived of secular plate and base metal that it is easy to forget how evenly balanced between Church and laity contemporary wealth and therefore contemporary commissions must have been. There are, however, a few remarkable survivals: the three silver drinking-cups from the Dune treasure (304, 305 and 306) and the Metropolitan silver cup (308), as well as several silver spoons (297–9). It must be admitted at once that of the four cups only two can with real assurance be attributed to England, the earliest silver-gilt Dune cup (304), whose interior lion medallion has close parallels in English art, and the elegantly-engraved Dune cup (305) with figures and animals caught up in foliage tendrils, stylistically a work of the 1180s. The debt to Limoges of the New York and Dune nielloed silver cups (306 and 308) has already been mentioned. However, given the 1178 Cologne commission of the precentor's staff (307), which belongs to the same artistic orbit, the Angevin origins of this workshop must remain uncertain.

Survivals of church plate and jewellery are rare indeed. The Dune and New York cups were dug up. It is also in excavations (though this is often a euphemism for the crude discoveries of the 19th century) that most of the precious metalwork in this exhibition came to light, and then generally in tombs which had escaped the vandalism of earlier centuries. The Larkhill hoard (319 and 320) was excavated virtually as it was deposited around 1173–4, the finger-rings representing part of the capital of a wealthy layman. All the other finger-rings (311–17 and 324c) come certainly or at least very probably from the tombs of bishops or abbots. The Larkhill rings are precious for their firmly-dated context and because they shed light on a less elevated section of feudal society. The bishops' rings vary considerably in shape, and no doubt in date although that is largely a matter of speculation. To these survivals can be added Matthew Paris' drawings of rings at St Albans (318); no survival can match in splendour the lost 'pontifical' ring shown here, which Henry of Blois presented to St Albans. These rings were highly personal items. Although items which were of secondary value or old-fashioned may, for reasons of economy, have been buried with these bishops of Durham (see 311, 312 and 313) and Chichester (see 314), the personal ring was not replaced with a lesser example at death.

One cannot be so confident with the funerary chalices and patens. At a humble level are the base-metal mortuary sets (323). At the other end of the scale is the handsome silver set

from Chichester (322); this may be simple in style, but many of the late-12th- and early-13th-century chalices and patens were never elaborate, as with the Berwick St James example (321). Also from tombs came the crosiers, not in precious metal but none the less fine examples of the metalworker's art, a series to be studied for variety of form and foliage (267–73 and 324f). The joyous variety of foliage types in English 12th-century art may be followed with the exhibited crosiers from the first quarter of the century to its end. It is most unfortunate that the tombs in which these rings, chalices and crosiers were found did not reveal the identities of their occupants. Only with the tomb of Archbishop Hubert Walter, who died and was buried at Canterbury in 1205, do we have a complete identified set of tomb furniture (324 and 493), here with textiles surviving as well.

The main stylistic trends of the later 12th century in England are represented by three objects in metal. First the crucifix in Monmouth (241), the most complete of 12th-century English altar crosses (c. 1170–80), which even retains a classical gem in one of its terminals. The winged symbol of St Matthew engraved on the reverse is eloquent of this moment in the history of 12th-century art when the figures begin to relax, the draperies to take on the form of the limbs they cover. The Liberal Arts casket (287) has already been mentioned for the quality of its drawing and enamel; the figures are draped in softly modelled garments and one figure even turns his back on the spectator, a pose ultimately derived from classical art. Lastly, from the early 13th century, the silver *repoussé* ciborium from St-Maurice d'Agaune (309) is the counterpart in metal of the English manuscripts in the group of the Leyden Psalter (79). Its cycle of the *Infancy of Christ* stands at the end of an English Romanesque metalwork tradition of which the earlier stages can be seen in the three enamelled ciboria (278, 279 and 280). Yet, together with the English Psalters of c. 1200 (79 and 82) it is symptomatic of something new, a supreme expression of England's role in those formative years when new sources of artistic inspiration were being tapped. The small cast Achilles and Chiron group which crowns its cover is a direct antique 'quotation'. So too is the *gravitas* of the little figures on the Liberal Arts casket (287), with their softly-modelled toga-like mantles.

What additional evidence do the documents provide about goldsmiths' work at this period? The pre-Conquest written sources make it clear that the goldsmith was pre-eminent among artists; Anglo-Saxon metalwork enjoyed an international reputation. The Conquest brought disastrous consequences for the English church treasuries; during the reigns of the two Williams there is extensive evidence (though usually partisan) of expropriation and melting-down. This need imply no more than a temporary change of taste; priority was given to the enormously expensive early Norman building programme of castles and churches. And the lists of metalwork donated by the Norman bishops to their various cathedrals hardly seem less impressive than those of their Anglo-Saxon predecessors, although these lists scarcely ever specify when or by whom a given work was made. Osmund, Bishop of Sarum (1078–99), Ernulf, Bishop of Rochester (1115–24), Henry of Blois, Bishop of Winchester (1129–71), Hugh du Puiset, Bishop of Durham (1153–95) and Hubert Walter, Archbishop of Canterbury (1193–1205) all made major gifts of metalwork.

Such lists make clear the scale and diversity of what was being produced in Romanesque England. Already at the end of the 11th century and in spite of Rufus' crippling levies, Osmund gave Sarum six shrines of silver-gilt; ten 'texts' (that is, book-covers) of silver-gilt; two pyxes, one holy-water

bucket, two basins, all silver-gilt; one gold chalice; seven silver-gilt chalices with their patens; a silver Mass vessel for wine and another for water; a silver-gilt reliquary for the arm of St Aldhelm; three incense-vessels, two silver with silver spoons, the third of precious stone; a chrismatory; two silver vessels for the oil and cream; a silver-gilt altar frontal; two ivory horns; 27 silver-gilt reliquaries (or phylacteries), nine with silver chains, two of crystal and one of jet; as well as a huge list of precious vestments. Henry of Blois' list of gifts to Winchester is even more impressive.

But it is difficult to conjure up from such lists an idea of what a great church treasury or decorated altar would have looked like. No easier is it to attach particular objects to particular owners. The two celebrated enamel plaques (277) can be associated with Henry of Blois because he is represented on one of them, but we do not know why or when they were made, and the great ring which he gave to St Albans survives only in Matthew Paris' drawing (318). We do not even know in most cases for whom and how the earliest containers for Becket's relics (302, 303 and 292) were commissioned. For this reason the little gold pendant (303) is particularly precious; as a gift from the great bishop of Bath, Reginald fitz Jocelin, to the dowager Queen Margaret of Sicily it can be associated with the aftermath of the negotiations for the lifting of the excommunication on Bishop Roger of Sarum.

The personal treasuries of the great laymen of the period did not even have the status of consecration to protect them. A few secular objects are exhibited here: silver spoons and drinking-cups, rings, a mirror-case, belt-buckles, a gold pendant reliquary, and so on. But they make a poor showing, even against the limited evidence of what has been lost. In 1205 at Reading King John took inventory of a part of the royal insignia and treasures, those which were in his storehouse at the New Temple in London. The immense list corrects any notion that the bulk of precious metalwork was in the hands of the Church. It also opens up vistas on a whole range of objects which do not appear in church lists and have certainly not survived: to mention only one group, two enamelled belts, four big belts with gold fixtures and a big belt with garnets, sapphires and pearls. We simply do not know what these would have looked like.

All we can do is be grateful for what has survived. There are just over one hundred post-Conquest pieces or groups in this exhibition. This assembly by no means represents a severely selective choice from among many (as is the case for instance with the stone sculpture and the manuscripts). Rather it is a very full sample of what survives, except in the case of the knockers, lead fonts and ironwork. It is doubtful whether a complete list of all surviving English Romanesque metalwork would reach more than twice the number here. Nevertheless, clear criteria have been applied in selecting the exhibits. Only five of the really great pieces are missing from the exhibition: the Durham knocker, the Coronation spoon, one 'bronze' comparable to 234, one of a set of enamel plaques (see 290b) and an enamelled casket related to 286. Other pieces sometimes called English have been excluded because the attribution seems doubtful. The choice has had to be a personal one, based on criteria of style (fallible as that method is), sometimes helped by archaeological evidence. The grounds on which stylistic judgements have been made are, however, not as flimsy as might at first appear: there are well-established series of reasonably datable manuscripts and stone-carvings against which the metalwork can be judged. But it must be stressed that the canon of English Romanesque metalwork is a provisional one which will and should be the object of numerous revisions, additions and subtractions as these extraordinary works of art become better known and attract further study. N.S.

222 The Sutton, Isle of Ely, disc-brooch

Silver, hammered and engraved; slightly convex disc, with remains of a separate silver base-plate for a pin on the back; engraved with: (border) a continuous pattern of touching segments of circles, (disc) four intersecting circles each framing a concave-sided quadrant field, the outer areas of the disc divided by small triangular fields, stylized zoomorphic- or plant-motifs in the outer sections; round-headed silver rivets at the intersections of the circles and where they meet the border (only eight out of nine survive); (back) two inscriptions: (on the pin-plate) an indecipherable rune-related inscription, (round the edge) in Latin characters, in Old English, an alliterative line and two rhyming couplets, which probably mean: 'Aedvwen owns me, may the Lord own her. May the Lord curse the man who takes me from her, unless she give me of her own free will'; *diam* 149/164mm
Anglo-Saxon; late 10th or early 11th century
London, Trustees of the British Museum, MLA.1951, 10-11, 1

Hickes reported that this brooch was ploughed up in Sutton, Isle of Ely, in Cambridgeshire in the 1690s, within a lead casket which also contained a hoard of silver coins of William the Conqueror (1066–87), five gold rings and a plain silver dish. It is an outstanding English example of the Ringerike style, found also on the St Paul's graveyard slab (95). N.S.

PROVENANCE Acquired from H. O'Conner, Dublin, 1951
BIBLIOGRAPHY G. Hickes, *Linguarum Vett. Septentrionalium Thesauri. . .*, III, 1703, pp. 186–8; R.L.S. Bruce-Mitford, 'Late Saxon Disc-Brooches,' in *Dark Age Britain*, ed. D.B. Harden, 1956, pp. 193–8, pls. XXVIII–XXIX; Wilson, 1964, pp. 7, 48–50, 86–90, 174–7 (no. 83), pls. XXXI–XXXII; Fuglesang, 1979, no. 50; Graham-Campbell, 1980, no. 146

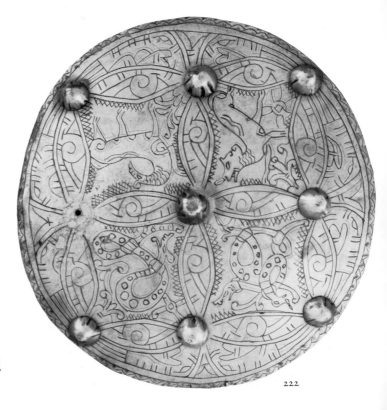

222

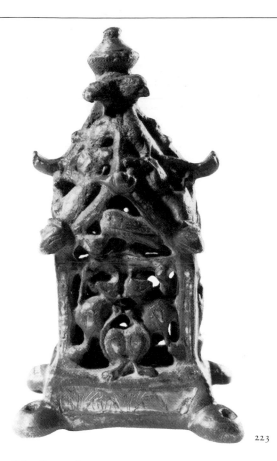

223

223 The Canterbury censer-cover

Copper-alloy, cast, not gilded but inlaid with engraved silver plates, sometimes nielloed; in the form of an openwork church tower, with gables and hipped roof, topped by a knob-shaped terminal beneath which are four protruding heads of animals and a bird; gables and hipped areas between decorated with the bodies of animals, their heads and tails forming projecting elements at the corners; the four square side fields have more or less symmetrical groups of pairs of animals or birds, except in one case where there is a central mask-head; borders inlaid with silver, as are the bodies of the creatures, lower border and inset nielloed plates with rudimentary acanthus foliage designs; the four corners of the cover have loops through which the suspension chains of the censer passed; *h* 118 mm
10th century
London, Trustees of the British Museum, MLA.1927, 11-16, 1

This is one of three surviving Anglo-Saxon censer-covers with the same church tower shape; compare the tower of Sompting in Sussex. All are of much the same date. No other European censers of this form have survived, although the traditional Romanesque censer is often in the form of an architectural structure (compare **261**). The incense bowl has been lost in all three cases, so that its original form cannot be reconstructed. Wilson (1975) suggested that the Canterbury cover is an early Winchester-style object, its acanthus predating, for example, the Benedictional of St Aethelwold. The use of silver inlay on bronze is a pre-Conquest technique that does not seem to occur in the 12th century, but the nielloing of silver, which also has a long Anglo-Saxon history, continued as a popular technique with Romanesque metalworkers (as in **296, 302** and **308**). N.S.

PROVENANCE Found *c.* 1867, northern end of Palace Street, Canterbury; by descent to A.H. Crippen; acquired 1927
BIBLIOGRAPHY Wilson, 1964, pp. 43–7, 53–4, 122–4 (no. 9), pls. XII–XIV; 1975, p. 204, pl. XXIIIb

224 The Brasenose disc

Copper-alloy, cast, *champlevé*, engraved, enamelled and gilded; probably a disc-brooch, although no vestiges of pin and clasp survive; triple ribbed border, with two rows of beading; slightly convex central roundel, decorated with a cross formed by four loop-shaped arms, around a small circle in the centre; between the arms four medallions, each with a reserved and engraved bird, its contorted pose dictated by the circular frame: all four differ in minor details but they are basically of two types, which alternate; backgrounds enamelled: white in the outer fields, blue in the four bird medallions, yellow in the cross, green in the central circle; *diam* 63 mm
Anglo-Saxon; 10th or 11th century
Oxford, Ashmolean Museum, 1887. 3072

The great period of *champlevé* in north-western Europe began in the second quarter of the 12th century and by the third quarter of the 12th century major workshops were already active in England (see **278–89** and **290**). But Romanesque *champlevé* was a 'revival', rather than an experimental new departure; at no time from the late classical period onwards did the technique die out completely, though the few surviving pieces from this time are difficult to date and to localize. In England there have been several 'finds', which suggest a pre-Conquest production of simple *champlevé* enamels on copper, the figures reserved and engraved, the glasses fired in unmixed fields. The Brasenose disc is particularly important, because its birds compare closely with drawings in Anglo-Saxon manuscripts of the 10th century (Temple 1976, illustrations 20–4, 34–7, 39–40) and its localization to an English workshop is therefore assured. So far only two examples with a more sophisticated use of mixed glasses have been found in England, of the so-called Kettlach type, one from Bedlington, Northumberland, and the other from Hyde Abbey, Winchester, but it is not certain whether these are imports. Therefore the Brasenose disc is exhibited here as a securely English representative of early *champlevé*. N.S.

PROVENANCE Found at Brasenose College, Oxford, *c.* 1887
BIBLIOGRAPHY Hinton, 1974, no. 27 (with bibliog.); Wilson, 1975, p. 204; V.I. Evison, 'An enamelled disc from Great Saxham', *Proceedings of the Suffolk Institute of Archaeology and History*, XXXIV, part 1, 1977, pp. 1–13, particularly pp. 3–4, pl. Ie, fig. 3e

224

225 The Pitney brooch (not illustrated)

Copper-alloy, cast, engraved and gilded; openwork disc-
brooch, convex, with a 'scalloped' border; remains of pin- and
hinge-attachments on the back; spiral design made up of the
entwined bodies of two stylized animals; *diam* 39 mm
Late 11th century (?)
London, Trustees of the British Museum, MLA.1979, 11-1, 1

The brooch is exhibited as an outstanding example of Insular
Urnes-style ornament of the late Viking period. Such ornament
continued to be admired and copied until well on into the 12th
century, for example on capitals from the Norwich cloister
(126). N.S.

PROVENANCE Found in Pitney churchyard, Somerset, *c.* 1870–80; acquired 1979
BIBLIOGRAPHY Zarnecki, 1955b, p. 176, figs. 4–5; Graham-Campbell, 1980, no. 147 (with
bibliog.)

226 Figure of a standing saint

Copper-alloy, hollow-cast, not gilded; standing female (?)
figure; nimbus with pin-hole for attachment; the right hand
raised with palm open, the left hand holding something, a
scroll (?) beside the head; *h* 83 mm, *w* 21 mm, *d* 12 mm (max)
Anglo-Saxon; mid-11th century
York, The Yorkshire Museum, 632.47

The style of this figure is ultimately derived from the great
period of the Winchester School of *c.* 1000; compare an ivory
in St-Omer (Beckwith, 1972, no. 25, ill. 57). It was found with
the *Virgin and Child* (227) and its scale indicates that it could
come from the same object. Is it possible that the saint, utterly
different in style and in bolder relief, belonged to the original
scheme and that 227 was a later addition or replacement to the
same object? N.S.

PROVENANCE Found with 227, 30 Colliergate, York, July 1853

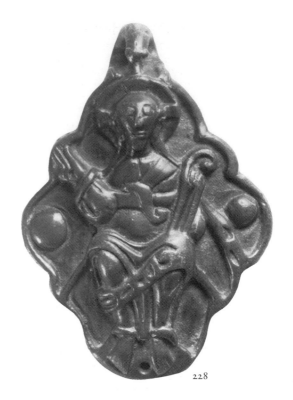

228

227 Virgin and Child

Copper-alloy, mould-cast, not worked after casting or gilded;
the back flat, with slightly hollow-cast body except for three
horizontal and one vertical flat strips which may correspond
to the lines of a (lost) throne with back-rest and vertical post,
though how the figure was originally attached is not clear; the
Virgin seated, with Christ blessing and seated sideways on her
left knee; *h* 94 mm, *w* 38 mm
North of England; 1050–75 (?)
York, The Yorkshire Museum, 631.47

The close, densely packed drapery patterns and the oval
delineation of the knees surrounded by furrows and groups of
pleated folds lead one to seek parallels in Scandinavian art for
this flat linear treatment of the draperies and for the ovoid
forms – compare a cast figure of Christ in Copenhagen, but
the York figure is much earlier in date and was no doubt made
locally. Perhaps it was a replacement or 'mend' to the object
from which 226 also comes. The sideways position of the Child
on the Virgin's knee is often found in England, as on the
celebrated stone relief of the *Virgin and Child* in York (153),
although Maclagan's claim that the latter is related in style to
this cast *Virgin and Child* cannot be accepted. On the other
hand, the two-dimensional quality of the bronze is similar to
local mid-11th-century sculpture, for example on the
Nunburnholme Cross, and on the seal of St Mary's,
York. N.S.

PROVENANCE As 226
EXHIBITION London, 1930, no. 79, pl. 16
BIBLIOGRAPHY Maclagan, 1921–3, p. 483, drawing on p. 485; Longhurst, 1926, p. 21, fig. 8;
Rice, 1952, pp. 235–6, pl. 90a; Saxl, 1954, p. 29 (fig. 10), 70, n. 14

226 227

228 The Sandford-on-Thames reliquary

Copper-alloy, cast, engraved, extensive traces of gilding; suspension loop formed by the body of a bird whose beak bites the upper edge, its body acting as a lip behind which the back-plate of the reliquary would originally have slotted; within an irregular eight-lobed frame, Christ is seated on a schematic 'rainbow', flanked by two undecorated round protruberances; frontal and hieratic, He blesses with His right hand and supports a book on His left knee; inscribed round the side is a Leonine hexameter: + INTUS QVOD LATET CVNCTO NOS CRIMINE LAXET ('What is hidden within, may it release us all from sin'); the strokes of the letters were engraved only after the extreme points of the square capitals had been marked out with a small punch, an unusual procedure reminiscent of the so-called *a globolo* technique of gem-cutting; back hollow-cast and slightly concave; between Christ's feet, an original pin-hole for attachment to the lost back-plate; *h* 71 mm, *w* 49 mm
Anglo-Saxon or Norman; mid- or second half 11th century
Oxford, Ashmolean Museum, 1891.10

The inscription defines the function of this reliquary or phylactery, which was probably for suspension either as a liturgical ornament near the altar or as a personal adornment (compare 303 and 310). Stylistically this 'bronze' seems to be unique; in spite of proposing various comparisons with Anglo-Saxon and German works, Hinton could reach no definite conclusion beyond suggesting that it may be English and of the 11th century, 'an important example of the early development of the Romanesque style'. This is probably correct. The Sandford Christ may well be contemporary with such early Romanesque stone sculpture as the crossing capitals of Bayeux Cathedral (illustrated in Zarnecki 1966, pl. VIIb), for although the detailed handling is different, the capitals share the same approach to relief, the volume of the figure treated in planes, the various elements of the composition put together in a tentative and inorganic manner. Mid-11th-century sculpture parallel to this phase in Normandy is poorly represented in England, so that the isolation of the Sandford Christ may be a pure accident of survival. On the other hand, it is possible that the 'bronze' is a reflection of the earliest Norman intervention in English art, associated with the court of Edward the Confessor and pre-Conquest buildings in London and south-east England. N.S.

PROVENANCE Found on site of Preceptory of Knights Templar, Sandford, near Oxford; presented by the family of R.J. Spears, FSA, 1891
EXHIBITION London, 1930, no. 86, pl. 16
BIBLIOGRAPHY Hinton, 1974, no. 30 (with bibliog.)

229 The Lundø crucifix (*illustrated overleaf*)

Copper-alloy, the Christ cast, engraved and gilded, the cross engraved and gilded, *repoussé* plaques pinned to its front terminals; much of the gilding lost; lower knop and socket not original.

Christ shown with arms, legs, torso and loincloth almost precisely frontal and symmetrical; His head falls on to His right shoulder; cast nimbus fastened with its pointed end to the back of the head, and with a central pin (now a screw); the cross of the nimbus projecting; arms slightly bent at the elbows and pinned at head level; loincloth arranged in soft folds falling vertically around a central V-shaped 'apron' with two knots at the belt and decorated lower hem; arms, legs and torso rendered with finely grooved lines, which accentuate the emaciation of body and rib-cage; head boldly modelled with long, straight nose above a downward-pointing moustache and full beard; closed eyes; curved eye-brows; ridged forehead; hair centrally parted and falling in long coils on to the shoulders.

Cross with projecting square terminals framed by palmette borders; borders of cross (front) with stylized foliage and ribbon patterns, (back) plain where they are chamfered back from the central fields of the cross; engraving: (front) above the crucifix figure, the Ascension of the spirit of Christ on the cross (Luke XXIII. 46): Christ assisted by two angels is drawn up to heaven by the two hands of God; He turns back and looks downwards, His cheek resting on His hand; below the crucifix figure, an inscription mutilated by rivet-holes: AILMAR/F()IT.PA()A/RE.CRVCE/M()NMI()/ an entire line lost at the end ('Ailmar had the cross (of the Lord?) prepared . . .'); two Evangelist symbols survive in the terminals: (top) the Eagle of St John, (bottom) the Lion of St Mark (head damaged); (back) the Archangel Michael with four huge wings spreading into the arms of the cross, armed with a round shield and a long spear which he plunges into the mouth of the dragon whose sinuous tail spirals upwards from the bottom of the cross; the terminals with stylized acanthus, each composition different; *h* 552 mm (excluding knop and socket), (Christ) 270 mm, *w* 409 mm
Cross Anglo-Saxon, *c*. 1050–75; Christ Anglo-Saxon or (?) Scandinavian, possibly 1050–75; lower knop and socket 13th or 14th century
Copenhagen, Danish National Museum, D.894

This altar or processional cross is included in this exhibition as an outstandingly beautiful representative of the later stages in the evolution of the Winchester School drawing style. The *Ascension* and *St Michael* engravings were compared by Oman with, among other manuscripts, 1. Also comparable is the Cambridge, Corpus Christi MS 198, perhaps from Worcester (Temple, 1976, no. 88). The degree of stylization, particularly in the border motifs and the acanthus of the back terminals, suggests a late Anglo-Saxon or even post-Conquest date (Temple, ills. 297, 299; Kauffmann, 1975, ills. 17–18). The English origins of the cross are confirmed by the inscription referring to the donor or artist; Ailmar is the Anglo-Saxon Aethelmaer. The Christ, however, appears to be related to Ottonian art, although the torso is rendered in the same detailed manner as the Anglo-Saxon ascending Christ of the upper terminal of the cross (Blindheim). An English parallel for the unusual treatment of the nimbus dates from no earlier than *c*. 1100; compare 232. The loincloth with 'apron-fold' has a long history in English Romanesque art, from the earlier of the two crucifixions (7) to the Monmouth crucifix (241). Since the *corpus* appears to have been made for this very cross and to be contemporary with it, the entire cross was probably made in Denmark, where later crucifixes reflect the tradition of the Lundø Christ (Blindheim, figs. 12–13). N.S.

PROVENANCE Acquired by the Museum from the parish church of St Clement at Lundø, North Jutland (diocese of Viborg)
EXHIBITION London, Victoria and Albert Museum, *Danish Art Treasures through the Ages*, 1948/9, no. 107
BIBLIOGRAPHY Nørlund, 1926, p. 43, fig. 29; Oman, 1954, pp. 383–4, figs. 16–24; ed. A. Roussell, *The National Museum of Denmark*, 1957, p. 92; Oman, 1962, pp. 198–9, pl. XIV; Martin Blindheim, 'En gruppe tidlige, romanske krusifikser i Skandinavia og deres genesis', *Kristus fremstillinger: 5. nordisk symposium for ikonografiske studier 1976*, 1980, pp. 43–65 (For the St Michael image in 11th-century Anglo-Saxon and Norman manuscripts see Alexander, 1970, pp. 85–100, pls. 16–20; also Dodwell, 1954, pl. 21. For the cult of St Michael in Denmark, see Ebbe Nyborg, 'Mikaels-altre', *Hikuin*, 3, 1977, pp. 157–82, 335.)

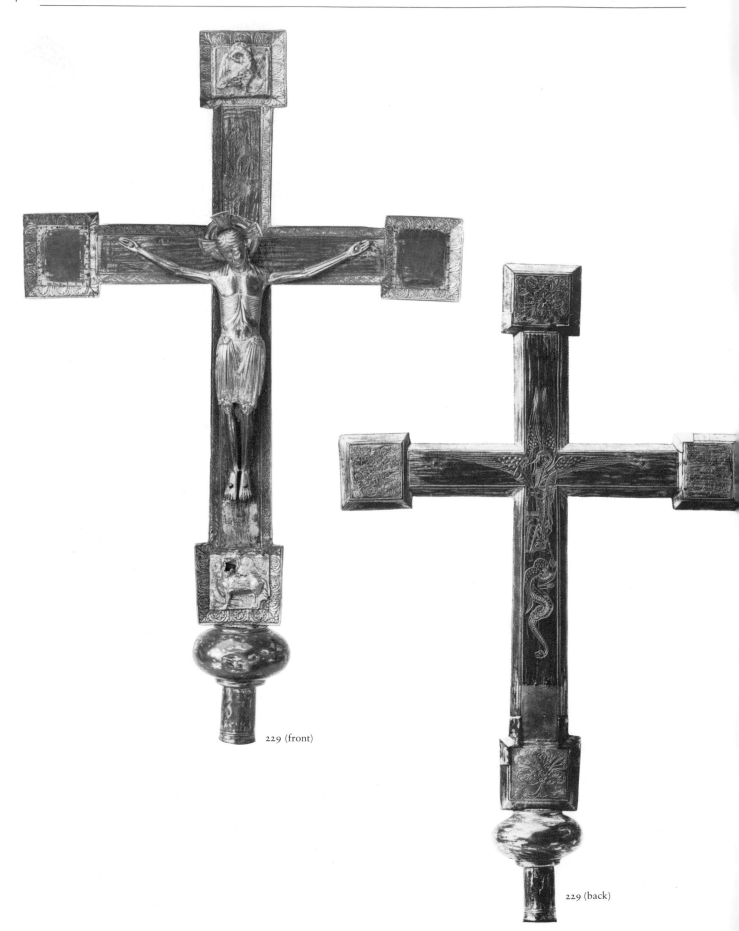

229 (front)

229 (back)

230 The dead Christ

Copper-alloy, cast, engraved, not gilded; part of right arm and both legs below the knees lost; the arms and part of the loincloth solid-cast and flat on the back, the body hollow-cast; original loop-hole for attachment on the back of the head; arms bent steeply upwards, head falling forward on to the right breast. Sharply-drawn angular features, aquiline nose and downward-pointing moustache, long hair in parallel ribbed waves falling on to the shoulders; torso with rib-cage rendered in descending lines on either side of a deep furrow; loincloth with big knot on right hip and central 'apron-fold', knees uncovered and rendered as boldly rounded protuberances; *h* 104 mm
c. 1080
Cambridge, University Museum of Archaeology and Anthropology, Z.11503

The stark pathos with which the head of the dead Christ is treated marks this figure as a descendant of certain Ottonian crucifixes, the ultimate ancestors of the late Gothic *crucifixus dolorosus*. From the angle of the right arm and from the presence of the unusual metal loop behind the head, this could have been part of a *Descent from the Cross*, rather than a *Crucifixion*. In spite of the strong Ottonian stylistic echoes, the loincloth is treated in similar fashion to that of the Christ on the later *Crucifixion* page of the manuscript **7**. It stands at the beginning of the series of crucifix figures in this exhibition whose style is characterized by a central 'apron-fold' hung from the belt of the loincloth. There is no reason to doubt the English origins of this remarkable work of art. N.S.

PROVENANCE Inscription on old label 'Cambridge (CAS.1883)', implying that the figure was bought or found in Cambridge

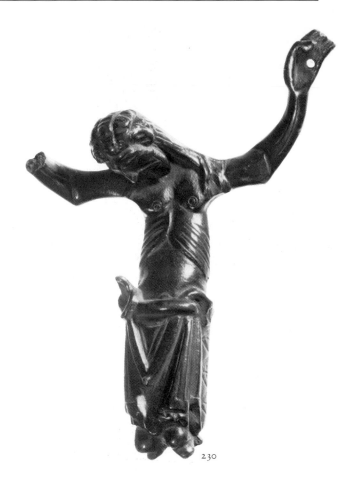

230

231 The mourning Virgin (*illustrated on p. 74*)

Brass (79.5% copper, 15.9% zinc; only 2.7% lead and 2.0% tin (XRF analysis, British Museum lab.)), hollow-cast, engraved, not gilded; four pin-holes for attachment to a flat surface; the Virgin Mary leans her head on her left hand, which she supports at the elbow with her right hand, in the traditional gesture of mourning; scalloped halo, slightly broken; long tunic with hood, ribbed sleeve, overmantle with low collar, 'apron-fold' over the breast and very deep cuffs; drapery borders arranged in a series of rippling folds; *h* 108 mm.
Late 11th or early 12th century
London, Trustees of the British Museum, MLA. 1968, 7-7, 1

With the age-old posture of grief the mother of Christ accepts with calm resignation the moment of His crucifixion. Her voluminous draperies are arranged in patterns of great subtlety. This figure must have been part of an applied *Crucifixion* group, like certain of the surviving Scandinavian altars such as the Sahl retable (Nørlund, 1926, p. 179), where similar scalloped haloes are also used; compare also the *Mourning Virgin* (**239**). Late Anglo-Saxon drawing styles persist, but here the movement of the draperies is contained within the silhouette and there are no 'flying folds' as on the John of Beverley crosier (**183**), which is probably contemporary with the Ushaw Virgin and may also come from the north-east. The date of this small masterpiece may well be as late as the early years of the reign of Henry I. N.S.

PROVENANCE According to oral tradition, excavated near Durham in the 19th century; given to Ushaw College, Durham; sold Sotheby's, 16 May 1968, lot 56; acquired 1968

232 Crucifix figure (*not illustrated*)

Brass (73.9% copper, 22.9% zinc; only 1.6% lead and 1.5% tin), hollow-cast, engraved, not gilded; Christ frontal, with horizontal arms curved and notched at the elbows, His left hand bent downwards; the legs exactly symmetrical resting on a plain foot-rest, with a spike beneath; the head and halo fall far over on to His right shoulder, so that they would have projected beyond the bars of the original cross; halo cast in one with the rest of the figure, with trapezoidal cross-pieces extending beyond its circular frame; eyes closed in death; end of nose damaged; loincloth falling in straight pleats to just above the knees but covering the backs of the legs where they break forward from the cross; the belt, with V-shaped 'apron-fold', and pleats engraved with simple lines in groups, crosses or zigzags, and with rows of small incised pits, which give the loincloth a richly decorated effect; *h* 154 mm, *w* 131 mm.
First quarter 12th century
Private collection, on loan to the British Museum

Although dated by Swarzenski *c.* 1070, this figure seems rather to belong to the early 12th century. In style it is difficult to parallel, but the Ushaw Virgin (**231**) has certain features in common, particularly the rippling borders of the garments. Both figures seem to have been found in the north-east of England and are of ungilded brass. Is it possible that they represent a local Early Romanesque tradition of metal casting? If so, they are markedly different in style from the contemporary stone sculpture of the region. N.S.

PROVENANCE Recorded in 1889 as found beneath the chancel floor of a Holderness Church; sold Sotheby's, 16 Dec 1949, lot 67
BIBLIOGRAPHY Revd J. Charles Cox, *Proc. Soc. Antiq.* 1887–9, 2nd series, XII, pp. 403–4; *idem*, *The Reliquary*, III (new series), Jan–Oct. 1889, p. 133; Swarzenski, 1954, fig. 150; Bloch, 1979, p. 320, ill. 193

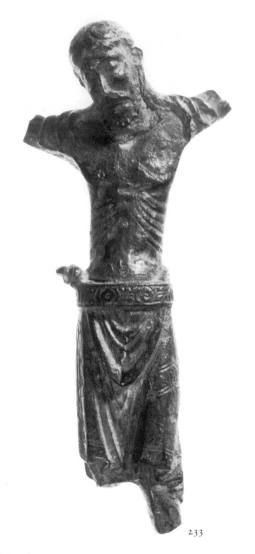

233

Never previously published, this moving image of the dead Christ is stylistically related to two of the most beautiful of all Romanesque bronze crucifix figures, now in Angers and the British Museum (Bloch, 1979, ills. 190–1); they are not included in this exhibition because both are first recorded in Anjou-Maine (at Soudan, near Angers, and at Le Mans). They are therefore presumably Angevin in the strict sense, rather than English; they appear to date from the first quarter of the 12th century and still display marked Ottonian influence. The Cambridge figure is probably somewhat later. In the fluid, gently modelled folds and rich decoration of the loincloth, the walrus ivory Christ found in Worship Street in the City of London (200) is a worthy parallel, again of outstanding artistic quality. The Cambridge 'bronze' Christ was acquired in London, though there is no evidence that it was excavated there. N.S.

PROVENANCE Old label inscribed 'London, 15.10.1886. A. von Hügel' (Baron Anatole von Hügel, curator of the University Museum from 1883–1921)

233 Crucifix figure

Copper-alloy, hollow-cast, engraved, no traces of gilding; arms and legs lost; Christ, not crowned, with centrally parted hair in long braids falling on to His shoulders; head slightly inclined to His right, eyelids closed in death; features sensitively modelled, with a long aquiline nose, downward-pointing moustache and beard; torso finely rendered, with rib-cage curving outwards and downwards from beneath the breast; loincloth with prominent knot on right hip and a broad belt decorated with stylized foliate motifs, from beneath which hangs an 'apron-fold'; further foliate motifs decorate a band on the left thigh and the lower edges of the loincloth, which falls behind the left knee; the legs were originally parallel and set slightly to the figure's right; the right arm projected at a slightly lower angle from the shoulder than the left; *h* 125 mm
c. 1130–40
Cambridge, University Museum of Archaeology and Anthropology, z.11502

234 Three sleeping soldiers at the Holy Sepulchre

Copper-alloy plaque, cast in one piece, engraved and punched, gilding renewed; a rectangular frame encloses three openwork round-headed arches with open spandrels; the three soldiers in high relief, each wearing a three-quarter-length armoured surcoat, which also covers the head, and a tunic over the lower part of the legs, pointed shoes, pointed helmet with nasal; a kite-shaped shield with prominent boss in front of each figure; the left soldier holds a spear, the central one leans his head on his hand in an attitude of repose; all three figures wear swords whose scabbards project from beneath the shields; shields engraved with chevron, lozenge or a floral motif; chain-mail rendered with a pattern of rings made with a small hollow punch; the feet of the soldiers break forward from the lower edge of the plaque and originally rested on a rounded surface; *h* 92 mm, *w* (of frame) 72 mm
English (?); *c.* 1140–50
Glasgow Museums and Art Galleries, Burrell Collection, 5 and 6/139

Known as the 'Temple Pyx', this plaque was said in 1833 to have been found in the Temple Church, London 'during some of the repairs which have of late years taken place in that edifice' (*Gentleman's Magazine*, 6 October 1833, p. 305). This supposed origin was probably born from a misleading antiquarian association of the soldiers with the celebrated 13th-century effigies of knights in the Temple Church. A wash drawing (Society of Antiquaries of London, Portfolio: Early Medieval Prints and Drawings, f. 2) reproduces the plaque, together with five other groups or single 'bronze' figures, all apparently from the same object, 'found in the Cabinet of the late Revd Mr Betham, Fellow of Eton College' (Edward Betham, 1707–83). The other five bronzes are lost but included two angels, a standing figure, perhaps St John with book, a man with arms raised, perhaps from a *Deposition*, and the *Ascension of Christ*. A single soldier of slightly smaller dimensions (*h* 76 mm), probably from the same object, is in the Wallace Collection, London (J.G. Mann, Wallace Collection Catalogues: Sculpture, HMSO, London, 1931, S151, pl. 38, from the Nieuwerkerke Collection).

The four soldiers may have formed part of a *Holy Sepulchre* group, on guard but asleep with their backs turned towards the

scene of Resurrection, which would have been visible within the sepulchre through the pierced arches. Four of the lost Betham figures would then have come from a group of the *Deposition of Christ* slotted into the top of the *Holy Sepulchre*, which thus acted as a cross-foot (Wells, in London 1975, no. 371, cited the early-12th-century Nuremberg *Deposition* and *Holy Sepulchre*, reproduced in Springer, 1981, no. 7, ills. K. 55–6.)

However, the position of the Betham *Ascension* group remains problematical. Although the Burrell plaque has been considered both German and Mosan, it was already in England before the golden age of the medieval collector and its style as well as the style of the lost Betham plaques can be paralleled in English manuscripts, such as **20**, **26** and **33**, and sculpture, for example the rood from Barking Abbey and the Wareham lead font (Zarnecki, 1953a, pls. 65, 66). N.S.

PROVENANCE Edward Betham; Crofton Croker Collection; Lord Londesborough, sold Christie's 10 July 1888, lot 698; General Pitt-Rivers; John Hunt; acquired by Sir William Burrell, 1936
EXHIBITIONS Glasgow Museum and Art Galleries, *The Burrell Collection*, 1949, no. 695; Manchester, 1959, no. 107; London, 1975, no. 371; Arts Council, 1977, no. 185
BIBLIOGRAPHY T.D. Kendrick, *Antiq. J.*, XVI, 1936, p. 51 ff., pl. IX; XXI, 1941, p. 161, pls. 32–3; Zarnecki, 1959, p. 455, fig. 56; Springer, 1981, p. 118, ill. K.159

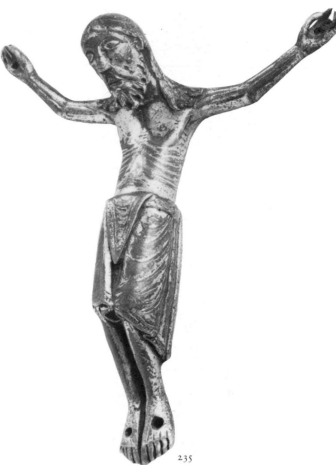

235

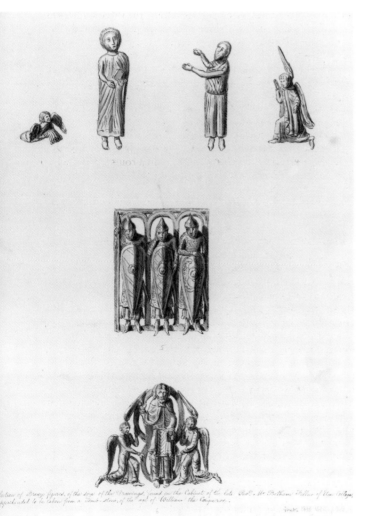

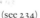

(see 234)

235 Crucifix figure

Copper-alloy, solid-cast (the back undecorated), engraved and gilded; four nail-holes; Christ almost precisely frontal, His body breaking forward from the cross at the hips; arms bending gently upwards and engraved with fine lines for the muscles and tendons; head large in relation to the body, and powerfully expressive of suffering, falling forward onto the breast; moustache, beard and hair finely engraved; the loincloth with central 'apron-fold', unknotted, is tucked between the knees, falling below the back of the left knee; borders and belt of loincloth hatched with simple lines or cross patterns; *h* 185 mm, *w* 165 mm
Second quarter 12th century
Private collection, on loan to the British Museum

This figure is closely related to one in Ghent and with it attributed by Bloch to England, in a series deriving from the earlier representation of Christ in the manuscript (**7**; Kauffmann, 1975, fig. 5). The overall impression is one of dignified calm, quite different from the other English crucifixes in this exhibition. However, the loincloth arrangement with central 'apron-fold' is a typically English feature, also found for example in **230**, and can be closely compared with the crucified Christ in the Worcester Chronicle (**33**; Kauffmann, 1975, ill. 141), which dates from *c.* 1130–40. This monumental image of Christ seems to be a somewhat later English relative of the Angevin 'bronze' crucifix figures in Angers and the British Museum (Bloch, 1979, ills. 190–1), compare **233**. N.S.

PROVENANCE Augustus Welby Pugin (1812–52); by indirect descent to Dr Leonard Mackey; private collection
BIBLIOGRAPHY Bloch, 1979, pp. 291–330, particularly p. 320, ill. 189

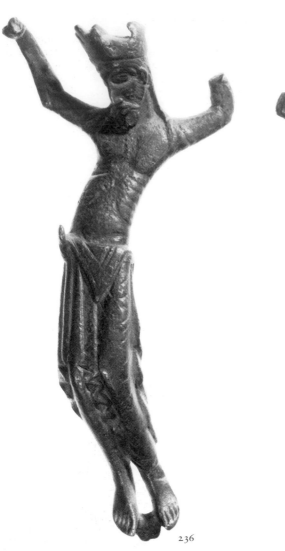

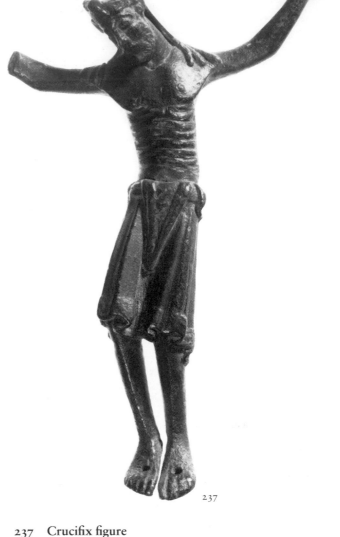

236

237

236 Crucifix figure

Copper-alloy, hollow-cast, engraved, traces of gilding; left arm
broken off, and its stump bent upwards from the elbow; Christ
crowned, His arms raised steeply from the shoulders; long,
narrow face, with sharply-pointed chin; hips and knees pushed
out to the left of the cross, creating a curved C-silhouette; long
loincloth, which covers the left knee and shin, a series of
rippling folds between the legs and a small central 'apron-fold'
at the belt, with a protruding knot on the right hip; *h* 160 mm
Second quarter 12th century
Cambridge, University Museum of Archaeology and
Anthropology, z.11501

With its 'mannered' silhouette and the marked elongation of
head and body, this Christ seems to be contemporary with
manuscripts such as 50 with its various representations of
Christ on the cross, and with Oxford, Corpus Christi MS. 2,
f. 1ᵛ (Kauffmann, 1975, ill. 196), where the Deposition is shown
with the limbs of Christ extended and distorted in similar
fashion. The style of the drapery and the form of the head
recall an English (?) Bible fragment in Brussels (Saxl, 1954,
fig. 13). N.S.

PROVENANCE Old label inscribed 'Kent'; gift of Cambridge Archaeological Society, 1883

237 Crucifix figure

Copper-alloy, hollow-cast, engraved, traces of gilding; right
hand lost; Christ crowned, His head falling to His right; arms
curving upwards; broad parallel horizontal incisions define the
ribs and stomach; right leg raised slightly away from the left;
loincloth with sharply-pointed central 'apron-fold' between
two knots on the hips; *h* 165 mm
English (?); second quarter 12th century
Cambridge, University Museum of Archaeology and
Anthropology, 1905.66

The style of this Christ is hard to parallel in English art,
although the loincloth is arranged with the typically English
'apron-fold'. It is similar to the sadly mutilated relief of Christ
on the cross from Barking Abbey (Saxl, 1954, pl. XXX). N.S.

PROVENANCE Baroness Anatole von Hügel, through H.A. Chapman, at Felixstowe, 1905

238 Crucifix figure (not illustrated)

Copper-alloy, hollow-cast, engraved, no traces of gilding but heavily corroded; pin-holes through hand and both feet (right hand lost); Christ crowned, His arms bent at the elbows and wrists to form a Z/reversed-Z silhouette; the horizontal bar of the cross passed behind the head; elongated features, pointed beard, shoulder-length hair; torso and arm tendons rendered with groups of parallel lines; long loincloth covering the left knee, with knot on right hip and small 'apron-fold' falling from belt; knees set well to the left of the vertical bar of the cross; *h* 141 mm, *w* 117 mm
Second quarter 12th century
Ludlow Museum, Shropshire County Museum Service, SHRCM.HO 1921

In spite of its pitifully corroded condition, it is still possible to appreciate the quality of this powerful rendering of the crucified Christ, with its expressive zigzag silhouette (for an even more mannered treatment of the silhouette, see **236**). According to Wright, this figure was found in the castle at Ludlow, one of the principal strongholds of Norman power in the Welsh Marches from the late 11th century onwards. N.S.

EXHIBITION Manchester, 1959, no. 112
BIBLIOGRAPHY Thomas Wright, *The History and Antiquities of the Town of Ludlow, and its Ancient Castle*, 2nd edn, 1826, p. 265 (engraving)

239 The mourning Virgin (not illustrated)

Copper-alloy, hollow-cast, gilded; from the back, two projecting spikes pierced with small holes for horizontal pins, an unusual system of attachment for an applied figure; the Virgin Mary, left hand against her cheek in the traditional gesture of mourning, looks upwards to her left; *h* 104 mm
c. 1150
London, Victoria and Albert Museum, M.20.1952

The figure must come from a *Crucifixion* or *Descent from the Cross*, and is related stylistically to mid-12th-century work such as the rood from Barking Abbey and the Wareham lead font (Zarnecki, 1957a, pls. 18–27). Like **231**, this is a rare survival of an applied 'bronze' from a larger ensemble, either from the left arm of a big crucifix or from a group composition decorating a *châsse* or altarpiece. However, the surviving metal altars in Scandinavia which have *Crucifixion* groups are in a *repoussé* technique, not cast (Nørlund, 1926, pl. VII). N.S.

PROVENANCE Given by Dr W.L. Hildburgh, 1952

240 Crucifix figure

Pewter (68% tin, 32% lead); solid-cast, engraved, gessoed and painted; remains of a pin through Christ's chest; the angle of His left arm bent downwards from the shoulder is not original; Christ's head falling on to His shoulder; loincloth with big knot on the right hip and long oval fold outlining the left knee; hands, legs and feet broken off; *h* 126 mm, *w* 65 mm
c. 1160–70
Ludgvan Parish Church, Cornwall, on loan to the British Museum

This is a unique survival of a Romanesque pewter crucifix figure (for the use of pewter for funerary chalices and patens, see **323**). Devon and Cornwall were probably the main sources of tin in Europe in the early Middle Ages (John Hatcher, *English Tin Production and Trade before 1550*, 1973, particularly pp. 18–20). Given its material, there must be every likelihood that the Ludgvan crucifix was made locally, but this is no provincial work of art. In spite of its ruined condition, its high artistic quality can still be appreciated; here is an example of a major metalworker employing not gold, silver or copper, but tin. The drapery style is comparable to that in the Copenhagen Psalter (**76**). The big knot on the hip is a particular mannerism of the mid-12th century. The fine detail on the body and draperies would have been applied in paint over a gesso ground. Vestiges of red paint still survive on the loincloth. N.S.

PROVENANCE Found at Ludgvan Parish Church, 1912/13, in the south wall of the chancel
BIBLIOGRAPHY Maclagan, 1940, p. 509, pl. XCIII; A.H. Hitchens, *Ludgvan Parish Church. A short history*, (?) 1973

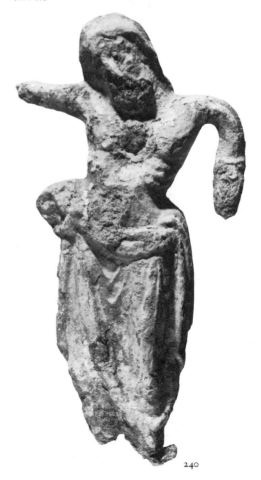

240

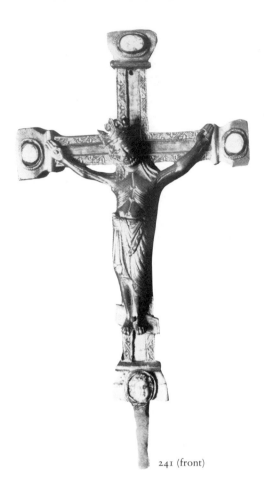

241 (front)

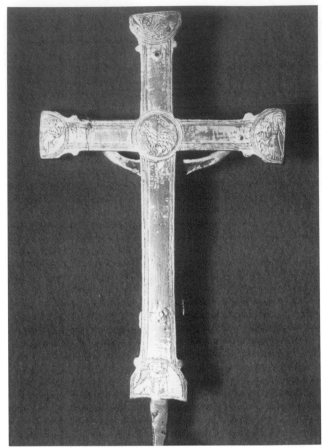

241 (back)

241 The Monmouth crucifix

Copper-alloy, cast and hammered, engraved and gilded, set
with semi-precious stones.

Cross with four irregular trapezoidal terminals and a spike
for slotting into a cross-foot; at a later date the lower terminal
was trimmed to fit a cross-foot with a curved upper surface;
(front) borders engraved with a repeating motif of trefoil
leaves, alternately set on opposite sides of the border frame
within a beaded zigzag; undecorated sunk central field between
the borders; plain diagonal foot-rest cast in one piece with the
cross; within each terminal a raised beaded setting for: three
milky-blue opals (not original – they do not fit the original
beaded settings), and, at the bottom, a Roman (? early
Imperial) onyx cameo, carved with a head of Medusa, probably
part of the original cross; (back) engraved: a central medallion
of the Lamb of God, with cross-standard; the four Evangelist
symbols in the terminals; the arms plain with continuous
beaded borders; *h* 296 mm, *w* 159 mm

Christ, crowned, attached by only three nails, His arms
rising diagonally, head and torso falling slightly to His right
but legs and feet frontal and symmetrical; the body breaks
boldly forward from the cross between shoulders and feet;
crown engraved with a lozenge pattern on the circlet and
beading on the 'lily' flowers; eyebrows, eyes, nose and cheeks
puckered together and framed by a finely striated fringe of hair
and a short beard, the hair falling in long coils onto the
shoulders; the arms and torso accented by deeply-incised lines,
the torso with rib-cage curving outwards on either side of a
central depression with two stylized 'tear-drops' above and

below; the loincloth, with central 'apron-fold' and belt knotted
on the right hip, falls across the knees diagonally to the left
calf; hems arranged in a regular zigzag and engraved with a
series of parallel lines; belt with a minute zigzag pattern;
h 146 mm, *w* 116 mm
c. 1170–80
Monmouth, Church of St Mary and the Archbishop of Cardiff

With the Lundø crucifix (**229**), this is the only complete English
altar-cross of the Romanesque period to survive. *Corpus* and
cross were made to go together. Christ, crowned and victorious
over death, is here rendered with quiet dignity, in a tradition
which goes back to Ottonian art. The form of the crown and
of the cross also originate in Germany (compare the crown and
'second' altar-cross at Essen), although both types were
established in England by the time of the Conquest, as shown
in the New Minster *Liber Vitae* (Temple, 1976, ill. 244). The
disposition of the loincloth with central 'apron-fold' is
common to other English crucifix figures (**230**, **232**, **233**, etc.).

The antique Medusa gem is set in the position normally
reserved for Adam at the foot of the cross of Golgotha, but its
function may have been purely decorative, if one assumes that
figured gems originally decorated the other three arms of the
cross before their replacement by opals. The incorporation of
the gem in this context is in any case a striking illustration of
that admiration for antique hardstone carvings which was so
widespread and deeply felt in the Middle Ages, as evidenced
by the great cameo of St Albans (**318**) and the episcopal rings
(**314** and **324c**).

The Christ is still markedly hieratic, His head strongly stylized in a mid-12th-century tradition, as is the border decoration of the cross, akin to that of 50. But there is a minute attention to surface details: the loincloth is richly modelled with soft folds. Of exceptional beauty are the engraved figures on the reverse: the Evangelist symbols belong to a long English tradition, which chose to represent them as if caught and frozen in the midst of frenzied movement; the Lamb is cousin to the naturalistically-rendered animals in the bestiary 84; above all, the Winged Man of St Matthew, kneeling with his book held up towards the Lamb in his covered hands, is similar to figures on the Liberal Arts casket (287) and other English works of art of the period c. 1170–80, such as the Copenhagen Psalter (76). The Monmouth crucifix, never previously published, may be considered a major work of this major period, when English artists were closely in touch with the latest developments in northern France, the Low Countries and the Rhineland. N.S.

PROVENANCE Discovered by Mrs Christie Arno, 1981

242 St John mourning the Crucifixion
(*illustrated on p. 74*)

Copper-alloy, solid-cast, engraved and gilded; finished 'in the round'; base originally pinned from below; the young Apostle is shown in the traditional pose of a mourner, head on hand; his book is supported within a broad swathe of drapery held across his left arm; delicately engraved cross-hatching of the garments at neck and wrists and of the book-cover; hair minutely rendered in soft waves, and cut short into a close cap around the head; gilding (extensively damaged) all over, even beneath the base; *h* 91 mm, *w* 17 mm (at base)
England or north-western France; *c.* 1180
London, private collection

This figure is probably from a *Crucifixion* or *Deposition*; the mourning figures of the Virgin Mary and St John would have stood on small foliage mounts at each side of the cross. Such *Crucifixion* and *Deposition* groups set into elaborate cross-feet (see also 234) are common from the 13th century onwards, but a few Romanesque examples also survive (Springer, 1981, nos. 7, 16, 25, 38). Lasko pointed out the close stylistic connections of this figure with Mosan art and plausibly suggested that the artist was an Englishman adapting a Mosan model. Closely-studied adaptations of Mosan prototypes occur *c.* 1180 in manuscripts, not only in England (Kauffmann, 1975, no. 87) but also on the other side of the Channel, particularly at St-Omer (compare also the stone relief at Coudres in Haute-Normandie). Therefore the Rattlesden St John could also be an import. Nevertheless, its presence in Suffolk, whether due to patron or artist, bears witness to contemporary English admiration for Mosan metalwork (also shown in 278–80 and 277). The fact that the figure cannot be attributed with certainty to one or other side of the Channel only serves to underline the artistic unity around 1180 of the so-called 'Channel School'. N.S.

PROVENANCE Found at Rattlesden, Suffolk, 1972; sold Christie's 5 December 1972, lot 47
BIBLIOGRAPHY Lasko, 1972b, pp. 269–71, pl. XXX

243 Font

Lead; *h* 325 mm, *diam* (at top) 550 mm, *diam* (at base) 490 mm
c. 1130–40; St James' Church, Lancaut, Gloucestershire
Gloucester, Dean and Chapter of Gloucester Cathedral

This font was restored in 1890, as recorded by an inscription inside, and is one of six similar lead fonts surviving in the county. They were cast in flat strips, then welded together to form a cylinder, the bottom being cast last. A block consisting of four arcades, two enclosing seated figures, probably Apostles, and two with foliage, the figure and foliage arcades alternating, was impressed in a mould. Four fonts are decorated with twelve arcades, one with eleven, that from Lancaut is the smallest, and has only ten. The font was cast as two flat strips along the colonnettes which are, therefore, wider. England was a principal producer of lead in the Middle Ages and, not surprisingly, 30 lead fonts survive in England and 16 of these are Romanesque. Outside England a few lead fonts still exist in France.

The Gloucestershire fonts have a strip of delicate palmettes at the top and bottom, though the bottom strip is missing on the Lancaut font. The bases, the colonnettes, the capitals, the arches and the spandrels are richly decorated. The scrolls within the arcades resemble designs in manuscripts, for example the Winchcombe Psalter, *c.* 1130–40 (27), while the linear and decorative treatment of the figures recalls the Anglo-Saxon figure style in, for example, the Troper (3), though the chip-carved band across the robe of one figure is a typically Romanesque device. The font is a fine example of the continuing popularity of pre-Conquest styles in the 12th century. G.Z.

EXHIBITION Barcelona, 1961, no. 615
BIBLIOGRAPHY Zarnecki, 1957a, pp.10ff

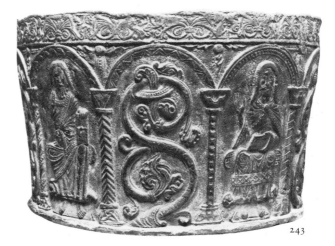

243

244 Font

Lead; decorated by a pair of arches repeated five times, the vertical joins showing clearly along the plain colonnettes; the arcades made of alternately plain colonnettes and spiral ones with beading, supporting trefoil capitals; arches above of two types, those with running scrolls alternating with arches decorated with the double rope ornament; on the spandrels, pairs of simple leaves and projecting brackets which support the rim of the font; the bases of the arcades are inverted trefoil capitals and these rest on a continuous cable; within the arcades are the single figures of a king and an angel, repeated five times; the king has no nimbus but is crowned and holds a sceptre: his cloak is fastened on the right shoulder with a brooch in the Roman fashion; his head is well modelled in three-quarter view, but the rest of the body is in very low relief and the arms and hands are exceedingly small; the silhouette narrows towards the feet; this also applies to the angel, who is nimbed, has very small wings and is making a gesture of blessing; delicately drawn draperies are predominantly of the nested V-fold type; originally, there were inscriptions above the figures but either because of the bad casting or through wear, only the letter O above one of the kings is readable, and VENI above an angel; *h* 320 mm, *diam* (at top) 560 mm
c. 1130
Lower Halstow, Kent, St Margaret's Church

The font was badly damaged, probably by the Puritans and, as a result, the surface was entirely plastered over and, in the process, the shape was changed from round to square. In 1921, gunfire from a nearby battery caused cracks in the plaster and this led to the discovery of a lead font concealed inside. The following year the damage to the font was judiciously repaired with a lead lining.

The decoration and illegible inscription raises the question: was the king intended to represent Solomon? Medieval men frequently likened their churches to his temple and at least one font (at Liège) cast in bronze, was made in imitation of the bronze basin, the 'molten sea', in the temple of Solomon (I Kings VIII. 23–26). But this is only a speculation.

The font is strongly influenced by the Winchester School style, especially in the proportions of the figures, narrowing towards the feet, a feature found in many manuscripts. Such a strong dependence on Anglo-Saxon models suggests a date not later than *c.* 1130. G.Z.

BIBLIOGRAPHY Zarnecki, 1957a, pp. 14–15, pls.40–4

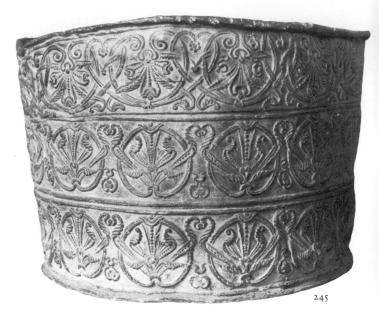

245

245 Font

Lead; many dents, and top rim is misshapen; leaf motifs in three registers, the top being different from the lower two and placed upside-down; the mould was made with two blocks of three leaves each, repeated four times along each register with an additional single leaf at the end; after casting, the strip was welded to form a cylinder and a wide join is visible on the outside and inside; the bottom, cast separately, was also welded; the drainage hole is not original; the base and rim project slightly; crude perforations in the top register must be connected with fixing a cover, which was obligatory from the 13th century onwards to prevent the hallowed water from being used in black magic; *h* 490 mm, *circumference* 2.050 m (at top), 1.990 m (at bottom)
c. 1170; St Mary's, Barnetby-le-Wold, Lincolnshire
London, Redundant Churches Fund

The leaf designs are very delicate and especially fine is the top register with the 'orchid leaf', a design which originated in manuscript painting (for example the Bury Bible, **44**). The thin, wiry forms point, however, to a considerably later date. G.Z.

BIBLIOGRAPHY Bond, 1908, p. 75 ff; Zarnecki, 1957a, p. 20

246 Belt-hasp (*not illustrated*)

Copper-alloy, cast and engraved, six holes for pinning on to a belt; decorated on one side only with two addorsed winged dragons; *h* 38 mm, *w* 26 mm
Late 11th or early 12th century
Winchester City Museum; Winchester Research Unit,
BS.SF.2361

Similar stylized animals are found in post-Conquest Durham and Canterbury manuscript initials (**11**, **13** and **41–3**). N.S.

PROVENANCE Found in Lower Brook Street, Winchester, 1968, in a 13th-century context
EXHIBITION Winchester, 1973, no. 99

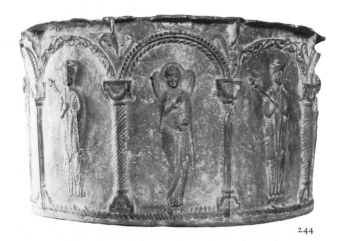

244

247 The Gloucester candlestick

(illustrated on pp. 41 and 73)

Copper-alloy, with unusually high silver content (between 22.5% (base) and 5.76% (pan) – unpublished analysis by Roger Brownsword); intricate wax-casting, in three main sections; three-sided base on dragon feet, with lower knop; cylindrical stem, with central knop; hemispherical drip-pan, with upper knop; assembled round a vertical rod (? not original), which emerges as a pricket from the pan; the larger heads probably cast separately and slotted into the bodies (see a headless figure on the lower knop); four silver roundels, nielloed, set into central knop; beads of blue glass inlaid cold into the eyes, flowers (lower knop) and the three dragon bodies (base); gilding extensively renewed, e.g. over a crack in the upper section.

Overall openwork decoration, with beasts and human figures enmeshed in foliage: (base) the heads and bodies of three dragons form the feet, three naked figures sit or kneel on their backs and their wings form the lower edges of the side fields, in which a naked figure holding the tail of a winged beast is flanked by two other winged beasts; (lower knop) two centaurs, one bearded and with wings, and a naked figure riding a griffin, each with a claw-foot on the head of the central figure below; (central knop) the four Evangelist symbols in beaded medallions, joined by nielloed silver flowers set into the gilt copper; (stem) two spiral bands, above and below knop, inscribed: + ABBATIS PETRI GREGIS/ ET DEVOTIO MITIS/ + ME DEDIT ECCLESIE SC Ī PETRI GLOECESTRE ('The gentle devotion of Abbot Peter and his flock gave me to the church of St Peter at Gloucester'); in the fields between this inscription, pairs of winged beasts and naked figures in combat, clambering or biting the foliage stems; (upper knop) a centaur and two figures riding beasts; (pan) three dragons support the rim, their jaws clamped over the edge, their tails sprouting a beast-head which spews out the three branches on which they rest; the side fields filled with entwined stems, on the rim small central heads and an inscription: + LVCIS ON(VS) VIRTVTIS OPVS DOCTRINA REFVLGENS PREDICAT VT VICIO NON TENEBRETVR HOMO ('This flood of light, this work of virtue, bright with holy doctrine instructs us, so that Man shall not be benighted in vice'); on inner edge of rim is inscribed (in a different and somewhat later (late 12th century?) lettering): + HOC CENOMANNENSIS RES ECCLESIE POCIENSIS. THOMAS DITAVIT CVM SOL ANNVM RENOVAVIT ('Thomas of Poché gave this object to the church of Le Mans when the sun renewed the year'); *h* 500/512 mm (without pricket), *w* 205 mm (at base)
Commissioned 1107–13
London, Victoria and Albert Museum, M.7649.1861

This famous candlestick was commissioned by Abbot Peter (1107 *(sic)*–1113) and the monks of the Benedictine Abbey of St Peter, now the Cathedral, at Gloucester. From the individual character of the inscription and the presence of all four Evangelist symbols, it seems unlikely that the candlestick ever had a pair (Springer, 1981). It was either an altar candlestick or to be set on a stand beside the altar.

The rim inscription refers to the message that the candlestick holds: the struggle between light and darkness, the forces of good and evil, is embodied in a generalized way in the combats between men and beasts; the symbols of the Evangelists are shown as the sources of true light, that is of Christian doctrine. The dedicatory inscription is specific that the candlestick was made for Gloucester. Nevertheless opinions have varied as to the nationality of the artist and the place of manufacture.

Doubts about the Insular origin of the candlestick are based on the similarity of its form and iconography (tall stem with three knops, dragon feet, openwork foliage and enmeshed figures) to Continental examples, including the early 11th-century pair of candlesticks made for Bishop Bernward of Hildesheim and 12th-century survivals, as at Rheims and Prague. However, this argument is not conclusive, since English art of the early 12th century often bears the unmistakable stamp of German influences (e.g. **17**). More compelling are the close stylistic comparisons established by Harris with manuscript illumination at Canterbury in the late 11th and early 12th centuries (Harris, 1964, see **11** and **41–3**). No artistic milieu outside England offers such parallels to the inhabited foliage designs of the candlestick.

Harris claimed that the candlestick was made by 'a Canterbury artist', but given the Gloucester commission, this would imply a monastic metalworking centre at Canterbury. It is more probable that the artist was a professional, in active demand for major commissions in southern England. The high-silver copper-alloy which he employed seems to be unique at this period and may have been melted-down scrap (perhaps including by chance some debased Roman silver coins) rather than a stock of carefully-controlled brass. Nevertheless, he was a metalworker of supreme accomplishment, a draughtsman-modeller of great originality, whose imagination leads the spectator towards the farthest reaches of the fantastic.

One of the great masterpieces of European Romanesque art, the candlestick is closely related to the best English drawings of the period *c.* 1100. With no other work in metal does the relationship with manuscript illumination stand out so strongly, and it is unlikely that the master who made the candlestick was exclusively a specialist coppersmith. What is more, his repertoire extended also to the use of glass inlay, and niello. N.S.

PROVENANCE Benedictine Abbey of St Peter, Gloucester; Le Mans Cathedral by late 12th century; recorded in the d'Espaular Collection, Le Mans, 1856; Soltykoff sale, Paris, 8 April 1861, lot 121; acquired 1861
EXHIBITION London, 1930, no. 38, pl. 12
BIBLIOGRAPHY Cahier/Martin, *Mélanges d'Archéologie*, IV, 1856, p. 279 ff; Oman, 1958; Bloch, 1961, p. 55 ff; Harris, 1964, p. 32 ff; Springer, 1981, p. 117 ff; Borg (forthcoming)

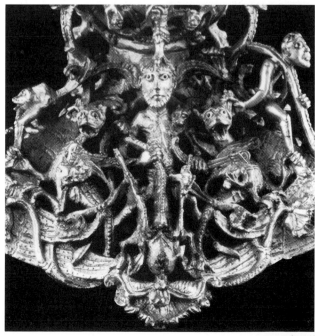

247 (detail)

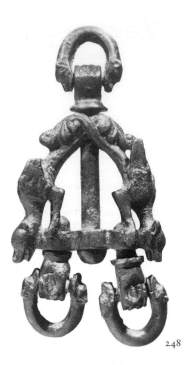

248

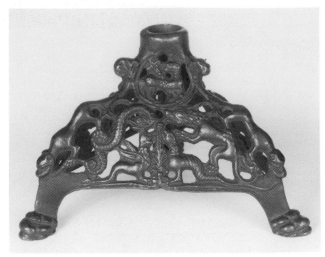

249

248 Double swivel for straps

Copper-alloy, cast in the round in several sections: a frame formed by two winged dragons and two swags of stylized foliage; through the top and cross-bar of this frame, one long and two shorter bolts; each ends in a clenched hand which grasps a thin rod; this acts as a swivel to three rings whose loops end in beast-heads; the three bolts turn through 360 degrees; the three rings swivel freely around the clenched hands; *l* 86 mm, *w* 42 mm
First half 12th century
London, Trustees of the British Museum, MLA.1954, 12-8, 1

The function of this object is uncertain. Too large to be a vervelle for hawking and too small to have belonged to a set of horse reins, the rings could perhaps have served as a distributor for a twin dog-leash. For the stylized acanthus, compare the St Albans Josephus manuscript (British Library, Royal 13. D. VI, f. 47, not exhibited). The form of the dragons suggests a date no later than the mid-12th century. Dragon-head door rings were popular from the 12th century onwards both in England and Scandinavia (Mende, 1981, pp. 146–7, ills. 54, 55, 212, 214, 437–40), and these tiny beast-head rings are a small-scale reflection of this monumental tradition. N.S.

PROVENANCE A note in the British Museum Registers states that it was drawn by Augustus Franks, who described it as 'from Cirencester'; acquired 1954

249 Foot of a candlestick

Bronze (81.2% copper, 8.56% tin, 9.68% lead, 0.11% zinc – analysis by Roger Brownsword), cast, not gilded; three-sided, on claw feet; dogs at the angles biting the feet; each side decorated in openwork with a medallion of the Lamb of God, a dragon facing a griffin, and a lion facing a coiled serpent; round socket for the shaft; *h* 76 mm, *w* 116 mm
c. 1130
London, Trustees of the British Museum, MLA.78, 11-1, 90

This was probably one of a pair of small altar candlesticks. It is unusual for a Romanesque candlestick foot in that the animal and foliage decoration is not symmetrical. The attribution to an English coppersmith, first proposed by von Falke and Meyer, is supported by the similarity of the animal ornament to English manuscript initials, such as those of Cambridge, St John's College MSA.8, a Canterbury book of *c.* 1130 (**43a**). The fact that the copper-alloy includes a high percentage of tin and virtually no zinc may also point to an English origin. N.S.

PROVENANCE Presented by Major-General Augustus Meyrick, 1878
BIBLIOGRAPHY von Falke, Meyer, 1935, pp. 10, 99 (no. 61), ill. 63

250 Terminal for a stylus (?)

Copper-alloy, cast, engraved and punched; in the form of a winged dragon, a flattened circular projection emerging from its mouth; *l* 42 mm
Second quarter 12th century (?)
Winchester City Museum, NR.111

If this was indeed part of a stylus, the flattened end would have been used for preparing wax tablets. N.S.

PROVENANCE Found on New Road site, Winchester

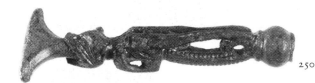

250

251

251 Stylus (?)

Copper-alloy, cast, engraved and gilded (bent at a later date);
polygonal shaft tapering to a point, the top ending in a winged
beast which originally held something in its jaws, perhaps a flat
scraper (cf. 250); *l* 114 mm
12th century
London, Museum of London, 15193, ex-Guildhall Museum
1939–140

Pointed styli were used for writing on wax tablets. Winged
beasts occur in the same position on a pre-Conquest stylus
from Canterbury (C.A. Raleigh Radford, 'Small bronzes from
St Augustine's Abbey, Canterbury', *Antiq. J.*, XX, 1940,
pp. 506–7), a bone stylus in York and a bronze pin in
Copenhagen (Ward-Perkins, 1949). N.S.

PROVENANCE Found in London Wall, date unknown
BIBLIOGRAPHY *Catalogue: Collection of London Antiquities in the Guildhall Museum*, 2nd
edn., 1908, no. 67; J.B. Ward-Perkins, 'A Medieval Spoon in the Guildhall Museum, London',
Antiq. J. XIX, 1939, pp. 313–6, illustrated; *idem*, 'An eleventh-century bone stylus from York',
Antiq. J. XXIX, 1949, pp. 207–9

252 Needle

Copper-alloy, cast, engraved and punched; animal-head
terminal; *l* 124 mm
Second or third quarter 12th century
Winchester City Museum; Winchester Research Unit,
WP.SF.1137

'Needles of this kind could be used for laid and couched work
on linen, embroidery of the kind of the Bayeux Tapestry'
(Winchester, 1973). The date may be estimated by comparing
the needle with certain beak-heads (Henry, Zarnecki, 1957–8,
pl. XI (2)). N.S.

PROVENANCE Found Wolvesey Palace (Room 37), Winchester, 1967, in a 14th-century context
EXHIBITION Winchester, 1973, no. 97

253 Animal head

Copper-alloy, not gilded; the head cast in the round, hollow,
with a flat base and a hasp at the back; *h* 15 mm, *w* 15 mm,
d 25 mm
English (?); 12th century
Bury St Edmunds, Moyse's Hall Museum, 1979.288A

The original function of this object is unknown. The aperture
suggests that it could be used either for pouring or to allow
something to pass through it – compare the animal masks on
censers such as 261 – but the hasp was probably for attachment
to a strap. The flat base excludes the possibility that this was
the spout of a leather ewer, and the high relief makes it unlikely
that it was attached to a book-strap. N.S.

PROVENANCE Found about one mile south-east of the Abbey at Bury St Edmunds, Suffolk, 1979

254 Finial from a small shrine

Copper-alloy, solid-cast and gilded; at base, three expanding
prongs (one broken), with holes for attachment; top, animal
head, probably a wolf's, gripping a human head in its mouth;
l 86 mm
English or Scandinavian; late 12th century
London, Victoria and Albert Museum, M.25. 1962

Oman suggested that this is a projecting finial from the cresting
of a shrine; compare the Eriksberg shrine in Stockholm. The
detailed modelling of the head with finely rendered strands of
hair makes a dating not long before 1200 probable. It is not
impossible that small shrines of Scandinavian type were made
in the north of England in the 12th century. N.S.

PROVENANCE Bought in Chester by Sir John Evans, 1896; presented by Dr Joan Evans, 1962
BIBLIOGRAPHY Oman, 1962, p. 203, pl. XXIVa

252

253

254

255 Mirror-case

Circular copper-alloy plaque; cast, chiselled, engraved and gilded; mirror a sheet of silver, originally polished, held within a serrated border, which is soldered onto the mirror-back; case decorated with four dragons, their heads turned back, each with four claw feet, beaded decoration along the body and a serpentine tail; they are caught up in foliage, the stems incised with three parallel grooves and ending in petalled flowers which form a quatrefoil around a larger 'daisy' flower in the centre; four smaller flowers on the edge between the dragons; the two swags of foliage on the rim with their suspension rings are modern additions, contemporary with the manufacture of the neo-Gothic mirror-case for Spitzer (see below); the clasp with pin was adapted at the same time but is original; *diam* 111 mm, *d* 5 mm
English or German; *c.* 1180–1200 (?)
New York, The Metropolitan Museum of Art, 47.101.47, The Cloisters Collection, 1947

When first recorded in the Spitzer Collection this mirror-case was hinged to a neo-Gothic case with a representation of St George and the dragon, probably made up to Spitzer's requirements; the whereabouts of the 19th-century pastiche is unknown. As to the New York case, it is a unique survival of one half of a Romanesque double mirror-case. There is a single 12th-century mirror-frame in Brussels (Musée du Cinquantenaire, v.2132). Another surviving Romanesque mirror (from Bussen in Swabia) has a handle, whereas this case functioned as one of a pair, like numerous surviving 14th-century ivory mirror-cases. But it was held together by a clasp with a pin; it did not slot into its pair. The surfaces of the copper were extensively worked after casting, in a technique analogous to *champlevé*. For similar petalled 'daisy' flowers, see **324**. The dragons are typical of both English and German art of the later 12th century. Capitals with salamanders and other long-tailed animals are found in the West Country from the 1180s onwards, for example on the Glastonbury Lady Chapel north door of *c.* 1184–6. N.S.

PROVENANCE First recorded in the Spitzer Collection, 1890–2; acquired from Brummer, 1947
EXHIBITION New York, 1975, no. 86
BIBLIOGRAPHY Swarzenski, 1954, fig. 460

256

256 Belt-buckle

Copper-alloy; square hammered plate, its edges bent to form a tray; attached to the tray by round-headed pins a cast winged harpy, its tail ending in a second head (top right); hinge and cast buckle formed by two winged dragons which bite a central berry; pin with stylized beast-head; *h* 31 mm, *w* (of plate) 31 mm, (total) 53 mm
English (?); late 12th or early 13th century
His Grace the Duke of Northumberland, KG, PC, GCVO, FRS

Winged harpies were a popular theme of northern France capital sculpture from the mid-12th century onwards and they soon migrated to England, reaching Canterbury by the 1160s (Kahn, 1982, pp. 128–9). Similar exotic beasts are found on other early belt-buckles, including Limoges examples (Fingerlin, 1971, pp. 37, 39), some of which may date to the later years of the 12th century (according to M.-M. Gauthier – verbal communication); compare also a belt-plate from Molsheim (Fingerlin, 1971, no. 476). N.S.

PROVENANCE Found in the River Witham, near Lincoln, 19th century; Willson Collection; Alnwick Collection
BIBLIOGRAPHY J. Collingwood Bruce, *A Descriptive Catalogue of Antiquities, chiefly British, at Alnwick Castle*, 1880, p. 94 (Case K, no. 529), pl. XXIII (fig. 3)

257 Openwork mount (*not illustrated*)

Copper-alloy, mould-cast in a single piece and bent, with three pin-holes back and front for attachment; gilding not original; on one side a horseman, wearing a helmet with nasal, carrying a kite-shaped shield and axe; on the other Samson in foliage, astride the lion and rending its jaws; two vertical prongs decorated with chevron; *h* 65 mm (max), *w* 35 mm
12th century
London, Museum of London, 59.94/45

This object has been described as 'designed to clasp the slightly tapering end of a slender object such as a single-edged comb or a comb-case' (Spencer). Openwork mounts of the same unusual shape have recently been excavated at Abingdon and Wharram Percy, whilst a third example, from Escharen (Holland), has been claimed as the mount of a sword scabbard (information, John Clark). Whatever its precise function, the London mount is an interesting survival of an intricately-designed Romanesque fitting, roughly cast and finished, for everyday use. Knights and the Samson episode seem to have been popular themes throughout Europe for the decoration of houses and castles, judging by the few 12th-century secular schemes to have survived. Compare also the subject-matter of contemporary vernacular epic poetry. N.S.

PROVENANCE Found in Angel Court, London, 1912; collection of Edward Beasley (1869–1947); acquired 1959
BIBLIOGRAPHY B.W. Spencer, 'Two additions to the London Museum', *Transactions of the London and Middlesex Archaeological Society*, 20, Part 4, 1961, pp. 214–17, illustrated

258

258 Domestic lamp

Copper-alloy, cast and engraved; top hook and drip-pan not original; cylindrical openwork 'tower' tapering towards the top, cast in one piece, in three tiers: five round-headed arches, three animals in roundels, eight rectangular openings beneath pierced circles; between the tiers, a roll moulding between fillets; the pinnacle formed by three animal heads projecting from a platform, through which the original hook would have passed; the lower pan cast in one piece with original suspension hook, six projecting 'petals' to hold tapers; *h* 310 mm, *w* 180 mm, *d* 180 mm
12th century
London, Museum of London, 1374

This was never a highly finished casting. The architectural motifs and the animals would be consonant with an early Norman date, but as a day-to-day artefact the lamp may well have been several decades out of fashion by the time it was made. An English origin is probable, as later medieval lamps of similar form have been found in England. N.S.

PROVENANCE Found at St Martin's le Grand, early 19th century; John Walker Bailey Collection; acquired 1881
BIBLIOGRAPHY *J. Brit. Archaeol. Assoc.*, 26, 1870, p. 371, pl. 20; I.A. Richmond, 'Stukeley's Lamp', *Antiq. J.*, XXX, 1950, pp. 22–7, pl. XIIb

259 Engraved bowl (*illustrated overleaf*)

Copper-alloy, hammered and engraved; deep bowl with flat, narrow rim; the interior engraved with scenes relating to the legendary mission of St Thomas the Apostle to the Indians, beginning just above the central medallion with a representation of a towered building inside a city wall, Caesarea; six scenes follow in a continuous narrative frieze, clockwise, around the sides of the bowl: (1) Christ takes Thomas by the hand, while an envoy, Abbanus, looks on, waiting to lead the Apostle to: (2) the wedding feast of the daughter of King Gundoforus; (3) the Apostle blesses the young married couple; (4) Thomas, with Abbanus, stands before the King, while the King offers him gold to build his palace; (5) two royal figures kneel before Thomas, begging to be converted; (6) a scene of baptism, probably representative of Thomas' mass conversion of Gundoforus' people; the final scene takes place in the central medallion: Misdaeus, king of 'upper India', is seated, facing an attendant and the Apostle; beneath the rim a continuous inscription, in three verses:
[+ AD CONVERTE]NDOS.THOMAS.TRANSMITTITVR INDOS :/ CVIVS.VIRTVTES. CVPIVNT SI SCIRE.FIDELES./HAEC P(ER)SCRVTEN[TVR QV]AE CORAM SCVLPTA VDE[NTVR] ('Thomas goes to convert the Indians. If the faithful wish to learn of his virtuous acts, let them study what is engraved here'); around the central medallion, two verses:
+ P(ER)FIDVS INMODICA FERVENS MIGDONIVS IRA/P(ER) [for prae-]CIPIT.ABSCIDI.THOMAE CAPVT ENSE MINACI ('The treacherous Migdonius [for Misdaeus], burning with unbridled rage, gave orders that Thomas' head should be cut off with a fearful sword'); two areas of damage to the rim, but the missing parts of the inscription can be supplied by comparison with the similar Thomas bowl in Jerusalem (Weitzmann-Fiedler, 1981, no. 16); the rim engraved with hatched triangles; *h* 75 mm, *diam* 332 mm
c. 1120–30
London, Trustees of the British Museum, MLA.1915, 12–8, 179

For a full discussion of the scenes selected for illustration, and their relationship to the apocryphal texts, see Weitzmann-Fiedler. The bowl was originally one of a pair, the lost second bowl continuing the story. A complete pair of Thomas bowls survives in Jerusalem (Weitzmann-Fiedler, nos. 16, 17), the first of which has inscriptions identical to those of the British Museum bowl. Engraved bowls of this type were long known as 'Hansa dishes', but since they date from a period earlier than the formation of the Hansa League and were undoubtedly made in a number of widely separated centres, this name has been abandoned in the recent literature. Weitzmann-Fiedler catalogues 189 examples ranging from the late 11th to the early 13th centuries, with enormously varied subject-matter, some apparently related to Latin schoolbook texts, other moralistic or mythological or purely decorative. Some may perhaps have been used for the penitential washing of hands in nunneries.

Where the bowls were made is not known. There must have been several centres of production, perhaps including Regensburg, but the bowls were widely traded. Several have been found in England, but few of these can claim to be English on grounds of style. The St Thomas dish however is undoubtedly engraved by an English artist. Among the finest of the surviving bowls, its figure style has been compared by Boase and Geddes with various English manuscripts, but seems to be closest to Canterbury manuscripts of the 1120s, for example the St Augustine manuscript in Florence (not exhibited; Kauffmann, 1975, ills. 49–50). Its 'pair', the bowl in Jerusalem (Weitzmann-Fiedler, no. 16) shares the same inscriptions, yet its iconography differs, and in style it is utterly different, thus leaving unresolved the vexed questions of how and where these bowls were made. The production of Limoges enamels raises the same set of questions in the Romanesque period. N.S.

PROVENANCE Possibly found in the Thames at London; collection of William Ransom, Hitchin; given by F. Ransom, 1915
BIBLIOGRAPHY O.M. Dalton, 'On Two Medieval Bronze Bowls in the British Museum', *Archaeologia*, LXXII, 1922, pp. 133–60; Boase, 1953, p. 195; Geddes, 1980, p. 146 (n. 13); Weitzmann-Fiedler, 1981, particularly pp. 39–48, 78 (no. 14), pls. 27–30

260a and b Two fragments of *vernis brun*

Gilt copper-alloy plaques, hammered, decorated with *vernis brun* (literally in French 'brown varnish', a misleading term but too widely used to be abandoned): the technique consists of darkening areas of copper by coating them with a linseed oil mixture, and heating them so that a residue of the browned oil adheres to the surface; the areas to be gilded are then scraped free of darkened oil, so that the gold amalgam adheres to the metal and not to the browned areas.

260a Part of a border, perhaps from a book-cover, crucifix or *châsse*, with a trefoil foliage meander; *l* 127 mm

260b Fragment of a plaque, with a repeating pattern of squares and crosses; *w* 70 mm

Rheno-Mosan or English; second or third quarter 12th century
London, Department of the Environment, Directorate of Ancient Monuments and Historic Buildings (laboratory), 801968/9

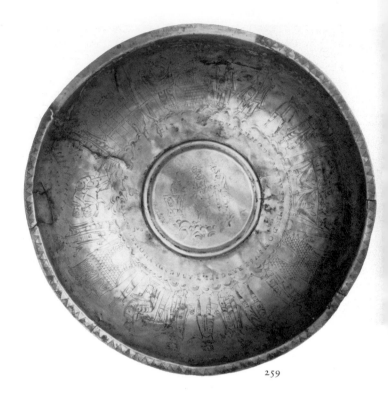

259

A description of the technique of *vernis brun* is given in Theophilus (Dodwell, 1961, p. 129). The fragments can be assumed to be contemporary and possibly from the same object. The cross pattern has Ottonian antecedents (the thrones of the Essen and Conques statues). The stylized trefoil meander is commonly found in 12th-century manuscript borders on both sides of the Channel, but it can also be closely paralleled in Mosan and Rhenish metalwork, in just the two regions where *vernis brun* was a popular technique. There is therefore a distinct possibility that the fragments are imports. On the other hand, the artistic exchanges between England and the main European metalworking regions are so well documented in the 12th century that an English origin can by no means be excluded as a possibility. N.S.

PROVENANCE Excavated at Battle Abbey, Sussex, 1980

260b

260a

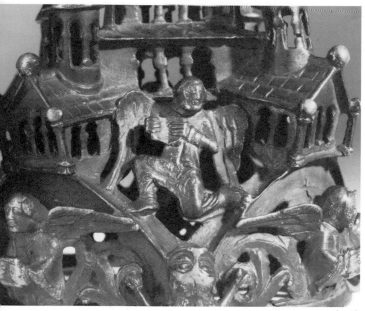

261 (detail)

261 Censer-cover

Brass (84.6% copper, 9.7% zinc, only 3.0% tin, 2.7% lead), cast, engraved, formerly gilded; in openwork: central tower in three stories; from the corners, four projecting gables topped by cylindrical turrets; between them, the four symbols of the Evangelists with book or scroll; the bottom defined by four arches, each filled with a half-length angel holding an open book; the base of the arches formed by half-figures of lions, their forepaws resting on leaves, their mouths open to allow the passage of suspension chains; the top ring for the chain which lifted the cover from the incense bowl (lost); *h* 129 mm, *w* 124 mm
English (?); mid- or third quarter 12th century
London, Trustees of the British Museum, MLA.1919, 11-11, 1

This masterpiece of wax-casting is one of the most elaborate Romanesque 'architectural' censers to survive. Theophilus, in *De Diversis Artibus*, describes how to model and cast a turreted censer in the likeness of the Celestial Jerusalem (Dodwell, 1961, pp. 113–9). This censer is unique in style, though certain of its architectural details can be paralleled, such as on a cover in Copenhagen (Tonnochy, 1932, pl. VIIB). It does not fit comfortably into any of the major stylistic groups of Romanesque 'bronzes', for example those from the Rhine-Meuse region, and the comparison with the much later Oslo cross-foot proposed by Springer is not conclusive. However, the single figure which can be judged on the basis of its drapery style, the symbol of St Matthew, bears a certain resemblance to English drawing styles of the middle years of the 12th century; compare the walrus ivory tau-cross 205 (Swarzenski, 1954, figs. 306–7). N.S.

PROVENANCE Bequeathed to the Museum by Robert John Steggles, 1919
EXHIBITION Manchester, 1959, no. 103
BIBLIOGRAPHY A.B. Tonnochy, 'A Romanesque censer-cover in the British Museum', *Archaeolog. J.*, LXXXIX, 1932, pp. 1–16; Tonnochy, 1937, particularly pp. 56–7, pl. VI; Springer, 1981, p. 210

262 Treble bell *(not illustrated)*

Cast from bell metal (77% copper, 23% tin); inscription –
+ SCA·MARIA; *diam* 464 mm, *wt* 1½ cwt
Late 12th century
Littleborough, Nottinghamshire, The Incumbent and Parochial Church Council of St Peter and St Paul

This treble bell from Littleborough is the only example of this type to bear an inscription; only twenty-seven are known, and they are peculiar to England and unknown on the Continent. The distinctive feature is the flat surface on the inside of the lip, which tilts slightly upwards and outwards. This unusual shape of the lip results from the founder's method of keying the heavy wax lip section to the core to prevent it from dropping in a horizontally moulded bell. The main proportions of the core upon which the wax model was formed deviate little from the standard shape evolved in the mid-11th century.

The upper moulding wires, between which the inscription is placed, were not strickled but applied as strips of wax stuck on to the model bell. Most of the letters, of which there are three forms of the letter 'A', appear to have been cast in moulds from wax, of which the overflow was carefully trimmed away from all except the bow of the first letter 'A' in 'Maria'. This letter also shows how the master letter from which the mould had been made was built up by the overlapping of the oblique strokes. The bow of the letter 'R' shows how two of the three thin strips of which it is composed did not complete the curve. The initial cross and the letter 'I' appear to have been built up on the model, for the tips of the cross and serifs of the letter overlap the moulding wires. G.E.

263 Doorknocker *(not illustrated)*

Bronze-cast; an animal's head, quite bald and bat-like, dominated by large almond-shaped eyes, a nose with pronounced nostrils and a large mouth displaying sharp teeth; attached to a circular base with a collar of stylized petals; a vertical ridge through the centre of the head; emphatic lines for the eyebrows and wrinkles extending from the nose to the corners of the mouth; the ears set well to the back of the head; the iron ring not original; *diam* 105 mm, *d* (relief) 95 mm
c. 1140; (?) Gloucester
Dormington Church, Herefordshire

This small knocker is unusual as it is not in the form of a readily recognizable lion's head. It was thought to be of late 12th-century date (RCHM, *Herefordshire*, II, 1932, p. 71), but it was subsequently judged to be so similar to some of the stone sculptures of Kilpeck Church, in the same county, that a mid-12th-century date, similar to that given to Kilpeck, was suggested for the bronze (Zarnecki, 1950b, p. 301). This date was accepted by Beckwith (*Burl. Mag.*, 1956b, pp. 228 ff.) and Mende (1981, p. 216, no. 28), who further believes that the Dormington knocker is a derivative of the famous knocker of Durham Cathedral (p. 21), which is, however, now considered to have been made in the 1170s (Geddes, 1982, p. 127). Since the two works are stylistically totally different, there is no need to relate the date of the Dormington bronze to the Durham knocker. The date of Kilpeck is now believed to be between 1135–40, which should provide a new guide for the dating of this knocker. Dormington Church was, like Kilpeck, the property of Gloucester Abbey and that is probably where the knocker was made. G.Z.

BIBLIOGRAPHY Zarnecki, 1950b, p. 301; Beckwith, 1956b, pp. 228–235; Mende, 1981, no. 28

264 Doorknocker (*illustrated on back cover*)

Bronze-cast; in the form of a lion's head with its mane
emerging from a circular base and conventional leaves
alternating on each side of a wavy stalk against a hatched
background; the lion devours a man whose head, with a long
moustache and forked beard, protrudes from its mouth; a ring
decorated with scroll-work, cast as a separate but interlocking
piece, through the beast's mouth; the lion's cheeks puffed and
with triangular marks simulating whiskers; *diam* 235 mm,
projection from base 850 mm
c. 1200; (?) York
Adel, Yorkshire, Rector and Churchwardens of Adel Parish
Church

A very similar but smaller knocker is preserved in the Church
of All Saints, Pavement, York, and a larger and more
spectacular example is in Luborzyca, Poland (**265**). In addition,
a 14th-century imitation of this type of knocker exists in
St Gregory's Church, Norwich.
 Meyer claims ('Deutschordenkunst im mittelalterlichen
England', *Anzeiger des Germanischen Nationalmuseums*, 1963,
pp. 28–34) that the three knockers in England were made in the
late 14th century in the territories which belonged to the Order
of the Teutonic Knights. However, his stylistic arguments are
not convincing and no similar knockers exist in those territories
or in Germany. Recently his views were endorsed by Mende
(1981).
 It has been argued (Zarnecki, 1964, pp. 111–18) that these
objects were made in England, probably in York, *c.* 1200 and
that they imitate knockers made in Lower Saxony in the second
half of the 12th century (such as for instance in the Schnütgen-
Museum, in Cologne, no. 29). G.Z.

BIBLIOGRAPHY Zarnecki, 1964; Mende, 1981, no. 154 with bibliog.

265 Doorknocker (*not illustrated*)

Bronze-cast; *diam* 260 mm, projection from base 140 mm
c. 1200; (?) York
Luborzyca, Poland, Church of the Elevation of the Holy Cross

This is a somewhat more elaborate version of the doorknocker
at Adel (**264**). It has been suggested (A. Bochnak and
J. Pagaczewski, *Zabytki przemyslu artystycznego w kościele
parafialnym w Luborzycy*, 1925, p. 10) that this knocker was
originally on one of the churches within the royal castle on
Wawel Hill in Cracow and was moved to Luborzyca in 1433.
There is a possibility (Zarnecki, 1964, p. 116) that if the
Luborzyca knocker was made in York, it was subsequently
taken by the Archbishop of York, Walter de Grey, to Rome
when he attended the Fourth Lateran Council in 1215, and was
given to Vincentius Kadlubek, Bishop of Cracow, who was also
there. His successor, Ivo Odrowąz (1218–29) was the founder
of Luborzyca and there is every likelihood that it was he who
gave the knocker to this church. G.Z.

BIBLIOGRAPHY Zarnecki, 1964, p. 116; Mende, 1981, no. 156 with bibliog.

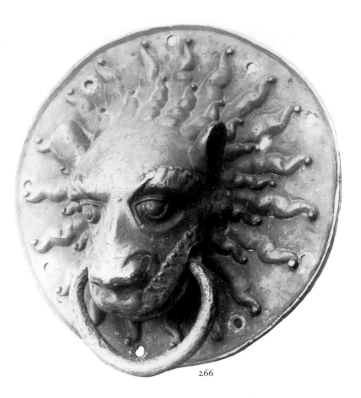

266

266 Doorknocker

Bronze-cast; in the form of a lion's head emerging from a
circular disc with holes for fixing it to the door – apparently
four out of nine of the holes are modern; elongated head has
eyebrows and moustache made up of stylized curls or tufts;
two rows of larger curls, representing the animal's mane, link
the head to circular base; well-modelled eyes with pupils
indicated by lines; nostrils are emphasized by deep holes; the
ring not original and far too small; *diam* 372 mm, *d* (of
relief) 125 mm
c. 1200; Lindsell, Essex
London, Trustees of the British Museum, 1909, 6-5, 1

Before entering the Museum, the knocker was at Brazen-Head
Farm, Lindsell, Essex. According to Christy (1909, p. 382), the
name of the farm derived from the knocker dates from before
1500 and so this knocker was not a spoil of the Reformation
but was probably made for a church of importance before
being removed to Lindsell, not later than the 15th century.
 It is a work in which Romanesqe stylization is combined
with subtle modelling and it was praised for its 'sculptural
virtuosity' (New York, 1970: Hoffmann, no. 89). In a recent
study, Mende (1981, no. 77) questions the English
workmanship of the piece, and in this, as in other views
concerning English doorknockers, she accepts the conclusions
of Christy (1909). No convincing evidence has been produced
to support the belief that the Lindsell doorknocker is
Continental; Hoffmann accepts it as English and the same view
is adopted here. G.Z.

EXHIBITION New York, 1975
BIBLIOGRAPHY M. Christy, 'Notes on an early medieval lattern doorknocker from Lindsell, co.
Essex', *Proc. Soc. Antiq.*, XXIII, 1909, pp. 380–9

267 Head of a crosier (*not illustrated*)

Copper-alloy, cast, engraved, punched and gilded; crook: keel on the outer edge, single scroll framing a winged dragon which bites the top of the crook, its body and wings engraved and stippled with a small punch; shaft cylindrical with a bulbous godrooned knop; *h* 200 mm, *w* 90 mm
First quarter 12th century
Chichester, Dean and Chapter of Chichester Cathedral

The dragon with long snout, sinuous tail and carefully engraved wings is cousin to the beasts which bite the rim of the pan on the Gloucester Candlestick (**247**). As with the candlestick, many parallels are also to be found in Canterbury manuscripts. However, given the corroded condition of the crosier, a direct relationship with the candlestick cannot be definitely proved. N.S.

PROVENANCE Probably found in one of four unidentified bishops' tombs in the Cathedral, 1829, perhaps with a base-metal chalice and paten (**323**) and a sapphire and gold 'stirrup' ring
EXHIBITIONS London, 1939, no. 44; Manchester, 1959, no. 113
BIBLIOGRAPHY *Gentleman's Magazine*, 1829, part I, p. 545; Dalton, Mitchell, Couchman, 1926, pp. 213–4, pl. XXXVII (fig. 1)

268 a–c Top of a crosier (*c not illustrated*)

In three sections, remounted on a modern wooden shaft:

268a the crook, copper-alloy, cast in the round and gilded; the shaft cylindrical, tapering upwards into the polygonal crook; its outer scroll develops into a complex pattern of branches, almost symmetrical, with frilly leaves enclosing berries; two silver nielloed bands, decorated with spiral foliage scrolls and with a lozenge pattern, filled with stylized four-petalled flowers; *h* 160 mm, *w* 76 mm; a modern copper mount now divides this from:

268b the upper knop, with its two collars, copper-alloy, *repoussé*, engraved and gilded; plain spherical knop; upper collar with foliage meander; lower collar: eight roundels in three vertical rows, enclosing six stylized lions and two larger winged griffins, all against hatched grounds, very worn, most of the gilding lost; *h* 108 mm;

268c the lower spherical knop, with two collars, one polygonal; undecorated, gilded, *h* 82 mm

Crook and upper knop English(?), mid-12th century, the nielloed bands contemporary(?); lower knop 13th century, when the three sections were assembled together
St David's, Dean and Chapter of St David's Cathedral

The elegant foliage of the crook with berries cupped in frilly pods is difficult to parallel, whether in England or elsewhere. It approximately resembles certain foliage capitals of northern French monuments of *c.* 1150–80 and details of Mosan/ Rhenish cast metalwork of the same period (Lasko compared **288**), as well as the enigmatic disc-cross at Kremsmünster (Swarzenski, 1954, fig. 321). But these are loose parallels. Perhaps this graceful lattice of branches and leaves is a bold simplification of the more exotic flowers which adorn English manuscript initials of the period *c.* 1130–80? The nielloed silver bands seem to be original and their patterns reappear in English metalwork, as in the tight scroll-work of **299–301** and the lozenge pattern of the roof of **288**. Note also that the collar of another crosier from St David's (**270**) repeats the scroll-work and lozenge pattern of these nielloed bands. Lasko suggested that the collar with animal roundels is later, but their repetitive 'heraldic' poses, ultimately based on traditional textile

268a

268b

patterns, are perfectly in harmony with a mid-12th century or even earlier date, perhaps contemporary with a column carved with griffins from Reading Abbey (**127s**). The technique of engraving on the collar is similar to that on the nielloed bands. But if there is no reason to postulate any late-12th-century additions to the crosier, it must have been mended at an advanced date in the 13th-century; the polygonal form of the collar of the lower knop suggests a mid-13th-century date, as does the stem of the chalice from the same tomb. Clear's attribution of the tomb to Bishop Richard de Carew (d. 1280) is entirely plausible. N.S.

PROVENANCE Found in the grave of a bishop in front of the pulpitum, together with a 13th-century gold and sapphire ring and a mid-13th-century silver chalice at St David's Cathedral, 1865/6
EXHIBITION Barcelona, 1961, no. 545 (notice P. Lasko)
BIBLIOGRAPHY Clear, 1866, p. 61, plan (grave 2), ill.; Hope, 1907, pp. 488–90, pl. LIIIB; Watts, 1924, p. 10, pl. 4 (left); Beckwith, 1972, p. 98; Campbell, 1979, particularly figs. 43–4

269

closely compared to the border decoration of the 'Crosby relief' of the 1150s from St-Denis (S. McK. Crosby, *The Apostle Bas-Relief at Saint-Denis*, 1972, *passim*) and to certain St-Denis stained glass borders of the 1140s. In the third quarter of the 12th century, this type of flower became more stereotyped and can be found, for instance, in Rhenish metalwork and also in Normandy, as on the stone reliefs at Fécamp. Therefore although the ancestry of these large blossoms can be traced to England, the crosier could well have been made in France, perhaps in the Norman Duchy itself, where the latest developments in the Ile-de-France were readily accessible. But, whether or not it is by an English goldsmith, the problem of its attribution is only a symptom of the close artistic relationships which existed between England, Normandy and the Ile-de-France at this period. See also dom Pommeraye, *Histoire de l'abbaye de St-Amand de Rouen*, 1662, particularly pp. 16–7, 83–4, for financial connections between the nuns of St-Amand and both Henry II and Bishop Roger of Sarum. N.S.

PROVENANCE Found under the pavement of a shop at 86 rue de la République, Rouen, 1964
EXHIBITIONS Paris, 1965, no. 214; Rouen, Caen, 1979, no. 275 (notice D. Gaborit-Chopin)
BIBLIOGRAPHY Elisabeth Chirol, 'Crosses de deux abbesses de Saint-Amand mises au jour à Rouen, le 29 mai 1964', *Bulletin de la Commission des Antiquités de la Seine-Maritime*, XXV, 1964-5, pp. 209–21

270a and b Fragments of a crosier

In two sections:

270a The crook: copper-alloy, cast, engraved and gilded; fragment of iron spike at bottom; octagonal shaft tapering upwards, the outer scroll with small buds breaking off it and developing into a magnificent 'orchid' blossom; *h* 180 mm, *w* 107 mm

270b Part of the wood staff, with copper-alloy, hammered, embossed, engraved and gilded mount, and part of a plain spherical knop (in Clear's engraving this is shown with a); the mount decorated with panels of tightly-scrolled foliage and a lozenge pattern filled with four-petalled flowers and leaves, a row of fluted leaves and a row of frilly leaves joined at their bases by triangles; remains of four big leaves with beaded stems and berries at the top of the mount; *h* 195 mm, (collar) 72 mm, *circumference* 70 mm (top), 95 mm (bottom) *c.* 1150–80
St David's, Dean and Chapter of St David's Cathedral

No associated finds are recorded with this crosier. The decorative motifs on the mount can be paralleled elsewhere on English metalwork: the scroll-work is particularly close to that on the Bury St Edmunds crosier-mount (**300**), the lozenge pattern studded with flowers to the roof of the Fitzwilliam casket (**288**) while the border leaf patterns occur on the Dune drinking-cup (**306**) and on the silver nielloed mounts of the St David's crosier (**268**). Such minor comparisons are significant because they prove that there was a common decorative repertoire used by English metalworkers, much as there was a common stock of border decorations for manuscripts. However, the crowning glory of this superb crosier is its great 'orchid' blossom, comparable in splendour to the finest foliage initials of the British Library, Cotton MS Nero C.IV (**61**; Wormald, 1973, pls. 96–7, 101) and, above all, of Camarillo (California), Doheny Library MS7 (Kauffmann, 1975, ills. 247, 249). N.S.

PROVENANCE Found in the grave of an unidentified bishop on the south side of the presbytery at St David's Cathedral, 1844
BIBLIOGRAPHY Jones, Freeman, 1856, p. 113, map facing p. 138 (no. 17); Clear, 1866, p. 63, ill.; Hope, 1907, p. 488, pl. LIIIA; Watts, 1924, p. 10, pl. 4 (right)

269 Crosier

Wood shaft: modern reconstruction, based on excavated fragments; total *h* 1.550 m. Crook and knop: copper-alloy, cast and hammered, engraved and gilded; cylindrical lower stem with beaded bottom edge beneath a row of engraved hatched triangles; depressed spherical knop (beading above and below), engraved with four double blossoms; polygonal upper mount tapering into the crook which ends in a bulbous moulding, flanked by two small rolls, and a single large blossom; *h* 213 mm, *w* 81 mm. Bottom spike: cone-shaped with a bulbous moulding as on the crook; much loss of gilding; *h* 133 mm
Anglo-Norman (?); second or third quarter 12th century
Rouen, Musée départemental des Antiquités, 64.2.10.

The crosier was found on the site of the north-east corner of the cloister of the Benedictine nunnery of St-Amand. It was in three pieces (the knop separated from the crook and subsequently attached) within the intact stone coffin of one of the abbesses, who remains unidentified. Both the casting and the engraving are of the highest quality. Gaborit-Chopin cited certain English manuscripts and ivories as parallels. To these may be added, for example, the foliage on some of the capitals from Hyde Abbey, Winchester, dating from the 1130s (**128c**), which resembles the flowers engraved on the knop. However, the Rouen crosier flowers are not typical of English art. Particularly unusual is the blossom on the crook, with its beaded trefoil frame and pods cupped within delicate sprays of foliage which are arranged with absolute symmetry. It may be

270a

270b

271 Head of a crosier (*not illustrated*)

Copper-alloy, cast, engraved; octagonal stem rising from a moulded 'Attic' base with two ring mouldings below it; the outer scroll of the crook ends in an animal head from which a forking branch emerges; its lower stem ends in a leaf, its upper stem forms the inner scroll of the crook ending in a single large blossom (two holes through the flower may originally have been set with coloured glass beads); spherical knop; short section of wood staff, partly renewed; *h* 180 mm
c. 1170–90
Mr Samuel Whitbread, on loan to the British Museum

The blossom has three elegant beaded sprays growing upwards from a calyx: the central spray has side shoots which pass, one in front of and one behind the outer sprays, as in the foliage of the Dunstable Priory central west door (*c.* 1176–90) and of the 'Aylesbury group' of fonts. It has been suggested that the fonts reflect St Albans sculpture and metalwork of the third quarter of the 12th century (Marks, 1970; Thurlby, 1982b, pp. 228–9). Thus the crosier might be considered the sole surviving representative of that famous metalworking centre. However, in its relative simplicity, it embodies the austerity of Cistercian ideals in the period following the death of St Bernard of Clairvaux (1153). Warden was founded in 1136 as a daughter house of Rievaulx. The two abbots who are most likely to have owned the crosier are Hugh, active in the 1170–80s, and Payne, d. 1198 or 99 (Knowles, Brooke, London, 1972, p. 146). N.S.

PROVENANCE Found by Bradford Rudge in a stone coffin to the north-east of the cloister of Warden Abbey, 1835 (*Bedfordshire*, CRO, X404/22); S.H. Whitbread, C.B.; deposited on loan to the Museum, 1925
EXHIBITION Bedford, Elstow Moot Hall, 1968
BIBLIOGRAPHY Dalton, Mitchell, Couchman, 1926, pp. 211–12, pl. XXXVII (fig. 1)

272 Top of a crosier

Jet crook, with octagonal shaft, simple leaf motifs breaking off its main scroll; silver-gilt mount with two clips covering a fracture, decorated with *repoussé* work in two zones: (below) three creatures with tightly-scrolled foliate tails; (above) a half-length angel and three beasts, of which two are winged griffins, among tight scrolls of foliage; depressed spherical jet knop, with plain copper mounts pinned above and below; short section of the wood stem of the crosier, with traces of paint and gilding, carved with a projecting leaf (broken off);
h 315 mm, *w* 85 mm
Last quarter 12th century (the mount nearly contemporary)
Chichester, Dean and Chapter of Chichester Cathedral

Jet was rare and highly prized throughout the Middle Ages, as inventories of the 14th and 15th centuries make clear, and only a few Romanesque jet objects have survived. The main source of jet must have been beach refuse; it was not mined in England until a much later date, for example at Whitby. The present piece is exceptional in size. The simple leaves breaking off from a foliate scroll are probably of later 12th-century date, resembling the tight spiral initials found in some manuscripts (compare Kauffmann, 1975, ill. 259). The *repoussé* mount covers a split but this mend seems to have been made almost immediately after the crosier was carved; the naturalistically-formed animals with long supple bodies have relatives in the late 12th- and early 13th-century bestiaries, such as the griffin in the 'Worksop Bestiary' (**85**). N.S.

PROVENANCE Found at Chichester Cathedral, in the coffin of an unidentified bishop, 1829, with an *intaglio* ring (**314**) and a 13th-century chalice and paten
BIBLIOGRAPHY *Gentleman's Magazine*, 1829, part I, p. 545; engraving by Thomas King, separately published 1830; Dalton, Mitchell, Couchman, 1926, p. 215, pl. XXXVIII (fig. 2); Longhurst, 1926, p. 37, pl. 39

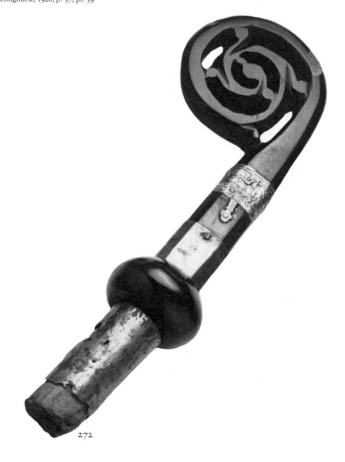

272

273 Part of the crook of a crosier

Copper-alloy, cast, engraved and gilded; only the inner scroll
of the crook survives; the outer scroll originally slotted into it
(on the right) and was further pinned into position, where it
passed between the 'front' and 'back' sides of the leaf (top left);
two other pins attached it to the leaf (bottom left); an eagle
with delicately engraved plumage stands in the centre, encircled
by a branch from which sprout tightly-curled buds of trefoil
foliage with berries; *h* 75 mm, *w* 55 mm
c. 1180–1210
St David's, Dean and Chapter of St David's Cathedral

The eagle is rendered in a strikingly naturalistic fashion, very
much in that spirit which invades European art from the 1180s
onwards, as in the animals which inhabit the cresting of the
Cologne St Albinus and Siegburg St Anno shrines. However,
there is no need to look so far afield for the St David's artist.
The crosier is probably the product of a West Country
workshop. For its foliage, compare some of the early capitals
at Wells (1180s); for the eagle, a bird carved among the
voussoirs of the north door of the Glastonbury Lady Chapel
of *c*. 1184–6. This style continued well into the 13th century,
as seen in a bird acting as a springer above a pier of the nave
of Llandaff Cathedral. The earliest parts of St David's
Cathedral, whose rebuilding was begun *c*. 1180, were the work
of stonemasons closely associated with this West Country
tradition. Three silver mounts, apparently from the same
crosier, have not been traced. Judging by a photograph (Hope,
fig. 8), they were of the same date as the crook. Compare also
Zarnecki, 1957a, pl. 80. Clear attributed the tomb in which the
crosier was found to Bishop Thomas Bek (1280–93). N.S.

PROVENANCE Found in the grave of a bishop in front of the pulpitum at St David's, together
with a ring of *c*. 1200 and a 13th-century silver chalice and paten, and a penny of Edward
I, 1865/6
BIBLIOGRAPHY Clear, 1866, p. 62, plan (grave 3), ill.; Hope, 1907, pp. 490–1, pl. LIIIC

274 Enamelled foot of a cup from Jutland

Short tapering cylindrical foot: copper, *champlevé*, engraved,
enamelled and gilded; spiralling fields, with animals and
foliage reserved against deep blue and red grounds; *h* 25 mm,
diam 45 mm (top), 69 mm (bottom)
Mid-12th century
Copenhagen, Danish National Museum, D.4763

This fragment is a rare and beautiful early survival of English
champlevé enamelling. The winged dragons are closely similar
to creatures in the initials of Canterbury manuscripts which
date at the latest to the second quarter of the 12th century,
compare Dodwell 1954, pls. 18b, 42a, 45g. Compare also the
dragons and foliage of the lower rim of **276**, which was
probably part of a similar secular drinking-cup. N.S.

PROVENANCE Found at Villestrup mark, parish of Astrup, near Aalborg, Jutland, 1900
BIBLIOGRAPHY Jørgen Olrik, *Drikkehorn og Sølvtøj fra Middelalder og Renaissance*, 1909,
pp. 55–6, fig. 4

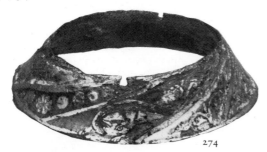

274

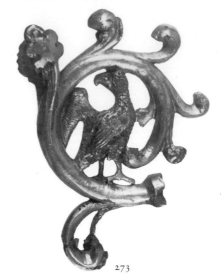

273

275 The Masters plaque *(illustrated on p. 5)*

Round-headed plaque: copper, hammered, *champlevé*,
engraved, enamelled and gilded; figures and other details
reserved, their engraved lines filled with red enamel;
background deep blue, haloes yellow and white; very worn, to
the extent that it is not certain whether the hair of the devils
was stippled with a punch or the reserved metal is pitted. The
Last Judgement: Christ with arms spread, holding an orb
topped by a cross, hovers with two angels above a scene of the
torments of Hell; within the flying folds of Christ's mantle,
four human heads, souls of the blessed; below, a tumult of
figures, including (left) a naked figure in chains who is thrust
downwards by a flying devil with a pronged fork; other
hairy devils drive the damned towards the flames of Hell, represented
by a cauldron; the gates and walls of Hell beyond; *h* 138 mm,
w 86/88 mm
c. 1150–60
London, Victoria and Albert Museum, M.209.1925

The plaque was pinned to a wooden core, but its original
function and setting are unknown. This is a unique *Last
Judgement*. Christ is shown with two angels as in certain
representations of the *Ascension*, but the Hell scenes belong to
the usual repertory of a *Last Judgement* or a *Harrowing of
Hell*. The vigorous drawing style is not far removed from that
of **61**, which includes scenes of Hell orchestrated by the same
race of hairy devils and souls in torment. The Sherborne
Cartulary (**46**), another comparable manuscript, can be dated
on internal evidence to *c*. 1146. The Lambeth Bible (**53**) shows
a contemporary interest in the manifold patterning of draperies
and extremely 'mannered' elongation of the figures. The
plaque is probably datable to the 1150s, an early example of
Romanesque *champlevé* enamel. However, unlike most of the
other English enamels in this exhibition, it owes nothing to
contemporary Mosan, German or Limoges enamelling. The
artist relies for his effect on elaborate closely-knit interior
drawing of the figures; his busy grid of lines is coloured with
red enamel, but since red is also used for the flames and
architecture of Hell, his scene is difficult to 'read'. As an
enameller his technique was limited: a simple four-colour
palette, no use of mixed fields of enamel. N.S.

PROVENANCE Given by Dr Robert Masters (1713–98), Fellow of Corpus Christi College,
Cambridge, to the Revd Thomas Kerrich (1748–1828), 1796; passed indirectly to Hugh Wyatt
of Worthing; acquired 1925
EXHIBITIONS London, 1930, no. 41, pl. 13; Barcelona, 1961, no. 548
BIBLIOGRAPHY Mitchell, 1925, pp. 169–70, pl. 1; Chamot, 1930, no. 4; Swarzenski, 1954,
fig. 325; Gauthier, 1972, no. 80

276 Cover from a drinking-cup

Copper, *repoussé*, *champlevé*, engraved, punched, enamelled
and gilded; the crowning knop lost; never hinged; depressed
hemisphere, divided into ten raised pointed oval fields,
alternately plain within borders of tongue-leaves or small
trefoil flowers in kidney-shaped frames, and decorated with a
man and animals in combat and enmeshed in foliage within
'twisted ribbon' borders; the lower edge with a design of five
pairs of winged dragons, joined together by a continuous stem
which grows from their mouths and from their tails; the figures
reserved, most of the enamel of the grounds lost but traces of
white, yellow, green, two blues and opaque red; extensive
traces of gilding; *h* 55 mm, *diam* 164 mm
Third quarter 12th century
London, Trustees of the British Museum, MLA.50,7-22,1

For the layout in raised oval fields, compare the Dune drinking-
cup and the Agaune ciborium (**306** and **309**). The fantastical
subject-matter suggests that this was the cover of a secular
drinking-cup, rather than of a ciborium, as Chamot believed.
On the other hand, the range of coloured glasses seems to have
been similar to that of the English ciboria, and the foliage can
be paralleled on the Warwick ciborium (**280**). But there can be
no question of attributing the cover to the English 'ciborium
workshop'; compare the Copenhagen foot (**274**) part of
another secular cup, where the dragons and foliage of the lower
rim can also be found. The enameller has adapted to his own
medium the subject matter of the inhabited initial, taking over
the long sinuous winged dragons, lions, birds and grotesques,
as well as a single nude man, from the stock of 'clambering'
and 'combat' scenes which are a particular feature of such
books as the two-volume Winchester Bible in Oxford (Bodleian
MS Auct. E. inf. 1–2, **63**). N.S.

PROVENANCE Collection of S.P. Cox of the Inner Temple and Farningham, Kent; sold
Christie's, 8 July 1850, lot 8; bought by Webb; acquired 1850
BIBLIOGRAPHY Chamot, 1930, pp. 8, 31 (no. 14), pl. 8 (top)

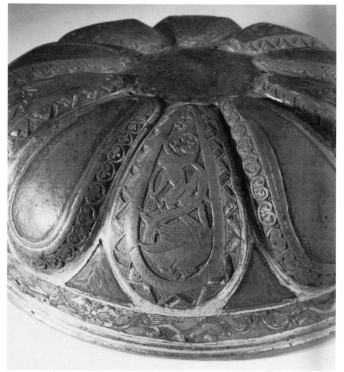

276 (detail)

277a and b The Henry of Blois enamel plaques
(illustrated overleaf)

Two semicircular 'dished' plaques: copper, hammered,
champlevé, engraved, enamelled and gilded; *diam* 178/179 mm

277a Two censing angels, emerging from clouds; the border
inscribed:

+ MVNERA GRATA DEO PREMISSVS VERNA FIGVRAT.
ANGELVS AD CELVM RAPIAT POST DONA DATOREM;
NE TAMEN ACCELERET NE SVSCITET ANGLIA LVCTVS,
CVI PXA [*for pax*] VEL BELLVM MOTVSVE QVIESVE PER ILLVM.

('The aforementioned slave shapes gifts pleasing to God. May
the angel take the giver to Heaven after his gifts, but not just
yet, lest England groan for it, since on him it depends for peace
or war, agitation or rest.')

277b A kneeling tonsured donor with a crosier, identified by
inscription as HENRICVS EPISCOP(VS), presenting an oblong
object; the border inscribed:

+ ARS AVRO GEMMISQ(UE) PRIOR, PRIOR OMNIBVS AVTOR.
DONA DAT HENRICVS VIVVS IN ERE DEO,
MENTE PAREM MVSIS (ET) MARCO VOCE PRIOREM.
FAME VIRIS, MORES CONCILIANT SUPERIS.

('Art comes before gold and gems, the author before
everything. Henry, alive in bronze, gives gifts to God. Henry,
whose fame commends him to men, whose character
commends him to the heavens, a man equal in mind to the
Muses and in eloquence higher than Marcus (that is, Cicero).')

By a Mosan goldsmith; before 1171
London, Trustees of the British Museum, MLA.52, 3–27, 1

These plaques were made by a Mosan goldsmith for Henry of
Blois with whom no other surviving work can with any
certainty be associated (see also **61**, **145**, **147-9**, **151** and **318**).
Opinions differ as to who is referred to in the first inscription as
'the aforementioned slave' (the artist? the donor?). However, as
the plaques must originally have been above and beneath a central
scene or relic, perhaps with other intervening plaques, the
inscriptions should not be read as a sequence; in any case one
is in hexameters, the other in elegiac couplets. Therefore the
original evidence to identify the 'slave' is lost. Opinions also
differ as to what object Bishop Henry is presenting: it has been
suggested that it is a representation of the shrine of St Swithun,
but no evidence exists to connect Henry with a refurbishment
of the Winchester shrine. The most plausible theory is that
Henry is presenting an altar, set with precious coloured-stone
roundels. If so, the plaques either formed part of the decoration
of the altar itself, or possibly decorated the top and bottom
terminals of a large cross set on the altar. The first inscription
has been interpreted as referring to the events of the civil war,
and the plaques have therefore been dated before King
Stephen's death in 1154. Although such an interpretation
cannot be excluded as a possibility, the only certainty is that
the plaques were not made posthumously and therefore date
before Henry's death in 1171. It is not known whether the
plaques were commissioned for Winchester, Glastonbury or
some other English house.

Recent study in the British Museum laboratory has
confirmed the very close similarity between the plaques and a
particular group of Mosan plaques, eleven in all, of which one
is in the British Museum, four in the Victoria and Albert
Museum, four in the Metropolitan Museum of Art, New York,
and two in the Louvre. The palette and distribution of the
coloured glasses is the same, although this is not obvious since

277a

277b

the Henry of Blois plaques have lost most of their gilding and this has seriously falsified their appearance. Also closely similar is the drawing style, clearly visible in X-rays; the poses of the figures are typically Mosan, and other details including the epigraphy are common to both series. The Henry of Blois plaques are by a major Mosan goldsmith. Given the references to England in the first inscription, they were probably executed in England. They bear eloquent testimony to the presence of a great Mosan artist in England around the middle years of the 12th century, executing a commission for one of the foremost patrons of the time. N.S.

PROVENANCE First recorded joined together as a plate in 1813; sold as part of the effects of Thomas Fisher in 1837; presented by the Revd George Murray at the desire of the late Revd Henry Crowe, 1852
EXHIBITION London, House of the Society of Arts, *Works of Ancient and Mediaeval Art*, 1850, no. 320
BIBLIOGRAPHY Haney, 1982a, pp. 220–30; Stratford, 1983 (with bibliog.)

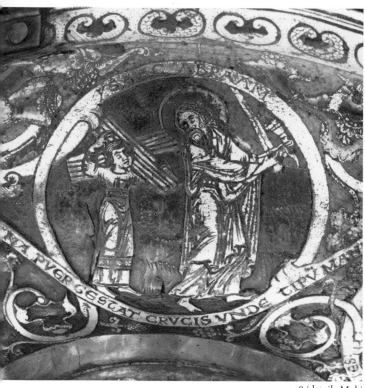

278 (detail: M4b)

278, 279 and 280 Three enamelled ciboria

These three famous objects have acquired the names of the
Morgan, Balfour and Warwick ciboria (they will be identified
as M, B and W). They were receptacles for the reserved
Eucharistic hosts, to be placed or suspended on or near the
altar. In the Middle Ages, the word usually used for this vessel
was 'pyxis' (*pyx*, literally 'a small box').

If the lost cover of W is assumed to have been in line with
the others, all three share a common form: a depressed
hemispherical cup and bowl on a short round foot, with a
bulbous finial above a row of cast leaves. They were not
originally hinged: W was held closed with clips, while M had
until recently an armature of wire with a suspension loop
around its finial. All are of copper, hammered, *champlevé*,
engraved, punched, enamelled and gilded. Within are two
enamelled medallions which refer to the sacrifice of the Mass:
Christ with double-armed cross and book, blessing (in the
cover), the Lamb of God with cross-standard, its blood flowing
into a chalice (in the bowl). On the outside, an overall carpet
of flowers and branches richly enamelled covers the finial and
foot and forms a series of medallions, six on the cover framing
New Testament scenes, six on the bowl framing their Old
Testament typological counterparts.

These scenes have Latin verse inscriptions, identical to some
which once commented on a cycle of 12th-century wall-
paintings in the Worcester chapter house, as they are known
from a manuscript (281); in the catalogue entries below, some
inscriptions have been compared to the Worcester manuscript,
where their sense is only clear by reference to the full Worcester
poem. The precise relationship of the ciborium scenes to the
lost Worcester paintings can only be a matter of conjecture, but
at least the Worcester poem proves beyond dispute that the
ciboria are English. It also implies that they may reflect on a
miniature scale more extensive typological cycles, painted on
walls or vaults and in stained glass.

What is more, the layout of medallions formed by branches
with big blossoms between can be paralleled, for instance, in
the paintings on the choir vault of the Hospital chapel of the
Petit-Quévilly, Rouen, of *c.* 1170.

Technique and palette are closely similar on the three
ciboria; only the precise distribution of colours and reserved
areas varies. The glasses used are: white, yellow, three greens,
turquoise, two blues, lilac, opaque red, very dark red, and they
are distributed so that the single-colour backgrounds of the
scenes, spandrels and flowers are reversed between cover and
bowl.

Within the mixed fields, as of the large blossoms,
combinations of several colours shade into each other, e.g.
white/yellow/green or white/turquoise/azure blue. Many
features of technique and palette derive from the Mosan
workshop of the Master of the Stavelot Portable Altar of
c. 1150–60 (Stuttgart, 1977–79, no. 544).

The three ciboria are closely related in their form,
iconography, inscriptions and technique, but W stands out as
totally different in style from M and B, which are undoubtedly
the work of a single artist. To compare the corresponding
scenes on the three ciboria is highly revealing. Nowhere else in
medieval art can the use of a common workshop model-book
be so clearly demonstrated from a near-identity of
iconography, while it can be equally clearly seen that the
model-book was available to two artists, probably
contemporaries but of widely differing artistic pedigrees. N.S.

EXHIBITIONS Catalogue of Antiquities, Works of Art and Historical Scottish Relics exhibited
in Edinburgh, July 1856, Edinburgh 1859, pp. 122–124, ill. (B; references to W); Manchester
Art Treasures, 1857 (B, W – see Augustus W. Franks, 'Vitreous Art', pp.21–23, in ed. J.B.
Waring, *Art Treasures of the United Kingdom from the Art Treasures Exhibition, Manchester
. . .*, 1858); London, South Kensington Museum, Special Exhibition of Works of Art . . ., June
1862, Catalogue, 1862, no. 1101 (M), 1101* (B); London, Burlington Fine Arts Club, Catalogue
of a Collection of European Enamels . . ., London, 1897, no. 48(B), 53 (M); Barcelona, 1961,
no. 543 (W); New York, 1970, nos. 171 (M), 172 (W); Edinburgh, 182, B25
BIBLIOGRAPHY Henry Shaw, *The Decorative Arts Ecclesiastical and Civil of the Middle Ages*,
1851, not paginated (W); A.H. Constable, in: *Scottish National Memorials*, 1890, pp. 45–53,
frontispiece, pls. II–III (B); James, 1898–1903, pp. 99–115; von Falke, Frauberger, 1904, p. 92,
ills. 31, 32 (M, B); Chamot, 1930, nos. 11–13; Braun, 1932, p. 307, pl. 60; Swarzenski, 1932,
p. 336, ill. 284 (W); Boase, 1953, pp. 194–5, pl. 69b; Oman, 1953, pp. 156–7; Saxl, 1954, p. 63,
fig. 45; Swarzenski, 1954, figs. 447–50, 453; Stone, 1955, pp. 100, 248 (n. 19), pl. 70b; Cox,
1959, particularly pp. 170–2, pls. LIIIa, LIVa, LVb (W); Sauerländer, 1971, p. 515; Gauthier,
1972, pp. 159–61, 362 (nos. 114–15); Lasko, 1972a, pp. 238–9, pl. 281; Campbell, 1979,
particularly pp. 369; N. Stratford, 'Three English Romanesque Enamelled Ciboria', *Burl.
Mag.*, April, 1984

278 The Morgan ciborium *(illustrated also on p. 77)*

Scenes, identified by inscriptions on the branches, reading
anticlockwise:

On the cover: [M1a] the *Nativity* (+ VIRGO MARIA FVIT QVE
DOMINVM GENVIT: ('Mary the Virgin who bore the Lord');
[M2a] the *Presentation in the Temple* (+ OFFERTVR
MAGNVS.NVNC. .A POPVLIS.DEVS.AGNVS: ('Now God, the
Lamb, is offered up by the people'); this refers to the
corresponding scene of the Sacrifice of Cain and Abel (M2b);
[M3a] the *Baptism of Christ* (+ BAPTIZAT MILES REGEM
NOVA GRATIA LEGEM: ('A soldier baptises a king and thus
institutes the new law'), cf. B1a; [M4a] *Christ carrying the
cross* (+ SIC. ALAPIS.CESVS.PIA.DICITVR.HOSTIA IHESVS:
('Thus wounded by buffeting, the holy Jesus is led a victim to
the sacrifice'), cf. B2a; [M5a] the *Crucifixion* (+ VT VIVAS
MECVM FELIX HOMO DORMIO TECVM: ('So that you may live
with me, blessed man, I sleep with you'), cf. 281, where these
words are spoken by Christ to his Church); [M6a] *The holy
women at the sepulchre* (+ SVRGIT.DE TVMVLO.PETRA.XPC.
QVEM.PETRA. TEXIT. ('The stone rises up from the tomb,
Christ rises up whom the stone covered'), cf. B4a.

On the bowl: [M1b] *Aaron's flowering rod* (+ VIRGO
DVCEM.FERT.VIRGA.NVCEM.NATVRA.STVPESCIT. ('A Virgin

bears the Lord, just as a branch bears fruit and all Nature is amazed'); [M2b] the *Sacrifice of Cain and Abel* (+ AGNVS.ABEL.MVNVS.AGNVM.PRIV(S) OPTVLIT.VNVS. ('Abel's gift is a lamb. In former times, one man offered a lamb'), cf. W2; the line can only be understood as preceding the inscription of M2a; [M3b] the *Circumcision of Isaac* (+ PRECESSIT LAVACRVM.SACRA.CIRCVMCISIO SACRVM. ('Holy circumcision anticipated ritual cleansing'), cf. B1b, W3; the words refer to the Baptism (M3a) which this scene prefigures; [M4b] *Isaac carrying the wood to his sacrifice* (+ LIGNA PVER GESTAT CRVCIS VNDE tIPVM MANIFESTAt ('The boy carries the wood and thus prefigures the cross'), cf. B2b, W4; the line refers to Christ carrying the cross (M4a), Isaac's wood being in two bundles forming a cross; [M5b] *Moses and the brazen serpent* (+ SERPENS SERPENTES XPC NECAT IGNIPOTENTES: ('Christ the serpent kills the fire-bearing serpents') ; the verse refers to Christ's victory on the cross over Satan (M5a); [M6b] *Samson and the harlot of Gaza* (+ SAMSON DE GAZA CONCLVSVS AB HOSTIBVS EXIT: ('Samson escapes from his enemies at Gaza'), cf. B4b, referring to the escape of Christ from the tomb (M6a).

Silver hinge and clasp not original; in 1862 a wire armature and suspension loop was still twisted around the finial, removed at some date after 1897; foot appears squashed in 19th-century photographs; since straightened out, a process accompanied by some regilding of borders, parts of foot and most of interior; colour scheme organized so that dominant background colours are reversed between cover and bowl: thus, on cover, green surrounds a pale blue circular area edged with white in medallions and azure blue fills spandrels behind blossoms, while on bowl, medallions have azure blue surrounding a green circular area, spandrels being of green and turquoise; majority of figures reserved but certain areas of drapery and bodies also enamelled; although there are no translucent colours, M includes areas of speckled enamel, where glass granules of separate colours have been fired together, e.g. in M6a (the chest and lid of the tomb, respectively purplish and yellowish); all line drawing and inscriptions filled with dark blue glass, except on bowl, where inscriptions are in red; *h* 195 mm; *diam* (of bowl) 155 mm

c. 1160–70

New York, Pierpont Morgan Library

This ciborium is very close in style to the Balfour ciborium, with the same large 'octopus' flowers which are also comparable to the foliage of **61** (Wormald, 1973, pls. 1, 12 and 100–2). The drawing of the figures with large expressive heads, dynamic poses and linear draperies schematized into panelled folds with nested V-folds would seem to be somewhat later than the earliest drawings in the Winchester Bible (**64**). The Morgan ciborium is particularly important for the insight that it provides into the sources of this 'ciborium workshop' within the circle of the Master of the Stavelot Portable Altar: not only the technique and palette, including the enamelling of some of the figures and draperies, but also the use of circular 'panels' behind scenes are derived from this Mosan milieu. On the other hand, the drawing style is wholly Insular.

The 'Morgan ciborium' has sometimes been referred to as the 'Malmesbury ciborium', a name based on an insubstantial oral tradition, which may well be actively misleading: the style of this artist is not related to the Malmesbury porch sculptures.

N.S.

PROVENANCE First recorded in the collection of the Revd G.W. Braikenridge 'said to have originally belonged to Malmesbury Abbey', 1862; sold with the collection of W. Jerdone Braikenridge, of Claremont, Clevedon (Somerset), Christie's 27 February 1908, lot 50; purchased by J. Pierpont Morgan from the Hoentschel Collection, 1911

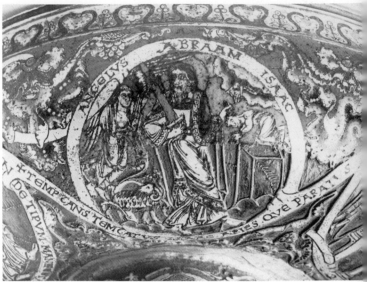

279 (detail: B3)

279 The Balfour ciborium

Scenes and inscriptions, arranged as on M, reading anticlockwise:

On the cover: [B1a] the *Baptism of Christ*, cf. M3a; [B2a] *Christ carrying the cross*, cf. M4a; [B3a] the *Crucifixion* (+ IN CRVCE MACTATVR.PERIT.ANGVIS OVIS.REVOCATVR ('He is slain on the cross, the serpent perishes, the sheep is reclaimed'); [B4a] *The holy women at the sepulchre*, cf. M6a; [B5a] the *Harrowing of Hell* (+ MORS.HOMINE(M) STRAVIT. DS HA(N)C. LIGAT hVNC RELEVAVIT. ('Death overthrew mankind. God binds death fast and has raised up mankind once more'); [B6a] the *Ascension* (+ QVO CAPVT ASCENDO MEA MEMBRA VENITE. SEQVENDO ('Where I ascend as your head, you the members of my body must follow').

On the bowl: [B1b] the *Circumcision of Isaac*, cf. M3b, W3; [B2b] *Isaac carrying the wood to his sacrifice*, cf. M4b, W4; [B3b] the *Sacrifice of Isaac* (+ TEMPtANS TEMtATVS ISAAC ARIES QVE PARATVS ('The test has been overcome, here is Isaac, and the ram appears'); this line is incomprehensible without its sequel, which refers to the ultimate sacrifice of the ram; cf. W5; [B4b] *Samson and the harlot of Gaza*, cf. M6b; [B5b] *David slaying the bear* (+ VRSVS :OVEM.LEDIT DAVIT IVVAT hV(N)C Q(VO)Q(VE) CEDIT ('The bear wounds the sheep. David comes to its rescue and kills the bear'), cf. **281**, where as here the scene of rescue is paralleled by the *Harrowing of Hell*; [B6b] *Elijah's ascension* (+ IGNEVS.HELIAM.CVRRVS LEVAT AD ThEORIAM ('The fiery chariot lifts Elijah to the heavens').

Extensive areas of damage to enamel and gilding, particularly of the bowl; palette as on M but without M's circular enamelled areas behind scenes; backgrounds reversed between bowl and cover: in medallions, azure blue (cover), green (bowl); in spandrels, green (cover), azure blue (bowl); *h* 180 mm, *diam* (of bowl) 159 mm, (of foot) 82 mm

c. 1160–70

London, Victoria and Albert Museum, M.1.1981

For a discussion of the style and dating, see the Morgan ciborium (**278**). Only the distribution of colours and the areas of the figures chosen to be enamelled rather than reserved differentiate the Balfour from the Morgan in style. Both share the same vigorous, linear manner of drawing, while the

280 (detail: W5)

the ciborium before 1871, it is clear that the palette was as on M and B, and that the line-drawing of figures, buildings, etc. was filled with red enamel; rim with a simple motif of repeating leaves; four equally-spaced double pin-marks on the rim prove that the bowl was never hinged or clasped, but clipped to the cover; *h* 116/117 mm, *diam* (of bowl) 196 mm, (of foot) 100 mm

By a Mosan or north French goldsmith; third quarter 12th century

London, Victoria and Albert Museum, M.159–1919

This is the largest of the three ciboria and in some ways the masterpiece of the group. In spite of its sadly damaged condition, the quality of the drawing can still be appreciated. The technique, iconography and inscriptions prove that it was made within the same workshop tradition as the Morgan and the Balfour ciboria, presumably employing a common model-book. But the foliage is here drier and more schematized, the figure style totally different: heads are minutely observed and framed by flowing hair, bodies are swathed in draperies that model the figure rather than reduce it to pattern, firm swags of cloth form supple curves and loops. The antecedents of this artist's style can be seen on the Liège font and the shrine of St Hadelin at Visé; his contemporary parallels are to be found in Mosan and northern French manuscripts, enamels and stained glass, such as windows from Troyes (Grodecki, Brisac, 1977, no. 104, ill. 121) and manuscripts from St-Omer. A significant comparison can be made between the scenes of the *Sacrifice of Isaac* (W5 and B3b); W omits the angel who arrests Abraham's sword in the act of striking his son and substitutes a hand which emerges from clouds, thus adding a second hand to the Hand of God which already exists as part of the scene at the top right. This omission of the angel on W creates a confusion which does not exist on B, and this in spite of the fact that W is physically larger. Such an iconographic reduction suggests that the artist of W was working from an alien model-book, and this supposition lends strength to the foreign comparisons already proposed for his figure style.

The Warwick ciborium was first recorded, its cover already lost, in a watercolour by John Talman (d. 1726) (Society of Antiquaries, Harleian Collection, vol. II, f. 30, cf. Oxford, Bodleian Gough Maps 43, no. 84, a similar watercolour). On the verso is a pen inscription: 'It was bought about August 1717 out of a Brasier's shop in London and is now in the possession of Mr George Holmes Deputy-Record-Keeper in the Tower of London.' By the time it was exhibited at Manchester in 1857 it had already suffered considerable damage; according to the catalogue, '. . . the enamels are unfortunately nearly all destroyed.' It was further damaged in a fire at Warwick Castle in 1871. N.S.

PROVENANCE Bought by George Holmes, 1717; collection of the Earl of Warwick, before 1856 (Shaw); on loan to the Victoria and Albert Museum, 1917; purchased 1919

iconography of their common scenes is identical: there are no less than seven of these, out of 12. Compare, for instance, the *Baptism of Christ* (B1a) with M3a. Both ciboria are certainly by the same artist.

No documentary evidence seems to exist for the traditions associating the Balfour ciborium with earlier Scottish history, first with King Malcolm Canmore (1056–92) and, later, with Mary, Queen of Scots (Constable). By the time it was first exhibited in Edinburgh in 1856, it had been in the possession of the family of the Balfours of Burleigh for a considerable period; it has been variously called the 'Bruce ciborium', the 'Kennet ciborium' and the 'Balfour of Burleigh ciborium', after the names of the Balfour family and its estates. N.S.

PROVENANCE Balfour family of Burleigh, by 1856; on loan to the Victoria and Albert Museum, 1924; acquired by the museum with the aid of a grant from the National Heritage Memorial Fund, 1981

280 The Warwick ciborium (*illustrated also on p. 76*)

Cover lost; scenes on bowl arranged as on M and B but with inscriptions running in a continuous band beneath top border, reading anticlockwise:

[W1] *Moses and the burning bush* (+ QVI VELVD ARDEBAT RVBVS Et NO(N) IGNE CALEBAT ('Just as the bush was burning yet not consumed by the fire'); this line refers to the Virgin birth and must formerly have prefigured the scene of the *Nativity* on the cover, cf. 281); [W2] the *Sacrifice of Cain and Abel*, cf. M2b, i.e. it was parallel to the *Presentation in the Temple*; [W3] the *Circumcision of Isaac*, cf. M3b, B1b, parallel to the *Baptism of Christ*; [W4] *Isaac carrying the wood to his sacrifice*, cf. M4b, B2b, parallel to *Christ carrying the cross*; [W5] the *Sacrifice of Isaac*, cf. B3b, parallel to the *Crucifixion*; [W6] *Jonah and the Whale* (+ REDITVR Vt SALVVS QVE(M) C[]TI CLAVSERAt ALVVS ('As he has returned safe whom the belly of the whale had imprisoned'); this is the first line of a couplet (cf. 281) referring to the Resurrection, so that the scene of *The Holy Women at the tomb* was certainly its parallel on the lost cover.

Most of enamel and gilding destroyed in 1871, after which the foot was reattached to the cup; it was also given a new base-plate on to which the ruined medallion with the Lamb of God was soldered, before being reset into the broken centre of the cup; from traces of enamel and from watercolour views of

281 Verses originally painted in the chapter house at Worcester (not illustrated)

Worcester Cathedral, Chapter Library, MS F.81, ff. 233ᵛ–234

The manuscript is exhibited here firstly as evidence for a large-scale cycle of typological wall-paintings in 12th-century England, comparable in its ambitious scope to the choir aisle glazing at Canterbury Cathedral (91 and 92) and to other lost cycles, as at Bury St Edmunds, and secondly because many of its verses occur on the three enamelled ciboria, 278, 279 and 280, and thus suggest that their tiny roundels reflect a monumental prototype, perhaps even a lost cycle at Worcester, and are certainly of English manufacture.

The main text of the book, dated by Ker (1964) to the first half of the 12th century, is St Jerome's commentary on the Psalter, which ends on the exhibited verso with Psalm 150. A single folio already ruled was left spare at the end of this final gathering, and on to this in the late 12th century was copied a long series of verses, which ends half-way down the left column of f. 234ᵛ (not visible as exhibited).

The series begins at the top of the left-hand column of the exhibited recto with a heading in red ink: versus capituli/In circuitu dom(u)s ('the verses of the chapter [or of the chapter house]. Around the walls of the house'). There follow 18 Leonine hexameters, which ask the spectator to 'look upon these pictures' and learn their message: what the old law foreshadowed, the life of Christ and his mother brought to fulfilment. The rest of the left-hand column and the whole of the right-hand column continue with groups of lines, mostly Leonines but with the occasional elegiac couplet, in sets of two, three and four lines, each captioned in red ink on the right with a heading, referring to the scene for which they were composed as an inscription: for example, the first heading is de Nativitate Christi, followed by four lines which comment on the Nativity.

Throughout the poem, a New Testament episode is followed by three Old Testament scenes, introduced as its typological counterparts. There are ten complete groups of OT/NT inscriptions. They seem to have been copied from the walls of the circular Norman chapter house at Worcester, which is divided into ten bays (James). Wilson plausibly suggested that each inscription related to a painting in a medallion, four per bay, on the triangular groin-vaults which radiated from the central pier of the chapter house. The precise date of the lost paintings at Worcester is not known, though the chapter house itself dates from the first quarter of the 12th century (Stratford, 1978). Some of these verses also occur around a series of medallions on 12 pages of 13th-century date in Eton College MS 177 (ten are illustrated in Wilson, pls. I–X) and in the Sherborne missal of 1396–1407 (illustrated in The Sherborne Missal, introduction by J.A. Herbert, Roxburghe Club, 1920).

N.S.

BIBLIOGRAPHY James, 1898–1903, pp. 99–115; J.K. Floyer, S.G. Hamilton, Catalogue of MSS . . . of Worcester Cathedral, 1906, p. 41; Canon Wilson, 'On Some Twelfth-Century Paintings on the Vaulted Roof of the Chapter House of Worcester Cathedral', Associated Architectural Societies' Reports and Papers, XXXII, 1913–14, part I, pp. 132–48; ed. I. Atkins, N.R. Ker, Catalogus Librorum MSS. Bibliothecae Wigorniensis made in 1622–23 by Patrick Young, 1944, p. 32 (no. 4); Cox, 1959, pp. 165–78; Ker, 1964, p. 211; Strohm, 1971, particularly pp. 184–6; Stratford, 1978, pp. 51–70; N. Stratford 'Three English Romanesque Enamelled Ciboria,' Burl. Mag., April, 1984

282 The Chartres crosier (not illustrated)

Copper, the stem and crook cast, the knop hammered: champlevé, engraved, punched, enamelled and gilded; short lower stem with inscription: + FRATER WILLELMVS. ME FECIT ('Brother William made (or commissioned) me').

Knop, made in two hemispherical sections, enamelled with four scenes based on 1 Samuel. XVI–XVII, in roundels formed by branches, with inscriptions alternately on the upper and lower branches reading anticlockwise: 1. the young David harping, while anointed from a horn of oil by Samuel (+ SCRIBE FABER LIMA. DAVID hEC FVIT VNC[– –] TO PRIME ('Write, workman, with your file. This is David's first anointing')); 2. David with a shepherd's crook and sling, faces the armoured Goliath who holds a tall spear and a kite-shaped shield (+ HIC FVNDA FVSVS. P(RO)PRIIS. MALE VIRIBVS VSVS. GOLIAS. CECIDIT. ('Here laid out by a sling, after ill-using his proper strength, Goliath is slain'; the last two words are inscribed below 3.)); 3. David grips the fallen Goliath's head, which he is about to strike off with Goliath's sword (+ DAVID.HIC.CAPVt.ENSE.RECIDIT ('Here David cuts off the head with a sword')); 4. David with a shepherd's crook rescues a lamb from the mouth of the lion (+ VRSE CADIS.VERMI DATVS A PVERO.S: INERMI.('O bear, you fall, given to the worms by an unarmed boy')).

Crook, cast, ending in a beast's head with glass beads set in the eyes, is a near-contemporary repair, pinned irregularly over upper stem, with some splitting at join; circular upper stem enamelled with a lattice which frames, alternately, flowers and figures: (from the bottom) two zones, with Virtues in combat, victorious over Vices, identified by inscriptions: Faith (FIDES) and Idolatry (IDOIATRIA); Modesty (PUDITICIA) and License (LIBIDO); Charity (CARITAS) and Envy (INVIDIA); Sobriety (SOBRIETAS) and Lust (LVXVRIA); Generosity (LARGITAS) and Avarice (AVARITIA); Concord (CONCORDIA) and Discord (DISCOR[– –]A); above, four zones enamelled with fabulous creatures and grotesques. On knop, not only grounds but most of draperies and attributes are enamelled, whereas on upper stem, figures and attributes are reserved, only backgrounds and flowers enamelled; palette: white, yellow, pale green, deep green, turquoise, grey-blue, pale blue, azure blue, opaque bright red, dark red; on knop, backgrounds azure blue with green spandrels, figures brilliantly enamelled against these dark grounds, with much use of white and grey-blue, and accents of bright red; on stem, backgrounds behind flowers azure blue emphasizing the brilliance of the enamelled blossoms; behind figures, dark red and pale blue used; line drawing filled with blue enamel except where dark red is used for the grotesques; inscriptions also filled with blue, except Willelmus inscription in turquoise; h 224 mm, w (of crook) 90 mm, diam (of knop) 64 mm

c. 1170

Florence, Museo nazionale del Bargello, Carrand Collection, no. 662 (303–763)

This crosier is sometimes mistakenly known as the 'Ragenfroi crosier', after a 10th-century bishop of Chartres. The beast-head terminal of the crook is clearly a mend, although it must be near-contemporary with the rest of the crosier; it is roughly pinned onto the enamelled stem, where it abruptly cuts through the main lattice of grotesques. Simple crosiers with beast-heads have been discovered in several 12th-century French tombs, although the type is certainly not exclusively French. Nevertheless this French group lends support to the tradition that the crosier was found in a tomb at Chartres, although no solid documentary evidence has so far been discovered. In any

283

case, the knop and stem of this crosier are English, probably
by two different artists. The drawing of the *David* scenes is
marvellously assured. Their iconography has been compared
with scenes in the Dover Bible (Campbell). In layout they relate
to the Morgan and Balfour ciboria (**278** and **279**), although
their palette is totally different. Even so, the use of white with
pale grey, and areas of bright red, suggest, as with the ciboria,
a common debt to the Mosan workshop of the Master of the
Stavelot Portable Altar. The foliage of the crosier also differs
from the ciboria in being less exuberant, with thinner stems,
which even pierce each other and sometimes end in tight tufts,
as on the Boston casket (**284**). One scene, *David and the bear*,
is common to the crosier and the Balfour ciborium but its
composition and inscription do not coincide in detail.
Nevertheless, on technical grounds the knop must be the work
of an artist related to the Master of the two ciboria. The stem
of the crosier is markedly less assured in its drawing. Its close
connection with the Troyes casket has long been recognized
both for the iconography of the Virtues and Vices and in its
drawing-style; this connection is discussed in the notes on **283**,
which is attributed to the same artist, from a West Country
context *c*. 1170. Finally, the stem of the Whithorn crosier (**285**)
has the same lattice arrangement, with punched borders, the
same blossoms, a closely similar palette and the same repertoire
of grotesques. N.S.

PROVENANCE First recorded in 1839 (Willemin), in the Cabinet of M. Crochard at Chartres
and said to come from a tomb in the abbey church of St-Père, Chartres; subsequently in the
collections of Francis Douce; Samuel Meyrick; Jean-Baptiste Carrand (1792–1871); left to
Florence by Louis Carrand, 1887; acquired 1889
EXHIBITIONS Manchester, *Art Treasures*, 1857 (see Augustus W. Franks, 'Vitreous Art', pp. 20–
1, in ed. J.B. Waring, *Art Treasures of the United Kingdom from the Art Treasures Exhibition,
Manchester . . .*, 1858); Barcelona, 1961, no. 546
BIBLIOGRAPHY Willemin, Pottier, *Monuments français inédits*, 1839, I, pp. 21–2, pl. XXX; de
Mély, *La Crosse dite de Ragenfroid* (extract from *Gazette Archéologique*, 1888); Chamot,
1930, no. 15, pl. 3a; Katzenellenbogen, 1939, p. 21 (n. 3); Saxl, 1954, p. 63, n. 68; Swarzenski,
1954, figs. 451, 452; Cox, 1959, pp. 175–8; Lasko, 1961, p. 496; Oman, 1967, pp. 299–300,
fig. 40; Gauthier, 1972, pp. 158, 361–2 (no. 113); Campbell, 1979, pp. 364–9, figs. 37–41, 45–7

283 The Troyes casket

Rectangular box (lid lost), constructed from copper plaques,
hammered, *champlevé*, engraved, punched, enamelled and
gilded; formerly hinged, with front clasp; sides decorated with
twelve groups of Virtues in combat, victorious over Vices, each
pair set within castellated arcading and identified by
inscriptions along the top and bottom edges of the casket;
columns, bases, capitals and arches engraved in sunk relief, and
gilded: capitals and bases with fluted leaf decoration, except
central capital (front and back), which has two pendant angle
leaves; columns alternately chiselled with scalloped decoration
and pricked with rows of dots; arches chiselled with engraved
leaves above an enamelled band; the female crowned Virtues
are reserved, except for certain attributes (crowns, shields);
they are dressed in long robes and attack the Vices with spears,
swords, a whip and a mace, several of them holding round or
kite-shaped shields; the Vices, again in reserve, are usually
shown naked and unarmed, in all manner of contorted poses:
trampled, stabbed in the mouth or eye, bound, gripped by the
hair; rows of pricked dots are used freely to decorate hems,
crowns and attributes; the pairs are (from left to right): (front)
Gentleness (MANSVETVDO) and Wrath (IRACVNDIA); Sobriety
(SOBRIETAS) and Drunkenness (EBRIETAS); Frugality
(PARSIMONIA) and Debauchery (GANEA); Charity (CARITAS)
and Hatred (ODIVM); (right end) Pity (MISERICORDIA) and
Impiety (IMPIETAS); Truth (VERITAS) and Falsehood
(FALSITAS); (back) Faith (FIDES) and Idolatry (IDOLATRIA);
Humility (HVMILITAS) and Pride (SVPERBIA); Generosity
(LARGITAS) and Avarice (AVARICIA); Chastity (CASTITAS) and
Lust (LVXVRIA); (left end) Forbearance (PACIENCIA) and
Anger (IRA); Concord (CONCORD(I)A) and Discord
(DISCORDIA); the roughly-cut inscriptions, with a few
minuscule letter forms, are original; compare the lettering on
the Florence crosier (**282**); the enamelled backgrounds are of
opaque pale blue and azure blue, translucent deep green and
dark red; only limited use of mixed enamel (for the ground,
shields, crowns, arches and castellated architecture), always

with white; unusually, there is no yellow glass; engraved on the base: M + I + REGИAVLT, above a wreathed shield, which consists of: on a chevron, between in chief two wings and on base a palm branch in pale, a rose; *h* 51 mm, *l* 103 mm (max), *d* 49 mm

c. 1170

Troyes, Cathédrale de Troyes

Probably for secular use, this exquisite small-scale masterpiece was already associated in 1861 (Le Brun) with the Florence crosier (**282**); it is decorated with similar groups of the Virtues and Vices in combat, although the pairings differ in detail. The iconography, as well as the technique of enamel, engraving and punching, mark the two works as close cousins. Indeed, Lasko believed that they were 'by the same hand'; the drawing on the crosier is less assured but this is probably due to the difficulty of engraving on narrow, steeply curved surfaces, so that Lasko's claim may be accepted.

The theme of the conflict between Virtues and Vices was universally popular in the early Middle Ages, not only through the dissemination of Prudentius manuscripts (such as **16**) but also within the framework of contemporary sermons and other moralistic texts. The Troyes casket belongs to a tradition of representing not the narrative of Prudentius' epic poem but a universal victory, although there is nothing generalized about the way the Virtues attack their victims 'with rarely paralleled violence' (Katzenellenbogen). Little attempt is made to

differentiate the Vices, except with Drunkenness, who is shown trying to pull a broken spear from his mouth. The casket and the Florence crosier belong to a specifically West Country series of the Virtues and Vices: on the outer south doorway at Malmesbury (early 1160s) and on two fonts at Southrop in Gloucestershire and Stanton Fitzwarren in Wiltshire of *c.* 1180 (Zarnecki, 1953a, figs. 96–8). Their drawing style would place the two enamels at an intermediate stage *c.* 1170, earlier than the Glastonbury Lady Chapel north door of *c.* 1184–6, which however still retains certain features of their style. The Bridlington statuette (**162**) is a parallel manifestation of the same stylistic phase.

The M.I. Regnault of the inscription on the base of the box, probably of 16th- or 17th-century date, has not been identified, since the name is extremely common in the Départements of the Aube and the Yonne (the arms are probably those of a Regnault de Beaucaron) (see Regnault de Beaucaron, *Donations et fondations d'anciennes familles champenoises et bourguignonnes 1175–1906*, 1907, pp. 9–23, 521). The casket is first recorded in 1861 in the possession of the Abbé Tridon, who presented it to the Cathedral Treasury. N.S.

PROVENANCE Regnault family; Abbé Tridon; Troyes Cathedral Treasury, 1861
EXHIBITIONS Paris, Exposition universelle, 1900, official catalogue, p. 292 (no. 2420); Barcelona, 1961, no. 547; Paris, 1965, no. 174
BIBLIOGRAPHY A. Gaussen, *Portefeuille Archéologique de la Champagne*, 1861, pp. 10–16; pl. 17, no. 1 (text by Eugène Le Brun); Chamot, 1930, p. 33; Katzenellenbogen, 1939, p. 21, fig. 21; Saxl, 1954, pp. 75–6 (n. 68); Swarzenski, 1954, fig. 454; Cox, 1959, pp. 175–8, pl. LVIIc; Lasko, 1961, p. 496; Green, 1968, p. 155 (n. 50)

284

284 The Boston casket

Constructed from copper plaques, hammered, *champlevé*, engraved, punched, enamelled and gilded; rectangular box, with hipped roof, formerly on two hinges with a front clasp; four gilt copper feet (modern?); hole in centre of roof for suspension loop (cf. **287**); roof decorated with foliage designs: fully enamelled with a symmetrical pattern of interlacing branches against a reserved ground (on the central plaque), and partly enamelled, stems and the edges of leaves reserved and punched against an enamelled ground (on the framing plaques); a varied range of enamel glasses (white, yellow, pale yellow-green, apple green, turquoise, two blues, opaque red and purple) used in mixed combinations for the flowers, without symmetry except in the framing fields where azure blue fills the backgrounds, while green and translucent purple alternate behind the blossoms themselves; box sides decorated with foliage scrolls enclosing 10 roundels, which frame: (front) two goats standing on their hind legs facing each other, and two quadrupeds, the left one with a monkey's head and wearing a cap; (ends) two affronted griffins and two addorsed quadrupeds; (back) a lion, a rabbit and a centaur with bow and arrow; figures and foliage stems reserved, engraved, punched and gilded against enamelled grounds of turquoise and azure blue, only the flowers being modelled with mixed enamel combinations; unusually, no use of dark green or lilac glasses; extensive areas of damaged enamel; *h* 53/55 mm, *l* 109 mm, *d* 68/69 mm

c. 1170

Boston, Museum of Fine Arts, 52.1381, Helen and Alice Colburn Fund

The box was probably made for secular use, although exotic beasts also occur on the Florence and Edinburgh crosiers (**282** and **285**). The enamelled blossoms of the roof are relatives of the flowers on the Morgan and Balfour ciboria (**278** and **279**), but here all is tidier, there is less exuberant vegetable growth, the stems are thinner; on the sides of the box, the flowers have even become small tufts and the stems pierce each other, as in the foliage on the knop of the Florence crosier (**282**). Near-contemporary are the initials in the Bosham manuscripts, and in manuscripts from St Albans, Durham and Norwich, which date from the 1160s–80s (**69–70**, **77**, and **78**); these books continue to employ large blossoms but combine them with tightly-coiled and tufted stems, as well as exotic animals in roundels (Kauffmann, 1975, ills. 286–7, 289). Although the fantastical subject-matter of the casket was popular for calendar illustration (**23**), it is with the illustrated bestiary that it can most obviously be paralleled (see **84**, **85** and **86**). Compare also the fabulous subjects which decorate the south doorway at Barfreston (Kent), *c.* 1180 (Zarnecki 1953a, figs. 87–90). The enamelling of the Boston casket, particularly of the roof, is of great beauty, a salutary reminder of how much secular patronage no doubt contributed to the livelihood of the best artists in 12th-century England. N.S.

PROVENANCE Debruge Duménil Collection, by 1847 (Jules Labarte, *Description des objets d'art qui composent la collection Debruge Duménil*, 1847, p. 581 (no. 680)); possibly in Soltykoff sale, Paris, 8 April, 1861, lot 91; and in Mannheim sale, Paris, 17 April 1868, lot 1; collection of Mme Jules Frésart, Liège, by 1905; purchased through the Alice and Helen Colburn Fund, 1952.
EXHIBITIONS Liège, *L'art ancien au pays de Liège*, 1905, general catalogue, no. 279, illustrated; Liège, *Exposition de l'art de l'ancien pays de Liège et des anciens arts wallons*, 1930, no. 179; New York, 1970, no. 170
BIBLIOGRAPHY *Bulletin of the Museum of Fine Arts*, Boston, LV, nos. 301, 302, autumn–winter 1957, p. 78, fig. 28; Marks, 1970; Campbell, 1979, p. 367, fig. 48; Gauthier, 1979, p. 81

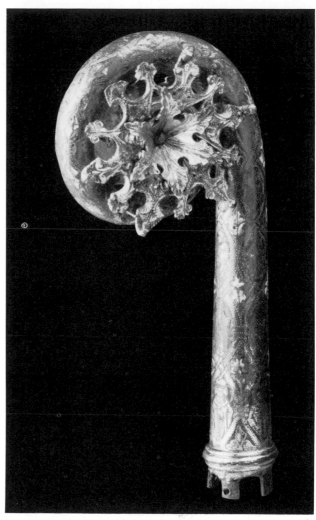

285

285 The Whithorn crosier

Copper, cast and hammered, *champlevé*, engraved and punched, enamelled and gilded; constructed in several pieces: the inner scroll of the crook slots into the outer scroll near the base of the crook; large separately cast blossoms decorate both faces of the crook, each with two layers of leaves joined by a transverse pin, whose head in one case still forms the central ovary of the blossom; the two flowers differ slightly but each consists of two layers of petals and an ovary; the pointed inner petals were intended to cover the gaps between the large three-pronged 'orchid' forms behind them, but these inner petals are now out of alignment; at the base of the crosier-head, a triple moulding and four projecting lugs, with pin-holes for attachment to a wooden inner shaft (part of this was found in the excavation) and a knop (lost), which would have masked the joint between the shaft and the head of the crosier; stem and crook enamelled with a lattice, forming oval fields, its intersections marked by a knot or lozenge; the smaller fields with flowers brilliantly enamelled in mixed combinations of colours on azure blue grounds; palette: white, yellow, two greens, turquoise, two blues, lilac, bright opaque red and dark translucent red; the oval fields decorated with reserved figures, against dark red or dark green backgrounds, their engraved lines filled with red enamel; from the bottom, in five zones, each with four figures: 1. half-length bishops, one with halo;

2. standing figures with scrolls, one of whom seems to be writing; 3. seated figures, with books or scrolls; 4. standing figures, at least one female and holding a scroll; 5. seated figures; the remaining zones, which continue around the outer scroll of the crook, show grotesques and exotic animals; damaged condition of the upper parts makes further identification impossible; *h* 193 mm, *w* (of crook) 90 mm
c. 1180–90
Edinburgh, National Museum of Antiquities of Scotland

From the associated finds, it is clear that the crosier was buried long after the period of its manufacture. Therefore its Whithorn provenance does not help with the problem of where it was made or of the identity of the bishops on the lower stem. For Whithorn, a see re-founded probably *c.* 1128 from York, see also 310. Typically English are the big blossoms of the crook, like those of 61. The lattice layout, with pricked borders, the enamelled flowers and the grotesque animals provide a direct link with the Florence crosier (282), which however seems to be somewhat earlier in date. In spite of the damaged condition of the crosier, the elegantly drawn figures in their voluminous, softly-modelled garments can still be appreciated. They recall certain standing and seated voussoir figures on the Glastonbury Lady Chapel's north door, *c.* 1184–6 (Zarnecki, 1953a, figs. 129, 130). This West Country comparison is significant, since the iconography of the Florence crosier also has West Country connections (see 282 and 283). N.S.

PROVENANCE Excavated in the wooden coffin of an unidentified bishop in the east end of the Premonstratensian Cathedral Priory church of Whithorn, Galloway, 1964; associated finds included a silver Gothic chalice with hexagonal foot (information Mr Ritchie)
EXHIBITION Edinburgh, 1982, B26
BIBLIOGRAPHY Oman, 1967, pp. 299–300, figs. 36–44; Campbell, 1979, pp. 367, 369, fig. 42

286 Fragment, formerly enamelled

Copper, hammered, *champlevé* for enamel; a figure clambering among branches; *h* 47 mm, *w* 46 mm
Last quarter 12th century
Winchester City Museum; Winchester Research Unit,
BS.SF.153

This sadly mutilated fragment, from which not only the enamel but also the engraved and gilded surfaces have been erased, provides important archaeological confirmation for the attribution to England of a beautiful enamelled casket in Florence (not exhibited, illustrated in Swarzenski, 1954, fig. 489). The Winchester fragment probably formed part of a similar secular casket. N.S.

PROVENANCE Found in Lower Brook Street, Winchester, 1965, in a 15th-century context

286

287 The Liberal Arts casket (*illustrated on p. 74*)

Constructed from copper plaques, hammered, *champlevé*, engraved, punched, enamelled, soldered together and gilded; rectangular box, with hipped roof, formerly on two hinges; front hasp and staple, and the suspension ring in the roof not original.

Roof decorated with geometric designs of foliage (most of the enamel lost): a lattice framing enamelled flowers, quatrefoils and trefoils at the interstices, the frame of the lattice mauve studded with white dots and edged with white (in the central field); two patterns in the framing fields: reserved or enamelled four-petal flowers (white/turquoise/azure blue) and rows of scalloped petals (white/yellow/green/turquoise/pale blue/deep blue/lilac); box sides decorated with six medallions, containing personifications of the Liberal Arts with Philosophy and Nature, each figure identified by an inscription; sprays of foliage in the spandrels; extensive areas of damaged enamel; figures, medallions and the edges of leaves reserved, engraved (their lines filled with blue or red glasses), punched and gilded; backgrounds and flowers enamelled with a wide range of colours, often in mixed combinations with white; outside the medallions, the backgrounds alternated between azure blue and turquoise; within the medallions, translucent glasses survive (deep green, dark blue and dark red), the translucence due to bubbles and cracks in the glass acting as reflecting agents (British Museum Laboratory report 1982); three medallions include areas of speckled enamel (granules of several colours, predominantly turquoise, fired together).

The seated figures are: (front) left, Grammar, a woman with a switch and her boy pupil holding a parchment (GRAMATICA); right, Rhetoric, a man holding scales, and Music, a woman playing a psaltery (RETORICA.MVSICA); (back) left, Arithmetic gazing downwards attentively at a board, and Geometry with a pair of compasses (ARISMATICA.GEOMETRIA); right, Astronomy, back turned to the spectator, holding up an astrolabe, and Dialectic, a woman with an arrow pointing from her mouth (ASTRONOMIA. DIALETICA); (on the left end) Philosophy, a crowned figure seated frontally holding a sceptre and a disc, which is divided into three segments (blue, red and white) and inscribed with 3 letters, probably for pi and theta (PHILOSOPHIA); (on the right end) Nature, a seated woman with bared breast, suckling Knowledge, a small figure kneeling beside her (NATVRA. SCIENCIA); *h* 59/61 mm, *l* 100/101 mm, *d* 51/53 mm
c. 1180–1200
London, Victoria and Albert Museum, M.7955.1862

The iconography has several unusual features (Evans): Rhetoric is shown as a man and holds the scales usually attributed to the Cardinal Virtue, Justice; the back-turned pose of Astronomy and Dialectic's arrow are unparalleled; and this is a unique example of Nature suckling Knowledge as a parallel to Philosophy. Evans concludes: 'In this elegant and iconographically abstruse *objet d'art* – perhaps made to hold the writing-materials of a courtly scholar – the *artes* seem to have been introduced as a decorous ornamental motif The designer of the box evidently felt free to treat them with unusual liberty and inventiveness.' Technically also the casket is a virtuoso piece, combining translucent and speckled glasses with a wide range of mixed enamels; it is the most sophisticated of all the English 12th-century enamels. The drawing style of this artist is massively assured. His softly modelled draperies and expressive heads bear all the hallmark of a late-12th-century date, and this is borne out by the use of such a compositional device as the 'classical' pose of

Astronomy with back turned; compare the figures on Nicolas of Verdun's Klosterneuburg pulpit, finished in 1181, and in the Ingeborg Psalter. (See also Margarete Koch, *Die Rückenfigur im Bild, von der Antike bis zu Giotto*, 1965, ills. 32–4, 52.) Yet the enamelled flowers and the punched borders occur in identical form on the Florence crosier (282), the similarity being such as to suggest a common workshop tradition. This masterpiece is worthy to stand beside the greatest European enamels of the later 12th century. Its sadly damaged condition is greatly to be lamented. N.S.

PROVENANCE Soltykoff sale, Paris, 8 April 1861, lot 92, bought by Webb; acquired 1862
EXHIBITION Barcelona, 1961, no. 549
BIBLIOGRAPHY Chamot, 1930, pp. 33–4 (no. 16), pls. 4, 13 (b–c); Swarzenski, 1932, pp. 361–2, ill. 303; Swarzenski, 1954, fig. 488; Lasko, 1961, p. 496; Gauthier, 1972, pp. 14, 315 (no. 1); Lasko, 1972a, p. 239, pl. 280; Evans, 1978, pp. 313–14, pl. 4

288 The Fitzwilliam casket

Roof: a single copper plaque, hammered into four hipped fields, *champlevé*, engraved, punched, enamelled and gilded, framing a flat rectangular plaque of *repoussé* silver, into which is set a modern suspension ring; the enamel fields decorated with large blossoms, a repeating leaf border and a lozenge pattern filled with stylized foliage; palette: white, yellow, green, turquoise, pale blue, azure blue, lilac, purple, opaque red; probably repolished and regilded in the 19th century; borders and reserved areas stippled or decorated with a small circular punch; the silver central plaque *repoussé* with a repeating foliage pattern, cut down at the left edge, decorated like the enamels with the small circular punch around its sides; box: of wood (modern), to which are pinned gilt-copper *repoussé* plaques, decorated with elegant sprays of foliage and berries; beaded top border; over the edges of these plaques are pinned six silver semicircular *repoussé* plaques with half-length angels (or Virtues), each holding a book and gesturing with one hand; both semicircular silver and copper spandrel plaques cut down; not originally made for a box of this size; repairs to hinges, modern silvered copper base-plate and feet, front clasp lost; *h* 57 mm, *l* 110 mm, *w* 58 mm
Repoussé plaques Mosan, *c*. 1170; enamels English, late 12th century
Cambridge, Fitzwilliam Museum, M.27.1904

The original function of the casket can no longer be deduced, since its wooden interior is modern. Although its first known appearance is in 1862, the casket is unlikely to be a 19th-century pastiche (Sauerländer). The English pedigree of the roof enamels is evident; compare 289, which shares the same foliage, punched and stippled border patterns and even the same remarkable dark translucent enamel colours. By analogy a date late in the 12th century is probable. On the other hand, the *repoussé* angels are closely similar to figures on the reliquary of the arm of Charlemagne (Louvre), a Mosan work dating from *c*. 1166–70 (Stuttgart, 1977–79, no. 538, ill. 328), while the spandrel foliage confirms this Mosan origin. The foliage of the silver plaque on the roof can also be compared with the Charlemagne arm-reliquary. All this *repoussé* work evidently goes together and is reused from some other object. Since the roof enamels must by definition have been made for a box of these very dimensions, and since they require a flat central plaque, since the present central plaque is one of the *repoussé* plaques, cut down for its present position and then given the punched border common to the roof enamel plaques – and since it would be a remarkable coincidence if a 19th-century faker had found a set of Mosan plaques of almost exactly the right date to mount on a box of almost exactly the right size, it is probable that the present assemblage is substantially that of the late 12th century, repaired in the 19th century. The historical significance of the Fitzwilliam casket is therefore considerable; it provides evidence of the direct re-use of the best near-contemporary Mosan metalwork by an English enamel workshop. For evidence of a major Mosan artist active in England in the 12th century, see 277, and for the Mosan-derived foliage at Walton-on-the-Hill, see Zarnecki, 1957a, pl. 16. N.S.

PROVENANCE Magniac Collection, 1862; Hollingworth Magniac sale, Christie's, 7 July 1892, lot 496; bequeathed by Frank McClean, 1904
EXHIBITIONS Manchester, 1959, no. 95; Barcelona, 1961, no. 545; New York, 1970, no. 167
BIBLIOGRAPHY J.C. Robinson, *Notice of the Principal Works of Art in the Collection of Hollingworth Magniac Esq. of Colworth*, 1862, no. 3; Dalton, 1912a, no. 58; Swarzenski, 1954, fig. 499, Zarnecki, 1957a, pl. 17; Saverländer, 1971, p. 515.

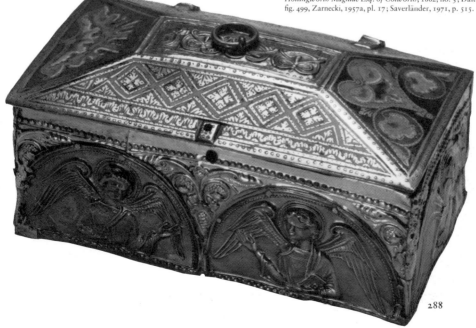

288

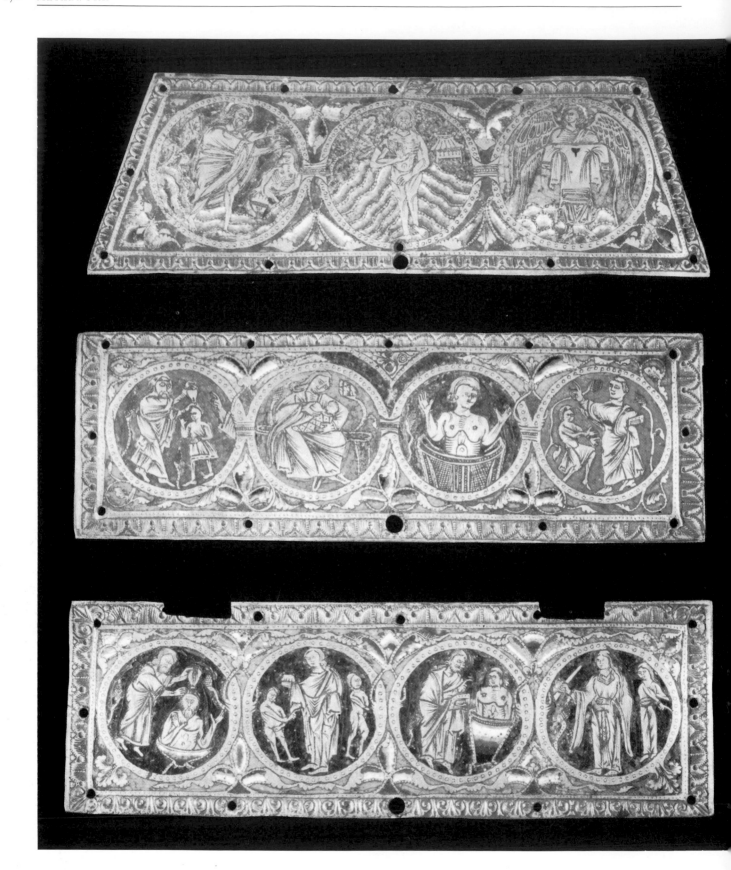

289 a–c Three enamelled plaques from a casket

Plaques from a casket with hipped roof, pinned originally to a metal or wood inner casing (compare the shape of the smaller caskets, **284** and **287**); **a** from the front of the roof, **b** and **c** from the front and back of the box; see the slots and holes for hasp and hinges; copper plaques, *champlevé*, engraved, punched, enamelled and gilded; palette: white, yellow, three greens, three blues, lilac, opaque red, including translucent blues and greens; speckled enamel of yellow/green/blue behind Christ on **a**; borders chiselled with a repeating leaf motif; medallions with sprays of foliage between: **a**, the *Baptism of Christ*, divided between three medallions: (from left) the personification of the River Jordan with upturned amphora beside St John the Baptist; Christ standing in the Jordan, with the dove of the Holy Spirit hovering in the border above His head, an enigmatic structure in the background, the attendant angel with Christ's garment; **b**, (from left) an elderly man anointing a boy; a seated woman suckling a baby; a young man naked with hands raised in prayer, immersed in a font; a tonsured man with book blessing or instructing a boy; **c**, (from left) the baptism of an elderly man naked in a font (this is baptism both by immersion and by affusion, for water is being poured from an ewer over the head of the baptised); an enigmatic scene with a woman standing between two naked boys; a man immersed in a font being baptised by an elderly man with a book; two women, one holding a lighted candle; **a** *w* 135 mm (top), 167 mm (bottom), *h* 57 mm; **b** and **c** *w* 167/169 mm, *h* 57 mm
c. 1200(?)
Private collection

This casket was apparently connected with the sacrament of baptism. Three of the eight unidentified scenes are of baptism by immersion; compare scenes of the baptism of St Paul by Ananias (Eleen, 1982, particularly pp. 90–1, 106–7). A fourth scene shows a boy anointed with chrism, also part of the rite of baptism. Campbell suggested that this was Samuel anointing David, but it is more probable that the scene is generally representative of the sacrament rather than of a particular biblical episode. The other scenes perhaps refer to catechism or instruction of the young; compare the mother suckling a baby with the same scene on the Liberal Arts casket (**287**), where she is identified as Nature suckling Knowledge. The heavy draperies and massive proportions of the figures suggest a date towards the very end of the 12th century. This artist is less assured than, for instance, the artist of **287**, although the similar layout of the scenes in pricked medallions with the same foliage between suggests a common workshop tradition. Technically the enamelling is of the highest quality. Translucent greens and blues were achieved by firing a thin underlayer of coarse white glass, which acts as a reflecting agent beneath the coloured top surface (British Museum Laboratory report, 1982). The closest comparable enamelling is found on the roof of the Fitzwilliam casket (**288**). However, the use of speckled enamel behind Christ in an assemblage of yellow, green and blue glasses is unique within the group; with the Mosan workshops, speckled enamel is always restricted to details of architecture or furniture to simulate a roughened texture, whereas here it is used for the sky in contrast to the waters of the river Jordan. N.S.

PROVENANCE A.M. Silver; sold Sotheby's 8 May 1935, lot 128; Robert von Hirsch; sold Sotheby's 22 June 1978, lot 225
EXHIBITION Berne, *Kunst des frühen Mittelalters*, 1949, no. 344
BIBLIOGRAPHY Swarzenski, 1954, fig. 491; Campbell, 1979, particularly p. 368, n. 22

290 a–f Six enamel plaques, with scenes from the lives of Sts Peter and Paul

Six rectangular copper plaques (a seventh, not exhibited, in Lyon); grooved beaded borders, four corner pin-holes (**d** also has a regular series of pin-holes down its left side, which may be original); figures, plants, scrolls and buildings reserved, engraved, often decorated with busy punched and hatched patterns, then gilded; a thin reserved 'frame' forms enamelled border strips partly or wholly around the four sides of most of the plaques; the 'frame' is pricked with small dots and occasionally there is a small reserved flower in the corners; mixed enamel in smaller fields, for the border strips, clouds, water, a few draperies; the larger fields (backgrounds, haloes) filled with single colours; much loss of enamel (**a**, **b** and the Lyon plaque restored with coloured pastes in the 19th century); palette: dark blue, turquoise and green dominant, used for backgrounds and haloes, often in alternation; wholly exceptional in the 12th century is the nearly complete absence of red glasses: only on one occasion (**d**) are they used and then only for the engraved line drawing, alternating with the usual dark blue; instead of red, purples and lilacs are freely used, often in combination with white or turquoise, and their presence gives the palette a sombre resonance; another common 12th-century glass which is rarely used here is yellow; however, combined with green, it does occur as speckled enamel for seats; white dots decorate some of the border strips, which have various combinations of turquoise, green, lilac, purple and white; *h* 84/87 mm, *w* 125/128 mm
c. 1170–80

290a St Peter walking on the water, saved by Christ, whose scroll is inscribed: MODICE.F.(idei)Q(ua)R(e) DVBIT(asti) (Matthew XIV. 31: 'O thou of little faith, wherefore didst thou doubt?'); to the right, the miraculous draught of fishes (Luke V, John XXI); plaque heavily restored with modern pastes; extensive areas of the dark blue background and of Christ's halo renewed, but their colour is close to the original fragments of glass which survive in these fields.

Nuremberg, Germanisches Nationalmuseum KG.609

PROVENANCE Collection of Dr med. Hermann von Eelking, Bremen; acquired 1880

290b St Peter affirms Christ's divinity; his scroll inscribed: +TV ES XPS FILI(us) D(e)I VIVI (Matthew XVI. 16: 'Thou art the Christ, the Son of the living God'); he receives the keys of Heaven; on Christ's scroll: +D(ab)O TIBI CLAVES REGNI CELOR(um) (Matthew XVI. 19: 'I will give unto thee the keys of the kingdom of Heaven'); until recently, the plaque was heavily restored just like **a**.

Dijon, Musée des Beaux-Arts, Collection Trimolet no. 1249

PROVENANCE Collection of Anthelme Trimolet of Lyon (1798–1866); acquired 1878 (see E. Gleize, *Catalogue descriptif des objets d'art formant le Musée Anthelme et Edna Trimolet*, 1883, no. 1249)

The next plaque in the series is the Lyon plaque, not exhibited (Lyon, Musée des Beaux-Arts, Objet d'Art D.79, acquired 1880 from the Stein Collection, Paris). It shows St Paul's conversion on the road to Damascus; the words 'Saul, Saul, why persecutest thou me?' (Acts IX. 4) are inscribed on Christ's scroll.

290c The plaque shows St Paul let down in a basket from the walls of Damascus; the inscription along the top reads: +A.FR(atr)IBVS DIMISSVS.E(st).IN.SPORTA. ('He is let down by the disciples in a basket', cf. Acts IX. 25).

London, Victoria and Albert Museum, M.312.1926

For the iconography of this episode, see Erika Dinkler-von Schubert, '"Per murum dimiserunt eum." Zum Ikonographie von Acta IX.25 und 2 Cor. XI.33', *Studien zur Buchmalerei und Goldschmiedekunst des Mittelalters, Festschrift für Karl Hermann Usener*, 1967, pp. 79–92, particularly ill. 5; Eleen, 1982, p. 92 (fig. 166). The same scene occurs in Oxford Bodleian MS Auct.D.I. 13, f.1 (Bodleian, 1951, pl. 16).

PROVENANCE First recorded in the John Edward Taylor Collection, 1897; sold at Christie's, 1 July 1912, lot 62; presented by Mrs H. P. Mitchell, 1926
EXHIBITION London, Burlington Fine Arts Club Exhibition of European Enamels, 1897, case I, no. 8 (catalogue pl. III)

290d St Paul disputing with the Greeks and Jews; at the left, the Apostle as orator; his scroll inscribed: DISPVTABAT CV(m) GRECIS (Acts IX. 29: 'He . . . disputed against the Grecians', an episode immediately following on his escape from Damascus); he is faced by five figures, the front one seated and wearing a Jewish cap, holding a scroll: & REVINCEBAT IVD(aeos) (Acts XVIII. 28: 'He . . . convinced the Jews').

London, Victoria and Albert Museum, M.223.1874

PROVENANCE Purchased from Webb, 1874

290e St Paul among his disciples; the dominant figure of the Apostle is seated in the centre, flanked by two rows of ten nimbed figures, who belong to three of the communities to whom Paul addressed his Epistles; they are named on a long scroll held by Paul, which runs across the plaque, curving upwards at the sides and lending an illusion of depth between

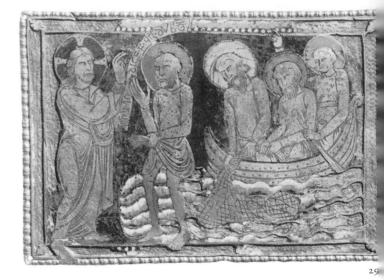

29

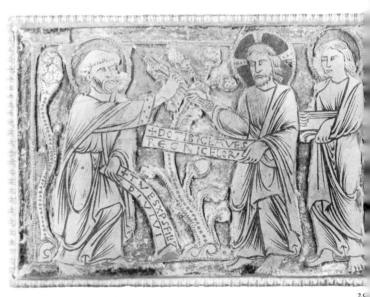

29

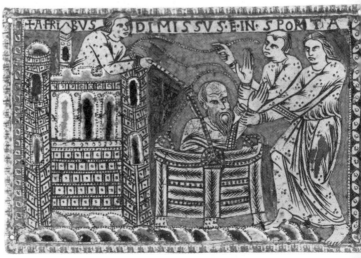

29

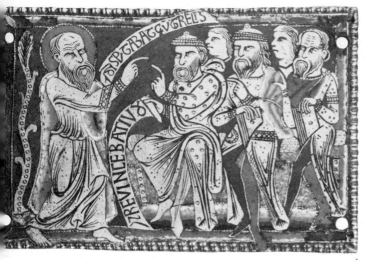

290d

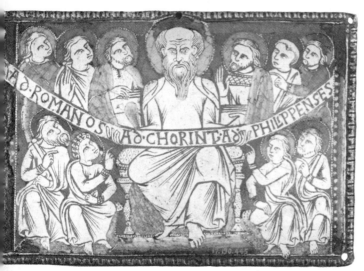

290e

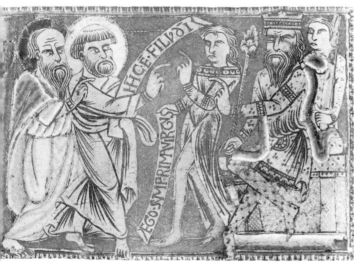

290f

the front and back rows of disciples: AD.ROMANOS AD.CHORINT(hios).AD.PHILIPPENSES. ('To the Romans, to the Corinthians, to the Philippians').

New York, The Metropolitan Museum of Art, 17.190.445.

PROVENANCE John Pierpont Morgan; bequeathed 1917

290f Sts Peter and Paul proclaiming Christ's divinity; Peter's scroll inscribed: IHC.E(st).FILI(us D(e)I ('Jesus is the Son of God', cf. Acts IX. 20); he faces a seated crowned figure, perhaps the Emperor Nero of apocryphal tradition; two attendants, one with a sword, the other with a scroll: EGO.SVM PRIMA VIRTVS ('I am the leading power', cf. Acts VIII. 10).

Dijon, Musée des Beaux-Arts, Collection Trimolet, no. 1250

PROVENANCE As b

All seven plaques must come from the same object, perhaps a large altar antependium or *châsse*. Their narrative subject-matter, with no typological overtones, is based with one exception on the New Testament, from which several inscriptions are directly borrowed. Peter and Paul cycles are rare in Romanesque art. The original destination of the plaques is unknown, for not one can be traced back beyond the 1870s; several first appear in collections whose major sources of supply were the Paris and London art markets. Gauthier drew attention to the parallels between some of the compositions and 12th-century mosaics in Norman Sicily, but the relationship is by no means direct. Four scenes are disputations: a figure on the left advances with arm raised. A fifth (e) has a frontally-seated dominant figure, flanked by two tiers of smaller figures. Both these compositional formulae hark back to Ottonian art. So too does the palette, dominated by purple, dark green, dark blue and turquoise, and as in Ottonian art, coloured 'backdrops' or 'frames' are used behind the scenes, and colours are distributed without reference to the content of a scene: haloes alternate; in e the colours of the mantles of the upper row of disciples alternate to achieve symmetry. But here the Ottonian palette has been transformed in a typically English way; compare the Albani Psalter (**17**). The compositions are also transformed: the sense of enveloping space typical of Ottonian art is here replaced by closely-packed groupings. Not only the drawing style but also the use of 'frames' is comparable to miniatures by the second artist of the Brussels Gregory manuscript, a Mosan work of the third quarter of the 12th century (Helmut Buschhausen, *Der Verduner Altar*, 1980, ill. 37). But certain English manuscripts are even closer: the large, expressively rendered heads can already be paralleled in mid-12th-century manuscripts (Boase, 1953, pls. 51b, c); the draperies still borrow conventions from the 'damp-fold' tradition, but other figures are related to later works. Contrast the archaizing figure of the seated Jew in **d** with the seated Nero in **f**, whose softly-modelled tunic with folds pouched over the waist probably dates from no earlier than the 1170s. Particularly close in style to the New York St Paul is a drawing of Christ in St John's College, Cambridge, MS H.6, f.iiiv (in this exhibition, **66**, but open at another page; however see Mitchell, 1926, pl. IIB), while the St Peter in Nuremberg may be compared with a figure in **84**. The plaques represent a phase of English art in particularly close touch with developments on the other side of the Channel. N.S.

EXHIBITIONS London, Burlington Fine Arts Club Exhibition of European Enamels, 1897 (catalogue, pl. III); Barcelona, 1961, nos. 542a, b, c; New York, 1970, no. 168
BIBLIOGRAPHY Mitchell, 1926, pp. 161–73; Borenius, Chamot, 1928, pp. 276–87; Chamot, 1930, pp. 35–7 (no. 18), pls. 10–13; Boase, 1953, p. 195, pl. 51c; Swarzenski, 1954, figs. 443–5; Sauerländer, 1971, p. 514; Gauthier, 1972, no. 116; Lasko, 1972a, p. 239, pl. 283

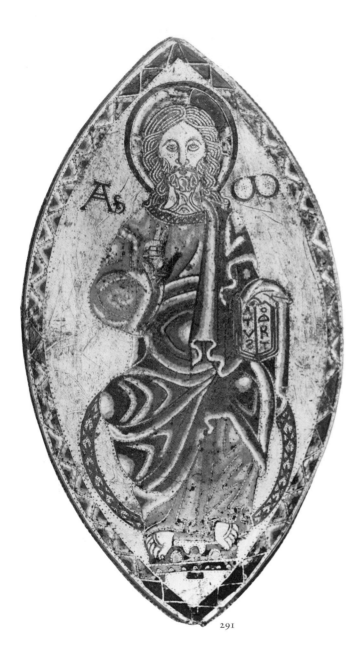

291

291 Christ enthroned

Oval copper plaque, markedly convex (trial tool marks on
back), *champlevé*, enamelled, engraved, punched and gilded;
four pin-holes for attachment; palette: white, yellow, two
greens, turquoise, three blues, lilac, bright opaque red; Christ
seated on the rainbow, blessing with His right hand, an open
book on His left knee enigmatically inscribed: (from top to
bottom, left to right) ATVS/ODRT; Alpha and Omega to either
side of Christ's head; enamelled zigzag border; tiny punched
dots along the edges of the border, the reserved lines of Christ's
drapery and the silhouettes of Christ and the rainbow;
engraving of Christ's features and hair filled with red enamel,
except for the eyes, which are modelled with turquoise and
dark blue; a colour scheme of strong contrasts: dark green-
yellow-turquoise, set against dark blue-pale blue-white;
Christ's halo in no less than seven colours: its cross yellow-
green, the halo dark blue-white-lilac-red-turquoise; *h* 210 mm,
w 113 mm
English (?), in a Limoges tradition; third quarter 12th century
Nuremberg, Germanisches Nationalmuseum, KG.690

Probably from a large book-cover or *châsse*, or the centre of
the back of an altar-cross. All the coloured glasses are standard
to both Mosan and English Romanesque enamelling but here
they are used in brilliant, strongly-contrasting combinations,
which mark this artist as deeply indebted to the early Limoges
workshops. Other technical and stylistic factors are common
to Limoges: the obsessive punching of silhouettes and reserved
lines in the metal, the multi-coloured halo and the use of
several colours in the modelling of the head. But no surviving
Limoges work is strictly comparable to the Nuremberg Christ.
His draperies are realized in enamel, boldly divided into a few
round and ovoid fields; nested V-folds are reserved in the metal
and modelled with white on and below the knees. This
arrangement of the drapery seems to be based on the English
'damp-fold' tradition; compare the seated Aaron in the Bury
St Edmunds Bible (**44**; illustrated in Boase, 1953, pl. 59). But
here it is modified by the controlling forces of a *champlevé*
technique and a close kinship to Limoges in the distribution of
colours. Therefore, like **293** and **294**, the plaque seems to be
by a Limoges artist active in the Anglo-Norman domains. In
his technical accomplishment and in the sureness of his line-
drawing the Master of the Nuremberg Christ is the equal of
the very best of the early southern enamellers. N.S.

PROVENANCE In the collection of A.J.B. Beresford Hope by 1862 (photograph in Victoria and
Albert Museum archives); sold Christie's 13 May 1886, lot 281, acquired by the Museum
EXHIBITIONS London, South Kensington Museum, *Special Exhibition of Works of Art of the
Medieval, Renaissance and Modern periods*, 1862 (Catalogue, ed. J.C. Robinson, revised edn.
1863, no. 1087)
BIBLIOGRAPHY Isa Belli Barsali, *Lo Smalto in Europa*, (Elite, Le Arti e gli stili in ogni tempo
e paese), 1966, pp. 41 (ill. 14), 43; *Germanisches Nationalmuseum Nürnberg. Führer durch
die Sammlungen* (guide to the collections), 1977, no. 37, colour pl. (notice by Rainer Kahsnitz)

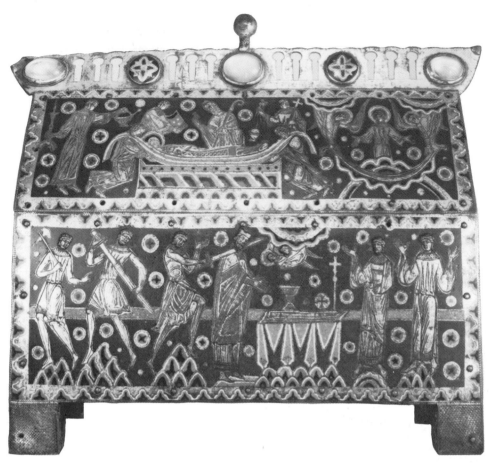

292

292 *Châsse* for relics of St Thomas Becket

Gabled *châsse*, the main box constructed from copper plaques hammered, *champlevé*, engraved, enamelled and gilded, pinned to a wooden core; the door in one end lost; (front) the martyrdom and burial of St Thomas Becket; (end) Christ in Majesty seated on the rainbow; (back) four nimbed figures and a diaper of four-petal flowers in disks; pierced, gilded cresting, set with three rock crystals and two enamelled studs; palette dominated by azure blue; three other blues (including turquoise), red, white, yellow and green used in strongly contrasting combinations, often in mixed fields against the azure blue grounds; *h* 280 mm, *l* 385 mm, *w* 115 mm
Limoges; *c*. 1190
British Rail Superannuation Fund, on loan to the British Museum

No surviving Limoges enamel has an English provenance which can be traced back with certainty to the 12th century, but the history of this *châsse* at least implies that it has been in this country since before the Dissolution of the Monasteries; it is perfectly possible that it was indeed in England by *c*. 1200. It is included in this exhibition as representative of the most accomplished work of the southern enamellers towards the end of the 12th century.

The town of Limoges belonged politically within the Angevin domains from the time of the marriage of Eleanor of Aquitaine to Henry II in 1152. It is therefore probable that Anglo-Norman England was prominent from an early period as a market for Limoges. In France, the earliest recorded reference to 'Limoges work' occurs in a letter of *c*. 1170 written by a certain John, attached to the circle of Archbishop Thomas Becket during his exile (Jules Labarte, *Histoire des arts industriels au Moyen Age . . .*, 2nd edn., III, 1875, pp. 133–6).

In England, while there is no evidence, there is every likelihood that such enamels were actually made by itinerant Limoges craftsmen. Several items in this exhibition seem to be English or at least Anglo-Norman productions in a Limoges technique. This *châsse* also represents the earliest surviving example of a Limoges Becket *châsse*; 45 are known to survive, the majority dating from the 13th century. For the early dissemination of Thomas Becket's relics, see 302 and 303. N.S.

PROVENANCE First recorded by the Revd William Stukeley in the mid-18th century as having been in 'a Popish family of old in St Neots' (Huntingdonshire), who had supposedly acquired it at the time of the Dissolution; subsequently in the collections of Sir John Cotton; Stukeley; Gustavus Brander; Thomas Astle; Major H. Chase-Meredith; sold Sotheby's 17 July 1930; Kofler-Truniger Collection; sold Sotheby's 13 December 1979, lot 6; acquired by British Rail Superannuation Fund
BIBLIOGRAPHY Gauthier, 1975, p. 251, pl. VII, 2; Caudron, 1977, pp. 9–33

293 Chalice (*illustrated on p. 75*)

Copper, hammered, *champlevé*, engraved, enamelled and
gilded; of typical Romanesque form (compare **321** and **322**);
in three sections, the hemispherical bowl of the same diameter
as the concave tapering foot, and divided from it by a short
stem with 'milled' knop; on the bowl: four bust-length figures
(Christ blessing and three angels, all holding books), within
semicircular fields, which form a lobed division of the surface
and are topped by a large blossom between each figure; stylized
flowers with pointed petals in the lower spandrels; on the foot,
a similar layout with four bust-length saints holding books;
palette: white, yellow, green, turquoise, two blues, pink,
opaque red; *h* 131 mm; *diam* (of bowl) 103 mm
By a Limoges workshop, active in England(?); *c.* 1200
Private collection, on loan to the British Museum

Throughout the Middle Ages, a continuous attempt was made
to legislate that chalices should be of gold or silver; only
precious metals were thought appropriate to the most sacred
of the liturgical vessels of the Christian Church. Nevertheless
in certain decrees a specific exemption is made in favour of
enamelled copper chalices 'of Limoges work'. They must
therefore have been relatively common. Yet the Rusper chalice
remains to this day a unique survival of a Limoges chalice (the
authenticity of a virtually identical chalice in the Stoclet
Collection has been doubted). The drawing-style of the
champlevé is unusual for early Limoges (contrast **292**), but can
be closely paralleled on a plaque of unknown origin, now in
Rouen (**294**) and on the *châsse* in the Cathedral of Châlons-sur-
Marne (Francis Salet, in *Mémoires de la Société d'Agriculture,
Commerce, Sciences et Arts de la Marne*, 1959, pp. 88–90,
pl. XVII – verbal information, Marie-Madeleine Gauthier). The
early Sussex provenance of the chalice is of great potential
significance: is it possible that it was made by an Anglo-
Norman workshop, producing southern-type enamels by the
end of the 12th century? A parallel, though earlier, northern
'Limoges' example is **291**. On the other hand, Limoges was
widely traded from the third quarter of the 12th century
onwards, compare **308**. In spite of former attributions to a
Mosan or an English artist, technique and palette clearly betray
his Limoges origins; compare Gauthier, 1972, no. 74 (p. 341).
When the chalice was dug up in 1840, it was heavily corroded;
it was completely regilded soon afterwards. Nevertheless it can
still be appreciated for the fine quality of its enamel. N.S.

PROVENANCE Found in an unidentified coffin, probably of one of the prioresses, on the site
of the Benedictine Nunnery of Rusper, near Horsham, Sussex, 1840, together 'with a cover
or paten of gilded copper, engraved, but so much oxidized as to crumble to powder' (Way)
EXHIBITIONS London, South Kensington Museum, Special Exhibition of Works of Art of the
Medieval, Renaissance and Modern periods, 1862 (Catalogue, ed. J.C. Robinson, revised edn.
1863, no. 1107); New York, 1970, no. 180a
BIBLIOGRAPHY Albert Way, 'Notices of an Enamelled Chalice, and of other Ancient Reliques,
found on the Site of Rusper Priory', *Sussex Archaeological Collections*, IX, 1857, pp. 303–11;
Oman, 1953, p. 156; Gauthier, 1972, no. 73 (pp. 340–1)

294 Enamel plaque

Copper, hammered, *champlevé*, engraved, enamelled and
gilded, with five pin-holes for attachment; gilding mostly
destroyed; a quadrilobed plaque with an enamelled angel (or
the symbol of St Matthew), emerging from clouds and holding
a book, within a cloud-patterned border; the reserved
backgrounds engraved with discs, lozenges and 'stars'; palette:
white, yellow, pale green, turquoise, two blues, pink, opaque
red; *h* 80 mm, *w* 80 mm
By a Limoges workshop, active in England(?); *c.* 1200
Rouen, Musée départemental des Antiquités, Inv. 1213

295

294

In style and technique this plaque is closely comparable to the
Rusper chalice (**293**). In its fine state of preservation, it allows
a mental reconstruction of the enamel of the chalice as it must
have appeared before it was buried. Although far from typical
of early Limoges in style, this workshop was certainly trained
in the southern techniques of enamelling. The plaque must
come either from a large altar-cross with the angel (or
Evangelist symbol) on one of the arms, or from a *châsse*. N.S.

PROVENANCE Germeau sale, Paris, Hôtel Drouot, 4 May 1868, lot 70

295 Harness pendant

Copper-alloy, *repoussé*, engraved, enamelled and gilded;
medallion with suspension loop; most of the blue enamel and
gilding lost; within a beaded border, two addorsed lions
rampant on either side of a stylized central tree; *h* 56 mm, *diam*
44 mm
English(?); late 12th or 13th century
Salisbury, Council of the Salisbury and South Wiltshire
Museum, 1/1923 (OS. C. 64)

Probably a pendant for suspension from a horse harness,
perhaps from the peytrel (the band around the front of the
horse); compare a 13th-century aquamanile in Oslo (von Falke,
Meyer, 1935, pl. 262). 'Heraldic' compositions with two
animals or birds flanking a central tree were common currency
in the 12th century through their popular dissemination on
textiles, on, for example, the Hubert Walter dalmatic
(Canterbury). For this reason their place of manufacture can
rarely be established, but see certain English manuscript initials
(Dodwell, 1954, pls. 45–7). For references to other Romanesque
horse trappings, see Stuttgart, 1977–79, part I, no. 601. N.S.

PROVENANCE Found at Old Sarum within the area of the Castle by Col. W. Hawley, 1910
(Hawley's MS diary, 'Old Sarum Excavations 1910', p. 13)

296 The St-Maurice d'Agaune flask

Silver, cast, engraved, punched and nielloed; cylindrical bottle, tapering towards the base, with rounded shoulders narrowing to a neck which in turn widens towards the top; separate polygonal cone-shaped stopper with suspension ring, undecorated, probably not original; a second suspension ring, on the side of the neck, is undoubtedly original; from the stopper, a string with a paper relic ticket: *Unus dens S. Mauritii* (a tooth of St Maurice), written perhaps in the 18th century and wax-sealed with the Abbey chapter seal of Agaune; neck and shoulders decorated with a stepped 'key' pattern, cross and zigzag motifs and simple foliage meanders; on the body of the flask four winged dragons, their long tails developing into foliage stems from which three large flowers grow; *h* 139 mm
c. 1130–40
Treasury of the Abbey of St-Maurice d'Agaune, diocese of Sion (Switzerland)

This flask was always intended for suspension, since the ring on the neck is original. Perhaps it was hung from the belt as a container for perfume or some other elixir? Compare a 13th-century Limoges *ampulla* (British Museum, MLA.94,2-17,8). The same decorative motifs are found on manuscript borders of the second quarter of the 12th century (compare **47–50**; Kauffmann, 1975, ills. 173–80). The dragons with foliate tails can also be closely paralleled in English manuscripts. In the Mostyn Gospels (**22**; Kauffmann, 1975, ill. 57), and certain Canterbury manuscripts (Kauffmann, 1975, ills. 52, 55 and 56), the bodies of the beasts are decorated with similar hatched and speckled patterns and the flowers are made up of the same three elements breaking out from a small clasp or stud. However, on the flask some of the flowers are richer than in these manuscripts, with central ovary and 'capped' petals, already anticipating such works as the carved shafts from Winchester (**147**). Particularly close are the flowers on some of the pages (not exhibited) of Cambridge, St John's College MSA.8 (**43a**), dating from *c.* 1130. The flask seems then to be contemporary with the dragon capitals from Reading and Hyde Abbey, Winchester (**127a, n** and **128e**), whilst the group of manuscripts from Winchcombe, which includes **27**, are already in a richer and more exuberant vein. A lost marble (Purbeck?) shaft from Hyde Abbey, Winchester, also appears to have been decorated with similar dragons (Society of Antiquaries, Prints and Drawings (Early Medieval), f. 5, engraved in *Archaeologia*, XIII, 1800, pl. XXIIID). However, none of these comparisons does full justice to the goldsmith who engraved the Agaune flask; he was a draughtsman of extraordinary abilities, whose control of line is not surpassed by any of his English contemporaries. His dragons with rapacious claws, long sinuous necks and ferocious heads are organized in a perfectly balanced design round the curved sides of the bottle. The flask is the only surviving English secular object in nielloed silver of the first half of the 12th century. The later Dune and New York drinking-cups (**306** and **308**) suggest a certain continuity of tradition in the use of nielloed animal ornament for secular plate. N.S.

PROVENANCE Uncertain. Not listed in the early inventories of the Abbey treasury in so far as they were edited by Aubert (see **309**)
BIBLIOGRAPHY Jean-Marie Theurillat, *Le Trésor de Saint-Maurice*, 2nd edn., 1967, p. 28; P. Bouffard, *Saint-Maurice d'Agaune. Trésor de l'Abbaye*, 1974, p. 188

296

297 The Taunton spoon

Silver, hammered and worked while hot, engraved; traces of
gilding in the bowl, probably for a gilt border; no traces of
niello; shallow pointed oval bowl, slightly bent upwards; at its
junction with the handle, a symmetrical foliate element: two
stems form a heart-shaped frame enclosing a reversed palmette;
handle in two sections: flat main bar, decorated with a stylized
animal head, an alternating zigzag motif of trefoils and a raised
square panel of interlace; polygonal terminal section, tapering
down to a second but smaller animal head; the finial a plain
cone-shaped knob; back of handle and bowl undecorated; *l* (of
bowl) 71 mm, (of handle) 143 mm
English (?); mid-12th century
Taunton, Somerset Archaeological and Natural History
Society, OS.AA.4

In form particularly close to one of the Iona spoons (**298b**), this
was probably, like them and **299**, for secular use. For the heart-
shaped palmette, compare a (?) Bec manuscript (Swarzenski,
1954, fig. 320 – verbal communication, Jeffrey West); but this
and the other decorative motifs are typical of the range of
ornament found in 12th-century English manuscript borders, as
in the Bury Bible (**44**), so that an English origin is perfectly
possible. Taunton Castle was a major administrative centre in
the 12th century, held by the bishops of Winchester. It played
an important role as a military stronghold during the civil war
of Stephen's reign; the foundation walls of a great tower-keep,
excavated in the 1920s, were perhaps built by Henry of Blois
(see **277**). The date traditionally assigned to the spoon, *c.* 1200,
is probably too late, on the basis of its decoration. N.S.

PROVENANCE Found within the perimeter of the destroyed keep of Taunton Castle, 1928
BIBLIOGRAPHY H. St George Gray, 'A Medieval Spoon found at Taunton Castle', *Antiq J.*
vol. X, 1930, pp. 156–8; A.W. Vivian-Neal, H. St George Gray, 'Materials for the History of
Taunton Castle', *Proceedings of the Somersetshire Archaeological and Natural History Society
for the Year 1940*, LXXXVI, 1941, p. 64, pl. III; How, 1952, p. 30, pl. 4

298 a and b Two Iona spoons (a *not illustrated*)

Both spoons silver, hammered and worked while hot, engraved
and part-gilded; both with shallow oval, pointed bowl, handle
in two sections with a stylized animal head at the junction with
the bowl, and square panel dividing a flat rectangular main bar
from a rounded section, ending in a finial;

298a Plain ungilded bowl (much damaged); lattice enclosing
stylized four-petalled flowers filled with niello on main bar;
six-petalled flower on square panel; plain conical finial;
l 165 mm

298b Bowl with gilt border; engraved blossom as if growing
out of the animal's mouth at the junction with the handle;
main bar engraved with a linked leaf motif; square panel with
chamfered corners, engraved with a four-petalled flower motif;
lower stem notched like a twig at one end, conical finial with
leaves at the other; *l* 200 mm

Mid-12th century
Edinburgh, National Museum of Antiquities of Scotland,
HX.32/3

These are two of a group of four spoons, the other two closely
resembling **b**. They were found buried together, carefully
wrapped for concealment (together with a 13th-century
repoussé gold hair-fillet). In spite of being found on the site of
the nunnery church on Iona, the spoons were probably made
for secular use. They share various features with the other early
spoons in the exhibition (**297** and **299**), as well as with the
Coronation spoon (How, 1952, p. 24, pl. 1): the shape of the

297

298b

bowl, the two-part handle, the animal head, etc. The
decorative motifs engraved on the Iona spoons suggest that
they were made a full half-century before the foundation of the
Benedictine nunnery at Iona in 1203. The simple nielloed
flowers of **a** and on the square panel of **b** resemble those on
one of the Lark Hill rings (**320e**), deposited *c.* 1173–4, and
various manuscript borders (as in **48** recto). The linked-leaf
motif of the main bar of **b** recalls the rims of the drinking-cups
in New York and Stockholm (**306** and **308**); the blossom of **b**
is found in English manuscripts of the period *c.* 1130 and
subsequently, for example the Psalter and other manuscripts
from Winchcombe (Kauffmann, 1975, ills. 144, 146; Pächt,
Alexander, 1973, no. 104, pl. X). N.S.

PROVENANCE Found Iona, 1922
EXHIBITION Edinburgh, 1982, no. C.42
BIBLIOGRAPHY Alex. O. Curle, 'A note on four silver spoons and a fillet of gold found in the
Nunnery at Iona . . .', *Proceedings of the Society of Antiquaries of Scotland*, 1923–4, LVIII (5th
series-vol. X), pp. 102–11; How, 1952, p. 26, pl. 2

299 The Pevensey spoon (*not illustrated*)

Silver, hammered, engraved, nielloed and part gilded; shallow
pointed oval bowl (much damaged), edged with gilding; handle
in two sections: flat main bar, oval in outline, decorated on one
side only with an animal head biting the bowl, a tight spiralling
foliage scroll originally filled with niello within a beaded frame
and a small flower in a square frame; terminal section twisted
with beaded grooving; the finial a small animal head; the
whole handle gilded, except the nielloed field; *l* 217 mm
Second half 12th century
London, Trustees of the British Museum, MLA.1931,12-15,1

For other Romanesque spoons of similar form, see **297** and **298**.
The spoon was dated to the 11th century by Wilson, but its
nielloed foliage scroll is closely comparable to the patterns on
the Lincoln seal matrix of 1148–60 (**360**, below), the Durham
book-clasps from the Puiset Bible of *c*. 1170–80 (**301**) and the
Bury St Edmunds crosier mount (**300**). For a discussion of the
relationship of this group with Lower Saxony, see **301**. N.S.

PROVENANCE Found in a pit under the stairs at the entrance to the Keep of Pevensey Castle,
Sussex; presented by HM Commissioners of Works, 1931
BIBLIOGRAPHY R.S. Simms, 'Medieval Spoon from Pevensey Castle', *Antiq. J.* XII, 1932, pp. 73–
4; How, 1952, p. 28, pl. 3; Wilson, 1964, no. 59, pp. 60–1, 159–60, pl. XXVII

360 (reverse)

300 Crosier mount (*illustrated on p. 48*)

Silver, engraved, punched and gilded; cylindrical collar on
modern wood mount; three bands of decoration: (from top)
a continuous scroll of tightly spiralling branches enclosing
small flowers; a double-strand interlace punched with two
rows of dots; flowers within kidney-shaped frames joined by
small 'buttons'; *h* 37 mm, *diam* 35 mm (both of collar)
Last quarter 12th century
Bury St Edmunds, Moyse's Hall Museum, 1976. 285

For the flowers, compare the 'Sainte-Coupe' at Sens, an
enigmatic object whose artistic origins remain obscure
(Catalogue *Les Trésors des Eglises de France*, 1965, no. 817,
pl. 102), but see also the repeating border motifs in English
manuscripts from the mid-12th century onwards, although here
the flowers are already hinting at the naturalism of the years
c. 1200 (Zarnecki). For the scrolled foliage, see under **301**,
where several other objects in this exhibition with the same
motif are also mentioned. If the crosier mount does indeed
come from Abbot Samson's tomb, it was by no means old-

fashioned in style by the time he was buried in 1211. For
Samson, see *The Chronicle of Jocelin of Brakelond*, ed. and
translated H.E. Butler, (Nelson's Medieval Texts), 1949,
passim, and particularly p. 87, for his gift of 'a crosier-head of
silver, finely wrought', which he had acquired during a journey
abroad. N.S.

PROVENANCE Found in a coffin on the site of the chapter house, Bury St Edmunds Abbey, 1903,
identified at the time as probably that of Samson of Tottington, abbot 1182–1211 (see *Bury
Free Press*, January 3 and 10, 1903; *West Suffolk, Illustrated*, compiled by H.R. Barker, 1907,
p. 57)
BIBLIOGRAPHY Zarnecki, 1967, pp. 412–13, fig. 14

301

301 One of two book-clasps from the Puiset Bible

Two rectangular copper-alloy plaques back to back with a
central hole for the pin, attached through the leather strap of
the book fastening by four corner pins with spherical heads;
the back plaque plain and gilded (1845); the front plaque
engraved with a grooved and beaded border, its central field
inlaid with silver, engraved and nielloed with a tightly-scrolled
design of spiralling branches enclosing small flowers; borders
and central pin-hole gilded; *h* 30 mm, *w* 67 mm
England or Lower Saxony, probably contemporary with the
Puiset Bible; *c*. 1170–80
Durham, Dean and Chapter of Durham Cathedral

For a discussion of the close connections between the book-
clasps and metalwork produced in the circle of Duke Henry
the Lion of Saxony and Bavaria, see Geddes, 1980. Almost
identical silver nielloed scroll-work appears on the border
plaques of the arm-reliquary of St Laurence from the Guelph
Treasure, now in Berlin and perhaps dating to *c*. 1175 (see
Johannes Sommer, 'Der Niellokelch von Iber', *Zeitschrift für
Kunstwissenschaft*, 11, 1957, pp. 109–36, particularly pls. 13,
18–24, 26). Other objects in this exhibition are decorated with
similar scroll-work, including **270** and **300**, and three other
objects in nielloed silver: a crosier from St David's (**268**) and
a spoon from Pevensey (**299**), both excavated, as well as **360**,
the seal-matrix of Lincoln, first recorded between 1148 and
1160. The last of these is important not only for its early date
but because it must have been made at Lincoln itself, not
imported. It seems therefore certain that even if the sources of
this nielloed group are Lower Saxon, at least some of these
objects were made in the British Isles. As to the date of the
Durham clasps, one of the original bindings (vol. II) is stamped
with a pattern which resembles in simplified form the scroll-
work of the clasps (see **474**); the metal stamp for this pattern
was cut in imitation of the clasps, so that they must have been
attached to the Bible from the moment of binding. There is no
good reason to doubt that they were made expressly for the
Bible. They were used on Volume I of the Bible, when it was
re-bound in 1845, but have now been detached. The Bible is
discussed on p. 128 (**77**), its bindings on pp. 348–9 (**474**). N.S.

BIBLIOGRAPHY Mynors, 1939, no. 146; Swarzenski, 1954, fig. 487; Geddes, 1980, particularly
pp. 142–5, pl. XXID

302 Reliquary casket, with scenes of the murder and burial of St Thomas Becket

Oblong silver box, with hipped roof; interior originally divided into two sections by a partition. Constructed on a base-plate from eight plaques, each with a plain gilded frame around an engraved and nielloed field; ungilded beaded strips soldered to form the edges of the plaques; roof crowned by a simulated 'ruby' (in fact pink glass backed by a red copper foil), which is set into a separate plate and framed by beaded mounts with two side loops for suspension; two hinges and a front clasp, with slots for horizontal pins, each decorated with a small mould-cast half-flower, with radiating petals; (ends) two symmetrical but differing foliage designs (on the roof) and two half-length angels or Virtues, one holding a book; (front) Becket's martyrdom, inscribed: s(anctus).TOMAS.OCCIDIT ('St Thomas dies'); the tonsured saint receiving the sword-stroke, three soldiers on the right; (on the roof) an angel holding a cross and blessing the scene below; (back) Becket dead, tonsured and wearing the pallium, his body supported by two monks; the inscription: [--]T()SANGVIS.E(st).S(ancti).TOM E. ('. . . is the blood of St Thomas'); (on the roof) an angel receives the naked soul of St Thomas; *h* 55 mm, *w* 69 mm, *d* 42 mm
By a Rhenish goldsmith, in England(?); *c.* 1173–80
New York, The Metropolitan Museum of Art, 17.190.520, gift of J. Pierpont Morgan, 1917

The second inscription has given rise to various more or less fanciful interpretations. The first letter is illegible, owing to a mend, but could have been an I, making the abbreviated word I(n)T(us) ('within') referring to relics of Becket's blood in the casket. The two compartments inside were presumably for phials of St Thomas' blood, which justified the presence of the blood-red glass on the roof of the box. Becket's murder on 29 December 1170 was followed in 1173 by his formal canonization, which led to an immediate and widespread distribution of relics of his blood, his garments and other possessions (see also 303). The popularity of his cult throughout Western Christendom was actively encouraged by Church interests. By the 13th century trade in his relics was commonplace, as shown by the series of Limoges Becket caskets (292), but in the period immediately following the canonization, England was self-evidently the source of all Becket relics. There must therefore be a strong possibility that this box was made in England. However Breck's suggestion that the reliquary relates to John of Salisbury's gift of two phials of Becket's blood to Chartres in 1176 remains only a charming hypothesis, even if the box is first recorded in a French collection.

As to the goldsmith, there are no parallels for this drawing style in English 12th-century art. However, there is a group of nielloed and enamelled objects connected with the Rhineland, particularly a destroyed plaque with the *Crucifixion* from the cover of the necrology of the Benedictine Abbey of Bleidenstadt am Taunus, where the drawing of the heads and the sketchy treatment of the draperies with groups of hatched lines find close parallels in the Becket scenes (Dietrich Kötzsche, 'Eine romanische Grubenschmelzplatte aus dem Berliner Kunstgewerbemuseum', *Festschrift für Peter Metz*, 1965, pp. 154–69). This German group has been dated to the 1160s and early 1170s (Dietrich Kötzsche, 'Die Kölner Niello-Kelchkuppe und ihr Umkreis', New York, 1975, pp. 139–62). The German connections of the Becket box find confirmation in the similarity of the feathery, symmetrical foliage designs on its roof to Rhenish metalwork of the 1170–80s, as on the St Anno shrine at Siegburg, and to stone sculpture in the Rhineland, for example a relief at Schwarzrheindorf, near Bonn (H.A. Diepen, *Die romanische Bauornamentik in Klosterrath*, 1931, pl. LIII, no. 4). If Kötzsche's date for the Rhenish group in the 1160s–early '70s is accepted, then the New York box could belong to the earliest years after Becket's canonization and may well be the first Becket reliquary to have survived. This exquisite work of art can be plausibly attributed to a major German goldsmith working for an English patron. N.S.

PROVENANCE Collection Louis Germeau, Préfet de la Haute-Vienne, by 1865; Germeau sales, Paris, Hôtel Drouot, 4–7 May 1868, lot 41; Hôtel Drouot 13–25 February 1905, lot 931; acquired by J. Pierpont Morgan; presented 1917
EXHIBITIONS The Pierpont Morgan Treasures, Wadsworth Atheneum, Hartford, 1960, no. 11; New York, 1970, no. 85
BIBLIOGRAPHY Alfred Darcel, *Gazette des Beaux-Arts*, XIX, December 1865, pp. 508–10, engraving; J. Breck, 'A Reliquary of St Thomas Becket made for John of Salisbury', *Bulletin, Metropolitan Museum of Art, New York*, XIII, October, 1918, pp. 220–4; Borenius, 1932, pp. 78–9, pl. XXIX (1–2); Hanns Swarzenski, *The Berthold Missal*, 1943, pp. 50–1 (fig. 71); Swarzenski, 1954, fig. 490; Sauerländer, 1971, p. 515

303 Reliquary pendant of Queen Margaret of Sicily

Gold, hammered and engraved; suspension loop, cast
separately and soldered, in the form of a beast's head with open
jaws, through which a chain would have passed; front: four
framing strips of gold, soldered on to the back plate, acted as
mounts for a (lost) crystal or piece of horn, behind which relics
were displayed; these are listed in the inscriptions engraved on
the framing mounts, reading clockwise: (on the inside at the
top) + DE SANGVINE S(an)C(t)I THOME M(arty)RIS. DE
VESTIBVS SVIS SANGVINE SVO TINCTIS; (on the outside at the
top) DE PELLICIA. DE CILITIO. DE CVCVLLA. DE
CALCIAMENTO. ET CAMISIA ('Of the blood of St Thomas
martyr. Of his vestments stained with his blood: of the cloak,
the belt, the hood, the shoe, the shirt'); on the back are
engraved two standing figures, a crowned woman holding out
her hands and a mitred bishop with a crosier, who is blessing
her with his right hand. They are identified by inscription:
+ ISTVD REGINE MARGARITE SICVLOR(um) TRA(n)SMITTIT
PRESVL RAINAVD(us) BATONIOR(um) ('Bishop Reginald of
Bath hands this over to Queen Margaret of Sicily');
h 49 mm, *w* 31 mm
1174–83
New York, The Metropolitan Museum of Art, 63.160, Joseph
Pulitzer Bequest, 1963

This reliquary was made for Bishop Reginald of Bath as a gift
to Queen Margaret of Sicily. It is an early survival of a
reliquary in which the relics were displayed rather than hidden
from the gaze of the faithful within a closed container, as for
example with 310, which however was also worn as a personal
adornment. For the dissemination of Becket's relics, see under
302.

The historical associations of the New York pendant give it
a special importance: Reginald fitzJocelin, bishop of Bath
(1174–91), chiefly remembered today as the instigator of the
new work at Wells (*c.* 1180), was one of the major English
churchmen of his time, dying soon after his election to the
archbishopric of Canterbury in 1191. In the period before
Becket's murder (29 December 1170), Reginald was a leading
supporter of Henry II against the Archbishop, and he went to
Italy to plead the King's case with the Pope on two separate
occasions following the murder. Margaret of Navarre, wife of
the Norman William I of Sicily and after 1166 regent for her
young son William II, died in 1183, thus providing a latest
possible date for the pendant. No surviving document records
a meeting between Reginald and Margaret, but a papal letter
refers to the assistance he received from her in soliciting the
Pope in 1172 for the absolution of Reginald's father, Jocelin,
Bishop of Sarum, who had been excommunicated by Becket,
Reginald attending in person at Benevento, and Margaret
sending a letter (ed. J.C. Robertson, J.B. Sheppard, *Materials
for the History of Thomas Becket, VII*, Rolls Series, 1885,
pp. 509–10). Some such kindness must have inspired Reginald's
gift of relics. The marriage of William II of Sicily to Henry II's
daughter Joan in 1177 would have been an appropriate
occasion for the presentation of the gift, although Reginald
himself was not present. Margaret had been involved in the
feud between Becket and Henry II and after 1170 continued to
act as a friend and intermediary between the King and Pope
Alexander III. She was surrounded by ecclesiastics who were
devoted to Becket's cause; the murder which deeply shocked
Europe was seen as a central issue in the struggle between
Church and State. An early devotion to Becket's cult at the
court of Sicily, one of the Pope's staunchest allies, is therefore

303

predictable. As early as 1179 two dedications of churches to the
new martyr are recorded in Sicily.

The style of the engraved figures and of the lettering of the
pendant confirms an English, as opposed to Sicilian origin
(although this has recently been proposed by Caviness) and a
date in the late 1170s. N.S.

PROVENANCE Collection of Piero Tozzi ('said to have been found in Sicily'); acquired 1963
(Joseph Pulitzer Bequest)
BIBLIOGRAPHY Hoving, 1965, pp. 28–30; Newton, 1975, pp. 260–2, fig.; Caviness, 1977, p. 149

304, 305 and 306 Three drinking vessels from 'The Dune Treasure' (*illustrated on following pages*)

In 1881 a hoard of gold and silver, about 122 items, was
unearthed at Dune, in the parish of Dalhem on the Isle of
Gotland in the Baltic. The hoard seems to have been deposited
either in 1361 or soon after, possibly in connection with the
events attendant on the Danish invasion in this year; the latest
dated object is a coin minted for Winrich von Kniprode, Grand
Master of the Teutonic Order (1351–1382). The hoard must
have belonged to a rich Gotland merchant and embraces many
classes of object, from plate for feasts (drinking-cups, knives,
spoons) to jewellery and personal adornments (necklaces, arm
bands, costume and belt fittings). The range of date of the
hoard is also wide, some items being as late as the mid-14th
century, and their cultural origins are mixed: local artefacts
rub shoulders with German, Byzantine with English. Three
items have been chosen for exhibition as important examples
of Romanesque secular plate. Although they are not
representative of the full range and diversity of the Dune
Treasure, they illustrate something of the variety of cups which
would have been used at the table of a great lord, where
individual items would have been the rule, rather than 'sets'.
Only one of the three vessels can with confidence be attributed
to an English goldsmith (305) but there is nothing implausible
about the English stylistic connections of the other two.
Gotland was an important Baltic trading-post throughout the
Middle Ages; the close political, ecclesiastical and economic
contacts between Britain and the Scandinavian kingdoms in the
12th century are fully documented.

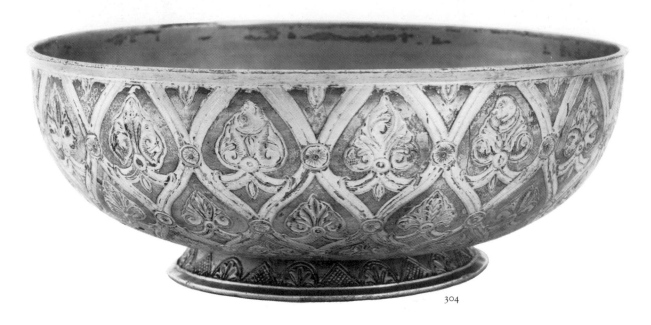

304

304 Drinking-cup

Hammered silver, engraved and partly gilded, with a lattice pattern enclosing blossoms; short foot with engraved triangles alternating with leaves; (inside) a roundel engraved within a foliate border with a scroll inhabited by a lion and a winged animal whose tail forms the foliage scroll; *h* 67 mm (max), *diam* 174 mm (max)
Probably English; second quarter 12th century
Stockholm, Statens Historiska Museum, 6849:9

Animal roundels were a traditional ornament inside drinking vessels in Western Europe from at least the 11th century but Anglo-Saxon examples, though they probably once existed, have not survived. The inhabited scroll-work of the Dune roundel can be closely paralleled in Anglo-Norman sculpture of the late 11th and early 12th centuries, for example the Knook (Wiltshire) tympanum of *c.* 1100 (Zarnecki, *Battle Conference* 1978, pp. 182–3, pl. 22). Scandinavian comparisons also exist, such as the Tingelstad wind-vane (Swarzenski, 1954, fig. 216).

There are several English manuscript initials of the first quarter of the 12th century or somewhat later, particularly from Canterbury, with similar inhabited scroll-work (Dodwell, 1954, pls. 36(a), 39(a), 46(b)–(c)). For the stylized scroll of the border, see **49** verso, of *c.* 1140. The blossoms on the outside of the cup must be contemporary with the roundel. They suggest a dating in the second quarter of the 12th century for the cup as a whole, comparable with the repeating flowers of early stained glass borders, but here each blossom is unique in design. Northern France and England (for instance an unpublished voussoir fragment at St Albans) offer parallels for the leaf forms. For the motif of heads, in one case two monkey heads, growing out of the leaves, there are parallels in capitals from Hyde Abbey, Winchester (1130s) and several manuscripts from the 1130s onwards, such as the British Library MS Harley 624 (Dodwell, 1954, pl. 45a). The cup is a small masterpiece. (For Dune, see p. 283) N.S.

BIBLIOGRAPHY äf Ugglas, 1936, pp. 16–7 (no. 3), pl. XI; Andersson, 1983, pp. 23–5 and 58–9, pls. 17A–G

305 Drinking cup (*illustrated on p. 75*)

Hammered silver, engraved, the figures, foliage and inscriptions enhanced with gilding; tall undecorated foot, with runic inscription: 'Siali(?) wrote the runes'; depressed hemispherical bowl, inscribed (top rim): + ME IVSSIT PROPRIO ŽALOGNEV SVMPTV FABRICARI : ERGO POSSIDEAR POSTERITATE SVA : VALE. ('Zhalognev ordered me to be made at his own expense, so that I might belong to his progeny in the future. Farewell.'); (bottom rim) + SIMON ME FECIT ('Simon made me'), upside-down; also upside-down, a continuous series of foliage scrolls runs round the bowl, inhabited by figures: clambering, wrapped in the stems, fleeing from or in combat with lions, a bowman attacking a lion, etc; *h* 155 mm, *diam* 147 mm (max)
By an English goldsmith, Simon, for a Slav patron; *c.* 1180–90
Stockholm, Statens Historiska Museum, 6849:7a–b

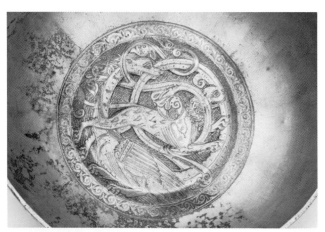

304 (detail)

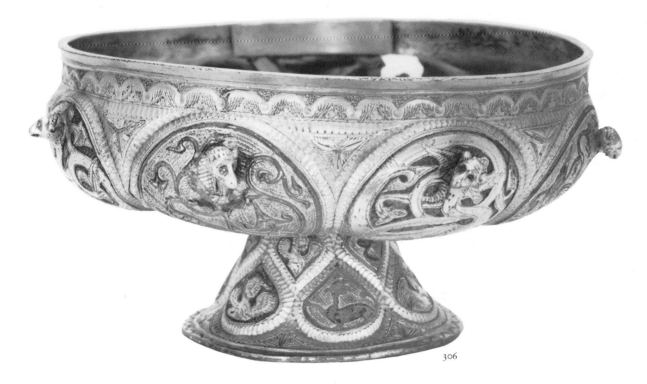

306

Ugglas believed the foot to be a 14th-century addition, the bowl reversed and re-used, having originally been the cover for a cup or ciborium (compare **276**, **278** and **279**). In this way, the figures and the Simon inscription would have been legible, the Zhalognev inscription upside-down. However a similarly-shaped foot exists on another 12th-century drinking-cup in Leningrad (Darkevich, 1966, pp. 12 (no. 13), 109 (pl. 3)). Andersson believes that the Dune cup is the lid from a double-cup, split up and given the present foot soon after it was made. In this case, the Zhalognev inscription was added the right way up to the new foot. Nothing is known of the goldsmith, Simon, and the patron Zhalognev has not been identified; Ugglas proposed that he might have been a Russian merchant trading in Gotland. The first letter of his name is inscribed as the Cyrillic *Zh*, the other letters being transcribed into their Latin equivalents. But whatever the circumstances of the commission, Simon was English. His foliage, particularly the large 'octopus-leaves', and his robust drawing style are distinctively Insular, comparable for example to figures on the Dunstable (Beds) west door of *c.* 1176–90 or the Worksop Bestiary (before 1187) (**85**): the drapery folds are still arranged into groups of V-shaped pleats or converge schematically towards a single point, but they have a weight and suppleness which anticipates the art of *c.* 1200. Similar small lions inhabit the initials in many English manuscripts of the last quarter of the 12th century (**78**). An English enamelled casket in Florence (not exhibited) offers a comparable drawing style and the same range of combat scenes between men and animals. The cup is among the finest English works of the 1180s. Sadly worn in places, its original splendour can easily be imagined, with the gilt details standing out against the silver backgrounds. (For Dune, see p. 283) N.S.

BIBLIOGRAPHY äf Ugglas, 1936, p. 16 (no. 1), pls. VIII–IX; Andersson, 1983, pp. 25–9, and 59–60, pls. 18A–I

306 Drinking-cup

Hammered silver, nielloed and gilded; depressed hemispherical bowl with short foot; rim decorated with repeated leaf motif; bowl and foot divided into oblong pointed fields by a lattice engraved with fluted leaves; within the larger fields, fantastic winged creatures, their heads cast separately, their tails developing into branches and flowers which envelop them; alternately gilded against a nielloed ground, and nielloed against a gilded ground; the smaller fields of cup and foot also alternate, with a repertoire of winged grotesques; backgrounds hatched, using a small punch; inside: a cast medallion with a lion and a dragon among foliage is surrounded by a radiating series of gilded concave oblong fields, the remaining outside fields being left ungilded; *h* 73 mm, *diam* 137 mm (max)
Angevin or German; last quarter 12th century
Stockholm, Statens Historiska Museum, 6849:6

The cup is by the same goldsmith or at least the same workshop which made the New York bowl where the borrowing of motifs from early Limoges is even more pronounced – see **308**. However the lion and dragon in foliage (inside the cup) are similar to animals found in Cologne goldsmiths' work of the 1180s, for example, on the Siegburg St Anno shrine. For the dating and localization of the group, see **307** and **308**. (For Dune, see p. 283) N.S.

BIBLIOGRAPHY äf Ugglas, 1936, p. 16 (No. 2), pl. X; Swarzenski, 1954, fig. 458–9; Andersson, 1983, pp. 19–23, and 56–8, pls. 16A–P

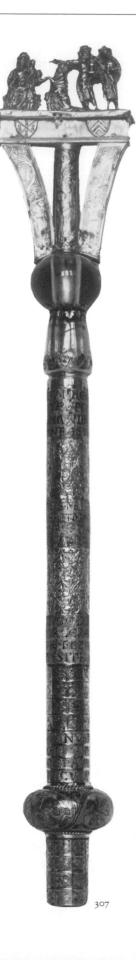

307

307 The Cologne precentor's staff

A composite object of several periods: (A) the crowning group of the *Adoration of the Magi*, silver-gilt, cast and engraved, set on a platform which is repaired around its top edge and decorated with shields of arms of the von Gennep and von der Mark (or Eppstein) families, mid-14th century; (B) below the platform, a three-pronged stand of nielloed silver, engraved with huntsmen, birds and animals, including a unicorn; the style of these scenes suggests a date in the second quarter of the 13th century, by comparison with niello plaques in the Treasury of Notre-Dame at Namur from Oignies; (C) a cylindrical and a spherical rock crystal in gilt foliage mounts, which may be post-medieval; the crystals, however, may be of the same date as: (D) the rest of the staff, wood with silver mounts, embossed and engraved, partly nielloed and gilded; the main stem of D has plain silver mounts; above, the mounts are richly decorated in four ornamental and four inscribed zones, with a knop; it is clear that in 1902 D was divorced altogether from A, B and C (see catalogue, Düsseldorf, 1902 and an old photograph in Clemen 1937, fig. 262); the order of the silver mounts of D has also been reconstructed since Clemen, 1938, fig. 263, was taken; the present arrangement of the mounts, which may not be original, is, from the bottom: 1 a decorative gilt band with a checkerboard of embossed flowers; 2 the knop with a rope moulding and plain narrow band above and below, engraved and nielloed with an eagle and birds in foliage scrolls on a hatched background; 3 nielloed inscription (*d*, below); 4 as 1; 5 inscription *c*; 6 decorative band, with embossed lattice of heart-shaped foliage; 7 inscription *b*; 8 as 6; 9 inscription *a*.

The inscription, in groups of four lines, reads from the top: (*a*) + SV(M) PRECENTOR(VM). BA CVL(VS). SPECIALIS. (ET). HOR(VM) + I(N) MANIB(VS). QVOR(VM)FERAR IN FESTIS. BACVLOR(VM) (*b*) + LAVS. MEA. SOLLEMPNIS (ET) ERIT. MEA. FAMA. P(ER)HENNIS + IN. FESTIS. MAGNIS. RENOVANDA. QVIB(VS) LIB(ET). ANNIS (*c*) + HVGO. DEC̄. CLERI. VIR PARCERE. NESCIVS. ERI + ME. FECIT. FIERI. ME IVSSIT. HONORE. TENERI (*d*) + ANNVS. MILLENVS CENTEN(VS). SEPTVAGEN(VS) + OCTAV(VS). XPI. PRIM(VS) BACVLO [F]VIT. ISTI ('I am the special staff of the precentors, to be carried by those appointed to do so on feast days. To me shall be solemn praise and perpetual renown, which shall be renewed every year at the great feast days. Hugh the Dean (or Hugh, an ornament of the priesthood), a man unsparing with money, ordered me to be made and carried in honour. The first year of this staff was 1178'); this reading of the inscription is based on Schulten 1980, except that an alternative reading *Decanus* for *Decus* is proposed in *c*; *h* 1.470 m (complete staff) (This description was prepared with the assistance of Roswitha Neu-Kock.)

Staff, Angevin or German, 1178; three-pronged stand, Mosan, second quarter 13th century; *Adoration of the Magi* and platform, Cologne(?), *c*. 1350
Cologne, Hohe Domkirche

The *Adoration* group seems to have been made at the command of Archbishop Wilhelm von Gennep (1349–62), judging by the arms on the platform. It was designed to fit on the three-pronged stand but this is also later in date than the staff, which is the part of the object with which this exhibition is concerned. As to the rock crystals, although set in much later mounts, it is possible that they belonged to the original staff, since its core tapers upwards through the centre of the crystals. This is a unique survival of a Romanesque precentor's (cantor's) wand for carrying in processions on great feast-days

(see Victor Gay, *Glossaire archéologique du Moyen Age et de la Renaissance*, I, 1887, pp. 128–30 (article on 'Bâton de Chantre')). It was commissioned for Cologne and made in 1178; the donor has been identified as Hugo, Dean of the Cathedral Chapter and Provost of the church of S. Maria Ad Gradus, just to the east of the cathedral, who is recorded between 1166 and 1181 (Witte). This is thus the one dated and apparently localized work among a group of related silver nielloed pieces, of which 306 and 308 are also exhibited here. However, the nielloed decoration has little in common with contemporary metalwork in the Rhineland. Only the stamped leaf patterns of the four gilded mounts have German parallels, and then with work from Lower Saxony (Swarzenski, 1932). As to the nielloed motifs on the knop, they coincide with the decorative repertoire on early Limoges enamels, although, given the technique of nielloed silver, this part of the staff cannot be attributed to a Limoges coppersmith. Its origins are perhaps to be sought in the Angevin domains, where the earliest Limoges productions were known and admired (compare 291, 292, and 293). The mounts with the nielloed inscription of 1178 obviously go with the 'Angevin' knop. The embossed 'German' mounts are probably contemporary. The simultaneous occurrence of Angevin and German motifs is also to be found on the Stockholm cup (306). N.S.

EXHIBITIONS Kunsthistorische Ausstellung, Düsseldorf, 1902, catalogue, p. 53 (no. 454); Jahrtausend-Ausstellung der Rheinlande, Cologne, 1925, catalogue, p. 147, (showcase 18, no. 7); Die Heiligen Drei Könige-Darstellung und Verehrung, Cologne Wallraf-Richartz-Museum, 1982/3, no. 21
BIBLIOGRAPHY Fritz Witte, *Die Schatzkammer des Domes zu Köln*, 1927, p. 13, ill., 18; Swarzenski, 1932, pp. 382, 384, ill. 330; Paul Clemen, *Der Dom zu Köln* (Die Kunstdenkmäler der Stadt Köln, part 1, section III), 1st edn., 1937, p. 330, figs 262–3; 2nd edn., 1938, pp. 333 (fig. 263), 337 (fig. 270), 338; Swarzenski, 1954, fig. 455; Walter Schulten, *Der Kölner Domschatz*, 1980, no. 10; Johann Michael Fritz, *Goldschmiedekunst der Gotik in Mitteleuropa*, 1982, p. 200, ill. 109

308 Bowl of a drinking-cup

Hammered silver, engraved, nielloed and gilded; depressed hemispherical bowl, foot lost (for its shape, compare 306). Interior gilded, roundel lost; rim with repeated leaf motif; bowl divided into triangular and four-sided fields by a lattice engraved with fluted leaves; nielloed studs between the fields; backgrounds, with nielloed *vermiculé* patterns; engraved and gilded foliage and animals: pairs or single winged dragons in the triangular fields, a naked man between two dragons in the larger fields; the heads cast separately;

h 80 mm, *diam* 155 mm (at rim), *w* 165 mm
Angevin or German; last quarter 12th century
New York, The Metropolitan Museum of Art, 47.101.31, The Cloisters Collection, 1947

The bowl has many details in common with a cup from the Dune Treasure (306) and must be from the same workshop. Both were probably drinking-cups without covers. In form they resemble the three English ciboria (see 278, 279 and 280); the traditional shapes of some liturgical and secular vessels were no doubt interchangeable in the 12th century, just as they were in the early Christian period. Virtually every motif of the decoration can be traced to the early Limoges workshops: the *vermiculé* backgrounds, the lattice of fluted leaves, the repeating leaf motif of the rim, the separately cast heads, the fantastic winged creatures. But no objects could be less typical of early Limoges than the New York and Stockholm cups: in technique (the use of precious metal and niello) and in style (nudes boldly modelled, their muscles carefully articulated; tightly coiled, intricate foliage). For the nudes, compare the initials in 63. But another possible claimant to this workshop is the Rhineland, as evidenced by 307 (the precentor's staff made for Cologne Cathedral). The Dune cup was found in Gotland and the New York bowl either in Hungary (Basilewsky) or western Siberia (Darkevich). Other vessels of similar shape and based on the same decorative tradition though of different workmanship have been found in Russia, near Surgut in Siberia and in the Urals; a cup from the same Siberian region, now in the Hermitage, may even be by this workshop (Darkevich 1966, no. 69). It is therefore possible that its activities centred at least for a period on the Baltic and that its productions were traded overland as far as Siberia. However the origins of the workshop must remain disputed as between the Angevin domains, where Limoges motifs could so easily have been assimilated, and the Rhineland, which can lay some claim to the Dune and Cologne pieces. As to the date of this workshop's production, the Cologne staff is of 1178, but much of this Limoges repertoire was first widely current in the later years of the 12th century. N.S.

PROVENANCE Collection Alexander Basilewsky; Leningrad State Hermitage; acquired 1947
EXHIBITION New York, 1970, no. 169
BIBLIOGRAPHY A. Darcel, A. Basilewsky, *Collection Basilewsky. Catalogue raisonné, précédé d'un essai. . . .*, 1874, pp. 65 (essai); 51, no. 139, pl. XXI (catalogue); Marc Rosenberg, *Geschichte der Goldschmiedekunst, vol. 2: Niello*, 1925, p. 49, fig. 50; Swarzenski, 1932, pp. 388–9; Swarzenski, 1954, fig. 457; Darkevich 1966, pp. 38–9 (no. 68)

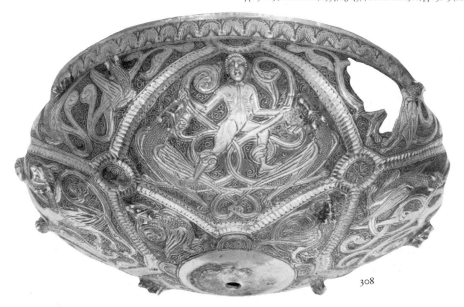

308

309 The St-Maurice d'Agaune ciborium

(illustrated on p. 26)

Cup and cover: silver, repoussé, engraved, punched and gilded (the present overall gilding not original, since a few areas of silver escaped the gilding and thereby suggest that originally only certain details were gilded, cf. 304 and 305); finial: cast silver, chiselled and gilded; covered cup in the form of two depressed hemispheres, with tapering concave circular foot (a damaged section mended with a copper plate); composed of double 'skins' of silver: interior plain but gilded, with three pin-marks in the centre of the cup, where the cast finial group was formerly attached (see below); exterior with figured roundels and triangular fields framed by the outer skin: embossed half-length angels in the triangular spandrels; borders with tufts of stiff-leaf foliage bending alternately to the left and right against stippled backgrounds; a cycle of scenes from Christ's early life in the roundels: (anti-clockwise) on the cover, the Annunciation, Visitation, Annunciation to the Shepherds, Nativity, Adoration of the Magi; on the cup, the Magi before Herod, Journey of the Magi, Presentation in the Temple, Massacre of the Innocents, Baptism of Christ; foot also composed of two skins, again with triangular fields framing inserted half-length angels; also elliptical medallions (only three survive) with seated figures holding books and flanked by foliage stems; seated figures repoussé, using a single stamp; three different stamps used for the angels of cover, cup and foot; finial group, cast in the round, Chiron and Achilles; the young Achilles rides the centaur Chiron, who holds a cup; it is pinned on to a round base-plate, inserted into the top of the cover; by the 17th century, this group is recorded in the interior of the cup; h 260 mm (overall), (of Chiron group) 42 mm, diam (of cup) 158 mm, (of foot) 109 mm

c. 1200–1210

Treasury of the Abbey of St-Maurice d'Agaune, diocese of Sion (Switzerland)

The venerable Benedictine Abbey of St-Maurice d'Agaune, founded in the early 6th century on the site of the martyrdom of the soldiers of the Theban legion, was reformed in 1128, to become a house of Regular Canons. Aubert prints three inventories of the Treasury which include the ciborium, the earliest of between 1550–72 (Reliquiare sancti Caroli magni ecclesiae datum, super quo victos infideles jurare faciebat ad fidem ei servandam; 'Reliquary of St Charlemagne, given by him to the church, one which he made his vanquished heathen enemies swear service to him'), the next of 1659 (Item, crater quem dicunt fuisse Caroli Magni; intro habet centaurum. Olim in eo fiebat vinagium; 'cup which is said to have belonged to Charlemagne, a centaur inside, once used for holy wine'), the third of the 1730s (Crater Caroli Magni vermiculatus; 'The ornamented cup of Charlemagne'). Charlemagne was a benefactor of the abbey in the late 8th to the early 9th centuries and several objects in the Treasury were associated

traditionally with his patronage. The Chiron and Achilles group, which was removed from inside the cup in the 19th century (Berthier), was probably originally made to crown the cover as it does today; it fits perfectly and the pin-marks inside the cup do not seem to be original. The liturgical purpose of the vessel seems assured. From its shape, it was a ciborium, the receptacle for the reserved Eucharistic Host, similar to 278, 279 and 280. The story of Christ's infancy and early life is told in a series of scenes reminiscent of the pictures which habitually prefaced English Psalters, whilst the spandrel angels are a decorative feature often painted or carved on buildings or choir screens. The seated figures on the foot may be the Cardinal Virtues (Homburger) but they could equally well be the Evangelists, since they are of indeterminate sex. The education of the young Achilles by the centaur Chiron seems thoroughly out of place on a sacred vessel, but Chiron carries a cup which suggests some reference to the Christian chalice.

As to the style and date of the roundels, Homburger was the first to demonstrate their close relationship to certain English manuscripts: the Annunciation and Visitation to their counterparts in the Westminster Psalter (82) and the Imola Psalter; the Annunciation to the Shepherds with the same scene in the Leyden Psalter (79). The seated figures on the foot were struck from a stamp whose design was based on a figure similar to the Christ in Majesty of the Westminster Psalter (82; Morgan, 1982, ill. 9), while the unusual arched setting of the Visitation occurs again in an English New Testament picture-book (Morgan, 1982, ill. 51).

The elegant foliage tufts of the borders belong to the formalized world of early stiff-leaf sculpture, of c. 1200, in buildings such as Wells and Lincoln. The comparable manuscripts are dated by Morgan c. 1190–1210. Nothing demonstrates more outspokenly than the beautiful group of Chiron and Achilles that renewed interest in antique art which is associated specifically with the years c. 1200. As to 'localizing' the artist of the ciborium, the manuscript evidence is inconclusive: the sources of his style can be traced in the St Albans-Westminster manuscripts of c. 1200 (82 and 83) but it is the group of manuscripts associated with the Leiden Psalter (79) which seems closest. If the Psalter itself may be somewhat earlier, the New Testament picture-book (Morgan, 1982, no. 16, ills. 50–3) is probably more or less contemporary and shares with the ciborium the same strongly-characterized faces and vigorously-arranged draperies. Does this unique survival represent all that is left of a major English repoussé tradition which ran parallel to the finest illustrated manuscripts of the early 13th century? N.S.

PROVENANCE In the Abbey Treasury before 1572
EXHIBITIONS Barcelona, 1961, no. 564; Aachen, 1965, no. 682; New York, 1970, no. 90
BIBLIOGRAPHY Edouard Aubert, Trésor de l'abbaye de St-Maurice d'Agaune, 1870–72, pp. 172–4 (no. XXI) 239 (no. 9), 247, 249 (no. 13), pl. XXXIV; J.-J. Berthier, La Coupe dite de Charlemagne du Trésor de St-Maurice, 1896; Homburger, 1954, pp. 339–53; Lasko, 1961, p. 496; Zarnecki, 1963, pp. 157–8, pl. LVI, 14; Jean-Marie Theurillat, Le Trésor de St-Maurice, 2nd ed., 1967, pp. 28, 31; Sauerländer, 1971, p. 515; Lasko, 1972a, p. 239, pl. 282; Morgan, 1982, p. 61

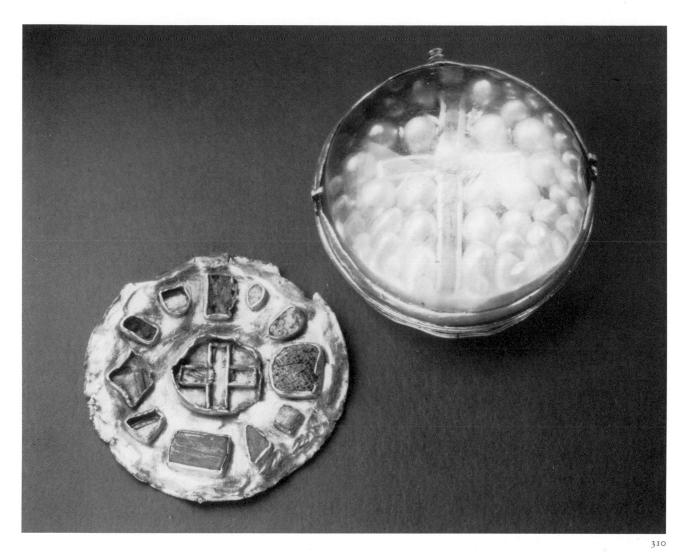

310

310 Reliquary pendant

Beneath a domed rock crystal, a circular gold base-plate sewn
with gold wire forming loops which frame pearls around a
gold-mounted wooden cross; the crystal magnifies the size of
the cross and pearls; crystal and base-plate are mounted in gold
surrounds and were locked together by a nut screwed down at
the top; remains of two suspension loops for a chain and an
inscription: (clockwise from top) + SEXPSTI:NINIAN/
ANDREEX MAVRIS:GEORGII:MERG:D(?)NOR:F(?)
ERG:B(?)O/NEF(?)SE:MARIE. ('Of Jesus Christ, of Ninian, of
Andrew of the Moors, of George, of Margaret(?), of
Norbert(?), of Fergus(?), of Boniface(?), of St Mary'); backing
plate exhibited separately: circular, with settings for relics,
some of which survive; the central setting for a relic of the True
Cross; w 50 mm

c. 1200

London, Trustees of the British Museum, MLA.1946, 4-7, 1

This pendant may have been made for a bishop of Galloway,
to be worn suspended from a chain around the neck, similarly
to 303, or suspended near the altar. The relics were hidden
from view, the image of the True Cross being represented for
the spectator by means of the simple wood cross beneath the
crystal, which is not itself a relic. The abbreviated names in the
relic list are not all easy to decipher, but if the present reading
is correct, the list includes Sts Andrew, Fergus and Margaret,
all of whom are suggestive of a Scottish origin for the reliquary.
St Norbert of Xanten was founder of the Order of Regular
Canons of Prémontré, and St Ninian apostle of Cumberland
and Galloway. Since the Cathedral of Galloway at Whithorn
was Premonstratensian and closely associated with the cult of
St Ninian, who heads the list of saints on the reliquary, the
pendant has been attributed to an early bishop of Galloway,
a see which was revived under the province of York, probably
c. 1128 (see under 285). N.S.

PROVENANCE Presented by the National Art-Collections Fund, 1946
EXHIBITION Edinburgh, 1982, B.27
BIBLIOGRAPHY A.B. Tonnochy, 'The Ninian Reliquary', *Brit. Mus. Qu.* XV, 1952, p. 77; C.A.
Ralegh Radford, 'Two Reliquaries Connected with South-West Scotland', *Trans.
Dumfriesshire and Galloway Natural History and Antiquarian Society for 1953–54*, 3rd series,
XXXII, 1955, pp. 119–23

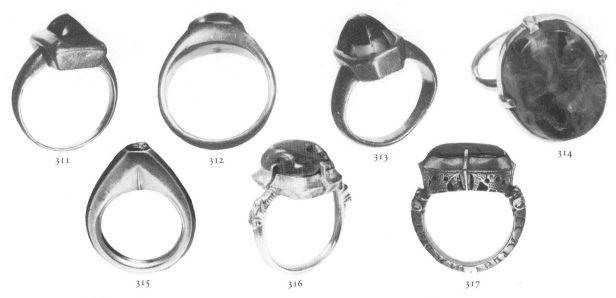

311 312 313 314

315 316 317

311–17 Seven gold finger-rings

This is a representative selection of rings, worn by the very wealthy; contrast the humbler silver rings in the Lark Hill hoard (**320**). By the 12th century, bishops and certain privileged abbots were invested with a ring, which they wore as a symbol of marriage to the Church. The three examples from bishops' tombs at Durham are set with sapphires, a gem particularly favoured for episcopal rings, and it may be that the other three sapphire rings exhibited here were also made for a bishop or abbot (see Marbode of Rennes' popular poem *De Lapidibus* on the sapphire and its properties, as the 'gem of gems' warding off deception (ed. and translated John M. Riddle, *Sudhoffs Archiv-Zeitschrift für Wissenschaftsgeschichte*, vol. 20)). Even more elaborate and sumptuous rings were made in the 12th century, although none has survived; but see the 'pontifical' ring of Henry of Blois drawn by Matthew Paris (**318**, 7.). The Chichester bishop's ring (**314**) is set with an antique-type *intaglio*; compare Archbishop Hubert Walter's ring which is also set with a gnostic gem (**324c**). Some *intaglio* rings were probably used as signet-rings in the 12th century, although documentary evidence is wholly lacking: the Chichester gem for instance was cut in mirror image, apparently in the medieval period. Although the original meaning of these gems was often lost or at least misunderstood, they were apparently highly prized for their exotic qualities and even credited with certain medicinal properties; see Matthew Paris' drawing of the big antique cameo at St Albans (**318**, 8.), which Matthew associates with the power to ease women in childbirth. All seven rings must, from their size, have been worn over gloves.

As to their dating and place of manufacture, the evidence is limited: the Lark Hill hoard was deposited by *c.* 1173–4 and Matthew Paris records a 12th-century stirrup-shaped ring (**318**, 3.), but the dates traditionally ascribed to the three Durham rings must be treated with caution, because the coffins in which they were found cannot be unconditionally attributed to particular bishops. Whether or not such and such a ring was made by an English as opposed to French goldsmith is even more difficult to establish, as the various types of ring fashionable in the 12th century seem to have been worn on both sides of the Channel. The most that can be said is that 13 out of the 14 rings in this exhibition are known to have been buried in England, including Archbishop Hubert Walter's ring (**324c**).

311 Ring

Projecting rectangular bezel faceted to receive a cabochon sapphire; thin rounded hoop; of the same type as three of the Lark Hill rings (**320a–c**); *h* 32 mm, *w* 25 mm
Durham, Dean and Chapter of Durham Cathedral

PROVENANCE Found in grave no. 4 on the site of the chapter house, 1874; tomb identified by Fowler in 1874 as that of Bishop Ranulf Flambard (1099–1128) but the identification has been questioned (Wilson); associated finds included a pewter chalice and a crosier decorated with Urnes-style ornament
BIBLIOGRAPHY Fowler, 1880, particularly pp. 387–9; Wilson, 1964, p. 7 (n. 2); Oman, 1974, no. 13E

312 Ring

Rounded hoop broadening into an oval bezel, set with a sapphire; *h* 31 mm, *w* 26 mm
Durham, Dean and Chapter of Durham Cathedral

PROVENANCE Found in grave no. 5 in the chapter house, 1874; Fowler's identification of the tomb as that of Bishop Geoffrey Rufus (1133–40) cannot be taken as certain
BIBLIOGRAPHY Fowler, 1880, pp. 390–1; Oman, 1974, no. 13A

313 Ring

Projecting octagonal bezel set with a domed sapphire; rounded hoop; *h* 33 mm, *w* 26 mm
Durham, Dean and Chapter of Durham Cathedral

PROVENANCE Found in grave no. 3 in the chapter house, 1874; Fowler attributed this grave to Bishop William of Ste-Barbe (1143–52), but again this is not certain
BIBLIOGRAPHY Fowler, 1880, pp. 391–2; Oman, 1974, no. 13B

314 Ring

Openwork oval bezel, acting as a setting for a bloodstone *intaglio*; thin hoop attached to the centre of a cross of two bands of gold which form the backing to the gem and are embellished with delicate trefoil foliage; the *intaglio* with the well-known late-antique amuletic figure of Abraxas (with the head of a cock, two serpentine tails and holding a shield and club); *h* 32 mm, *w* 27 m.
Chichester, Dean and Chapter of Chichester Cathedral

This gem was cut in mirror image, probably as a signet, since the shield is normally held in the figure's left hand, the weapon

in his right. It is possible that the gem is a medieval copy, since club and shield have a distinctly non-classical form. The trefoil foliage on the bezel suggests a late-12th-century date. (For another ring with *intaglio*, see (324C.) N.S.

PROVENANCE Drawn and fully described as part of the furnishings of an unidentified bishop's coffin in the cathedral, 1829; the often repeated attribution of the ring to Bishop Seffrid (1125–45) must be incorrect, since the ring was found with a jet crosier mended in the late 12th century (272) and a 13th-century chalice and paten
EXHIBITION Oxford, Ashmolean Museum and London, The Worshipful Company of Goldsmiths, *Finger Rings from Ancient Egypt to the Present Day*, 1978 (catalogue by Gerald Taylor, 1978, no. 293)
BIBLIOGRAPHY *Gentleman's Magazine*, 1829, part I, p. 545; drawn in 1829 by Thomas King (separately published engraving, 1830); Edmond Waterton, 'On Episcopal Rings', *Archaeol. J.*xx, 1863, pp. 234–5 (fig. 6); Dalton, Mitchell, Couchman, 1926, p. 215; Henig, 1978, pp. 166 (n. 20), 285 (M.19); Cherry, 1981a, no. 116

315 Ring

'Stirrup-shaped' hoop, polygonal in section, rising to a pointed bezel, set with an irregular six-sided sapphire; keeled beneath the bezel; *w* 37 mm
London, Trustees of the British Museum, MLA.85,6–15,1

This is the largest surviving example of the type known as a 'stirrup ring'; other examples are – two rings from unidentified bishops' tombs at Chichester, one incorrectly attributed to Bishop Hilary (d. 1169). The type is known to have existed in France by the mid-12th century; see one of the Matthew Paris drawings (318, 3.). N.S.

PROVENANCE Found at Wittersham (Kent); bequeathed by the Revd E.H. Mainwaring, 1885
BIBLIOGRAPHY Dalton, 1912b, no. 1782; Oman, 1974, no. 15D; Cherry, 1981a, no. 119

316 Ring

Projecting bezel, its irregular shape dictated by the untrimmed sapphire held in four claws; the junction between bezel and thin hoop decorated with two animal heads; *w* 29 mm
London, Trustees of the British Museum, MLA.AF,1867

PROVENANCE Collection of Fritz Hahn; acquired with the Franks Bequest, 1897
BIBLIOGRAPHY Dalton, 1912b, no. 1828; Oman, 1974, no. 14E

317 Ring

Oval bezel, its sides decorated in openwork with engraved birds; set with a cabochon sapphire held in four claws; the junction between bezel and hoop, decorated with two animal heads; the hoop trapezoidal in section with beaded outer edge, the two sides engraved to receive a nielloed inscription: AVE MARIA GRA/TIA PLENA DMI. ('Hail Mary, full of the grace of the Lord'), a variation on the angelic salutation at the Annunciation; *w* 30 mm
London, Trustees of the British Museum, MLA.1925,1–13,1

This splendid ring has been dated to the later 12th or early 13th centuries. Its place of manufacture could have been either England or France. N.S.

PROVENANCE Found at Cannington, Somerset, 1924
BIBLIOGRAPHY O.M. Dalton, 'A Medieval Gold Ring found at Cannington', *Antiq. J.* V, 1925, pp. 278–9; Oman, 1974, no. 15A; Cherry, 1981a, no. 124

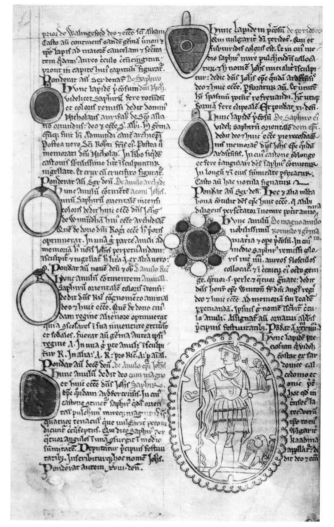

318

318 Drawings of jewellery at St Albans

Matthew Paris (d. ?1259)

Part of a short treatise on the rings and gems of St Albans Abbey, written and illustrated by the monk Matthew Paris, and included by him in his manuscript collection of documents, known as the *Liber Additamentorum*; the verso with eight coloured drawings and Latin commentaries, briefly summarized:

1. Pendant, with oval sapphire in gold mount; given by the goldsmith Nicholas of St Albans; formerly the property of St Edmund Rich, Archbishop of Canterbury (d. 1240) and then of his brother, St Robert (d. by 1244); inside the hoop was a nielloed representation of the Crucifixion.
2. Gold ring with sapphire (cf. 312); given by John of Wymondham, Archdeacon of St Albans, who acquired it as a gift from Roger, Prior of St Albans (d. 1231); the letters J and O for John were nielloed on it.
3. Stirrup-shaped gold ring set with a sapphire (cf. 315); the initials R and A nielloed on the hoop, for the donor Richard, known as 'Animal', who had been given it by Queen Eleanor of Aquitaine, with whom he had been taught in his youth, it having previously belonged to her (i.e. it was in existence by *c.* 1140).

4. Ring with irregular sapphire set in a thin gold frame and held by four claws (cf. **316**); given by John, Bishop of Ardfert, province of Cashel (Ireland) (deposed 1221, d. 1245).

5. Pendant, with a green peridot mineral set with a small sapphire; donor as 4.

6. Pendant, set with irregular sapphire; donor as 4.

7. Big 'pontifical' ring, with an oval central sapphire in a gold setting formed by four flower-shaped claws, and surrounded by four pearls and four garnets; given by Henry of Blois, Bishop of Winchester (1129–71), who had his name inscribed on the hoop during his own lifetime.

8. Roman (late Antique?) sardonyx cameo which was almost too large to be held in the hand, engraved with an emperor in armour, holding the Palladium and a staff or spear with a snake wound around it; the silver mount with six claws was inscribed on the reverse in niello with the names of the owner, St Alban, and the donor, King Ethelred the Unready (d. 1016) (the mount is of 12th-century type, so that the inscription appears to be commemorative); described as giving relief to women in childbirth.

1251–59

London, British Library, MS Cotton, Nero D.1, ff. 146ᵛ–147

The monk Matthew Paris is writing in the 1250s as the antiquarian historian of his abbey. His manuscript is exhibited here to illustrate the range of jewellery which might have been expected in the treasury of any of the great English monasteries by the early years of the 13th century. Three of the pieces were at St Albans by 1200: 3. is particularly important as evidence for the existence of stirrup-shaped rings in France by the mid-12th century; 7. provides unique evidence for the grandest type of ceremonial bishop's ring known as 'pontifical', worn when celebrating, and what is more, it was the gift of one of the great English patrons of the period, Henry of Blois (see **277**); and 8., a great antique cameo, a royal Anglo-Saxon benefaction apparently reset in the 12th century, is symptomatic of the value set on antiquities throughout the Middle Ages. Of the other five rings and pendants, all are still of Romanesque type, even if they were presumably made in the 13th century; three can be compared with other rings in the exhibition.

The treatise is followed by a written record of the works of art due to Richard the Painter between 1241 and 1250. Matthew himself probably died in 1259, so the text on the jewellery must date between 1251 and 1259. N.S.

BIBLIOGRAPHY *Matthew Paris, Chronica Majora*, VI, ed. H.R. Luard, Rolls Series 1882, pp. 384–8, colour pl.; C.C. Oman, 'The Jewels of Saint Albans Abbey', *Burl. Mag.*, LVII, 1930, pp. 80–2; Oman, 1932, particularly p. 224 (n. 33), plates 2, 3; Richard Vaughan, *Matthew Paris*, 1958, pp. 81–2, 209–10; Cherry, 1981a, nos. 115, 120–1; Dodwell, 1982, p. 109, pl. 25

319a–r Coins from the Lark Hill hoard
(illustrated on p. 339)

This hoard of jewellery and 229 coins, 208 of Henry II's first issue, was found at Lark Hill near Worcester in 1853. Despite the unusual presence of a few Continental coins, the hoard is likely to be of local origin since West Country mints are relatively well represented. Lark Hill belongs to a group of hoards which may be associated with the baronial troubles of 1173–4

London, Trustees of the British Museum

ENGLISH COINS

The following 13 coins of Henry II, 1154–89, are all of his first, Cross and Crosslets ('Tealby') type struck from the beginning of the issue in 1158 until *c.* 1170:

319a Penny of Bristol by the moneyer Tancred, class B, 1.37 g (21.1 gr), BMC 12; British Museum, CM 1917, 12-2-44

319b Penny of Bury St Edmunds by the moneyer Henri, class E, 1.47 g (22.7 gr), BMC 29; British Museum, CM 1917, 12-2-93

319c Penny of Canterbury by Alferg, moneyer of the Abbot of St Augustin's, class A, 1.43 g (22.1 gr), BMC 54; British Museum, CM1855, 4-4-13B

319d Penny of Canterbury by the moneyer Raul, class E, 1.45 g (22.3 gr), BMC 87. British Museum, CM 1917, 12-2-94

319e Penny of Canterbury by the moneyer Ricard, class B, 1.42 g (21.9 gr), BMC 150; British Museum, CM 1917, 12-2-16

319f Cut halfpenny of Carlisle by the moneyer Willam, class C, 0.64 g (9.9 gr), BMC 216; British Museum, CM 1855, 4-4-13B

319g Penny of Exeter by the moneyer Rogier, class D, 1.45 g (22.4 gr), BMC 270; British Museum, CM 1917, 12-2-36

319h Penny of Ipswich by the moneyer Nicole, class D, 1.45 g (22.4 gr), BMC 320; British Museum, CM 1917, 12-2-39

319i Penny of Lincoln by the moneyer Rauf, class E, 1.45 g (22.4 gr), BMC 413; British Museum, CM 1917, 12-2-139

319j Penny of London by the moneyer Alwin, class A, 1.46 g (22.5 gr), BMC 445; British Museum, CM 1917, 12-2-63

319k Penny of Northampton by the moneyer Engelram, class A, 1.24 g (19.1 gr), BMC 614; British Museum, CM 1917, 12-2-78

319l Cut halfpenny of uncertain mint and moneyer, class A, 0.67 g (10.4 gr), BMC 861; British Museum, CM 1917, 12-2-176

319m Cut farthing of uncertain mint and moneyer (possibly Geffrei of London), class A, 0.37 g (5.7 gr), BMC 870; British Museum, CM 1855, 4-4-13C

FOREIGN COINS

Considerable difficulty remains in attributing the immobilized French feudal issues to specific rulers.

319n Penny of Malcolm IV of Scots, 1153–65, of Roxburgh by an uncertain moneyer (possibly Hugo), type III, 1.37 g (21.1 gr) (Stewart, 1967, pl. I, 13); British Museum, CM 1855, 4-4-17

319o Denier of the County of Anjou, possibly struck during the period of Foulkes V, 1109–29, 0.84 g (12.9 gr) (Poey d'Avant, 1862, no. 1499); British Museum, CM 1917, 12-2-191

319p Denier of the Duchy of Burgundy, possibly struck during the period of Oddo II, 1142–62, 0.94 g (14.5 gr) (Poey d'Avant, 1862, no. 5659); British Museum, CM 1855, 4-4-18

319q Denier of the Abbey of St Martin of Tours struck in the mid-12th century, 0.71 g (10.9 gr) (variety of Poey d'Avant, 1862, no. 1646); British Museum, CM 1917, 12-2-187

319r Fragment of a denier of the County of Boulogne, possibly struck late in the period of Eustace IV (son of Stephen, King of England), 1146 or 7-53, 0.31 g (4.8 gr) (Poey d'Avant, 1862, no. 6618); British Museum, CM 1855, 4-4-17 M.M.A.

BIBLIOGRAPHY Akerman, 1855; Lawrence, 1919, pp. 45–60; Allen, 1951, pp. liv–vi (Works cited refer to the Bibliography on pp. 322–3)

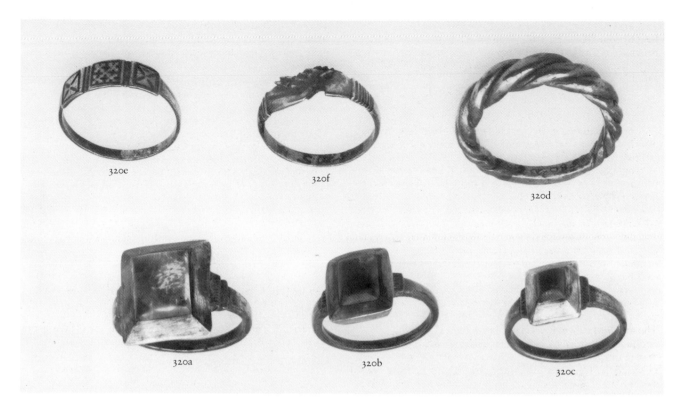

320e 320f 320d

320a 320b 320c

320a–f Six silver finger-rings from the Lark Hill hoard

The firm date which can be assigned to the deposition of the hoard is of central importance to a reconstruction of the chronology of Romanesque rings. In addition, the hoard provides valuable evidence of the types of ring which were commonly worn in Henry II's reign; the use of cheap materials to simulate precious stones acts as a corrective to the notion that only the very wealthy wore rings in the 12th century. On the other hand, the presence of a few foreign coins in the hoard means that the English origins of the Lark Hill rings can be no more than a strong presumption (for a series of gold rings in this exhibition, see 311–17). Four types of ring were found at Lark Hill:

320a–c With projecting faceted rectangular bezels and thin flat hoops, set with: (a) a crystal, backed by traces of red foil; (b) a cabochon amethyst; (c) yellow paste; junction between hoop and bezel decorated with one or more engraved ribs (for a similar use of coloured backing foil, see 302); w a 25 mm, b 23 mm, c 22 mm
London, Trustees of the British Museum, MLA.54,8-20,1/2/3

320d Two thick wires plaited together, of thicker section at the top and hammered flat at the back; a common type of Viking and late Anglo-Saxon ring, though this example may be an archaic survival; w 28 mm
London, Trustees of the British Museum, MLA.54,8-20,6

320e With rectangular bezel, divided into three square fields decorated with cross patterns, either nielloed or reserved against a nielloed ground; thin, flat hoop; a rare survival of a Romanesque nielloed ring, but compare the same nielloed cross patterns on the ring of Archbishop Absalon of Lund (d. 1201) from his tomb at Sorø (Fritze Lindahl, 'Om Absalons gravklaedning', Nationalmuseets Arbejdsmark, 1973, p. 149 (fig. 5)); w 21 mm
London, Trustees of the British Museum, MLA.54,8-20,4

320f The bezel formed by two clasped hands; thin, flat hoop; the earliest surviving medieval example of a 'fidelity ring', a common type from the 13th century onwards; w 20 mm
London, Trustees of the British Museum, MLA.54,8-20,5 N.S.

BIBLIOGRAPHY J.Y. Akerman, 'Account of silver rings and coins discovered near Worcester,' *Archaeologia*, XXXVI 1855, pl. XVII, nos. 1–6; Cherry, 1981a, nos. 111–14

321 Chalice (*not illustrated*)

Silver, hammered, part-gilded; in three parts, of more or less equal height: hemispherical bowl with pinched lip; cylindrical stem with small central knop; short round foot of same diameter as bowl, on a narrow rim; inside of bowl and lip, stem and rim of foot gilded; h 149 mm, *diam* 125 mm
Second half 12th or 13th century
London, Trustees of the British Museum, MLA.79,7-25,1

This is a classic example of one of the commonest forms of Romanesque chalice; compare 322–3. Oman dated this type to the period 1180–1280, his earliest firmly-dated example being from the tomb of Absalon, archbishop of Lund (d. 1201), at Sorø (Fritze Lindahl, 'Om Absalons gravklaedning', *Nationalmuseets Arbejdsmark*, 1973, pp. 147–8 (fig. 2)). However, the type was already in existence by the mid-12th century; a pewter example was found in the tomb of Bishop Ulger (d. 1148) in the Cathedral of Angers (catalogue, *Trésors des Eglises de France*, 1965, no. 260). N.S.

PROVENANCE Early history unknown, but associated with a 15th-century silver paten; presented by the Vicar and Churchwardens of Berwick St James (Wiltshire), 1879
BIBLIOGRAPHY J.E. Nightingale, *Proc Soc. Antiq.*, 2nd series, VIII, 1879–81, pp. 152–5, ill.; Hope, Fallow, 1887, p. 6, engraving; J.E. Nightingale, *The Church Plate of the County of Wilts. Diocese of Salisbury*, 1891, pp. 66–7, ill.; Jackson, 1911, pp. 100–1, fig. 134; Oman, 1957, pp. 41, 299

322a and b Chalice and paten (not illustrated)

Silver, parcel-gilt;

322a chalice: shallow hemispherical bowl with slightly pinched lip, concave tapering foot of nearly the same height and diameter as bowl, flattened spherical knop and short polygonal shaft; much damage; knop and rim of foot gilded; h 111/116 mm, diam (of bowl) 109/111 mm, (of foot) 99/101 mm;

322b paten: within a quatrefoil, engraved and gilded medallion with the Lamb of God and cross standard, surrounded by a roughly executed inscription: + AGNVS DEI QVI TOLLIS PECATA MVNDI MISERERE NOBIS ('Lamb of God, you who bear the sins of the world, have mercy upon us' – the words sung at the fraction (breaking of the Host) during preparation for Communion); diam 121/123 mm
12th century
Chichester, Dean and Chapter of Chichester Cathedral

The chalice is of typical Romanesque form and can be paralleled all over Europe in the 12th and well into the 13th centuries. The Lamb of God is the of the most widely employed of images not only for patens (compare 324e) but also for the insides of ciboria (such as 278, 279 and 280) which were receptacles for the reserved Host. N.S.

PROVENANCE Found in an unidentified bishop's coffin in the Cathedral, 1829, together with fragments of a 12th-century ivory (or bone) crosier and a sapphire and gold stirrup ring; drawn in situ by Thomas King (engraving published separately, 1830)
BIBLIOGRAPHY Hope, Fallow, 1887, pp. 6, 17; J.E. Couchman, Sussex Archaeological Collections, LIII, 1910, pp. 204, 226, pls. 16–17; Dalton, Mitchell, Couchman, 1926, pp. 214–5; Oman, 1957, pp. 47, 299, 304

323a and b A mortuary chalice and paten
(not illustrated)

Undecorated base metal (lead or pewter) chalice and paten, of Romanesque form (cf. 322):

323a chalice: h 100/108 mm, diam 111/121 mm (incomplete)

323b paten: diam 123 mm (incomplete)

12th century
Chichester, Dean and Chapter of Chichester Cathedral

This chalice and paten are typical of the base-metal communion sets which were commonly buried with priests during the Middle Ages. A well-known statute issued in 1229 by William de Blois, Bishop of Worcester, specified that every church in the diocese should possess two chalices, one of silver for celebrating Mass, the other of tin and unconsecrated to be buried with the priest at his death (ed. F.M. Powicke, C.R. Cheney, Councils and Synods, with other documents relating to the English Church, II, Part I, 1205–65, 1964, p. 171). Like the Chichester set, most of the numerous surviving mortuary sets are poorly preserved. N.S.

PROVENANCE Probably the chalice and paten recorded as having been found in an unidentified bishop's coffin in the Cathedral, 1829, together with a small gold and sapphire stirrup ring and a crosier, which may be 267
BIBLIOGRAPHY Gentleman's Magazine, 1829, part I, p. 545; Dalton, Mitchell, Couchman, 1926, p. 214

324a–f The furnishings of Archbishop Hubert Walter's tomb

Hubert Walter, Archbishop of Canterbury (1193–1205), was one of the great statesmen of the 12th century, whose influence was felt in every walk of life, both secular and ecclesiastical, under successively Henry II, Richard I and John. He died at his manor of Teynsham on 13 July 1205, and was buried the following day in the Cathedral of Christ Church, Canterbury, where his splendid Purbeck marble tomb can still be seen in the south aisle of the Trinity Chapel. The tomb was opened up in 1890: within a Caen stone coffin, the archbishop's remains were found undisturbed, his vestments and various items of metalwork being in a good state of preservation. All the metal furnishings of the tomb are here exhibited, together with some of the textiles (493).

Canterbury, Dean and Chapter of Canterbury Cathedral

EXHIBITION Manchester, 1959, no. 111
BIBLIOGRAPHY Stratford, Tudor-Craig, Muthesius, 1982, pp. 71–93, pls. XVII–XXVI (with full bibliog.)

The metalwork (a, b, c and f not illustrated)

324a and b Two silver-gilt pins, their heads hammered flat, with the edges cut out, then engraved on one face only with a flower, its petals flat and fanning out like those of a daisy, from a central ovary; h 113 mm
English(?); last quarter 12th century

The pins attached the chasuble to the pallium at the shoulders. For similar flowers, compare 302, although there the petals are cast and delicately moulded, as they are on certain Mosan and Rhenish works, for example the back of a phylactery in Namur and the cresting of the St Anno Shrine at Siegburg.

324c Gold finger-ring with rounded hoop, the bezel open beneath, projecting beyond the hoop and set with a green plasma, cut en cabochon; stone antique (Graeco-Egyptian (?)) engraved with a serpentine creature with rays emanating from its head, identified by a roughly cut inscription in Greek: CHNOPHIS; h 29 mm
12th century

The ring was found lying loose in the coffin. In form it is of typical Romanesque type (compare 311). Antique amuletic gems, engraved with the rayed lion-headed serpent god, Chnoubis (often mis-spelt as here) have survived in large numbers; they were considered excellent for stomach complaints. In the 12th century antique gems were admired as precious and exotic survivals; see 314, where a similar gem in a bishop's ring may even be a medieval copy of an antique prototype.

324d and e Chalice and paten: d chalice: silver-gilt and engraved; depressed hemispherical cup with slightly pinched lip, its sides engraved with a series of intersecting arches ending in blossoms, which alternate with smaller trefoil leaves; knop with projecting facets, hatching and, top and bottom, a row of beading; round foot tapering upwards to a polygonal top, its sides 'petalled'; engraved blossoms on hatched backgrounds in each 'petal', a row of hatched triangles along the lower edge; h 142 mm; e paten: silver-gilt, engraved with a medallion of the Lamb of God and cross-standard, surrounded by the

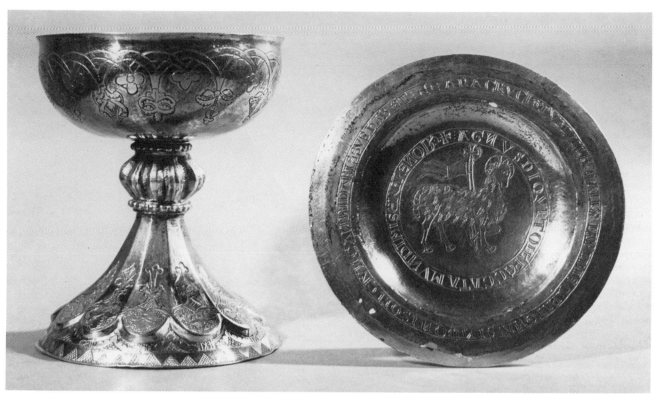

324d and e

inscription: + AGNVS D(e)I QVI TOLL(is) PECCATA MVNDI MISERERE NOB(is) ('Lamb of God, you who bear the sins of the world, have mercy upon us'); a second inscription on the rim: + ARA CRVCIS TVMVLIQ(ue) CALIX LAPIDISQ(ue) PATENA : SINDONIS OFICIVM CANDIDA BISSVS HABET. ('The altar represents the Cross, and the chalice the tomb, and the paten the stone, and the white *corporale* the winding-sheet'); *diam* 140 mm
Mid-12th century

Both the paten and the chalice, which seems to have been buried with wine in it, were placed to the right side of the Archbishop's body. The paten is of exactly the dimensions to cover the chalice and was probably made to go with it. For another *Lamb of God* paten, see **322b**. A similar lamb is engraved on the reverse of the Monmouth crucifix (**241**). The author of the outer inscription is not known, but this elegiac couplet was already popular by the later 12th century (it appears, for instance, on a portable altar of *c.* 1180 in Cologne). Its sentiments derive from the age-old tradition of drawing parallels between the events of Christ's Passion and their re-enactment in the Eucharist. The chalice with tall, petalled foot is already prophetic of the elegantly-tapering shape of the Gothic chalice, but its engraved blossoms and trefoil flowers belong to a mid-12th-century repertory which can be found in such manuscripts as British Library MS Cotton, Nero C.IV (**61**). Compare also the engraved blossoms in the bowls of the Iona spoons (**298b**). The hatched triangles of the lower rim are paralleled on the Dune drinking-cup (**304**).

324f Crosier: crook with silver-gilt inner scroll, decorated with three knobs; adjoining section of crook renewed; bottom section of crook wood, studded with original pins for a lost metal cladding; wood on main shaft in part restored; iron bottom spike beneath a plain silver-gilt collar with beaded edges; depressed spherical knop, silver-gilt with engraved row of leaves and beading above and below, and remains of a plain lower collar; on the knop, settings for four antique engraved gems (one lost), left to right: a pale carnelian, decorated with a horse; a red jasper, with a female figure holding wheat-ears and seated on a rock above a recumbent river-god; a red sard, with a hand holding three ears of wheat; the carnelian late Etruscan or Roman, the other gems Graeco-Roman
12th century

The crosier was found in fragments lying across the archbishop's body from right foot to left shoulder. The simple scrolled crook is of a common Romanesque form, as is the bottom spike (compare **269**). The use of antique gems, highly prized in the Middle Ages for their decorative and amuletic properties, cannot be paralleled on any other surviving crosier of the 11th or 12th centuries. With the gem ring from the same tomb, their presence underlines the highly personal and sumptuous nature of Hubert Walter's burial. N.S.

Decorative Ironwork

During the Romanesque period wrought ironwork was a popular medium for decorating chests and doors. So many examples still survive in English churches that it has been possible to date the ironwork fairly closely by comparing the date of a doorway with the style of the ironwork and the construction of the door itself.

Little is known about Anglo-Saxon wrought-iron ornament, but illustrations in manuscripts (Rouen MS A.27; British Library, MS Cotton, Claudius B.IV) indicate that quite elaborate scrolled designs were used. During the 12th century, the most common element found on doors was a large ornamental C shape attached to the hinge strap. This could be quite plain or embellished with barbs, scrolled or animal-head terminals (325). Later in the century lobed terminals surrounded by a cluster of iron tendrils came into fashion, as at Castle Hedingham Church in Essex, Canterbury Cathedral (chancel, north aisle), Eastwood in Essex and Kingston Lisle in Oxfordshire.

A small number of doors decorated with figurative motifs survive at Staplehurst in Kent (325), Stillingfleet in Yorkshire, Old Woking in Surrey, Runhall in Norfolk and Worfield in Shropshire. They have all lost part of their design and most have been rearranged. This makes their iconography hard to interpret. However, recurring symbols are a cross, dragon, snake, bird and boat.

The closest parallels for these 'picture' doors are found in eastern Sweden where the ironwork survives in much better condition. The Swedish examples depict a few specific scenes like the Crucifixion or a hunter and his prey, surrounded by a mass of incidental ornament. It is likely that only a few motifs on the English doors were intended to tell a story and the subject matter was not necessarily religious.

The door from Little Hormead (326) represents the third type of Romanesque iron decoration, with its bold use of geometric motifs.

A few battered remains of Romanesque iron grilles survive in the cathedrals of Canterbury, Lincoln and Winchester. The first two are based on back-to-back C scrolls clasped by iron collars, while at Winchester more complex clusters of scrolls are clasped together.

Wrought-iron door and chest decoration continued to be made in increasingly elaborate styles until the mid-14th century, when it was superseded by carved woodwork. J.G.

BIBLIOGRAPHY Gardner, 1927; J. Geddes, *English Decorative Ironwork 1100–1350*, Ph.D thesis, London University, Courtauld Institute, 1978. W.A. Scott Robinson, 'The Church of All Saints, Staplehurst', *Archaeologia Cantiana*, IX, 1874; *Victoria County History*, Hertfordshire, IV

325

325 South door

Mostly 12th and 13th centuries; All Saints Church, Staplehurst, Kent
Staplehurst Parish Church, Kent

The door now hangs in a simple 13th-century doorway, but it has clearly been altered to fit its present position. Fragments of masonry along the north wall of the nave and south of the chancel arch indicate there was an earlier building on the site. The boards of the door have rebated edges and are held by six half-round ledges. These are fastened both by trenails and iron roves. The shoulder cut into the opening edge, and the rounded iron band at the top of the door, relate to the original Romanesque doorway.

The large C hinge and upper three straps are made in the same way, with a punched triangular pattern along their edges ending in a raised animal-head. The fourth strap down, ending in tendrils, has a chiselled edging pattern also found on the right-hand C.

Much of the figurative design is missing and what remains looks partly rearranged. Between the third and fourth straps down was a lattice pattern, between the next straps are traces of short curved bars and between the upper two straps are a bird, possibly a stork, and a broken triquetra. The square interlace pattern once had some motif in each corner. At the top of the door are four fish, and a boat with a flat keel, mast and furled sail. In the centre is a cross within a barbed circle.

On the right are fragments of a C with flat animal-head terminals. Above is a flying dragon with a snake underneath it, a scrolled cross, small boss and short crescent.

The position and appearance of the iron suggests it is of at least two dates: the main C hinge and straps 1, 2 and 3 from the top were added in the 13th century when the door was moved and the iron partly rearranged; the rest, including the top edging band, right C and strap 4 belong to the original 12th-century door, except for strap 5 which may be recent.

BIBLIOGRAPHY W.A. Scott Robinson 'The Church of All Saints, Staplehurst', *Archaeologia Cantiana*, IX, 1874; Gardner, 1927, p. 60

326 North door

First half 12th century; St Mary's Church, Little Hormead, Hertfordshire
The Rector and Churchwardens of Great Hormead with Little Hormead and Wyddial

The doorway for which this door was made has single-nook shafts and scalloped capitals characteristic of the first half of the twelfth century. The boards of the door slot together with a V-edged tongue and groove. The central area of the door is divided into two square panels, framed by a double row of barbed iron scrolls. The two squares are filled with geometric designs. The interstices of the upper design are filled with four short barbed scrolls; a cross is missing from the centre. The lower square also has four short barbed scrolls and originally had four dragons, of which one survives. At the bottom traces of four vertical scrolls can be seen.

The main element of decoration on this door is the barbed strap, also found on the Horning chest (**327**). The bold geometric design is most unusual on English doors of this period, but is also found on the heavily-restored door at Skipwith, Yorkshire and in a more elegant form on the south-west doors of Durham Cathedral nave.

Isolated figurative elements such as the dragon occur on a few doors from the 12th to the 14th centuries. A man is found on the church doors at Leathley, Yorkshire and Sempringham, Lincolnshire, while there is a harpy on the door at Wyton, in Cambridgeshire.

BIBLIOGRAPHY *Victoria County History*, Hertfordshire, IV, pp. 76–7

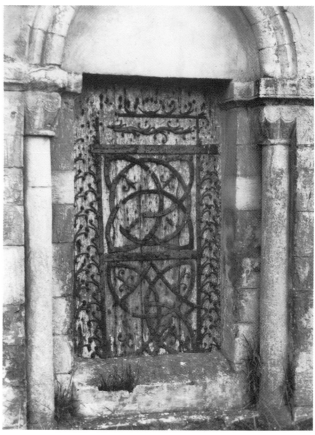

326

327

327 Chest

12th century; St Benedict's Church, Horning, Norfolk
Horning, The Vicar and Parochial Church Council of St Benedict's

The body of the chest is dug out from a single log and the lid made from one plank. On the lid are three hinge straps terminating in simple curls made by splitting the straps in two. Between the hinges are two barbed straps decorated with pairs of C scrolls. On the front are five straps in fleur-de-lis form with pairs of scrolls below them. The ends of the chest have been strengthened with plain straps, and there are two plain square lock plates on the front.

A dug-out trunk is the crudest form of chest and was made throughout the Middle Ages. Other examples decorated with Romanesque ironwork are at Morville, Shropshire, and Margaret Roding, Essex.

The barbed straps on the lid are a common 12th-century design frequently found on church doors of the period, as at Little Hormead (**326**), Heybridge and Elmstead in Essex, Kirtling in Cambridgeshire and Quidenham in Norfolk. Decorative straps ending in fleurs-de-lis were made throughout the Middle Ages and are hard to date on stylistic grounds alone.

Seals

The wax impressions of seals on medieval documents, although small and often surviving only as rather damaged fragments, are of special importance. They are valuable because it is often known precisely when they were made – for example the second great seal of Henry II (333) can be dated to the opening weeks of 1155, and because, given the destruction of much English medieval metalwork and ivory carving, they provide crucial evidence for the artistic achievements of small-scale sculpture; the two angels bearing the cross on the second seal of Waltham Abbey (361), probably from a silver matrix made in the 1180s, show a style and skill which stand comparison with the surviving metalwork produced in the area of the Lower Rhine and Meuse valleys during the same period.

Quite apart from their importance in establishing precise sequences of stylistic development, seals offer unique insights into the tastes of individual patrons and corporations, both in the quality of the work done and in the messages carried by the design and the surrounding inscription. Richard Bassett, the Justiciar under Henry I, chose to have himself shown as a foot-soldier combatting a beast guided by a demon (372). No doubt this was intended to convey the idea that he pursued the cause of justice by attacking evil. But while there are many good reasons for studying seals as works of art and propaganda, this was not their primary function. The rise of the seal in the 11th and 12th centuries is, in itself, a fascinating story and a symptom of the times.

In the early Middle Ages, Western Europe knew two different types of sealing. In the first form, an important charter or diploma had a wax impression of the seal of the emperor, or other great man, applied to its front surface adjacent to the text, authenticating the transaction in much the same way that a signature would today. The other use, and probably far more widespread, was to seal a letter closed and at the same time to indicate to the recipient, who had sent it, whether it was genuine and if anyone had opened it. It is clear that a man with a wide range of correspondents would have needed a good memory for seals, for forgery was widespread. Lanfranc, the first Norman Archbishop of Canterbury, was deceived by a letter purporting to come from the Archbishop of Rouen: 'As to Robert . . . he brought a letter sealed with your seal, which I know well; in that letter (if it was genuine) you urged me to receive him honourably . . . and even to give him material help from my own resources . . . I am greatly astonished if the letter he presented was a forgery.'[1] Despite such abuses the system must have worked well enough, since its history is a long one.

Of the two common types of early medieval sealing (leaving aside the use of bulls, small stamped lead discs most often associated with the papacy), the first, the open diploma, seems to have been ignored in the British Isles but for the second, letters sealed closed, there is some evidence. Not only are there comments about them like those of Lanfranc, quoted above, there are also several surviving seal matrices whose primary function must have been sealing correspondence since, in practice, there is little else for which they can have been used. This use of a seal is occasionally made explicit: the legend round the rim of Thor Longus' seal (370), made at the beginning of the 12th century, reads 'Thor sends me to a friend' (*Thor me mittit amico*).

While the sealing of correspondence must have been the main function of matrices up to the end of the 11th century, during the 12th the widespread sealing of charters developed in England and noticeably increased on the Continent. The reasons for the change are complex but perhaps the most important of them in England was a development that took place in the royal administration of Edward the Confessor. Kings, bishops and others in high office needed in the course of their duties to send out instructions and notifications. Such messages could be delivered either by word of mouth or as a short note. The fact that they are called '*gewrit*' in Anglo-Saxon sources suggests that they were normally committed to writing. On arrival at its destination such a document would be opened and this involved breaking the seal, destroying the evidence that this was a genuine letter from its sender. In the middle of the 11th century it was decided, apparently at the Confessor's court, that there were instances when it would be advantageous to preserve the seal so that it continued to authenticate the adjoining message. Thereafter, when it was desirable, the seal was attached to a thin strip of parchment specially cut along the bottom of the 'writ' (328) rather than on the strip that was used to tie it up. By 1086, when the Domesday Book was compiled, various inhabitants of the country were showing open sealed letters as evidence of property tenure, but up to this point only King Edward, King William, Bishop Odo of Bayeux and possibly Queen Matilda seem to have issued such documents. Ultimately it is to this invention, the open sealed writ, that we owe the survival of impressions of English medieval seals.

By the end of the 11th century and increasingly by the mid-12th, people were realizing that a seal gave a document an appearance of veracity, and this had several results. One was to encourage the use of seals on charters, a practice with no precedent before the Conquest. As on the open writs, the seals on charters tended to hang from the bottom of the sheet, though they were nearly always on a separate tag of parchment passed through a slit in the principal membrane rather than on a strip integral with it. Another result was to encourage retrospective forgery. Because Anglo-Saxon and Early Norman charters had not borne seals they did not have the fullest possible appearance of authority. To rectify this, several religious houses rewrote charters and attached forged seals. Some of these forgeries are very accurate copies of the genuine article. Others, for example the seal of St Dunstan at Westminster Abbey, are necessarily fanciful since there can have been no genuine impression left to imitate.

There can be little doubt that the new legalistic mentality of the 12th century encouraged people to obtain things in writing and have them authenticated. There was a popular belief at the time that this had come about as a result of the Norman Conquest and that in the imagined golden age of the Anglo-Saxon kings people had been naturally honest, making such precautions unnecessary. If there is truth in this idea it can be only a part of the explanation since the trend was not confined to England. As the century progressed an increasing number of

people found it necessary to own a seal matrix and by c. 1200 it is clear that for anyone in business, indeed for almost anyone above the level of peasant, it had become a necessity. We can chart the growth of this usage to some extent. In a famous case at Battle Abbey, Henry II's Chief Justiciar, Richard de Lucy, commented acidly on the seal of Gilbert de Baillol: 'It was not the custom of old for every lesser knight to have a seal, they are proper only for kings and magnates.'[2] A few years later, around 1182, one of the first acts of Abbot Samson of Bury St Edmunds was to force his monks to give up their own seals so that they could no longer sign away the abbey's possessions in pledges to moneylenders. Samson's biographer Jocelin says that between them the monks possessed 33 seals. His comments are indicative of a common use to which seals were put: deals involving pawning and small money transactions.[3] These, being ephemeral, have not survived any more than original letters so that for knowledge of the appearance of seals we have to rely on those used on writs and charters and also on the very patchy survival of the matrices.

The two earliest surviving matrices, of the 9th and late 10th centuries, are of bronze but subsequent examples, up to about 1150, are of bone, ivory or even stone. From such a small sample one can hardly draw statistical conclusions but it is noticeable that the vast majority of surviving late-12th- and 13th-century matrices are once again of metal. This can scarcely reflect the changing availability of materials but it quite probably has something to do with the amount of wear and tear they were expected to endure. Prestige was doubtless also an issue and many of the richest patrons had matrices of precious metal: those of Lincoln Cathedral (360) and Exeter City (378) are silver and those of the bishops of Durham are recorded as being of the same material.

All this had artistic consequences, for while bone and ivory can only be engraved, silver and bronze can be both cast and engraved. This means that it is easier to produce deeper and more smoothly rounded forms and details in metal and conversely that ivory seals tend to be more linear. A stylistic change from linearity to plasticity and depth is noticeable in the years around 1180 and it is quite possible that at this period metal was readopted for many matrices because it made it easier to achieve the desired aesthetic effect. Be that as it may, casting a matrix was always more expensive than engraving one since it involved extra labour, time and materials. Even after metal matrices came back into fashion the majority were still simply engraved.

There is a further type of matrix for which we have the evidence of wax impressions from about 1140. This is an engraved gemstone, usually of Roman or Greek origin, surrounded by a metal rim with a legend engraved in it, and sometimes set in a finger ring. They appear most often in use as counterseals, that is to say on the reverse side of the wax used for a larger seal. It is doubtful, though, whether this was their primary function. Several of them have legends such as 'break, open and read' which make it clear that they were intended for sealing correspondence. This is also the implication of the common gem legend 'Sigillum secretum' ('secret seal'), which suggests that among the well-to-do it was not uncommon to have two seals – a large 'public' seal for official business and a smaller private one. There are several reasons why this need was felt. The most obvious was that, with the increasing use of seals on large charters after about 1100, the seals grew in size so that a height of up to 80 mm was not uncommon. This self-evidently prestigious and grand object was cumbersome for everyday use and also required a large quantity of wax, so a small secondary seal was devised

which occasionally served as a counterseal. That these, in the early decades of their use, c. 1140–70, were almost invariably antique gems is worthy of note, for there is no obvious reason why such magnates could not have commissioned 'modern' small seals. We know that ancient antiquities were collected in the mid-12th century; the Bishop of Winchester, Henry of Blois, while in Rome c. 1150, brought a quantity of Roman sculpture back to England. Henry was one of the earliest recorded users of a gem counterseal, and it is likely that using such an antique conferred the status of 'gentleman of taste'. This fashion continued until the end of the century, and indeed for the rest of the Middle Ages clerks or men of letters such as John of Salisbury and Elias of Dereham used gem seals for all purposes until they gained an official post, which required the use of a large 'public' seal.

The increase in the numbers of seals and the gradual growth in their size presented artists and patrons with scope for experimentation in design. Certain classes of seal, for example royal seals and to a lesser extent bishops' seals, adopted a pattern in the 11th century which survived beyond the end of the 12th. Occasionally individuals deviated so that in the 1120s, for example, three bishops, Alexander of Lincoln, Seffrid of Chichester and Simon of Worcester, were shown on their seals enthroned rather than standing. This idea was probably adopted from the German Empire, but it found no following. On other types of seal, most notably those of the various monastic and cathedral chapters, there was a remarkable variety of images. This is all the more surprising as the approach until 1100 was fairly uniform and the standard image was a representation of a church building. This established fashion was challenged by a move towards representing the church's patron saint, an idea which may well have been introduced from the Continent. Images of the Virgin Mary or St Peter enthroned became popular in England too around the turn of the century (see 351 and 352). However, it was not long before a series of compromises appeared on which saint and building were shown together. The most obvious design placed the figure inside the church (358), but variations, where he or she sits or stands on top of or behind the structure, were just as common. Some of these formulae can be provided retrospectively with iconographic meaning. For example the seal of Rochester Cathedral shows St Andrew sitting on the roof. The church is thus characterized as his throne or sedes, a Latin word which at the time meant both a seat and an episcopal see. But what should one make of the seal of St Paul's Cathedral, London (353), showing the saint standing on the roof? The image of the church as a footstool is neither flattering nor readily understandable.

Apart from these three subjects – the church, the patron saint or a combination of the two – there was a fourth serious possibility, a narrative scene. The priories of Hurley and Binham (354), both dedicated to the Virgin Mary, chose the Annunciation, and Llanthony (359) the Baptism of Christ rather than the isolated image of St John the Baptist. The effect was to illustrate simultaneously the saint and a major event in his life. Both these scenes are well known, but in other cases there is a visual statement of a more esoteric type. Evesham Abbey was dedicated jointly to the Virgin Mary and St Egwin. They both appear on the seal (355), but not as static figures: Our Lady is handing a crosier to Egwin. The implication is that he was specially chosen by the Virgin to be Bishop of Worcester, and received his office from her.

In addition to these historical and allegorical narratives, allusion was also used. On the Walden Abbey seal (362) St James carries a staff and a scrip, and the background is

strewn with scallop-shells. All these details refer to the pilgrimage to the famous shrine of St James at Compostela in north-western Spain. Perhaps it is permissible to assume that the saint is turning to give encouragement to others to follow. Less obvious are the references on the Great Malvern seal (352), which shows Our Lady enthroned with the Christ Child in her lap. She carries in one hand a small globe and in the other a stick with a flowering top. Given the crown on her head, it is natural to think of these as royal orb and sceptre, and yet comparison with any of the contemporary royal seals shows differences in the way the regalia are held and in their size and form. While clearly referring to orb and sceptre, these objects also allude to two prophecies concerning Christ. The small orb is a fruit and recalls Elizabeth's words to Mary (Luke 1.42) 'Blessed art thou among women and blessed is the fruit of thy womb'. Equally the sceptre is a flowering branch indicative of the Messianic prophecy (Isaiah 11.1): 'A rod shall grow out of the root of Jesse and a flower shall rise from his root'. Although neither of these references would have been nearly as obscure at the time as they seem to us now, there is none the less a sophistication in the way in which they are realized which belies the apparent simplicity of the design. But it was a basic tenet of 12th-century thought that all was not simply as perceived by the senses. Truth was veiled and could only be reached through revelation and perceptive meditation.

Stylistically seals from the period 1050–1200 can be divided into three groups. The first phase can be seen as an amalgam of Late Anglo-Saxon and Anglo-Norman currents. From 1120–30 follows High Romanesque and, from c. 1180 to the turn of the century and beyond, a style which is known as Transitional, though it is distinct in character from both Romanesque and Gothic. Within each of these groups there are, naturally enough, subdivisions and in some cases remnants of the past or hints of the future.

The Anglo-Saxon aesthetic predilections for lively poses, a calligraphic drawing style, and pastel rather than saturated colour survived in manuscript illumination well into the 12th century. In seals there is an Anglo-Saxon revival in the first quarter of the 12th century. The lively pose of Thor Longus (370), the flying hems of Henry I's cloak (330) and the sharp linearity caused by engraving the matrix, as on the seal of Bishop Ralph Flambard of Durham (339), all find close parallels in mature Anglo-Saxon drawings of the mid-11th century, even if the 12th-century versions have lost some of the extremes of mannerism found just before the Conquest. That this is revival as much as survival is suggested by the rather different appearance of Anglo-Norman seals in their first two decades. The seals of William the Conqueror and Bishop Osbern of Exeter (338), to name but two, owe very little to English tradition. They employ larger surface forms and are more self-consciously symmetrical, lacking the animation of Anglo-Saxon art. Whether a return to Englishness around 1100 can be seen as part of a wider reconciliation between the invader and the invaded is an open question but it should be noted that Henry I's English queen, Matilda, whom he married in 1100, had a seal which is emphatically Romanesque (336). Hence modernity is found where nostalgia might be expected. On her seal and that of Westminster Abbey (351), which is quite possibly by the same artist, symmetry and liveliness in detail are combined with a love of order and organization in the fold forms which is typical of the perfectionism at the heart of Romanesque notions of beauty.

It is these qualities which are so evident in the works of the second and third quarters of the 12th century. A comparison between the seals of Henry I (330) and Stephen (331) shows precisely this change in the direction of precision and clarity of form. In addition there is a new emphasis on three-dimensional qualities, and one way of achieving this was by using curvilinear damp-fold. The masterpiece of the style is the Bible from Bury St Edmunds painted by Master Hugo (44), but another work in the same vein is the seal from Bury (356), possibly also by Hugo. The curving tubular folds not only cross the surface but seem to disappear behind forms, emphasizing their roundness. Furthermore the congregation of folds around the edges of the figures meant that when wax impressions were varnished, as they usually were at this period, the dark varnish settled in the folds and added an extra tonal element to the illusion of relief. However, substantial form was not pursued to the exclusion of all else. The proliferation of fine detail, for example on the seals of Godstow Abbey (357) and Great Malvern Priory (352), and the increasing interest in graceful outline, on such works as the second seal of Henry II (333) and the counterseal of Canterbury Cathedral (358), parallel concerns shown in other media.

There is clearly a point beyond which these developments became mannered and in the last quarter of the century leading artists began looking to quite new sources of inspiration which led to a willingness to experiment that was revolutionary in its effects. A major source was the metalwork of the Meuse and Rhine valleys. There, the ever-present influence of Carolingian classicism had preserved a more organic approach to figure composition, and this developed in the second half of the century into an interest in twisting poses emphasized by myriad folds pulled across and around the forms of the body. On English seals we see reflections and extensions of these ideas. The angels on the seal of Waltham Abbey (361) find their closest parallels in Mosan metalwork and Wiliam de Mandeville, Earl of Essex, had a seal made around 1180 (376) which is based on that of the Count of Flanders. The probable source of the design for the second counterseal of Richard, Bishop of Winchester (346), is not Mosan art but later Roman sculpture, where the same interests are manifest. The presence of Henry of Blois' collection at Winchester would explain the availability of, and possibly the taste for, such a model. The dynamic and robust qualities of this new art are seen late in the century in the seals of Richard the Lionheart (334) and Walden Abbey (362), but by about 1200 there is already evidence of a quieter, less forceful and more poised mood.

These stylistic developments, which are so well documented on seals, confirm the chronology of English Romanesque art which has been worked out in other media over the last 30 years. It is a bonus that seals show the astonishing quality of small-scale English sculpture in metal and ivory. Apart from being a symptom of a rising bureaucracy and new legalistic attitudes, they are a crucial indicator of the pretensions of patrons and the inventiveness of artists. T.A.H.

NOTES

1. Helen Clover and Margaret Gibson, *The Letters of Lanfranc, Archbishop of Canterbury*, Oxford, 1979, pp. 136–7. See also p. 111, note 2 and p. 81
2. Searle, 1980, pp. 214–5
3. Butler, 1949, pp. 30, 38

NOTES TO THE CATALOGUE ENTRIES

The word seal is used both for a matrix (or die), usually made of metal or ivory, and for impressions of it left in wax. Unless otherwise stated in the catalogue entries, the exhibits are wax impressions, but where a matrix is catalogued its material is given. The date assigned to the seal here is not necessarily the date of the wax impression exhibited, rather it is the date by which the matrix was in use.

Where only one measurement is recorded, the seal was intended to make a circular impression; where two are given,

the seal is oval. The words given for the legend are only those which occur around the rim of the face of the seal. Lettering on the background, on scrolls held by figures, or in the case of a matrix on its reverse, will be referred to in the main discussion. In many cases, where the edges of surviving impressions are damaged, the legend is a reconstruction based upon surviving letters, but where these are insufficient to allow a full reconstruction, only a fragment is given. In all cases the obverse is illustrated unless otherwise stated.

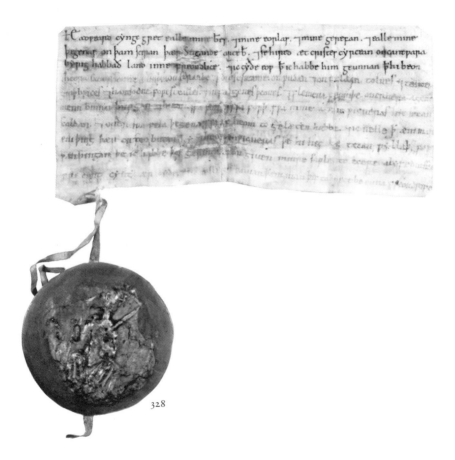

328

328 Edward the Confessor, King of England 1042–66

diam 70 mm

c. 1050

Legend: + SIGILLUM EADWARDI ANGLORUM BASILEI (both sides)

London, British Library, Campbell Charter XXI.5

Although we know nothing about the seals of English kings before Edward's it is possible to infer that his was revolutionary. First, it was used on small letters of notification in such a way that they could be opened without the seal being broken, therefore the recipient might keep the 'writ' as permanently authenticated evidence of the king's will. Secondly, the wax was impressed on both front and back whereas previously, when letters were always sealed closed, the seal probably had only one face. Finally, the design showing the king enthroned was new to England. The 'orb and sceptre' image was borrowed unchanged from the Ottonian rulers of Germany; had the importation occurred earlier, in the reign of

Cnut, it should by 1050 have evolved from its source, even if only slightly.

Much of what Edward did amounted to self-aggrandizement. In having a two-sided seal he was competing with the two-sided *bullae* of the Pope and the Byzantine and German emperors, and in showing himself enthroned he was vying with the rulers of France and Germany. Edward also began the rebuilding of Westminster Abbey, to rival the largest contemporary churches in Europe, and attempted to have the crown jewels remade (he was thwarted by the goldsmith, Abbot Spearhavoc of Abingdon, who absconded with the precious materials). In about 1050 he issued the first English coin showing the king enthroned (380), an idea not taken up again for 200 years.

The earliest of the three surviving writs bearing his seal may date from 1052.

BIBLIOGRAPHY Wyon, 1887, nos 7, 8; Birch, 1887, nos 12, 13; R.L. Poole, 'Seals and Documents', *Studies in Chronology and History*, ed. A.L. Poole, 1934 pp. 90–111; Harmer, 1952, pp. 94–105; Bishop, Chaplais, 1957, p. XIX–XXIII and pl. III; Heslop, 1980, pp. 9–11

329 William Rufus, King of England 1087–1100

diam 86 mm
September 1087–May 1092
Legend: +WILLELMUS DI GRA REX ANGLORU (both sides)
Windsor, the Provost and Fellows of Eton College, on loan to
the British Library, BL loan no. 1

On the Conqueror's death the Duchy of Normandy passed to
his eldest son, Robert, while his second son, William, became
King of England. William Rufus, none the less, retained on this
seal the equestrian image his father has used as Duke, merely
changing the legend.

On the majesty side, unlike his immediate predecessors,
Rufus wears a cape-like cloak clasped across the throat, which
is reminiscent of the famous mid-11th-century drawing
showing King Edgar, between St Dunstan and St Ethelwold, in
British Library MS Cotton, Tiberius A. III. This comparison
also highlights the restraint of the seal. It is simple in detail and
outline, whereas the drawing of Edgar has an excited linear
treatment of the surface. Such animation and decorative effect
was possible on seals and can be seen for example on that used
by the kings of Scotland *c.* 1107–1165, which is a derivative of
Rufus', with the same general disposition of drapery and boss-
like projections either side of the throne cushion. Its vitality of
detail represents a move backwards to the taste of the pre-
Conquest period. The image of Rufus enthroned could, on the
other hand, be seen as an English design subject to Norman
discipline.

This is the earliest surviving English seal to incorporate the
phrase 'by the grace of God' (*Dei Gratia*), perhaps borrowed
from German seals.

BIBLIOGRAPHY Wyon, 1887, nos 15, 16; Birch, 1887, no. 22; Durham Seals, XIII, no. 3013;
Bishop, Chaplais, 1957, pp. xix–xxiii, pl. 30; Saxl, 1954, pl. 1c, p. 19

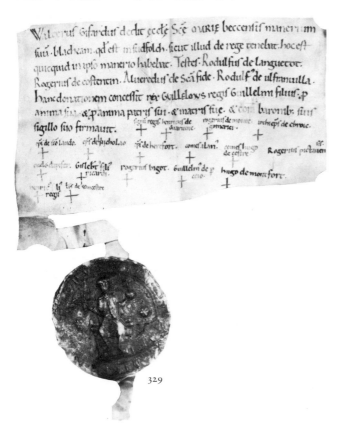

329

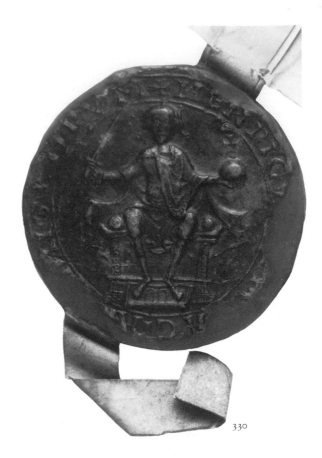

330

330 Henry I, King of England 1100–35, so-called third seal

diam 83 mm
c. 1106
Legend: +HENRICUS.DEI.GRACIA.REX.ANGLORUM (both
sides)
London, British Library, Cotton Charter II, 2

The number of different seals used by Henry I, which
impressions are genuine and which fake, and their precise
chronology, are all matters which have been, and doubtless will
continue to be, debated. This seal is variously regarded by
different scholars as the king's second, third or fourth seal. It
was apparently in use by April 1107, whereas its predecessor
had been in use through at least part of 1105.

Certain items of Henry's regalia, for example the Byzantine-
derived pendilae with three pearls or lobes hanging on either
side of the crown, were common to the seals of all the Norman
sovereigns. But the bird (the Holy Spirit?) on the cross-topped
orb is an innovation (occurring first on Henry's preceding seal)
which continued to appear on the great seal until Henry II's
death. It is uncertain whether such details reflect actual royal
insignia or are simply devised for the seals.

This example shows more distinctly than the so-called
second seal a return to an Anglo-Saxon aesthetic, with
fluttering hems, linear detailing and energetic outlining, which
seems to be part of a conscious revival in the first two decades
of the 12th century (cf. **349** and **370**).

BIBLIOGRAPHY Walter de Gray Birch, 'The Great Seals of Henry I', *J. Brit. Archaeol. Assoc.*
XXXIX, 1873, pp. 233–62; Wyon, 1887, nos. 21, 22; Birch, 1887, no. 26; Saxl, 1954, pp. 19–20,
pl. 1d; P. Chaplais, 'Seals and Original Charters of Henry I', *Eng. Hist. Rev.*, 75, 1960, p. 275;
B. Dodwell, 'Norwich Cathedral Charters', *Pipe Roll Society*, new series vol. 40, 1974, pp. 6–7

331 Stephen, King of England 1135–54, first seal
(*obverse illustrated on p. 78*)

diam 83 mm
January 1136
Legend: + STEPHANUS DEI GRATIA REX ANGLORUM
+ STEPHANUS DEI GRATIA DUX NORMANORU
London, British Library, seal no. xxxix.10

Stephen was consecrated King on Christmas Day 1135 and by
February 1136 was using this seal (Regesta Regum, 1968,
no. 99). Although it hardly deviates from Henry I's seals in its
basic layout, the majesty side of this seal has a precision in the
spacing and layering of folds which makes it unequivocally
Romanesque rather than Late Anglo-Saxon in style.

Here the equestrian image, which had evolved slowly up to
this point, finds its first classic statement on the royal seal. The
short shield held in front of the body and the sword arm
stretched out behind were to remain the norm not just for kings
but for nearly all equestrian seals until the close of the Middle
Ages. It instantly found favour, being copied, for example, by
the de Clare Earls of Pembroke and of Hertford (e.g. Hunter
Blair, 1943, pl. II g.).

BIBLIOGRAPHY Walter de Gray Birch, 'On the great seals of King Stephen, *Trans. Royal Soc.
Lit.*, 2nd series XI, 1878, pp. 1–29; Wyon, 1887, nos 25, 26; Birch, 1887, nos 43–5; Durham
Seals, XIII, no. 3019; Barcelona, 1961, nos 933–4; Regesta Regum, 1968, pp. XV–XVIII, and
1969, pls. I, II

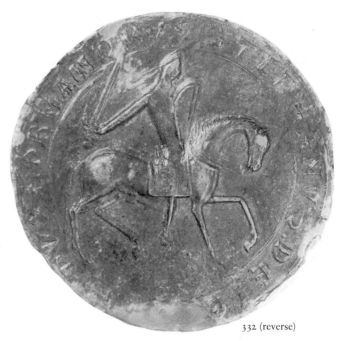

332 (reverse)

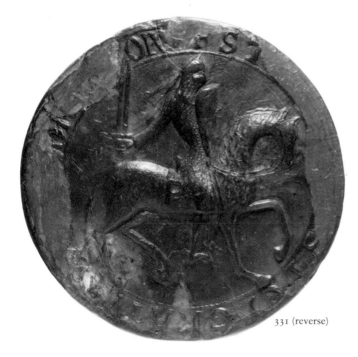

331 (reverse)

332 Stephen, King of England 1135–54, so-called third seal

diam 95 mm
1137–8
Legend: + STEPHANUS : DEI GRATIA : REX ANGLORUM
+ STEPHANUS : DEI GRATIA : DUX NORMANNORU
Sir Berwick Lechmere

Although it has become known as his third seal and has been
regarded as a forged first seal, this is Stephen's second seal and
was in use in 1138 and the first half of 1139 (the final seal was
in use from June/September 1139: Regesta Regum, 1968,
no. 493 onwards).

In condemning it as a forgery of the first seal, the editors of
Regesta were able to list 20 ways in which it deviated from the
genuine article. This number can be increased – for example,
the punctuation differs. Normally 12th-century forgeries are
sufficiently accurate to make detection difficult (there may be
several yet to discover), which suggest that this is an
independent and valid second seal. Furthermore, as the late
Professor Darlington pointed out, it appears on some genuine
documents granted to a variety of different beneficiaries and the
examples can be dated between the last known use of the first
seal and the first use of the final seal. Although forgery was
widespread – 17 of the surviving 59 sealed charters of Henry I
have been condemned as spurious, and for the two Williams
the rate is nearly 50% – this seal of Stephen can be reprieved.

While similar in many respects to the first seal, it has greater
solidity of form and density of detail. It makes up in grandeur
what it loses in delicacy.

BIBLIOGRAPHY W.H. St John Hope, *Proc. Soc. Antiq.* 2nd series, XIX, 1901–3, pp. 60–3; Saxl,
1954, p. 20, pl. IIa; Regesta Regum 1968, pp. XV-XVII and 1969, pl. I & II; R.R. Darlington,
ed. 'The Cartulary of Worcester Cathedral Priory', *Pipe Roll Society*, new series vol. 38, 1968,
pp. lxvii–lxviii

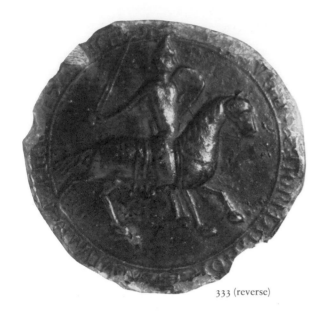

333 (reverse)

333 Henry II, King of England 1154–89, second seal

diam 92 mm

January 1155

Legend: + HENRICUS : DEI : GRATIA : REX ANGLORUM
+ HENRICUS : DUX : NORMANNOR : ET :
AQUITANOR : ET : COMES : ANDEGAVOR

Durham, Dean and Chapter of Durham Cathedral, 3.1.Reg.1a

Henry arrived in England on 7 December 1154 to claim the throne and was crowned at Westminster Abbey on 19 December. A surviving writ (P.R.O.DL 10/23) issued at Northampton in mid-January 1155 still bears his first seal, but by the time he reached York and Nottingham in February he was using his second seal (British Library, Harley Charter III.B.49; British Library, Cotton Charter XI.14). The most likely explanation is that a matrix of rather poor quality was hastily produced in December 1154 to serve immediate needs while another was prepared for permanent use. This was not yet ready when the King left London on 4 January. It confirms the information we have in other instances in the Middle Ages that it took about six weeks to make a large two-sided seal.

This seal is still firmly within the earlier 12th-century tradition and incorporates the fluttering cloak hems and the symmetrical pose, with widely splayed knees, which had been standard since Henry I. The exaggerated curvilinearity of the outline and of the evenly spaced plate-folds show an increase in elegance over the seals of Stephen and indicate that these mannerisms were already current in the mid-1150s. They find a contemporary equivalent in painting, for example in the bending silhouettes and multiplied surface decoration of the figures in the Lambeth Bible (53 and 53a).

Up until this point kings had been shown wearing the knee-length tunic of the early Middle Ages. After Henry's second seal the floor-length tunic, which had in fact been a feature of courtly dress for decades, was accepted for this official image of royalty.

BIBLIOGRAPHY Wyon, 1887, nos 32–3; Walter de Gray Birch, 'On the Seals of Henry II and his son, the so-called Henry III', *Trans. Royal Soc. Lit.* 2nd series XI, 1878, pp. 301–37; Birch, 1887, nos 56–76; Durham Seals, XIII, no. 3021; Boase, 1953, p. 275, pl. 88a; Saxl, 1954, pl. IIb, p. 20; Barcelona, 1961, nos. 939–40

334 Richard, King of England 1189–99, first seal

diam 100 mm

August 1189

Legend: + RICARDUS DEI GRACIA REX ANGLORUM
+ RICARDUS DUX NORMANNORUM ET
AQUITANORUM ET COMES ANDEGAVORUM

London, British Library, loose seal XXXIX.11

Henry II died at Chinon on 6 July 1189 while Richard was also in France. After the burial at Fontevrault, the new King proceeded slowly to England, arriving at Portsmouth on 13 August. The coronation took place at Westminster on 3 September and two days later Richard was using his first seal. Presumably its production was put in hand before his return; in either case the work can be dated to August 1189.

In every respect this is the most revolutionary of the 12th-century great seals. It marks, for example, the earliest appearance of royal heraldry, in the form of a lion rampant on the equestrian side, and bears the curious emblematic additions of crescents, *estoiles* and plants on the majesty side. It is the style, though, which is most striking. All the decorative tricks such as the fluttering hems and curving outlines on Henry II's second seal (333) have been abandoned in preference to a compact and far more naturalistic figure. The evenly spaced drapery folds and identically angled profiles of Romanesque art have given way to subtly varied undulating folds which swathe the figure and give a far stronger impression of the body beneath. Striking too are the diagonal folds of cloth which curve across the stomach and return down from one knee, breaking the symmetry of the pose.

BIBLIOGRAPHY Wyon, 1887, nos. 35–6; Birch, 1887, nos. 80–6; Durham Seals, XIII, no. 3022; L. Landen 'The Itinerary of Richard I', *Pipe Roll Society*, new series vol. 13, 1935, Appendix A, pp. 173–80; C.H. Hunter Blair, 'The Great Seals of Richard I', *Archaelogia Aeliana*, 4th series XXXI, 1953, pp. 95–7; A. Ailes, *The Origins of the Royal Arms of England*, 1982, pp. 64–74

334

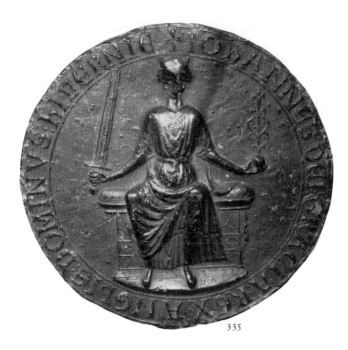

335

335 John, King of England 1199–1216

(*reverse illustrated on p. 1*)

diam 98 mm

May 1199

Legend: + IOHANNES : DEI : GRACIA : REX : ANGLIE : DOMINUS :
HIBERNIE :
+ IOHS : DUX : NORMANNIE : ET AQUITANIE : COMES :
ANDEGAVIE :

Windsor, Provost and Fellows of Eton College, 27, no. 3

After Richard's death on 6 April 1199, John returned from
France, arriving in England on 25 May. He was crowned two
days later. By mid-June he was using this seal.

Compared with the forcefulness of Richard's two seals,
John's is both elegant and restrained. The loose-fitting ankle-
length tunic is belted at the waist and an ample cloak drapes
his knees. Both garments are rendered by a multiplicity of small
naturalistic folds. The small portions of drapery behind the
figure's right calf and hanging over the throne to his left subtly
enliven the image. These and the asymmetry of the legs, with
his right out to one side, add variety and spatial illusion,
making it appear that we are slightly to the king's left.

This seal, Richard's (**334**) and others apparently produced in
connection with royal patronage (e.g. those of Waltham and
Walden abbeys, **361** and **362**) are an impressive testimony to
the abilities of the metalsmiths working in and around the
court in the last two decades of the 12th century.

BIBLIOGRAPHY Wyon, 1887, nos. 39–40; Birch, 1887, nos. 91–9; Durham Seals, XIII, no. 3024;
New Paleographical Society, Facsimiles 1st series, vol. II, 1903–12, pl. 125

336 Matilda, Queen of England 1100–18

80 × 55 mm

1100–16

Legend: + SIGILLUM.MATHILDIS.SECUNDAE.DEI.CRACIA.
REGINAE.ANGLIE

Durham, Dean and Chapter of Durham Cathedral,
1.11.Spec.23

Henry I married Matilda, great-granddaughter of the Anglo-
Saxon King Edmund Ironside, in November 1100. She would
probably have had a seal made immediately, but the two
surviving impressions are not certainly datable before 1116.

The design finds a close parallel in the seal of the Abbess of
Caen, who at this period was Henry I's sister, Cecilia. One may
be a copy of the other, or both may be based on a lost common
prototype, arguably the seal of the Conqueror's Queen,
Matilda. Holy Trinity, Caen, was founded by Queen Matilda,
mother of Abbess Cecilia. A broad similarity in the images on
their seals might explain why '*secunda*' had to be used in this
legend to differentiate between the two Queens Matilda.

Executed in an advanced formal Romanesque style, the
gently curving dished folds are equidistant and set up rhythms
foreshadowing the more hieratic figures in the so-called
Shaftesbury Psalter (**25**). Only the flicked-up drapery of the
skirt hems recalls the Anglo-Saxon animation which was then
being revived on the seals of Matilda's husband. Given
Matilda's Anglo-Saxon ancestry and contemporary opinion of
her marriage to Henry, her avoidance of pre-Conquest
reminiscences is perhaps surprising.

The matrix, with the legend suitably altered, seems to have
been re-used by Henry's second wife, Adeliza.

BIBLIOGRAPHY Birch, 1887, nos. 787–8; Durham Seals, XIII, no. 3018; Hunter Blair, 1943, p. 20,
pl. xv; Saxl, 1954, pp. 19–20, note 2, pl. IIIa; Regesta Regum 1956, nos 1108 & 1143; New
Paleographical Society, Facsimiles 1st series, vol. II, 1903–12, pls. 71a & 71b; Heslop, 1980,
p. 13

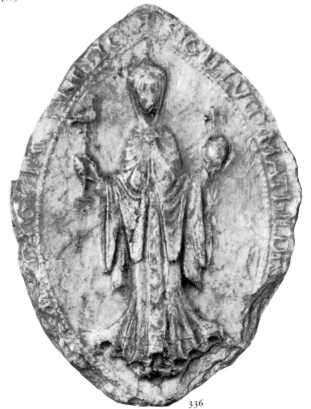

336

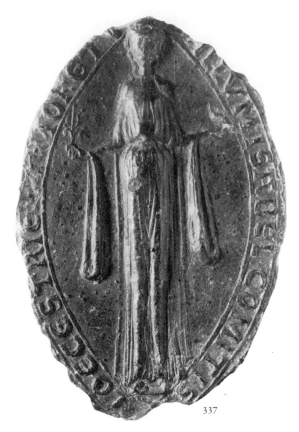

337

337 Isabella, Countess of Gloucester 1189–1217

88 × 54 mm

1189–99

Legend: + SIGILLUM ISABEL' COMITISSE: GLOECESTRIE ET
 MORETUNE

 gem counter: + EGO SU'AQUILA: CUSTOS D'NE MEE
Mr Christopher Methuen Campbell *et al.*, on deposit at the
National Library of Wales, Penrice and Margam MS 2042

The unfortunate Isabella married Prince John in 1189. By this
marriage John gained the Earldom of Gloucester, which had
belonged to her late father. Although Isabella had been
repudiated by 1199 she continued to use this seal, which bore
her titles as John's wife.

A reason for dating the seal early in the period, probably to
1189, is the long trailing *manches*, or sleeves. Although popular
from the mid-11th century, they fell from favour c. 1180–90,
shortly after the demise of the fashion for tightly tailored
dresses. Isabella's dress is transitional in that it is in the new
loose-fitting style but still has trailing cuffs.

The flower and the bird which she holds are common as
attributes on ladies' seals (e.g. Hunter Blair, 1943, pl. xvb;
Constance, daughter of Conan IV of Brittany), though the bird
is usually larger than shown here and apparently intended for
hunting. Hawking was a popular aristocratic pastime and is
often shown in calendars as the occupation for the month of
May. The image of a woman with a flower was a popular
'labour' for April, Venus's month. Thus the general
connotations of the attributes would be aristocracy, leisure,
springtime and love.

Isabella inherited her father's gem seal but changed its legend
so that the eagle should protect 'my lady' rather than the Earl.

BIBLIOGRAPHY R.B. Patterson, *Earldom of Gloucester Charters*, 1973, pp. 24–5, pl. XXXI

338 Osbern, Bishop of Exeter 1072–1103

75 × 48 mm

(?) 1072 (but not certainly in use until after 1087)
Legend: + SIGILLUM OSBERNI EXONIENSIS.EPISCOPI
Devon Record Office, Exeter City Archives ED/SN/1

The seals of Gundulf of Rochester, Odo of Bayeux (**499**) and
Osbern of Exeter are the earliest Anglo-Norman episcopal seals
of which we have any visual knowledge. The three are similar
in showing a full-length standing bishop, holding a staff in his
left hand and raising his right in blessing. The vestments are
simpler than on episcopal seals after about 1100; there is no
mitre or dalmatic.

Osbern's seal is distinctive in its group in being a tall oval,
and in showing the bishop with a halo. In both respects it is
similar to the contemporary seal of Helgot, Bishop of Soissons
(though he is shown three-quarter length). Oval and vesica
(pointed oval) seals seem to have originated in Flanders or
northern France around the middle of the 11th century and
their use in England before 1100 is often, if not always,
indicative of Continental influence. It is not impossible that the
shape derives from a figure in a mandorla – the Assumption
of the Virgin or, for seated figures, Christ in Majesty. The halo
could then be explained as a vestige of this origin.

BIBLIOGRAPHY George Oliver, *Monasticon Dioecesis Exoniensis*, 1846, p. 119; Hope, 1887,
p. 272; Birch, 1887, no. 1536 (wrongly attributed to Bishop Robert); Heslop, 1980, pp. 11–12

338

339 Ralph Flambard, Bishop of Durham 1099–1128
(*not illustrated*)

74 × 47 mm
Before *c.* 1121
Legend: + SIGILLUM RANNULFI DUNELMENSIS EPISCOPI
Durham, Dean and Chapter of Durham Cathedral, 2.1.Pont.II

Flambard acted as William Rufus' chief minister and was
appointed Bishop of Durham in 1099. Unfortunately we have
no impression of his seal from the early part of his episcopate,
though there is no reason to doubt that he used the matrix
which impressed this seal from the start. It is a development
of the first generation of Anglo-Norman episcopal seals. Where
they eschewed surface enrichment to concentrate on the basic
forms of the figure, Flambard is shown in relatively low relief
with engraving to pick out the details, especially on the
vestments. However the effect is neither particularly linear nor
energetic so that any reminiscence of Anglo-Saxon style is
muted. The wide elbow-length cuffs suggest that he is wearing
a dalmatic between the alb, with its long, tight sleeves, and the
chasuble. This seems to have been an innovation of the 1080s
and 1090s, occurring also on Anselm's seal (340).

Technical similarities between this seal and that of
Winchester Cathedral suggest that both may be the work of
one man.

BIBLIOGRAPHY Hope, 1887, p. 282; Birch, 1887, no. 2436; Durham Seals, XIV, no. 3110; Hunter
Blair, 1922; Saxl, 1954, pl. IIIb, p. 21; H.S. Offler, Durham Episcopal Charters, *Surtees Society*,
179, 1968, see nos. 13 and 18 for the dating; Heslop, 1980, p. 13

340 Anselm, Archbishop of Canterbury 1093–1109
(*not illustrated*)

78 × 67 mm
1093–1103
Legend: + SIGILLUM ANSELMI GRATIA DEI ARCHIEPISCOPI
London, British Library, Campbell Charter VII.5

Anselm's seal combines features from two separate traditions,
the Anglo-Norman and Anglo-Saxon. From the former it takes
a standing figure blessing, from the latter (as represented by the
lost seal of Wulfstan, Bishop of Worcester) the open book in
the left hand and the crosier in the right. There may also be
an element of compromise in the shape of the seal, which is
a broad oval rather than a circle or a vesica.

The forceful but subtle modelling of the figure is very assured
for the date. That, and the soft pleating of folds on the
chasuble, may well reflect the classicizing Mosan tradition
which was shortly to produce the Liège Font.

None of the surviving impressions can be securely dated
before 1103 (Rochester, Dean and Chapter muniment 778).
This leaves a 10-year period during which the matrix could
have been made.

BIBLIOGRAPHY Hope, 1887, p. 288; Birch, 1887, no. 1169; Heslop, 1980, pp. 12–13

341 William, Bishop of Exeter 1107–*c.* 1136
(*not illustrated*)

67 × 45 mm
Before 1133
Legend: + SIGILLUM WILLELMI EXONIENSIS EPISCOPI
Devon Record Office, Exeter City Archives, ED/PP/I

This finely-worked seal may well come from a matrix made at
the beginning of Bishop William's rule. If it does, then it is one
of two episcopal seals from the decade, the other candidate

being that of Bishop Richard of London. Both of these seals
contrast with contemporary royal seals (330 and 336) in giving
more emphasis to three-dimensional form and less to surface
detail. This concentration on basic naturalism and delicate
modelling on such a small scale can only be satisfactorily
paralleled in ivory carvings from the region around Liège (cf.
Lasko, 1972a, pl. 173). With the evidence of St Anselm's seal
(340) this suggests that there were close links between the
artistic patronage of English bishops and the art of the Low
Countries in the years around 1100.

BIBLIOGRAPHY G. Oliver, *Monasticon Dioecesis Exoniensis*, 1846, p. 136; Birch, 1887, no. 1535

342 Ralph, Archbishop of Canterbury 1114–22

87 × 53 mm
1114–22
Legend: + RADULFUS DEI GRATIA CANTUARIENSIS ARCHIEPS
London, Public Record Office DL27/46

The seal of Ralph, Archbishop of Canterbury is the only
English episcopal seal to survive from the second decade of the
12th century, and it shows various developments. For example
there is a large mitre with two lateral lobes, a type that was
to appear frequently over the next 25 years. Most striking
though is the controlled ridging of the drapery. The regularity
of these forms and the balance of the whole figure are in
keeping with mature Romanesque notions of organization. The
multiplicity of folds is reminiscent of slightly later illumination
from St Albans (17) or even of certain Burgundian sculpture,
for example Gislebertus' work at Autun.

BIBLIOGRAPHY Birch, 1887, no. 1170

342

343

343 Robert, Bishop of Bath 1136–66

75 × 50 mm
1136–56
Legend: + SIGILLUM RODBERTI DEI GRACIA BATHONIENSIS
EPISCOPI
London, British Library, Harley Charter 75.A.30

Robert, Prior of Lewes and a protégé of Henry of Blois, Bishop of Winchester, became Bishop of Bath in 1136. He espoused the royalist cause in the civil war and is probably the author of the *Gesta Stephani*, a lively account of the conflict and its attendant woes.

This seal was in use by 1156 (Canterbury, Cathedral Archives A51). The slight proportions of the figure are reminiscent of episcopal seals of the early 12th century (341) but there is a typically Romanesque use of plate-folds and beading on the lower part of the chasuble. The neatness and relative understatement of these stylizations are common at this period in the west of England (cf. 355). The curious ogee-domed mitre also recurs in the west, on the seal of Roger of Worcester.

The charter is representative of a type, popular after about 1130, which bears two seals, that of the bishop or abbot and that of the chapter. It is a reminder that the interests of these parties were not always akin. A beneficiary was well advised to seek the seals of both.

BIBLIOGRAPHY W. St John Hope, 'The seals of the Bishops of Bath and Wells', *Somerset Archaeological and Natural History Society Proceedings*, vol. XXXIV, pt. 2, 1889, pp. 29–39; Birch, 1887, no. 1409

344 Hugh du Puiset, Bishop of Durham 1153–95
(not illustrated)

82 × 54 mm
Before *c.* 1160
Legend: + HUGO DEI GRATIA DUNELMENSIS EPISCOPUS
Durham, Dean and Chapter of Durham Cathedral, 3.1.Pont.22

The seal of Hugh du Puiset is the only English bishop's seal to use a clear curvilinear damp-fold style; though others, such as

Richard of Winchester's first seal (345), are a development from it. The rarity of the style in this medium is surprising given its popularity in painting and its use by a famous metalworker, Master Hugo of Bury. The damp-fold style does however appear in Scotland, on the seal of Arnald, Bishop of St Andrews (Durham, misc. charter 1321 of 1160–2 ?), which is virtually a copy of this one (it even has the legend bounded by a row of dots between two lines). Durham was an important 'clearing house' for artistic ideas north of the Border. Not only is there the evidence of seals, but the cathedral was also a major influence on Scottish architecture.

BIBLIOGRAPHY Hope, 1887, 284; Birch, 1887, no. 2440; Durham Seals, XIV, no. 3114; Hunter Blair, 1922, pp. 3, 4, 10 and 11; Saxl, 1954, pl. IIIe and p. 64

345 Richard, Bishop of Winchester 1174–88, first seal

57 × 82 mm
Before 1180
Legend: + RICARDUS DEI GRATIA WINTONIENSIS EPISCOPUS
Counterseal 35 × 32 mm
Legend: + SUM CUSTOS ET TESTIS SIGILLI
Windsor, Provost and Fellows of Eton College, E.C.R.17, no. 2

This splendid seal shows a late form of damp-fold, with the drapery of the chasuble clinging to the form of the chest and stomach. However the linear emphasis so common in late versions of this style (cf. 344) is subordinated here to the solid stocky rendering of the figure. Although Richard had ceased using it by 1185, the seal continued to have an influence. William Longchamp's seal as Bishop of Ely is clearly based upon it.

The counterseal of this impression is a gem showing a small figure presenting a globe to a seated figure. It has been doubted whether it dates from antiquity or is a medieval imitation. Presumably Richard valued it since he passed it to his illegitimate son, Herbert Poore, who used it before becoming Bishop of Salisbury in 1194.

345

346 (obverse)

346 (reverse)

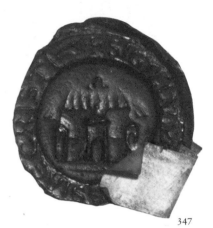

347

346 Richard, Bishop of Winchester 1174–88, second seal

85 × 53 mm
Before April 1185
Legend: + RICARDUS DEI GRATIA WINTONIENSIS EPISCOPUS
Counterseal 47 × 29 mm
Legend: SUNT MICHI SINT Q BONI PETRUS PAUL Q PATRONI
London, British Library, Harley Charter 43.1.38

Nothing better explains the changes in style around 1180 than the juxtaposition of Richard's two seals (this and 345). The asymmetries introduced into the fall of his chasuble, the looping diagonals across the front and the angling of one side at the back all break with the Romanesque conventions of earlier bishops' seals. This new formula was used as a model for several other seals (e.g. Eustace, Bishop of Ely) in the 1190s.

It is on the counterseal, however, that the implications of the new style are fully expressed. There, away from the hieratic requirements of the large public seal, the Apostles Peter and Paul stand in *contrapposto*. The best parallels for this striking classicism are to be found on late antique sarcophagi, examples of which may have been at Winchester in Henry of Blois' collection of Roman sculpture. Among contemporary works, only the St Peter on the shrine of St Anno, at Siegburg near Cologne, is comparable (Cologne, 1972, p. 322).

The similarity of lettering leaves no doubt that the main seal and counterseal are by the same artist. By relinquishing his small gem seal and adopting one of contemporary workmanship, and with a Christian subject, Richard was keeping up to date with the latest trends.

BIBLIOGRAPHY Hope, 1887, pp. 274, 282; Birch, 1887, nos. 2242–4; Warner, Ellis, 1903, no. 67; Saxl, 1954, pl. va, pp. 21–2

347 Christ Church Cathedral, Canterbury, first seal

diam 47 mm
Probably before 1070, certainly before 1107
Legend: + SIGILLUM ECCLESIAE CRISTI
London, British Library, Campbell Charter XXII.2

The earliest impression of this seal (also the earliest surviving impression of any English conventual seal) is on a document at Canterbury which can be dated 1096–1107. However the matrix was probably earlier than that since it bore an image of a building which corresponds to what we know of the Anglo-Saxon cathedral at Canterbury. This early church was destroyed by fire in 1067 but there is a description of it which indicates that it had an apsidal east end and nave aisles with tower-porches leading into them. All of these are shown here, suggesting that the topography is correct in general terms. If so we can infer that there was also an apse at the west and a pair of transeptal porticus at either end.

Archbishop Lanfranc and the early Norman priors of Christ Church would hardly have countenanced this old church appearing on a seal made after 1070, when their splendid new church was begun. The implication is thus that the matrix predates the new building.

The relatively small size of this seal, the image of the building and the raised legend rim find parallels among the few other late Anglo-Saxon ecclesiastical seals whose appearance is known. It is however distinctive in its topographical accuracy and in the lettering of the legend which uses angular forms for only E and Є.

BIBLIOGRAPHY Birch, 1887, no. 1368; Warner, Ellis, 1903, no. 29; Heslop, 1980, pp. 7–8; Heslop, 1982a, *passim*

348 Bath Abbey

diam 58 mm
Late 11th century
Legend: +SIGILLUM SCI PETRI BADONIS ECCLESIE
London, British Library, Harley Charter 75.A.30

In many ways this conforms to the norm for Late Anglo-Saxon conventual seals. It is round and shows a building without figures, and the legend formula ends with the place name followed by ECCLESIA. Furthermore there is no punctuation or separation between the words and the letters C and G have square forms.

However in its strength of relief, in the abstraction of the representation of the building and in its greater size it is clearly later than seals such as those of Exeter or Canterbury Cathedrals (347), which seem to date from around 1050.

BIBLIOGRAPHY Birch, 1887, no. 1437

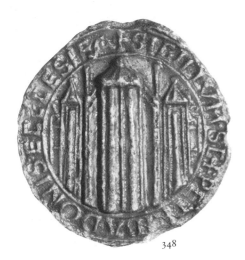

348

349 Matrix: St Albans Abbey

Walrus ivory; 82 × 57 mm
c. 1100–20
Legend: +SIGILLUM.SCI.ALBANI.ANGLORU PTOMARTIRIS
London, Trustees of the British Museum, MLA.38,12–32, 19

This is the most important ivory matrix surviving from the post-Conquest period. Its date is suggested by its close similarity to, and probable derivation from, the so-called second and third seals of Henry I (330), in use from 1100–*c.* 1120. Like them it is a classicized version of Late Anglo-Saxon style, its basic forms enlivened by engraving. Together with those from Westminster and Gloucester (351 and 352), Winchester Cathedral and several other foundations, this seal marks the beginning of the use of the enthroned full-length saint as a subject for English conventual seals.

The condition of this matrix is now rather worn, which is hardly surprising given its 400 years of use. Enough impressions survive to trace its gradual deterioration (366a is a clear, early example). Surprisingly the splendid little lion's-head handle on the reverse is relatively unworn.

There is a famous instance of this seal being forged, by the goldsmith Anketil at St Albans in the mid-12th century.

BIBLIOGRAPHY Birch, 1887, nos. 3939–43; Durham Seals, XV, no. 3537; Tonnochy, 1952, no. 852; Pächt, Dodwell, Wormald, 1960, p. 176

350 Abbey of St Peter, Gloucester

73 × 48 mm
c. 1120
Legend: +SIGILLU SCI PETRI DE GLOECESTRA
Hereford, Dean and Chapter of Hereford Cathedral, A541

The pose and attributes of the figure on this seal are similar to those on that of Wulfstan, Bishop of Worcester (1602–95) and the matrix from Evesham (355), and may represent the standard formula used for late Anglo-Saxon bishops' or abbots' seals. This scheme, showing an enthroned figure with an open book in his left hand and a staff in his right, also occurs on the conventual seal of Ely and on one of the earliest surviving abbots' seals, that of Walter of Battle.

The design is strongly reminiscent of the image of St Benedict, with the monks of Christ Church, Canterbury, in the manuscript, British Library, Arundel 155 f. 133 of *c.* 1020. Although the dedication of Gloucester is to St Peter, there is no visual proof that this seal represents him, the figure having neither papal attributes nor the keys of Heaven. It is possible that the figure represents the abbot or even St Benedict.

Despite its Anglo-Saxon antecedents, the style is Romanesque in its symmetry and in the attempt at evenly-disposed folds. The hemline of the cloak is restrained and generally the design is kept simple. This combination of factors suggests a date around 1120.

BIBLIOGRAPHY Birch, 1887, nos. 2192–4; Morgan, 1966, p. 8

349

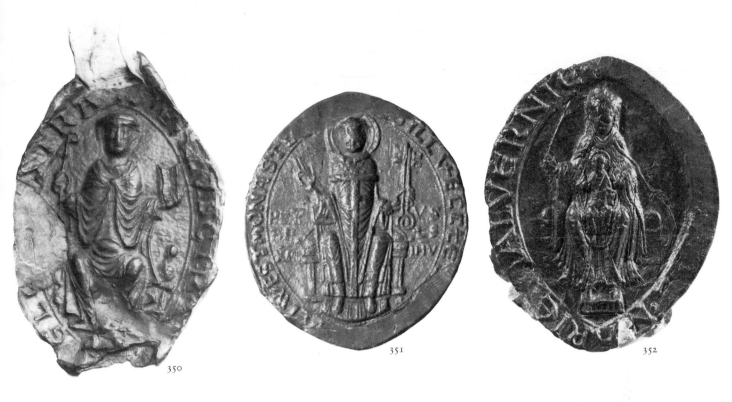

350

351

352

351 Westminster Abbey, first seal

80 × 68 mm

c. 1100 (before 1136)

Legend: + SIGILLU ECCLE SCI PETRI APLI WESTMONASTERII

London, Muniments of the Dean and Chapter of Westminster, WAM 1172A

The date c. 1100 suggested for this seal is based on its close stylistic similarity to that of Queen Matilda (336). The concentric, evenly-spaced, dished folds are comparable, as are the beaded border and details such as the rendering of the eyes and the use of double engraved lines near hems and cuffs. The quality of the relief and the regularity of design are also similar. The only doubt about their being by the same artist is raised by the style of the lettering. Whereas Matilda's seal uses uncial e, m and h, the Westminster seal has angular E and C and the forms are heavier. This could indicate an earlier date for the Westminster seal but may equally be a stylistic device. The rounder uncials and thinner letters are more graceful and appropriate to a queen, whereas St Peter is complemented by strong, square forms.

St Peter is shown in pontificals with the pallium but without either mitre or camelaucum (the early form of papal tiara). He is described on the background as 'apostle of Christ Jesus' and holds the keys to Heaven and Hell.

BIBLIOGRAPHY Birch, 1887, no. 4299; Chaplais, 1960, nos. 2, 5; Barcelona, 1961, no. 930; Heslop, 1980, p. 13

352 Great Malvern Priory

74 × 55 mm

c. 1125–45

Legend: + SIGILLUM.SCE.MARIE.MALVERNIE.

Hereford, Dean and Chapter of Hereford Cathedral, loose seal

This seal and that of Worcester Cathedral are attributed to the artist who made the seal for St Augustine's, Daventry, which can be dated approximately 1130–40 by the type of episcopal vestments the saint is wearing. Thus a date in the second quarter of the century can be suggested for this artist's activity. There are other seals which are similar in iconography and overall design, for example those of Abingdon and Reading Abbeys. The latter was founded in 1121, giving a *terminus post quem* for its seal, which also suggests the second quarter of the century for the whole group.

This composition, with the Virgin and Child placed frontally and symmetrically, seems to have appeared in Germany in the early 11th century but it did not become widespread until the 12th. The design not only implies that Mary is Christ's throne but uses symmetry to emphasize their perfection. The clarity and compactness of the group is enlivened by linear detail, such as the Virgin's knotted veil flying out to one side and the flaring hem of her skirt.

The objects in her hand, while alluding to orb and sceptre and reinforcing the royal status suggested by her crown, also refer to prophecies concerning the birth of the Messiah: the flowering stem to the rod of Jesse, and the small globe to the fruit of Mary's womb.

BIBLIOGRAPHY Birch, 1887, no. 3601; Saxl, 1954, pp. 19 and 22, pl. vd; Heslop, 1978 *passim*; Heslop, 1981a, pp. 57–8

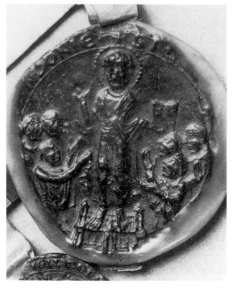

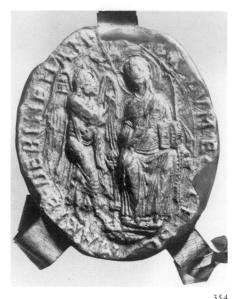

353

354

355

353 St Paul's Cathedral, London

diam 64 mm

c. 1120–40, before 1154

Legend: + SIGILLUM CAPITULI SANCTI.PAULI.LUNDONIE.

London, Royal Hospital of St Bartholomew, Ch. 1445

The St Paul's seal shows an individual approach to combining patron saint and building on a seal. St Paul, blessing and holding an open book, stands on the roof of the church while two groups of three clerics adore him. Although the origin of the design is not clear, it did exercise influence on later seals, notably on the City of London seal of *c.* 1220 (Pedrick, 1904, pl. xi).

Stylistically the linearity of the drapery can be seen as Late Anglo-Saxon. However the compactness and symmetry of the design are completely Romanesque and the insistent use of profiles in the subordinate figures is reminiscent of the approach to composition seen in several scenes (e.g. the *Incredulity of St Thomas*) in the Psalter made for Christina of Markyate (**17**) usually dated 1119–23.

It is possible that the small church at the base is derived from an earlier seal of the cathedral, for in its design and quality of relief it recalls the first seal of Christ Church Cathedral, Canterbury (**347**).

BIBLIOGRAPHY Birch, 1887, nos. 1963–5; Durham Seals, xv, no. 3341a; M. Gibbs, 'Early Charters of St Paul's Cathedral', *Camden Society Third Series*, 58, 1939, nos. 159, 176, 213

354 Binham Priory

70 × 51 mm

c. 1120–40

Legend: + SIGILLUM ECCLE SCE MARIE DE BINEHAM

London, Public Record Office, E42/399

In showing Mary seated holding an open book, this design is closely related to the *Annunciation* in the Psalter made, probably at St Albans, for Christina of Markyate (**17**). Binham was a dependency of St Albans and so the link is perhaps not unexpected. There are however differences between the scene in the Psalter and on the seal. For example, there is a small flowering stem just discernible behind the open book in Mary's left hand, which presumably refers either to the stem of Jesse

or to Aaron's rod, foretelling or typifying the birth of Christ. This suggests that Mary's book is open at some such passage in the Old Testament. In the Psalter miniature the leafy stem is simply painted against the background, so that it lacks the direct visual association with prophetic writing.

The Psalter is usually dated between 1119 and 1123, and as the seal represents an iconographical refinement, it is probably rather later. Stylistically it is closest to the seal of Sopwell Priory, another cell of St Albans founded in 1140, and may be the work of the same artist. However Sopwell seems more advanced in the gracefulness of the pose of the enthroned Mary, in its use of the damp-fold convention and in the lettering of the legend.

BIBLIOGRAPHY Birch, 1887, no. 2642; Prior, Gardner, 1912, p. 172; Pächt, Dodwell, Wormald, 1960, p. 176; Heslop, 1981a, p. 58

355 Evesham Abbey

76 × 54 mm

c. 1130–40

Legend: . . . SCI EGWINI. . . .

Durham, Dean and Chapter of Durham Cathedral, 2.4.Ebor 26a

Evesham Abbey had a double dedication to the Virgin Mary and St Egwin, its founder and Bishop of Worcester *c.* 700. The seal shows Mary presenting a pastoral staff to Egwin, thus appearing to invest him with the see of Worcester. Similar scenes are not uncommon. A slightly earlier one occurs on the enamelled Pala d'Oro of San Marco in Venice, where St Peter is shown giving a crosier to St Mark. The Evesham seal may well have been the first English example to adopt this formula, although a similar iconography occurs on the contemporary seal of St Neot's (Birch, 1887, no. 3957). Also related to, indeed possibly deriving from this scheme are the seals of Gervase, Abbot of Westminster (**364**) and Godstow Abbey (**357**). They suggest a date in the 1130s for the whole group.

The style of the Evesham seal has a restrained elegance and naturalism found on others from the west of England at this period, for example those of Great Malvern and Bishop Robert of Bath (**343**).

BIBLIOGRAPHY Durham Seals, xv, no. 3464

356 Bury St Edmunds Abbey, second seal

92 × 65 mm
c. 1150
Legend: + SIGILLUM SANCTI EADMUNDI REGIS ET MARTIRIS
Oxford, Bodleian Library, MS Ch.Suffolk 10*

The overall design of this seal, showing St Edmund enthroned
with orb and flowering rod, derives directly from the previous
seal of the abbey (formerly on Oxford, Bodleian Library,
Suffolk charter 2 of c. 1139–48), which seems also to have had
this legend. The style of the lettering suggests that the second
seal is by the artist responsible for Abbot Hugh's seal (365),
made presumably at the beginning of his rule in 1157.

With the Durham pulpitum reliefs (154), this seal is the most
accomplished three-dimensional rendering of English
curvilinear damp-fold style which is associated *par excellence*
with Master Hugo of Bury St Edmunds, a painter, sculptor and
metal-caster. It has been suggested most plausibly, because of
its style, quality, place of origin and likely date, that this seal
is his work. Thus we may have a hint of Hugo's relief style,
which must have been so splendidly manifest on the bronze
doors he cast for the west front of the church.

BIBLIOGRAPHY Birch, 1887, no. 2796; Durham Seals, XV, no. 3418; Saxl, 1954, pl. VId;
Zarnecki, 1957a, pp. 7, 28–9; R.M. Thompson, 'The Archives of the Abbey of Bury
St Edmunds', *Suffolk Record Society*, vol. XXI, 1980, p. 52, no. 51

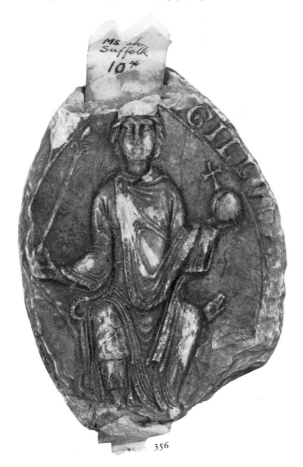
356

357 Godstow Abbey (*not illustrated*)

85 × 60 mm
c. 1133 (foundation date) to c. 1150
Legend: + SIGILLUM SCE MARIE ET SCI IOHIS BAPTISTE
 GODESTOENS ECCL'IE
Durham, Dean and Chapter of Durham Cathedral, 1.5.Ebor.8

Like the seal of Evesham, from which it may well derive, this
reflects a double dedication to the Virgin Mary and to St John
the Baptist. They are shown holding aloft a disc bearing an
image of the Lamb of God and St John holds a scroll with the
words *Ecce Agnus Dei*. As in the cases of houses dedicated
separately to Mary and to John, they are explicitly shown in
terms of their contact with Christ (cf. 359).

Below, Ediva, the founding Abbess, clasps Mary's feet in a
gesture of supplication. The prominently displayed hanging
cuffs to the sleeves of her dress indicate that at this period the
habits worn by nuns were still very closely related to the
fashion of the secular world.

BIBLIOGRAPHY Birch, 1887, no. 3209; Durham Seals, XV, no. 3489

358 Christ Church Cathedral, Canterbury, second seal
(*illustrated on p. 78*)

diam 80 mm
1155–8
Legend: + SIGILLUM ECCLE XPI CANTUARIE : PRIME SEDIS
 BRITANNIE :
Counterseal: 57 × 35 mm
Legend: + EGO SUM VIA VERITAS ET VITA
London, British Library, Additional Charter 67, 123

The first seal (347) was still in use in 1155 but was replaced
with this seal by 1158. Although the design is based on the first
seal, in that it shows a largely symmetrical building and has
a raised rim for the legend, it is larger, has more detail and
contains figures. In all these respects it follows newer 12th-
century trends. Unlike the building on the first seal, this one
makes few concessions to the appearance of the actual church
at that date, but it does show the picturesque skyline of towers
surmounted by crosses, cockerels and an angel which are
known from other sources.

The most remarkable feature of this new seal is that a
counterseal was made especially for it. Similarity in the letter
forms and the use on both of a colon with voided points suggest
that they were made by the same artist, possibly at the same
time. Up to this point, and for a while afterwards, engraved
antique gems in a medieval setting were normally used. In this
seal, Canterbury anticipates the tendency of the last quarter of
the century to commission a completely 'modern' work. Nearly
all available ancient gems are small and have pagan
iconography, but this variation allows both for a more
impressive scale and for a Christian image. The counterseal
does not appear on the reverse of all impressions of the
conventual seal and was probably used most often for sealing
letters.

Prestige may well have been involved in the commissioning
of the new seals as the legend of the larger one refers to Christ
Church as the 'first see of Britain'. This piece of propaganda
relates to the conflict over primacy between Canterbury and
York.

BIBLIOGRAPHY Birch, 1887, nos. 1369–72; Heslop, 1982a, *passim*

359 Llanthony Priory (not illustrated)

76 × 53 mm
(?) c. 1180
Legend: + SIGILLUM ECCLESIE SCI IOHIS BAPTISTE DE LANTHONIA
Hereford, Dean and Chapter of Hereford Cathedral, A1169

The Augustinian Priory at Llanthony, founded in 1103 as one
of the first houses of regular canons in Britain, was dedicated
to St John the Baptist. Instead of an isolated image of the saint,
the Baptism of Christ, the culmination of the Baptist's life and
prophecy, was chosen for the seal. Just as on the seals of houses
dedicated to the Virgin, where she is usually shown with the
Christ Child (352 and 360), or occasionally at the Annunciation
(354), St John is shown here at the moment of his closest
contact with God.

 Although this seal is only known from its use on this charter,
from the time of Prior John de Kingston in 1316, it is clearly
12th century. Stylistically this splendidly compact narrative
depends for its soft naturalism on the art of the Low Countries
(cf. e.g. the Liège Font and the Shrine of the Virgin at Tournai,
Cologne 1972, G1 and K5). This makes a date in the early
Transitional period most probable (cf. 361 and 376).

BIBLIOGRAPHY Morgan, 1966, p. 8; D.H. Williams, *Welsh History through Seals*, 1982, p. 29

360 Matrix: Lincoln Cathedral

(illustrated on pp. 78 and 281)
Silver, with nielloed reverse; 75 × 52 mm
1150–60
Legend: SIGILLUM: CAPITULI: SANCTE MARIE LINCOLNIENSIS
 ECCLESIE
Lincoln, Dean and Chapter of Lincoln Cathedral

This matrix was used to impress the seal on a charter datable
1148–60. Its iconography follows the earlier cathedral seal (still
in use c. 1150, Birch, 1887, nos. 1785–6, P.R.O. E42/280) quite
closely except that here the Virgin does not hold a globe but
only the flowering rod/sceptre whose 'organic' nature rather
than manufactured origin is clearly visible. This is noteworthy
in view of the interest in the Tree of Jesse, to which it alludes,
in Lincoln in the 12th century (see Zarnecki, 1964, pp. 11, 19,
21).

 Apart from furnishing evidence that important
establishments were having matrices made of silver by 1160,
this object is crucial in the discussion of the origin and
development of the tight niello scrollwork which is best known
from Saxony in the 1170s. On the reverse of the matrix,
concealed by a silver plate probably in the early years of this
century, is an image of Christ seated on the rainbow which is
also seen in stone carving (Zarnecki, 1964, pl. 20a). This only
survives in outline but the background contains spirals of niello
comparable with, for example, the clasps of the Puiset
Bible (301). The early date and English origin of the matrix
throw into question German primacy in the use of this motif
and suggest its possible derivation from late Celtic or Insular
art, for example the spirals on hanging-bowl escutcheons.

BIBLIOGRAPHY Birch, 1887, nos. 1787–96; W.H. St John Hope, *Proc. Soc. Antiq.* XIV, 1893,
pp. 13–15; Durham Seals, xv, no. 3340; *Registrum Antiquissimum* ed. K. Major, *Lincoln
Record Society*, vol. 41, 1950, Appendix I, vol. 67, 1973, no. 2681; Geddes, 1980, note 30; Prior,
Gardner, 1912, pp. 172, 211, 293

361

361 Abbey of the Holy Cross, Waltham, second seal

74 × 54 mm
Before 1201
Legend: + HOC EST SIGILL ECCLESIE SANCTE CRUCIS DE
 WALTHAM
London, Public Record Office, E42/97

Founded before the Conquest and patronized by King Harold
Godwinson, Waltham was formed for secular canons; it
became a priory of regular canons in 1177 and an abbey in
1184. These changes of status were part of Henry II's penance
for the murder of Thomas Becket. No doubt it was cheaper to
'reform' an existing house than to begin from nothing; none
the less Henry spent many hundreds of pounds on work at the
church in the late 1170s and early 1180s. This period is the most
likely for the making of this seal, whose astonishing beauty and
assured craftsmanship suggest that a court goldsmith may have
been involved. This charter was issued by Walter, Abbot of
Waltham 1184–1201.

 The design, showing two angels supporting the cross, goes
back to the Early Christian East, but was used during the 12th
century especially for relics of the True Cross. It was used
earlier in the century (before 1138) on the first seal of Waltham,
though there the angels are standing, not kneeling.

 Convincing parallels for the style of the second seal can be
found around 1180 only in such centres of metalworking as
Liège and Cologne. Perhaps the closest surviving object is a
small cast-metal angel now in Frankfurt (Stuttgart 1977
no. 547). A similar style is echoed in the portals of Glastonbury
Lady Chapel, built between 1184 and 1186.

BIBLIOGRAPHY Birch, 1887, no. 4250; Pedrick, 1902, pp. 132–3; Hope, 1915–16, p. 95; C.H.
Hunter Blair, *Proc. Soc. Antiq.* XXXII, 1919–20, pp. 144–6

362 Abbey of St James, Walden (*not illustrated*)

75 × 48 mm
Before 1213
Legend: + SIGILLUM: ECCLESIE: SANCTI: IACOBI: DE: WALEDENA
London, Public Record Office, E25/112

Although founded in the 1130s, Walden gained the status of an abbey only in 1190, the year in which the patronage passed from the Mandevilles to the Crown. This could well have been the occasion for making this seal. Its earliest surviving occurrence is on P.R.O.DL 27/6 which dates from before 1213.

St James's attributes, the staff and the scallop-shells, refer to the pilgrimage to his shrine at Compostela. Because of the popularity of this pilgrimage, the figure of James was sympathetically imagined as the prototype for all pilgrims. This may account for his unusual pose, apparently walking along and turning to look behind him, as though encouraging his followers.

Stylistically the closest comparisons can be made with the scenes in roundels on the ciborium from St-Maurice d'Agaune (**309**), which is usually thought to be English and to date from *c*. 1200. The similarity with this seal tends to confirm this. The drapery styles on both are based on contrasts: of broad, flat-topped folds with finer curving ones, and of angular hems with softer outlines where the cloth hangs closer to the forms of the body.

BIBLIOGRAPHY Birch, 1887, no. 4241; Pedrick, 1902, pp. 131–2

363 Matrix: Evesham

Stone; *diam* 60 mm
(?) Late 11th century
Legend: destroyed
Mrs A.M. Tustin

The provenance of this matrix, from Evesham, suggests that it might come from the abbey there. The cope, tonsure and crosier make it clear that the figure is an abbot or prior. Furthermore, since he has no halo he is probably not a monastic saint, like St Benedict, shown as patron of a church (but cf. Gloucester **350**). It is with the seal of Gloucester in particular, but also with those of Ely and Abbot Walter of

Battle (Birch, 1887, nos. 3109–10 and 2617–8) and Wulfstan, Bishop of Worcester (Heslop, 1980, pl. IIb), that the general format of this example can be most convincingly compared. The noteworthy difference is the omission of a book from the figure's left hand (his right on the matrix).

In its size and proportions, with the legend rim taking up nearly a third of the radius, it is most comparable with 11th-century seals such as that of Wulfstan, which may date from just before the Conquest. However, the regularity of the drapery pattern and the modelling of the head are virtually Romanesque, so that a date towards the end of the 11th century is more likely. The crosier volute is surprisingly florid and the twin knops quite possibly unique.

364

364 Gervase, Abbot of Westminster 1138–*c*.1157

84 × 60 mm
(?) 1138–9
Legend: + SIGILLU GERVASII ABBATIS SANCTI PETRI WESTMONASTERII
London, Muniments of the Dean and Chapter of Westminster, WAM 1172A

The image on this seal is unusual and surprising. It shows Gervase with the Virgin and Child rather than alone with the attributes of abbatial staff and book (cf. **367**). Here Gervase holds his crosier as though he might have received it from Christ or Mary, but in fact all their hands are otherwise occupied. More curiously, the Virgin sits at one end of a long, two-seater throne as though to leave room beside her for the Abbot.

Westminster Abbey was dedicated to St Peter, as the legend on this seal makes clear, so the appearance of Mary requires explanation. Presumably it demonstrates Gervase's own devotion and represents a visit by him, in a vision, to the heavenly realm (cf. Talbot, 1959, pp. 74–7), albeit Gervase was not notably spiritual.

The composition probably derives from a presentation image of the sort seen on the Evesham seal (**355**).

BIBLIOGRAPHY Chaplais, 1960, nos. 5 and 6; Barcelona, 1961, no. 930

363

365 366 367

365 Hugh, Abbot of Bury St Edmunds 1157–80

80 × 54 mm
1157–60
Legend: + SIGILLUM HUGONIS ABBATIS SANCTI AEDMUNDI
Oxford, Bodleian Library, MS Ch. Suffolk 5*

The format here, a standing frontal figure with a book in his left hand and a staff in his right, was to become standard for abbots and priors and indeed may well already have been so at this date.

To judge by the epigraphy, this seal is by the same maker as the second seal of the abbey (356). Both use letters occupying the full width of the rim, single large median point punctuation and capital G with a serif on the inward-turning end. The quality of relief as well as certain details of the figure, such as the rounded shoulders, also indicate a close relationship between the two. If indeed it can be attributed to Master Hugo (cf. 44), this is evidence that he was still working for the abbey in the late 1150s, and that he did not always utilize the curvilinear damp-fold so often associated with him.

BIBLIOGRAPHY R.M. Thomson, 'The Archives of the Abbey of Bury St Edmunds', *Suffolk Record Society*, vol. XXI, 1980, p. 51, no. 39

366 Simon, Abbot of St Albans 1167–83

82 × 51 mm
1167–83
Legend: + SIGILLUM SIMONIS ABBATIS ECCL'IE SANCTI ALBANI
Durham, Dean and Chapter of Durham Cathedral, 2-2, Spec. 4b

Although Simon has the usual abbatial attributes, an open book in his left hand and a crosier in his right, he is wearing episcopal vestments. The right to wear these had been granted to St Albans by the Pope in 1161. This may well be the earliest

English abbot's seal to represent them, although one or two other major houses, Bury St Edmunds for example, seem to have been entitled to the insignia for some years. At Bury it was not until Abbot Samson's time (1182) that the mitre etc. appeared on a seal.

The traces of nested V-folding near the point of the chasuble and the broad clinging area across the abbot's torso are reminiscent of the style of the principal illuminator who worked in the books which Abbot Simon gave to the library (70), and for which today he is most remembered.

366a An impression of the abbey seal (349) also appears on this charter.

BIBLIOGRAPHY Birch, 1887, no. 3946; Durham Seals, XV, no. 3538; Saxl, 1954, pp. 21–2, pl. IVᶜ

367 Walter, Abbot of Westminster 1175–90

73 × 47 mm
1175–90, presumably early in this period
Legend: + SIGILLV . . .
London, Muniments of the Dean and Chapter of Westminster, WAM 573

This seal is a rare example of Romanesque plate-fold drapery dating from the 1170s. Normally such a style would be assigned to the second quarter of the 12th century. It forms a striking contrast to the clinging damp-fold of Richard of Winchester's first seal (345) and the asymmetries of his second (346), with which it is contemporary. Nor is the apparently old-fashioned nature of Abbot Walter's seal to be attributed to provincial or rustic workmanship, for the design is balanced and well executed. It shows that a rich patron in a major centre, London, did not necessarily share, if indeed he noticed, what we now regard as the progressive taste of his peers.

368 Matrix: Godwin the Thane, and on the reverse Godgyth the Nun given to God *(illustrated on p. 78)*

Walrus ivory; *diam* 45 mm, handle 40 mm high
Primary use, Godwin *c.* 1040–42
Legends: + SIGILLUM : GODWINI MINISTRI
 + SIGILLUM GODGYÐE MONACHE DODATE
London, Trustees of the British Museum, 1881, 4-4, 1

The date of Godwin's matrix depends on its close connection with the 'arm and sceptre' coinage of King Harthacnut (**379**). It is debatable whether the seal copies the coin design or whether they both depend on a lost source, for example a seal of Harthacnut.

The splendid handle decoration illustrates Psalm 110: 'The Lord said unto my lord, sit thou at my right hand, until I make thine enemies thy footstool. The Lord shall send a rod of strength out of Zion; rule thou in the midst of thine enemy.' This may imply that Godwin used the seal in the service of his earl or even of the king.

By comparison with the crisp cutting and clear design of the handle of Godwin's matrix, Godgyth's seal on the reverse is poor. It shows her three-quarter-length and seated, though only the two ends of her bolster cushion are visible. Small private seals showing a seated figure (cf. **369** and **370**) are unlikely to have been used before the King himself adopted such a format (Edward the Confessor *c.* 1050, **328**), which suggests a date in the third quarter of the 11th century. Perhaps it was made for Godwin's widow or daughter who entered a nunnery at the time of the Conquest, as many Anglo-Saxon ladies did for security.

BIBLIOGRAPHY Tonnochy, 1952, no. 2; E. Okasha, *Handlist of Anglo-Saxon non-Runic Inscriptions*, 1971, no. 117; Heslop, 1980, pp. 5–6

369 Matrix: Wulfric *(not illustrated)*

Walrus ivory; *diam* 40 mm, handle 14 mm high
Second half 11th century
Legend: + SIGILLUM WULFRICI
Private collection

Like Godwin (**368**), Wulfric is shown with a sword, indicating that he belongs to the military class. Curiously he brandishes it while seated, and points with the other hand. The use of three-quarter-length seated figures on personal seals is a stage between figures like Godwin and full-length examples such as Thor Longus (**370**). The profile head but largely frontal torso link it closely to Godgyth's matrix (**368**) and it is probably of similar date. This dynamic design is typical of Late Anglo-Saxon style. Unusually there is no inscribed line separating the legend from the figure.

BIBLIOGRAPHY Elizabeth-Ann Hastings, 'An Anglo-Saxon Seal matrix', *Burl. Mag.* vol. 119, 1977, pp. 308–9; Heslop, 1980, pp. 6–7

370 Thor Longus *(not illustrated)*

47 × 30 mm
Before 1118
Legend: + THOR ME MITTIT AMICO
Dean and Chapter of Durham Cathedral, Misc. Ch. 722

The seal of Thor Longus is in the tradition of Wulfric's (**369**). A later date for Thor's seal is suggested by the fact that the figure is full-length rather than three-quarter-length and that the seal is vesica shaped. There is no later surviving small private seal of the type, which existed as early as the 10th century, showing the military man, unmounted, bearing a sword. By 1120 this form had given way to the equestrian image, borrowed from royal seals, which was more in keeping with post-Conquest notions of how a gentleman fought.

Stylistically this is similar to the seals of Henry I, though the pose is more animated. It recalls in its design a remarkable silver penny issued around 1109 (**415**).

BIBLIOGRAPHY W.S. Walford and A. Way, 'Examples of Medieval Seals', *Archaeol. J.*, vol. XIV, 1857, p. 48–9; Birch, 1895, no. 17073; Heslop, 1980, p. 16

371 Robert, Earl of Leicester 1118–68

diam 75 mm
Probably as early as 1118, certainly before *c.* 1150
Legend: + SIGILLUM : ROBERTI : COMITIS : LEGRECESTRIE
London, British Library, Harley Charter 84.H.19

To judge by its style this is one of the earliest equestrian seals to survive. The horse has a short, broad head, quite different from the rather serpentine creatures of the mid-12th century. Furthermore Robert still carries a long shield and a lance, features that were becoming outmoded by the 1130s, when equestrian figures tended to be shown with a shorter, broader shield and carrying a sword. These changes may well represent developments in the pattern of warfare. Interestingly Robert is shown wielding his lance overarm, a feature found on the Bayeux Tapestry, where lances are used for stabbing or as javelins (see Brown, 1980–1, II, pp. 12–13).

The liveliness of the pose and its rendering have more in common with Late Anglo-Saxon style than with the stiffer or more hieratic Norman and Romanesque tendencies, which suggests an early date, perhaps around 1118, when Robert became Earl.

This impression is late and bears a gem counterseal ('Victory holding a rudder', 29 × 25 mm, legend, + SECRETUM ROBERTI COITIS LEIRCESTRIE) and is one of the earliest surviving examples of such a use by a layman.

BIBLIOGRAPHY : Birch, 1892, nos. 5669–71

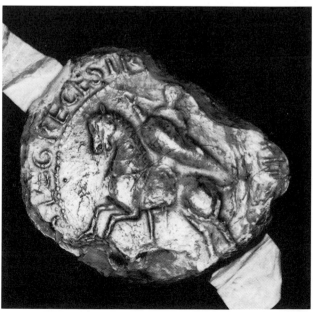

371

372 Richard Bassett, Justiciar of England *c.* 1127– *c.* 1135 (*not illustrated*)

diam 80 mm
Before 1129
Legend: destroyed
London, British Library, Harley Charter 44.4.19

This seal has been famous for centuries by virtue of its unusual subject-matter. Although this unique surviving impression is damaged it has deteriorated hardly at all since it was drawn for Sir Christopher Hatton's *Book of Seals* (**499**). Hatton's artist shows a winged griffin with a man in its jaws. On the original there is no trace of the wings and the animal has a snout rather than a beak. It seems to be a wolf. Furthermore the figure in its jaws, with long bony limbs and ears set at the top of the back of the head, is more like contemporary representations of demons, as in the *Martyrdom of St Lawrence* in a manuscript in the British Library (Cotton, Caligula A.XIV) than humans. The implication is therefore that the Devil is directing the beast to attack Bassett, the brave upholder of justice.

The design is bare of any unnecessary detail and concentrates on strong modelling and the drama of the combat.

BIBLIOGRAPHY L. Loyd and D.M. Stenton, *Sir Christopher Hatton's Book of Seals*, 1950, no. 407; Henderson 1978, pp. 26–42; D.M. Stenton, *English Justice between the Norman Conquest and the Great Charter*, 1965, pp. 60–1

373 Matrix: Snorri the Tollgatherer

(?) Walrus ivory; *diam* 38 mm
c. mid-12th century
Legend: + SIGI.SNARRI.THEOLENARII
York, The Yorkshire Museum

Snorri, shown standing in a knee-length garment, extends his right hand (on an impression), in which is a bag. Above it are three small discs, presumably depicting coins. The man who owned this matrix has not yet been traced in documents, but his stated profession, tollgatherer, and the fact of its being represented, suggest that the seal was used in day-to-day business transactions rather than on charters. Its date is difficult to establish, but the nature of the style, lettering and punctuation suggest the mid-12th century.

BIBLIOGRAPHY Interim, *Bulletin of the York Archaeological Trust*, vol. 1, no. 3, 1973, pp. 37–8

374 Matrix: Alfred

(?) Walrus ivory; *diam* 33 mm
First half 12th century
Legend: + SIGILLUM ALFREDI
Totnes, Elizabethan House Museum

Unfortunately the exact archaeological context of this find is not recorded and so is no help in dating it. The matrix is interesting in having a bird for its motif. In the late 12th century it was commonplace for individuals in business to have a bird or beast, fleur-de-lys or other simple device on their seals (cf. e.g. Ellis, 1978, P150, P462 or P894). But to judge from its material, style and lettering, for example the square G, this matrix is earlier than any surviving impression of such a design. It suggests that the use of such motifs as flora and fauna predates the widespread use of seals on charters.

BIBLIOGRAPHY S.E. Rigold, *Devon Association Transactions*, vol. 86, 1954, p. 252, illus. 6a

375 Matrix: Richard Cano (*not illustrated*)

Bone; 47 × 38 mm
Third quarter 12th century
Legend: + SIGILL RICARDI CANO DE BR ...
Salisbury, Council of the Salisbury and South Wiltshire Museum

Considering the 12th-century love for scenes of combat, it is surprising that they are found so infrequently on seals. This seal and Richard Bassett's (**372**) are rare examples. The shape and size of seals can hardly have been the restricting factor, since contemporary boardgame pieces, or tablemen, frequently show such subjects (see Mann, 1977). It must reflect 12th-century thought on seals that an otherwise ubiquitous genre was neglected here. Perhaps combat was sensed as too disruptive a subject for objects whose function was to stablize. This may explain why on this example the 'dragon' is diminutive. Where animals do occur on seals, they are usually lions or griffins, that is, associated with strength or guardianship.

The tall flat-topped shield carried by a man on foot suggests a date in the second half of the century (cf. Lasko, 1972a, pl. 270 and the Lewis Chessmen, **212**). The original owner has yet to be identified, though an Alexander Canu, from Wiltshire where this matrix was found, occurs in the Pipe Rolls for 1169.

BIBLIOGRAPHY Beckwith, 1972, no. 77; Cherry, 1972; Henderson, 1978, pp. 26–42

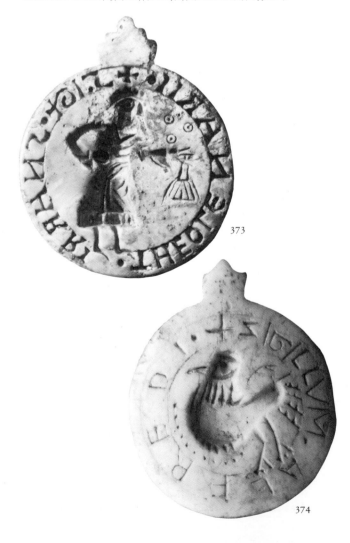

373

374

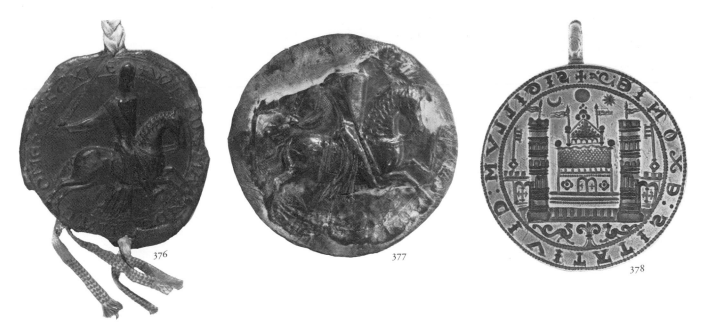

376

377

378

376 William de Mandeville, Earl of Essex 1166–89, second seal

diam 82 mm
c. 1180
Legend: WILL DE MANDEVILLA COMES ESSEXIE
London, Muniments of the Dean and Chapter of Westminster, WAM XCIII

This splendid seal is a close variant of that used by Philip of Alsace, Count of Flanders, from 1168. Philip and William were on Crusade together in 1177 and 1178 and it was doubtless then that William saw and admired the Count's seal (Stuttgart 1977, no. 67, pl. 15). Despite the use of a particular prototype, the English seal shows a good deal of independence. For example, the long elegant surcoat descends to fill the base where Philip's artist had shown a leafy plant. And William's image is more vigorous because of the slightly twisting torso, which gives the figure a three-dimensional quality. There is other evidence of the influence of Mosan art in England at this period, but when one is able to compare model and variant, as in this case, it is the linear grace and striking energy of the English work which is so distinctive and impressive.

The shield shows the quartered arms of Mandeville and is one of the earliest English heraldic references we have. Details of the armour too are fascinating. The round-topped helmet copies that of the Count of Flanders but the loose mail sleeve is original, as is the very pointed, evenly tapering sword, which contrasts strongly with the broader, blunter swords held by Kings Richard and John (334 and 335).

BIBLIOGRAPHY Sotheby's Sale Catalogue, 4 July 1972, lot 1745

377 Waleran, Earl of Warwick 1184–(?)1203

diam 76 mm
1184–1203
Legend: + SIGILLUM WALERANNI . . .
London, British Library, Cotton Charter XI.16

Various details such as the horse trappings, the wavy mane, the crosses on the sword blade and the cross-hatched rendering of the mail indicate that this seal is by the same maker as William de Mandeville's (376). However there are differences in the overall design which make Waleran's seal more compact. The elbow of his right arm is closer to the body and hence the sword is too. Similarly, the horse's head and neck are drawn in closer to the rider. The advantage of bringing these forms in towards the centre is that the overall design can be enlarged. Thus the figure is more massive and imposing, if less graceful, than that of the Earl of Essex.

There are several others among the corpus of equestrian seals of this period which are related to the work of this artist (e.g. Patrick, Earl of Dunbar, Hunter Blair, 1943, pl. IIIc). It has not yet been possible to link him with any ecclesiastical commission so it seems that the bulk of his work was for the aristocracy.

BIBLIOGRAPHY Birch, 1892, nos. 6263–5

378 Matrix : Exeter City

Silver; *diam* 65 mm
c. 1200, before 1209
Legend: + SIGILLUM CIVITATIS EXONIE
Devon Record Office, Exeter City Archives

Borough seals, although known on the Continent before the mid-12th century, did not appear in England until the 1190s (e.g. York and Oxford). The design of these seals was fairly consistent across Europe. There is almost always a crenellated wall with one or more of the following elements: towers, figures, flags, a ship if the town was a port, or a visual reference to the place-name, such as an ox on the Oxford seal.

Exeter's seal incorporates as its central element a building which appears in various forms on ecclesiastical seals in the city, but expands this design with fortified towers with flags, thus linking town and church. It is the earliest of the many surviving civic matrices and was made by one Luke (LUCAS ME FECIT on the handle) and paid for by a wealthy citizen, William Prudum (+ WILL PRUDUM ME DEDIT CIVITATI EXONIE CUIUS ANIME PROPICIETUR DEUS AM[en] on the reverse). Luke seems also to have made the seal for Taunton in Somerset.

BIBLIOGRAPHY L. Jewitt and W.H. St J. Hope, *The Corporation Plate . . . of England and Wales*, vol. 1, 1895, p. 136; Birch, 1892, no. 4919; H. Lloyd Parry, *The Exeter Civic Seals*, 1909, pp. 1–5; E. L. Weeks, 'Prudum, Prudom etc. of Exeter and the first city seal', *Reports and Transactions of the Devon Association*, vol. 47, 1915, pp. 248–56

Coins

The coinage system which was inherited by William I at the Conquest and which was to prevail during the entire period of Romanesque art, and indeed beyond, was already established in its essentials before the death of Edgar in 975. A year or two earlier, a major currency reform swept away the motley coinage of largely aniconic and regionally variable types characteristic of the 10th century and succeeded in imposing in its place the long-sought-for ideal of a single type uniform throughout the country. The obverse showed a representation of the king and its legend set out his name and title. The reverse bore a cross and its legend named the moneyer responsible for striking the coin and answerable to the king for its being of the correct weight and fineness; it also named the place where the coin was produced. This pattern of design and organization was to be followed almost without exception for the next three hundred years. A development of this system which soon became established practice was a periodic change of type; dies with one particular version of the obverse bust and reverse cross were issued to all mints for a period of a few years and then replaced by others with a new pair of designs which were recognizably different variants on the same two standard themes. Only one type was officially current, and coins of the superseded type had to be brought to the mints to be exchanged for coins of the new type. Foreign coins entering the country, whether good-quality German issues or baser French ones, were rigorously excluded from circulation and had to be melted down and recoined into English money.

In 1066, therefore, William the Conqueror found a sophisticated coinage system, under royal control, with uniform, periodic types being struck in silver consistently around 92.5% fine from centrally-produced dies by some two hundred moneyers working in between sixty and seventy towns around the kingdom. He maintained this efficient and profitable sector of Anglo-Saxon administration virtually unaltered throughout his reign. The late Anglo-Saxon moneyers were contractors of wealth and position who employed others actually to strike the coins but, being of merchant rather than aristocratic rank, they and their office were not politically significant and most of them continued to function in the Norman period. Apart from the king's name, the appearance of the coinage was also little affected; the obverse design continued to present variations on the basic theme, inspired by German and ultimately Byzantine prototypes, which had been adopted by Edward the Confessor in the late 1050s. Like most successful monetary systems, the Norman coinage was artistically conservative and this pattern of periodic types lasted until it was disrupted by the troubles of the civil war in Stephen's reign.

In the later Anglo-Saxon period there had been considerable fluctuations in the weight of different types, and even within issues the standard had sometimes varied. The one major change which William I made to the system was the stabilization of the weight of the coinage. His first five types were struck to a consistent standard of about 21 grains (1.36 grammes) and in the next type the weight was raised to a level possibly trying to achieve a standard of 22½ grains (1.46 grammes) – although the distribution peak of surviving

specimens is nearer 22 grains (1.43 grammes) – a level which was to remain the official norm until 1279. It was the stability of the new, heavier-weight penny which gave rise to its being called a 'sterling', which in turn became a by-word for high quality in other things than just the coinage.[1] This weight may well have been chosen to bring the English coinage into line with the stable and internationally accepted pfennigs of the archbishops of Cologne.[2] The silver standard was maintained at the Anglo-Saxon level of 92.5% fine.

It is convenient to speak of 'mints' when discussing towns where coinage was produced, but the Winchester evidence[3] shows that minting activities at this period were not confined to one location; each moneyer had his furnace in his own business premises in a particular quarter of the city. While the situation may not necessarily have been identical in all places, the evidence from the other major centres of Canterbury[4] and now York[5] seem to point in the same direction.

The order in which the distinctive types of the Norman coinage were produced has been worked out by sound numismatic techniques and the currently accepted sequence is unlikely to be altered in any major respect, although some areas of uncertainty remain, e.g. in the ordering of some of the types in the earlier part of Henry I's reign. To arrive at precise dates for the duration of each of these types is more difficult. Once a periodic system became established, it would have been natural for it to settle down into a regular rhythm with generally fixed lengths of time allotted to each type. There is however no proof that these terms were invariably of equal length, and indeed, the number of types to be fitted into the number of years in the reigns of the Norman kings means that some alteration in any hypothetical fixed-term scheme has to be accepted. The 21 years of the reigns of William I and William II have to be divided among 13 types in the name of 'King William' and the 34 years of Henry I among 15 types. The available numismatic and historical evidence is rarely sufficient to provide fixed points. All the proposed dates for the types of the Norman coinage are therefore to some extent conjectural. These uncertainties should nevertheless not be exaggerated; the chronological margins are likely to be variable only to the extent of some two or three years either way. Duration of circulation is another factor which must be taken into account when using coins for dating purposes. Whatever the intention may have been, a number of large hoards, especially from the reign of Henry I, show that a coin's life-time in currency cannot necessarily be equated with the period of issue of its type. Again however this aspect should not be over-emphasized for, of all medieval artefacts, coins remain among the most amenable to close dating. While they are statistically more likely to have been current during, or shortly after, their period of issue, it must be borne in mind that they sometimes survived in circulation 15 to 20 years after they were struck.[6]

During the Romanesque period, the silver penny was the sole denomination struck in England. Although round halfpennies had maintained an exiguous existence from c. 886 to c. 973, they did not feature in the later Anglo-Saxon coinage and after an apparently brief and unsuccessful experiment under Henry I[7] no more were produced in England until 1280. The

need for small change was met by cutting pennies into halves and quarters along the lines of the reverse cross. Cut-halfpennies and cut-farthings are consistently under-weight as a few grains of silver shaved off the cut edge were less likely to be noticed than any tampering with a full round coin and the temptation was apparently irresistible. There are no parallels to the very rare non-currency gold pieces produced throughout the Anglo-Saxon period for donative purposes, but Byzantine and Arabic gold coins occasionally feature in the documentary sources.[8]

Although there were some native sources of silver in the West Country and in Wales and, from late in the reign of Henry I, also in Cumberland, most of the bullion for the coinage came from the melting of Continental coins entering the country as a result of a favourable balance of trade.[9]

The coins were hand-struck between two iron dies. Following long-established medieval practice, the designs were impressed onto the dies by means of a limited range of positive punches of simple form from which all the components of the obverse effigy, reverse type and legends could be built up, with the occasional help of a burin for a few of the finer details. As dies for the whole country were normally made centrally, this technique ensured a uniform and recognizable official style. This was unlikely to have been achievable by direct engraving undertaken by several different hands, and was intended to make forgeries easier to detect. The characteristics of local schools of artists and craftsmen are thus not evident on the coinage. (Occasionally as a result of being cut off from supplies by war or in other emergencies, moneyers were forced to resort to locally-made dies but these are usually slavish copies of the official designs in amateurish hand-engraving (430). The limitations imposed on the designer by this technique mean that too much should not be read into the detail of the types, especially as he was obliged to think up new variants for each successive issue. Old designs are sometimes repeated after an interval when the original issue had ceased to be current, e.g. the cross fleury of William I's first type reappears twice for Henry I, in types I and x. In types which were longer-lived or which were struck more intensively over a shorter period – and it is often difficult to distinguish between the two – the style of the earlier coins is generally superior to those struck later; the neat, detail-rich effigies of the first dies give way to grosser, more perfunctory versions of the original image, often accompanied by increasingly curtailed obverse legends (contrast 424 and 425). The lower die or pile (467) was secured by wedges into a wooden anvil, a thin silver blank placed upon it and then the upper die or trussel was positioned above it and struck with a hammer. At this period the lower die was always the obverse or head side, and the upper die the reverse. In the earlier Norman period the English moneyers followed Anglo-Saxon practice in using non-circular blanks from which the coins were chopped out after striking with a tool similar to a small pastry-cutter.[10] This method of production resulted in coins with a well-defined edge which was less vulnerable to clipping; it was however time-consuming and required considerable expertise in the preparation of the sheet-metal from which the blanks were cut, if the finished coins were to conform to the prescribed weight-standard. This was to cause problems under Henry I and Stephen.

The tight central control which had been successfully exercised over the coinage during the early Norman period began to show signs of strain under Henry I. Coins were carelessly produced, flan size first declined and then fluctuated wildly and, more dangerously, the weight-standard which was the corner-stone of the English coinage system fell away from the consistently high level it had maintained since the middle of the Conqueror's reign. Henry I brought in some measures of reform in 1108 (412) but, after a period of improvement, standards deteriorated yet again and exemplary action was required before the old standards of William I were successfully re-imposed for the last three types of the reign (422–427).

The traditional coinage system fell apart during the civil war between Stephen and Matilda. The substantive types of Stephen himself (428–433) maintained the old standards although his first type lasted from 1135 to 1142, much longer than had become customary. Some students even wish to extend type I as late as c. 1150.[11] Although the present writer prefers the earlier chronology, there are formidable problems in reaching a satisfactory dating sequence for the coinages struck during Stephen's reign. The royal monopoly was broken and the currency was invaded by imitations of the official issues, many of them base and light-weight. Some with independent designs, which are among the most attractive and interesting of the entire medieval series, were struck in the names of barons from both sides (440–442 and 452). Stability was restored with the last type of the reign but the old system did not long outlast the accession of Henry of Anjou, Matilda's son, as Henry II in 1154.

The 'Tealby' type introduced in 1158 marked a major change in the organization of the coinage. The periodic system was abandoned in favour of an immobilized obverse type, that is the design and legend were maintained as close to the original model as the die-cutters could manage from the beginning to the end of the type. The minute differences in the detail of the effigy which have assisted numismatists to establish a sequence of issues had no deliberate contemporary significance. The resulting 'classes' into which the coinage is divided are thus quite different in character from the 'types' of the earlier reigns: one class was not recoined during the striking of the next and coins produced in the first year of the coinage remained legally current until it was demonetized after 1180. The old practice of naming the mint and moneyer on the reverse continued unchanged. Although the standard of weight and fineness was consistently maintained, the appearance of the coinage reached an all-time low. The 'pastry-cutter' technique was largely given up and the coins were carelessly struck on square or polygonal flans, often too small to receive more than a partial impression of the dies. At the same time the trend towards the reduction in the number of mints which had become manifest under Henry I and continued apace under Stephen was sharply accelerated. The new coinage system no longer required mints all round the country to cope with continual recoinages. After the restriking of the Stephen coinage was completed, most of the 30 mints closed so that by the last class of the 'Tealby' coinage only 12 were still operational.

The method of manufacture of most 'Tealby' coins was an invitation to clippers, despite the dire penalties for those who were caught, and by 1180 reform was clearly called for. The 'pastry-cutter' technique and the coins with well-defined edges it produced were re-introduced and a foreign goldsmith, Philip Aimer of Tours, was imported to superintend the recoinage. Although Philip himself quickly fell foul of the authorities, the Short Cross coinage was a success and rapidly became the international currency of its day, enjoying the doubtful accolade of being widely copied by Continental issuers trying to cash in on the deservedly high reputation and universal acceptability of the English penny. The weight was well up to the standard of $22\frac{1}{2}$ grains and after the initial troubles with Philip Aimer, the rights and wrongs of which are now difficult to disentangle, the fineness apparently settled down at the

traditional norm. The obverse type remained immobilized throughout the type until its close in 1247, retaining its legend of HENRICVS REX through the reigns of Henry II, Richard I, John and beyond the end of our period into the early years of Henry III. The Short Cross coinage saw a further reduction in the number of mints from 11 at its start to 9 just before the poor state of the currency required a partial recoinage in 1205. For this purpose the complement rose temporarily to 16 but had fallen to just 3 by 1247.

During the Short Cross period the English medieval coinage increased sharply in volume with minting increasingly concentrated in the major trading towns. As the period progressed, London and Canterbury played a dominant role, well illustrated by the Bainton, North Humberside, hoard, found in 1982 and deposited on the eve of the reform of 1205, in which the mints were represented in the following proportions: London, 49%; Canterbury, 33%; others, 18%.

The strength of the English coinage throughout the Romanesque period was founded on the profits from wool and was sustained by the vigilance of the Norman and Angevin kings in enforcing standards, and their skill in adapting the efficient currency system inherited from their Anglo-Saxon predecessors to changing conditions. M.M.A.

NOTES

1. Grierson, 1961
2. Grierson, 1976, p. 95
3. Biddle, 1976, pp. 396–422
4. Urry, 1967
5. Hall, 1980 and 1981
6. Archibald, 1974, pp. 234–71
7. Seaby, 1951, pp. 280–5, Grierson, Brooke, 1951, pp. 286–89

8. Grierson, 1951, pp. 75–81
9. Sawyer, 1965, pp. 145–64
10. Sellwood, 1962, pp. 57–65, which will require slight modification in the light of the 10th-century dies recently found in York and described by Hall, 1980 and 1981
11. Seaman, 1978, pp. 58–72

NOTES TO COINS BIBLIOGRAPHY

The basic works of reference for the coinage of this period are the two British Museum catalogues: G.C. Brooke, *The Norman Kings*, 1916 (BMC.NK), and D.F. Allen, *The Cross-and-Crosslets ('Tealby') Type of Henry II*, 1951 (BMC.T). No similar general work has yet appeared for the Short Cross series; the fundamental paper is that of L.A. Lawrence, 'The Short-Cross coinage, 1180–1247', BNJ, XI, 1914, pp. 59–100. A scholarly account of the introduction of the coinage based on the documentary sources is given by Allen in BMC.T, pp. lxxii–lxxiv and lxxxviii–cxiv. The results of more recent work are to be found in papers contributed to the *Numismatic Chronicle*, *Coin Hoards*, the *British Numismatic Journal*, *Spinks's Numismatic Circular* and *Seaby's Coin and Medal Bulletin*. Full details of the extensive recent literature may be noted in the half-yearly abstracts published by the American Numismatic Society in its *Numismatic Literature*; a more critical review appears every six years in the International Numismatic Commission's *Survey of Numismatic Research*. An authoritative and well-illustrated handlist of the coins of this period incorporating the latest work (some of it as yet unpublished elsewhere), although with only minimal commentary, is

J.J. North, *English Hammered Coinage*, vol. I, 2nd edn., 1980. G.C. Brooke, *English Coins*, originally published in 1932, provides this background information, although even the revised edition of 1950 now requires considerable emendation in the light of more recent research. C.H.V. Sutherland, *English Coinage, 600–1900*, 1973, is a general survey with the emphasis on art in coinage.

Abbreviations for periodicals etc.
BMC *British Museum Catalogue* (for BMC.AS etc. see below under BMC)
BNJ *British Numismatic Journal*
CH *Coin Hoards*
EHR *English Historical Review*
NC *Numismatic Chronicle*
SCMB *Seaby's Coin and Medal Bulletin*
SNC *Spinks's Numismatic Circular*
SNR *Survey of Numismatic Research*
TRHS *Transactions of the Royal Historical Society*

COINS AND COINAGE BIBLIOGRAPHY

Abingdon Chronicle
J. Stevenson (ed.), *Chronicon Monasterii de Abingdon*, I, 1858
Akerman, 1855
J.Y. Akerman, 'Account of silver rings and coins discovered near Worcester', *Archaeologia*, XXXVI, 1855, pp. 200–2
Allen, 1951 see BMC.T
American Numismatic Society see *Numismatic Literature*
Andrew, 1934–7
W.J. Andrew, 'The die for Stephen's coinage in the Guildhall Museum and secondary evidence there of an unpublished penny of Henry I', BNJ, XXII, 1934–7, pp. 29–34
Archibald, 1974
M.M. Archibald, 'Medieval Coins as Dating Evidence', *Coins and the Archaeologist*, eds. P.J. Casey and R. Reece, 1974
Archibald, 1981
M.M. Archibald, Medieval Series, British Museum Occasional Paper no. 25, *Department of Coins and Medals: New Acquisitions no. 1 (1976–77)*, ed. E.M. Besly, 1981
Biddle, 1976
M. Biddle et al., *Winchester Studies, I, Winchester in the Early Middle Ages*, 1976
Blunt, Stewart, 1977
C.E. Blunt and B.H.I.H. Stewart, 'A parcel from the Shillington (1871) hoard', SNC, 1977, p. 354
BMC British Museum Catalogues:
BMC.AS H.A. Grueber and C.F Keary, *A Catalogue of English Coins in the British Museum: Anglo-Saxon series*, II, 1893
BMC.Byz W. Wroth, *Catalogue of the Byzantine Coins in the British Museum*, 2 vols., 1908
BMC.NK G.C. Brooke, *A Catalogue of English Coins in the British Museum: the Norman Kings*, 2 vols., 1916
BMC.T D.F. Allen, *A Catalogue of English Coins in the British Museum: the Cross-and-Crosslets ('Tealby') Type of Henry II*, 1951

Boon, 1981
G.C. Boon, 'Treasure trove from Angevin Wales', SCMB, 1981, pp. 194–6
Boon, Dolley, 1971
G.C. Boon and M. Dolley, 'A third type for the Cardiff Mint under Henry I', BNJ, XI, 1971, pp. 172–3
Brooke, 1916 see BMC.NK
Brooke, 1950
G.C Brooke, *English Coins*, 3rd edn., 1950
Bryant, 1968
K.G. Bryant, 'An Awbridge penny of Stephen', *Crowther's Fixed Price List*, 6, 1968, pp. 2–3
CH
Royal Numismatic Society, *Coin Hoards*, published about annually, I, 1975 to date
Dannenberg, 1876
H. Dannenberg, *Die deutschen Münzen der sachsischen und frankischen Kaiserzeit*, 2 vols., 1876
Dodwell, 1982
C.R. Dodwell, *Anglo-Saxon Art: a New Perspective*, 1982
Dolley, 1962
M. Dolley, 'The 1962 Llanthrithyd treasure trove and some thoughts on the first Norman coinage of Wales', BNJ, XXXI, 1962, pp. 76–9
Dolley, 1966
M. Dolley, *The Norman Conquest and the English Coinage*, 1966
Dolley, Elmore-Jones, 1961
R.H.M. Dolley and F. Elmore-Jones, 'A new suggestion concerning the so-called "Martlets" in the "Arms of St Edward"', *Anglo-Saxon Coins*, ed. R.H.M. Dolley, 1961, pp. 215–6
Dumas, 1979
F. Dumas, 'Les Monnaies normandes (X^e–XII^e siècles)', *Revue numismatique*, 6th

series, XXI, 1979, pp. 84–140

Elmore-Jones, 1969
F. Elmore-Jones, 'Davit on Gip', *Crowther's Fixed Price List*, 1, 1969, p. 3

Elmore-Jones, Blunt, 1967
F. Elmore-Jones and C.E. Blunt, 'A remarkable parcel of Norman pennies in Moscow', BNJ, XXXVI, 1967, pp. 86–92

Folkes, 1763
M. Folkes, *Table of English Coins*, 2nd edn., with plates, 1763

Ghyssens, 1971
J. Ghyssens, *Les petits Deniers de Flandre des XIIe et XIIIe siècles*, 1971

Grierson, 1951
P. Grierson, 'Oboli de Musc', EHR, 1951, pp. 75–81

Grierson, 1961
P. Grierson, 'Sterling', *Anglo-Saxon Coins*, ed. R.H.M. Dolley, 1961, pp. 266–83

Grierson, 1976
P. Grierson, *Monnaies du Moyen Age*, 1976

Grierson, Brooke, 1951
P. Grierson and C. Brooke, 'Round halfpennies of Henry I', BNJ, XXVI, 1949–51, pp. 286–9

Grueber, Keary, 1893 see BMC.AS

Hall, 1980
R. Hall, 'Numismatic finds from the excavations of Viking Age York', SCMB, 1980, pp. 371–3

Hall, 1981
R. Hall, 'More Viking age numismatica from excavations in Coppergate, York', SCMB, 1981, p. 230

International Numismatic Commission see SNR

Inventory
J.D.A. Thompson, *Inventory of British Coin Hoards*, AD 600–1500, 1956

Keynes, 1978
S. Keynes, 'An interpretation of the Pacs, Pax and Paxs pennies', *Anglo-Saxon England*, 7, 1978, pp. 165–73

Lawrence, 1915
L.A. Lawrence, 'The Short-Cross coinage, 1180–1247', BNJ, XI, 1915, pp. 59–100

Mack, 1966
R.P. Mack, 'Stephen and the Anarchy, 1135–1154', BNJ, XXXV, 1966, pp. 38–112

Nightingale, 1982
P. Nightingale 'Some London moneyers, and reflections on the organization of English mints in the eleventh and twelfth centuries', NC, 1982, pp. 34–50

North, 1980
J.J. North, *English Hammered Coinage*, I, 2nd ed., 1980

Numismatic Literature
American Numismatic Society, *Numismatic Literature*, half-yearly, 1947 to date

Poey d'Avant, 1858
F. de Poey d'Avant, *Monnaies féodales de France*, 1858

Poole, 1955
A.L. Poole, 'From Domesday Book to Magna Carta, 1087–1216', 2nd edn., 1955

Sawyer, 1965
P. Sawyer, 'The wealth of England in the eleventh century', TRHS, XV, 1965, pp. 145–64

Schlumberger, 1878
G. Schlumberger, *Numismatique de l'Orient latin*, 1878

SCMB
Seaby's Coin and Medal Bulletin, monthly, 1947 to date

Seaby, 1951
P.J. Seaby, 'A round halfpenny of Henry I', BNJ, XXVI, 1949–51, pp. 280–5

Seaman, 1978
R.J. Seaman, 'A re-examination of some hoards containing coins of Stephen', BNJ, XLVIII, 1978, pp. 58–72

Sellwood, 1962
D.G. Sellwood, 'Medieval minting techniques', BNJ, XXXI, 1962, pp. 57–65

SNC
Spinks's Numismatic Circular, monthly, 1896 to date

SNR
International Numismatic Commission, *Survey of Numismatic Research*, I, 1960–5, II, 1966–71; III, 1972–7

Stewart, 1967
I.H. Stewart, *The Scottish Coinage*, 1st edn., 1967

Stewart, 1971
I.H. Stewart, *The Scottish Coinage*, 2nd edn., 1971

Sutherland, 1973
C.H.V. Sutherland, *English Coinage, 600–1900*, 1973

Thompson, 1956
J.D.A. Thompson, *Inventory of British Coin Hoards*, AD 600–1500, 1956

Twining, 1967
Lord Twining, *European Regalia*, 1967

Urry, 1967
W. Urry, *Canterbury under the Angevin Kings*, 1967

Whitting, 1961
P.D. Whitting, 'The Byzantine Empire and the coinage of the Anglo-Saxons', *Anglo-Saxon Coins*, ed. R.H.M. Dolley, 1961, pp. 23–38

Wroth, 1908 see BMC. Byz

Yvon, 1970
J. Yvon, 'Esterlins à la croix courte dans les trésors français de la fin du XIIe et de la première moitié du XIIIe siècle', BNJ, XXXIX, 1970, pp. 24–60

NOTES TO CATALOGUE ENTRIES

The coins are, without exception, made of silver.

They have been selected to provide a corpus of illustrations of every major type of the regular coinage issued between 1066 and 1205. Products of as many as possible of the mints in operation at some time during this period have been included and recently acquired coins of previously unrecorded mints or moneyers in the type have been preferred. The requirements of the exhibition, in particular the need to show both sides of certain coins, explain the inclusion of more than one example in some types.

The legends are transcribed as close to the original as modern type-setting will allow but it has not been possible to reproduce all the letter forms as they appear on the coins. Diphthongs and other ligatured letters are presented as two separate letters and retrograde and inverted letters are normalized. The Anglo-Saxon *wen* appears as P, as is appropriate for the Norman coinage where the Anglo-Saxon *wen* and Roman P are indistinguishable in shape. The exact forms of the letters and the full details of the coin-types may be noted on the plates where every coin is illustrated life-size. Areas of the legends not visible on the coins are enclosed within brackets; where possible, missing letters are supplied from other specimens.

BMC followed by a number denotes the coin of that number in the appropriate British Museum Catalogue.

Weights are given in grammes and troy grains.

Many of the coins have long pedigrees but, for reasons of space, it is possible to give only the immediate source and, where known, the ultimate hoard- or site-provenance. For the same reasons, references to most hoards are limited to the entries in J.D.A. Thompson, *Inventory of British Coin Hoards AD 600–1500*, 1956, where full bibliographical details of earlier publications may be found. Recent sale catalogues also generally provide full pedigrees of important lots.

Works cited in this section refer to the Bibliography above.

HARTHACNUT Sole Reign 1040–2

379 Penny of Arm and Sceptre type (BMC type II) struck at London by the moneyer Lefstan, 1040–2

Obv.: HARÐCNUTE
 Diademed bust to left, holding sceptre in left hand
Rev.: + LEFSTAN ON LVNDE
 Quatrefoil over short cross voided
wt 1.15 g (17.8 gr)
London, Trustees of the British Museum, CM, acquired before 1838

After its earliest appearance on an English coin *c.* 978, a sceptre is a regular if intermittent feature of subsequent coin types but on this issue the king's arm and hand are included in the design for the first time. The close correlation of detail, down to the abnormal placing of the sceptre/sword in the figure's left rather than right hand, suggest that this type was the model for the obverse of Godwin's seal (**368**).

BIBLIOGRAPHY BMC 15; North, 1980, no. 811

EDWARD THE CONFESSOR 1042–66

380 Penny of Sovereign type (BMC type IX) struck at London by the moneyer Wulfred, *c.* 1056–9

Obv.: EADPARD R + ANGLOR
 King enthroned facing but head to right, holding sceptre and orb
Rev.: + PLVFRED ON LVNDE ˙.˙
 Short cross voided with bird in each angle
wt 1.19 g (18.4 gr)
London, Trustees of the British Museum, CM 1867, 8–12–369

The fall of the drapery and the way the head is turned to the right demonstrate that this highly unusual obverse design was derived from the personification of Constantinopolis on the reverse of the solidi of the Byzantine Emperor, Justin II, 565–78. The birds on the reverse, wrongly interpreted in later efforts to provide 'arms' for Edward the Confessor as martlets, are probably eagles. The obverse design should be compared with the similar but front-facing representation of Edward on his seal (**328**).

PROVENANCE From the Chancton, Sussex, hoard found in 1866 (*Inventory* 81)
BIBLIOGRAPHY BMC 1021; Dolley, Elmore-Jones, 1961, pp. 215–26; North 1980, no. 827; Whitting, 1961, p. 35

381 Penny of Pyramids type (BMC type XV) struck at Colchester by the moneyer Wulfwine, *c.* 1065–6

Obv.: EADPARD REX
 Crowned bust to right; in front, sceptre
Rev.: + PVLFPINE ON COLECE
 Short cross voided with a pyramid in each quarter
wt 1.23 g (19.0 gr)
London, Trustees of the British Museum, CM 1867, 8–12–97

On this, his last type, Edward wears a closed crown with side pendants ultimately derived from Byzantine prototypes (discussed by Twining, 1967, pp. 7–10). This type of crown first appeared on the coinage with the type introduced *c.* 1062 and was inspired by the issues of the German kings and emperors, Conrad II, 1024–39 and Henry III, 1039–56, (e.g. Dannenberg, 1876, pp. 311–13, pl. 13). The Abingdon Chronicle (I, pp. 462–3) records that the king ordered an imperial crown from his goldsmith-abbot Spearhavoc in 1052 but he never took delivery as Spearhavoc absconded with the precious raw materials. The coin types suggest that he had acquired one sometime within the next decade. Thereafter however it is a closed crown, with the rare exceptions noted below, which is used on the English coinage until 1135.

PROVENANCE From the Chancton, Sussex, hoard found in 1866 (*Inventory* 81)
BIBLIOGRAPHY BMC 150; North, 1980, no. 831

382 Penny of Pyramids type (BMC type XV) struck at Winchester by the moneyer Anderboda, *c.* 1065–6

Obv.: EADPARD RE +
 Crowned bust to right; in front, sceptre
Rev.: + ANDERBODA ON PIN
 Short cross voided with a pyramid in each angle
wt 1.11 g (17.1 gr)
London, Trustees of the British Museum, CM 1851, 3–13–16

Anderboda also worked for both Harold II and William I (**384** and **387**).

PROVENANCE From the Soberton, Hampshire, hoard found in 1851 (*Inventory* 334)
BIBLIOGRAPHY BMC 1500; North, 1980, no. 131

HAROLD II January–October 1066

383 Penny of Pax type (BMC type I) struck at Lincoln by the moneyer Wulfmaer, 1066

Obv.: + HAROLD REX ANGL
 Crowned head to left; in front, sceptre
Rev.: + PVLMER ON LINCO
 PAX between two lines across field
wt 1.50 g (23.1 gr)
London, Trustees of the British Museum, CM, acquired before 1838

Harold is shown moustached and close-bearded, whereas on the Bayeux Tapestry he appears without the beard. The meaning of the word PAX here and on other Anglo-Saxon and Norman types (**396** and **410**) has given rise to much discussion, most recently by Keynes, 1978, pp. 165–73, who points to parallels with the Chrismons on contemporary documents. Another possibility is that the word stands for the King's Peace, which died with him and was reproclaimed at his successor's coronation when the new king promised that Church and people should keep '*verram pacem*'.

BIBLIOGRAPHY BMC 52; North, 1980, no. 836

379 380 381 382 383 384 385

386 387 388 389 390 391 392

393 394 395 396 397 398 399

400 401 402 403 404 405 406

407 408 409 410 411 412 413

384 Penny of Pax type (BMC type I) struck at Winchester by the moneyer Anderboda, 1066

Obv.: + HAROLD REX AN
Crowned head to left; in front, sceptre ·.
Rev.: + ANDERBODE ON PI
PAX between two lines across field
wt 1.13 g (17.4 gr)

London, Trustees of the British Museum, CM 1851, 3–13–91

Anderboda also worked for Edward the Confessor and William I (**382** and **387**).

PROVENANCE From the Soberton, Hampshire, hoard found in 1851 (*Inventory* 334)
BIBLIOGRAPHY BMC 109; North, 1980, no. 836

WILLIAM I As Duke of Normandy, 1035–87

385 Penny of Normandy of Group B/C struck at Rouen during the reign of Duke William before his conquest of England in 1066

Obv.: No legend
Devolved Christian Temple with double pediment
Rev.: Pseudo-legend of lines and motifs
Cross pattée with a pellet in each angle
wt 0.75 g (11.5 gr)

London, Trustees of the British Museum, CM C4403

BIBLIOGRAPHY Dumas, 1979, pl. XIX, nos. 3–4; Poey d'Avant, 1858, pl. VI, no. 18

386 Penny of Normandy of Group C struck at Rouen towards the end of the reign of William I or possibly a little later

Obv.: No legend
Geometric design, ultimately derived from Carolingian Christian Temple type
Rev.: Legend almost illegible but traces of usual
NORMANN(I)A
Cross pattée with a pellet in each angle
wt 0.93 g (15.1 gr)

London, Trustees of the British Museum, CM C4402

William I's English coinage owed nothing to these prolific but anonymous issues of his Normandy Duchy, badly produced to a low weight standard in base metal (*c.* 60% declining to *c.* 40% compared to the consistent figure of *c.* 92.5% fine silver in contemporary English issues), which employed concurrently a varied repertoire of evolving geometric types. A very few coins of the pre-Conquest groups have been found in England but not one of those struck after 1066. The heavy, fine-metal English coins, tariffed at an appropriate premium, circulated increasingly in Normandy as its currency became progressively infiltrated by the issues of surrounding feudal states. The different currency patterns in the two parts of the Anglo-Norman empire were maintained until Normandy was lost to Philippe Auguste of France in 1204 (Dumas, 1979 and Yvon, 1970).

BIBLIOGRAPHY Dumas, 1979, pl. XX, nos. 1–2; Poey d'Avant, 1858, pl. V, nos. 2–4

WILLIAM I As King of England, 1066–87

387 Penny of Profile / Cross Fleury type (BMC type I) struck at Winchester by the moneyer Anderboda, 1066–c. 1068

Obv.: + PILLEV RSE + AI
Crowned bust facing, head to left; in front, sceptre
Rev.: + ANDERBODE ON PII:
Cross fleury
wt 1.26 g (19.5 gr)

London, Trustees of the British Museum, CM, acquired before 1838

As in other areas of Anglo-Saxon government, William I recognized the merits of the centralized coinage system and maintained it virtually unaltered. Most of the Anglo-Saxon moneyers who, like Anderboda, had worked earlier for Edward the Confessor and Harold II (**382** and **384**) continued in office after 1066. Anglo-Saxon names continue to predominate among the moneyers until the reign of Henry I.

BIBLIOGRAPHY BMC 53; North, 1980, no. 839

388 Penny of Profile / Cross Fleury type (BMC type I) struck at Hastings by the moneyer Dunninc, 1066–c. 1068

Obv.: + PILLEMVS REX
Crowned bust to left; in front, sceptre
Rev.: + DVNNIC ON AESTI
Cross fleury
wt 1.28 g (19.8 gr)

London, Trustees of the British Museum, CM, acquired in 1810

The continuity of design as well as in organization is demonstrated by the very similar general aspect of William's first type and that of Harold II. The effigy is however shorn of its beard to adumbrate the Conqueror's appearance. The legends are a curious mixture of Latin and English: on the obverse the King's name and title are in Latin but start with the Anglo-Saxon letter *wen* for W and the reverse is all in English, suggesting that the clerk who drafted the legends was also an Anglo-Saxon. Norman French very rarely appears on offical dies (**424**) but it makes an occasional appearance on some of the baronial issues of Stephen's reign (**452**).

PROVENANCE Purchased from the estate of B.C. Roberts, 1810
BIBLIOGRAPHY BMC 20; North, 1980, no. 839

389 Penny of Bonnet type (BMC type II) struck at London by the moneyer Godric, c. 1068–71

Obv.: + PILLEMVS REX
Crowned bust facing
Rev.: + GODRIC ON LVNDEI
Voided cross with pile in each angle
wt 1.08 g (16.6 gr)

London, Trustees of the British Museum, CM 1864, 7–13–2

William wears a closed imperial crown on all his types. Wido, Bishop of Amiens, records that William brought one with him from Normandy in 1066 (quoted by Twining, 1967, p. 105) but he may also have worn a crown inherited from his Anglo-Saxon predecessors on occasion. The differing forms of imperial crown on the coins were however dictated by the designer's need to vary the design and not by any intention to portray particular crowns.

PROVENANCE Purchased at Capt. R.M. Murchison Sale, Sotheby's 27 June 1864, lot 8
BIBLIOGRAPHY BMC 121; North, 1980, no. 842

390 Penny of Bonnet type (BMC type II) struck at York by the moneyer Roscetel, *c.* 1068–71

Obv.: + PILLEMV REX
 Crowned bust facing
Rev.: ROSCETEL ON EOI
 Voided cross with pile in each angle

wt 1.35 g (21.9 gr)

London, Trustees of the British Museum, CM, acquired before 1838

Following late Anglo-Saxon practice, coinage dies for use all round the kingdom were made in London. Coins struck as far apart as London (**389**) and York (this coin) thus looked identical in style, ensuring that forgeries would be more easily detected. Before the end of the reign the purveyance of the dies had already become hereditary in the family of FitzOtho, descendants of Otto the Goldsmith, presumably a German and one of the continentals who had already made good under Edward the Confessor (Dodwell, 1982, p. 78). Several of the moneyers at York continue to have Scandinavian names ending in -cetel, first noted at York under Aethelred II, and probably indicating close family connections between the moneyers there such as can be proved documentarily at other mints such as London (Nightingale, 1982).

BIBLIOGRAPHY BMC 175; North, 1980, no. 842

391 Penny of Canopy type (BMC type III) struck at Oxford by the moneyer Aegelwine, *c.* 1071–4

Obv.: · · + PILLEMVS REX·
 Crowned bust facing between two pedimented columns
Rev.: + IEGELPI ON OXENEFO

wt 1.29 g (19.9 gr)

London, Trustees of the British Museum, CM, acquired in 1810

The unparalleled elaboration of a normal obverse design in this type recalls the convention of contemporary illuminated manuscripts in placing figures and scenes within an architectural frame. The design was however directly inspired by German coins, for example those of the Emperor Henry III, 1046–56 (Dannenberg, 1876, pl. 38, no. 884).

PROVENANCE From the St Mary Hill, London, hoard found in 1774 (*Inventory* 250); purchased from the estate of B.C. Roberts, 1810
BIBLIOGRAPHY BMC 208; North, 1980, no. 843

392 Penny of Two Sceptres type (BMC type IV) struck at Steyning by the moneyer Dermon (Dereman), *c.* 1074–7

Obv.: + PILLEM REX ANGLI
 Crowned bust facing, between two sceptres
Rev.: + DERMON ON STENI
 Cross fleury over saltire with trefoil of pellets at each cross-end

wt 1.32 g (20.0 gr)

London, Trustees of the British Museum, CM 1980, 10–30–1

In this novel variant of the obverse bust, the king holds two items of regalia which may represent the short sceptre and long rod with which English kings were invested at their coronation. (For a discussion of this regalia see Twining, 1967, pp. 180 and 208–9.)

PROVENANCE Purchased from Spink, 1980
BIBLIOGRAPHY North, 1980, no. 844

393 Penny of Two Stars type (BMC type V) struck at Bath by the moneyer Osmacr, *c.* 1077–80

Obv.: + PILLEM REX AN
 Crowned bust facing between two stars
Rev.: + OSMIER ON BAÐAI
 Cross botonnée over quadrilateral

wt 1.34 g (20.7 gr)

London, Trustees of the British Museum, CM 1914, 4–11–16

Stars are a recurring feature of Norman coin-types (**404**, **414** and **424**). They also appear beside the effigy on William II's seal (**329**) although not on those of his father. They have traditionally been associated with Halley's Comet, which was seen as a good portent for William on its appearance before the Conquest, and with other 'stars' which were regarded as omens. Stars are however often associated with kings and appear on German coins (e.g. of Otto II with Bishop Wilderold of Strassburg, 991–9, Dannenberg, 1876, pl. 118, no. 940a).

PROVENANCE Purchased at P.W.P. Carlyon-Britton Sale, Sotheby's 17 November 1913, lot 70
BIBLIOGRAPHY BMC 295; North, 1980, no. 845

394 Penny of Sword type (BMC type VI) struck at Thetford by the moneyer Godric, *c.* 1080–3

Obv.: + PILLELM REX I
 Crowned bust facing, holding sword
Rev.: + GODRIC ON ÐTFRD
 Cross pattée over quadrilateral fleury

wt 1.37 g (21.1 gr)

London, Trustees of the British Museum, CM 1847, 5–18–60

This is the first English coin-type to present the king holding a sword, although this symbol of royal power had already appeared on the seal of William I.

PROVENANCE Purchased at Lt Col Durrant Sale, Sotheby's 19 April 1847, lot 118
BIBLIOGRAPHY BMC 435; North 1980, no. 846

395 Penny of Profile / Cross and Trefoils type (BMC type VII) struck at Exeter by the moneyer Sewine, *c.* 1083–6

Obv.: + PILLELM REX
 Crowned bust to right, holding sceptre
Rev.: + SEPINE ON IEXSEC
 Cross pattée with trefoil in each angle

wt 1.32 g (20.4 gr)

London, Trustees of the British Museum, CM 1970, 11–6–20

PROVENANCE Purchased at R.P.V. Brettell Sale, Glendining 28 October 1970, lot 279
BIBLIOGRAPHY North, 1980, no. 847

396 Penny of Paxs type (BMC type VIII struck at Salisbury by the moneyer Osbern, *c.* 1086–7)

Obv.: + PILLELM REX
 Crowned bust facing with right arm across chest holding sceptre over left shoulder
Rev.: + OSBERN ON SIER
 Cross pattée; in each angle, an annulet enclosing one letter of the word PAXS

wt 1.43 g (22.1 gr)

London, Trustees of the British Museum, CM, before 1832

Although the large numbers of Paxs type pennies from the large Beaworth hoard make it the commonest Norman coin in modern collections, it was among the scarcer – but not one of the rarest – types of William I before the find. The difficulty in dividing the types in the name of 'King William' between

William I and William II is discussed on p. 320. Brooke, who is followed here, made a proportional division for want of better evidence and gave eight types to the father and five to the son (Brooke, 1916, pp. lxviii–lxx). Dolley (1966, pp. 15–17) proposed a sequence of two-year, rather than three-year, types with the result that the Paxs type becomes the second-last, rather than the last, type of William I. The adherence to a triennial cycle from the start of the Conqueror's reign would however offer another possibility: that, as in the reigns of Edward the Confessor and Harold II, the first type of William II was also a Pax(s) type and possibly to be associated with the *verram pacem* of the coronation oath (383). As a consequence of this dating, the other five types of William II would have lasted for just two years each. There is at present no firm evidence which would allow a decision to be made between these and any other dating-schemes.

PROVENANCE From the Beaworth, Hampshire, hoard found in 1833 (*Inventory* 37)
BIBLIOGRAPHY BMC 902; North, 1980, p. 848

397 Penny of Paxs type (BMC type VIII) struck at Worcester by the moneyer Estmaer, *c.* 1086–7

Obv.: + PILLELM REX
 Crowned bust facing with right arm across chest holding sceptre over left shoulder
Rev.: + ESTMIER ON PIHR
 Cross pattée; in each angle, an annulet enclosing one letter of the word PAXS

wt 1.31 g (22.2 gr)

London, Trustees of the British Museum, CM, acquired in 1833

PROVENANCE From the Beaworth, Hampshire, hoard found in 1833 (*Inventory* 37)
BIBLIOGRAPHY BMC 1148; North, 1980, no. 848

398 Penny of Paxs type (BMC type VIII) struck at Cardiff by the moneyer Aelfwi Turi, *c.* 1086–7

Obv.: XPILLELM RE +
 Crowned bust facing with right arm across chest holding sceptre over left shoulder
Rev.: + IE(?LF)PI TVRI CARITI
 Cross pattée; in each angle, an annulet enclosing one letter of the word PAXS

wt 1.37 g (21.1 gr)

London, Trustees of the British Museum, CM, acquired in 1833

The traditional attribution of the issue to which this coin and the next belong to a Welsh mint or mints has been questioned because the Normans did not establish themselves in South Wales before the death of the powerful Welsh prince, Rhys ap Tewdwr, in 1093 and then only with difficulty after a serious rebellion. Noting a die-link with a coin, of irregular style, of Shrewsbury, Dolley (1962) preferred to attribute these coins to an uncertain mint in the Welsh Marches. The mint-signatures are however acceptable for Cardiff and as the Domesday Book records that Rhys ap Tewdwr had to pay an annual rent of £40 to the English king (quoted by Poole, 1955, p. 287) it would seem quite possible that he should have struck coins in William's name of the current English type in order to pay it. Although they were struck from locally-made dies of rough style, these coins are of good weight and, later, the Cardiff mint did occasionally use locally-made dies (Boon, Dolley, 1971, and Boon, 1981).

PROVENANCE From the Beaworth, Hampshire, hoard found in 1833 (*Inventory* 37)
BIBLIOGRAPHY BMC 584; North, 1980, no. 848

399 Penny of Paxs type (BMC type VIII) struck at 'Devitun' by the moneyer Thierry, *c.* 1086–7

Obv.: + PILLNEM REX I
 Crowned bust facing with right arm across chest holding sceptre over left shoulder
Rev.: + TVRRI ON DEVITVN
 Cross pattée; in each angle, an annulet enclosing one letter of the word PAXS

wt 1.39 g (21.4 gr)

London, Trustees of the British Museum, CM, acquired in 1833

For general discussion, see 398. The traditional identification of the mint with St David's in Pembrokeshire has been questioned, but the writer sees no reason to doubt this attribution.

PROVENANCE From the Beaworth, Hampshire, hoard found in 1833 (*Inventory* 37)
BIBLIOGRAPHY BMC 885; North 1980, no. 849

WILLIAM II 1087–1100

400 Penny of Profile type (BMC type I) struck at Maldon by the moneyer Lifsun, *c.* 1087–90

Obv.: + PILLELM REX
 Crowned bust to right, holding sword
Rev.: + LIFSVNE ON MIELI
 Cross pattée over saltire fleury

wt 1.35 g (21.8 gr)

London, Trustees of the British Museum, CM 1877, 11–5–48

The cross-hatched guide-lines drawn by the die-cutter to assist him in laying out the design are visible on the obverse of this coin.

PROVENANCE From the Tamworth, Staffordshire, hoard found in 1877 (*Inventory* 350)
BIBLIOGRAPHY BMC 34; North, 1980, no. 851

401 Penny of Profile type (BMC type I) struck at Tamworth by the moneyer Bruninc, *c.* 1087–90

Obv.: + PILLELM REX
 Crowned bust to right, holding sword
Rev.: + BRVNIC ON TAMPR
 Cross pattée over saltire fleury

wt 1.30 g (20.0 gr)

London, Trustees of the British Museum, CM 1877, 11–5–72

PROVENANCE From the Tamworth, Staffordshire, hoard found in 1877 (*Inventory* 350)
BIBLIOGRAPHY BMC 47; North 1980, no. 851

402 Penny of Cross in Quatrefoil type (BMC type II) struck at Colchester by the moneyer Aelfsi, *c.* 1090–3

Obv.: + PILLELM RE
 Crowned bust facing, holding sword
Rev.: AEFSI ON COLECES
 Cross pattée in quatrefoil

wt 1.39 g (21.4 gr)

London, Trustees of the British Museum, CM 1902, 5–3–212

PROVENANCE Purchased from Lincoln & Co., 1902
BIBLIOGRAPHY BMC 79; North, 1980, no. 852

403 Penny of Cross in Quatrefoil type (BMC type II) struck at Wallingford by the moneyer Colbern, *c.* 1090–3

Obv.: + PILLELM RE
> Crowned bust facing, holding sword

Rev.: + COLBRN ON PAL
> Cross pattée in quatrefoil

wt 1.40 g (21.6 gr)

London, Trustees of the British Museum, CM 1915, 5–7–25

The cross-hatched guide-lines drawn by the die-cutter to assist him in laying out the design are visible on the reverse of this coin.

PROVENANCE From the Tamworth, Staffordshire, hoard found in 1877 (*Inventory 350*); Sir John Evans collection; J. Pierpont Morgan; purchased 1915
BIBLIOGRAPHY BMC 160A; North, 1980, no. 852

404 Penny of Cross Voided type (BMC type III) struck at Leicester by the moneyer Sewine, *c.* 1093–6

Obv.: + PILLELM RE
> Crowned bust facing, between two stars

Rev.: + (SEP)INE ON LEH
> Voided cross pattée over cross annulettée

wt 1.39 g (21.4 gr)

London, Trustees of the British Museum, CM 1979, 3–17–3

On the use of stars in coin-types see above, (**393**).

PROVENANCE From the Shillington, Bedfordshire, hoard found in 1871 (*Inventory* 330); purchased from Spink's, 1979
BIBLIOGRAPHY Blunt, Stewart, 1977; North, 1980, no. 853

405 Penny of Cross Pattée and Fleury type (BMC type IV) struck at Bristol by the moneyer Barcwit, *c.* 1096–9

Obv.: + PILLELM R
> Bust crowned facing, holding sword

Rev.: + BARCIT ON BRICSI
> Cross pattée over saltire fleury

wt 1.37 g (21.1 gr)

London, Trustees of the British Museum, CM 1955, 7–8–146

PROVENANCE Purchased at R.C. Lockett Sale, Glendining, 5 June 1955, lot 1034
BIBLIOGRAPHY North, 1980, no. 855

406 Penny of Cross Fleury and Piles type (BMC type V) struck at Lewes by the moneyer Brihtmaer, *c.* 1099–1100

Obv.: + PILLELM RE +
> Crowned bust facing, holding sceptre; star at right

Rev.: + BRIHMIE(R) ON LIEP
> Cross fleury with pile in each angle

wt 1.37 g (21.2 gr)

London, Trustees of the British Museum, CM 1848, 8–19–186

PROVENANCE Purchased at Earl of Pembroke Sale, Sotheby, 31 July 1848, lot 56; from the collection formed by Thomas Herbert, 8th Earl of Pembroke, *d.* 1733
BIBLIOGRAPHY BMC 266; North, 1980, no. 856

HENRY I 1100–35

407 Penny of Annulets type (BMC type I) struck at Canterbury by the moneyer Wulfric, 1100–*c.* 1102

Obv.: HNRI RE + NI
> Crowned bust facing, between two annulets

Rev.: + PVLFRIC ON CNT
> Cross fleury; three pellets on pile in each angle

wt 1.39 g (21.5 gr)

London, Trustees of the British Museum, CM 1847, 6–23–1

The evidence for the ordering of the early types of Henry I is rather tenuous but the flan-size and epigraphy support the view that this was his first type. (The dating is based on an association of the improvements evident in types V and XIII with the reforms of the coinage in 1108 and 1125 respectively.)

PROVENANCE Purchased from Revd E.J. Shepherd
BIBLIOGRAPHY BMC 1; North, 1980, no. 857

408 Penny of Annulets type (BMC type I) struck at London by the moneyer Algar, 1100–*c.* 1102

Obv.: + HNRI RE + NL
> Crowned bust facing, between two annulets

Rev.: + ALGAR ON LVNDN
> Cross fleury; three pellets on pile in each angle

wt 1.42 g (21.9 gr)

London, Trustees of the British Museum, CM, acquired in 1810

PROVENANCE Purchased from the estate of B.C. Roberts, 1810
BIBLIOGRAPHY BMC 7; North 1980, no. 857

409 Penny of Profile/Cross Fleury type (BMC type II) struck at Leicester by the moneyer Owthin, *c.* 1102–4

Obv.: + HENR RE
> Crowned bust to left; in front, sceptre

Rev.: + OPÐIN ON LECSTR
> Cross fleury

wt 1.25 g (19.3 gr)

London, Trustees of the British Museum, CM 1955, 7–8–148

PROVENANCE Purchased at R.C. Lockett Sale, Glendining, 5 June 1955, lot 1047
BIBLIOGRAPHY North, 1980, no. 858

410 Penny of Pax type (BMC type III) struck at Norwich by the moneyer Haworth, *c.* 1104–6

Obv.: + HENRI RE
> Crowned bust facing

Rev.: + HAPOÐ O NORÐP
> PAX between two lines; above and below, two annulets

wt 1.08 g (16.7 gr)

London, Trustees of the British Museum, CM 1915, 4–7–62

This Pax type, unlike others (**383** and **396**), does not appear to be the first type of the reign, but Brooke was uncertain whether it should be placed second or third (Brooke, 1916, p. lxvi). In either position, it would also be difficult to associate its introduction with the peace which followed the battle of Tinchebrai on 28 September 1106 or with any known re-issue of Henry's Coronation Charter, so the reason for this revival of a Pax type remains obscure.

PROVENANCE Said to have been 'found on the site of a Benedictine nunnery in Norwich' (?Carrow Abbey); purchased from Spink's, 1915
BIBLIOGRAPHY BMC 27A; North, 1980, no. 859

411 Penny of Annulets and Piles type (BMC type IV) struck at Shrewsbury by the moneyer Wulfric, *c.* 1106–8

Obv.: +HENRIC RE
 Crowned bust facing; at left, sceptre
Rev.: + PVLFRIC ON SROB
 Cross of four annulets with pile in each angle
wt 1.30 g (20.0 gr)

London, Trustees of the British Museum, CM, acquired in 1810

This type marks the nadir of declining flan-size and standard of production evident in the types of Henry I's early years. Contemporary chronicles note the poor state of the coinage and the fact that in 1108 the king took steps to reform it. Although there are too few specimens of these issues to provide really valid statistics, they do appear to weigh, on average, rather less than they should. The king wears a crown decorated with lilies for the first time since the Conquest.

PROVENANCE Purchased from the estate of B.C. Roberts, 1810
BIBLIOGRAPHY BMC 32; North, 1980, no. 860

412 Penny of Voided Cross and Fleurs type (BMC type V) struck at London by the moneyer Wulfgar, *c.* 1108–10

Obv.: +HENRIC · REX
 Crowned bust facing, holding sceptre; star at right
Rev.: + PVLFGAR · ON · LVNDE:
 Voided cross pattée with trefoil in each angle
wt 1.18 g (18.2 gr)

London, Trustees of the British Museum, CM 1847, 3–19–1

The sudden dramatic improvement in the appearance of the coins of this type dates their introduction to the measures taken by Henry I in 1108 to reform coinage abuses.

PROVENANCE Purchased from J. Edwards, 1847
BIBLIOGRAPHY BMC 34; North 1980, no. 861

413 Penny of Pointing Bust and Stars type (BMC type VI) struck at London by the moneyer Sigar, *c.* 1110–12

Obv.: +HENRI REX
 Crowned bust three-quarters to right, holding sceptre; three stars to right
Rev.: + SIGARVS ON LVND
 Cross pattée over satire with three annulets at cross-ends; star in each angle
wt 1.28 g (19.7 gr)

London, Trustees of the British Museum, CM 1896, 6–9–91

In the reign of Henry I die-cutters occasionally adopted the curious practice of Latinizing the moneyer's Anglo-Saxon name while leaving the rest of the reverse legend in English (see also 'Edricus', **420**).

PROVENANCE Purchased at H. Montagu Sale, Sotheby's 11 May 1896, Part II, lot 301
BIBLIOGRAPHY BMC 37; North, 1980, no. 862

414 Penny of Pointing Bust and Stars type (BMC type VI) struck at Wareham by the moneyer Derlinc, *c.* 1110–12

Obv.: +HENRIC REX
 Crowned bust three-quarters to right, holding sceptre; three stars to right
Rev.: + DERLINC: ON: PARA
 Cross pattée over saltire with three annulets at cross-ends; star in each angle
wt 1.33 g (20.5 gr)

London, Trustees of the British Museum, CM, acquired in 1810

The king is shown pointing in the conventional gesture of command. As on type IV (**411**) he wears a lily crown, although it is possible that the closed crown, which had been shown invariably since the Conquest, was still intended.

PROVENANCE Purchased from the estate of B.C. Roberts, 1810
BIBLIOGRAPHY BMC 39; North 1980, no. 862

415 Penny of Cross in Quatrefoil type (BMC type IX) struck at Sandwich by the moneyer Wulfwart, *c.* 1112–14

Obv.: +HENRI REX
 Crowned bust facing, holding sceptre; star and quatrefoil to right
Rev.: + PVLFPART: ON: SAN
 Cross pattée within quatrefoil; quatrefoil in each outer angle
wt 1.28 g (19.7 gr)

London, Trustees of the British Museum, CM 1977, 5–14–10

This type has hitherto been placed after the Quatrefoil and Stars type, BMC type VII (**416**), but stylistic considerations suggest that it should be grouped with the other two types which show the full arm with sceptre, BMC types V and VI (**412–414**). If this order is accepted, then this type becomes the first of the 'snicked' types (see **416**).

PROVENANCE Purchased at R.P. Mack Sale, Glendining, 23 March 1977, lot 253
BIBLIOGRAPHY North, 1980, no. 865

416 Penny of Quatrefoil and stars type (BMC type VII) struck at Stamford by the moneyer Archel, *c.* 1114–16

Obv.: +HENRI REX
 Crowned bust facing
Rev.: + AR(C)hEL: ON: STAN
 Quatrefoil with annulet-topped pile set in each angle
wt 1.40 g (21.6 gr)

London, Trustees of the British Museum, CM 1973, 8–23–16

All coins of BMC types VII to XII (and a few coins in later groups) have a small cut or 'snick' at the edge. This is explained in an undated passage in William of Malmesbury where he records that the king, finding that cracked coins were being refused even although they were of good silver, ordered that all coins should be cut, presumably to compel acceptance of the others (quoted and discussed by Brooke, 1916, pp.cxlvi and cxlviii).

PROVENANCE From the Lincoln (Malandry) hoard found in 1971–2 (CH I, no. 359)
BIBLIOGRAPHY North, 1980, no. 863

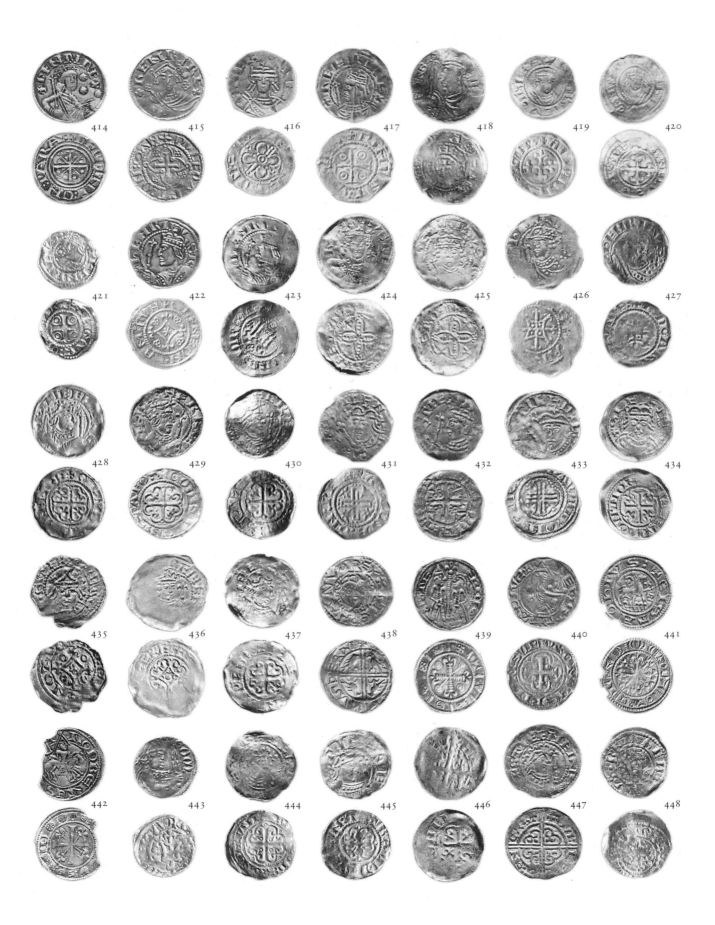

414 415 416 417 418 419 420

421 422 423 424 425 426 427

428 429 430 431 432 433 434

435 436 437 438 439 440 441

442 443 444 445 446 447 448

417 Penny of Profile/Cross and Annulets type (BMC type VIII) struck at Winchester by the moneyer Wimund, *c.* 1116–18

Obv.: +HENRI REX
Crowned bust to left; in front, sceptre
Rev.: +PIMVNT: O(N:) PIN
Cross pattée with annulet enclosing pellet in each quarter

wt 1.33 g (20.6 gr)

London, Trustees of the British Museum, CM 1896, 6–9–88

PROVENANCE Purchased at H.Montagu Sale, Sotheby, 11 May 1896, Part II, lot 287
BIBLIOGRAPHY BMC 52; North, 1980, no. 864

418 Penny of Double Inscription type (BMC type XI) struck at Thetford by the moneyer Aschetil, *c.* 1118–20

Obv.: +h(E)NRI
Crowned bust to left holding sceptre
Rev.: Inscription in two concentric circles:
+ASChE(TIL)/+ON TETFO:

wt 1.15 g (17.7 gr)

London, Trustees of the British Museum, CM 1973, 8–23–128

This highly unusual type, with the effigy almost filling the obverse, has the only double-inscription reverse type known before the introduction of the groat in 1279. Both these features are again reminiscent of earlier German types (for obverse cf. Dannenberg, 1876, pl. 47, nos. 1075–7, and for reverse pl. 2, nos. 37–9). Dolley (1966, pp. 23–4) showed that BMC type XI must precede BMC type XII.

PROVENANCE From the Lincoln (Malandry) hoard found in 1971–2 (CH I, no. 359)
BIBLIOGRAPHY North, 1980, no. 867

419 Penny of Full Face/Cross Fleury type (BMC type X) struck at Ipswich by the moneyer Ailwine, *c.* 1120–2

Obv.: +HENRICVS RE+A
Crowned bust facing
Rev.: +AILPINE: ON: GIP:
Cross fleury

wt 1.36 g (21.0 gr)

London, Trustees of the British Museum, CM 1973, 8–23–43

This is the most common of the types of Henry I prior to the post-reform issues, BMC types XIII–XV. The presence of large numbers of coins of this type in the Lincoln hoard, buried towards the end of the reign *c.* 1135, illustrates the possible longevity of coins of Henry I in circulation.

PROVENANCE From the Lincoln (Malandry) hoard found in 1971–2 (CH I, no. 359)
BIBLIOGRAPHY North, 1980, no. 866

420 Penny of Full Face/Cross Fleury type (BMC type X) struck at Stafford by the moneyer Edric, *c.* 1120–2

Obv.: +HENRICVS REX: AN
Crowned bust facing
Rev.: +EDRICVS: ON: STF
Cross fleury

wt 1.30 g (20.0 gr)

London, Trustees of the British Museum, CM 1973, 8–23–89

The major hoard found at Lincoln in 1971–2 provided much valuable evidence for the middle period of Henry I's coinage. Although Stafford had been recorded as a mint for William II and for Stephen, it was not known for Henry I. The Lincoln hoard brought to light coins of this mint in types X and XIII.

PROVENANCE From the Lincoln (Malandry) hoard found in 1971–2 (CH I, no. 359)
BIBLIOGRAPHY North 1980, no. 866

421 Penny of Smaller Profile/Cross and Annulets type (BMC type XII) struck at Southwark by the moneyer Algar, *c.* 1122–4

Obv.: +HENRICVS
Crowned bust to left; in front, pellet within circle of pellets
Rev.: +ALGAR: ON: SVD:
Cross pattée; pellet within annulet in each angle

wt 1.26 g (19.4 gr)

London, Trustees of the British Museum, CM 1973, 8–23–129

This was the type in issue when, on the King's orders, Roger, Bishop of Salisbury, the Justiciar, summoned all the moneyers of England to Winchester at Christmas 1124 to answer for their malpractices. The Anglo-Saxon Chronicle says that all the moneyers were punished by mutilation and the Winton Chronicler excludes only his own local moneyers from Winchester. From the continuation of the same moneyers' names in later types, it is clear that many did manage to escape, probably like Brand of Chichester, by buying their way out of trouble: in 1130 he pays £20 towards his fine '*ne esset disfactus cum aliis monetariis*' ('so that he should not be mutilated like the other moneyers') (Brooke, 1916, pp. cxliv–vi). Algar, the moneyer responsible for this coin, also continued to strike coins at Southwark in the next two types.

PROVENANCE From the Lincoln (Malandry) hoard found in 1971–2 (CH I no. 359)
BIBLIOGRAPHY North, 1980, no. 868

422 Penny of Star in Lozenge Fleury type (BMC type XIII) struck at Northampton by the moneyer Gefre, *c.* 1125–9

Obv.: +HENRICVS R
Crowned bust to left, holding sceptre
Rev.: +GEFRE: ON · HAMTVN
Quadrilateral fleury; star in centre, trefoil of annulets in each outer angle

wt 1.13 g (17.4 gr)

London, Trustees of the British Museum, CM 1973, 8–23–158

This type marks the return to the larger flan-size and higher weight-standard of the early Norman coinage after the reform of 1125. Gefre, like Oddo of Bury (**424**), is one of the new moneyers appointed after the reform who have Norman names. It is not possible to say whether these names represent genuinely 'new men' among the moneyers, the effects of intermarriage of Normans with the old moneyer dynasties (Nightingale, 1982), or even a growing fashion for Norman names 20 years or more earlier.

PROVENANCE From the Lincoln (Malandry) hoard found in 1971–2 (CH I, no. 359)
BIBLIOGRAPHY North, 1980, no. 869

423 Penny of Star in Lozenge Fleury type (BMC type XIII) struck at Northampton by the moneyer Geffre, *c.* 1125–9

Obv.: +HENRICVS R
Crowned bust to left holding sceptre
Rev.: +GE(FRE: ON) NORhA
Lozenge fleury, star in centre; trefoil of annulets in each outer angle

wt 1.36 g (21.0 gr)

London, Trustees of the British Museum, CM 1973, 8–23–159

This coin and **422** were struck from the same obverse die. The previous coin shows the last use of the old ambiguous mint signature for Northampton, HAMTVN, whereas this coin employs for the first time the new explicit form NORHA which was to remain standard thereafter.

PROVENANCE From the Lincoln (Malandry) hoard found in 1971–2 (CH I, no. 359)
BIBLIOGRAPHY North, 1980, no. 869

424 Penny of Pellets in Quatrefoil type (BMC type XIV) struck at Bury St Edmunds by the moneyer Oddo, c. 1129–33

Obv.: HENRICVS REX
 Crowned bust facing holding sceptre; at right, star
Rev.: +O(DDO) DE SANC EDMVN
 Quatrefoil with star in centre and pellets along limbs; lis in each angle
wt 1.12 g (17.3 gr)

London, Trustees of the British Museum, CM 1973, 8-23-195

Coining rights had been granted to the Abbot of Bury St Edmunds by Edward the Confessor and his right to one moneyer had been confirmed by all three Norman kings. Surviving coins show that two moneyers, Godric and Oddo, were working at Bury in types XIII and XIV so presumably they were working consecutively. Oddo's reverse die is in French rather than English, using DE rather than the usual ON.

PROVENANCE From the Lincoln (Malandry) hoard found in 1971–2 (CH I, no. 359)
BIBLIOGRAPHY North, 1980, no. 870

425 Penny of Pellets in Quatrefoil type (BMC type XIV) struck at Shrewsbury by the moneyer Aelfwi(?), c. 1129–33

Obv.: +hENRICVS R ·
 Crowned bust facing, holding sceptre; at right, star
Rev.: +A(————O)N: SROB
 Quatrefoil with star in centre and pellets along limbs; lis in each angle
wt 1.24 g (19.1 gr)

London, Trustees of the British Museum, CM 1973, 8-23-232

This is an example of the grosser style of official dies distributed later in the type and also characterized by rougher letters which take up more room so that the obverse legend is curtailed and the King's title disappears. It should be contrasted with the previous coin of neat style and full obverse legend struck from an early die of the type. Shrewsbury was recorded as a mint only in type IV for Henry I until the Lincoln hoard produced coins of types X, XIII and XIV.

PROVENANCE From the Lincoln (Malandry) hoard found in 1971–2 (CH I, no. 359)
BIBLIOGRAPHY North, 1980, no. 870

426 Penny of Quadrilateral on Cross Fleury type (BMC type XV) struck at Lincoln by the moneyer Siward, c. 1133–5

Obv.: (+)hENRICVS
 Crowned bust three-quarters to left, holding sceptre
Rev.: +SIPAR(D ON LINC) O
 Quadrilateral fleury on cross fleury
wt 1.36 g (21.0 gr)

London, Trustees of the British Museum, CM 1973, 8-23-259

A wholesale change in the personnel of the mints had not followed the reform of 1125 (**421** and **422**) at the start of type XIII but a large number of moneyers were sacked and new men appointed at the start of type XV. Siward of Lincoln and Aedgar of London (**427**) are examples of these new arrivals, many of whom continued into the first type of Stephen. Presumably only those who had cleared their fines were allowed to continue; Brand of Chichester (mentioned under **421**) was evidently one of the casualties, as he is last noted in type XIV.

PROVENANCE From the Lincoln (Malandry) hoard found in 1971–2 (CH I, no. 359)
BIBLIOGRAPHY North, 1980, no. 871

427 Penny of Quadrilateral on Cross Fleury type (BMC type XV) struck at London by the moneyer Aedgar, c. 1133–5

Obv.: +hENRICVS :
 Crowned bust three-quarters to left, holding sceptre
Rev.: +AEDGAR: ON: LVNDE:
 Quadrilateral fleury on cross fleury
wt 1.44 g (22.2 gr)

London, Trustees of the British Museum, CM 1910, 10-15-14

PROVENANCE From the Watford, Hertfordshire, hoard found in 1818 (*Inventory* 372); purchased after the E.W. Rashleigh Sale, Sotheby's, 21 June 1909, lot 249
BIBLIOGRAPHY BMC 235; North, 1980, no. 871

STEPHEN 1135–54

Substantive Types

428 Penny of Cross Moline ('Watford') type (BMC type I) struck at Pembroke by the moneyer Gilpatric, 1135–41

Obv.: + STIEFNE RE·
 Crowned bust to right, holding sceptre
Rev.: + GILPA(TR)IC: ON: PAN:
 Cross moline with joined lis in each angle
wt 1.43 g (22.0 gr)

London, Trustees of the British Museum, CM 1914, 7-9-4

Unlike other coins from Welsh mints (**398, 399, 451** and **452**), this penny was struck from official, London-made dies. Gilpatric is first recorded in Henry I type X and is noted in 1130 paying fines for using out-of-date dies, no doubt an even greater than normal temptation in view of the distance from his source of supply. The King is shown wearing an open lily crown on almost all the coins of this reign.

PROVENANCE Purchased at G.J. Bascom Sale, Sotheby's, 15 June 1914, lot 85
BIBLIOGRAPHY BMC 88A; North, 1980, no. 873

429 Penny of Cross Moline ('Watford') type (BMC type I) struck at Stafford by the moneyer Godric, 1135–41

Obv.: + STIFNE REX:
 Crowned bust to right, holding sceptre
Rev.: + GODRIC: ON: STAFO:
 Cross moline with joined lis in each angle
wt 1.48 g (22.8 gr)

London, Trustees of the British Museum, CM, acquired before 1838

PROVENANCE Presented by R. Clutterbuck from the Watford, Hertfordshire, hoard found in 1818 (*Inventory* 372)
BIBLIOGRAPHY BMC 99; North, no. 873

430 Penny of Cross Moline ('Watford') type (BMC type I) struck at Stafford by the moneyer Godric, 1135–41

Obv.: + STIFNE REX :
 Crowned bust to right, holding sceptre
Rev.: + GODRIC : ON : STAFO :
 Cross moline with joined lis in each angle
wt 1.08 g (16.6 gr)

London, Trustees of the British Museum, CM 1974, 2–12–83

During the Civil War between Stephen and Matilda, some moneyers were unable to obtain dies from London as usual and were forced to have replacements made locally. This coin was struck from the same official, London-made obverse die as the previous coin. The official reverse die then paired with it must have broken and had been replaced by a locally-made die produced by direct engraving rather than by means of punches (see p. 321).

PROVENANCE From the Prestwich, Lancashire, hoard found in 1972 (CH I, no. 360)
BIBLIOGRAPHY North, 1980, no. 873

431 Penny of Cross Voided and Mullets type (BMC type II) struck at Pevensey by the moneyer Alwine, *c.* 1142–50

Obv.: + STIEFNE
 Crowned bust three-quarters to left, holding sceptre
Rev.: + ALPINE : ON : PE(V)E
 Voided cross with mullet in each angle
wt 1.22 g (18.8 gr)

London, Trustees of the British Museum, CM 1867, 11–25–9

Type II is known only from those areas in the south and east of the country – London, Bedford, Kent, Sussex and East Anglia – which were under Stephen's direct control.

PROVENANCE Purchased from W. Webster, 1867
BIBLIOGRAPHY BMC 167; North, 1980, no. 878

432 Penny of Profile/Cross and Piles type (BMC type VI) struck at Castle Rising by the moneyer Rodbert. *c.* 1150–3

Obv.: + STIEFNE
 Crowned bust to left holding sceptre in left hand
Rev.: + RODBRET ON : RIS
 Cross fleury, pile surmounted by trefoil of annulets in each angle
wt 1.31 g (20.2 gr)

London, Trustees of the British Museum, CM 1896, 6–9–93

Like type II, type VI was confined to the southern and eastern areas where Stephen was in control. Although the trend was towards a reduction in the number of mints, the peculiar circumstances of Stephen's reign caused a number of new mints, of which Castle Rising is one, to be opened.

PROVENANCE Purchased at H. Montagu Sale, Sotheby's, 11 June 1896, Part II, lot 305
BIBLIOGRAPHY BMC 180; North, 1980, no. 879

433 Penny of 'Awbridge' type (BMC type VII) struck at Ipswich by the moneyer Davit, *c.* 1153–4

Obv.: + STIEFNE :
 Crowned bust three-quarters to left, holding sceptre
Rev.: (+ D)AVIT : ON : GIPE
 Cross voided within quatrefoil with lis in each angle
wt 1.46 g (22.6 gr)

London, Trustees of the British Museum, CM 1968, 12–16–1

Peace was concluded in 1153 at Winchester between Stephen and the Angevin party, now led by Matilda's son, the future Henry II. The 'Awbridge' type, called after the Hampshire hoard from which many of the coins are derived (*Inventory* 16), was struck for Stephen at mints throughout the country with the significant exception of those which had issued coins in the Empress's name. This is the only one of Stephen's types to show the King bearded. Although English coins did not reach the Baltic in the numbers they had during the period of the Danegeld payments, the discovery of hoards in Scandinavia and Russia (Elmore-Jones, Blunt, 1967), are evidence of continuing trade with that area.

PROVENANCE Purchased from Messrs Crowther; said to have been 'recently' found at Archangel, USSR
BIBLIOGRAPHY Bryant, 1968; Elmore-Jones, 1969; North, 1980, no. 881

Regional Issues, *c.* 1142–53

434 Penny of Cross and Fleurs type (BMC type III) struck at Northampton (probably) by the moneyer Willem

Obv.: + SIEFNE
 Crowned bust facing
Rev.: + PILLEMI : ON : NOR
 Cross pattée with lis in each angle
wt 1.21 g (18.6 gr)

London, Trustees of the British Museum, acquired in 1818

Type III is confined to Northampton and possibly Huntingdon.

PROVENANCE Presented by Sir Joseph Banks from the collection formed by his sister, Sarah Sophia Banks
BIBLIOGRAPHY BMC 176; North, 1980, no. 896

435 Penny of Lozenge Fleury and Annulets type (BMC type IV) struck at Nottingham by an uncertain moneyer

Obv.: + STE(FN)ER :
 Crowned bust facing
Rev.: (——) O : O(N :) SNOTI(?N)
 Lozenge fleury with star in centre and annulet in each angle
wt 0.99 g (15.3 gr)

London, Trustees of the British Museum, CM 1854, 6–21–55

Type IV is known only from Lincoln and Nottingham.

PROVENANCE Purchased at J.D. Cuff Sale, Sotheby's, 8 June 1854, lot 761
BIBLIOGRAPHY BMC 178; North, 1980, no. 897

436 Penny of Lozenge and Fleurs type (BMC type V) struck at Leicester by the moneyer Simun

Obv.: (——)PENE R
 Crowned bust three-quarters to right, holding sceptre
Rev.: + S(IMVN ON) LERE
 Lozenge within tressure of eight arcs from which spring four fleurs

wt 1.06 g (16.2 gr)

London, Trustees of the British Museum, CM 1909, 10–6–102

Type V is recorded only for Leicester.

PROVENANCE Purchased at W.C. Hazlitt Sale, Sotheby, 5 July 1909, lot 1050
BIBLIOGRAPHY BMC 179; North, 1980, no. 898

Other issues of Stephen's reign

437 Penny with the King's name and title replaced by 'PERERIC M' struck at Ipswich by the moneyer Paien in (?)1137

Obv.: + PERERIC M
 Crowned bust to right holding sceptre
Rev.: + PAIE(N:)ON:GIPESP:
 Cross moline with joined lis in each angle

wt 1.25 g (19.3 gr)

London, Trustees of the British Museum, CM 1977, 12–5–1

The PERERIC coins (most lack the M) were struck from London-made dies identical in style to official coins of Stephen issued early in type I but not quite at its start. The meaning of the curious obverse inscription has been much disputed; some see it as a slightly corrupt version of a French form of 'Empress M' and others as a deliberately ambiguous legend which committed the issuers to neither side. The issue cannot be as late as the period of Matilda's ascendancy in 1141 and it might be associated with Stephen's absence in Normandy in 1137 when Roger of Salisbury, whose loyalty to Stephen was equivocal, was left in charge in England (Archibald).

PROVENANCE Purchased Christie's, 4 November 1977, lot 76; probably a stray from the Prestwich, Lancashire, hoard found in 1972 (CH I, no. 360)
BIBLIOGRAPHY Archibald, 1981, no. 27; North, 1980, no. 928

438 Penny of 'Martlets' type struck at Derby by the moneyer Walchelin

Obv.: + STEPHANVS REX
 Crowned bust to right; in front, sceptre
Rev.: + W(ALCH)ELINVS DERBI
 Cross voided with a bird in each angle

wt 1.35 g (20.9 gr)

London, Trustees of the British Museum, CM, acquired in 1810

This coin was struck from locally-made engraved dies but is of good weight and apparently fine. It was probably produced during the period of Stephen's captivity on the initiative of his supporter, Robert de Ferrers, Earl of Derby. The obverse effigy loosely follows the official first type of Stephen but the reverse is copied from the Sovereign type of Edward the Confessor (380), which had long ceased to be current. An example of the latter may have turned up fortuitously in a newly-discovered hoard, or even have been kept as a souvenir of the saintly King, but it possibly owed its selection to the moneyer seeing in the birds a punning allusion to his own name, which sounds like 'falcon'. Walchelin was closely associated with Earl Robert and was a benefactor of Darley Abbey.

PROVENANCE From the Ashby-de-la-Zouche, Leicestershire, hoard found in 1788 (*Inventory* 14); purchased from the estate of B.C. Roberts, 1810
BIBLIOGRAPHY BMC 245; Mack, 1966, no. 175a; North, 1980, no. 900

439 Penny of Two Figure type struck at York, *c.* 1138–41

Obv.: + STEFID
 Full-length figures of a man in mail and pointed helmet and a woman
Rev.: Decorative motifs in place of legend
 Cross fleury over saltire pommée

wt 1.15 g (17.8 gr)

London, Trustees of the British Museum, CM 1912, 11–7–5

The remarkable group of coins (**439–442**) whose stylistic affinities link them with each other and with the mint of York, have pictorial types outside the normal English repertoire and derived from seals and interrelated foreign coin-types. The double-figure type is found on Byzantine seals and on many coins, such as those of Constantine X (1059–67), shown with his wife Eudocia (BMC. Byz., II, pl. lxi, 7, 8); these also inspired the *ducalis* struck from 1140 by Roger II, the Norman King of Sicily, showing him and his son in a similar pose (Grierson, 1976, no. 236–7). The two figures on the York coin have been variously identified but it is now generally accepted that they represent Stephen and his wife, Queen Matilda, although it is curious to see an English 12th-century queen shown apparently unveiled, with flowing hair and wearing a diadem rather than a crown. This type was issued during the period of Stephen's captivity from February to November 1141 and is thought to symbolize the joint support of the royal sceptre by the King and the Queen who, after her husband's capture, led the counter-measures against the Angevin faction.

PROVENANCE Purchased from Spink's, 1912
BIBLIOGRAPHY BMC 261; Mack, 1966, no. 220c; North, 1980, no. 922

440 Penny of Mailed Figure type of Eustace Fitzjohn struck at York by the moneyer Thomas Fitzulf, *c.* 1139–41

Obv.: EVSTACIVS +
 Full-length mailed figure standing to right, holding upright sword
Rev.: + THOMAS FILIUS VLF
 Cross pattée in quatrefoil with annulet on each cusp and in each outer angle

wt 1.23 g (19.0 gr)

London, Trustees of the British Museum, CM 1864, 7–13–16

Eustace Fitzjohn was a Yorkshire baron who fought on the side of the Scots at the Battle of the Standard in 1138 but was reconciled to Stephen later, possibly at the peace in 1139, although the date is uncertain. The moneyer is probably to be identified with Thomas FitzUlviet, an Alderman of York who appears in the Pipe Roll of 1130 (Mack, 1966, pp. 80–1). The armed figure is derived ultimately from the representations of the Emperor in military dress and soldier-saints on Byzantine coins but directly as adapted by the Crusader Counts of Edessa who sprang from the same house of Boulogne as Stephen's queen, Matilda (e.g. coins of Baldwin I, 1097–1100, Schlumberger, 1878, pl. I, 1 and 2). Attention has recently been drawn by P.J. Seaby, in a lecture to the British Numismatic Society, to the close relationship between the types and symbols used in the legends of some of the York issues with those found on the coins of Boulogne. The *petits deniers* on which they appear are dated to the period after 1145 (Ghyssens, 1971).

PROVENANCE Purchased at Capt. R.M. Murchison Sale, Sotheby's, 27 June 1864, lot 40
BIBLIOGRAPHY BMC 266; Mack, 1966, no. 223a; North, 1980, no. 929b

441 Penny of Lion type of Eustace Fitzjohn struck at York, *c.* 1139–41

Obv.: +EISTAOHIVS:
 Beast passant to right over arcade of four arches
Rev.: Letters of legend replaced by ornaments
 Cross fleury over ornamental saltire

wt 1.22 g (18.8 gr)

London, Trustees of the British Museum, CM, acquired before 1810

Another fragmentary coin of the Lion type reading +()CII FII IOANIS makes it virtually certain that the coins in the name of Eustace should be attributed to Eustace Fitzjohn.

PROVENANCE Acquired before 1810, possibly the coin illustrated in Folkes, 1763, pl. II, 2
BIBLIOGRAPHY BMC 269; Mack, 1966, no. 226a; North, 1980, no. 930

442 Penny of Robert de Stuteville struck at York, *c.* 1138–41

Obv.: +RODBERTUS (DE STV)
 Mailed figure on horseback galloping to right
Rev.: Letter D followed by ornaments in place of letters
 Cross pattée over saltire fleur-de-lisée

wt 1.06 g (chipped, 16.4 gr)

London, Trustees of the British Museum, CM, acquired in 1831

Little is known about Robert de Stuteville except that he was one of the barons who gathered in York in 1138 to consider measures to be taken to counter the Scottish invasion. The obverse type is clearly derived from contemporary baronial seals (cf. **371**), although mounted-figure types had already appeared on the coinages of Norman Sicily (for Roger I, 1072–1101: Grierson, 1976, no. 166) and Denmark (for Eric Emune, 1134–7: Grierson, 1976, no. 242).

PROVENANCE Purchased at C. Barclay Sale, Sotheby's, 21 March 1831, lot 50
BIBLIOGRAPHY BMC 271; Mack, 1966, no. 228; North, 1980, no. 932

443 Penny attributed to Patrick, Earl of Salisbury, struck at Salisbury by an uncertain moneyer

Obv.: ()COM
 Helmeted bust to right, holding sword; to left, star
Rev.: +S() ON:SA
 Quadrilateral over cross fleury

wt 1.02 g (15.8 gr)

London, Trustees of the British Museum, CM 1842, 10-2-7

The two known examples of this issue have been found in Wiltshire so the mint identification is reasonably secure; the attribution to the local count follows less certainly from that, but on neither coin is any of the name legible.

PROVENANCE From the Winterslow, Wiltshire, hoard found *c.* 1804 (*Inventory* 378); purchased from R.S. Vidal Sale, Sotheby's, 27 July 1842, lot 38
BIBLIOGRAPHY BMC 292; Mack, 1966, no. 271; North, 1980, no. 947

444 Penny of Durham variety of the Cross Moline type struck by the moneyer Fobund, *c.* 1139–41

Obv.: + STIEFNE REX
 Crowned bust to right, holding sceptre; pellet to left and mullet to right of sceptre
Rev.: + (FOB)VND : star ON D star VNI star
 Cross moline with joined lis in each angle with annulet on points of lis and in each outer angle

wt 1.05g (16.2gr)

London, Trustees of the British Museum, CM 1974, 2–12–144

The addition of annulets to a coin-type is often a sign of an ecclesiastical issue (e.g. at York under Edward the Confessor) and the group of annulet-marked coins from the mint of Durham have been attributed to the bishop, Geoffrey Rufus, who died on 6 May 1141.

PROVENANCE From the Prestwich, Lancashire, hoard found in 1972 (CH I, no. 360)
BIBLIOGRAPHY Mack, 1966, cf. no. 188; North, 1980, no. 916

445 Penny of Roundels group of Cross Moline type struck at Thetford by the moneyer Baldewine, *c.* 1141

Obv.: + STIEFNE
 Crowned bust to right, holding sceptre
Rev.: + BALDEWI:ON:TE
 Cross moline with pellet on each limb, joined lis in each inner angle and annulet in each outer one

wt 1.03 g (15.9 gr)

London, Trustees of the British Museum, CM 1974, 2–12–118

Coins with pellets ('roundels') added in varied numbers and positions to the normal Cross Moline reverse type are confined to mints in East Anglia. They are associated with the period between February and November 1141 when Stephen was in captivity; East Anglia was one of the areas from which the King's party under his wife, Queen Matilda, drew support.

PROVENANCE From the Prestwich, Lancashire, hoard found in 1972 (CH I, no. 360)
BIBLIOGRAPHY Mack, 1966, pp. 65–7; North, 1980, no. 895/1

446 Penny of Cross Moline type struck from an erased obverse die at Norwich by the moneyer Iun, *c.* 1141

Obv.: (+S)TIEFNE R
 Crowned bust to right, holding sceptre; large cross over whole die with small cross in second and fourth numismatic quarters
Rev.: (+IVN:ON:N)ORPI
 Cross moline with joined lis in each angle

wt 1.25 g (19.3 gr)

London, Trustees of the British Museum, CM 1974, 2–12–136

Several of the dies used for this East Anglian group of coins from erased dies are known from coins struck before they were defaced. It is likely that they were erased because it was the intention to withdraw them from use but that they had to be pressed back into service when dies were urgently needed by the King's supporters in East Anglia during his captivity and new ones could not be obtained from London.

PROVENANCE From the Prestwich, Lancashire, hoard found in 1972 (CH I, no. 360)
BIBLIOGRAPHY Mack, 1966, pp. 59–63; North, 1980, no. 924

447 Penny of Scottish Border group of Cross Voided type struck at Newcastle by the moneyer Wilclm, *c.* 1139–41

Obv.: + STIEFNE RE:
 Crowned bust to right, holding sceptre
Rev.: + WI:LEL:N:ON CAST
 Long cross voided over cross moline type of Stephen type I
wt 1.38 g (21.3 gr)

London, Trustees of the British Museum, CM 1974, 2–12–156

This group of Newcastle coins has stylistic affinities with those from Durham (**444**) and York (Mack, 1966, no. 217). Early in type I, Newcastle had received official dies from London but thereafter it employed dies either produced locally or, as here, made by a die-cutter serving other northern mints.

PROVANANCE From the Prestwich, Lancashire, hoard found in 1972 (CH I, no. 360)
BIBLIOGRAPHY Mack, 1966, no. 190; North, 1980, no. 908

448 Penny in the name of 'King Henry'

Obv.: + hENRICVS:RE:
 Crowned bust facing, between two stars
Rev.: + ON:SI()VRNI
 Cross bottonnée over quadrilateral
wt 1.04 g (16.1 gr)

London, Trustees of the British Museum, CM, acquired in 1810

Coins of this, and other, groups reading HENRICVS and HENRICVS REX have been attributed to Henry of Anjou, the future Henry II, during the reign of Stephen before the Treaty of Winchester in 1153 (Mack, 1966, pp. 88–93). It is not possible to accept that Henry would have used the title of king before his accession and coronation in 1154. The coins cannot however be as late as that since some are associated with type I hoards and others, such as this type, with hoards from the pre-1153 period. While accepting that these coins were struck at mints in the Angevin sector of the country and, in their later phase, during the period when Henry of Anjou had replaced his mother as the active leader of their party, it is preferable to regard them as struck in the immobilized name of Henry I.

PROVANANCE Purchased from the estate of B.C. Roberts; ultimately from the Winterslow, Wiltshire, hoard found in *c.* 1804 (*Inventory* 378)
BIBLIOGRAPHY BMC 281; Mack, 1966, no. 256; North, 1980, no. 941

449 Penny attributed to Henry of Blois, Bishop of Winchester, probably struck at York, 1141

Obv.: + hEN(RI)CVS EPC
 Crowned bust to right; in front, sceptre; mullet to right
Rev.: S(TE)PhANVS · REX
 Cross pattée over saltire fleur-de-lisée
wt 1.03 g (chipped, 15.9 gr)

London, Trustees of the British Museum, CM 1848, 8–19–187

The reverse type associates this coin with those of other supporters of Stephen (**439–442**) struck at York during the King's captivity from February to November 1141. Henry rejoined his brother's party in July 1141 and, according to William of Malmesbury, claimed to have acted as vice-regent at this time (Mack, 1966, pp. 84–5). Henry's immense wealth allowed him to indulge his tastes as a connoisseur and patron of the arts (**277**).

PROVANANCE Purchased at Earl of Pembroke Sale, Sotheby's, 31 July 1848, lot 35; illustrated in Folkes (1763, pl. I, 21)
BIBLIOGRAPHY BMC 272; Mack, 1966, no. 229; North, 1980, no. 934

EMPRESS MATILDA In England, 1139–48

450 Penny of the Empress Matilda of Cross Moline type (as Stephen BMC type I) struck at Bristol by the moneyer Turchil, *c.* 1141

Obv.: MATILDA IN:
 Crowned bust to right, holding sceptre
Rev.: + TVRCHIL (ON B) RI:
 Cross moline with joined lis in each angle
wt 1.25 g (19.3 gr)

London, Trustees of the British Museum, CM 1974, 2–12–146

Matilda, Henry I's only surviving legitimate child, was the widow of the Emperor Henry V and wife of Geoffrey, Count of Anjou. She arrived in England to promote her claim to the throne in 1139 and her party based their activities in Bristol. Most of her rare coins were probably issued during the period of her greatest success in 1141. Struck from engraved rather than punched dies, they make no concession to portraiture and are on a lower weight-standard than their Stephen prototypes. Matilda was never crowned queen and the only title used on her coins is that of Empress.

PROVANANCE From the Prestwich, Lancashire, hoard found in 1972 (CH I, no. 360)
BIBLIOGRAPHY North, 1980, no. 935

451 Penny of Empress Matilda class B3 struck at Cardiff by the moneyer Elwine, 1141

Obv.: (:I)MPE(ATRI·)
 Crowned bust to right, holding sceptre
Rev.: + (ELWIN)E · DE · (C)AIERDI
 Cross with three pellets at cross-ends over saltire fleury
wt 1.04 g (16.1 gr)

London, Trustees of the British Museum, CM 1981, 7–3–11

The Wenallt hoard, probably buried later in 1141, brought to light a remarkable series of previously unrecorded local types from Bristol, Cardiff and the 'new' mint of Swansea (**452**). Struck in the names of Stephen, Empress Matilda and contemporary Norman barons of South Wales, these coins are lighter in weight than regular issues of Stephen. Glamorgan was a lordship of Robert, Earl of Gloucester, Matilda's half-brother and chief supporter, who had his headquarters at Bristol.

PROVANANCE From the Coed-y-Wenallt, Glamorgan, hoard found in 1980
BIBLIOGRAPHY Boon, 1981

452 Penny of Henry of Neubourg struck at Swansea by the moneyer Henri, 1141

Obv.: (+h)ENRIC (DE NO)VO B
 Crowned bust to right, holding sceptre
Rev.: (+h)ENRI:ON:(S)WEN(S)
 Pelleted cross with fleur-de-lis in each angle
wt 0.98 g (15.1 gr)

London, Trustees of the British Museum, CM 1981, 7–3–13

Henry of Neubourg, a younger son of the first Norman Earl of Warwick, controlled the lordship of Gower whose *caput* was Swansea. The discovery of coins in Henry's name gives credence to a much later statement that he reconquered Gower in Stephen's time – before the end of 1141, on the evidence of the hoard. This is the earliest mention of Swansea.

PROVANANCE From the Coed-y-Wenallt, Glamorgan, hoard found in 1980
BIBLIOGRAPHY Boon, 1981

453 Penny of David I, King of Scots, 1124–53, of type IVc, struck at Carlisle by the moneyer Ricard, 1141

Obv.: + DAVIT : REX
Crowned bust to right, holding sceptre
Rev.: + RICA(RD)·O(N)·CAR followed by pattern of pellets and dashes
Cross pattée; annulet enclosing pellet in each angle
wt 1.40 g (21.6 gr)

London, Trustees of the British Museum, CM 1974, 2–12–167

The earliest coins in the name of a king of Scots were of English types struck by David I after his capture of Carlisle and the nearby silver mines in 1136. This later independent type, also struck at mints in Scotland, was well represented in the hoard found at Prestwich which lay in the Honor of Lancaster, the extensive land-holding granted to David by the Empress Matilda in 1141.

PROVENANCE From the Prestwich, Lancashire, hoard found in 1972 (CH I, no. 360)
BIBLIOGRAPHY North, 1980, no. 911; Stewart, 1967, p. 132; 1971, p. 195

454 Penny of Henry, only son of David I of Scots, type I (as Cross Moline type of Stephen), struck at Corbridge by the moneyer Erebald, *c.* 1138–41

Obv.: + hENRICVS :
Crowned bust to right, holding sceptre
Rev.: + EREBA(LD) · ON COREB :
Cross moline with joined lis in each angle
wt 1.39 g (21.4 gr)

London, Trustees of the British Museum, CM 1974, 2–12–153

The dating of Henry's issues presents problems. Corbridge was the *caput* of the Earldom of Northumberland which was claimed earlier for Henry but only formally granted to him by Stephen in 1139. It is possible however that coins were struck there in his name when Northumberland was overrun by the Scots in 1138.

PROVENANCE From the Prestwich, Lancashire, hoard found in 1972 (CH I, no. 360)
BIBLIOGRAPHY Mack, 1966, no. 283; North, 1980, no. 912; Stewart, 1967, p. 132; 1971, pp. 191–3

HENRY II 1154–89

455 Penny of Cross and Crosslets ('Tealby') type, class A, struck at London by the moneyer Pires Sal, 1158–*c.* 1161

Obv.: + hE(NRI RE)X ANG (L)
Crowned bust three-quaters to left, holding sceptre
Rev.: (+ P)IRES : SAL : (ON : L)VN :
Cross pattée with saltire in centre; cross pattée in each angle
wt 1.45 g (22.4 gr)

London, Trustees of the British Museum, CM, acquired in 1818

Henry II did not turn his attention to the problems of the coinage until four years after his accession, in 1158. The coinage then introduced is known as the 'Tealby' issue after the large hoard found at Tealby, Lincolnshire, from which this coin derives. It is possible that Pires Sal, identified in the Pipe Roll as Petrus de Salerna, was the moneyer of the Bishop of London (Allen, 1951, p. cxlvi). From this type onwards, the English King is invariably shown wearing an open crown until Henry VII re-introduced an imperial crown at the end of the 15th century.

PROVENANCE Presented by Sir Joseph Banks from the collection formed by his sister, Sarah Sophia Banks; ultimately from the Tealby, Lincolnshire, hoard found in 1807 (*Inventory* 352)
BIBLIOGRAPHY BMC 545; North, 1980, no. 952/2

456 Penny of Cross and Crosslets ('Tealby') type, class 2 struck at Canterbury by the moneyer Ricard, *c.* 1161–5

Obv.: + hENRI : RE :
Crowned bust three-quarters to left, holding sceptre
Rev.: (+)RI(CA)RD : O(N) : CA
Cross pattée with saltire in centre; cross pattée in each angle
wt 1.44 g (22.2 gr)

London, Trustees of the British Museum, CM 1947, 11–2–44

Richard Deodatus was a royal, not an archiepiscopal, moneyer and his coins have survived in very large numbers. His wealth is demonstrated by his being able to pay off within three years his share of the colossal fine for coinage offences, imposed on him and his relative Solomon, of 600 marks, the equivalent of 96,000 of his pennies. He is recorded as constable of Canterbury Castle in the following reign (Allen, 1951, p. cxxi and Urry, 1967, p. 116).

PROVENANCE Purchased from L.A. Lawrence, 1947
BIBLIOGRAPHY BMC 111; North, 1980, no. 957

457 Penny of Cross and Crosslets ('Tealby') type, class CI, struck at Bury St Edmunds by the moneyer Willam, *c.* 1161–5

Obv.: + hENRI : R : AG
Crowned bust three-quarters to left, holding sceptre
Rev.: + PILLAM : S : EDMVN
Cross pattée with saltire in centre; cross pattée in each angle
wt 1.46 g (22.5 gr)

London, Trustees of the British Museum, acquired before 1838

BIBLIOGRAPHY BMC 52; North, 1980, no. 956

The illustrations opposite include Coins from the Lark Hill Hoard (**319a–r**); these are catalogued on page 292.

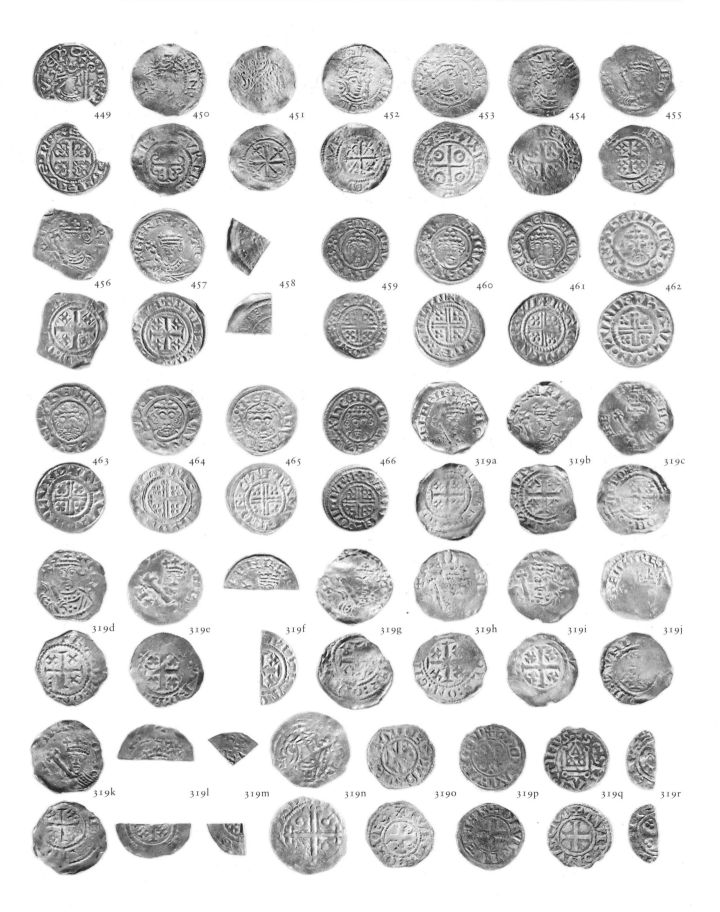

449 450 451 452 453 454 455

456 457 458 459 460 461 462

463 464 465 466 319a 319b 319c

319d 319e 319f 319g 319h 319i 319j

319k 319l 319m 319n 319o 319p 319q 319r

458 Cut farthing of Cross and Crosslets ('Tealby') type, class A, struck at Chester by the moneyer Willem, c. 1158–61

Obv.: + he(NRI REX ANGL)
 Only sceptre-head area visible
Rev.: (+ WILLEM : ON : CE) STE
 One quarter of reverse type with cross crosslets visible
wt 0.45 g (7.0 gr)

London, Trustees of the British Museum, CM 1840, 11–27–10

Throughout the Romanesque period in England the penny was the only denomination struck, and halfpence and farthings were made by cutting the pennies into halves and quarters along the lines of the reverse cross. During the 'Tealby' coinage there was a sharp reduction in the number of mints in operation; Chester, which had been one of the most prolific of the Anglo-Saxon mints, closed sometime between 1165 and 1168.

PROVENANCE Purchased from Messrs Till, 1840
BIBLIOGRAPHY BMC 233; North, 1980, no. 952

Short Cross Coinage 1180–1247

459 Penny of Short Cross type, class 1a, struck at Exeter by the moneyer Iordan, 1180

Obv.: HENRICVS · REX
 Crowned bust facing, holding sceptre
Rev.: + IORDAN · ON · EXER
 Short cross voided with cross pommée in each angle
wt 1.18 g (18.2 gr)

London, Trustees of the British Museum, CM E2037, acquired before 1838

Contemporary chroniclers are agreed that the reason for the recoinage in 1180 was the deplorable state of the currency but another compelling reason was the Crown's desire to increase its share of the profits from the coinage. The exchanges where new coin was obtained in return for old and foreign money or bullion now became a royal prerogative. In a period of booming trade this was a valuable source of revenue (Allen, BMC T, pp. lxii-iii and xciii).

BIBLIOGRAPHY North, 1980, no. 962

460 Penny of Short Cross type, class 1b, struck at London by the moneyer Fil Aimer 1180–1

Obv.: HENRICVS · REX
 Crowned bust facing, holding sceptre
Rev.: + FIL AIMER · ON · LVN
 Short cross voided with cross pommée in each angle
wt 1.55 g (23.9 gr)

London, Trustees of the British Museum, CM 1950, 6–6–35

A French goldsmith, Philip Aimer of Tours, was brought over to superintend the new coinage in 1180 but he was soon suspected of striking coins of deficient fineness and was dismissed.

PROVENANCE Purchased from the estate of L.A. Lawrence, 1950
BIBLIOGRAPHY North, 1980, no. 963

461 Penny of Short Cross type, class 1b, struck at York by the moneyer Isac c. 1180–9

Obv.: HENRICVS · REX
 Crowned bust facing, holding sceptre
Rev.: + ISAC · ON · EVERWI
 Short cross voided with cross pommée in each angle
wt 1.41 g (21.7 gr)

London, Trustees of the British Museum, CM 1865, 3–18–149

PROVENANCE From the Eccles, Lancashire, hoard found in 1864 (Inventory 152)
BIBLIOGRAPHY North, 1980, no. 963

462 Penny of Short Cross type, class 1c, struck at London by the moneyer Raul in the later 1180s

Obv.: HENRICVS · REX
 Crowned bust facing, holding sceptre
Rev.: + RAVL · ON · LVNDE
 Short cross voided with cross pommée in each angle
wt 1.48 g (22.8 gr)

London, Trustees of the British Museum, CM 1915, 5–7–1291

The volume of output increased sharply in the Short Cross coinage and very large hoards of them have been found. This coin was one of nearly 11,000 found at Colchester. The Eccles hoard (**461** and **465**) brought to light 6,000 more.

PROVENANCE From the Colchester, Essex, hoard found in 1902 (Inventory 94); Sir John Evans; J. Pierpont Morgan; purchased 1915
BIBLIOGRAPHY North, 1980, no. 964

RICHARD I 1189–99

463 Penny of Short Cross type, class II, struck at London by the moneyer Raul c. 1189–91

Obv.: HENRICVS REX
 Crowned bust facing, holding sceptre
Rev.: + RAVL · ON · LVND
 Short cross voided with cross pommée in each angle
wt 1.43 g (22.0 gr)

London, Trustees of the British Museum, CM 1915, 5–7–1292

Despite the change of monarch, the immobilized obverse legend continued the name of the King's father, who had introduced the type. Immobilization was widespread on the Continent, especially among the French feudal coinages, and arose from a reluctance to shake confidence in a well-established currency by changing its appearance.

PROVENANCE as **462**
BIBLIOGRAPHY North, 1980, no. 965

464 Penny of Short Cross type, class IIIa, struck at Canterbury by the moneyer Mcinir *c.* 1192–4

Obv.: HENRICVS REX
 Crowned bust facing, holding sceptre
Rev.: +MEINIR · ON · ON · CA
 Short cross voided with cross pommée in each angle
wt 1.44 g (22.2 gr)

London, Trustees of the British Museum, CM 1912, 4–6–28

'Mainer the Rich', as this moneyer is called in contemporary sources, was borough reeve of Canterbury and founder of the hospital of St Mary, known as Maynard's Hospital and still standing in Stour Street, Canterbury (Urry, 1967, pp. 85, 114).

PROVENANCE Purchased Sotheby's sale, 19 December 1911, lot 476 (part)
BIBLIOGRAPHY North, 1980, no. 967/1

JOHN 1199–1216

465 Penny of Short Cross type, class IVb, struck at Canterbury by the moneyer Samuel *c.* 1194–1205

Obv.: HENRICVS REX
 Crowned bust facing, holding sceptre
Rev.: +SAMVEL · ON · CA
 Short cross voided with cross pommée in each angle
wt 1.49 g (23.0 gr)

London, Trustees of the British Museum, CM 1865, 3–18–85

Again, no change is made in the legend or type to mark the accession of a new king with a different name.

This coin is representative of the coins of very devolved obverse style struck just before the reform of the coinage in 1205, and should be contrasted with **466** by the same moneyer struck after it.

PROVENANCE From the Eccles, Lancashire, hoard found in 1864 (*Inventory* 152)
BIBLIOGRAPHY North, 1980, no. 968/2

466 Penny of Short Cross type, class va*, struck at Canterbury by the moneyer Samuel in 1205

Obv.: HENRICVS REX
 Crowned bust facing, holding sceptre
Rev.: SAMVEL · ON · CAN (initial mark, cross pommée)
 Short cross voided with cross pommée in each angle
wt 1.33 g (20.5 gr)

London, Trustees of the British Museum, CM E 2027, acquired before 1838

The main object of the reform of the coinage instituted by King John in 1205 was to recoin all the old clipped and underweight coin in circulation, but the opportunity was also taken to improve the style of the obverse effigy, which should be contrasted with that on the previous coin by the same moneyer. A considerable number of the pre-reform moneyers were replaced by new men in 1205.

BIBLIOGRAPHY North, 1980, no. 969

467

467 Die for a penny of Stephen, *c.* 1140

This pile (lower die) bears the design of an obverse of a penny of Stephen, BMC type I (**428, 429** and **430**). It reads + STIEFNE, without title and lacks an inner circle, both features of the latest major grouping within the type. Hexagonal in shape, with a blunt spike below the shoulder, it is made of iron with a hardened tip and measures: *l* 149 mm, *w* 42 mm (at thickest part) and 29.5 mm (across the face of the die).

London, Museum of London, 7869

The die has not been matched on any extant coint and is somewhat irregular in the layout of the legend; otherwise the style is compatible with its being official and the hexagonal outline of the die-head can be paralleled on mis-struck regular coins. (For mode of employment see p. 321.) This is the only die for an English coin to survive from the 12th century and, until the discovery in recent excavations at York of dies for a penny of Athelstan and a Viking Sword-type from York (Hall, 1980 and 1981), it was the earliest English die known.

PROVENANCE Found in the Little Bell Alley (which later became part of Copthall Avenue, Moorgate) before 1908
BIBLIOGRAPHY Andrew, 1934, pp. 33–4 (drawing of die inaccurate); *Guildhall Museum Catalogue*, 1908, p. 291, no. 76

468 Coin-brooch, *c.* 1110–12 or later

This brooch is copied from the reverse of a penny of Henry I, BMC type VI (**413** and **414**), reading + GOTPINE : ON : GLOECI, Godwine (moneyer) at Gloucester. It is made of thin, stamped, latten, the letters having been engraved onto the die rather than punched as on official coinage dies (see p. 321); *diam* 20.2 mm. A piece of wire soldered across the back is bent at one end to form the catch and at the other into a loop for attaching the pin, which is 27 mm long.

London, Museum of London, 4086

Gloucester is a rare mint in Henry I's reign and no coins of type VI are known so that the brooch is the only evidence for its operation in this type. Godwine is recorded in type IV, but not later. Whether the die was ever used to strike coins or was made specifically for producing brooches is impossible to say.

BIBLIOGRAPHY Andrew, 1934, pp. 29–33; *Guildhall Museum Catalogue*, 1908, p. 126, no. 9

468

Bindings

The majority of the surviving bindings made in England during the 12th century have wooden boards covered with leather which was originally white, or else was dyed a deep pink or red, now usually faded. The leaves of the book, folded into quires, are sewn on split leather thongs, which are laced through holes in the boards and secured with wooden pegs in grooves on the inside or the outside of the boards. The boards themselves are usually of oak and are flush with the edges of the leaves; they are either cut with a straight edge or are slightly chamfered or bevelled. The spines are flat and often show semicircular tabs at head and tail, and a number of bindings are secured with one or two clasps on leather thongs which fasten on pins projecting from near the centre line of the lower board.[1]

Shortly before the middle of the century a fashion emerged for tanned leather bindings, often a reddish-brown, decorated with blind impressions (without gilding) of decorative and pictorial stamps. These stamped Romanesque bindings were first produced in Paris from c. 1140 and were made about a decade later in Winchester, and later still in London and possibly in Durham.

When W.H.J. Weale[2] first described these stamped bindings he assumed that they were made in England, but G.D. Hobson,[3] who devoted the larger part of a book and several articles to the subject, came to the conclusion that the majority came from Paris. A number of German and Austrian scholars[4] have made sound claims for the German and Austrian origins of some of the bindings. In 1976 Howard M. Nixon[5] described and illustrated the Winchester examples and summarized the state of knowledge to date, and two years later Christopher de Hamel[6] devoted a chapter of his doctoral thesis to the French bindings, almost all of which cover glossed books of the Bible. He slightly reorganized G.D. Hobson's main groups and dated them, arguing very convincingly in favour of their monastic origin, and attributing their disappearance after c. 1200 to the emergence in Paris of the professional stationers.

Of the 13 known English stamped Romanesque bindings[7] three were made in Winchester and date from c. 1150; three can be attributed to London c. 1185 or a little later; and the four-volume Puiset Bible has been ascribed to Durham and dated to the late 12th century. It is possible that of the three early 13th-century examples one came from Oxford, but the argument for this attribution is far from convincing.

For this exhibition the best-preserved pre-1200 bindings representing the three places of origin have been chosen. The arrangement of the bindings into groups is based on the tools used to decorate them. H.M. Nixon has illustrated the Winchester stamps; the tools found on the bindings attributed to London and to Durham are shown on pp. 346 and 348. Each binding has been described in detail and the original sewing structure, where still in existence, has been noted. In order not to give the impression that all 12th-century English bindings are of decorated brown leather, a plain example has been included as well. M.F.

NOTES

1. Pollard, 1962.
2. Weale, 1894.
3. Hobson, 1929, *idem*, 1934/5, *idem*, 1938/9.
4. e.g. M.J. Husung, *Jahrbuch der Einbandkunst*, 1929–30, pp. 3–14; *idem*, *Archiv für Buchbinderei*, 1933, pp. 25–6, 33–4, 41–2, 57–9; 1934, pp. 62–4; 1935, pp. 1–5; 1936, pp. 41–3, 49–51, 89–92; 1938, pp. 57–61; 1939, pp. 51–5; R. Schilling, *Jahrbuch der Einbandkunst*, 1929–30, pp. 15–31; I. Schunke, *Festschrift E. Kyriss*, 1961, pp. 17–32; O. Mazal, *Festschrift J. Stummvoll*, 1970, pp. 273–84.
5. Nixon, 1976.
6. de Hamel, 1978, pp. 234–312.
7. Nixon 1976, p. 537.

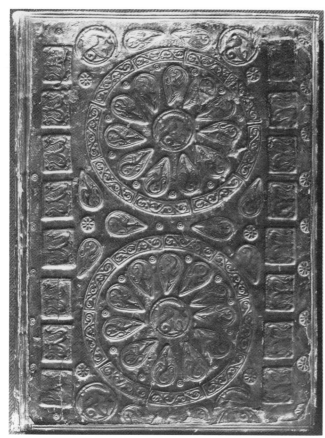

469 (upper cover)

469 (lower cover)

469 and 470 Winchester bindings

Three Romanesque bindings made in Winchester are known:
469, 470, and that once covering the Cartulary of St Swithun's
or *Codex Wintoniensis* (Hobson, 1929, no. XXI: British
Library, Add. MS 15350; not in the exhibition). They date
probably from *c.* 1150.

The tools used to decorate these bindings have been illustrated
by I I.M. Nixon, 1976, pl. X, and consist of:
(1) circular, dragon; (2) lobe-shaped, dragon; (3) concentric
circles; (4) segment with acanthus scroll; (5) circular, eight-
petalled rosette; (6) rectangular, two birds with human heads,
back to back; (7) square, deer running to the left, with
horseshoe marking on shoulder; (8) rectangular, feeding bird
bent over semicircle; (9) rectangular, goat running to the left,
with foliage; (10) arch-shaped, feeding ram; (11) square, cock;
(12) square, figure riding a monster; (13) rectangular, two
warriors with shields and spears; (14) rectangular, lion with
plumed tail looking to the right; (15) rectangular, two birds
entwined; (16) square, mermaid; (17) square, lion walking to
the right; (18) circular, winged monster; (19) vesica containing
two fleurs-de-lis. (Tools 14–19 occur on British Library Add.
MS 15350 only.)

469 Winton Domesday: *Liber de terris regis . . . in Wint[onia]* (Two 12th-century surveys of the borough of Winchester, first survey *c.* 1110, second survey 1148)

MS on vellum written in two columns; rubrics in red or in
alternate black and red letters; initials in red or blue; pricked
and ruled; *l* 253 mm, *w.* 180 mm, *d* 15 mm
c. 1148
Society of Antiquaries of London, MS 154

This manuscript was rebound in the mid-19th century with the
original covers onlaid. The original binding was of brown calf
over boards made of 26 vellum leaves from a 10th-century
Sacramentary, pasted together. These leaves have been
removed and are now society of Antiquaries MS 154*. They
show lacing holes from which the original sewing can be
reconstructed. The manuscript was originally sewn on two
alum-tawed leather thongs, probably split to allow figure-of-
eight sewing. The projecting slips were laced into the 'boards'.
There are traces of headbands laced in at an angle. The leaves
would have been cut flush with the 'boards'. There are no
traces of clasps. One vellum paste-down has been taken out
and is preserved with MS 154*. The binding is tooled in blind,
with on the upper cover a design of two circles within a frame
(tools 1–6) and on the lower cover a rectangular design (tools
3 and 7–10).

PROVENANCE [Winchester Cathedral]; John Young, Dean of Winchester; James West, 1756;
Gustavus Brander, 1776; Society of Antiquaries
BIBLIOGRAPHY Weale, 1894, R. 10, 11; Hobson, 1929, no. V; Brown, 1976; Nixon, 1976

470 Hegesippus, *Historia de excidio Judaeorum* (History of the scattering of the Jews)

MS on vellum written in two columns; rubrics in red; decorated initials; ruled and pricked; *l* 290 mm, *w* 210 mm, *d* 52 mm
c. 1150
Winchester Cathedral Library, MS XVII

The binding is of brown calf over wooden boards. The boards are slightly chamfered and are flush with the edges of the leaves. The manuscript is sewn on two split alum-tawed thongs with figure-of-eight sewing. The slips have been laced in through holes in the boards and lie in grooves on the outside of the boards. The pegs are not visible. There are double headbands in red, white and green silk over (?)vellum cores laced in at an angle, and two semicircular tabs, attached to the headbands. No bookmarkers remain but a hole in the centre of the head-tab suggests their one-time presence. There are remnants of spine leather and of one clasp on a leather thong, nailed in a groove on the upper cover; a pin-hole is visible on the lower cover, 70 mm from the edge of the board. There are vellum paste-downs and stubs. The binding is tooled in blind, with on the upper cover a design of two circles within a frame (tools 1–4, 6 and 11) and on the lower cover a rectangular design (tools 3, 7, 8, 12 and 13).

PROVENANCE Early history unknown; Phillipps; William Morris; Yates Thompson; Dyson Perrins; Winchester Cathedral
BIBLIOGRAPHY Hobson, 1929, no. XXII; Nixon, 1976

470 (lower cover)

471, 472 and 473 London Bindings

Three Romanesque bindings possibly made in London are known: **471, 472** and **473**. They date from *c.* 1185, and 35 tools have been used to decorate them (see p. 346).

471 Knights Templars, *Inquisitio de terrarum donatoribus . . . per Angliam* (Inquisition taken by Brother Geoffrey son of Stephen, bailiff of the Knights Templars, of all property in England previously granted to the order)

MS on vellum; rubrics in red; initials in red and/or green; pricked and ruled; *l* 258 mm, *w* 170 mm, *d* 27 mm
c. 1185
London, Public Record Office, E. 164/16

The binding is of brown calf over wooden boards. The boards are slightly bevelled and are flush with the edges of the leaves. The manuscript is sewn on three split alum-tawed thongs with figure-of-eight sewing. The slips are laced in through holes in the boards; they lie in grooves on the outside of the boards and are secured with square wooden pegs. There are remnants of

headbands in white, blue and red silk over rolled (?)vellum or leather cores laced in at an angle and secured with round pegs. The binding has one semicircular tab, attached to the headband, with a trace of an attachment for bookmarkers. There are remnants of two clasps on leather thongs nailed in grooves on the upper cover and traces of pin marks on the lower cover, 55 mm from the edge of the board. There are vellum paste-downs and one free vellum leaf at the front (the lower free leaf is not conjugate with the paste-down). The end-leaves were removed and replaced in 1928 in 'what appears to be their original position'. There are blanks at the end. The binding is tooled in blind to a rectangular design on each cover (upper cover: London tools 1, 8, 9, 11, 14, 15 and 27; lower cover: London tools 2, 5, 6, 7, 11, 19, 26 and 33).

BIBLIOGRAPHY Weale, 1894, R. 34, 35; Hobson, 1929, no. XVII; Lees, 1935; Nixon, 1976, p. 539

472 Petrus Lombardus, *Sententiarum libri quatuor* (Four books of sayings) (*not illustrated*)

MS on vellum written in two columns; rubrics in red; decorated polychrome initials; initials in red and blue; pricked and ruled; signed by scribe 'Johannes de Maraschis de Roma scripsit'; *l* 345 mm, *w* 245 mm, *d* 95 mm
Late 12th century
Oxford, Bodleian Library, MS Rawl. C. 163

The binding is of brown hide over wooden boards, and has been re-backed and restored. The boards are flush with the edges of the leaves. The manuscript was originally sewn on four split alum-tawed thongs. The slips are laced in through holes in the boards; they lie in grooves on the inside of the boards and are secured with square wooden pegs. There are traces of headbands laced in at an angle, and traces of pin-holes on the lower cover. There are vellum paste-downs (lifted). The binding is tooled in blind, with on the upper cover a rectangular design (London tools 1, 7, 8, 12, 14, 17, 18, 22, 27, 29, 31 and 32), and on the lower cover a design of a large circle within rectangular frames (London tools 2, 3, 4, 6, 10, 12, 13, 15, 16, 20, 21, 23, 24, 25, 26, 28, 30, 34 and 35).

PROVENANCE Llanthony Abbey; Richard Graves of Gloucestershire; Thomas Hearne, 1724; Bodleian Library
BIBLIOGRAPHY Gibson, 1901–4, pls. 1, 2; Hobson, 1929, no. XXIV; Nixon, 1976, p. 539; de Hamel, 1978, p. 251

473 Petrus Comestor, *Historia Evangelica* (*illustrated on p. 347*)

MS on vellum written in two columns; rubrics in red; initials in red or blue; pricked and ruled; *l* 230 mm, *w* 160 mm, *d* 40 mm
Possibly late 12th century
London, British Library, MS Egerton 272

The binding is of brown hide over wooden boards. The boards are slightly bevelled and are flush with the edges of the leaves (the slightly projecting square at the fore-edge is a result of the re-backing). The original sewing is not visible. The binding has been re-backed and repaired. There are traces of two clasps visible on the fore-edge of the upper cover. There are vellum paste-downs and one free vellum leaf at both ends. The binding is tooled in blind to a rectangular design on each cover (upper cover: London tools 1, 8, 9, 13, 14 and 24; lower cover: London tools 2, 5, 6, 7, 12, 15 and 26).

PROVENANCE Augustinian priory of St Mary Overy, Southwark; British Library
BIBLIOGRAPHY Weale, 1894, R. 36, 37; Fletcher, 1895, pl. II; Weale-Taylor, 1922, no. 6; Hobson, 1929, no. XVIII; Nixon, 1976, p. 539

Overleaf: Impressions of binders' tools used on bindings attributed to London (actual size)

471

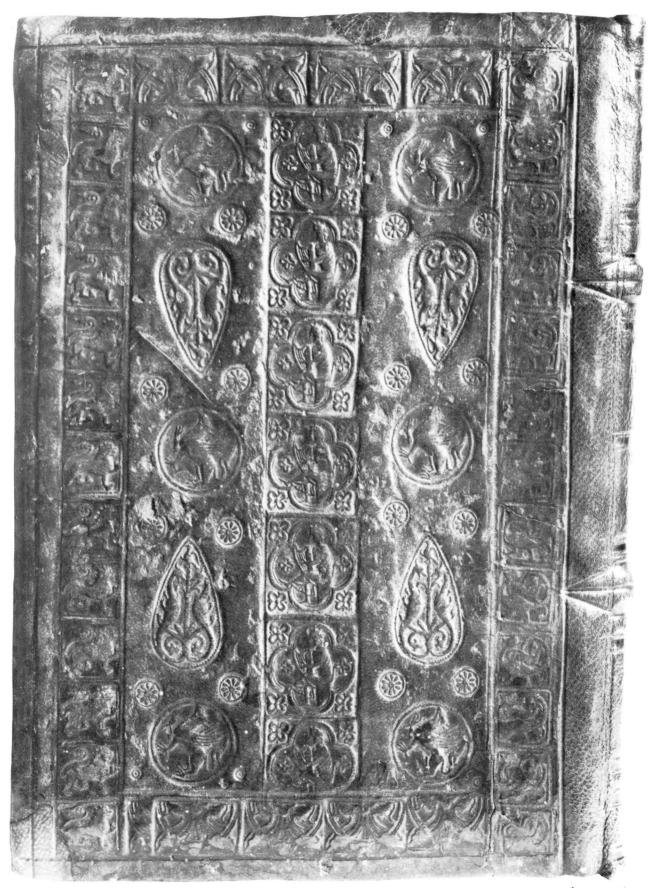

473 (lower cover)

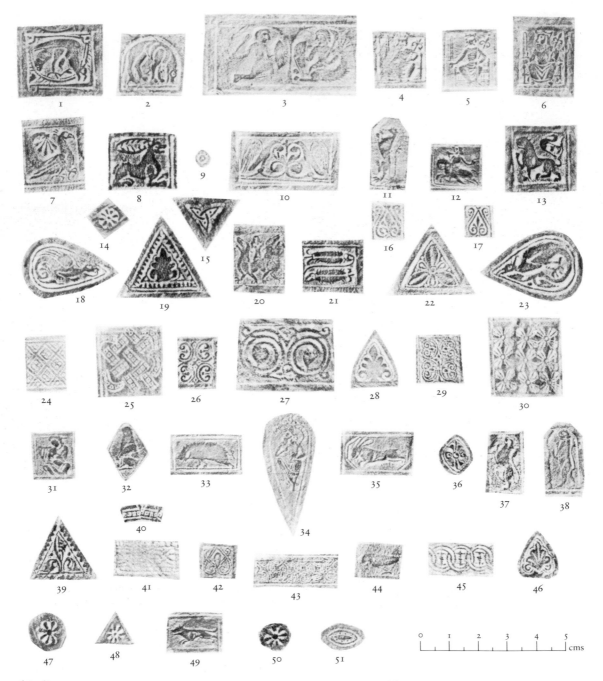

Durham bindings

The question whether the four volumes of the Puiset Bible (**474**) were bound in Durham hinges largely on whether the manuscript was written there. There has been some uncertainty about this but Kauffmann (1975, no. 98) ascribes the manuscript to Durham Cathedral Priory. The 51 tools used to decorate these volumes, though similar in motif to many of the Winchester tools, have not been found elsewhere. Impressions of these tools are illustrated above. (Please note that these are reproduced smaller than actual size.)

474 Puiset Bible

MS on vellum written in two columns; rubrics in red and blue or in alternate red and blue letters; illuminated initials; initials in red, blue and green (some brown); pricked and ruled; *l* 494 mm, *w* 342 mm, *d* 100/75/72/70 mm (as re-bound)
c. 1170–80
Durham Cathedral Library, MS A. II. I

All four volumes were rebound in 1845 by C. Tuckett & Son, London, in brown hide over wooden boards (with projecting squares), with part of the original covers onlaid. The original covers are of brown hide (vols. II and IV) and, possibly, sheepskin (vols. I and III). Each was re-sewn with new headbands, new brass bosses (five on each cover) and new clasps on vols. II-IV. On vol. I the re-binder has used two of

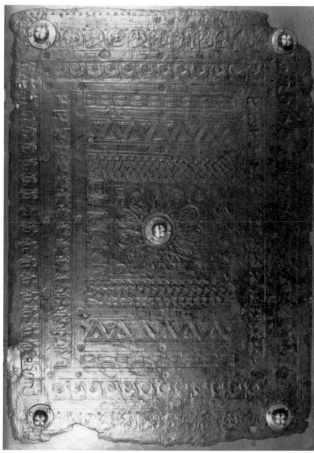

474 (Vol III, lower cover)

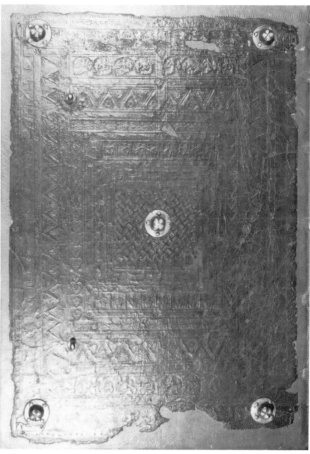

474 (Vol I, lower cover)

the original copper-alloy clasps, inlaid with silver, nielloed and engraved, attached to the upper cover with leather thongs (now separated from the cover) and fastened to two pins on the lower cover, now 80 mm from the edge of the board. The design of the engraving of the clasps is similar to that of one of the tools (Durham tool 27) used to decorate vol. II (see also **301**). Pin-holes are visible on the lower covers of all volumes. Vol. I has two original vellum end-leaves at the front and possibly one at the back; vols. II–IV have one original vellum end-leaf at each end. The bindings are tooled in blind to rectangular designs. Vols. I and IV have on the upper cover a centre circle built up of separate tools; vol. II has on the upper cover a small centre circle filled with strapwork tooling; and vol. III has on the lower cover a centre circle built up of separate tools. Vol. I upper cover: Durham tools 1, 2, 4, 9, 13, 16, 18, 19, 21, 25, 29, 36, 37, 46 and 47; lower cover: Durham tools 3, 4, 7, 8, 9, 15, 16, 19, 21, 22, 25, 37, 41, 45, 46 and 50. Vol. II upper cover: Durham tools 1, 3, 5, 9, 10, 11, 12, 13, 19, 20, 21, 24, 25, 27, 29, 31, 32, 33, 34, 35, 39, 42, 47 and 49; lower cover: Durham tools 5, 7, 9, 10, 19, 20, 24, 27, 29, 35, 36, 42, 43, 44 and 47. Vol. III upper cover: Durham tools 1, 2, 3, 7, 9, 13, 15, 19, 21, 23, 25, 36, 47 and 50; lower cover: Durham tools 1, 3, 7, 8, 9, 13, 14, 15, 19, 21, 23, 25, 36, 40 and 47. Vol. IV upper cover: Durham tools 3, 6, 7, 9, 13, 14, 17, 18, 19, 24, 26, 28, 38 and 51; lower cover: Durham tools 1, 2, 6, 8, 9, 13, 14, 17, 20, 21, 23, 24, 25, 26, 28, 30, 38, 48 and 51. See also **301** and **77**.

PROVENANCE Hugh du Puiset, Bishop of Durham; Durham Cathedral Priory; Durham Cathedral Library
BIBLIOGRAPHY Weale, 1894, R. 12–19; Hobson, 1929, nos. VI–IX; Mynors, 1939, no. 146; Kauffmann, 1975, no. 98; Nixon, 1976, p. 538; Geddes, 1980, pp. 140–8, pl. XXID

475 Fountains Abbey binding (*not illustrated*)

Liber Ezechialis

MS on vellum written in one column with marginal glosses (except for f. 2, which is written in two columns); some decorated initials in red and green; initials in red or green; pricked and ruled; *l* 298 mm, *w* 200 mm, *d* 59 mm
Late 12th century; written at Fountains Abbey
London, British Library, Henry Davis Gift, M. 49

The binding is of alum-tawed leather over wooden boards. The boards are cut straight and are flush with the edges of the leaves. The manuscript is sewn on four split alum-tawed thongs with figure-of-eight sewing. The slips have been laced in through holes in the boards and lie in grooves on the inside of the boards. The top and bottom thongs have been laced in at an angle. The pegs are not visible. There are semicircular tabs at head and tail finished with a button-hole stitch in pale blue silk. The original bookmarkers are attached to the head-tab. There are no headbands. The spine is flat and has been lined in between the thongs. One clasp on a leather thong is nailed in a groove on the upper cover and fastens on a pin projecting 67 mm from the edge on the lower cover. The clasp itself is of copper alloy, cast in a single mould and engraved in the form of a stylized animal (*l* 36 mm; *w* of the hasp 19 mm).

PROVENANCE Fountains Abbey, Yorkshire; Sir W.H. Ingilby; Wilfred Merton; Henry Davis; British Library
BIBLIOGRAPHY Pollard, 1962; Foot, 1983, no. 1

Pottery

Since Romanesque is not a term usually employed by those studying medieval pottery it may be asked whether pottery has any place in this exhibition. Romanesque is a style description primarily applied to architectural form and ornament recalling Roman forms. The interest of pottery at this period is that it provides an insight into the art of the ordinary people, as opposed to the rich and well-established patrons of royalty, the baronage and the Church.

The persistence of the late Saxon tradition is noticeable in pottery between 1050 and 1200. Late Saxon pottery is represented in eastern England by three types of wheel-thrown pottery: Thetford, St Neots, and Stamford ware. Established in East Anglia in the mid-9th century, it continued unaffected by the Norman Conquest to decline in the 12th century. Both Thetford ware and Stamford ware were fired in up-draught clay kilns, examples of which have been excavated at both those towns. St Neots ware is a shelly fabric. Stamford ware stands out from the two other wares in that it is sometimes glazed, and this must have made it particularly noticeable on the Romanesque table.

Since it was only 40 years ago that glazed Stamford ware was recognized as late Saxon, it is perhaps worth indicating the importance of archaeological excavation and of developments in the study of dating pottery of this period. It was the discovery of Stamford and Thetford ware in post-war excavations at Thetford that suggested that this pottery might be dated before AD 900. At the post-Conquest castles, notably Oxford, Castle Neroche in Somerset and Castle Acre in Norfolk, the phases and dates of the buildings have provided evidence for change and continuity in pottery after the Conquest. Finally, in the last 20 years, our knowledge has been considerably extended by the more detailed analysis of the sequence of pottery development in major urban excavations, notably at Stamford, Oxford, York and the important series of excavations in both the town and on the cathedral site of Winchester. The recent excavations at Seal House and Trig Lane, London, have revealed much new evidence of 12th-century pottery.

The Conquest had virtually no effect on pottery manufacture in England. Only at one site can Norman influence be detected; that is at Castle Neroche where in the fortifications (c. 1067–9) pottery in a local fabric was found with rim forms characteristic of northern France. This has been explained as the repertoire of an immigrant craftsman in the retinue of Robert of Mortain. However, the French influence had no long-term effect on the local production of pottery, for by the later 11th century the pottery from the castle was characterized by local rim forms and fabrics.

It is curious that in the 12th century pottery manufacture declined in quality (Hurst, 1976). Although at York and Stamford the manufacture of well-made pottery continued, the rest of the country shows a technical decline marked by a change in shapes. This decline is well illustrated by the use of glaze. A clear lead glaze is one of the most attractive features of Stamford and Winchester wares; it was applied by brushing. In the 11th century a different tradition of glazing developed, using a small quantity of lead applied as powder, producing a speckled glaze with much surface pitting. The decline is similarly reflected in the south of England by contrasting the quality of glaze on tripod pitchers with that on late Saxon Winchester ware. The 12th-century jugs from London, although splash-glazed externally, show new ways of decorating the exterior of the jugs with lines of brown or white slip under the glaze or the use of brown slip and applied pellets of white clay.

The development from late Saxon to Romanesque pottery, or early medieval pottery as it is generally described by ceramic historians, is marked by a change in forms, though it is clear that this began before the Conquest. The small late Saxon cooking pots may be contrasted with the Romanesque broad cooking pot with sagging base, and the globular late Saxon pitcher with the taller, thinner jug of developed Stamford ware.

Our knowledge of the total range of decorative techniques of 12th-century pottery is very limited. Linear, combed, or rouletted decoration was obviously popular and there is also evidence of zoomorphic handles or spouts (481 and 487). One of the most remarkable instances of 12th-century decoration is the bird modelled in relief (481), which foreshadows the development of three-dimensional ornament in later medieval pottery.

The bolder forms and the increasing use of decoration are two elements of the changes that took place in the manufacture of pottery in the 12th century. It is difficult to obtain a precise picture of these changes since the evidence is so limited. In particular our complete lack of knowledge of 12th-century bronze cooking vessels, bronze jugs and leather vessels makes it difficult to estimate the relative place of pottery in the arts of the period. J.C.

476 Cooking pot (*not illustrated*)

Thetford ware; *h* 192 mm
10th–11th century
Norfolk Museums Service, Norwich Castle Museum, 25.90

Thetford ware, a wheel-thrown, well-fired, grey reduced
pottery was produced in Ipswich, Thetford and Norwich in the
late Saxon period and in several rural kiln sites, for example,
Grimston, Langhale, and Bircham after the Conquest. It is a
hard, sandy ware, and this cooking pot is an example of the
most common type of vessel. The shape of the Thetford ware
cooking pot has been compared to the simple Roman olla
shape (Hurst, 1965) which survived in the Rhineland. This
cooking pot, produced in Norwich, shows the typical
decoration of a rouletted band around the shoulder of the pot.

PROVENANCE Found at Norwich
BIBLIOGRAPHY J.G. Hurst, 'Late Saxon Pottery', *The Fourth Viking Congress*, Aberdeen, 1965,
pp. 216–223; S. Jennings, *Eighteen Centuries of Pottery from Norwich*, 1981, p. 14, fig. 5,
no. 117

477 Spouted bowl

Thetford ware; *h* 105 mm, *diam* 243 mm
11th century
London, Trustees of the British Museum, MLA. 1957, 12-1,1

The spouted bowl is another form of late Saxon vessel used in
the preparation of food. This wheel-thrown example probably
produced at Thetford has an everted rim, hollow spout and
sagging base. The pottery found in the excavations at Thetford
from 1947 to 1949 is to be described by Rogerson and Dallas
in a forthcoming publication.

PROVENANCE Found in excavations at Thetford, 1948–9

478 Lamp of pedestal form

Thetford ware; made with circular base from which stem
gradually widens out to form circular bowl; *h* 116 mm,
diam 90 mm (at base)
11th century
Ipswich Museums and Galleries, 961.147, on loan to the British
Museum

Pottery lamps were made in two forms, the pedestal type as
here, and the spiked or pointed type (485). The pedestal type
was intended to stand on a flat surface. The bowl would be
filled with oil and the wick floated in it.

PROVENANCE Found in Westgate Street, Ipswich

479 Bowl (*not illustrated*)

St Neot's ware; made with inturned rim and sagging base;
h 110 mm, *diam* 265 mm
11th century
Bedford Museum, North Bedfordshire Borough Council, on
loan to the British Museum

St Neots ware is part of the wheel-made late-Saxon pottery
tradition that continued into the 12th century (Hurst, 1976). It
was produced in the Cambridge, Bedford, St Neots and
Northampton areas, probably in clamp kilns. The shapes of St
Neots vessels are similar to those of Thetford ware, although
the bowl with inturned rim is an especial feature of St Neots
ware.

PROVENANCE Found in Bedford

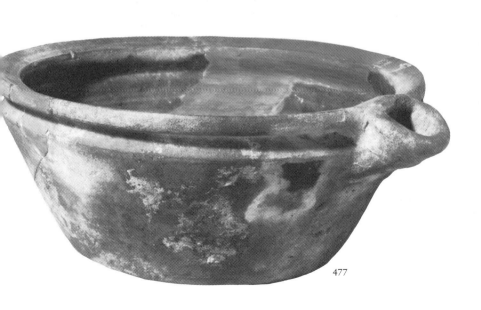

477

478

480 Pitcher (*not illustrated*)

Stamford ware; made with tubular spout and two small strap handles, whose attachment is marked at base by thumb impressions; covered externally by thick glaze; *h* 165 mm
11th-12th century
London, Trustees of the British Museum, MLA.B.200

This complete example of a Stamford ware pitcher shows the globular form of the late Saxon vessel for holding liquids. It is notable for the all-over covering of thick lead glaze, appearing yellow with a slight orange tinge. The origins of the use of glaze on late Saxon Stamford ware have been explored by Hurst (1969), and the latest summary of the evidence to be published is by Kilmurry (1980). It appears most probable that glaze arrived in eastern England via France.

PROVENANCE Found in the High Street, Oxford, on the site of the Examinations Schools, where formerly stood the Angel Inn; sometimes known as the 'Angel Inn' pitcher
BIBLIOGRAPHY Hobson, 1903, no. B.200; R.L.S. Bruce-Mitford, 'Two medieval pottery vessels', *Brit. Mus. Qu.*, XIII, 1938-9, pp. 35-7; J.G. Hurst, 'Red-painted and Glazed Pottery in Western Europe from the 8th to the 12th century,' *Med. Archaeol.*, XIII, 1969, pp. 93-147; K. Kilmurry, *The Pottery Industry of Stamford, Lincolnshire, c. AD 850-1250*, 1980

481 Fragment of Pitcher

Stamford ware; fragment of rim, shoulder and spout of elaborately decorated pitcher; *h* 155 mm
Mid- to late 12th century
London, Trustees of the British Museum, MLA.66,6-29,147

The Stamford ware tubular spouted pitcher developed in the mid-12th century. It probably had a lid, since this type of vessel is difficult to use without one. This also provides an explanation of the hole in the side of the rim. The tubular spout is attached by a bridge, the top of which is decorated by an interlace of applied loops. The spout itself has chevron incised decoration at the end, perhaps indicating that it was conceived

zoomorphically as the jaws of an animal. The body of the fragment is decorated with four surviving bands of incised lines, arranged in chevrons, and an applied bird. This well-modelled bird has the feathers on the backs of its wings indicated by incised lines. The use of zoomorphic decoration and decoration in relief foreshadows the developments in the decoration of pottery in the 13th century.

PROVENANCE Found in London; formerly in the Christy Collection
BIBLIOGRAPHY Hobson, 1903, no. B.88

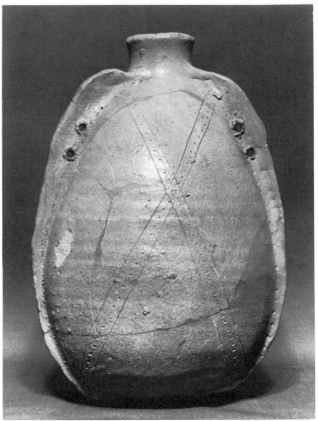

482

481

482 Costrel (pottery bottle)

Winchester ware; wheel-made and slightly squashed; ridges on side luted on; decorated by punching and incising; *h* 265 mm
10th century
Winchester City Museum; Winchester Research Unit,
ACS.RF.135

Winchester ware was recognized as a distinct Saxo-Norman glazed fabric during the important series of excavations in the 1960s in Winchester. Its early date was supported by the discovery in 1962 of sherds stratified among rubble from the demolition of the Old Minster in 1093-4. Further sherds were found stratified beneath the castle bank of 1067 in Winchester (Biddle, Barclay, 1974). Winchester ware was certainly being made as early as 950; it is likely that manufacture ceased in the 12th century. The forms consist of pitchers, bowls, cups and jars. The costrels, of which this is a virtually complete example, were used for carrying liquid, and their form indicates that they were copied from leather bottles.

PROVENANCE Found in Pit IX, Assize Courts South, Winchester, in a 10th-century context
BIBLIOGRAPHY Hurst, 1962, pp. 187-90; Biddle, Barclay, 1974, pp. 137-66; J.D.Frierman, *Medieval Ceramics*, F.S. Wight Art Gallery Exhibition, California, 1975, no. 120, p. 55

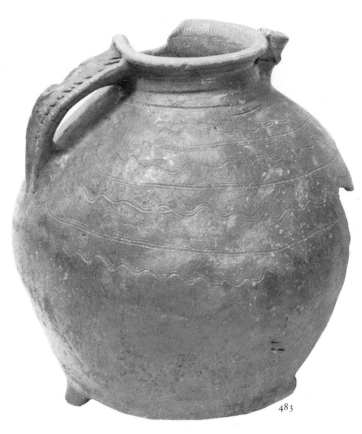

483

484 Cooking pot

Black shelly fabric; hand-made, with slightly sagging base, everted rim with flat top; *h* 155 mm
12th century
London, Museum of London, 24062

The shape of this cooking pot, particularly the width in relationship to the height, should be contrasted with that of the Thetford ware cooking pot (**476**) to appreciate the contrast between the form of the late Saxon and the Romanesque cooking pot. This development may indicate a major change in cooking from the preparation of small quantities of food to the cooking of stews for the whole family. The beginning of the change is dated *c.* 1000, well before 1066, and therefore is not a culinary consequence of the Norman Conquest.

PROVENANCE Found at the site of the Dyers Arms, Cannon Street, London, 1965, in a rubbish pit with a large group of other pottery (Guildhall Museum Excavation Register 1115)

484

483 Tripod pitcher

Cotswold fabric; pitcher with strap handle with incised lines, and tubular spout attached by a strip of clay; *h* 368 mm
12th century
Gloucester, City Museum and Art Gallery, A.25823

This illustrates the type of tripod pitcher produced in the Cotswold area in the 12th century. The fabric is sandy and black and the outside is covered by a patchy yellowish-green glaze. The decoration of alternate straight and wavy combed lines may be compared with the Oxford jug (**486**).

BIBLIOGRAPHY R.L.S. Bruce Mitford, *Antiq. J.*, XX, 1940, p. 106, fig. 4

485 Lamp of spiked form

Shelly fabric; bowl sub-circular in shape and blackened inside; base drawn out into spike rounded at bottom; *h* 75 mm, *diam* (of bowl) 76 mm
Late 11th or early 12th century
London, Trustees of the British Museum, MLA, 54.11-30, 52

This shape of pottery lamp was probably derived from glass lamps. The lamp was held in a circular holder, most usually hung.

PROVENANCE Found in Cannon Street, London, before 1854

485

486 Jug

Oxford early medieval ware; hand-made; neck with everted
rim and pulled lip; strap handle with thumbing at the sides and
stamped impressions in centre; neck decorated with vertical
combing and upper part of outside of body with alternately
wavy and straight combed bands; *h* 330 mm
12th century
Oxford, Ashmolean Museum, 1915,268a

The 11th- and 12th-century pottery of Oxford has recently
been assessed by M. Mellor (Durham, 1977). This hand-made
squat jug shows the continuation of a hand-made tradition.
The combing, finger-tip decoration and stamping on the handle
show the development of decoration on unglazed jugs in the
12th century.

PROVENANCE Found in Radcliffe Square, Oxford; presented to the Ashmolean Museum by the
executors of Mr J.W. Jackson
BIBLIOGRAPHY B. Durham, 'Archaeological Investigations in St Aldates, Oxford', *Oxoniensia*,
XLII, 1977

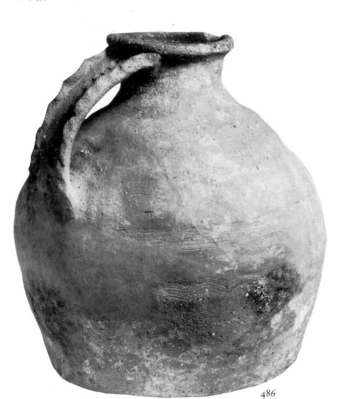

486

487

487 Tripod jug

Fine London ware; made with rod handle in animal form; neck
and upper part of body decorated with raised cordons dividing
bands of yellow and brown glaze; lower band includes line of
applied bosses in yellow clay; body decorated with brown clay
hanging loops with yellow clay bosses above chevrons of
brown and yellow clay; *h* 406 mm
12th century
London, Trustees of the British Museum, MLA.1915, 12-8, 191

This is one of the most elaborately decorated of the group of
12th-century London ware jugs identified after work on the
assemblages from Seal House and Trig Lane, London. The
fabric, rim and neck form, and base form are all typical of these
jugs. Another tripod jug is known in this group (Pearce, Vince)
which has elaborate white clay decoration. The zoomorphic
handle and the two-colour decoration indicate the range of the
decoration on 12th-century jugs in London.

PROVENANCE Found in London
BIBLIOGRAPHY J. Pearce, and A.G. Vince, 'A type series of medieval pottery from London dated
by dendro chronology', forthcoming

488

488 Jug

Fine London ware; made with strap handle, ribbing on neck, punched lip, and flat base; body decorated with five diagonal stripes of brown clay under green glaze; *h* 390 mm
12th century
London, Museum of London, 24287

This is one of the larger examples of 12th-century jugs in a fine London fabric, which has been dated and identified through work on the assemblages associated with the water frontages excavated at Seal House and Trig Lane, London. It provides an example of the decorative use of brown clay slip under glaze in the London area. The well-defined, gradually curving form provides an apt background for the decorative stripes, making this one of the more aesthetically pleasing Romanesque vessels.

PROVENANCE Found at Aldermanbury on site of new Guildhall Library, 1965, with a large group of similar vessels in a box-like structure within a pit (Guildhall Museum Excavation Register 1076.c)

489 Jug

Developed Stamford ware; tall, thin jug with strap handle attached near the rim; decorated with speckled green glaze; *h* 315 mm
Late 12th or early 13th century
London, Trustees of the British Museum, MLA.1969, 6-3, 1

The change from late Saxon Stamford ware to developed Stamford ware was marked by a gradual evolution of form as well as of glazing techniques. This developed Stamford ware jug shows the so-called 'glaze 3', basically a lead glaze dusted with copper filings before firing, so that the final appearance is mottled green on a paler background. The taller form as well as the glaze colour point the way to later medieval jugs.

PROVENANCE Found during excavations, 1963, on the site of a medieval pottery kiln at Stamford School, Stamford, Lincolnshire (Mahany, Birchard, Simpson, 1982)

489

The entry on ceramic floor tiles (552) appears on page 392.

Textiles and Embroideries

The rare surviving textiles give only a faint impression of the importance of such works in England during the Romanesque period. The one major example which survives is the so-called Bayeux Tapestry, which is really an embroidery in wool on linen cloth and is indeed the largest embroidery which has come down to us from the Middle Ages. This wonderfully lively narrative frieze, which recounts the events of the Norman Conquest of England from a Norman viewpoint but in an English style, was probably made in England about 1075.[1] Many other large pictorial wall-hangings are recorded in texts. In the first half of the 12th century, for example, there were hangings at St Albans depicting the stories of St Alban, the Good Samaritan and the Prodigal Son, hangings at Abingdon depicting Job, the Nativity and the Apocalypse, and hangings at Evesham depicting the story of St Egwin. In 1214 Sarum possessed hangings of Job, of Abraham and of Noah's Ark. It is not clear whether such hangings were of embroidery or of woollen tapestry, but they undoubtedly played a major part in the decoration of churches.

England exported large quantities of wool and some woollen cloth. Almost all the silk cloth used in England, however, was imported from the Near East, Byzantium, Italy or Spain. Much of it was plain cloth, but some was woven with repeating patterns, generally with birds, animals or monsters. It may well be that these exotic patterns from distant lands exercised some influence on Romanesque ornament. Some of the silks were used as wall-hangings or altar-hangings; others were made up as secular or ecclesiastical garments. Extant examples of these imported silks include tiny scraps from the shrine of Edward the Confessor, small pieces used as seal-bags at Canterbury Cathedral, and the vestments of Archbishop Hubert Walter.[2] The only silk weavings likely to have been produced in England are narrow tablet-woven ribbons of silk and gold thread, generally with geometrical patterns.

The most celebrated class of patterned textiles produced in England were gold embroideries, used for furnishings and altar-hangings and for dress, especially ecclesiastical vestments. Worked with gold thread in the technique known as underside-couching (see Glossary), on imported silk cloth, they have designs of foliage, birds, animals and religious scenes.[3] They were as much esteemed abroad as they were in England. The exhibition includes examples from the vestments associated with St Thomas of Canterbury at Sens Cathedral (**490**), mitres from various European treasuries (**491** and **492**), and examples from the tombs of Archbishop Hubert Walter at Canterbury and Bishop William de Blois at Worcester (**493** and **495**). D.B.K.

NOTES

1. Stenton, 1957, 1965
2. Robinson, Urquhart, 1934; Hope, 1893
3. Christie, 1938

490

490 Apparel of an amice

h approx 125 mm, *w* 610 mm
1140–70
Birmingham, Erdington Abbey

The apparel, of deep purple silk in compound twill weave, is embroidered with silver-gilt thread in underside-couching. The pattern, of foliate crosses within a lattice formed by interlaced circles, is similar to that of other vestments at Sens Cathedral described, in an inventory of 1446, as 'La chapelle de Mr Saint Thomas de Canturbérie'; this piece no doubt formed part of that set.

PROVENANCE Sens Cathedral; given by Monsignor de Cosnac, Archbishop of Sens, to Monsignor (later Cardinal) Wiseman, 1842; Revd Daniel Haigh; Erdington Abbey, *c.* 1852
EXHIBITIONS London, Burlington Fine Arts Club, *Exhibition of English Embroidery*, 1905, pl. XIX; London, 1963, no. 4
BIBLIOGRAPHY Christie, 1938, p. 56, no. 13

491 Mitre

h 229 mm, *w* 279 mm
1160–1220
London, Archbishop of Westminster, on loan to the Victoria and Albert Museum

The mitre is of white silk twill woven with a lozenge pattern and has bands of red silk compound twill. The embroidery is of silver-gilt thread in underside-couching. The pattern consists of foliate scrolls and circles and, between the horns of the mitre, small lozenges. One of the lappets is original; the other, with a human figure, perhaps an Apostle, was formerly attached to another, roughly contemporary mitre at Sens Cathedral. Applied ornaments, probably of metal, have been removed from the bands of red silk and from the circular compartments in the embroidery.

PROVENANCE From Sens Cathedral, where it was associated, by a tradition current in the 19th century, with St Thomas of Canterbury (the tradition is too recent to have any value as evidence, but is not entirely incompatible with the style of the foliate ornament); presented by Monsignor de Cosnac, Archbishop of Sens, to Monsignor (later Cardinal) Wiseman, 1842
EXHIBITIONS Barcelona, 1961, no. 553; London, 1963, no. 12
BIBLIOGRAPHY *Illustrated London News*, XXXVIII, 1861, p. 403; E. Chartraire, 1923, p. 234; Christie, 1938, p. 62, no. 24

492 Mitre (*not illustrated*)

h 191 mm, *w* 279 mm, *l* (of lappets) 419 mm
1180–1210
Namur, Le Trésor d'Oignies aux Soeurs de Notre-Dame

The mitre is of white silk twill. The embroidery is of silver-gilt thread, underside-couched, with outlines and details in silk thread. The front of the mitre depicts the Martyrdom of St Laurence (SC̄S LAVRENCIVS) and the back that of St Thomas of Canterbury (SC̄S THOMAS); above each martyr the hand of God appears from clouds. Between the horns of the mitre are small crescents. On the lappets are kings and other figures, with crescents and foliate sprigs.

This mitre is said to have belonged to Cardinal Jacques de Vitry (d. 1244). It is one of a group of four mitres with similar subjects; the other three are in the Cathedrals of Sens and Tarragona and in the Bayerisches Nationalmuseum, Munich. Dr Agnes Geijer has suggested that the embroidered versions of St Thomas' death are related to a Canterbury miniature of about 1180 and supposes that the mitres are 'the remains of an extensive serial production intended for distribution as propaganda for the cult of St Thomas'.

BIBLIOGRAPHY C. Rohault de Fleury, *La Messe*, VIII, 1889, p. 129, pl. DCLXII; Chartraire, 1923, p. 236; Christie, 1938, p. 60, no. 20; A. Geijer, 'Engelske broderier av romansk typ', in *Nordenfjeldske Kunstindustrimuseum Àrbok*, 1956, pp. 43–69

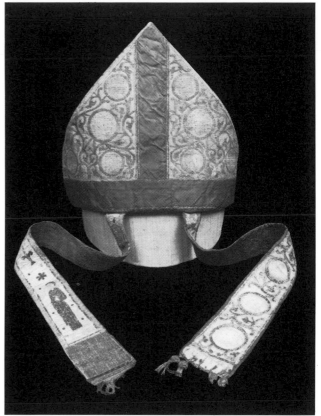

491 (back)

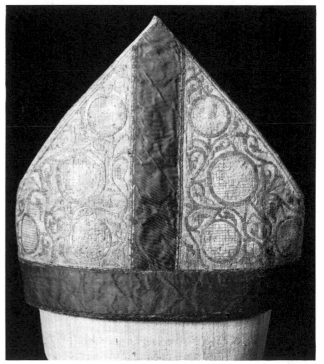

491 (front)

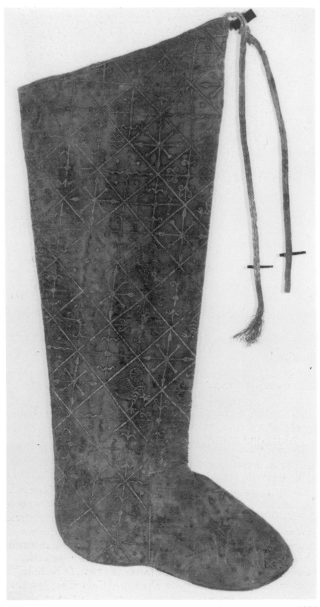

493a

493a and b Textiles from Archbishop Hubert Walter's tomb

The tomb at Canterbury, and all its metal furnishings, are discussed on pages 294–5 (**324**).

493a Pair of buskins

h approx 686 mm
1170–1200
Canterbury, Dean and Chapter of Canterbury Cathedral

The buskins are of silk compound twill which is discoloured to an amber tone with traces of green; it may have been blue originally. The embroidery is of silver-gilt thread in underside-couching. On the legs of the buskins is a lattice pattern enclosing foliate crosses and eagles; on the feet are stars, crosses and spots. Tablet-woven patterned ribbons for fastening are attached to the tops of the buskins.

EXHIBITION London, 1963, no. 6
BIBLIOGRAPHY Hope, 1893; Christie, 1938, p. 57, no. 15; Stratford, Tudor-Craig, Muthesius, 1982, pp. 80–7, pls. XXIB–C

493b Apparel of an amice

h 89 mm, *w* 565 mm
1170–1200
Canterbury, Dean and Chapter of Canterbury Cathedral

The apparel is of silk lampas, now discoloured to an amber tone but perhaps originally red. The embroidery is of silver-gilt thread in underside-couching, and silk thread in stem-stitch. The design shows seven circles, with foliate scrolls between. In the centre circle is Christ enthroned, with the letters Alpha and Omega. In the four circles on either side of the central one are the symbols of the four Evangelists with inscriptions LVCAS, MATHEVS, IOHANNES, MARCUS (the symbols of Mark and Luke have been accidentally interchanged). In the two outer circles are the archangels MICAEL and GABRIEL. Circular indentations are all that remains of small round ornaments that formed the junctions between the seven circles; they were probably silver buttons like those on the vestments of St Thomas of Canterbury at Sens.

EXHIBITION London, 1963, no. 9
BIBLIOGRAPHY Hope, 1893; Christie, 1938, p. 58, no. 17; Stratford, Tudor-Craig, Muthesius, 1982, pp. 80–7, pl. XXIIIA

493b

494 Fragment of embroidery

h 114 mm, *w* 95 mm
1180–1210
Wonersh, St John's Seminary

The fragment, of rose-coloured silk in compound twill weave, is embroidered with silk, silver and silver-gilt thread in underside-couching and stem-stitch. The design shows a mounted knight, with helmet and shield, advancing towards a star. Vestments with patterns of mounted knights were quite common in England in the late 12th and 13th centuries. The top edge of the fragment appears to be original; the other edges were cut when the fragment was used to patch a late-medieval chasuble.

PROVENANCE Said to have belonged to Westminster Abbey; Canon D. Rock; St George's (Roman Catholic) Cathedral, Southwark
EXHIBITIONS London, Burlington Fine Arts Club, *Exhibition of English Embroidery*, 1905, pl. XXV; London, 1963, no. 14
BIBLIOGRAPHY *Proc. Soc. Antiq.*, 2nd series, xi, 1886, p. 121: Christie, 1938, 65, no. 30

494

495

495 Fragments of a stole and maniple

w 64 mm
1190–1220
Worcester, Dean and Chapter of Worcester Cathedral

The fragments are of silk tabby, discoloured to brown. The embroidery is of silver-gilt and silk thread, in underside-couching and stem-stitch. The stole evidently showed the twelve Apostles, in rectangular compartments, on a background powdered with groups of three spots. The inscriptions included the names [IA]COBBVS, ANDRE[AS], PAULV[S], TADEVS, IHOAN, BA[RTH]OLOMEVS and probably MA[TEVS]. The maniple was perhaps decorated with the figures of the four major prophets; the inscriptions included the names DANIEL and IEREMI. Four trapezoidal panels, probably the ends of the stole and maniple, showed two kings and two bishops, beneath semicircular arches with pinnacles and towers; the figures included King Ethelbert (ADELBERTVS), St Nicholas (NICO[LA]VS) and perhaps St Thomas of Canterbury (TO . . .). Compare, in the 1245 inventory of St Paul's Cathedral, a stole and maniple of Roger, Chaplain to Richard FitzNigel, Bishop of London 1189–98, 'embroidered with figures of Apostles and prophets, identified by their names, while at the ends are embroidered Sts Thomas and Oswald, Nicholas and Edmund' (*Archaeologia*, L, 1887, p. 487).

PROVENANCE Fragments found in 1870 at Worcester Cathedral, in a tomb thought to be that of William de Blois, Bishop of Worcester 1218–36
EXHIBITION London, 1963, no. 15
BIBLIOGRAPHY H.B. Southwell, *A Descriptive Account of some Fragments of Medieval Embroidery found in Worcester Cathedral*, 1914; Christie, 1938, pp. 52–3, nos. 4–6

Rediscovery of the Romanesque

The purpose of this section is to show how the perception and appreciation of Romanesque as a distinct style of art emerged in the 17th, 18th and early 19th centuries. It is not a mere postscript to the exhibition, to bring the story up to date. Seeing Romanesque through later, relatively familiar eyes rather than peering dimly at it over a divide of almost a millennium acts as a reminder that succeeding generations have had different views of the style and have set different values upon it. The development of interest in Romanesque is also a little-explored aspect of the Gothic Revival, a movement too often discussed as if it were concerned exclusively with the pointed arch: it inspired a Romanesque-revival style in architecture which had a notable success in the 1830s and 1840s and continued to be practised throughout the 19th century. Lastly, the coinciding of the intellectual discovery of Romanesque with the flowering of the topographical tradition in English landscape art meant that great masters such as Girtin and Turner were led to depict Romanesque buildings (525–527 and 528–531). The display here of drawings and paintings not only testifies to this as an artistic phenomenon in its own right, but it also communicates something which is virtually impossible to convey in the rest of the exhibition: the scale and power of Romanesque architecture.

Romanesque art in England is not something exotic like Aztec or Assyrian art, suddenly revealed to the world by excavation after centuries of oblivion. Romanesque monuments have depended for their fate on the care or indifference felt towards them over the centuries: they have had to survive not just the physical vicissitudes of natural decay but also the changing attitudes of their custodians. In England Romanesque was first defined through architecture and architectural sculpture, rather than through manuscripts, wall-paintings or metalwork. Architecture constituted by far the most prominent evidence of the style and, through the diffusion of topographical drawings and engravings, it formed the visual images of Romanesque in the minds of the educated public. Buildings also had the advantage that they could be appreciated without the embarrassment felt by even sympathetic 18th- or 19th-century critics at the 'incorrect' figure drawing in Romanesque sculpture and illumination.

For Romanesque to be understood it had first to be defined. The process of definition was closely associated with the problem of naming the style. Even today the use of the word 'Romanesque' implies a more modern, art-historical approach than the 'Norman' commonly used in England during the past century. But the round-arched early medieval style has also been called 'Saxon', 'Anglo-Norman', 'Gothic', 'Monastic' or '*Opus Romanum*'. Its origins were more clearly recognized than those of the later, pointed style. It was early observed to be 'no other than a debased and corrupt Roman architecture'.[1] The chief difficulty was that on the one hand the style was apparently current both before the Norman Conquest and after it and yet, in addition to the great changes known to have been caused by the Conquest, there was the clear statement by William of Malmesbury that the Normans introduced *novum aedificandi genus* – 'a new kind of building'.[2] Some critics followed William Somner who, writing as early as 1640, had

suggested that the Normans introduced building in masonry whereas the Saxons had only built in wood.[3] Edmund Ledwich, a century later, raised the reasonable hypothesis that the novelty brought by the Normans was the pointed arch itself.[4] The gradual acceptance that the *novum genus* consisted of a new 'massiveness and enlarged dimensions' left unsettled the question of whether to call the round-arched style 'Saxon', after its originators, or 'Norman', after its boldest protagonists.[5]

When the very idea of stylistic periods in art was first propounded in England in the reign of Charles I, by men such as Lord Arundel, Inigo Jones and, later, John Evelyn, all non-classical architecture was called 'Gothic'.[6] As Roger North put it, 'The distinction now of building in the world, is reducible to Gothic and Regular', although within 'Gothic' he clearly distinguished between the 'elder' or 'round way' and the later, pointed style.[7] By 1713 Christopher Wren called the 'ancient . . . Manner' Saxon, a description which endured for a century.[8] Wren mistakenly believed such major Romanesque buildings as Christ Church Cathedral, Oxford, and the transepts of Winchester Cathedral to be Anglo-Saxon in date, but even when he was later corrected in his dating by such critics as Thomas Gray, his stylistic label was still used.[9] However, once serious attempts were made in the latter part of the 18th century to differentiate between the architecture of the Saxons and that of the Normans, it became desirable to find another, more general term for the round-arched style. In the 1770s men like James Bentham, James Essex and Ledwich referred back to contemporary descriptions of early medieval buildings, such as Bede on the 7th-century Northumbrian churches, which used terms like 'Roman work' (*Opus Romanum*) or 'in the Roman manner', and they adopted the expression for Romanesque as a whole. Thus Essex could sum up his analysis of the nave of Southwell Minster by saying it 'had the appearance of the earliest antiquity of *Romana opera*'.[10] The architecture of Lincoln Cathedral (apart from the Angel Choir) was epitomized in the 1780s as being 'in part the *Opus Romanum* and partly of the style of the first essays of Gothic'.[11]

This learned but cumbersome anticipation of the modern use of 'Romanesque' failed to oust the simpler names of 'Saxon' and 'Norman'. The great medievalist John Carter continued to use 'Saxon' though he was very well aware that most 'Saxon' buildings dated from after the Conquest. As he pointed out, to call Covent Garden Opera House, newly rebuilt by Smirke, 'Grecian' did not imply it was built by Greeks.[12] Another contemporary authority, William Wilkins the elder, attempted to distinguish between Saxon and Norman architecture, the latter term being reserved for the later, more ornamental forms of Romanesque.[13] It was 'Norman' that prevailed, largely through its adoption by Thomas Rickman in his definitive book, *An Attempt to Discover the Styles of English Architecture*, first published in 1817, which established the general nomenclature of medieval architecture we still use. The word 'Romanesque' was coined by the Reverend William Gunn as early as 1819 but it did not find general acceptance until well into the 20th century.[14]

The uncertainties and changes in the naming of Romanesque were not frivolous or comic. They were essential steps in the discovery of the style. Intellectual awareness of Romanesque as a distinct period of art did not emerge until the 17th century, but there was already some perception of its character by the later Middle Ages. Thanks to the ecclesiastical building-mania of the century after the Conquest there were Romanesque churches great and small in virtually every parish in the country, which had to be maintained or replaced. In 1499 Bishop King destroyed the 12th-century Bath Abbey, in favour of a new building half its size. In other great buildings immense trouble was taken to remove Romanesque detail without demolishing the basic fabric. As early as the 1330s the masons at Gloucester Cathedral (then St Peter's Abbey) erected a monumental screen of masonry to conceal the massive arcade and gallery of the Romanesque choir; even more astonishingly at Winchester in the later years of the 14th century, Bishops Edington and Wykeham buried the whole Romanesque nave of the Cathedral in a Perpendicular casing. A more economical up-dating was achieved by inserting contemporary tracery into round-headed windows, as at Peterborough or Norwich Cathedral.

This period of adaptation and 'modernization' of Romanesque buildings ended at the Reformation. The Dissolution of the Monasteries meant not only the destruction of churches and monastic buildings which must have been major examples of Romanesque architecture but also the dispersal of their furnishings and treasures, in particular of their libraries which undoubtedly still preserved in the 1530s early medieval texts, now completely lost. Yet the very severity of the blow provoked a few into a positive response. Even in the reign of Henry VIII John Leyland retrieved what manuscripts he could for the Royal Library. Of later collectors one of the most notable was Matthew Parker (497), Archbishop of Canterbury under Elizabeth, who used his position to rescue a great number of important manuscripts. These he bequeathed to Corpus Christi, his old college at Cambridge, where they still remain. Two generations later, the harvest of manuscripts gathered by Sir Robert Cotton (498) was so rich that it was eventually acquired by the nation. It forms the nucleus of the British Museum's collection.

The critical step towards a conscious perception of the Romanesque as a distinct style was also associated with artistic catastrophe: the Puritan iconoclasm of the Civil War years. Even before fighting broke out determined attempts were made by a group of antiquarians led by Sir Christopher (later Lord) Hatton, calling themselves 'Antiquitas Rediviva' ('Antiquity restored to life'), to record medieval tombs and manuscripts in word and picture. These surveys could today be carried out photographically but then they had to be made laboriously by skilled draughtsmen. Hatton commissioned a book of facsimiles of medieval charters (449) which included many 11th- and 12th-century examples. The draughtsmen reproduced the style and form as well as the content of the originals, depicting not just the script and the seals but even the seal ribbons. One of the younger antiquaries in the group, William Dugdale (500), extended and systematized this initiative after the Civil War in two great books, the *Monasticon Anglicanum*[15] published in 1655 and, three years later, the *History of St Paul's*. The *Monasticon Anglicanum* was concerned with the history rather than with the architecture of English monasteries but the major foundations were illustrated by one or two engravings and, occasionally, a plan: in nearly every case these prints are the earliest visual record of the building.[16] Dugdale was yet more innovatory in

the *History of St Paul's* (which, of course, dealt with the medieval Old St Paul's Cathedral in London). He included an account of the Cathedral building as well as of its dignitaries and illustrated the book with splendid engravings by Hollar which embraced general views of the exterior and interior as well as details of the tombs.[17] The views of the nave and transepts can be claimed as the first detailed depictions of an English Romanesque building.

At the same time as this topographical and antiquarian approach to medieval art was developing, there was introduced into England the concept that styles in art differed not just between one artist and another but between one period and another. The idea, evolved in Renaissance Italy, was brought to England, along with the word 'Gothic', by the circle of Lord Arundel and Inigo Jones in the reign of Charles I.[18] Jones himself gave a precocious example of it in the book on Stonehenge, published posthumously in 1655 by his pupil and heir, John Webb, in which he conjured up the very views of Old St Paul's that Hollar was drawing at that time. 'Who did not by the very Order of the Work assure himself, that the body of the Church of St Paul in London, from its Tower to the West end was anciently built by the Saxons: as the Quire thereof, from the said Tower to the East end by the Normans, it being Gothick work?'[19] The intelligent observer could now appraise a building by stylistic evidence, not only by history or legend.

The first generation to benefit from these new developments in the understanding of earlier art was that of John Aubrey, John Evelyn, Christopher Wren and, rather younger, Roger North. John Aubrey (504), who became the first chronicler of the Romanesque, had been inspired in his antiquarian studies by a passionate concern for the works of the past and grief at their destruction. He was also a member of the newly-founded Royal Society and was thus acquainted with methods of scientific inquiry. His account of the Romanesque is embedded in his most ambitious project, the *Monumenta Britannica*, which was intended to be a grand survey of prehistoric, Roman and medieval antiquities, including a history of architecture called the *Chronologia Architectonica*.[20] Here Aubrey outlined a dated and illustrated account of English architecture from the departure of the Romans to his own day (505). Although he, like his friends Evelyn and Wren, considered Romanesque and Gothic a degeneration from the 'Excellent Architecture' of ancient Rome, he took the trouble on his travels around the country to note down specific examples of medieval features and to group them by reign. He understood how arches evolved from having round heads to pointed, and windows from round-headed openings to complex traceried designs of many lights, even if his dating has sometimes been corrected by later research. His collection of Romanesque motifs included intersecting arches, observed in St Mary's at Devizes, Wimborne Minster and Hereford Cathedral, and the round-headed windows of Kilpeck Church, which he compared to those in the contemporary tower of Kington St Michael, Wiltshire.

This treatise by Aubrey, apart from its intrinsic interest, is also a testimony to the unrecorded discussions among scholars of the period about medieval architecture which created a recognized framework for its understanding. Aubrey noted such conversations with Dugdale and Wren and he invited Evelyn not merely to read the *Chronologia* but to make initialled annotations in the text.[21]

Christopher Wren's knowledge of medieval architecture was broadened by his practical experience as surveyor to some of its greatest monuments. In a report on Old St Paul's shortly before its destruction by the Great Fire in 1666, Wren criticized

the 'ill Building' of the Romanesque nave and dismissed its major features as 'great Pillars without any graceful manner and thick walls without Judgement', but he recognized that the use of the round arch belonged to 'the Roman Manner'.[22] He also acknowledged the building's 'Grandeur, which exceeds all little curiousity': it was a 'Monument of Power'.[23]

Roger North, a younger friend of Wren and amateur architect, was more positive about the Romanesque. In notes about medieval architecture, written c. 1698, he admitted: 'I must owne to prefer much the former, being the round way, which I conceive was derived from the Greek and Roman regular columns, but for want of art and learning in the reason of it, so rudely executed as we see. But devious from the right as it is, none can deny but it bears not only an air of grandeure [an interesting parallel to Wren's comment on Old St Paul's just quoted] but hath a strength and reasonableness beyond the other; and is such as an extraordinary high spirited judicious barbarian might be supposed originally to invent.'[24]

During the 18th century there was an immense increase in the number and scope of topographical and antiquarian studies. The Society of Antiquaries was successfully re-founded in 1717 and provided a forum where papers could be read and ancient objects exhibited and discussed.[25] It also sponsored the publication of fine engravings depicting a wide range of buildings, paintings, coins and even tapestry: these were later bound in a series of volumes called *Vetusta Monumenta*. From 1775 the Society published the papers communicated to it in the still current journal, *Archaeologia*. In the first volumes Romanesque subjects, while having to compete with topics varying from prehistoric stone circles to medieval viticulture, constitute about one-tenth of the material.

The first Secretary of the Antiquaries was William Stukeley (507), a scholar as omnivorous as Aubrey and an observant worker in the field. One of his major contributions to Romanesque studies came about when he visited Hereford in 1721 and recognized the importance of the late 11th-century Bishop's Chapel, a rare English example of a two-storeyed palace chapel (509). Although he was unsure of the building's date, referring generally to the vault having 'a taste of that kind of architecture used in the declension of the Roman empire', he carefully recorded the plans and interior views of both chapels.[26] His drawings are the best evidence of the building since it was shamefully demolished only sixteen years after his visit.

It was another distinguished member of the Society of Antiquaries, of a younger generation than Stukeley, who promoted – almost created – the study of Romanesque on its own, as distinct from the pointed, Gothic style. Charles Lyttelton (516) was the younger brother of Sir George (later Lord) Lyttelton, of Hagley Hall, Worcestershire, and a cousin of the Pitts and of the Grenvilles of Stowe. His preferment in the Church as Dean of Exeter and then, in 1762, Bishop of Carlisle, was aided by his powerful connections, but his election as President of the Antiquaries in 1765 was due to his own merit. His academic energies were devoted not to published work (his few articles were not printed until after his death) but to assembling materials on medieval architecture in general and Romanesque in particular through his own travels, and, even more, through an extensive correspondence with other antiquaries such as Borlase of Cornwall and Hutchins of Dorset. The special interest Lyttelton maintained in the Romanesque and the major role he played in awakening enthusiasm for it in others was spelt out by the dedication to him, itself significant, of *Anglo-Norman Antiquities* published by Andre Coltee Ducarel, a Huguenot lawyer and church

historian, in 1767.[27] 'The difference between the mode of architecture used by the Normans in their buildings, and that practised by the cotemporary [sic] Saxons in England was first remarked by your Lordship [Lyttelton] about the year 1742 at which time you kindly communicated your discovery to the antiquaries of your acquaintance, and favoured them with some rules whereby to distinguish the Norman structures from those of the Saxon'.[28] Ducarel ingenuously credited his own research into Norman architecture in its French homeland 'entirely' to Lyttelton.

Lyttelton himself was conscious of his pioneer role. In the folio of drawings of 'Saxon' buildings which he gradually assembled and which he bequeathed to the Society of Antiquaries, he wrote an introductory note claiming it was 'ye only collection of Saxon buildings that ever was made'. He traced his perception of Romanesque as a style of its own specifically back to Aubrey, describing to the Antiquaries in 1757 how he 'took the first hint of this different style of architecture from a loose sheet of Mr Aubrey's manuscripts in the Ashmolean, wherein he gives a rude drawing of the tower of St Mary's Church at Devizes and a window of the Chequer Inn at Oxford as Saxon architecture in contradistinction to Gothic' (i.e. f. 155 of the *Chronologia Architectonica*).[29]

While Lyttelton was defining Romanesque by an analysis of its detail, others were attempting to place it within the whole history of English post-Roman architecture. Although various projects during the 18th century to publish a full-scale history, notably those by Sanderson Miller and James Essex, failed to come to fruition, there were several substantial essays towards it. Thomas Warton used the opportunity of his *Observations on Spenser's Faerie Queen*, published in 1762, to write a long note on the 'beginning and progressive state of architecture in England down to the reign of Henry VIII'. His remarks on Romanesque were brief but pertinent. 'The Conqueror imported a more magnificent, though not a different plan[from Anglo-Saxon architecture]. . . . The style then used consisted of round arches, round-headed windows, and round massy pillars, with a sort of regular capital and base. This has been named the Saxon style, being the national architecture of our Saxon ancestors before the Conquest for the Normans only extended its proportions and enlarged its scale. But I suppose at that time it was the common architecture of all Europe.'[30] Warton cited some examples of the style, with dates that are still generally accepted: the transept of Winchester Cathedral, 1080; the nave of Gloucester Cathedral, 1100; the two towers of Exeter Cathedral, 1112; Christ Church Cathedral, Oxford, 1180.

Horace Walpole (515), although a boyhood friend of Lyttelton and fellow medievalist, gave the Romanesque short shrift in his *Anecdotes of Painting*, published the same year as Warton's book. He noted the round arch and zigzag ornament but ridiculed any research to discover 'when one ungracious form jostled out another.'[31] For him the elements of classical Roman architecture to be detected in the style were 'bad Latin': progress and beauty were only to be found in Gothic.

Another of Walpole's old friends to be a serious student of Romanesque was the poet Thomas Gray (519) who spent much of his later life investigating not literature but medieval architecture. He formed one of a group of antiquaries in and around Cambridge which included William Cole; James Essex, the leading Cambridge architect; and James Bentham, a minor canon of Ely Cathedral. By a curious paradox Gray, the most famous personality, was the least willing to make his work public and Essex, who had the greatest professional knowledge of medieval buildings, was never able to complete the *magnum*

opus for which he was assembling material half his life. So it fell to Bentham to publish in 1771 'some general observations and inquiries into the state of architecture at different periods' as part of the introduction to his *History . . . of the Cathedral Church of Ely*. Bentham was very much a local figure, involved with the affairs of his Cathedral and city, but his book was of national significance. Cole, who made a large contribution to the book, considered that it was impossible for 'so good a book' to come from a man of 'such obstinacy and ignorance' and that the real author was Bentham's brother Edward, Professor of Divinity at Oxford. [32] It is certainly true that much of the value of Bentham's section on the Romanesque is due to Thomas Gray and James Essex. In particular, Gray contributed the detailed analysis of Romanesque ornament; this went far deeper than the generalized history of the rest of the text which depended on documentary references rather than on observations. [33] Gray described and illustrated chevron or zigzag, billet moulding, nail-head and the spiral grooving and lozenge-work on the piers at Durham and elsewhere. Essex was able to interpret the actual fabric of Ely Cathedral for Bentham since from 1757 he was architect to a major restoration of the building for which Bentham acted as clerk of works. It was also thanks to Essex that the book was splendidly illustrated with accurate elevations, sections and plans of the Cathedral. Their collaboration did, however, have one ill effect. Their mistaken identification of the late-12th century infirmary hall as the church of the Saxon nunnery confused writers for the next 50 years as to what were the true stylistic differences between Saxon and Norman architecture.

The years around 1800 witnessed much concern and controversy about the Romanesque, its origins, its naming and its monuments, but there were few novel contributions to the debate. As one commentator complained, 'where so many are ready to teach, few are satisfied with what they learn.' [34] A typical production of the time is Taylor's *Gothic Architecture*, first printed in 1800 and again in 1801 and 1807, which is simply a collection of what had been published by earlier writers such as Wren, Warton and Bentham. Even John Milner, the combative Roman Catholic antiquary, Bishop of Castabala *in partibus infidelium* but resident in Winchester, had less to contribute on the round-arched style than on the origins of the pointed, which he detected in the intersecting arches of 12th-century wall arcading, most notably at St Cross. Milner and his friend John Carter, the antiquarian draughtsman, architect and controversialist, were leaders in the resistance to the cathedral restorations of James Wyatt. While those at Salisbury and Lichfield were concentrated on Gothic buildings, the restoration of Durham in the 1790s provoked some of Carter's most savage diatribes against Wyatt. [35] The most serious damage to the Romanesque fabric was the destruction of the apse and the vault of the chapter house in order to create a 'comfortable room', but the yet more alarming threat to replace the Galilee Chapel at the west end of the cathedral with a carriage drive – 'St Cuthbert's Promenade' as Carter dubbed it – was abandoned. The Dean and Chapter were induced to bow to a public protest, inspired by appreciation of the Romanesque architecture of the building, not by arguments of utility.

The most positive contribution of the period was the number not just of views of Romanesque buildings but of drawings and engravings of sections, details and ornament. William Wilkins the elder, father of the neo-classical architect, published in *Archaeologia* a series of Romanesque details, drawn chiefly from his home territory of East Anglia (520). [36] His example was followed by John Adey Repton, son of the landscape gardener, who included examples from southern England and especially Winchester (535), where he drew not merely St Cross but also Henry of Blois' palace at Wolvesey. Together with these didactic drawings, which are often of high technical and aesthetic quality, many hundreds of topographical drawings and watercolours were produced, both as works of art in themselves and for engraving. John Buckler was perhaps the most prolific, achieving such feats as the recording of every church and chapel in Wiltshire with one or two elevations of every building and detailed studies of features of interest. His sensitive watercolour of Romanesque details at Durnford Church shows that he was no mere hack (536).

To discuss the topographical drawings of Turner, Girtin, Cotman, de Wint – to name only the most eminent – in terms of English landscape art is too vast a subject to attempt here. Their choice of Romanesque subjects tended to be limited to a repertoire of favourite sites, such as Buildwas Abbey or Durham Cathedral, which were to be encountered on picturesque itineraries of the North Country or the Welsh Marches. The architecture was appreciated for its sublime effect as well as for its historical value. The very number of pictures produced shows that there were many potential patrons; by the early 19th century the educated public was prepared to consider Romanesque building no longer as uncouth objects of antiquarian interest only, but as powerful works of art.

This section is concerned principally with attitudes to Romanesque rather than with the physical restoration of Romanesque buildings or with new building in a Romanesque style. These latter aspects deserve more space than is available but even a brief glance helps to show how contemporary theory was expressed in practice.

The Romanesque parts of Ely Cathedral underwent a series of major repairs in the 17th and 18th centuries. [37] The external face of the nave north aisle was renewed in 1662 as part of the repairs to the building after its decay during the Civil War. In 1699 a far more serious restoration had to be considered, since on 29 March, without any warning, the north-west angle of the north transept collapsed. The Dean and Chapter ordered that the fabric should be replaced 'exactly in ye same manner and on ye same foundation it stood before.' [38] The job was given to Robert Grumbold, the leading Cambridge mason of the day, and advice was taken from the officers of the King's Works in London, including the Surveyor-General himself, Christopher Wren. [39] The result is a faithful reproduction of the original structure, including the capitals and bases of the gallery inside and the billet moulding. Even the grotesque heads on the north-west 'tourelle' were copied, although with the features of contemporary pouting *putti*. The only conscious anachronism occurs on the north front of the transept where a large rusticated doorway was introduced, resembling that in the tower of Wren's St Mary le Bow church, London, and the round-headed window above was given two mullions and a transom like those of Wren's Trinity Library, Cambridge. The cost of the restoration was £2,637 6s. 4d., raised by subscription (506).

The mid-18th-century restoration of the cathedral by James Essex has already been mentioned. It was mostly concentrated on the Gothic octagon and east end but in his first survey, of 1757, he discussed the structural problems of the west tower and the ruinous south-west transept. The only important feature destroyed in the restoration was the 12th-century pulpitum in the nave, a stone screen which closed the west end of the original choir. This became redundant when the choir was moved to the far east end of the building in 1770. Bentham,

who was the chief instigator of the change, maintained a discreet silence about the screen; however, Essex made some rough drawings of it giving the basic measurements (518).[40]

Moving to the Welsh Marches, the 12th-century church of Shobdon, a few miles from Hereford, was demolished in 1751–2 and its carved arches and doorways, now recognized as the key masterpiece of the Herefordshire School of sculpture, were incorporated in a gabled eye-catcher for the great house, Shobdon Court. This was not an act of frivolous vandalism. A new church of great character was built, in a spiky Gothic rather than in a round-arched style; it was undoubtedly less cold and uncomfortable than the old. The Romanesque sculpture was preserved and kept together by being built into the folly, instead of being abandoned. The tragedy is that little has been done in the past hundred years to preserve the sculpture from decay and vandalism.

In the city of Hereford itself occurred two unrelieved disasters for the Romanesque. In 1737 Bishop Egerton decided to demolish his remarkable double chapel of Sts Catherine and Mary Magdalene, whose recording by Stukeley has already been mentioned. The Bishop claimed he wished to replace the chapel with another 'more polite and neat pile in the present taste' and he organized a commission – including, it was said, his steward – to condemn the chapel as 'ruinous and useless'.[41] Demolition proved slow and costly but by 1757 all except the north wall had disappeared. The only positive aspect of the affair was the response made by the Society of Antiquaries which had an elevation and plan of the building drawn and engraved (509).

Even more serious was the collapse of the Romanesque west tower of Hereford Cathedral on Easter Monday 1786 which brought down with it two bays of the nave (508). Although the structural problems had been known for years they had only been aggravated by the piecemeal repairs attempted. By August the Dean and Chapter had petitioned for a faculty to curtail the nave by one bay. The Bishop refused but he was eventually overruled by the Archbishop of Canterbury and the nave was rebuilt shorter and without a west tower, principally to save money but also to create a more 'uniform' appearance.[42] Wyatt's estimate was for £6,500, though over £20,000 was eventually spent. Such economy meant that the Romanesque character of the former nave and west front was ignored and the triforium and clerestory rebuilt with simple Y tracery in Gothic openings. The new west front, in a pinched late medieval style, survived little more than a century before it was replaced in 1902–8 by John Oldrid Scott in an equally inappropriate but more robust Decorated style.

The arrival of full understanding and appreciation of the Romanesque is perhaps demonstrated not by the restoration of ancient buildings but by the design of new in an overtly neo-Romanesque style. The earliest so far identified – the rebuilding of Tickencote Church, in the former county of Rutland, and Spring Hill Tower, Broadway – belong to the 1790s, but the confident handling of their detail and the lack of critical surprise at their appearance show that the idea of such a style

was already current.

Tickencote Church, with its elaborately decorated east front and chancel arch, had long been famous as an example of Romanesque architecture, particularly as it was generally dated to before the Conquest (523). In 1792 it was rebuilt by S.P. Cockerell (father of the celebrated neo-classical architect, C.R. Cockerell) for a Miss Eliza Wingfield whose family had long been important in the locality. Cockerell retained the chancel as it was, though he regularized some of the external ornament: the nave, which appeared to be of later date, he rebuilt in a Romanesque style of his own to suit the chancel. Neither patron nor architect were archaeological enthusiasts, so the choice of style cannot have been too unconventional.

Spring Hill Tower, Broadway, the contemporary counterpart in secular architecture to Tickencote Church, did not owe its style to a previous building nor even to ancient associations of its site (546). It was designed by James Wyatt in 1794 for the 6th Earl of Coventry to be an eye-catcher from Croome Court, Worcestershire. Its essentially triangular plan links it with earlier triangular folly towers in Georgian parks, such as those designed by James Gibbs for Whitton Park, Middlesex, and the still surviving Gothic Temple at Stowe. Wyatt's use in Spring Hill Tower of specific Romanesque detail, as in the shafts and capitals of the window surrounds, gave an archaeological reference that was particularly relevant in the 1790s when, as mentioned above, the difference between Norman and Saxon architecture was the subject of lively academic debate.[43]

These two buildings were the harbingers of many scores of neo-Romanesque churches and castles and other public buildings constructed in the first five decades of the 19th century and even later. To trace their development would need another exhibition. The style was sometimes used unimaginatively, particularly in large and economical 'Commissioners' churches', such as St Botolph's, Colchester, and Christ Church, Tunbridge Wells, but it was also deployed on buildings of the scale and power of Penrhyn and Brancepeth Castles or of the churches of Sts Mary and Nicholas, Wilton (549), and Christ Church, Streatham.[44]

Yet the 19th-century Gothic Revival was principally a celebration of pointed architecture, not of the Romanesque. Pugin's conviction that Gothic and Christian were one and the same gradually spread to all ecclesiastical bodies; the models for secular architecure were late medieval manor houses, not early medieval castles. Architecturally Romanesque was in danger of being confined to gaols and to cheap medievalizing of Georgian churches. The major contribution of the Victorian age to Romanesque studies was in the academic field. The researches of scholars like Willis made the dating of the style and of its evolution much more precise; connoisseurs like Gambier Parry studied Romanesque manuscripts for their artistic as well as their historical and literary value. The insights, disputes, errors of the 17th- and 18th-century pioneers of the subject were gathered together into the great fund of modern scholarship. T.C.

NOTES

*Works cited in this section refer to the Bibliography opposite.

1. MS note by C. Lyttelton in his 'Book of Drawings of Saxon Churches', now in the library of the Society of Antiquaries.
2. Stubbs, 1887–9, ii, p. 306.
3. Somner, 1640, p. 86.
4. Ledwich, 1786, p. 194.
5. Bentham, 1771, p. 33.
6. de Beer, 1948, passim.

7. North, 1981, pp. 110–11.
8. Wren, 1750, p. 296.
9. Gray, 1937, ii 862 and iii 1302.
10. BL Add. MS 6768, p. 115.
11. Letter of 1775 from J. Bradley to 'Governor' Pownall: Pownall, 1788, p. 126.
12. Gentleman's Magazine LXXX, 1810, i, p. 130.

13. Wilkins, 1795, pp. 157–60.

14. Gunn, 1819, p. 80, note 7. Gunn adopted the term 'Romanesque', used, he claimed, to distinguish a Roman of foreign or dubious origin from a true 'Romano', to describe the way in which the round-arched style is 'a vitious deviation from true Roman architecture': Gunn, 1819, p. 6.

15. Much of the material for the *Monasticon* was contributed by Roger Dodsworth, a Yorkshire antiquary who died in 1654.

16. W. Somner's *Antiquities of Canterbury*, published in 1640, included a history of the Cathedral fabric but without illustrations. The first views of the Cathedral appeared in the *Monasticon*, whose publication was aided by Somner: they were prepared by Thomas Johnson (502) who drew a plan and three elevations of the building.

17. It has recently been emphasized 'how aware he [Dugdale] was of the importance of visual information': Griffiths, Kesnerová, 1983, p. 62.

18. For a full account of this development see de Beer, 1948, *passim*, especially pp. 155–6.

19. Jones, Webb, 1655, p. 68.

20. The *Monumenta Britannica* (now in the Bodleian Library, MS top. gen. c. 25) has only been published, in part, in recent years but the MS was known to 18th-century antiquaries (see note 29 below).

21. Bodleian Library, MS, top. gen. c. 25 f. 151r.

22. Wren, 1750, p. 275.

23. *Ibid.*

24. North, 1981, p. 111.

25. See Evans, 1956, chapters IV–X.

26. Drinkwater, 1954, p. 131.

27. Ducarel had already published in 1754, anonymously, a brief and much less scholarly account of his tour, which he made in 1752.

28. Ducarel, 1767, pp. i ii.

29. Lyttelton, 1770, p. 141. The main part of the *Monumenta Britannica* was at this time in a private collection in Dorset and was known to Lyttelton and other contemporary antiquaries; the MS was eventually reunited in the Bodleian.

30. Warton, 1762, ii, p. 186.

31. Walpole, 1762, p. 106.

32. Davis, 1814, p. 125.

33. Gray, 1937, ii, p. 864 and Bentham, 1817, pp. 13–17.

34. Dallaway, 1806, p. 3.

35. Cordingley, 1955, pp. 43–55.

36. Wilkins, 1795, plates xxv–xlii.

37. Cocke, 1979, *passim*.

38. Ely diocesan papers on deposit at the University Library, Cambridge: Ely Chapter Act Book 2/1/2, p. 229.

39. Three letters from Dean Lambe describing his meetings with the chief Officers of the Works and the Archbishop of Canterbury (preserved in the 4/5 bundle in the Ely diocesan papers; see previous note) were published by Gibbon, 1935.

40. British Library, Add. MS 6768, pp. 122–4 and Gray, 1937, ii, p. 865.

41. Duncumb, 1804, pp. 495–6.

42. Winnington-Ingram, 1952–4, p. 42.

43. See Frew, 1982, p. 148. Dr Timothy Mowl considers the early-18th century rebuilding of Shirburn Castle, Oxfordshire, as 'essentially neo-Romanesque' (private communication).

44. I am most grateful to Dr Timothy Mowl for allowing me to consult his closed DPhil thesis on the Norman Revival in the Bodleian Library.

ANTIQUARIAN BIBLIOGRAPHY

Bentham, 1771, 1817
J. Bentham, *The History and Antiquities of the Conventual and Cathedral Church of Ely*, 1771, 2nd edn., 1817

Blayney Brown, 1982
D. Blayney Brown, *Catalogue of the Collection of Drawings (Ashmolean, Oxford)*, vol. IV, 1982

Britton, 1807–21
J. Britton, *The Architectural Antiquities of Great Britain*, 1807–21

Britton, 1836
J. Britton, *Cathedral Antiquities*, 5 vols., 1836

Caroe, 1911
W.D. Caroe, 'Canterbury Cathedral choir during the Commonwealth and after, with special reference to two oil paintings', *Archaeologia*, LXII, 1911, pp. 353–66

Cocke, 1973
T.H. Cocke, 'Pre-19th-century attitudes in England to Romanesque architecture', *J. Brit. Archaeol, Assoc.*, 3rd series, XXXVI, 1973, pp. 72–97

Cocke, 1975
T.H. Cocke, 'James Essex, Cathedral Restorer', *Archit. Hist.*, XVIII, 1975, pp. 12–22

Cocke, 1979
T.H. Cocke, 'The architectural history of Ely Cathedral from 1540–1840' in 'Medieval art and architecture at Ely Cathedral', *Brit. Archaeol. Assoc. Conf.*, II, 1976, 1979, pp. 71–7

Colvin, 1968
H.M. Colvin, 'Aubrey's Chronologia Architectonica', *Concerning Architecture*, ed. J. Summerson, 1968, pp. 1–13

Cordingley, 1955
R.A. Cordingley, 'Cathedral innovations; James Wyatt, architect, at Durham Cathedral 1795–7', *Transactions of the Ancient Monuments Society*, III, 1955, pp. 31–55

Dallaway, 1806
J. Dallaway, *Observations on English Architecture*, 1806

Davis, 1814
W. Davis (ed.), *An Olio of Bibliographical and Literary Anecdotes and Memoranda*, 1814

de Beer, 1948
E.S. de Beer, 'Gothic: origin and diffusion of the term', *J. Warb. Court Inst.*, XI, 1948, pp. 143–62

Drinkwater, 1954
N. Drinkwater, 'Hereford Cathedral: The Bishop's Chapel of St Katherine and St Mary Magdalene', *Archaeol. J*, CXI, 1954, pp. 129–37

Drury, 1982
P.J. Drury, 'Aspects of the origins and development of Colchester Castle', *Archaeol. J.*, CXXXIX, 1982, pp. 302–429

Ducarel, 1767
A.C. Ducarel, *Anglo-Norman Antiquities Considered in a Tour through Part of Normandy*, 1767

Dugdale, 1658
W. Dugdale, *The History of St Paul's*, 1658

Duncumb, 1804
J. Duncumb, *Collections towards the History and Antiquities of the County of Hereford*, 1804

Evans, 1956
J. Evans, *A History of the Society of Antiquaries*, 1956

Fowles, 1980–2
J. Fowles (ed.), *Monumenta Britannica by John Aubrey (1627–1697)*, 1980–2

Frew, 1982
J. Frew, 'Some Observations on James Wyatt's Gothic Style 1790–1797', *J. Soc. Archit. Hist.*, XLI, 1982, pp. 144–9

Gibbon, 1935
R.H. Gibbon, 'John Lambe, Dean of Ely 1693–1708', *Church Quarterly Review*, CXIX, 1935, pp. 226–56

Girtin, Loshak, 1954
T. Girtin and D. Loshak, *The Art of Thomas Girtin*, 1954

Gray, 1937
T. Gray, *Correspondence*, ed. by P. Toynbee and L. Whitley, 3 vols, 1937

Griffiths, Kesnerová, 1983
A. Griffiths and G. Kesnerová, *Wenceslaus Hollar, Prints and Drawings*, 1983

Gunn, 1819
W. Gunn, *An Inquiry into the Origin and Influence of Gothic Architecture*, 1819

Hamper, 1827
W. Hamper (ed.), *The Life, Diary and Correspondence of Sir William Dugdale*, 1827

Harris, 1971
J. Harris, *A Catalogue of British Drawings for Architecture, Decoration, Sculpture and Landscape Gardening, 1550–1900, in American Collections*, 1971

Henry, Zarnecki, 1957–8
F. Henry and G. Zarnecki, 'Romanesque arches decorated with human and animal heads', *J. Brit. Archaeol. Assoc.*, 3rd series, XX–XXI, 1957–8, pp. 1–34, reprinted in Zarnecki, 1979 a (see general bibliography)

Hope, 1917
W.H. St J. Hope, 'Quire Screens in English churches with special reference to the 12th-century quire screen formerly in the Cathedral Church of Ely', *Archaeologia*, LXVIII, 1917, pp. 43–110

Johnson, 1976
E. Mead Johnson, *Francis Cotes*, 1976

Jones, Webb, 1655
I. Jones & J. Webb, *The Most Notable Antiquity of Great Britain vulgarly called Stone-Heng*, 1655

Ledwich, 1786
E. Ledwich, 'Observations on our ancient churches', *Archaeologia*, VIII, 1786, pp. 165–94

Legg, 1936
L.G. Wickham Legg (ed.), 'A relation of a short survey of the western counties

made by a lieutenant of the military company in Norwich in 1635, *Camden Miscellany*, XVI, 1936

Loyd, Stenton, 1950
L.C. Loyd and D.M. Stenton (eds.), *Sir Christopher Hatton's Book of Seals*, Northants Record Society, XV, 1950

Lyttelton, 1770
C. Lyttelton, 'On the antiquity of brick buildings in England', *Archaeologia*, I, 1770, pp. 140–7

McKisack, 1971
M. McKisack, *Medieval History in the Tudor Age*, 1971

Milner, 1809
J. Milner, *The History, Civil and Ecclesiastical and a Survey of the Antiquities of Winchester*, 2nd edn., 1809

Mowl, Earnshaw, 1981
T. Mowl and B. Earnshaw, 'The origins of 18th century Neo-medievalism in a Georgian Norman castle', *J. Soc. Arch. Hist.*, XL, 1981, pp. 289–94

North, 1981
R. North, *Of Building*, ed. H.M. Colvin and J. Newman, 1981

Piggott, 1950
S. Piggott, *William Stukeley*, 1950

Pownall, 1788
T. Pownall, 'The origin and progress of Gothic architecture, *Archaeologia*, IX, 1788, pp. 110–26

Rastall, 1787
W. Dickinson Rastall, *The History and Antiquities of the Town and Church of Southwell*, 1787

Rickman, 1817
T. Rickman, *An Attempt to Discover the Styles of English Architecture*, 1817

Somner, 1640
W. Somner, *The Antiquities of Canterbury*, 1640

Stubbs, 1887–9
W. Stubbs (ed.), *Willelmi Malmesbiriensis Monachi De Gestis Regum Anglorum*, 1887–9

Walpole, 1762
H. Walpole, *Anecdotes of Painting in England*, 1762

Warton, 1762
T. Warton, *Observations on the Fairy Queen of Spenser*, 1762

Wilkins, 1795
W. Wilkins, 'An essay towards an history of the Venta Icenorum of the Romans and of Norwich Castle', *Archaeologia*, XII, 1795, pp. 132–80

Willis, 1727, 1730
B. Willis, *A Survey of Cathedrals*, 1727 and 1730

Winnington-Ingram, 1952–4
A.J. Winnington-Ingram, 'The rebuilding of Hereford Cathedral 1786–1796', *Transactions of the Woolhope Naturalists' Field Club*, XXXIV, 1952–4, pp. 42–54

Wormald, Wright, 1958
F. Wormald and C.E. Wright, *The English Library before 1700*, 1958

Wren, 1750
S. Wren (ed.), *Parentalia*, 1750

Yates, 1843
R. Yates, *An Illustration of the Monastic History and Antiquities of the Town and Abbey of St Edmunds Bury*, 2nd revised edn., 1843

Exhibition Catalogues

London, 1971
Sir Godfrey Kneller, National Portrait Gallery, London, 1971

London, 1972
The Age of Charles I, Tate Gallery, London, 1972

London, 1980
Horace Walpole and Strawberry Hill, Orleans House Gallery, London, 1980

London, Manchester, Bristol, 1982–3
Great Britain, Arts Council, *John Sell Cotman 1782–1842*, Victoria and Albert Museum, London, Whitworth Art Gallery, Manchester, and Bristol Museum and Art Gallery, 1982–3

London, 1983
see Griffiths, Kesnerová, 1983

Manchester, London, 1975
Thomas Girtin, Whitworth Art Gallery, Manchester and Victoria and Albert Museum, London, 1975

Norwich, 1979
John Sell Cotman 1782–1842: Early Drawings (1798–1812) in Norwich Castle Museum, Norwich Castle Museum, 1979

York, 1973
A Candidate for Praise: William Mason, York Art Gallery, 1973

496 'Queen Bertha's Comb'

Ivory; *h* 100 mm, *w* 114 mm
(?) 12th century
London, Trustees of the British Museum, 1916–4.3.1

This liturgical comb is probably of 12th-century origin. In the late 16th or early 17th century it was inscribed in archaizing script 'Missū fuit pecten hoc a Gregorio papa ad Berthā Reginā' ('This comb was sent by Pope Gregory to Queen Bertha'). The claim was thus made, whether in good or bad faith, that the comb was a gift from Pope Gregory the Great to Queen Bertha, the Christian consort of the pagan king of Kent whom Gregory converted through the mission of St Augustine of Canterbury in 597. The distinguished provenance of the object in the 17th and 18th centuries, when it passed through the most celebrated antiquarian collections of the day, shows how a historical association, whether authentic or not, could ensure the preservation and appreciation of a medieval object. T.C.

PROVENANCE Thomas, Earl of Arundel; sold by 10th Earl of Stafford to Edward, 2nd Earl of Oxford, 1720; inherited by Duchess of Portland; bought by Horace Walpole, 1786; sold Strawberry Hill, 1842; given to British Museum, 1916
EXHIBITION London, 1980, no. 154

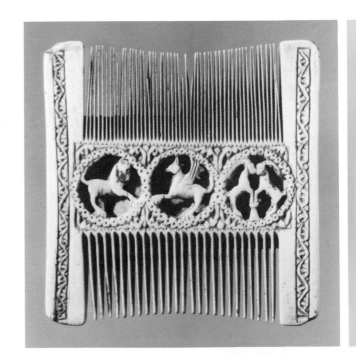

498

497 Matthew Parker, Archbishop of Canterbury
(1504–75) (*not illustrated*)

George Vertue (1684–1756)
Mezzotint engraving; *h* 320 mm, *w* 210 mm (image and title),
h 470 mm, *w* 299 mm (whole-sheet)
1729
London, Trustees of the British Museum, O'Donoghue III,
p. 411, no. 16

Parker's career spanned the troubled years of the Reformation
during which he rose from being chaplain to Anne Boleyn and
Master of Corpus Christi College, Cambridge, to Archbishop
of Canterbury under Elizabeth. He was deeply concerned at the
dispersal of the great monastic libraries and as Archbishop used
his position to retrieve many important manuscripts for his
own collection, which he bequeathed to his old college in
Cambridge. This print was prepared by the antiquarian
engraver George Vertue for an edition of 1729 of Parker's
magnum opus in defence of the Anglican church, *De
Antiquitate Brittannicae Ecclesiae.* T.C.

498 Sir Robert Cotton (1570–1631)

After Paul van Somer (*c.* 1576–1621/2); engraved by George
Vertue (1684–1756)
Mezzotint engraving; *h* 365 mm, *w* 221 mm
1744
London, Trustees of the British Museum, O'Donoghue I,
p. 506, no. 4

Sir Robert Cotton was one of the most distinguished
antiquaries of the early Stuart period. He amassed a great
collection of manuscripts, which remained intact after his
death to form one of the nuclei of the British Museum's
collection, in spite of a disastrous fire in 1731. He is depicted
with his hand on the Cotton Genesis, one of his most
celebrated manuscripts. This engraving of his portrait was
commissioned by the Society of Antiquaries and published in
1744 in *Vetusta Monumenta* vol. I, pl. LXXI. T.C

499 Sir Christopher Hatton's Book of Seals
(*illustrated on p. 79*)

Pen and ink and coloured wash; each f. *h* 444 mm, *w* 349 mm
1640/41
The Earl of Winchilsea's Trustees; Finch Hatton MS 170

In 1640 or 1641 Sir Christopher (later Lord) Hatton
commissioned 'a collection of rare charters and deedes, I meane
the copying of them in the letter, observing the shape of the
deede' (letter of William Dugdale to Sir Symon Archer, 4
March 1640/41: Hamper, 1827, p. 203). The early manuscripts
were copied with meticulous care, the vellum page being tinted
to appear like parchment and the shape of the charters and of
the seals and cords carefully reproduced. 128 folios were
completed before the Civil War put an end to the project. The
book is open to show charter no. 431 at the head of the right-
hand page (f. 92ʳ), which records in Latin and Anglo-Saxon a
grant to Christ Church, Canterbury, by Odo of Bayeux, half-
brother to the Conqueror. The original, which is one of the
Cotton MSS in the British Library (Cotton, Chart. XVI. 31), was
much damaged by the fire of 1731 (498), and the fine seal,
showing Odo on one side in clerical garb as Bishop of Bayeux
and on the other in armour as Earl of Kent, is now lost. The
other 12th-century charters depicted on the two pages on
exhibition are: on the left-hand page (f. 91ᵛ), no. 429, a charter
of William Longsword, brother of Henry II, *c.* 1154–64, and
no. 430, a charter of Henry I, 1114; on the right-hand page
(f. 92ʳ) a charter of Nigel de Mowbray, *c.* 1164–71. The other
two are 13th-century charters by the King of Man and the
Islands. T.C.

PROVENANCE By family descent from the compiler; deposited at the Northamptonshire Record
Office by the 14th Earl of Winchilsea, 1930
BIBLIOGRAPHY Loyd, Stenton, 1950, *passim*

500

500 Sir William Dugdale (1605–86)

Drawn and engraved by Wenceslaus Hollar (1607–77)
Engraving; *h* 257 mm, *w* 168 mm
Dated 1656
London, Trustees of the British Museum, O'Donoghue II,
p. 98, no. 2

Dugdale was a Warwickshire gentleman who devoted his life
to heraldic and antiquarian studies. He was a member of the
circle 'Antiquitas Rediviva' (see p. 361) in the 1630s and was
active recording monuments before the threat of the Civil War.
His publications included in 1655 the great *Monasticon
Anglicanum* (in partnership with Richard Dodsworth), which
is one of the books shown in the foreground of this engraving,
and in 1658 the *History of St Paul's*, the first well illustrated
account of a medieval building. His association with Hollar
was inspired by his desire to have visual records as well as
documentary histories of the past. T.C.

501 West front of Rochester Cathedral
(*not illustrated*)

Drawn and engraved by D. King
Engraving; *h* 240 mm, *w* 170 mm
1655
Private collection

The west front of Rochester Cathedral dates from the mid-12th
century. In spite of the insertion of a Perpendicular west
window and much alteration of the towers and turrets in the
18th and 19th centuries (their present design was based on this
engraving), it remains one of the most homogeneous
Romanesque façades in the country. The engraving was made
by King as an illustration to the *Monasticon Anglicanum* by
Dodsworth and Dugdale, and it was also published by King in
1656 in his book, *Cathedral and Conventual Churches*, the first
such book of engraved views of medieval churches. T.C

502 Choir of Canterbury Cathedral, looking east

Thomas Johnson (fl. 1634–85); signed
Oil on panel; *h*. 660 mm, *w* 1.041 m
Dated 1657
Mr Alban D.R. Caroe, FSA, FRIBA

The painting shows the interior of Canterbury Cathedral
looking east from the pulpitum, over the choir and sanctuary
which were both built in 1175–84 within the outer shell of the
early 12th-century east end. It is no naïve rendering but a
meticulous record of the architecture and fittings of the
building: some of the latter, such as the paintings on the aisle
walls, the screens by the high altar and the choir stalls
themselves, have since disappeared. The depiction of
iconoclasts at work on the stained glass in the south aisle
probably commemorates the havoc wrought by 'Blue Dick'
Culmer in 1643 rather than a renewed outbreak in 1657, by
which date iconoclasm was officially discouraged. T.C.

EXHIBITION London, 1972, no. 177
BIBLIOGRAPHY Caroe, 1911, pp. 353–62

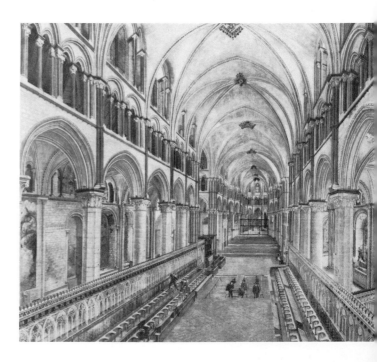

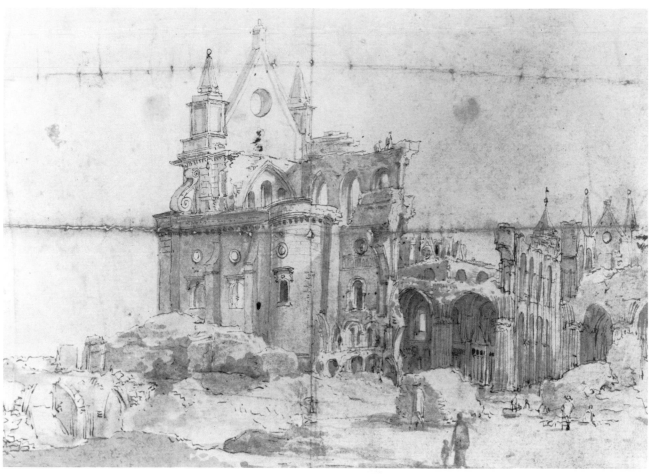

503

503 St Paul's Cathedral after the Great Fire

Thomas Wyck (*c.* 1616–77)
Pen and wash; *h* 123 mm, *w* 172 mm
c. 1667
City of London, Guildhall Library

The Romanesque nave and transepts of Old St Paul's Cathedral
survived until the Great Fire of London in 1666, although
externally they had been encased by a classical refacing in the
1630s restoration of the Cathedral by Inigo Jones. The massive
walls and piers withstood the fire but proved too damaged to
be repaired even temporarily, and they were all demolished in
favour of Wren's new building. The plates illustrating the
cathedral, both inside and out, in Dugdale's *History of St
Paul's* (1658), and the discussions in connection with rebuilding
the fabric before and after the fire constitute the first detailed
record of a medieval building in England. This view by Thomas
Wyck, a Netherlandish artist, depicts the ruined interior from
the north-west, looking across into the south transept, nave
and south aisle. T.C.

504 John Aubrey (1626–97) (*not illustrated*)

William Faithorne (1616–91); inscribed
Black lead and wash on vellum, tinted with red chalk;
h 192 mm, *w* 145 mm
Dated 1666
Oxford, Ashmolean Museum

John Aubrey, the Wiltshire-born antiquary, was deeply moved
by the devastation of the English past caused first by the
Dissolution of the Monasteries and then, in his own time, by
the Civil War, and he spent his life and property recording all
he could. Although he found it easier to amass material than
to publish it, as a Fellow of the newly-founded Royal Society
he realized the importance of ordering his information: in his
Chronologia Architectonica (505) he drafted the first history of
English architecture from the Saxon and Romanesque periods
onwards, founded not on documents but on details drawn from
specific buildings. T.C.

PROVENANCE Given by Faithorne to Aubrey and by Aubrey to the Old Ashmolean; deposited
by the Curators of the Bodleian Library

505 *Chronologia Architectonica*

John Aubrey (1626–97)
Pen and wash; *h* 314 mm, *w* 196 mm
c. 1670–90
Oxford, Bodleian Library, MS top. gen. c25 ff.153ᵛ, 154ʳ

The *Chronologia Architectonica* was prepared by Aubrey (504)
as part of his *Monumenta Britannica*, an ambitious work
intended to cover all aspects of British antiquities from
prehistory to Aubrey's own day, for which he was amassing
material most of his life. The *Chronologia* has not to this day
been published, but it was known to some 18th-century
antiquaries, such as Lyttelton and Gough. It differs from the
brief summaries of medieval architecture by Aubrey's
contemporaries, Christopher Wren and John Evelyn, with both
of whom Aubrey discussed the subject, not only in its greater
objectivity but also in the way that the successive periods of
medieval architecture were illustrated by details from specific
buildings. On the folios exhibited Aubrey depicted windows
and ornament from Winchester, Norwich, Devizes, Wimborne
and Battle and in one note observed that the intersecting
arcading on the 12th-century tower of St Mary's, Devizes,
could also be found on the west end of Hereford Cathedral
(collapsed 1786). T.C.

BIBLIOGRAPHY Colvin, 1968, *passim*

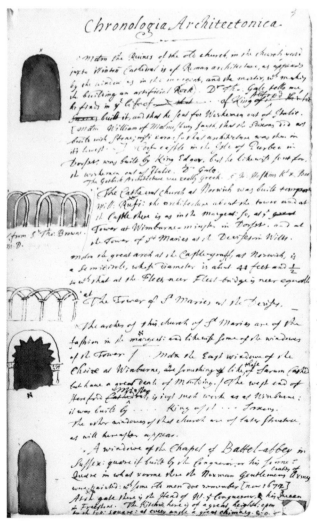

505

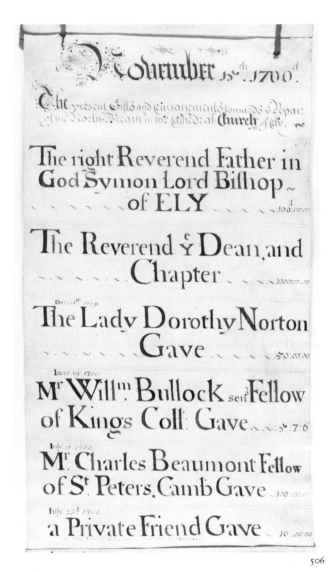

506

506 Roll of donors to the repair of the north transept of Ely Cathedral

Vellum, mounted on wooden roller; *h* 2.3 m, *w* 265 mm (roller
400 mm)
1700
Cambridge, University Library, EDC 4/5/36; lent by permission
of the Dean and Chapter of Ely Cathedral

The north-west corner of the north transept of Ely Cathedral
collapsed suddenly on 29 March 1699. Within three years it had
been rebuilt with exemplary care, at the considerable cost of
£2,637, reproducing the original except for the insertion of a
'Wrenian' window and rusticated doorway on the north side
(Cocke, 1979). The builder responsible was Robert Grumbold
of Cambridge, but Dean Lambe took advice from the officers
of the King's Works, including Wren himself (Gibbon, 1935).
The making of such an inscribed roll of donors to a restoration,
which was then hung in the building, was a common feature
in the 17th and 18th centuries. It is an impressive testimony to
the number of people willing to contribute towards rebuilding
authentically a part of the Cathedral which had no practical
use. T.C.

BIBLIOGRAPHY Cocke, 1979, pp. 72–3; Gibbon, 1935, *passim*

507 William Stukeley (1687–1765) (*not illustrated*)

Godfrey Kneller (1646–1723); signed
Pencil, ink and wash; *h* 289 mm, *w* 197 mm
Dated 1721
London, National Portrait Gallery, 4266

William Stukeley, the first Secretary of the Society of Antiquaries, was a great antiquarian polymath. His wide-ranging observations covered prehistoric, Roman and medieval monuments. While his dating and his deductions can now be open to question, his careful recording, for instance of the Romanesque Bishop's Chapel at Hereford (**509**), is of lasting value. T.C.

EXHIBITION London, 1971, no. 50
BIBLIOGRAPHY Piggott, 1950, *passim*

508 Former west end of Hereford Cathedral

After W. Merricke, engraved by J. Harris
Engraving; *h* 245 mm, *w* 177 mm
c. 1727
Society of Antiquaries of London

The Romanesque west end of Hereford Cathedral, although altered by the insertion of a new west window in the later Middle Ages, survived until Easter Monday 1786 when the west tower collapsed bringing down with it two bays of the nave. In the subsequent repair and restoration by James Wyatt in 1788–96 the nave was shortened by one bay and deprived of its Romanesque character. This engraving was one of the illustrations to Browne Willis's *Survey of Cathedrals* published 1727–30, which was the first book to contain the plan, dimensions and at least one elevation of every cathedral in England and Wales. T.C.

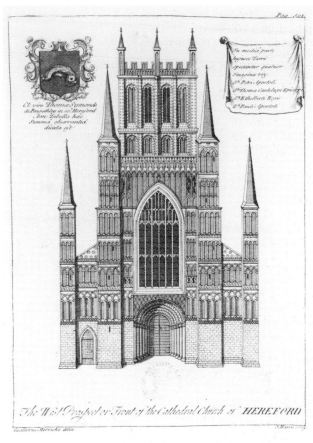

508

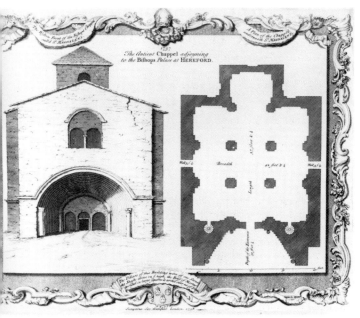

509

509 West front and plan of former Bishop's Chapel, Hereford

Engraving; *h* 312 mm, *w* 381 mm
c. 1737
Society of Antiquaries of London

The Chapel of Sts Catherine and Mary Magdalene, built *c.* 1090 by Bishop Robert of Lorraine, was an unusual example of a two-storied palace chapel. Its needless demolition in 1737 provoked the Society of Antiquaries into publishing this engraving of its plan and west front the next year. Browne Willis, apparently the promoter of the scheme within the Society, considered the vault of the Chapel to be 'undoubtedly of Roman architecture . . . built before the end of the eighth century' (*Vetusta Monumenta* I, text to pl. XIX). William Stukeley (**507**), who had visited the Chapel in 1721 and made a fuller and more accurate survey of it, agreed that the vault had 'a taste of that kind of architecture used in the declension of the Roman Empire' (Bodleian Library, MS top. gen. 113). These comments show how Georgian antiquaries, although they might make mistakes in their dating of Romanesque monuments, could understand their character. T.C.

BIBLIOGRAPHY Drinkwater, 1954, *passim*; Cocke, 1973, p. 89

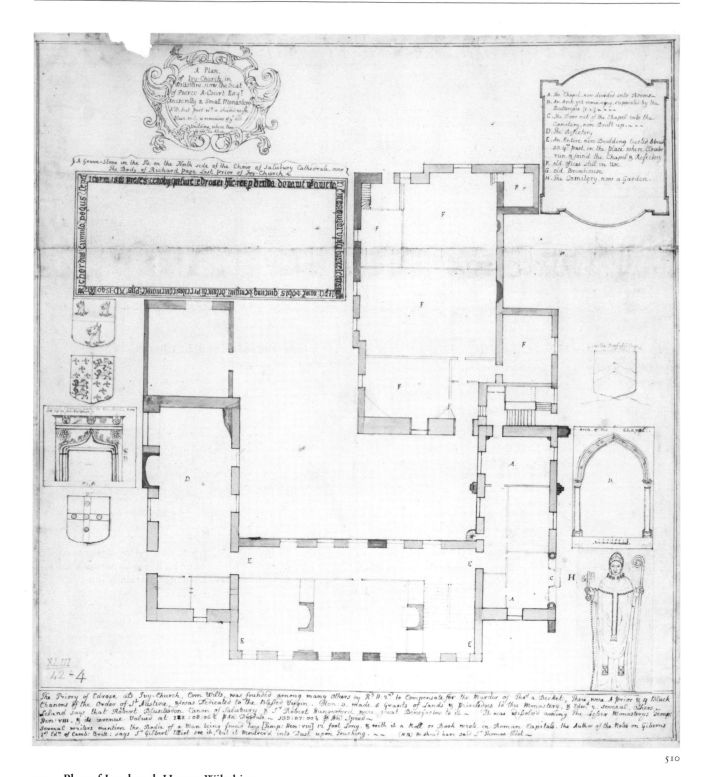

510 Plan of Ivychurch House, Wiltshire

Pen and ink; *h* 455 mm, *w* 394 mm
c. 1750
London, British Library, BL K. Top. XLIII, 42.4

Ivychurch House near Salisbury, Wiltshire (largely demolished in 1889) incorporated much of the fabric of the Augustinian priory of Ivychurch, founded *c.* 1140, which provided chaplains for the nearby royal palace of Clarendon. Many fragments of

Romanesque sculpture survive, including double capitals from the cloisters and two standing figures, displayed elsewhere in this exhibition (**157**). This mid-18th-century plan of the house indicated its surviving medieval features, including, in the bottom right hand corner, a drawing of the St Peter (**157a**). The drawing, although amateurish, is one of the earliest detailed records of Romanesque sculpture, depicted for its own sake, not as part of a building. T.C.

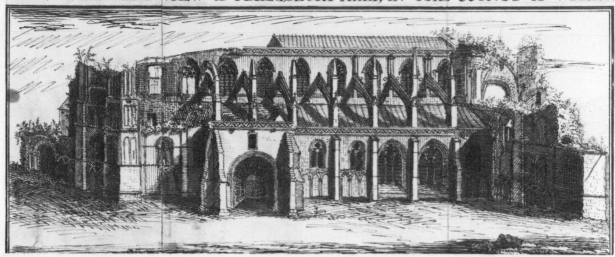

THE SOUTH WEST VIEW OF MALMSBURY ABBY, IN THE COUNTY OF WILTS.

511

511 Malmesbury Abbey Church from the south-west

Samuel Buck (1696–1779) and Nathaniel Buck (fl. 1727–53/9)
Pen and ink; *h* 210 mm, *w* 410 mm
c. 1730
London, Trustees of the British Museum, LB 13b

The church of the ancient Saxon Abbey of Malmesbury was rebuilt *c.* 1150. At the Dissolution most of the nave was retained as a parish church but the choir, crossing and west end were left to ruin. Samuel Buck and his younger brother Nathaniel were the first English topographical draughtsmen to attempt a country-wide survey of ancient buildings: between 1720 and 1753 they produced about 500 engraved views, often the earliest visual records of the buildings. This typical drawing was engraved in 1732 and published in their *Eighth Collection of Views* (pl. 10) in 1733. It is significant that by the 1720s there was a commercial market for such detailed views of medieval buildings. (I am grateful to the staff of the British Museum for allowing me to read their unpublished catalogue entry for this work.) T.C.

512 East front of Barfreston Church
(*illustrated on p.* 47)

Pen and wash; *h* 298 mm, *w* 226 mm
Dated 1749
Society of Antiquaries of London

The drawing comes from the portfolio, or 'Book of Drawings of Saxon Churches', compiled by Charles Lyttelton (**516**) for his own studies during his lifetime and bequeathed to the Antiquaries. He described it in an introductory note as the 'only collection of Saxon Buildings that ever was made'. It comprises drawings by professional draughtsmen, either commissioned by Lyttelton or given to him, and some engravings, particularly of manuscript illuminations. The drawings are, in general, of important Romanesque parish – as opposed to cathedral – churches, such as Iffley (**514**) or Adel, near Leeds, with an emphasis on buildings Lyttelton knew well, for example Halesowen Church near his family home in Worcestershire, and the Castle at Exeter where he was Dean. This drawing of the richly-sculpted east front of Barfreston Church, Kent, of *c.* 1180, shows its condition before it was 'tidied up' in a restoration of 1839–41 by R.C. Hussey. T.C.

513 Copy of the 'Waterworks Plan' from the Eadwine Psalter

Watercolour; *h* 640 mm, *w* 500 mm
c. 1750
Society of Antiquaries of London

In the 18th century it was realized that the 'waterworks plan' contained in the Eadwine Psalter (**62**), already in Trinity College Library, Cambridge, was an invaluable record of the 12th-century buildings of Canterbury Cathedral. This watercolour copy was sent by Charles Mason, a fellow of Trinity, to Charles Lyttelton (**516**) who had it engraved and published by the Society of Antiquaries in *Vetusta Monumenta* (vol. II, pl. XV). In spite of a few inaccuracies mentioned in a note on the drawing, the copy successfully reproduced the style as well as the detail of the original. T.C.

514 West front of Iffley Church

Isaac Taylor (1730–1807); signed
Pencil; *h* 243 mm, *w* 226 mm
Dated 1751
Society of Antiquaries of London

This drawing forms part of Charles Lyttelton's 'Book of Drawings of Saxon Churches' (see **516**). It shows the west front of Iffley Church, Oxfordshire, built *c.* 1175, before its restoration in the 19th century, with a Perpendicular window blocking the original circular window and with the gable lowered. Borlase, the Cornish antiquary, told Lyttelton in a letter of July 1753 that he considered Iffley 'fine' but 'sadly mauled' and hoped that a reconstruction of the original design could be drawn ignoring later alterations (British Library, Stowe MS 752, f. 159ʳ). T.C.

515 Horace Walpole, 4th Earl of Orford (1718–97)
(*not illustrated*)

After Joshua Reynolds (1723–92); engraved by J. McArdell
Mezzotint engraving; *h* 364 mm (including title), *w* 254 mm
Dated 1757
London, Trustees of the British Museum, O'Donoghue III, p. 377, no. 4

Horace Walpole is perhaps the best-known English medievalist of the 18th century although he was only the most articulate of a wide-ranging group of antiquaries and collectors. Walpole and his friends such as Thomas Gray (**519**) and Charles Lyttelton (**516**) brought the study of medieval art into the mainstream of intellectual and social life. Walpole's collection in his house, Strawberry Hill, Twickenham, included medieval objects such as 'Queen Bertha's Comb' (**496**), but it is interesting that in this engraving, approved by Walpole as his 'official' image, he is shown as a classical dilettante with an engraving of his most important antiquity, the Boccapadugli eagle. T.C.

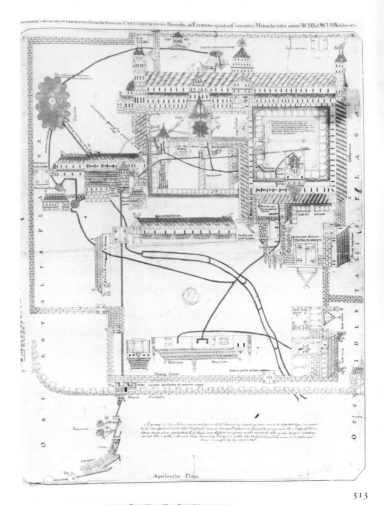

513

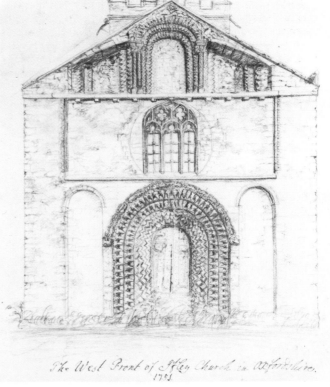

514

516 Charles Lyttelton, Bishop of Carlisle (1714–68)
(*not illustrated*)

After Francis Cotes (1726–70); engraved by James Watson
Mezzotint engraving; *h* 395 mm, *w* 274 mm
1770
Society of Antiquaries of London

Charles Lyttelton, the younger son of Sir George Lyttelton of
Hagley Hall, Worcestershire, pursued a career in the Church,
becoming successively Dean of Exeter and, in 1762, Bishop of
Carlisle. He was a dedicated student of British antiquities in
general and of early medieval architecture in particular. He
wrote little for publication but encouraged research by an
extensive correspondence with other scholars, such as Smart
Lethieullier and Andre Coltee Ducarel. He was an influential
member of the Society of Antiquaries from 1746 and was
elected President in 1765. On his premature death in 1768 the
Society commissioned the engraving and publication of his
portrait by Cotes, probably of *c.* 1768, now lost (Johnson,
1976, no. 271). T.C.

517 West front of St-Etienne, Caen

After Noel; engraved by I. Bayly
Engraving; *h* 383 mm, *w* 228 mm
c. 1767
Private collection

The Abbey of St-Etienne at Caen was known in the 18th
century to be the Abbaye aux Hommes founded by William I
and thus to be a key work in the quest for the specifically
Norman contribution to post-Conquest English architecture.
This engraving was prepared as pl. IV of *Anglo-Norman
Antiquities* by Andre Coltee Ducarel (1713–85), a Huguenot
antiquary who had made a tour through Normandy in 1752.
His interest in Norman architecture had been fostered by
Charles Lyttelton (516) who, appropriately, paid for this
engraving. Ducarel considered the west front of St-Etienne 'a
very plain, but neat building' (Ducarel, 1767, p. 51). T.C.

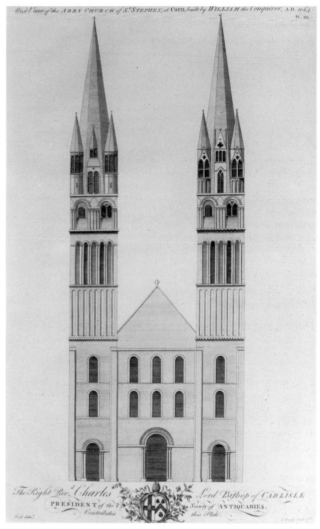

517

518 Details from the former Romanesque pulpitum of Ely Cathedral

James Essex (1722–84)
Pen and ink; *h* 254 mm, *w* 305 mm (double page), *h* 106 mm,
w 156 mm (each page)
c. 1776
London, British Library, Add. MS 6768, ff. 122–3

The Romanesque pulpitum in Ely Cathedral formed a solid
wall across the nave one bay (originally two bays) west of the
crossing. It was destroyed in 1770 when the choir was moved
out of the crossing into the eastern extremity of the church.
James Essex, who alone recorded details of the screen, was
consulting architect to the Ely Chapter but the responsibility
for the screen's destruction lies not with Essex but with the
Chapter and with the guiding spirit of the works of 1770, the
antiquary and historian of Ely, James Bentham (Bentham,
1771, p. 214). T.C.

BIBLIOGRAPHY Hope, 1917, pp. 43, 85–8

518

519 Thomas Gray (1716–71) (not illustrated)

After William Mason (1725–97); drawn by James Basire
Pencil; h 260 mm, w 203 mm
c. 1774
London, National Portrait Gallery, 425

Thomas Gray was, in his later years, as much a serious student of medieval architecture as a poet, studying the relevant texts and touring England to visit medieval buildings. His approach was more erudite than that of his boyhood friend, Horace Walpole (515). His masterly analysis of the different elements in Romanesque ornament was incorporated by James Bentham in the introduction to his *History of Ely* (Bentham, 1771, pp. 34–5), but otherwise Gray's work was unpublished. This portrait was prepared for a posthumous engraving of Gray, commissioned by his executor and fellow poet and antiquary, William Mason. T.C.

EXHIBITION York, 1973, no. 58

520 Reconstruction of the Romanesque Lincoln Cathedral (not illustrated)

James Essex (1722–84)
Engraving; h 300 mm, w 245 mm
1775
Society of Antiquaries of London

Essex's reconstruction was one of the illustrations for his lecture to the Antiquaries, 'Some Observations on Lincoln Cathedral', delivered in March 1775 and later published in *Archaeologia*, vol. IV, as the engraving exhibited here. Essex had a real knowledge of medieval architecture, particularly of its technical aspects. His restoration of Lincoln Cathedral from 1761 until his death in 1784, on which his *Observations* were based, was exceptional in its period for its moderation and archaeological accuracy (Cocke, 1975, pp. 16–20). Essex's reconstruction of the west front, although containing curious elements such as the great windows, demonstrates his ability to distinguish the authentic Romanesque features of the front from the many later additions. T.C.

521 Design for folly castle at Osterley Park

Robert Adam (1728–92); signed
Pen and wash; h 591 mm, w 438 mm
Dated 1774
London, The Victoria and Albert Museum (Osterley Park)

The design must always have belonged more to fantasy than to practical architecture: there was never a castle at Osterley either before or after Adam's time. The type of drawing is related both to the castle-style houses designed by Adam, such as Culzean Castle, Ayrshire, and to the 'Picturesque Scenery' drawings (now Sir John Soane's Museum drawer LXVIII set 1) of romantic castles in rugged landscapes sketched by Adam for his own amusement. The detailing is reminiscent of late Roman buildings, notably Diocletian's palace at Split (Spalato) in Dalmatia and, in the tower on the left, Scottish castles but the overall rendering of the motte and bailey site and the round-arched openings are much more convincing evocations of early medieval architecture than the symmetrical four-square blocks typical of 18th- and early 19th-century castles. T.C.

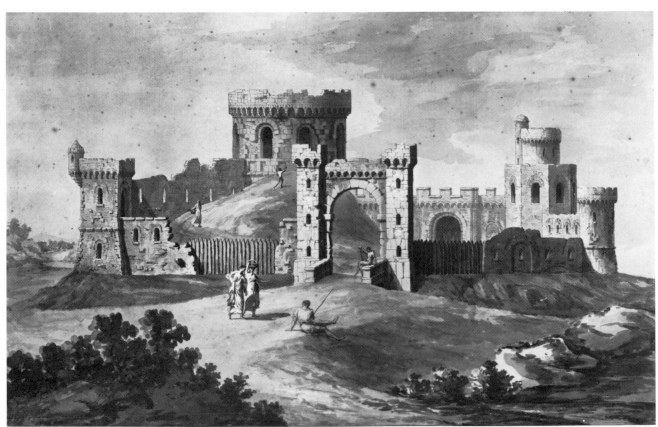

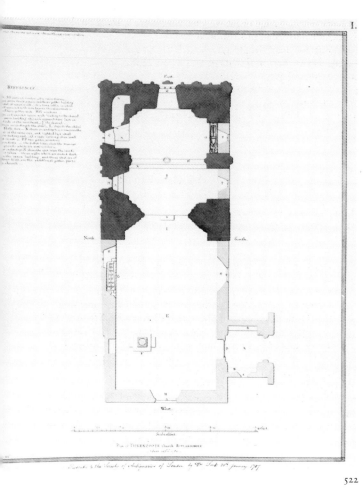

522

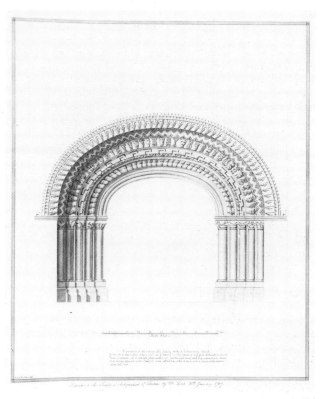

523

522 Plan of Tickencote Church

John Carter (1748–1817); signed
Pen and ink; *h* 390 mm, *w* 325 mm
Dated 1780
Society of Antiquaries of London

The chancel of Tickencote Church, Rutland (now in
Leicestershire) was built in the second half of the 12th century:
the east wall and chancel arch are profusely decorated. The
church was well known to 18th-century antiquaries such as
Stukeley and Lyttelton (**507** and **516**), partly because it lies on
the Great North Road. In 1792 it was rebuilt by S.P. Cockerell.
John Carter, one of the leading propagandists for medieval
architecture in the late 18th century, was a dedicated and
prolific recorder of its monuments. In this measured plan he
included every feature of interest in the original church and
carefully distinguished, by the use of a darker tone, the 'Saxon',
i.e. Romanesque, fabric of the chancel from the later
nave. T.C.

523 Chancel arch of Tickencote Church

by John Carter (1748–1817); signed
Pen and coloured inks; *h* 390 mm, *w* 325 mm
Dated 1780
Society of Antiquaries of London

The elaborate chancel arch at Tickencote dates from *c.* 1175:
it was carefully preserved when the rest of the church was
rebuilt in 1792 (see also **522**). Carter's attempt to show the
original polychromy of the arch, of which traces then
remained, shows his precocious understanding of medieval
art. T.C.

524 St Botolph's Priory, Colchester
(*illustrated on p. 44*)

R.B. Godfrey
Engraving; *h* 130 mm, *w* 185 mm
c. 1786
Society of Antiquaries of London

The church of St Botolph's Priory, Colchester, was built in
c. 1100–50; parts of the nave and the west front still survive.
Their gaunt but impressive ruins were well known and often
drawn in the 18th century. This crude engraving is typical of
the cheap topographical prints of the period which helped to
establish public awareness of Romanesque and other medieval
monuments. T.C.

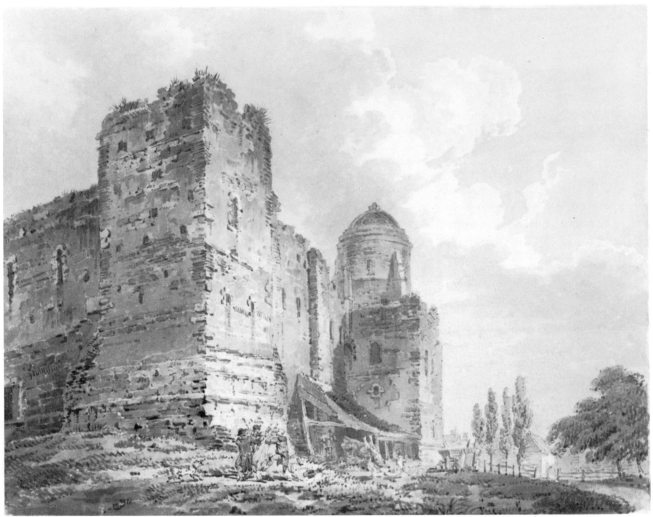

525

525 Colchester Castle

Thomas Girtin (1775–1802)
Watercolour; *h* 164 mm, *w* 218 mm
1793
Oxford, Ashmolean Museum

The castle is the largest example of the same type of early
Norman keep as the White Tower in London. It survives
remarkably intact in spite of damage in the 17th century and
the addition of a cupola in the 18th century when it was treated
as a giant garden ornament (Drury, 1982, *passim*). Girtin's
picture is based on a drawing of 1790 by James Moore, or on
the engraving after the drawing, prepared for *Monastic
Remains and Ancient Castles*, published by G.I. Parkyns in
1791–3. In this early drawing Girtin included the sensational
foreground scene of the press gang and converted the 18th-
century cupola into a Roman-looking dome. T.C.

BIBLIOGRAPHY Girtin, Loshak, 1954, no. 53

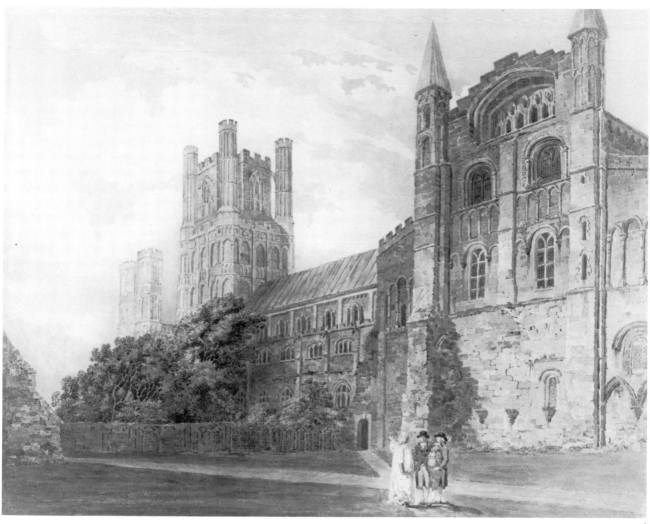

526

526 Ely Cathedral from the south-east

Thomas Girtin (1775–1802)
Watercolour over pencil; *h* 391 mm, *w* 478 mm
1793–4
Oxford, Ashmolean Museum

This view of Ely Cathedral depicts the Romanesque south
transept, nave and, behind the trees in the former cloister, west
tower and transept. The picture is based on a drawing by the
antiquarian publisher, James Moore, rather than being worked
up on the spot. It is an impressive example of how the
topographical tradition of depicting buildings developed by
British artists in the 18th century was transformed at the
century's close by a heightened awareness of the scale and
emotional power of the country's great monuments. T.C.

EXHIBITIONS Royal Academy, 1794, no. 346; Manchester, London, 1975, no. 5
BIBLIOGRAPHY Girtin, Loshak, 1954, no. 65

527 Lindisfarne Priory

Thomas Girtin (1775–1802)
Watercolour; *h* 528 mm, *w* 396 mm
1796–7
London, Trustees of the British Museum, 1855.2.14.21

Lindisfarne Priory, Northumberland, famous in Saxon times, was refounded in the late 11th century as a cell of Durham; its church resembles contemporary work in Durham Cathedral, in particular the massive nave piers with their incised patterning. The picturesque site of the priory on Holy Island and its historic associations made it a popular subject with topographical artists, including Turner and John Varley, although sometimes they depicted it from others' drawings, not from their own observation. Girtin visited Lindisfarne on his tour of the North in 1796. The single vaulting arch, incrusted with chevron, still survives. T.C.

BIBLIOGRAPHY Girtin, Loshak, 1954, no. 184

528 Southwell Minster from the north-west

J.M.W. Turner (1775–1851)
Watercolour; *h* 381 mm, *w* 470 mm
c. 1795
Preston, Harris Museum and Art Gallery

The nave and west towers of Southwell Minster, Nottinghamshire, date from the mid-12th century. They were well known to 18th-century antiquaries, although the simplicity of the architecture encouraged some to consider the building Saxon. Bishop Warburton, when editing Pope's *Epistle on Taste*, made a special journey to see Southwell as 'the purest Saxon work in the Kingdom' (Rastall, 1787, p. 54). Essex realized that it could not predate the Conquest (British Library, Add. MS 6768, p. 115). T.C.

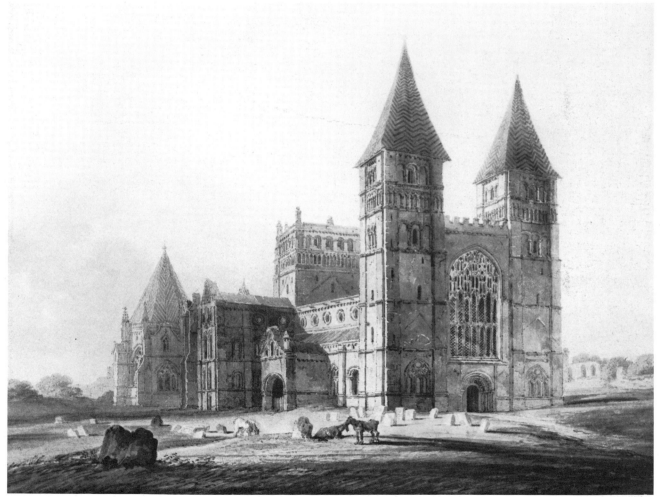

528

529 Buildwas Abbey (illustrated on p. 45)

J.M.W. Turner (1775–1851)
Pencil; *h* 274 mm, *w* 294 mm
c. 1795
London, Trustees of the British Museum, Turner Bequest
XXVII – A

Buildwas Abbey, Shropshire, was founded in 1135; its
surviving buildings, all now in ruins, date from the mid-12th
century. Turner's sketch, made during an early tour of Wales
and the Marches, shows part of the nave with its great piers
and scalloped capitals. T.C.

530 Interior of Durham Cathedral

J.M.W. Turner (1775–1851)
Watercolour; *h* 758 mm, *w* 579 mm
c. 1797
London, Trustees of the British Museum, Turner Bequest
XXXVI – G

The nave of Durham Cathedral was built *c.* 1100–30. In the
18th century its massive proportions and unrefined detail were
in general criticized but, by the century's close, its scale was
admired as sublime, as this impressive picture testifies. In 1797,
when Turner made the drawing on which this watercolour is
based, the cathedral was being subjected to a controversial
restoration with the advice of James Wyatt (see Introduction,
p. 363) but the nave has remained one of the major monuments
of Romanesque art in England. T.C.

531 Interior of Christ Church Cathedral, looking east
(illustrated on p. 46)

J.M.W. Turner (1775–1851)
Watercolour over pencil; *h* 678 mm, *w* 498 mm
c. 1800
London, Trustees of the British Museum, Turner Bequest L-G

Christ Church Cathedral, Oxford, was built in *c.* 1175 as the
church of the Augustinian Priory of St Frideswide. It survived
the Dissolution, slightly truncated, and since 1546 has served
both as Cathedral to Oxford diocese and Chapel to Christ
Church College. Its internal elevation is remarkable for the use
of a 'giant order' of piers which rise to embrace both arcade
and triforium. In Turner's brilliant unfinished drawing the
architecture is stressed by the use of white highlights while the
Perpendicular vault and the 17th-century furnishings are only
touched in. The screens visible in the transept, which were
provided by Dean Duppa in 1631–3, had Gothic detailing but
had semicircular tops to complement the round arches above
them, an early acknowledgement of the Romanesque. T.C.

532 West end of Hereford Cathedral, in ruins
(not illustrated)

After W. Hearne
Engraving; *h* 225 mm *w* 292 mm
c. 1797
Private collection

The engraving depicts the Romanesque west end of Hereford
Cathedral (508) after its collapse on Easter Monday 1786. In
the rebuilding by James Wyatt the nave was shortened by one
bay and the whole design deprived of any of the Romanesque

character of the original (see Introduction p. 364). The
antiquary and publisher John Britton commented 'the fall of
the western end of Hereford Cathedral is the most remarkable
event of modern times in the history of English cathedrals;
while the rebuilding of it, we cannot say restoration, is as
remarkable for its inconsistent and discordant character'
(Britton, 1836, vol. III (Hereford Section), p. 46). T.C.

533 Engraved details of Romanesque ornament

Engraving; *h* 240 mm, *w* 280 mm
c. 1800
Private collection

The engraving is plate 3 of the illustrations to *Essays on Gothic
Architecture*, first published in 1800, in which the publisher,
John Taylor, put together the then best known accounts of
medieval architecture, those by Wren, Warton, Bentham,
Grose and Milner. The modest size of the book and its
popularity – it rapidly went through three editions – indicate
the demand that existed by 1800 for such summaries. The
engraving was made up from details illustrating the article by
William Wilkins the elder on Norwich Castle and other
Romanesque buildings in East Anglia, published in
Archaeologia XII in 1795 (see p. 363; Wilkins, 1795). T.C.

Various Ornaments.

Fig. 1. Fig. 2. Fig. 4. Fig. 3. Fig. 5. Fig 6

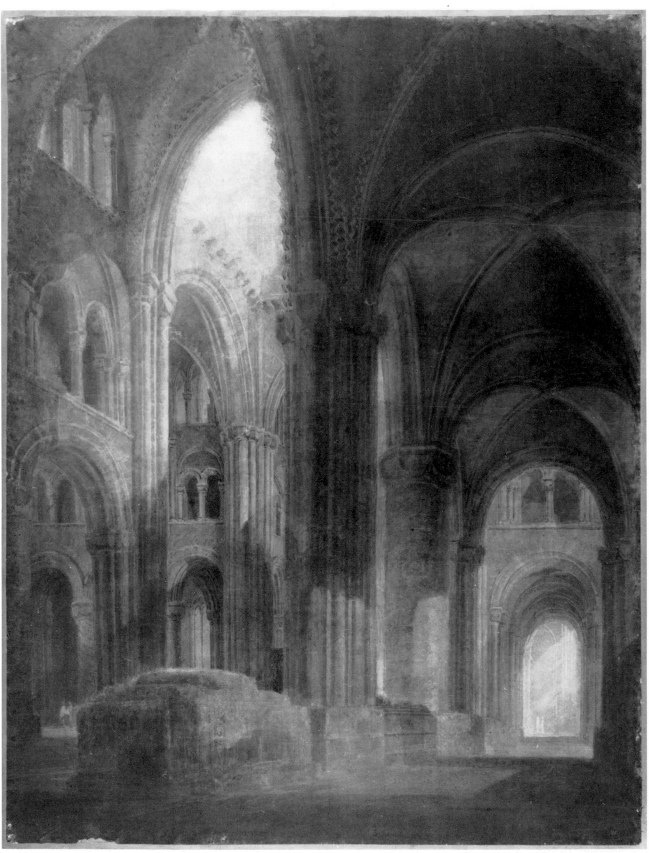

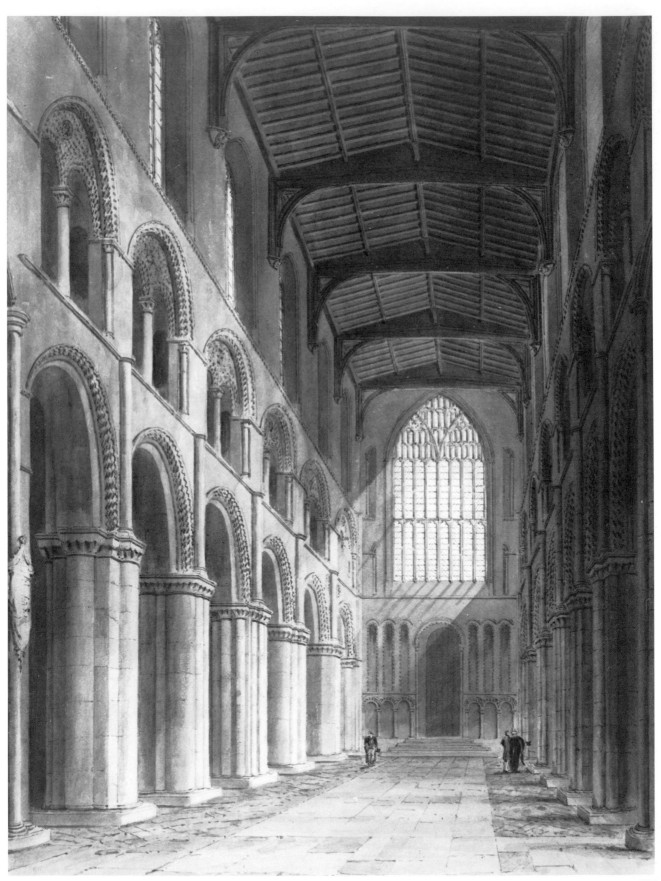

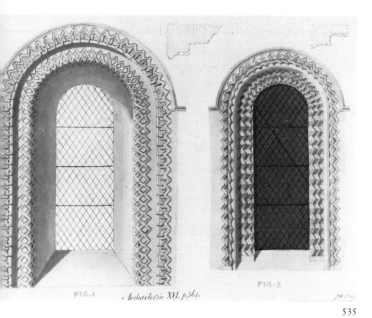

535

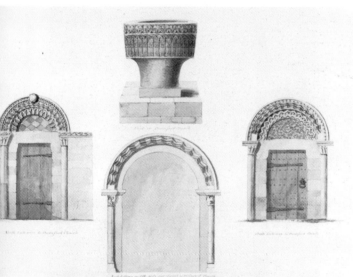

536

534 Porch of St Margaret's Church, York
(*not illustrated*)

John Varley (1778–1842)
Watercolour over traces of pencil; *h* 257 mm, *w* 362 mm
c. 1803–8
London, Victoria and Albert Museum, 780–1870

The porch of St Margaret's, York, dates from the 3rd quarter of the 12th century. It is said originally to have formed part of the Hospital of St Nicholas and to have been moved to St Margaret's after the ruin of the Hospital in the siege of York in 1644. The porch was described by Drake in his *Eboracum, or the History of York* of 1736. He considered it to be Saxon and the porch became one of the standard examples of Saxon architecture for antiquaries like Charles Lyttelton (**516**). Varley visited Yorkshire in 1803 probably in the company of William Mulready, who produced an almost identical view of the porch (now in the British Museum), but Varley appears to have based

the architectural detail, much simplified in his rendering, on the engraving of the porch in Drake. (I am grateful to Michael Kauffmann for allowing me to see his manuscript catalogue entry on this picture.) T.C.

535 Window in the church of St Cross, Winchester

John Adey Repton (1775–1860); signed
Pen and ink and coloured wash; *h* 195 mm, *w* 255 mm
c. 1805
Society of Antiquaries of London

The church of the Hospital of St Cross, Winchester, built by Bishop Henry of Blois in the third quarter of the 12th century, was much discussed around 1800 as an example of the transition between the Romanesque and Gothic styles (see Milner, 1809, ii, pp. 160–4). This drawing of a window formed one of a series of examples illustrating the successive periods of medieval architecture which was prepared by J.A. Repton, the pupil of John Nash and son of Humphrey Repton, the landscape gardener. Repton exhibited his drawings to the Society of Antiquaries in 1805 and they were published as an appendix to *Archaeologia* XVI in 1812. T.C.

536 Chancel arch, north and south doorways and font of Great Durnford Church, Wiltshire

John Buckler (1770–1851)
Watercolour; *h* 225 mm, *w* 320 mm (folio), *h* 640 mm, *w* 450 mm (volume)
1805
Devizes, Wiltshire Archaeological and Natural History Society

This drawing comes from the set of views of every church in Wiltshire commissioned by Sir Richard Colt Hoare, the great Wiltshire antiquary, from the topographical artist, John Buckler. The nave of Durnford Church is a relatively small but well-preserved building of *c.* 1130–40; its decoration is linked with that on the works of Bishop Roger of Salisbury at Old Sarum, only four miles to the south (Henry, Zarnecki, 1957–8, pp. 21–2). By the first decade of the 19th century an artist could record Romanesque ornament with as much delicacy as he might an Antique frieze. T.C.

PROVENANCE The library of Sir Richard Colt Hoare at Stourhead, Wiltshire

537 Nave of Rochester Cathedral, looking west

John Buckler (1770–1851)
Watercolour; *h* 531 mm, *w* 394 mm
Dated 1805
London, Trustees of the British Museum, 1888–1–16–5

The nave of Rochester Cathedral, built *c.* 1150, survives relatively unaltered, except for the Perpendicular rebuilding of the clerestory and insertion of a great west window. As early as 1635, the Cathedral was judged 'but small and plaine, yet . . . very lightsome and pleasant' (Legg, 1936, pp. 8–9). The picture is a good example of the meticulous and calm rendering of architecture achieved by an early 19th-century topographical artist of the calibre of John Buckler (**536**). T.C.

538 West front of Tewkesbury Abbey

Moses Griffith (1747–1819)
Pen and watercolour; *h* 252 mm, *w* 330 mm
c. 1800
London, Victoria and Albert Museum D–37–1939

The Romanesque abbey church at Tewkesbury,
Gloucestershire, although altered by the insertion of new
windows in the 14th and 15th centuries and reduced to
parochial status at the Dissolution, has retained its external
appearance remarkably intact. This view shows the west front
of *c.* 1121 and the central tower of *c.* 1140, two of the most
impressive examples of their kind in England. (The cresting of
the tower dates from 1660 and the Perpendicular west window
was rebuilt in 1687.) Moses Griffith began life as a
draughtsman-cum-servant to Thomas Pennant the antiquary,
and through his influence became a topographical artist. T.C.

539 St Luke's Chapel, Norwich Cathedral, from the east

John Sell Cotman (1782–1842)
Pencil and watercolour; *h* 352 mm, *w* 481 mm
1808
Norfolk Museums Service (Norwich Castle Museum)

St Luke's Chapel lies on the south side of the choir ambulatory
of Norwich Cathedral, built *c.* 1100 and one of the few major
Romanesque east ends not to have been completely altered in
later times. Cotman made many drawings of Romanesque
buildings both in Norfolk and in Normandy, combining
architectural accuracy with unusual sensitivity to their
aesthetic quality. T.C.

EXHIBITION Norwich, 1979, no. 65

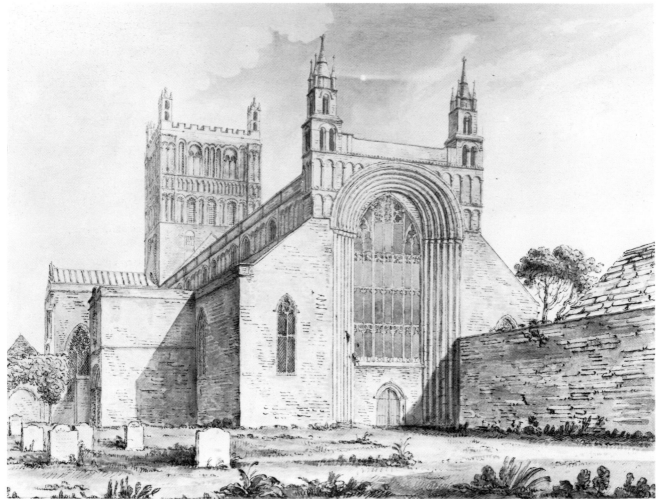

538

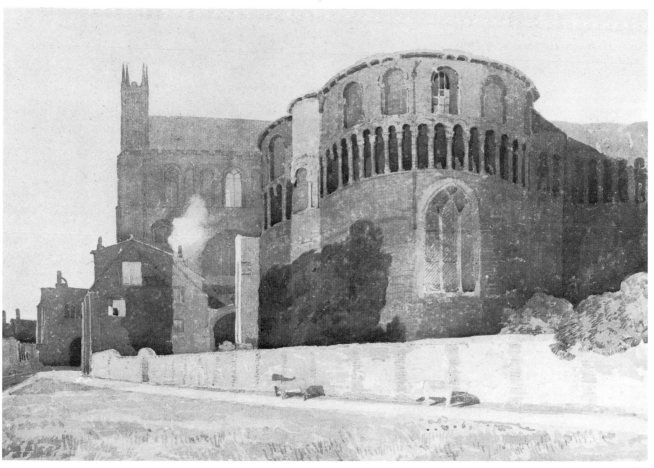

539

540

540 West front of the church at Castle Rising

John Sell Cotman (1782–1842)
Pencil and watercolour; *h* 309 mm, *w* 273 mm
1811
Oxford, Ashmolean Museum

The church of St Lawrence at Castle Rising in Norfolk was
built *c.* 1175. It boasts an exceptionally fine west front,
probably thanks to the lords of the great castle, after which the
village is named. Cotman's bold use of colour to give light and
atmosphere to the architecture marks a development from the
early, topographical watercolours by Turner and Girtin only
15 years before. The picture was etched by Cotman himself in
1813 as pl. XXXV of his *Norfolk Antiquities* (**541**). T.C.

EXHIBITION Arts Council, 1982–3, no. 85

541 West front of the church at Castle Rising
(illustrated on p. 43)

John Sell Cotman (1782–1842); after his own watercolour
Etching; *h* 362 mm, *w* 270 mm
1813
Oxford, Ashmolean Museum

Cotman's etching after his watercolour of Castle Rising church
was published as pl. XXXV of *Norfolk Antiquities*. Such
etchings helped to diffuse images of Romanesque monuments
of a far higher quality and sensitivity than the standard
commercial print (such as **524**). T.C.

542 South doorway of Kenninghall Church, Norfolk

John Sell Cotman (1782–1842); signed
Pencil and wash; *h* 243 mm, *w* 180 mm
Dated 1818
London, Trustees of the British Museum, 1902–5–14–48

Cotman made this drawing for etching and publication in his
Excursions of Norfolk. The doorway, the only surviving
Romanesque feature in the church, is unexceptional but
Cotman's vivid treatment of it is a reminder that such
doorways, to be found in hundreds of village churches, are one
of the commonest expressions of Romanesque architecture. It
also testifies to the thoroughness with which churches were
founded or rebuilt all over England after the Conquest. T.C.

543 The 'Norman Gateway', Bury St Edmunds

J.C. Smith (1778–1810); signed
Watercolour; *h* 575 mm, *w* 785 mm
Dated 1809
London, Victoria and Albert Museum , 1616–1871

The gateway was built in 1120–48 as part of the approach to
the great church of St Edmundsbury Abbey in Suffolk. It
survived the Dissolution because it was adapted as a bell-tower
to the parish church of St James at its foot. In this drawing the
louvres of the bell-openings (now removed) can be seen in the
top storey. The frontal view of the gateway stresses its
monumentality and the richness of its decoration, one of the
few surviving witnesses to the immensely rich artistic
achievement of the Abbey in the 12th century. T.C.

542

543

544

544 Boxgrove Priory from the west

Peter de Wint (1784–1849)
Black chalk with touches of white; *h* 266 mm, *w* 370 mm
London, Courtauld Institute Galleries, Witt Collection
No. 4318

Boxgrove Priory, Sussex, was founded *c.* 1117. Its nave and transepts date from the 12th century. Only the two easternmost bays of the nave survive intact, since at the Dissolution it was the monastic eastern parts of the church and not the parochial nave that were retained in use. This early view by de Wint shows the truncated nave and the present west wall of the church, which stands on the former pulpitum. T.C.

545 St John's Chapel in the White Tower, Tower of London

Frederick Nash (1782–1856)
Ink and watercolour; *h* 135 mm, *w* 110 mm
c. 1810
City of London, Guildhall Library

The chapel, traditionally known as Caesar's Chapel, rises through the two upper floors of the White Tower. It served the royal lodgings. It is the only apartment in the White Tower to retain its original late 11th-century form, even though it was in secular use as a record repository from the 17th century to the 19th. It was one of the examples of the 'ancient Saxon Manner' cited by Christopher Wren (Wren, 1750, p. 296) although he knew it in fact dated from the reign of the Conqueror. Frederick Nash was appointed architectural draughtsman to the Society of Antiquaries in 1807. T.C.

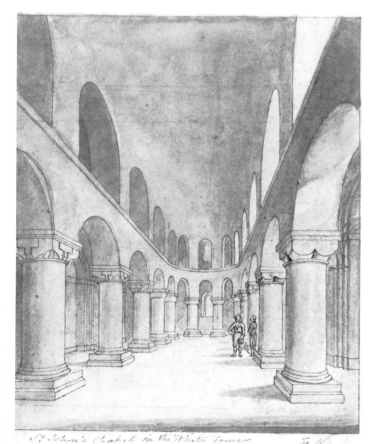

St John's Chapel in the White Tower

545

546 Plan and elevation of Spring Hill Tower, Broadway (*not illustrated*)

James Wyatt (1746–1813); signed
Pen and coloured wash; *h* 502 mm, *w* 343 mm
Dated 1794
Croome Estate Trustees

The tower, which still stands above the village of Broadway, Worcestershire, was built to the designs of James Wyatt in 1794, to serve as an eye-catcher from the Earl of Coventry's nearby mansion of Croome Court. Wyatt employed consciously Romanesque or 'Saxon' motifs in the detailing of the tower, perhaps the earliest example of such a practice in secular architecture (see Introduction, p. 364). (I am grateful to Dr Frew of St Andrew's University for his help with this exhibit.) T.C.

547 Design for Lea Castle, Worcestershire
(*not illustrated*)

John Carter (1746–1817)
Watercolour; *h* 254 mm, *w* 635 mm
c.1816
New York, Metropolitan Museum of Art, (The Elisha Whittelsey Collection, Elisha Whittelsey Fund, 1956)

This drawing depicts the north front of a projected house for John Knight at Lea Castle in Worcestershire. Its inclusion of a keep and its purity of detail make it a precocious example of secular neo-Romanesque. In the British Library (Add. MS 29942, ff. 136–8) there are additional designs in pencil for a Romanesque ice-house in the grounds: one is dated 1816. The house has been demolished but appears to have followed Carter's designs only in outline, the detail being Gothic not Romanesque. T.C.

BIBLIOGRAPHY Harris, 1971, no. 46

548 Lanfranc's Tower, Canterbury Cathedral

John Chessell Buckler (1793–1894); signed
Pen and wash; *h* 640 mm, *w* 500 mm
Dated 1832
Society of Antiquaries of London

The north-west tower of Canterbury Cathedral was built *c*. 1075 under Archbishop Lanfranc and was often given his name. The lowest stage was remodelled internally in the 15th century, but the tower remained otherwise intact until it was demolished in 1832 and replaced by a facsimile of the Perpendicular south-west tower. J.C. Buckler, son of John Buckler, the great antiquarian draughtsman, recorded the Romanesque tower in a series of meticulous drawings. In this section he included details of even the simplest moulding profiles and marked where they occurred on the tower. T.C.

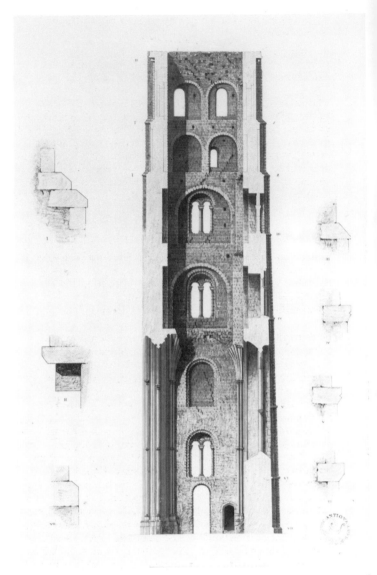

548

549 Church of St Mary and St Nicholas, Wilton
(*not illustrated*)

I. Haghe
Tinted lithograph; *h* 460 mm (with frame 620 mm), *w* 310 mm (with frame 465 mm)
c. 1845
The Rector and Churchwardens of Wilton

The church was built at Wilton, Wiltshire, in 1841–5 to replace the late Gothic parish church. It was designed by T.H. Wyatt (his partner D. Brandon was not involved) but the money and the ideas behind its construction were provided by the Hon. Sidney Herbert, the talented younger son of the 11th Lord Pembroke, best known for his championship of Florence Nightingale. The church is of monumental proportions with a nave and a bell-tower 57 and 108 feet high respectively. The inspiration for the design is clearly Romanesque but a Romanesque drawn less from English sources than from Italian, notably the two early medieval churches of S. Pietro and S. Maria in Toscanella (the modern Tuscania), north of Rome. T.C.

550 Six studies for the nave ceiling of Ely Cathedral
(*not illustrated*)

T. Gambier-Parry (1816–1888)
Charcoal on canvas; *h* 1.346 m, *w* 2.286 m (both max)
Mr Thomas Fenton

The ceilings in the west tower, west transept and nave of Ely Cathedral were painted by H.S. Le Strange and, after his death, by the gentleman artist and connoisseur T. Gambier-Parry from 1855 to 1878. The design was an ambitious attempt to match the Romanesque architecture of the building by tracing details of figures and foliage from contemporary manuscripts, combining them in new composite episodes, and then magnifying them to the scale of the ceiling. T.C.

551 The Bayeux Tapestry (*illustrated on p. 42 and 80*)

32 hand-coloured engravings by Charles Stothard (1786–1821)
Plate size 457 mm × 686 mm
Published 1819
London, Society of Antiquaries of London;
Bonaventure Books (Pls. II no. 3, III no. 2 and V no. 1)

Between 1816 and 1820, Charles Stothard made a complete coloured copy of the Bayeux Tapestry at the expense of the Society of Antiquaries and it is this historic copy – which reveals the state of the tapestry before its many repairs and reconstructions over the past 150 years – that is exhibited.

The Bayeux Tapestry itself is a vast length of narrow linen, hand-embroidered with a portrayal of the Norman Conquest of England in 1066 and the events leading up to it. The end part is missing and, in technical terms, it consists of eight lengths of plain linen, joined together to form a 'frieze' which is 70 metres long and 50 centimetres in depth. This is embroidered in laid and couched work with the additional use of stem and outline stitch in wools of eight colours – terracotta red, buff, yellow, three shades of green and two shades of blue.

In terms of visual content, the tapestry displays a continuing flow of scenes within borders. These borders contain animals, birds and human figures, which are often decorative but which occasionally participate in, or comment on, the main sequence of events. The narrative begins with a depiction of Edward the Confessor addressing Harold, and continues with representations of Harold's party crossing the Channel, being seized by Count Guy of Ponthieu on the coast of France, and then being taken to Duke William of Normandy. There follow portrayals of the co-operation of Harold and William in the Norman campaign against Brittany, the alleged oath made by Harold to William, and the return of Harold to England. The death of Edward and the coronation of Harold next led to an invasion fleet being prepared in Normandy and the subsequent invasion of England and Battle of Hastings. In its present incomplete state, the embroidery ends with the flight of the English.

The date of the tapestry must obviously be after 1066 and also before 1097 since it was commissioned by Odo, Bishop of Bayeux and Earl of Kent, who died in that year. It can be narrowed down more closely to the years before 1082 since Odo was then imprisoned by his half-brother, William the Conqueror, and, after his release in 1087, spent almost all his time away from England.

The tapestry is, in a sense, an Anglo-Norman enterprise. There was a long tradition of epic tapestries in Anglo-Saxon England and it was perhaps the sight of these that gave Odo the idea for a similar embroidered epic on the Norman Conquest. The English provenance is indicated by stylistic relationships with Anglo-Saxon drawings and is supported by other forms of evidence. Indeed, we can feel certain that the tapestry was made by Anglo-Saxon embroideresses. We can feel equally certain that the interpretation of these historic events was Norman. It not only presents the Norman viewpoint but even edits the 'story line' in terms of a French style of epic poetry which was of great interest to Odo himself – the *chanson de geste*. It should be added that Odo is given an importance in the events recorded in the tapestry which no chronicler of the time accords him.

It has been argued that the tapestry was originally a secular work of art intended for one of Odo's palaces. It is known to have been at Bayeux Cathedral in 1476 and to have been transferred to municipal ownership in 1803 but whether Odo himself bequeathed it to the Cathedral, or even donated it after he had been discredited and sent into captivity in Normandy in 1082, is a matter of speculation. C.R.D.

Floor tiles

552 Floor tiles

Earthenware, decorated in relief and glazed; 215 × 215 mm
approx, oblong border tiles 160 × 260 mm approx, *d* 30 mm
approx
1151–66; St Albans Abbey, chapter house
St Albans, The Cathedral and Abbey Church of St Alban

The tiles were found *in situ* in 1978 during the archaeological
excavation of the medieval chapter house, where the tiled floor
was in use from *c.* 1160 to 1539. It was heavily worn and some
areas had been relaid in connection with burials and repairs.
Almost every tile was cracked or broken by use, and many were
damaged in the 16th-century demolition. About 750 tiles,
approximately one-fifth of the floor, were found in position.

The medieval chapter house of St Albans Abbey was rebuilt
'from the foundations' by Abbot Robert of Gorham (1151–66),
probably after 1154 when Nicholas Breakspear was elected
Pope; his father, Robert of the Chamber, was buried in the
chapter house before or during its reconstruction. The tiles
were laid on the first mortar bedding within the new chapter
house and can be securely related to the rebuilding by Abbot
Robert. They are therefore to be dated at the latest to the
1160s.

At least 14 different designs are represented on the tiles (types
A–N), but only types A–G are at all frequent. The floor itself was
laid in a complex 'carpet' pattern in which areas of tiles of one
type were divided by borders of two types. In the western half
of the building, corresponding to the area west of the lectern,
the borders were laid with oblong tiles of type F. To the east,
areas laid with the elaborate tiles of type D – consisting of
intersecting double circles – were bordered by tiles of type C,
decorated with a floral design of 'stiff-leaf' type. The
impression is that the floor was organised in 'paths' and areas,
which may have guided processional movement and the
various uses to which the chapter house was put.

The dating proposed here is supported by detailed
comparisons with metalwork and manuscript painting. If it is
correct, it means that the pavement of the St Albans chapter
house is one of the earliest – perhaps the earliest – known in
England. Floor tiles decorated in relief were, however, an
Anglo-Saxon development. Polychrome-glazed, relief-
decorated floor tiles of Anglo-Saxon type are known from
several great monasteries, including Winchester, Bury St
Edmunds and St Albans. They seem to be designed for the
decoration not of pavements but of stepped areas, and
probably therefore for paving around altars. An intermediate
type, dating perhaps from the 11th or early 12th century, is
known at St Albans. The chapter house pavement may
therefore find its antecedents at St Albans itself. Other finds of
tiles of the chapter house type are restricted to St Albans and
its local dependencies. MARTIN BIDDLE AND BIRTHE
KJØLBYE-BIDDLE

EXHIBITION St Albans, *England's Premier Abbey*, 1982
BIBLIOGRAPHY Biddle, 1980; M. Biddle and B. Kjølbye-Biddle, *The Chapter House of St Albans Abbey*, Hertfordshire Archaeology, monograph, in preparation; see also Edgar Wigram, 'The Chapter House at St Albans', *St Albans and Hertfordshire Architectural and Archaeological Society*, 1924, pp. 35–42

Bibliography

Introduction

This is a selective bibliography of English Romanesque art, which includes all works cited frequently in this catalogue, and other books and articles which have made a significant contribution to the subject, particularly over the last 20 years. Works are listed by author, alphabetically. Exhibition catalogues and related symposia are listed separately at the end, by place. Two subjects not covered here are coins and antiquarian literature, whose specialized bibliographies are given at the ends of their respective chapters.

The appreciation of Romanesque art in England developed relatively late when compared with the long-established traditions of art historical research on the Continent (see Dynes, 1976). Important landmarks in the recognition of the intrinsic interest of the Romanesque style were, for architecture Clapham, 1930 and 1934, for sculpture Keyser, 1927, and for the minor arts, the Victoria and Albert Museum and Manchester exhibitions of 1939 and 1959. But in most early studies monuments or objects of the 12th century were discussed only as an episode in the general development of medieval art, as in the studies of English sculpture by Prior and Gardner (1912), or in the occasional magisterial corpus of museum collections and libraries, such as those on ivories and metalwork (Dalton, 1909, 1912a and 1912b), seals (Birch, 1887–1900) or manuscripts (James, 1900–4 and Mynors, 1939).

After 1950 art history became acceptable in England as an academic subject, and more intense research generated a steady flow of new publications which were less insular in their approach than older work. Cherry, 1967, provides a more detailed account of these. Kitzinger, 1940 and 1983, and Saxl, Wittkower, 1948 were notable pioneers in this more European outlook, the one dealing with European objects in a British collection, the other with evidence for Continental influence in British art. They were followed by other studies which awakened the interest of a wider audience in the Romanesque period (Zarnecki, 1951, 1953a, Boase, 1953, Saxl, 1954). But thirty years later the published literature on English Romanesque art nevertheless remains patchy and varies in scope and depth. The student of manuscripts or ivories can turn to several well-annotated surveys; there are no similarly detailed up-to-date introductions for architecture, sculpture or most metalwork of the period. This bibliography is therefore deliberately biased in favour of a more comprehensive coverage of those subjects where no recent bibliographies are easily accessible. It is, however, beyond its scope to mention every publication; for monuments the student is referred to the topographical index at the Society of Antiquaries, for recent excavations to the annual summaries in *Medieval Archaeology*; new publications on medieval subjects are listed annually in the *Antiquaries' Journal*.

It may be helpful to indicate here that the works listed below are of many different kinds: they include the monograph, or individual study of a monument or object, the comparative study, which discusses related works, the corpus which sets out to be a more or less complete gathering together of works with some common characteristics, whether they be provenance, present location, material or iconography, and the synthesis which aims to draw previous research into a coherent intellectual whole. All these different types, which may in some cases overlap, may be presented in widely different and not always easily obtainable forms: simple picture-books, conference transactions, articles in learned journals or *Festschriften*, unpublished theses.

For the novice the synthesis may provide the most helpful start; introductory books dealing with English Romanesque as a part of the history of European art are Zarnecki, 1971; Zarnecki, 1975c; and Kidson, 1967. Beckwith, 1964, covering early medieval art, has more detailed notes and references. Boase, 1953, although out of date in some respects, remains the only comprehensive and well-annotated survey of all aspects of English art of the 12th century. Useful picture-books covering English monuments are Musset, 1983 and Stoll, 1966; while Brooke, Swaan, 1974, on European monasteries generally, combines pictures with a good historical text. On iconography, the various short books by Anderson (1935, 1951, 1955 and 1963) are still among the most readable introductions, although they concentrate on the later middle ages. Other useful older works on this subject are Romilly Allen, 1887, and especially relevant for the 12th century, although concentrating on France, Mâle, 1978 (translation of the French text of 1922).

Architecture

The Norman Conquest had traditionally been accepted as a dividing point in architectural, as in other studies of the 11th century. Research on the later Anglo-Saxon period has been extensive, and cannot be fully covered here. New light has been shed by excavations, notably at Winchester (Biddle, 1970), by scrutiny of documentary evidence (Gem, 1975), and by examination of standing buildings or their remains, which have invariably revealed more complex building histories than suspected by older authorities (Baldwin Brown, 1925 and Clapham, 1930). Bibliographies up to time of publication are given in the invaluably thorough gazetteer of Anglo-Saxon buildings (Taylor, Taylor, 1965), which includes some monuments at least as late as the end of the 11th century (on which see Bony, 1967), also in the later analysis of this material (Taylor, 1978). A new account (Fernie, 1983b) includes the early Romanesque or late Saxon overlap period, which is also discussed in relation to buildings in East Anglia by Heywood, 1977 and 1982. New studies of the first mature English Romanesque building to be inspired by Continental precedent, Edward the Confessor's Westminster Abbey (Fernie, 1979 and Gem, 1981a) amplify the older work of Lethaby (1906 and 1925). For the mature Romanesque period as a whole there is not yet any comprehensive recent account to replace that of Clapham, 1934, other than the relevant sections in Boase, 1953, and in the general histories of medieval architecture by Webb, 1954, and Kidson (Kidson, Murray, Thompson, 1962, 1965), nor is there any convenient single gazetteer or catalogue drawing together all Romanesque work.

For the study of individual buildings the following can be helpful. Useful starting points are the general gazetteer of

cathedrals and abbeys (Morris, 1979) which includes bibliographies, and the Buildings of England series (Pevsner 1951–84; the sections on cathedrals, revised by Metcalf, in two separate volumes, forthcoming), which covers all of England in county gazetteers. The much larger Victoria County Histories, where they exist, are useful especially on the historical background; the Inventories of the Royal Commission on Historical Monuments (RCHM) have more architectural detail, but Dorset is the only county to have been fully published since 1950. A start has been made in publishing the rich photographic archives of the Courtauld Institute (e.g. collections on Lincoln and Canterbury). The documentary sources for the Royal works have been excellently covered by another official publication (Colvin, 1963). For castles there is a scholarly general account (Brown, 1954, 1962, 1970, 1976) and a gazetteer of Norman sites (Renn, 1968 and 1973). For other secular buildings the only survey is Wood, 1965, and very little can be added on individual secular buildings (but for the Bishop's Palace, Hereford, see Jones, Smith, 1960; the Palace of Henry of Blois at Wolvesey, Winchester, Biddle, 1969; the buildings of Roger of Salisbury, Stalley, 1971).

For many monuments the earlier works of such scholars as Willis, Bilson and Hope therefore remain indispensable, but there have been important new evaluations of a number of major churches. The Transactions of the annual conferences of the British Archaeological Association have brought together essays by different authors on various aspects of the cathedrals and abbeys studied (Brit. Archaeol. Assoc. Conf., 1975–80, covering Worcester, Ely, Durham, Wells and Glastonbury, Canterbury, and Winchester; see also under Fernie, Gem, Halsey, Stratford, Strik, C. Wilson). Other studies of major buildings include those of Battle Abbey (Hare, 1981), Canterbury Cathedral (Woodman, 1981), Chichester Cathedral (Andrew, 1977, 1980, 1982 and Gem, 1981b), Norwich Cathedral (Fernie, 1976), Romsey Abbey (Hearn, 1975), and the northern Cistercian buildings (Fergusson, 1970, 1971 and 1975). Excavation results have generally been less spectacular than for the pre-Conquest period; important exceptions are those revealing the great scale of the east end of the abbey of Bury St Edmunds (Whittingham, 1951 and Gilyard Beer, 1970), and the new discoveries concerning the late-11th-century cathedral at York (Gee, 1977; Phillips, 1975 and forthcoming).

While the established chronology has not been radically altered, recent research has provided new emphases. Comparative studies include the definition of regional characteristics (Brakspear, 1931; Clapham, 1952; and Cherry, 1978), the exploration of European filiations of particular features such as the rectangular ambulatory (Hearn, 1971) and different types of west towers and façades (Saxl, 1946; Bony, 1963; McAleer, 1963; and Rigold, 1979), of eastern rotundae (Gervers, 1969), and of the centrally-planned Bishop's Chapel at Hereford (Drinkwater, 1954 and 1955; Bandmann, 1964; and Bony, 1959). Rigold, 1977 provides a typology of base mouldings. The doyen of the comparative approach is Professor Bony, whose studies over the last 40 years (see Bony, *passim*), ranging from constructional techniques such as his fundamental study of the 'mur épais' (Bony, 1939a), to the use of ornament, have done so much to explore the way in which English Romanesque and Gothic architecture relate both to Anglo-Saxon precedent (e.g. Bony, 1981) and to contemporary Continental developments (Bony, 1957–8 and 1965). Investigations of the European connections of English buildings are also to be found in the study of Stavanger (Hohler, 1964), and with special emphasis on the importance of English Romanesque for early Gothic in France, in the discussions by

Héliot (1957, 1958 and 1965) and Branner (1963).

Among other types of approaches, an emphasis on the work of individual master masons (although this is a subject sparsely documented for the 12th century) has been the special concern of Harvey (1954, new edition forthcoming; also more generally, 1972 and 1974). The use of different building stones has been noted (Jope, 1964 and Tatton-Brown, 1980), but there is room here for further exploration. The relative responsibilities of masons and patrons in the design of buildings is still a matter for debate. On the role of architectural patrons see Stalley, 1969 and 1971 on Roger of Salisbury, and Cunningham, 1976 on the Bishops of Durham. The study of medieval metrology and its relationship to Romanesque church plans has produced some interesting conclusions (Fernie, 1979, 1982 and 1983a), as has the same author's exploration of the iconography of spiral piers (Fernie, 1977a and 1980).

Sculpture

Many of the bibliographical comments on architecture are relevant also for the study of sculpture for, compared with the Continent, England has relatively few examples of major Romanesque figure sculpture which do not form an integral part of a building. Older authorities, in accordance with widely-held views that the Norman Conquest disrupted more sophisticated Anglo-Saxon artistic traditions, attributed many of these separate and exceptional works to the pre-Conquest era and paid little attention to architectural sculpture of either period. After much debate by a previous generation (Kendrick, 1949; Clapham, 1948 and 1951; Rice, 1952 and 1960; Saxl, Wittkower, 1948; and Saxl, 1954) the honours are now more evenly divided: some new discoveries have been ascribed to the Anglo-Saxon period, notably a frieze fragment from Winchester (Biddle, 1966); the generally hesitant development of early- to mid-11th-century architectural decoration has been examined (Taylor, 1966 and 1978; Zarnecki, 1955a, 1955b and 1966; and Bony, 1967) although not always reaching a consensus on dating, while the consideration of English work in a broad European context has established a 12th-century date for some important major sculptures, for example the Chichester reliefs (Zarnecki, 1953b). The nature of the screens, roods and reredoses, and the general liturgical background for such works in both stone and metal have, however, been little discussed apart from Hope, 1917 on screens, although the documentary sources are plentiful. The *Rites of Durham* is a particularly important source (Rites, 1842 and 1903); for others see Lehmann-Brockhaus, 1955. The basic general reference books remain Braun, 1924, 1932 and 1940; for the Anglo-Saxon period see also Dodwell, 1982.

A fundamental contribution to a better understanding of English Romanesque sculpture has been the examination of hitherto neglected small-scale architectural sculpture, particularly capitals, supplementing Keyser's catalogue of tympana (Keyser, 1927). This has revealed how Anglo-Saxon and Viking artistic and iconographic traditions continued through the 12th century, adapted to mature Romanesque principles of architectural decoration, and combined with new ideas from a wide range of Continental sources. Investigations of this kind were pioneered by Professor Zarnecki (e.g. 1950b, 1951, 1953a, 1955b and 1966, several of these studies usefully reprinted in Zarnecki, 1979a), and have been pursued by many younger scholars. Some studies have examined the European context of common motifs (Zarnecki, 1955a; Henry, Zarnecki,

1957–8; and Borg, 1967); Higgitt (1972 and 1973) has investigated classical Roman sources. Others have drawn together work in similar materials, such as lead (Zarnecki, 1957a) and imported Tournai marble (Dunning, 1944 and Schwarzbaum, 1981); but there is room here for further research. The existence of 'regional schools' has been demonstrated, especially convincingly for the Herefordshire area (Zarnecki, 1950b and 1953a; and Morris, 1983), and other smaller groups of geographically-related monuments have been published, for example from Anglo-Danish York (Pattison, 1973) and 12th-century Northamptonshire (Maguire, 1970), Buckinghamshire (Thurlby, 1982b), and Gloucestershire (Gethyn-Jones, 1979). Two counties have been surveyed more systematically in as yet unpublished works: Oxfordshire: Hoffman 1963; Kent: Kahn, 1982. There is a catalogue of sculpture from Cluniac sites: Lockett, 1971, but there is still room for further investigation of the importance of individual patrons such as Henry of Blois (on which see Voss, 1932 and Turquet, 1974).

Among studies of individual works some have paid special attention to iconographic sources (e.g. Zarnecki, 1950a; Galbraith, 1965, 1968 and 1973; and Lang, 1977 and 1982). Research on sculpture of major buildings which has been of particular significance for an understanding of the development of the English Romanesque style includes the publications on Ely (Zarnecki, 1958), Lincoln (Zarnecki, 1964, 1970 and Fernie, 1977b), Worcester (Zarnecki, 1980), Reading (Zarnecki, 1949 and 1950a), Norwich Cloister (Norwich Exhibition, 1980, Franklin, 1983) and the as yet unpublished studies of Westminster Hall (Grant, 1976) and Southwell Minster (Kelly, 1971). The variety of artistic achievement has been further illuminated by the study of sculpture in lesser buildings (Baylé, 1980; Kahn, 1980; Marks, 1970; and Zarnecki, 1972a – the last concerning a rare example of a column-figure). Fragments recently discovered in excavations are usefully treated together in Thompson, 1983 (q.v. under Geddes, Greene, Kahn, Roberts and West).

The continuation of Romanesque sculptural traditions into the late 12th century is discussed generally by Zarnecki (1963 and 1976) and in connection with the Temple Church (Zarnecki, 1975a). Transitional sculpture has been investigated in the as yet unpublished survey by Thurlby (1976). The fragments from St Mary's, York, including large-scale figure sculpture, have received special attention (Marcousé, 1955; Sauerländer, 1959; and Wilson, 1983); important work of this period also existed at Canterbury (Jessup, Zarnecki, 1953).

Metalwork, ivory, seals, pottery, textiles

Two stimulating general European surveys (Swarzenski, 1954 and 1967; and Lasko, 1972a) draw together surviving works in metal, ivory and other precious materials, a fraction of the riches which once embellished Romanesque churches. A new edition of the 12th-century account of metalworking techniques by Theophilus (1961) is enlightening on the craftsmanship of such objects. Small-scale works of this kind, frequently now in museums, have been more accessible to scholars than architectural sculpture; and the tradition of publishing thoroughly-researched catalogues of such objects has been a well-established practice on the Continent since the early 20th century. The older volumes on metalwork, for example von Falke, Frauberger, 1904; von Falke, Meyer, 1935; and Nørlund, 1926, have been followed by more recent European studies including, or providing copious parallels for,

English work. These include Bloch, 1961 (seven-branched candlesticks); Gauthier, 1972 (enamels); Weitzmann-Fiedler, 1981 (engraved bronze bowls); Mende, 1981 (door-knockers); Springer, 1981 (bronze cross-bases); and Andersson, 1983 (silver bowls). English publications have mostly been concerned either with works in English collections, or with works for which an English provenance is assumed – not an easy matter to prove, as there were artistic traditions common to both sides of the Channel (as is discussed for example by Oman, 1953). Such surveys include those on plate (Hope, Fallow, 1887; Jackson, 1911; and Oman, 1957 and 1962); pastoral staves (Watts, 1924); censers (Tonnochy, 1937); spoons (How, 1952); rings (Dalton, 1912b; Oman, 1974; and Cherry, 1981a); and enamels (Mitchell, 1925 and 1926; and Chamot, 1930). But as such surveys are concerned either with the whole of the medieval period, or (in the cases of Wilson, 1964; Hinton, 1974; and Graham-Campbell, 1980) exclusively with pre-Conquest metalwork, they leave room for more detailed investigations of the style and iconography of objects of the Romanesque period of English provenance. Outside this catalogue there have been relatively few such studies: on the Gloucester candlestick (Oman, 1958, Harris, 1964, and Borg, forthcoming); on the Warden Abbey and Chichester crosiers (Dalton, Mitchell, Couchman, 1926); on a crosier in Florence (Campbell, 1979); on metalwork now at St-Maurice d'Agaune, Switzerland (Homburger, 1954); on a group of door-knockers (Zarnecki, 1964); on enamel plaques associated with Henry of Blois (Haney, 1982a and Stratford, 1983); and on the sanctuary ring of Durham Cathedral (Geddes, 1982) and other Durham metalwork (Geddes, 1980). On ironwork, i.e. door-fittings and grilles, there is an excellent recent discussion and catalogue, as yet unpublished (Geddes, 1978) expanding the account in Gardner, 1927.

Important collections of objects in tombs are those studied by Hope at Canterbury (Hope, 1893) and at St David's (Hope, 1907); and more recently the contents of Archbishop Hubert Walter's tomb at Canterbury (Stratford, Tudor-Craig, Muthesius, 1982).

Romanesque work in ivory and similar materials has been more adequately covered both in older catalogues (Dalton, 1909 and 1912a; Longhurst, 1926; and Goldschmidt, 1923, 1926) and in recent surveys by Beckwith (1972) and Williamson (1982 and 1983, which draw together the conclusions of important individual studies such as those by Beckwith, 1956a, 1956b, 1961, 1966a and 1966b, and by Hoving, 1964, on the remarkable Bury St Edmund's cross now in the Metropolitan Museum of Art – on which see also Parker, 1975). More recent additions to the literature are Stratford, 1977; Tcherikover, 1979; Heslop, Zarnecki, 1980; and two especially concerned with iconography: Heslop, 1981b (on the *Visitatio Sepulchri*) and Park, 1981 (a *Magi* scene).

Seals and seal dies have been a relatively neglected form of Romanesque art, although discussed illuminatingly by Saxl, 1954. The early, generally brief entries in catalogues (such as Birch, 1887–1900; Wyon, 1887; Hope, 1887; Greenwell, Blair, 1910–19; Hope, 1915–16; and Tonnochy, 1952) have been supplemented by a more recent general account of seals up to 1100 (Heslop, 1980), and by more detailed discussions of the art and iconography of individual Romanesque examples (Morgan, 1966; Cherry, 1972; Wormald, 1975; Henderson, 1978; and Heslop, 1981a and 1982a). For textiles, the best surveys, both covering the whole of the middle ages, are Christie, 1938 and the *Opus anglicanum* exhibition catalogue (London, 1963). The fabrics in Hubert Walter's tomb have been discussed by Muthesius (Stratford, Tudor-Craig,

Muthesius, 1982). For the special case of the Bayeux Tapestry see Stenton, 1957 and 1965; Dodwell, 1966; and Brooks, Walker, 1979. On pottery the only general survey is Hurst, 1976.

Painting, manuscripts, bookbindings, stained glass

In comparison with other parts of Europe (see Grabar, Nordenfalk, 1958 and Demus, Hirmer, 1970) major wall-paintings of the 12th century rarely survive in England. Tristram, 1944 provides a gazetteer, and a new survey by Park of all English medieval wall-painting is in progress. Individual studies exist of the group in Sussex (Baker, 1946), and of those in Canterbury Cathedral (Flynn, 1979). Park, 1983 provides a very thorough examination of the successive layers of paintings in the Holy Sepulchre chapel, Winchester. The paintings at Sigena, Spain, which can be attributed to English Winchester artists, are discussed by Pächt, 1961 and Oakeshott, 1972a and 1972b.

For a coherent understanding of English Romanesque paintings one has to turn to manuscripts. For full references to literature on this subject up to 1974 see Kauffmann, 1975. The transformation of pre-Conquest drawing tradition into the mature Romanesque style is discussed enlighteningly by Wormald (1943, 1944, 1952a, 1952b and 1955, to be reprinted in a forthcoming collection of essays). Recently progress of publications on this subject has been rapid; older conclusions have been usefully gathered together in several authoritative works, notably the series on English manuscripts published by Harvey Miller (Temple, 1976 on the pre-Conquest period; Kauffmann, 1975 on Romanesque; Morgan, 1982 on Gothic); the series of publications on the Bodleian Library collections (Pächt, Alexander, 1966, 1972 and 1973) and the general European survey of Romanesque Bibles (Cahn, 1982), all with good bibliographies. In addition several important monographs have been devoted to the manuscripts of different scriptoria, helped by the research on monastic libraries by Ker (1957, 1960 and 1964). The production of manuscripts is discussed by de Hamel, 1984. Among such scriptoria, Canterbury has been well studied in the pioneering work by Dodwell, 1954, followed by Lawrence, 1982. On Durham see Swarzenski, 1951 and Lawrence, 1981; on Worcester Kauffmann, 1978; on Rochester Richards, 1981; on St Albans Bateman, 1978 and Thomson, 1982; on Bury St Edmunds Parker, 1965 and also McLachlan, 1978a, 1978b and 1979 and Abou-el-Haj, 1983; and on the Bury Bible, Kauffmann, 1966; Thomson, 1975; and Parker, 1981. Manuscripts connected with individuals are discussed by Thomson, 1978 on William of Malmesbury and de Hamel, 1980 on Herbert of Bosham.

It is rare for the illuminations of individual manuscripts to be published fully. The few older facsimiles or virtually complete sets of reproductions (James, 1928, 1929 and 1935) have been supplemented by the exemplary detailed treatments given to the St Albans Psalter (Pächt, Dodwell, Wormald, 1960). The Winchester Bible was studied in Oakeshott, 1945, and then much more fully in Oakeshott 1981, the Winchester Psalter in Wormald, 1973. There are briefer accounts of the Lambeth Bible (Dodwell, 1959 and Denny, 1977) and the late-12th-century York Psalter (Boase, 1962), and an unpublished discussion of a Psalter in the Bodleian Library (Temple, 1972). Such studies have frequently emphasised the close relationships that existed between English scriptoria and Normandy, in some cases already before the Conquest (on this see further Pächt, 1950; Alexander, 1966 and 1970; and Avril, 1975). Angevin connections have also been explored (Ayres, 1974a, 1974b and 1976).

Examination of special types of manuscripts include bestiaries (McCulloch, 1960), medical books (Mackinney, 1965), Bede's Life of St Cuthbert (Baker, 1978) and the Utrecht Psalter copies (Heimann, 1975). Other important studies concentrating on iconography are James, 1951; Heimann, 1965 (on types and antitypes); and Heimann, 1966. Theological exposition is discussed generally by Henderson, 1981, and the influence of contemporary drama on painting by Pächt, 1962; other recent studies of the nature of medieval perception are Clancy, 1979 and Camille, 1982.

Bookbindings are covered in the older library catalogues (Weale, 1894 and 1898; Weale, Taylor, 1922; Gibson, 1901–4; and Fletcher, 1895), supplemented by Foot, 1983; Nixon, 1976 (on the Winton Domesday); and Pollard, 1962.

The only significant collection of Romanesque stained glass in England, that of Canterbury Cathedral, has been thoroughly examined, see Grodecki, 1952 and Caviness, *passim*, especially Caviness, 1981 which provides a full survey in the European Corpus Vitrearum series.

In conclusion, it should be observed that the listing of these studies under different headings is only a matter of bibliographical convenience. Many of the stylistic and iconographic investigations mentioned above have demonstrated the unity of the art of this period, and the close relationships that existed between its expression in various materials. This is further demonstrated in the general discussions of the broader themes of artistic influences in Western Europe, such as Saxl, Wittkower, 1948 or Baltrusaitis, 1931, of Byzantine influence in the west: Koehler, 1941, Kitzinger, 1966, and Demus 1970, or of the problems of the international style of *c.* 1200: Homburger, 1954 and the New York symposium, 1975. B.C.

★ Stars indicate works of interest to the general reader.

Abou-El-Haj, 1983
B.F. Abou-El-Haj, 'Bury St Edmunds Abbey between 1070 and 1124: a history of property, privilege and monastic over-production', *Art History*, 6, 1983, pp. 1–29
Alexander, 1966
J.J.G. Alexander, 'A little-known Gospel book of the late eleventh century from Exeter', *Burl. Mag.*, 108, 1966, pp. 6–14
Alexander, 1970
J.J.G. Alexander, *Norman Illumination at Mont St-Michel 966–1100*, 1970
Alexander, 1978
J.J.G. Alexander, 'Scribes as artists: the arabesque initial in twelfth-century English manuscripts', *Medieval Scribes, Manuscripts and Libraries, Essays Presented to N.R. Ker*, 1978, pp. 87–116
Alford, 1981
S. Alford, *Romanesque Sculpture in Dorset: a Selective Catalogue*, MA report, 1981, Courtauld Institute, University of London
Anderson see also Mrs Trenchard Cox
Anderson, 1935
★M.D. Anderson, *The Medieval Carver*, 1935
Anderson, 1951
M.D. Anderson, *Looking for History in British Churches*, 1951
Anderson, 1955
★M.D. Anderson, *The Imagery of British Churches*, 1955
Anderson, 1963
★M.D. Anderson, *Drama and Imagery in English Medieval Churches*, 1963
Andersson, 1983
A. Andersson, *Medieval Drinking-Bowls of Silver, Found in Sweden*, 1983
Andrew, 1977
M.R.G. Andrew, *The Architectural History of the Romanesque Cathedral at Chichester*, M Phil. dissertation, 1977, Courtauld Institute, University of London
Andrew, 1980
M.R.G. Andrew, 'Chichester Cathedral, the original east end: a reappraisal', *Sussex Archaeological Collections*, CXVIII, 1980, pp. 299–308
Andrew, 1982
M.R.G. Andrew, 'Chichester Cathedral, the problem of the Romanesque choir vault', *J. Brit. Archaeol. Assoc.*, CXXXV, 1982, pp. 11–22
Anselm, St, 1973
ed. Sister Benedicta Ward, *The Prayers and Meditations of St Anselm*, 1973
Avril, 1975
F. Avril, *Manuscrits normands XI-XIIème siècles*, Bibliothèque municipale de Rouen, Musée des Beaux-Arts, 1975
Ayres, 1974a
L.M. Ayres, 'The work of the Morgan Master at Winchester and English painting of the early Gothic period', *Art Bulletin*, LVI, 1974, pp. 201–23
Ayres, 1974b
L.M. Ayres, 'The role of an Angevin style in English Romanesque painting', *Zeitschrift für Kunstgeschichte*, 36, 1974, pp. 193–223
Ayres, 1976
L.M. Ayres, 'English painting and the Continent during the reign of Henry II and Eleanor', *Eleanor of Aquitaine, Patron and Politician*, ed. W.W. Kibler, 1976, pp. 116–45

Ayres, 1983
L.M. Ayres, 'Collaborative enterprise in Romanesque manuscript illumination and the artists of the Winchester Bible', *Brit. Archaeol. Assoc. Conf.*, VI, 1980, 1983, pp. 20–27

Baker, 1946
A. Baker, 'Lewes Priory and the Early Group of Wall-Paintings in Sussex', *Walpole Society*, XXXI (1942–3), 1946, pp. 1–44
Baker, 1978
M. Baker, 'Medieval illustrations of Bede's Life of St Cuthbert', *J. Warb. Court. Inst.*, 41, 1978, pp. 16–49
Baldwin Brown, 1903–37
G. Baldwin Brown, *The Arts in Early England*, 7 vols., 1903–37
Baldwin Brown, 1925
G. Baldwin Brown, *The Arts in Early England*, II, *Anglo-Saxon Architecture*, 2nd edn., 1925
Baltrusaitis, 1931
J. Baltrusaitis, *La stylistique ornementale dans la sculpture romane*, 1931
Bandmann, 1964
G. Bandmann, 'Die Bischofskapelle in Hereford zur Nachwirkung der Aachener Pfalzkapelle', *Festschrift Herbert von Einem*, 1964, pp. 2–26
Barlow, 1965
F. Barlow, *William I and the Norman Conquest*, 1965
Bateman, 1978
K.R. Bateman, 'Pembroke 120 and Morgan 736, a re-examination of the St Albans-Bury St Edmunds manuscript dilemma', *Gesta*, XVII, 1, 1978, pp. 19–26
Battle Conferences see Brown, 1979–83
Bayeux Tapestry see Stenton; Brooks, Walker, 1979; Dodwell, 1966
Baylé, 1979
M. Baylé, *La Trinité de Caen, sa place dans l'histoire de l'architecture et du décor romane*, 1979
Baylé, 1980
M. Baylé, 'Les chapiteaux de Stogursey (Somerset), ancien prioré de Lonlay l'Abbaye', *Bull. Mon.*, CXXXVIII, 1980, pp. 405–416
Baylé, 1982
M. Baylé, 'Interlace patterns in Norman Romanesque Sculpture', *Proc. Battle Conf.* V, 1982, ed. Brown, 1983
Beckwith, 1956a
J. Beckwith, 'An ivory relief of the Ascension', *Burl. Mag.*, XCVIII, 1956, pp. 118–122
Beckwith, 1956b
J. Beckwith, 'An Ivory relief of the Deposition', *Burl. Mag.*, XCVIII, 1956, pp. 228–235
Beckwith, 1961
J. Beckwith, 'An Ivory Relief of the Crucifixion', *Burl. Mag.*, CXIII, 1961, pp. 434–37
Beckwith, 1964
★J. Beckwith, *Early Medieval Art, Carolingian, Ottonian, Romanesque*, 1964
Beckwith, 1966a
J. Beckwith, 'A Rediscovered English Ivory', *V. and A. Mus. Bull.*, II, 4, October 1966
Beckwith, 1966b
J. Beckwith, *The Adoration of the Magi in Whalebone*, Victoria and Albert Museum, 1966
Beckwith, 1972
★J. Beckwith, *Ivory Carving in Early Medieval England*, 1972

Benson, Constable, 1982
R.L. Benson and G. Constable (eds.) with C.D. Lanham, *Renaissance and Renewal in the Twelfth Century*, 1982
Bernard, St, 1957–
St Bernard, *Opera S. Bernardi*, ed. J. Leclercq, C.H. Talbot, H.M. Rochais, 8 vols., Rome, 1957 etc. *Epistolae* in vols. VII–VIII
Biddle, 1966
M. Biddle, 'A late Saxon frieze sculpture from the Old Minster', *Antiq. J.*, XLVI, 1966, pp. 329–32
Biddle, 1969
M. Biddle, 'Wolvesey: the *domus quasi palatium* of Henry de Blois in Winchester', A.J. Taylor (ed.), *Chateau Gaillard . . . Conference at Battle*, 1966, 1969
Biddle, 1970
M. Biddle, *Excavations near Winchester Cathedral 1961–9*, 1970
Biddle, 1976a
M. Biddle et al., *The Winton Domesday, Winchester Studies*, I, *Winchester in the Early Middle Ages*, 1976
Biddle, 1976b
M. Biddle, 'The archaeology of the Church: a widening horizon', *The Archaeological Study of Churches*, ed. P.V. Addyman, R.K. Morris, CBA Research Report 13, 1976, pp. 65–71
Biddle, 1979
M. Biddle, *The Chapter House Excavation*, Fraternity of the Friends of St Albans Abbey, occasional publication, I, 1979
Biddle, 1980
M. Biddle and B. Kjølbye-Biddle, 'England's premier abbey. The Medieval Chapter House of St Albans Abbey and its excavations in 1978', *Expedition*, 22, 1980, pp. 17–32
Biddle, Barclay, 1974
M. Biddle, K. Barclay, 'Winchester ware', *Medieval Pottery from excavations*, ed. V.I. Evison, 1974, pp. 137–166
Bilson, 1909
J. Bilson, 'The architecture of the Cistercians with special reference to some of their earlier churches in England', *Archaeol. J.*, LXVI, 1909, pp. 185–280
Bilson, 1922
J. Bilson, 'Durham Cathedral: the chronology of its vaults', *Archaeol. J.*, 1922, pp. 101–60
Birch, 1887–1900
W. de G. Birch, *Catalogue of Seals in the Department of Manuscripts in the British Museum*, 6 vols., 1887, 1892, 1894, 1895, 1898, 1900
Bishop, Chaplais, 1957
T.A.M. Bishop, P. Chaplais, *Facsimiles of English Royal Writs to AD 1100*, 1957
Blair, 1920 see Greenwell, Blair XVII, 1920
Blair, 1922
C.H. Hunter Blair, 'Medieval seals of the Bishops of Durham', *Archaeologia*, 72, 1922, pp. 1–24
Blair, 1943
C.H. Hunter Blair, 'Armorials in English seals from the 12th to the 16th centuries', *Archaeologia*, LXXXIX, 1943, pp. 1–26
Bloch, 1961
P. Bloch, 'Siebenarmige Leuchter in Christlichen Kirchen', *Wall. Rich. J*, XXIII, 1961
Bloch, 1979
P. Bloch, 'Staufische Bronzen, die Bronzekruzifixe', in Stuttgart 1977–9, V (q.v.)

Boase, 1953
★T.S.R. Boase, *English Art 1100–1216*, Oxford History of English Art, 3, 1953
Boase, 1962
T.S.R. Boase, *The York Psalter*, 1962
Bodleian, 1951
English Romanesque Illumination, Bodleian Picture Book 1, 1951
Bond, 1908
F. Bond, *Fonts and Fontcovers*, 1908
Bony, 1937
J. Bony, 'Tewkesbury et Pershore – Deux élévations a quatre étages de la fin du XIe siècle', *Bull. Mon.*, XCVI, 1937, pp. 281–90, 503–4
Bony, 1939a
J. Bony, 'La technique normande du mur épais', *Bull. Mon.*, XCVIII, 1939, pp. 153–188
Bony, 1939b
J. Bony, 'Gloucester et l'origine des voûtes d'hemicycle gothique', *Bull. Mon.*, CXVIII, 1939, pp. 329–331
Bony, 1949
J. Bony, 'French influences on the origin of English Gothic architecture', *J. Warb. Court. Inst.*, XII, 1949, pp. 1–16
Bony, 1954
J. Bony, 'Le projet premier de Durham', *Urbanisme et Architecture, Etudes écrites et publiées en l'honneur de P. Lavedan*, 1954, pp. 41–49
Bony, 1957–8

thirteenth-century architecture', *J. Brit. Archaeol. Assoc.*, 3rd series, XX–XXI, 1957–8, pp. 35–52
Bony, 1959
J. Bony, 'La chapelle épiscopale de Hereford', *Actes du XIXe Congrès International d'Histoire de l'Art, Paris*, 1959, pp. 36–43
Bony, 1963
J. Bony, 'The Façade of Bury St Edmunds, an Additional Note', *Studies in Western Art*, I, Acts of the XXth Congress of History of Art, Princeton, 1963, pp. 92–104
Bony, 1965
J. Bony, 'Les origines des piles gothiques à fûts en délits', *Gedenkschrift Ernst Gall*, 1965, pp. 95–122
Bony, 1967
J. Bony, Review of Taylor, 1965, *J. Soc. Archit. Hist.*, XXVI, 1967, pp. 74–7
Bony, 1976
J. Bony, 'Diagonality and centrality in early ribvault architecture', *Gesta*, XV, 1–2, 1976, pp. 15–26
Bony, 1981
J. Bony, 'Durham et la tradition Saxonne', *Etudes d'art médiéval offertes à Louis Grodecki*, 1981, pp. 89–92
Borenius, 1932
T. Borenius, *St Thomas Becket in Art*, 1932
Borenius, Chamot, 1928
T. Borenius and M. Chamot, 'On a group of early enamels, possibly English,' *Burl. Mag.*, LIII, 1928, pp. 276–87
Borenius, Charlton, 1936
T. Borenius and J. Charlton, 'Clarendon Palace: an interim report', *Antiq. J.*, XVI, 1936, pp. 55–84
Borg, 1967
A. Borg, 'The Development of Chevron Ornament', *J. Brit. Archaeol. Assoc.*, 3rd series, XXX, 1967, pp. 122–40
Borg, forthcoming
A. Borg, *The Gloucester Candlestick* (Brit. Archaeol. Assoc. Conf. VII)
Brakspear, 1931
H. Brakspear, 'A west country School of Masons', *Archaeologia*, LXXXI, 1931, pp. 1–18
Branner, 1963
R. Branner, 'Gothic architecture 1160–1180 and its Romanesque sources', *Studies in Western Art*, I, Acts of the XXth Congress of History of Art, Princeton, 1963, pp. 92–104

Braun, 1924
J. Braun, *Der christliche Altar in seiner Geschichte und Entwicklung*, 1–11, 1924
Braun, 1932
J. Braun, *Das christliche Altergerät in seinem Sinn und in seiner Entwicklung*, 1932
Braun, 1940
J. Braun, *Die Reliquiare des christlichen Kultes und ihre Entwicklung*, 1940
Brett, 1975
M. Brett, *The English Church under Henry I*, 1975
Brit. Archaeol. Assoc. Conf.
British Archaeological Association Conference Transactions
I, 1975, 'Medieval art and architecture at Worcester Cathedral', 1978
II, 1976, 'Medieval art and architecture at Ely Cathedral', 1979
III, 1977, 'Medieval art and architecture at Durham Cathedral', 1980
IV, 1978, 'Medieval art and architecture at Wells and Glastonbury', 1981
V, 1979, 'Medieval art and architecture at Canterbury before 1220', 1982
VI, 1980, 'Medieval art and architecture at Winchester Cathedral', 1983
Brooke, 1969
★C. Brooke, *The Twelfth-Century Renaissance*, 1969
Brooke, 1971
C.N.L. Brooke, *Medieval Church and Society*, 1971
Brooke, 1983
R. and C.N.L. Brooke, *Popular Religion in the Middle Ages, 1000–1300*, 1983
Brooke, Keir, 1975
C.N.L. Brooke and G. Keir, *London 800–1216: The Shaping of a City*, 1975
Brooke, Pinder-Wilson, 1973
C.N.L. Brooke and R.H. Pinder-Wilson, 'The Reliquary of St Petroc and the Ivories of Norman

Brooke, Swaan, 1974
★C.N.L. Brooke and W. Swaan, *The Monastic World, 1000–1300*, 1974
Brooks, Walker, 1979
N.P. Brooks and H.E. Walker, 'The authority and interpretation of the Bayeux Tapestry', *Proc. Battle Conf.I, 1978*, ed. R.A. Brown, 1979, pp. 1–34, 191–9
Brown, 1969a
★R.A. Brown, *The Normans and the Norman Conquest*, 1969
Brown, 1969b
R.A. Brown, 'The Norman Conquest and the genesis of English castles', A.J. Taylor (ed.) *Chateau Gaillard . . . Conference at Battle, 1966*, 1969
Brown, 1954, 1962, 1970, 1976
★R.A. Brown, *English Castles*, 1954, 1962, 1970, 1976
Brown, 1979–83
R.A. Brown (ed.), *Proceedings of the Battle Conference of Anglo-Norman Studies (Proc. Battle Conf.)*
I, 1978, 1979
II, 1979, 1980
III, 1980, 1981
IV, 1981, 1982
V, 1982, 1983
Brown, 1976
T.J. Brown, 'The manuscript and the handwriting', *Winchester in the early Middle Ages*, Winchester Studies, I, ed. M. Biddle, 1976, pp. 520–22
Browne, 1847
J. Browne, *History of the Metropolitan Church of St Peter, York*, 2 vols., 1847
Butler, 1949
H.E. Butler (ed. and transl.) *Jocelin of Brakelond, Chronicle*, Nelson's Medieval Texts, 1949

Cahn, 1975
W. Cahn, 'St Albans and the Channel style in England', in New York, 1975, pp. 187–230 (q.v.)

Cahn, 1982
W. Cahn, *Romanesque Bible Illumination*, 1982
Camille, 1982
M. Camille, *Seeing and Reading; some visual consequences of medieval literacy and illiteracy*, unpublished paper, Cambridge University, 1982
Campbell, 1979
M.L. Campbell, '"Scribe faber lima", a crozier in Florence reconsidered', *Burl. Mag.*, CXXI, 1979, pp. 364–69
Caudron, 1977
S. Caudron, 'Connoisseurs of champlevé Limoges enamels in eighteenth-century England', *British Museum Yearbook*, 2, 1977, pp. 9–33
Cave, 1945
C.J.P. Cave, 'Capitals from the Cloister of Hyde Abbey', *Antiq. J.*, XXV, 1945, pp. 79–80
Cave, 1948
C.J.P. Cave, *Roof Bosses in Medieval Churches, an aspect of Gothic Sculpture*, 1948
Caviness, 1975
M.H. Caviness, 'The Canterbury Jesse Window', in New York, 1975, pp. 373–98 (q.v.)
Caviness, 1977
M.H. Caviness, *The Early Stained Glass of Canterbury Cathedral, c. 1175–1220*, 1977
Caviness, 1979
M.H. Caviness, 'Conflicts between *Regnum* and *Sacerdotium* as reflected in a Canterbury Psalter of c. 1215', *Art Bull.* 61, 1979, pp. 38–58
Caviness, 1981
M.H. Caviness, *The Windows of Christ Church Cathedral, Canterbury*, Corpus Vitrearum Medii Aevi, Great Britain, III, 1981
Caviness, 1982
M.H. Caviness, 'Canterbury Cathedral clerestory: the glazing programme in relation to the campaigns of construction', *Brit. Archaeol. Conf., V, 1979*, 1982, pp. 46–55
Caviness, forthcoming
M.H. Caviness, 'Suger's glass at Saint-Denis: the state of research', in *Abbot Suger and Saint-Denis, An International Symposium*, ed. Paula Gerson, forthcoming
Chamot, 1930
M. Chamot, *English Medieval Enamels*, 1930
Chaplais, 1960
P. Chaplais, 'The original charters of Herbert and Gervase Abbots of Westminster', *Early Medieval Miscellany for D.M. Stenton*, Pipe Roll Society, new series, 36, 1960
Chartraire, 1923
E. Chartraire, 'Mitres du Trésor de Sens', *Bulletin archéologique*, 1923
Cherry, 1967
B. Cherry, 'Recent work on Romanesque art and architecture in the British Isles', *Anuario de estudios medievales*, 4, 1967, pp. 467–86
Cherry, 1972
J. Cherry, 'The seal matrix of Richard Cano', *Wiltshire Archaeological and Natural History Magazine*, 67, 1972, pp. 162–63
Cherry, 1978
B. Cherry, 'Romanesque architecture in Eastern England', *J. Brit., Archaeol. Assoc.*, 131, 1978, pp. 1–29
Cherry, 1981a
J. Cherry, 'Medieval rings', A. Ward, J. Cherry, C. Gere, B. Cartlidge, *The Ring*, 1981
Cherry, 1981b
J. Cherry, 'A 12th-century mortar from Ryston Hall, Norfolk', *Norfolk Archaeology*, XXXVIII, part 1, 1981, pp. 67–72
Christie, 1938
A.G.I. Christie, *English Medieval Embroidery*, 1938
Clancy, 1979
M.T. Clancy, *From Memory to Written Record, England 1066–1307*, 1979
Clapham, 1930
A.W. Clapham, *English Romanesque Architecture before the Conquest*, 1930

Clapham, 1934
★A.W. Clapham, *English Romanesque Architecture after the Conquest*, 1934
Clapham, 1948
A.W. Clapham, 'The York Virgin and its date', *Archaeol. J.*, CV, 1948, pp. 6–13
Clapham, 1951
A.W. Clapham, 'Some disputed examples of pre-Conquest sculpture', *Antiquity*, XXV, 1951, pp. 191–5
Clapham, 1952
A.W. Clapham, 'The form of the early choir at Tewkesbury and its significance', *Archaeol. J.*, CVI, Supplement, 1952, pp. 10–15
Clark, 1976
C. Clark, 'People and language in post-Conquest Canterbury', *J. Medieval History*, 2, 1976, pp. 1–33
Clear, 1866
J.B. Clear, 'Contents of graves in St David's Cathedral', *Archaeologia Cambrensis*, XII, 3rd series, 1866
Colish, 1968
M.L. Colish, 'A twelfth-century problem', *Apollo*, July 1968, pp. 36–41
Colvin, 1963
H.M. Colvin (ed.), *The History of the King's Works*, I, *The Middle Ages*, 1, 2, 1963
Collingwood, 1927
W.G. Collingwood, *Northumbrian Crosses of the Pre-Norman Age*, 1927
Courcelle, 1967
P. Courcelle, *La Consolation de Philosophie dans la tradition littéraire*, 1967
Courtauld, 1976a, 1976b, 1978
Courtauld Institute Illustration Archives, general ed. P. Lasko, I, *Cathedrals and Monastic Buildings in the British Isles*: part 1, *Lincoln Romanesque West Front*, ed. G. Zarnecki, 1976; part 5, *Lincoln*, 1978; part 8, *Canterbury*, 1978
Cox see also M.D. Anderson
Cox, 1959
(Mrs) Trenchard Cox, 'The twelfth-century design sources of the Worcester Cathedral misericords', *Archaeologia*, XCVII, 1959, pp. 165–78
Cunningham, 1976
J.A. Cunningham, *The Extent of Episcopal Patronage in the North of England in the Second Half of the Twelfth Century*, MA report, 1976, Courtauld Institute, University of London

Dale, 1956
W. Dale, 'An English Crozier of the Transition Period', *Art Bull.*, XXXVIII, 1956, pp. 138–41
Dalton, 1909
O.M. Dalton, *Catalogue of the Ivory Carvings of the Christian Era in the British Museum*, 1909
Dalton, 1912a
O.M. Dalton, *Fitzwilliam Museum McClean Bequest, Catalogue of the Medieval Ivories, Enamels, Jewellery, Gems and Miscellaneous Objects*, 1912
Dalton, 1912b
O.M. Dalton, *Catalogue of the Finger Rings in the British Museum, London*, 1912
Dalton, Mitchell, Couchman, 1926
O.M. Dalton, H.P. Mitchell and J.E. Couchman, 'The Warden Abbey and Chichester Croziers', *Archaeologia*, LXXV, 1926, pp. 211–15
Darkevich, 1966
V.P. Darkevich, *Proizvedeniya Zapadnovo Khudozhestvennovo Remesla V Vostochnoi Europe (X-XIV vv)*, Arkheologiya SSSR – Svod Arkheologicheskikh Istochnikov E1–57, 1966
Delalonde, 1981
M. Delalonde, *Manuscrits du Mont Saint-Michel*, 1981
De la Mare, 1983
A.C. de la Mare, 'A probable addition to the Bodleian's holdings of Exeter Cathedral manuscripts', *Bodleian Library Record*, XI.2, 1983, pp. 79–88

Delisle, 1866
L. Delisle, *Rouleaux des morts du IX au XV siècle*, 1866
Demus, 1949
O. Demus, *The Mosaics of Norman Sicily*, 1949
Demus, 1970
O. Demus, *Byzantine Art and the West*, 1970
Demus, 1975
O. Demus, 'European Wall Painting around 1200', in New York, 1975, pp. 95–118 (q.v.)
Demus, Hirmer, 1970
★O. Demus and M. Hirmer, *Romanesque Mural Painting*, 1970
Denny, 1977
D. Denny, 'Notes on the Lambeth Bible', *Gesta*, XVI, 1977, pp. 51–64
Dodwell see also Theophilus
Dodwell, 1957
B. Dodwell, 'The foundation of Norwich Cathedral', *Transactions of the Royal Historical Society*, VII, 1957, pp. 2–3
Dodwell, 1954
★C.R. Dodwell, *The Canterbury School of Illumination, 1066–1200*, 1954
Dodwell, 1959
C.R. Dodwell, *The Great Lambeth Bible*, 1959
Dodwell, 1966
C.R. Dodwell, 'The Bayeux Tapestry and the French secular epic', *Burl. Mag.*, CVIII, 1966, pp. 549–60
Dodwell, 1971
★C.R. Dodwell, *Painting in Europe, 800–1200*, Pelican History of Art, 1971
Dodwell, 1982
C.R. Dodwell, *Anglo-Saxon Art: A New Perspective*, 1982
Drinkwater, 1954
N. Drinkwater, 'Hereford Cathedral: the Bishop's Chapel', *Archaeol. J.*, CXI, 1954, pp. 129–37
Drinkwater, 1955
N. Drinkwater, 'Addendum to the Bishop's Chapel', *Archaeol. J.*, CXII, 1955, pp. 74–5
Dunning, 1944
G.C. Dunning, 'The Distribution of Black Tournai Fonts in England', *Antiq. J.*, XXIV, 1944, pp. 66–8
Durham Seals see Greenwell, Blair, 1910–20
Dynes, 1976
W. Dynes, 'Tradition and Innovation in Medieval Art', *Medieval Studies, An Introduction*, ed. J.M. Powell, 1976

Eleen, 1982
L. Eleen, *The Illustrations of the Pauline Epistles in French and English Bibles of the Twelfth and Thirteenth Centuries*, 1982
Eames, 1980
E.S. Eames, *Catalogue of Medieval Lead-Glazed Earthenware Tiles in the British Museum*, I, II, 1980
Ellis, 1978, 1981
R.H. Ellis, *Catalogue of Seals in the Public Record Office: Personal Seals*, I, 1978, II, 1981
Emerson, 1981
R. Emerson, *Twelfth-Century Sculpture at Oakham Castle*, Leicestershire Museum Art Galleries Records Services, 1981
Evans, 1978
M. Evans, 'Allegorical women and practical men: The iconography of the *Artes* reconsidered', *Medieval Women*, ed. D. Baker, Studies in Church History, Subsidia 1, 1978

von Falke, Frauberger, 1904
O. von Falke and H. Frauberger, *Deutsche Schmelzarbeiten des Mittelalters*, 1904
von Falke, Meyer, 1935
O. von Falke and E. Meyer, *Romanische Leuchter und Gefässe. Giessgefässe der Gotik, Bronzegeräte des Mittelalters*, I, 1935

Farley, Wormald, 1940
M.A. Farley and F. Wormald, 'Three Related English Romanesque Manuscripts', *Art Bull.*, XXII, 1940, pp. 157–61
Fergusson, 1970
P. Fergusson, 'Early Cistercian churches in Yorkshire and the problem of the Cistercian crossing tower', *J. Soc. Archit. Hist.*, XXIX, 1970, pp. 211–20
Fergusson, 1971
P. Fergusson, 'Roche Abbey: the source and date of the eastern remains', *J. Brit. Archaeol. Assoc.*, XXXIV, 1971, pp. 30–42
Fergusson, 1975
P. Fergusson, 'The south transept elevation of Byland Abbey', *J. Brit. Archaeol Assoc.*, XXXVIII, 1975, pp. 155–76
Fernie, 1973
E. Fernie, 'Enclosed apses and Edward's church at Westminster', *Archaeologia*, CIV, 1973, pp. 235–60
Fernie, 1976
E. Fernie, 'The ground plan of Norwich Cathedral and the square root of 2', *J. Brit. Archaeol. Assoc.*, 129, 1976, pp. 77–86
Fernie, 1977a
E. Fernie, 'The Romanesque piers of Norwich Cathedral', *Norfolk Archaeology*, XXXVI, part IV, 1977, pp. 383–5
Fernie, 1977b
E. Fernie, 'Alexander's Frieze on Lincoln Minster', *Lincolnshire History and Archaeology*, 12, 1977, pp. 19–28
Fernie, 1979
E. Fernie, 'Observations on the Norman Plan of Ely Cathedral', *Brit. Archaeol. Assoc. Conf.*, II, 1978, 1979, pp. 1–7
Fernie, 1980
E. Fernie, 'The spiral piers of Durham Cathedral', *Brit. Archaeol. Assoc. Conf.*, III, 1977, 1980, pp. 49–58
Fernie, 1982
E. Fernie, 'St Anselm's Crypt', *Brit. Archaeol. Assoc. Conf.*, V (Canterbury), 1979, 1982, pp. 27–38
Fernie, 1983a
E. Fernie, 'The grid system and the design of the Norman cathedral', *Brit. Archaeol. Assoc. Conf.*, VI, (Winchester), 1980, 1983, pp. 13–19
Fernie, 1983b
★E. Fernie, *The Architecture of the Anglo Saxons*, 1983
Fingerlin, 1971
I. Fingerlin, *Gürtel des hohen und späten Mittelalters*, 1971
Fisher, 1962
E.A. Fisher, *The Greater Anglo-Saxon Churches*, 1962
Fletcher, 1895
W.Y. Fletcher, *English Bookbindings in the British Museum*, 1895
Flynn, 1979
K. Flynn, 'Romanesque wall paintings in the Cathedral Church of Christ Church, Canterbury', *Archaeol. Cant.*, XCV, 1979, pp. 185–95
Foot, 1983
M.M. Foot, *The Henry Davis Gift; a Collection of Bookbindings*, II, *A Catalogue of North European Bindings*, 1983
Forsyth, 1972
I.E. Forsyth, *The Throne of Wisdom*, 1972
Fowler, 1880
The Revd. J.T. Fowler, 'An account of excavations made on the site of the Chapter-house of Durham Cathedral in 1874', *Archaeologia*, XLV, 1880
Franklin, 1983
J.A. Franklin, 'The Romanesque cloister sculpture at Norwich Cathedral Priory', *Studies in Medieval Sculpture*, ed. F.H. Thompson, 1983, pp. 56–70
French, 1971
T.W. French, 'Observations on some Medieval Glass in York Minster', *Antiq. J.*, 51, 1971, pp. 86–93

Frodl-Kraft, 1970
E. Frodl-Kraft, *Die Glasmalerei: Entwicklung, Technik, Eigenart*, 1970
Fuglesang, 1979
S.H. Fuglesang, *Some Aspects of the Ringerike Style*, 1979

Gaborit-Chopin, 1978
D. Gaborit-Chopin, *Ivoires du Moyen Age*, 1978
Galbraith, 1965
K.J. Galbraith, 'The iconography of the Biblical scenes at Malmesbury Abbey', *J. Brit. Archaeol. Assoc.*, 3rd series, XXVIII, 1965, pp. 39–40
Galbraith, 1968
K.J. Galbraith, 'Early sculpture at St Nicholas's Church, Ipswich', *Proceedings of the Suffolk Institute of Archaeology*, XXXI, part 2, 1968, pp. 172–84
Galbraith, 1973
K.J. Galbraith, 'Further thoughts on the boar at St Nicholas's Church, Ipswich', *Proceedings of the Suffolk Institute of Archaeology*, XXXIII, part 1, 1973, pp. 68–74
Gardner, 1927
J.S. Gardner, *Ironwork*, I, 1927
Gardner, 1951
A. Gardner, *A Handbook of English Medieval Sculpture*, 2nd edn., 1951
Gauthier, 1972
M.M. Gauthier, *Emaux du moyen âge occidental*, 1972
Gauthier, 1975
M.M. Gauthier, 'Le Meutre dans la Cathédrale, thème iconographique médiévale'; *Thomas Becket, Actes du colloque international de Sédières, 19–24 août, 1973*, 1975
Gauthier, 1979
M.M. Gauthier, 'Emaux septentrionaux. Colloque du British Museum', *Revue de l'Art*, 43, 1979, pp. 79–82
Geddes, 1978
J. Geddes, *English Decorative Ironwork 1100–1350*, Ph.D. thesis, 1978, Courtauld Institute, University of London
Geddes, 1980
J. Geddes, 'The twelfth-century metalwork at Durham Cathedral', *Brit. Archaeol. Assoc. Conf.*, III (Durham), 1977, 1980
Geddes, 1982
J. Geddes, 'The Sanctuary Ring of Durham Cathedral', *Archaeologia*, CVII, 1982, pp. 125–9
Geddes, 1983
J. Geddes, 'Recently discovered Romanesque sculpture in south-east England', *Studies in Medieval Sculpture*, ed. F.H. Thompson, 1983, pp. 90–97
Gee, 1977
E.A. Gee, 'Architectural History until 1290', G.E. Aylmer and R. Cant, *A History of York Minster*, 1977, pp. 110–29
Gem, 1975
R.D.H. Gem, 'A recession in English architecture during the early eleventh century, and its effect on the development of the Romanesque style', *J. Brit. Archaeol. Assoc.*, 3rd series, XXXVIII, 1975, pp. 28–49
Gem, 1978
R.D.H. Gem, 'Bishop Wulfstan II and the Romanesque Cathedral Church of Worcester', *Brit. Archaeol. Assoc Conf.*, I, 1975, 1978, pp. 15–37
Gem, 1981a
R.D.H. Gem, 'The Romanesque rebuilding of Westminster Abbey', *Proc. Battle Conf.*, III, 1980, 1981, pp. 33–60
Gem, 1981b
R.D.H. Gem, 'Chichester Cathedral: when was the Romanesque church begun?' *Proc. Battle Conf.*, III, 1980 , 1981, pp. 61–4

Gem, 1982
R.D.H. Gem, 'The Significance of the 11th-century rebuilding of Christ Church and St Augustine's, Canterbury in the development of Romanesque architecture', *Brit. Archaeol. Assoc. Conf.*, V, 1979, 1982, pp. 1–19
Gem, 1983
R.D.H. Gem, 'The Romanesque Cathedral of Winchester: patron and design in the eleventh Century', *Brit. Archaeol. Assoc. Conf*, VI, 1980, 1983, pp. 1–12
Gervers, 1969
M. Gervers, 'Rotundae anglicanae', *Actes du XXIIe Congrès international d'Histoire de l'Art, Budapest, 1969*, 1972, pp. 359–76
Gethyn-Jones, 1979
E. Gethyn-Jones, *The Dymock School of Sculpture*, 1979
Gibson, 1901–4
S. Gibson, *Some Notable Bodleian Bindings*, 1901–4
Gibson, 1979
P. Gibson, *The Stained and Painted Glass of York Minster*, 1979
Gibson, 1981
M. Gibson, (ed.), *Boethius, his Life, Thought and Influence*, 1981
Gilbert, 1970
E.C. Gilbert, 'The date of the late Saxon Cathedral at Canterbury', *Archaeol. J.*, 127, 1970, pp. 202–10
Gilyard Beer, 1970
R. Gilyard Beer, 'The eastern arm of the Abbey Church at Bury St Edmunds,' *Proceedings of the Suffolk Institute of Archaeology*, 31, 1970, pp. 256–262
Godfrey, 1952
W.H. Godfrey, 'English cloister lavatories as independent structures', *Archaeol. J.*, CVI, Supplement, 1952, pp. 91–7
Goldschmidt, 1918, 1923, 1926
A. Goldschmidt, *Die Elfenbeinskulpturen aus der romanischen Zeit: Die Elfenbeinskulpturen*, II, 1918, III, 1923, IV, 1926
Goodgal, 1972
D. Goodgal, *Twelfth-century figure sculpture at St Mary's Abbey, York*, MA report, 1972, Courtauld Institute, University of London
Gough, 1786
R. Gough, *Sepulchral Monuments in Great Britain*, I, 1786
Grabar, Nordenfalk, 1958
★A. Grabar and C. Nordenfalk, *Romanesque Painting from the Eleventh to the Thirteenth Century*, 1958
Graham-Campbell, 1980
J. Graham-Campbell, *Viking Artefacts. A Select Catalogue, British Museum*, 1980
Grant, 1976
L.M. Grant, *Romanesque Sculptural Decoration at Westminster Hall*, MA report, 1976, Courtauld Institute, University of London
Green, 1968
R.B. Green, 'Virtues and Vices in the Chapter House vestibule in Salisbury', *J. Warb. Court. Inst.*, 31, 1968, pp. 148–58
Greene, 1983
J.P. Greene, 'Carved stonework from Norton Priory, Cheshire', *Studies in Medieval Sculpture*, ed. F.H. Thompson, 1983, pp. 202–7
Greenwell, Blair, 1910–20
W. Greenwell and C.H. Blair, 'Durham seals: catalogue made by the Rev. W. Greenwell . . . collated and annotated by C.H. Blair', *Archaeologia Aeliana*
VII, 1910, pp. 268–360, nos. 1-828
VIII, 1911, pp. 46–136, nos 829–1566
IX, 1912, pp. 281–336, nos. 1567–1992
XI, 1913, pp. 177–277, nos. 1993–2729
XII, 1914, pp. 287–332, nos. 2730–3012
XIII, 1915, pp. 117–56, nos. 3013–3087
XIV, 1916, pp. 221–91, nos. 3088–3250
XV, 1918, pp. 115–204, nos. 3251–3594
XVI, 1919, pp. 115–206, nos. 3595–3755
XVII, 1920, pp. 244–313, Introduction and notes

Grodecki, 1952
L. Grodecki, 'The ancient glass of Canterbury Cathedral', *Burl. Mag.*, XCII, 1952, pp. 294–7
Grodecki, 1976
L. Grodecki, *Les vitraux de Saint-Denis: Etude sur le Vitrail au XIIe siècle*, I, Corpus Vitrearum Medii Aevi, France, Etudes, I, 1976
Grodecki, Brisac, 1977
L. Grodecki and C. Brisac, *Le Vitrail roman*, 1977

Haldon, Mellor, 1977
R. Haldon and M. Mellor, 'Late Saxon and medieval pottery', B. Durham, 'Archaeological investigations in St Aldate's, Oxford', *Oxoniensia*, XLII, 1977, pp. 83–203
Halsey, 1980
R. Halsey, 'The Galilee Chapel', *Brit. Archaeol. Assoc. Conf.*, III, (Durham) 1977, 1980, pp. 59–73
de Hamel, 1978
C. de Hamel, *The Production and Circulation of Glossed Books of the Bible in the 12th and early 13th Centuries*, Ph.D. thesis, 1978, University of Oxford (see also de Hamel, 1984).
de Hamel, 1980
C. de Hamel, *The Manuscripts of Herbert of Bosham*, R.W. Hunt Memorial Exhibition, Bodleian Library, Oxford, 1980
de Hamel, 1984
C. de Hamel, *The Production and Circulation of Glossed Books of the Bible in the 12th and 13th Centuries*, 1984
Haney, 1981
K.E. Haney, 'The paint surfaces in the Psalter of Henry of Blois', *The British Library Journal*, 7, 1981, pp. 149–58
Haney, 1982a
K.E. Haney, 'Some Mosan sources for the Henry of Blois enamels', *Burl. Mag.*, XXXIV, 1982, pp. 220–30
Haney, 1982b
K.E. Haney, 'A Norman antecedent for English floral ornament of the mid-twelfth century', *Scriptorium*, XXXVI, 1982, pp. 84–6
Hare, 1981
J.N. Hare, 'The buildings of Battle Abbey: a preliminary survey', *Proc. Battle Conf.*, III, 1980, 1981, pp. 78–95
Harmer, 1952
F.E. Harmer, *Anglo-Saxon Writs*, 1952
Harris, 1964
A. Harris, 'A Romanesque candlestick in London', *J. Brit. Archaeol. Assoc.*, 3rd series, XXVII, 1964, pp. 32–52
Hartzell, 1981
K.D. Hartzell, 'The early provenance of the Harkness Gospels', *Bulletin of Research in the Humanities*, LXXXIV.1, 1981
Harvey, 1954
J.H. Harvey, *English Medieval Architects, a Biographical Dictionary down to 1550*, 1954, new edition forthcoming
Harvey, 1972
★J.H. Harvey, *The Medieval Architect*, 1972
Harvey, 1974
★J.H. Harvey, *Cathedrals of England and Wales*, 1974
Haskins, 1927
C.H. Haskins, *The Renaissance of the Twelfth Century*, 1927
Hearn, 1971
M.F. Hearn, 'The rectangular ambulatory in English medieval architecture', *J. Soc. Archit. Hist.*, XXX, 3, 1971, pp. 187–208
Hearn, 1975
M.F. Hearn, 'Romsey Abbey, a progenitor of the English National Tradition in Architecture', *Gesta*, XIV, I, 1975, pp. 27–40

Heimann, 1965
A. Heimann, 'A twelfth-century manuscript from Winchcombe and its illustrations. Dublin Trinity College MS.5.3', *J. Warb. Court. Inst.*, 28, 1965, pp. 86–109

Heimann, 1966
A. Heimann, 'Three illustrations from the Bury St Edmunds Psalter', *J. Warb. Court. Inst.*, XXIX, 1966, pp. 39–59

Heimann, 1975
A. Heimann, 'The lost copy of the Utrecht Psalter', in New York, 1975, pp. 313–38 (q.v.)

Héliot, 1957
P. Héliot, 'L'ordre colossal et les arcades murales dans les églises romanes', *Bull. Mon.*, CXV, 1957, pp. 241–61

Héliot, 1958
P. Héliot, 'Les oeuvres capitales du Gothique français primitif et l'influence de l'architecture anglaise', *Wall. Rich. J.*, XX, 1958, pp. 85–114

Héliot, 1965
P. Héliot, 'Sur les tours de transept dans l'architecture du Moyen Age', *Revue Archaeologique*, I, 1965, pp. 169–200, II, pp. 57–9

Henderson, 1978
G. Henderson, 'Romance and politics on some English medieval seals', *Art History*, I, 1978, pp. 26–42

Henderson, 1980
G.D.S. Henderson, *Bede and the Visual Arts*, Jarrow Lecture, 1980

Henderson, 1981
G. Henderson, 'Narrative illustration and theological exposition in medieval art', *Studies in Church History*, 17, 1981, pp. 19–35

Henig, 1978
M. Henig, *A Corpus of Roman Engraved Gemstones from British Sites*, British Archaeological Reports, British series, 8, 2nd edn., 1978

Henry, Zarnecki, 1957–8
F. Henry and G. Zarnecki, 'Romanesque arches decorated with human and animal heads', *J. Brit. Archaeol. Assoc.*, 3rd series, XX–XXI, 1957–8, pp. 1–34, reprinted in Zarnecki, 1979a

Heslop, 1978
T.A. Heslop, 'The Romanesque seal of Worcester Cathedral', *Brit. Archaeol. Assoc. Conf.*, I, 1975, 1978, pp. 71–9

Heslop, 1980
T.A. Heslop, 'English seals from the mid-ninth century to 1100', *J. Brit. Archaeol. Assoc.*, 133, 1980, pp. 1–16

Heslop, 1981a
T.A. Heslop, 'The Virgin's Regalia and 12th-century English seals', *Studies presented to Christopher Hohler*, ed. A. Borg and A. Martindale, British Archaeological Reports, International series, III, 1981, pp. 53–62

Heslop, 1981b
T.A. Heslop, 'A walrus ivory pyx and the Visitatio Sepulchri', *J. Warb. Court. Inst.*, 44, 1981, pp. 157–60

Heslop, 1982a
T.A. Heslop, 'The conventual seals of Canterbury Cathedral', *Brit. Archaeol. Assoc. Conf.*, V, 1979, 1982, pp. 94–100

Heslop, 1982b
T.A. Heslop, Review of Oakeshott, 1981 in *Art History*, 5, 1982, pp. 124–8

Heslop, Zarnecki, 1980
T.A. Heslop and G. Zarnecki, 'An ivory fragment from Battle Abbey', *Antiq. J.*, LX, 1980, pp. 341–2

Hewett, 1974
C.A. Hewett, *English Cathedral Carpentry*, 1974

Heywood, 1977
S. Heywood, *Minor Church Building in East Anglia in the 11th and Early 12th Centuries*, MA report, 1977, University of East Anglia

Heywood, 1982
S. Heywood, 'The ruined church at North Elmham', *J. Brit Archaeol. Assoc.*, CXXXV, 1982, pp. 1–10

Higgitt, 1972
J.C. Higgitt, *Roman Art and English Romanesque Sculpture*, MA Report, 1972, Courtauld Institute, University of London

Higgitt, 1973
J.C. Higgitt, 'The Roman Background to Medieval England', *J. Brit. Archaeol. Assoc.*, 1973, 3rd series, XXXVI, pp. 1–15

Hinkle, 1970
W.M. Hinkle, 'The gift of an Anglo-Saxon Gospel Book to the Abbey of Saint-Remi, Reims', *J. Brit. Archaeol. Assoc.*, XXXIII, 1970, pp. 21–35

Hinton, 1974
D.A. Hinton, *Catalogue of the Anglo-Saxon Ornamental Metalwork 700–1100 in the Department of Antiquities, Ashmolean Museum, Oxford*, 1974

Hobson, 1903
R.L. Hobson, *Catalogue of English Pottery, British Museum*, 1903

Hobson, 1929
G.D. Hobson, *English Bindings before 1500*, 1929

Hobson, 1934–5
G.D. Hobson, 'Further notes on Romanesque bindings', *The Library*, new series, XV, 1934–5, pp. 161–210

Hobson, 1938–9
G.D. Hobson, 'Some Early Bindings and Binders' Tools', *The Library*, new series, XIX, 1938–9, pp. 202–49

Hoffman, 1963
N. Hoffman, *The Romanesque Churches of Oxfordshire*, Ph.D. thesis, 1963, Courtauld Institute, University of London

Hohler, 1964
C. Hohler, 'The Cathedral of St Swithun at Stavanger in the twelfth century', *J. Brit. Archaeol. Assoc.*, 3rd series, XXVII, 1964, pp. 92–118

Hohler, 1981a
C. Hohler, 'Additional notes on the Eadwine Psalter', *Etudes d'art médiéval offertes à Louis Grodecki*, 1981, pp. 99–100

Hohler, 1981b
C. Hohler, *The Vanishing Past: Studies of Medieval Art, Liturgy and Metrology presented to Christopher Hohler*, ed. A. Borg and A. Martindale, British Archaeological Reports, International series, III, 1981

Homburger, 1949
O. Homburger, *Der Trivulzio Kandelaber*, 1949

Homburger, 1954
O. Homburger, 'Früh- und Hochmittelalterliche Stücke im Schatz des Augustinerchorherrenstiftes von Saint Maurice und in der Kathedrale zu Sitten', *Frühmittelalterliche Kunst in den Alpenländer. Actes du IIIe Congrès International pour l'étude du Haut Moyen Age*, 1954, pp. 329–53

Homburger, 1958
D. Homburger, 'Zur Stilbestimmung der figürliche Kunst Deutschlands und des westlichen Europas in Zeitraum zwischen 1190–1250', *Festschrift J. Gantner: Formositas Romanica*, 1958, pp. 29–45

Hope, 1887
W.H. St John Hope, 'The seals of English bishops', *Proc. Soc. Antiq.*, 2nd series, XI, 1887, pp. 271–306

Hope, 1893
W.H. St John Hope, 'The tomb of an archbishop recently opened in the Cathedral Church of Canterbury', *Vetusta Monumenta*, VII, 1893

Hope, 1907
W.H. St John Hope, 'The episcopal ornaments of William of Wykeham . . . and of certain bishops of St Davids', *Archaeologia*, 60, part 2, 2nd series, 10, 1907, pp. 465–92

Hope, 1915–16
W.H. St John Hope, 'Seals of the Abbey of Waltham Holy Cross in Essex', *Proc. Soc. Antiq.*, XXVIII, 1915–16, pp. 95–102

Hope, 1917
W.H. St John Hope, 'Quire screens in English churches with special reference to the 12th-century quire screen formerly in the Cathedral Church of Ely', *Archaeologia*, 68, 1917, pp. 43–110

Hope, Fallow, 1887
W.H. St John Hope and T.M. Fallow, 'English Medieval Chalices and Patens', *Archaeol. J.*, XLIII, 1887, pp. 137–61, 364–402

Houghton, 1913
F.T.S. Houghton, 'The stone lecterns at Abbots Norton, Crowle and Wenlock', *Birmingham and Midland Archaeological Society Transactions*, XXXIX, 1913, pp. 1–4

Hoving, 1964
T.P. Hoving, 'The Bury St Edmunds cross', *Metropolitan Museum of Art Bulletin*, XXII, 1964

Hoving, 1965
T.P.F. Hoving, 'A newly discovered reliquary of St Thomas Becket', *Gesta*, 4, 1965, pp. 28–9

How, 1952
G.E.P. and J.P. How, *English and Scottish Silver Spoons*, I, 1952

Hunter Blair see Blair, 1922 and 1943, and Greenwell, Blair, 1910–20

Hurst, 1962
J.G. Hurst, 'Winchester ware: A new type of Saxo-Norman glazed pottery', *Archaeol. J.*, 119, 1962, pp. 187–90

Hurst, 1976
J.G. Hurst, 'The Pottery', *The Archaeology of Anglo-Saxon England*, ed. D.M. Wilson, 1976

Jackson, 1911
C.J. Jackson, *An Illustrated History of English Plate*, I, 1911

James, 1898–1903
M.R. James, 'On two series of paintings formerly at Worcester Priory', *Proceedings of the Cambridge Antiquarian Society*, 10, new series, 4, 1898–1903, pp. 99–115

James, 1900–4
M.R. James, *Descriptive catalogue of Western Manuscripts in the Library of Trinity College, Cambridge*, 1900–4

James, 1901
M.R. James, *The Verses formerly Inscribed on Twelve Windows in the Choir of Canterbury Cathedral*, Cambridge Antiquarian Society, Octavo publications, 38, 1901

James, 1928
M.R. James, *The Bestiary*, Roxburgh Club, 1928, facsimile

James, 1929
M.R. James, *Fifty Drawings of Marvels of the East*, Roxburgh Club, 1929

James, 1935
M.R. James, *The Canterbury Psalter*, 1935, facsimile

James, 1951
M.R. James, 'Pictor in carmine', *Archaeologia*, 94, 1951, pp. 141–66

Jamison, 1943
E.M. Jamison, 'Alliance of England and Sicily in the second half of the twelfth century', *J. Warb. Court. Inst.*, VI, 1943, pp. 20–32

Jansen, 1979
V. Jansen, 'Superimposed wall passages and the triforium elevation of St Werburg's, Chester', *J. Soc. Archit. Hist.*, 38, 3, 1979

Jessup, Zarnecki, 1953
R.F. Jessup and G. Zarnecki, 'The Fausset Pavilion', *Archaeol. Cant.*, LXVI, 1953, pp. 1–14, reprinted in Zarnecki, 1979a

Jewell, 1982
R.H.I. Jewell, *The pre-Conquest sculpture at Breeden-on-the-Hill, Leicestershire*, Ph.D. thesis, 1982, Courtauld Institute, University of London

Jones, Freeman, 1856
W.B. Jones and E.A. Freeman, *The History and Antiquities of Saint David's*, 1856
Jones, Morey, 1931
L.W. Jones and C.R. Morey, *The Miniatures of the Manuscripts of Terence*, 1931
Jones, Smith, 1960
S.R. Jones and J.T. Smith, 'The great hall of the Bishop's Palace at Hereford', *Med. Archaeol.*, IV, 1960, pp. 69–80
Jope, 1964
E.M. Jope, 'The Saxon building stone industry in southern and Midland England', *Med. Archaeol.*, VIII, 1964, pp. 91–118

Kahn, 1977
D. Kahn, *The Sculptural Decoration of Halford Church, Warwickshire*, MA report, 1977, Courtauld Institute, University of London
Kahn, 1980
D. Kahn, 'The Romanesque sculpture of the Church of St Mary at Halford, Warwickshire', *J. Brit. Archaeol. Assoc.*, 133, 1980, pp. 64–73
Kahn, 1982
D. Kahn, *Romanesque Architectural Sculpture in Kent*, Ph.D. thesis, 1982, Courtauld Institute, University of London
Kahn, 1983
D. Kahn, 'Recent discoveries of Romanesque sculpture at St Albans', *Studies in Medieval Sculpture*, ed. F.H. Thompson, 1983, pp. 71–89
Katzenellenbogen, 1939
A. Katzenellenbogen, *Allegories of the Virtues and Vices in Medieval Art*, 1939
Kauffmann, 1966
C.M. Kauffmann, 'The Bury Bible (Cambridge CCC. MS.2)', *J. Warb. Court. Inst.*, 29, 1966, pp. 60–81
Kauffmann, 1975
★C.M. Kauffmann, *Romanesque manuscripts, 1066–1190*, A Survey of Manuscripts illuminated in the British Isles, 3, 1975
Kauffmann, 1978
C.M. Kauffmann, 'Manuscript illumination at Worcester in the eleventh and twelfth centuries', *Brit. Archaeol. Assoc. Conf.*, I, 1975, 1978, pp. 43–50
Kelly, 1971
F. Kelly, *The Romanesque Capitals of Southwell Minster*, MA report, 1971, Courtauld Institute, University of London
Kendrick, 1938
T.D. Kendrick, *Anglo-Saxon Art*, 1938
Kendrick, 1949
T.D. Kendrick, *Late Saxon and Viking Art*, 1949
Ker, 1957
N.R. Ker, *Catalogue of Manuscripts containing Anglo-Saxon*, 1957
Ker, 1960
N.R. Ker, *English Manuscripts in the Century after the Norman Conquest*, 1960
Ker, 1964
N.R. Ker, *Medieval Libraries of Great Britain, A List of Surviving Books*, 2nd edn., 1964
Ker, 1978
Medieval Scribes, Manuscripts and Libraries, Essays presented to N.R. Ker, ed. M.B. Parkes and A.G. Watson, 1978
Keyser, 1927
C.E. Keyser, *A List of Norman Tympana and Lintels*, 2nd edn., 1927
Kidson, 1967
★P. Kidson, *The Medieval World*, 1967
Kidson, Murray, Thompson, 1962, 1965
P. Kidson, P. Murray and P. Thompson, *A History of English Architecture*, 1962, 1965
Kitzinger, 1940, 1983
★E. Kitzinger, *Early Medieval Art in the British Museum*, 1940, 2nd edn., 1983

Kitzinger, 1966
E. Kitzinger, 'The Byzantine contribution to western art of the twelfth and thirteenth centuries', *Dumbarton Oaks Papers*, XX, 1966, pp. 25–47, reprinted in Kitzinger, *Art of Byzantium and the Medieval West: Selected Studies*, 1976, pp. 135–44
Knowles, 1940, 1963
D. Knowles, *The Monastic Order in England, 940–1216*, 1940, 2nd edn., 1963
Knowles, 1951
D. Knowles, *The Episcopal Colleagues of Archbishop Thomas Becket*, 1951
Knowles, Brooke, London, 1972
D. Knowles, C.N.L. Brooke and V. London (eds.) *The Heads of Religious Houses, England and Wales 940–1216*, 1972
Knowles, Hadcock, 1971
D. Knowles and R.N. Hadcock, *Medieval Religious Houses, England and Wales*, 2nd edn., 1971
Koehler, 1941
W. Koehler, 'Byzantine art in the west', *Dumbarton Oaks Papers*, I, 1941, pp. 63–87

Lang, 1977
J.T. Lang, 'The St Helena cross, Church Kelloe, Co. Durham', *Archaeologia Aeliana*, 5th series, V, 1977, pp. 105–19
Lang, 1982
J.T. Lang, 'St Michael, the Dragon and the Lamb on early tympana', *Transactions of the Architectural and Archaeological Society of Durham and Northumberland*, new series, 6, 1982, pp. 57–60
Lasko, 1960–1
P. Lasko, 'A Romanesque ivory carving', *Brit. Mus. Qu.*, XXIII, 1960–1, 12–16
Lasko, 1961
P. Lasko, 'Exhibition of Romanesque art at Barcelona and Santiago de Compostela', *Burl. Mag.*, CIII, 1961, pp. 494–9
Lasko, 1964
P.E. Lasko, 'An English Romanesque portable altar', *Apollo*, LXXIX, 1964, pp. 489–95
Lasko, 1972a
★P. Lasko, *Ars Sacra, 800–1200*, Pelican History of Art, 1972
Lasko, 1972b
P.E. Lasko, 'The "Rattlesden" St John', *Proceedings of the Suffolk Institute of Archaeology for 1972*, XXXII, 3, 1973, pp. 269–71
Lawrence, 1981
A. Lawrence, 'The influence of Canterbury on the collection and production of manuscripts at Durham in the Anglo-Norman period', *Studies presented to C. Hohler*, ed. A. Borg and A. Martindale, British Archaeological Reports, International series III, 1981, pp. 95–104
Lawrence, 1982
A. Lawrence, 'Manuscripts of early Anglo-Norman Canterbury', *Brit. Archaeol. Assoc. Conf.*, V, 1979, 1982, pp. 101–11
Lees, 1935
B.A. Lees, *Records of the Templars in England in the Twelfth Century*, 1935
Lehmann-Brockhaus, 1955
O. Lehmann-Brockhaus, *Lateinische Schriftquellen zur Kunst in England, Wales und Schottland vom Jahre 901 bis zum Jahre 1307*, I–IV, 1955
Lethaby, 1906
W. Lethaby, *Westminster Abbey and the King's Craftsmen*, 1906
Lethaby, 1915
W.R. Lethaby, 'Archbishop Roger's cathedral at York and its stained glass', *Archaeol. J.*, 72, new series, 22, 1915, pp. 37–48
Lethaby, 1925
W. Lethaby, *Westminster Abbey Re-examined*, 1925

Lockett, 1971
R.B. Lockett, 'A Catalogue of Romanesque sculpture from the Cluniac Houses in England', *J. Brit. Archaeol. Assoc.*, 3rd series, XXXIV, 1971, pp. 43–61
Longhurst, 1926
M.H. Longhurst, *English Ivories*, 1926
Longhurst, 1927
M. Longhurst, *Catalogue of carvings in Ivory*, Victoria and Albert Museum, London, 1927–9
Loyn, 1962
H.R. Loyn, *Anglo-Saxon England and the Norman Conquest*, 1962
Loyn, 1967
H.R. Loyn, *The Norman Conquest*, 2nd edn., 1967

McAleer, 1963
P. McAleer, *The Romanesque Church Façade in Britain*, Ph.D. thesis, 1963, Courtauld Institute, University of London
McCulloch, 1960
F. McCulloch, *Medieval Latin and French Bestiaries*, 1960
Mackeprang, Madsen, Petersen, 1921
M. Mackeprang, V. Madsen, C.S. Petersen, *Greek and Latin Manuscripts in Danish Collections*, 1921
Mackinney, 1965
L. Mackinney, *Medical Illustrations in Medieval Manuscripts*, 1965
McLachlan see also E. Parker
McLachlan, 1975
E.P. McLachlan, 'The Pembroke College New Testament and a group of unusual English Evangelist symbols', *Gesta*, XIV, 1, 1975, pp. 3–18
McLachlan, 1978a
E.P. McLachlan, 'The scriptorium of Bury St Edmunds in the third and fourth decades of the 12th century', *Medieval Studies* (Toronto), 40, 1978, pp. 238–48
McLachlan, 1978b
E.P. McLachlan, 'The Bury missal in Laon and its Crucifixion miniature', *Gesta*, XVII, 1, 1978, pp. 27–36
McLachlan, 1979
E.P. McLachlan, 'In the wake of the Bury Bible: followers of Master Hugo at Bury St Edmunds', *J. Warb. Court. Inst.*, 42, 1979, pp. 219–24
Maclagan, 1921–3
E. Maclagan, 'A Romanesque relief in York Minster', *Proceedings of the British Academy*, X, 1921–3, pp. 479–85
Maclagan, 1940
E. Maclagan, 'A crucifix figure from Ludgvan Church, Cornwall', *Antiq. J.*, XX, 1940, p. 509
Maguire, 1970
H.P. Maguire, 'A twelfth-century workshop in Northampton', *Gesta*, IX, 1, 1970, pp. 11–25
Mahany, Burchard, Simpson, 1982
C. Mahany, A. Burchard and G. Simpson, *Excavations in Stamford, Lincolnshire, 1963–69*, Society for Medieval Archaeology monograph series, 9, 1982
Mâle, 1922, 1978
★E. Mâle, *Religious Art in France; The Twelfth Century*, Princeton, 1978 (first published 1922, in French)
Mann, 1977
V.B. Mann, *Romanesque Ivory Tablemen*, New York Institute of Fine Art, Ph.D., 1977
Marcousé, 1955
R. Marcousé, 'Figure Sculpture at St Mary's Abbey', *Yorkshire Museum Papers*, I, 1955
Marks, 1970
R.C. Marks, *The Sculpture of Dunstable Priory c.1130–1222*, MA report, 1970, Courtauld Institute, University of London
Marks, 1973
R. Marks, 'The tympana of Covington and Thurleigh', *Bedfordshire Archaeological Journal*, 8, 1973, pp. 134–5

Mason, 1925
A.J. Mason, *Guide to the Ancient Glass of Canterbury Cathedral*, 1925
Matthew, 1966
D.J.A. Matthew, *The Norman Conquest*, 1966
Mellinkoff, 1979
R. Mellinkoff, 'Cain and the Jews', *Journal of Jewish Art*, 6, 1979
Mende, 1981
U. Mende, *Die Türzieher des Mittelalters*, Bronzegeräte des Mittelalters, 2, 1981
Meredith, 1980
J. Meredith, *The Impact of Italy on the Romanesque Architectural Sculpture of England*, Ph.D. thesis, Yale University, 1980
De Merindol, 1976
C. de Merindol, *La production des livres peints à l'abbaye de Corbie au XIIème siècle*, 1976
Miscampbell, 1981
C. Miscampbell, 'Rebuilding of St Augustine's Abbey, Canterbury', *Collectanea Historica : Essays in Memory of Stuart Rigold*, ed. A. Detsicas, 1981
Mitchell, 1925
H.P. Mitchell, 'English Enamels of the Twelfth Century', I, *Burl. Mag.*, XLVII, 1925, pp. 163–70
Mitchell, 1926
H.P. Mitchell, 'English Enamels of the Twelfth Century', II, *Burl. Mag.*, XLIX, 1926, pp. 161–73
Morgan, 1966
F.C. and P. Morgan, *A Concise List of Seals belonging to the Dean and Chapter of Hereford Cathedral*, Woolhope Naturalists' Field Club, Herefordshire, 1966
Morgan, 1981
N. Morgan, 'Notes of the post-conquest calendar, Litany and martyrology of the Cathedral Priory of Winchester with a consideration of Winchester diocese calendars of the pre-Sarum period', in *Studies presented to C. Hohler*, ed. A. Borg and A. Martindale, British Archaeological Reports, International series, III, 1981, pp. 133–72
Morgan, 1982
★N. Morgan, *Early Gothic Manuscripts I, 1190–1250*, A Survey of Manuscripts Illuminated in the British Isles, 4, 1982
Morris, 1979
★R. Morris, *Cathedrals and Abbeys of England and Wales : the Building Church, 600–1540*, 1979
Morris, 1983
R.K. Morris, 'The Herefordshire School: recent discoveries', *Studies in Medieval Sculpture*, ed. F.H. Thompson, 1983, pp. 198–201
Muratova, 1977
X. Muratova, 'Adam donne leurs noms aux animaux', *Studi Medievali*, XVIII, 2, 1977
Murray, 1913
H.J.R. Murray, *A History of Chess*, 1913
Musset, 1983
★L. Musset, *Angleterre romane, I, Le Sud de l'Angleterre*, Zodiaque, 1983
Mynors, 1939
R.A.B. Mynors, *Durham Cathedral Manuscripts to the End of the Twelfth Century*, 1939

Nelson, 1913
P. Nelson, *Ancient Painted Glass in England, 1170–1500*, 1913
Newton, 1975
P.A. Newton, 'Some new material for the study of the iconography of St Thomas Becket', *Thomas Becket, Actes du colloque international de Sédières 19-24 août 1973*, 1975
Newton, 1979
P.A. Newton, *The County of Oxford, a Catalogue of Medieval Stained Glass*, Corpus Vitrearum Medii Aevi, 1979
Nilgen, 1980
U. Nilgen, 'Thomas Becket as a patron of the arts', *Art History*, 3, 1980, pp. 357–74

Nixon, 1976
H.M. Nixon, 'The binding of the Winton Domesday', *Winchester in the Early Middle Ages, Winchester Studies*, I, ed. M. Biddle, 1976, pp. 526–40
Nørlund, 1926
P. Nørlund, *Gyldne Altre*, 1926

Oakeshott, 1945
W. Oakeshott, *The Artists of the Winchester Bible*, 1945
Oakeshott, 1972a
W. Oakeshott, *Sigena : Romanesque paintings in Spain and the Winchester Bible Artists*, 1972
Oakeshott, 1972b
W. Oakeshott, 'The Sigena paintings and the second style of rubrication in the Winchester Bible', *Kunsthistoriche Forschungen : Otto Pächt zu seinem 70. Geburtstag*, 1972
Oakeshott, 1981
W. Oakeshott, *The Two Winchester Bibles*, 1981
O'Connor, Haselock, 1977
D. O'Connor and J. Haselock, 'The Stained and Painted Glass', G.E. Aylmer and R.Cant, *A History of York Minster*, 1977, pp. 313–93
Oman, 1932
C.C. Oman, 'The goldsmiths at St Albans during the twelfth and thirteenth centuries', *St Albans and Hertfordshire Architectural and Archaeological Society Transactions*, 1932, pp. 215–36
Oman, 1953
C.C. Oman, 'Influences mosanes dans les émaux anglais', *L'Art mosan*, ed. P. Francastel, 1953, pp. 156–8
Oman, 1954
C.C. Oman, 'An eleventh-century English cross', *Burl. Mag.*, XCVI, 1954, pp. 383–4
Oman, 1957
C.C. Oman, *English Church Plate 597–1830*, 1957
Oman, 1958
C.C. Oman, *The Gloucester Candlestick*, 1958
Oman, 1962
C.C. Oman, 'English medieval base-metal church plate', *Archaeol. J.*, CXIX, 1962, pp. 195–207
Oman, 1967
C.C. Oman, 'The Whithorn crozier, a newly discovered English enamel', *Burl. Mag.*, CIX, 1967, pp. 299–300
Oman, 1974
C.C. Oman, *British Rings 800–1914*, 1974
Omont, 1902
H. Omont, *Miniatures du Psautier de St-Louis*, 1902, facsimile
Omont, 1906
H. Omont, *Psautier illustré XIIIe siècle*, 1906, facsimile

Pächt, 1950
O. Pächt, 'Hugo pictor', *Bodleian Library Record*, III, 1950, pp. 96–103
Pächt, 1956
O. Pächt, 'The illustrations of St Anselm's Prayers and Meditations', *J. Warb. Court. Inst.*, 19, 1956, pp. 68–83
Pächt, 1961
O. Pächt, 'A cycle of English frescoes in Spain', *Burl. Mag.*, CIII, 1961, pp. 166–75
Pächt, 1962
★O. Pächt, *The Rise of Pictorial Narrative in Twelfth-Century England*, 1962
Pächt, 1963
O. Pächt, 'The pre-Carolingian roots of early Romanesque art', *Congrès International d'Histoire de l'Art, Studies in Western Art*, I, 1963, pp. 67–75
Pächt, 1972
Kunsthistorische Forschungen : Otto Pächt zu seinem 70 Geburtstag, 1972

Pächt, Alexander, 1966, 1972, 1973
O. Pächt and J.J.G. Alexander, *Illuminated Manuscripts in the Bodleian Library*, Oxford, 3 vols. 1966, 1972, 1973
Pächt, Dodwell, Wormald, 1960
O. Pächt, C.R. Dodwell and F. Wormald, *The St Albans Psalter/Albani Psalter*, 1960
Park, 1981
D. Park, 'A new interpretation of a *Magi* scene on a Romanesque ivory comb', *J. Brit. Archaeol. Assoc.*, CXXXIV, 1981, pp. 29–30
Park, 1983
D. Park, 'The wall-paintings of the Holy Sepulchre Chapel', *Brit. Archaeol. Assoc. Conf.*, VI, 1980, 1983, pp. 38–62
Parker (E.) see also McLachlan
Parker, 1965
E. Parker, *The Scriptorium of Bury St Edmunds in the 12th Century*, Ph.D. thesis, 1965, Courtauld Institute, University of London
Parker, 1970
E. Parker, 'A twelfth-century cycle of New Testament drawings from Bury St Edmunds Abbey', *Proceedings of the Suffolk Institute of Archaeology*, XXXI, 1970, 263–302
Parker, 1975
E.C. Parker, 'The missing base plaque of the Bury St Edmund's cross,' *Gesta*, XIV, 1, 1975, pp. 19–26
Parker, 1981
E.C. Parker, 'Master Hugo as sculptor. A source for the style of the Bury Bible', *Gesta*, XXI, Essays in honour of Harry Bober, 1981, pp. 99–109
Parsons, 1974
D. Parsons, 'A note on the East End of Roche Abbey Church,' *J. Brit. Archaeol. Assoc.*, XXXVII, 1974, p. 123
Parsons, 1982
D. Parsons, 'The Romanesque Vices at Canterbury', *Brit. Archaeol. Assoc. Conf.*, V, 1979, 1982, pp. 39–45
Pattison, 1973
I.R. Pattison, 'The Nunburnholme Cross and Anglo-Danish sculpture in York', *Archaeologia*, CIV, 1973, pp. 209–34
Pedrick, 1902
G. Pedrick, *Monastic Seals of the 13th century*, 1902
Pedrick, 1904
G. Pedrick, *Borough Seals of the Gothic period*, 1904
Pevsner, 1951
★N. Pevsner (*et al.*), *The Buildings of England*, 46 volumes, 1951–84
Phillips, 1975
D. Phillips, 'Excavations at York Minster 1967–73', *Friends of York Minster Annual Report*, 46, 1975, pp. 19–27
Phillips, forthcoming
D. Phillips, 'The Cathedral of Archbishop Thomas of Bayeux at York', *The Excavations of York Minster 1967–73*, I, forthcoming
Philp, 1968
B. Philp, *Excavations at Faversham*, 1968
Pollard, 1962
G. Pollard, 'The construction of English twelfth-century bindings', *The Library*, 5th series, XVII, 1962, pp. 1–22
Porter, 1974
D.A. Porter, *Ivory Carving in Later Medieval England, 1200–1400*, Ph.D. thesis, State University of New York at Binghampton, 1974
Prior, Gardner, 1912
E.S. Prior and A. Gardner, *An Account of Medieval Figure-Sculpture in England*, 1912

Rackham, 1949
Bernard Rackham, *The Ancient Glass of Canterbury Cathedral*, 1949

Raspi Serra, 1969
J. Raspi Serra, 'English decorated sculpture of the early 12th century and the Como-Pavian tradition', *Art Bull.*, 51, 1969, pp. 352–62
RCHM Dorset, 1952–75
Royal Commission on Historical Monuments in Dorset
I, *West*, 1952
II, *South-East*, parts 1–3, 1970
III, *Central*, parts 1–2, 1970
IV, *North Dorset*, 1972
V, *East*, 1975
RCHM York, 1975
Royal Commission on Historical Monuments, England, City of York, IV, *Outside the City walls and East of the Ouse*, 1975
Read, 1926
Herbert Read, *English Stained Glass*, 1926
Regesta Regum, 1956, 1968, 1969
Regesta Regum Anglo-Normannorum
II, ed. C. Johnson and R.H.C. Davis, 1956
III, ed. H.A. Cronne and R.H.C. Davis, 1968
IV, ed. H.A. Cronne and R.H.C. Davis, 1969
Renn, 1968, 1973
D.F. Renn, *Norman Castles in Britain*, 1968, 2nd edn., 1973
Renn, 1982
D. Renn, 'The decoration of Canterbury Castle keep', *Brit. Archaeol. Assoc. Conf. V*, 1979, 1982, pp. 125–8
Rice, 1947
D. Talbot Rice, *The Byzantine element in Late Saxon Art*, the 1946 William Henry Charlton Memorial Lecture, 1947
Rice, 1952
D. Talbot Rice, *English Art 871–1100*, Oxford History of English Art, 2, 1952
Rice, 1960
D. Talbot Rice, 'Essai de classification de la sculpture anglo-saxonne aux Xe – XIIe siècles', *Cahiers Civ. Med.*, III, 1960, pp. 195–207
Richards, 1981
M.P. Richards, 'A decorated Vulgate set from 12th century Rochester, England', *Journal, Walters Art Gallery*, 39, 1981, pp. 59–67
Rigold, 1977
S. Rigold, 'Romanesque bases in and south-east of the limestone belt', *Ancient Monuments and their Interpretation; Essays presented to A.J. Taylor*, ed. M.R. Apted, R. Gilyard Beer, A.D. Saunders, 1977, pp. 99–138
Rigold, 1979
S.E. Rigold, 'The distribution of early Romanesque towers to minor churches', *Archaeol. J.*, 136, 1979, pp. 109–17
Rigold, 1981
Collectanea Historica, Essays in Memory of Stuart Rigold, ed. A. Detsicas, Kent Archaeological Society, 1981
Rites, 1593, 1842, 1903
A Description or Briefe Declaration of all the Ancient Monuments, Rites, and Customs belonging or beinge within the Monastical Church of Durham before the Suppression. Written in 1593, Surtees Soc., 15, ed. J. Raine, 1842; re-edited as vol. 107 by Revd Canon Fowler, 1903
Roberts, 1983
E. Roberts, 'Two twelfth-century voussoir stones from Sopwell House, St Albans', F.H. Thompson (ed.), *Studies in Medieval Sculpture*, 1983, pp. 190–97
Robinson, Urquhart, 1934
G. Robinson and H. Urquhart, 'Seal bags in the Treasury of the Cathedral of Canterbury', *Archaeologia*, LXXXIV, 1934
Romilly Allen, 1887
J. Romilly Allen, *Early Christian Symbolism in Great Britain and Ireland*, 1887
Rosenau, 1979
H. Rosenau, *Vision of the Temple*, 1979

Ross, 1940
M.C. Ross, 'An eleventh-century book-cover', *Art Bull.*, XXII, 1940, pp. 83–5

St Anselm see Anselm
St Bernard see Bernard
Salvini, 1969
★R. Salvini, *Medieval Sculpture*, 1969
Sauerländer, 1959
W. Sauerländer, 'Sens and York; an Enquiry into the Sculptures from St Mary's Abbey in the Yorkshire Museum', *J. Brit. Archaeol. Assoc.*, 3rd series, XXII, 1959, pp. 53–69
Sauerländer, 1971
W. Sauerländer, Review of *The Year 1200* exhibition, *Art. Bull.*, LIII, 1971, pp. 506–16
Saxl, 1946
F. Saxl, 'Lincoln Cathedral, the XIth-century design for the west front', *Archaeol. J.*, CIII, 1946, pp. 105–118
Saxl, 1954
F. Saxl, *English Sculptures of the Twelfth Century*, ed. H. Swarzenski, 1954
Saxl, 1957
F. Saxl, *Lectures*, 1957
Saxl, Wittkower, 1948
F. Saxl and R. Wittkower, *British Art and the Mediterranean*, 1948
Schilling, 1948
R. Schilling, 'Two unknown Flemish miniatures of the 11th century', *Burl. Mag.*, XC, 1948, pp. 312–17
Schwarzbaum, 1981
E. Schwarzbaum, 'Three Tournai tombslabs in England', *Gesta*, XX, 1981, pp. 89–97
Searle, 1980
E. Searle, (ed.), *The Chronicle of Battle Abbey*, Oxford Medieval Texts, 1980
Smalley, 1973
B. Smalley, *The Becket Controversy and the Schools*, 1973
Southern, 1958
R.W. Southern, 'The English origins of the Miracles of the Virgin', *Medieval and Renaissance Studies*, IV, 1958, pp. 183–200
Southern, 1960
R.W. Southern, 'The place of England in the twelfth-century Renaissance', *History*, XLV, 1960, pp. 201–16
Southern, 1963
R.W. Southern, *St Anselm and his Biographer*, 1963
Springer, 1981
P. Springer, *Kreuzfüsse, Ikonographie und Typologie eines hochmittelalterlichen Gerätes, Bronzegeräte des Mittelalters*, 3, 1981
Stalley, 1969
R.A. Stalley, *The Patronage of Roger of Salisbury*, MA report, 1969, Courtauld Institute, University of London
Stalley, 1971
R.A. Stalley, 'A 12th-century patron of architecture: A study of the buildings erected by Roger Bishop of Salisbury', *J. Brit. Archaeol. Assoc.*, 3rd series, XXXIV, 1971, pp. 62–83
Stark, 1973
S. Stark, *Catalogue of English Romanesque Fonts with Narrative Scenes*, MA report, 1973, Courtauld Institute, University of London
Stenton, 1957, 1965
F. Stenton *et al.*, *The Bayeux Tapestry*, 1957, 2nd edn., 1965
Stirnemann, 1976
P. Danz Stirnemann, *The Copenhagen Psalter*, 1976, dissertation, Columbia University
Stoll, 1966
R. Stoll, *Architecture and Sculpture in Early Britain*, 1966
Stone, 1955
★L. Stone, *Sculpture in Britain, the Middle Ages*, Pelican History of Art, 1955

Stones, 1978
A. Stones, Review of Kauffmann, 1975, *Speculum*, 53, 1978, pp. 586–90
Stratford, 1977
N. Stratford, 'A Romanesque ivory from Lichfield Cathedral', *British Museum Yearbook*, II, 1977
Stratford, 1978
N. Stratford, 'Notes on the Norman Chapterhouse at Worcester', *Brit. Archaeol. Assoc. Conf.*, I, 1975, 1978, pp. 51–70
Stratford, 1983
N. Stratford, 'The "Henry of Blois plaques" in the British Museum', *Brit. Archaeol. Assoc. Conf.*, VI, 1980, 1983, pp. 28–37
Stratford, Tudor-Craig, Muthesius, 1982
N. Stratford, P. Tudor-Craig and A.M. Muthesius, 'Archbishop Hubert Walter's tomb and its furnishings', *Brit. Archaeol. Assoc. Conf.*, V, 1979, 1982, pp. 71–89, pls. XVII–XXVI
Strik, 1982
H.J.A. Strik, 'Remains of the Lanfranc building in the great central tower and the north-west choir transept area', *Brit. Archaeol. Assoc. Conf.*, V, 1979, 1982, pp. 20–26
Strohm, 1971
P. Strohm, 'The Malmesbury medallions and twelfth-century typology', *Medieval Studies*, 33, 1971
Swarzenski, 1932
G. Swarzenski, 'Aus dem Kunstkreis Heinrich des Löwen', *Staedel-Jahrbuch*, VII–VIII, 1932
Swarzenski, 1951
H. Swarzenski, 'Der Stil der Bibel Carilefs von Durham', *Form und Inhalt, Kunstgeschichtliche Studien Otto Schmidt*, 1951, pp. 89–96
Swarzenski, 1954, 1967
★H. Swarzenski, *Monuments of Romanesque Art: The Church Treasures of Northern Europe*, 1954, 2nd edn., 1967
Swarzenski, 1963
H. Swarzenski, 'Fragments from a Romanesque Bible', *Eassais en l'honneur de Jean Porcher*, 1963

Talbot, 1959
C.H. Talbot, *The Life of Christina of Markyate*, 1959
Tatton-Brown, 1979
T. Tatton-Brown, 'Canterbury Cathedral Excavations', *Archaeol. Cant.*, XCV, 1979, pp. 276–8
Tatton-Brown, 1980
T. Tatton-Brown, 'The use of Quarr stone in London and east Kent', *Med. Archaeol.*, 20, 1980, pp. 213–5
Taylor, 1969
A.J. Taylor (ed.), *Château Gaillard, European Castle Studies*, III Conference at Battle, Sussex, (1966), 1969
Taylor, Taylor, 1965
H.M. and J. Taylor, *Anglo-Saxon Architecture*, 1, 2, 1965
Taylor, 1966
H.M. and J. Taylor, 'Architectural sculpture in pre-Norman England', *J. Brit. Archaeol. Assoc.*, 3rd series, XXIX, 1966, pp. 3–51
Taylor, 1978
H.M. Taylor, *Anglo-Saxon Architecture*, 3, 1978
Tcherikover, 1979
A. Tcherikover, 'Two Romanesque ivory combs', *J. Brit. Archaeol. Assoc.*, CXXXII, 1979, 7–21
Temple, 1972
E. Temple, *The XII century Psalter in the Bodleian Library*, MS. Douce 293, Ph.D. thesis, 1972, Courtauld Institute, University of London
Temple, 1976
★E. Temple, *Anglo-Saxon Manuscripts 900–1066*, A Survey of Manuscripts illuminated in the British Isles, 2, 1976

Theophilus, 1961
Theophilus, *De Diversis Artibus*, ed. C.R. Dodwell, 1961
Thompson, 1983
F.H. Thompson (ed.), *Studies in Medieval Sculpture*, Society of Antiquaries Occasional Papers (new series), III, 1983
Thomson, 1975
R.M. Thomson, 'The date of the Bury Bible re-examined', *Viator* (Berkeley), 6, 1975, pp. 51–8
Thomson, 1978
R.M. Thomson, 'The scriptorium of William of Malmesbury', *Medieval Scribes . . . essays presented to N.R. Ker*, ed. M.B. Parkes and A.G. Watson, 1978
Thomson, 1982
R.M. Thomson, *Manuscripts from St Albans Abbey, 1066–1235*, 1982
Thurlby, 1976
M. Thurlby, *Transitional Sculpture in England*, Ph.D. dissertation, 1976, University of East Anglia
Thurlby, 1980
M. Thurlby, 'Romanesque Sculpture at Tewkesbury Abbey', *Bristol and Gloucestershire Archaeological Society Transactions*, XCVIII, 1980, pp. 89–94
Thurlby, 1982a
M. Thurlby, 'A twelfth-century figure fragment from Lewes Priory', *Sussex Archaeological Collections*, 120, 1982, pp. 215–222
Thurlby, 1982b
M. Thurlby, 'Fluted and chalice-shaped. The Aylesbury group of fonts', *Country Life*, CLXXI, 1982, pp. 228–9
Tonnochy, 1937
A.B. Tonnochy, 'The censer in the Middle Ages', *J. Brit. Archaeol. Assoc.*, 3rd series, II, 1937, pp. 47–62
Tonnochy, 1952
A.B. Tonnochy, *Catalogue of British Seal Dies in the British Museum*, 1952
Torre, 1690–91
J. Torre, 'Antiquities of York Minster', 1690–91, York Minster Library, MS.L.1 (7)
Tristram, 1944
E.W. Tristram, *English Medieval Wall-Paintings, I, The Twelfth Century*, 1944
Tselos, 1952
D. Tselos, 'Unique portraits of the Evangelists in an English Gospel book of the twelfth century (Pierpont Morgan MS.777)', *Art Bull.*, 34, 1952, pp. 257–77
Turner, 1966
D.H. Turner, *Romanesque Illuminated Manuscripts in the British Museum*, 1966
Turquet, 1974
J.C. Turquet, *Henry of Blois, Patron of Sculpture*, MA report, 1974, Courtauld Institute, University of London

äf Ugglas, 1936
C.R. äf Ugglas, *Gotländska silverskatter från Valdemarstågets tid*, 1936
Urry, 1967
W. Urry, *Canterbury under the Angevin Kings*, 1967

Voss, 1932
L. Voss, *Heinrich von Blois, Bischof von Winchester*, 1932

Wareham, 1960
W. Wareham, 'The reconstruction of a late Romanesque doorway, Kirk-Ella (Elveley) Church', *J. Brit. Archaeol. Assoc.*, 3rd series, XXIII, 1960, pp. 24–39
Warner, Ellis, 1903
G.F. Warner, H. Ellis, *Facsimiles of Royal and other Charters in the British Museum*, 1903

Watts, 1924
W.W. Watts, *Catalogue of Pastoral Staves, Victoria and Albert Museum*, 1924
Weale, 1894, 1898
W.H.J. Weale, *Bookbindings and Rubbings of Bindings in the National Art Library, South Kensington Museum*, I, 1898, II, 1894
Weale, Taylor, 1922
W.H.J. Weale and L. Taylor, *Early Stamped Bookbindings in the British Museum*, 1922
Webb, 1954
★G. Webb, *Architecture in England: the Middle Ages*, Pelican History of Art, 1954
Webster, 1938
J.C. Webster, *The Labours of the Months in Antique and Medieval Art to the end of the 12th century*, 1938
Weitzmann-Fiedler, 1981
J. Weitzmann-Fiedler, *Romanische gravierte Bronzeschalen*, 1981
West, 1983
J. West, 'A carved slab fragment from St Oswald's Priory, Gloucester', *Studies in Medieval Sculpture*, ed. F.H. Thompson, 1983, pp. 41–53
Westlake, 1881
N.H.J. Westlake, *A History of Design in Painted Glass*, I, 1881
Whittingham, 1951
A.B. Whittingham, 'Bury St Edmunds Abbey, the plan, design and development of the church and monastic buildings', *Archaeol. J*, CVIII, 1951, pp. 168–87, 192
Williams, 1897
Emily Williams, *Notes on the Painted Glass in Canterbury Cathedral*, 1897
Williamson, 1982
★P. Williamson, *An Introduction to Medieval Ivory Carvings*, 1982
Williamson, 1983
P. Williamson, *Catalogue of Romanesque Sculpture, Victoria and Albert Museum, London*, 1983
Willis, 1842–63
R. Willis, *Architectural History of some English Cathedrals: papers delivered . . . 1842–63*, 1, 2, reprinted 1973
Wilson, 1964
D.M. Wilson, *Catalogue of the Antiquities of the later Anglo-Saxon Period, vol. I, Anglo-Saxon Ornamental Metalwork 700–1100 in the British Museum*, 1964
Wilson, Klindt Jensen, 1966
★D.M. Wilson and O. Klindt Jensen, *Viking Art*, 1966
Wilson, 1975
D.M. Wilson, 'Tenth-century metalwork', *Tenth-Century Studies*, ed. D. Parsons, 1975
Wilson, 1978
C. Wilson, 'The sources of the late twelfth-century work at Worcester Cathedral', *Brit. Archaeol. Assoc. Conf.*, I, 1975, 1978, pp. 80–91
Wilson, 1983
C. Wilson, 'The original setting of the apostle and prophet figures from St Mary's Abbey, York', *Studies in Medieval Sculpture*, ed. F.H. Thompson, 1983, pp. 65–78
Winterbotham, 1981
J.J. Winterbotham, *The Norman Conquest and Church Architecture in Sussex*, M.Phil,. dissertation, 1981, Courtauld Institute, University of London
Wood, 1965
M. Wood, *The English Medieval House*, 1965
Woodfield, 1963
P. Woodfield, 'A Norman tympanum found in Coventry', *Antiq. J.*, XLIII, part ii, 1963, pp. 293–4
Woodforde, 1954
C. Woodforde, *English Stained and Painted Glass*, 1954
Woodman, 1981
F. Woodman, *The architectural history of Canterbury Cathedral*, 1981

Wormald, 1942
F. Wormald, 'A Romanesque Drawing at Oxford', *Antiq. J.*, XXII, 1942, pp. 17–21
Wormald, 1943
F. Wormald, 'The development of English illumination in the twelfth century', *J. Brit. Archaeol. Assoc.*, 3rd series, VIII, 1943, pp. 31–49
Wormald, 1944
F. Wormald, 'The survival of Anglo-Saxon illumination after the Norman Conquest', *Proc. Brit. Acad.*, XXX, 1944, pp. 1–19
Wormald, 1952a
F. Wormald, *English Drawing of the Tenth and Eleventh Centuries*, 1952
Wormald, 1952b
F. Wormald, 'Some illustrated manuscripts of the lives of the Saints', *Bulletin of the John Rylands Library*, 35, 1, 1952, pp. 248–66
Wormald, 1952c
F. Wormald, 'A medieval description of two illuminated Psalters', *Scriptorium*, VI, 1952, pp. 18–25
Wormald, 1955
F. Wormald, 'Decorated initials in English manuscripts from AD 900–1100', *Archaeologia*, XCI, 1955, pp. 107–36
Wormald, 1962
F. Wormald, 'An English 11th-century Psalter with pictures', *Walpole Society*, XXXVIII, 1962, pp. 1–13
Wormald, 1973
F. Wormald, *The Winchester Psalter*, 1973
Wormald, 1975
F. Wormald, 'The English seal as a measure of its time', New York 1975, pp. 591–4 (q.v.)
Wormald, Alexander, 1977
F. Wormald and J.J.G. Alexander (eds.) *An Early Breton Gospel Book*, 1977
Wyon, 1887
A.B. and A. Wyon, *The Great Seals of England*, 1887

Zarnecki, 1949
G. Zarnecki, 'The buried sculptures of Reading Abbey, chapters of an archaeological "detective story"', *Illustrated London News*, 16 April 1949, pp. 524–5
Zarnecki, 1950a
G. Zarnecki, 'The Coronation of the Virgin on a capital from Reading Abbey', *J. Warb. Court. Inst.*, 13, 1950, pp. 1–12, reprinted in Zarnecki, 1979a
Zarnecki, 1950b
G. Zarnecki, *Regional Schools of English Sculpture in the Twelfth Century*, Ph.D. thesis, 1950, Courtauld Institute, University of London
Zarnecki, 1951
★G. Zarnecki, *English Romanesque Sculpture 1066–1140*, 1951
Zarnecki, 1953a
★G. Zarnecki, *Later English Romanesque Sculpture 1140–1210*, 1953
Zarnecki, 1953b
G. Zarnecki, 'The Chichester reliefs', *Archaeol. J.*, CX, 1953, pp. 106–19, reprinted in Zarnecki, 1979a
Zarnecki, 1955a
G. Zarnecki, 'The Winchester acanthus in Romanesque sculpture,' *Wall. Rich. J.*, XVII, 1955, pp. 211–15, reprinted in Zarnecki, 1979a
Zarnecki, 1955b
G. Zarnecki, 'Sources of English Romanesque sculpture', *Actes du XVIIe Congrès international d'Histoire de l'Art*, The Hague, 1955, pp. 171–8
Zarnecki, 1955c
G. Zarnecki, 'The carved stones from Newark Castle', *Transactions of the Thoroton Society, Nottinghamshire*, LX, 1955, pp. 23–8
Zarnecki, 1957a
G. Zarnecki, *English Romanesque Lead Sculpture*, 1957

Zarnecki, 1957b
G. Zarnecki, 'A newly discovered relief at Ruardean', *Transactions of the Bristol and Gloucestershire Archaeological Society*, 1957
Zarnecki, 1958
★G. Zarnecki, *The Early Sculpture of Ely Cathedral*, 1958
Zarnecki, 1959
G. Zarnecki, Exhibition of Romanesque Art in Manchester, *Burl. Mag.*, CI, 1959, pp. 452–6
Zarnecki, 1963
G. Zarnecki, 'The transition from Romanesque to Gothic in English sculpture', *Acts of the 20th International Congress of the History of Art*, 1963, (reprinted in Zarnecki, 1979a)
Zarnecki, 1963–4
G. Zarnecki, 'A Romanesque bronze candlestick in Oslo and the problem of the "Belts of Strength"', *Kunstindustrimuseet Oslo Årbok*, Oslo, 1963–4, pp. 45–66, reprinted in Zarnecki, 1979a
Zarnecki, 1964
G. Zarnecki, 'A group of English medieval door-knockers', *Miscellanea Pro Arte: Festschrift für H. Schnitzler*, 1964, reprinted in Zarnecki, 1979a
Zarnecki, 1964, 1970
★G. Zarnecki, *Romanesque Sculpture at Lincoln Cathedral*, Lincoln Minster Pamphlets, 2nd series, 2, 1964, 2nd edn., 1970, reprinted in Zarnecki, 1979a

Zarnecki, 1966
G. Zarnecki, '1066 and architectural sculpture', *Proc. Brit. Acad.*, LII, 1966, pp. 87–104, reprinted in Zarnecki, 1979a
Zarnecki, 1967
G. Zarnecki, 'Romanesque objects at Bury St Edmunds', *Apollo*, LXXXV, 64, 1967, pp. 412–3
Zarnecki, 1969
G. Zarnecki, 'A Romanesque casket from Canterbury in Florence', *Canterbury Cathedral Chronicle*, 1969, p. 64, reprinted in Zarnecki, 1979a
Zarnecki, 1971
★G. Zarnecki, *Romanesque Art*, 1971
Zarnecki, 1972a
G. Zarnecki, 'A 12th-century column-figure of the standing Virgin and Child from Minster-in-Sheppey, Kent', *Kunsthistorische Forschungen Otto Pächt*, 1972, reprinted in Zarnecki, 1979a
Zarnecki, 1972b
★G. Zarnecki, *The Monastic Achievement*, 1972
Zarnecki, 1975a
G. Zarnecki, 'The west doorway of the Temple Church in London', *Beiträge zur Kunst des Mittelalters, Festschrift für Hans Wentzel zum 60. Geburtstag*, 1975, reprinted in Zarnecki, 1979a
Zarnecki, 1975b
G. Zarnecki, 'Deux reliefs de la fin du XIIe siècle à la Cathédrale d'York', *Revue de l'Art*, 30, 1975, pp. 17–20, 92–3, reprinted in English in Zarnecki, 1979a

Zarnecki, 1975c
★G. Zarnecki, *Art of the Medieval World*, 1975
Zarnecki, 1976
G. Zarnecki, 'English 12th-century sculpture and its resistance to St-Denis', *Tribute to an Antiquary, Essays presented to Marc Fitch*, 1976, pp. 83–92, reprinted in Zarnecki, 1979a
Zarnecki, 1978
G. Zarnecki, 'The Romanesque capitals in the south transept of Worcester Cathedral', *Brit. Archaeol. Assoc. Conf.*, I, 1975, 1978, pp. 38–42, reprinted in Zarnecki, 1979a
Zarnecki, 1979a
G. Zarnecki, *Studies in Romanesque Sculpture*, 1979 (collected essays)
Zarnecki, 1979b
G. Zarnecki, 'Romanesque sculpture in Normandy and England in the eleventh century', *Proc. Battle Conf. I*, 1978, 1979, pp. 168–90
Zarnecki, 1979c
G. Zarnecki, 'A Romanesque capital from Canterbury at Chartham', *Archaeologia Cant.*, XCV, 1979, pp. 1–6
Zarnecki, 1981
G. Zarnecki, 'The Eadwine portrait', *Études d'art médiéval offertes à Louis Grodecki*, 1981, pp. 93–100
Zarnecki, Kidson, 1976 see Courtauld Insititute Illustration Archives

Exhibition catalogues and related publications

Aachen, 1965
Aachen, *Karl der Grosse: Werk und Wirkung*, 1965

Barcelona, 1961
Barcelona, *El Arte Románico*, Exposición organizada por el Gobierno español bajo los auspicios del Consejo de Europa, 1961
Boston, 1940
Boston, Museum of Fine Arts, *Arts of the Middle Ages*, 1940
Brussels, 1973
Brussels, Bibliothèque royale de Belgique, *English Illumination 700–1500*, 1973
Brussels, 1979
Brussels, Palais Royale, *St-Michel et sa Symbolique*, 1979

Cleveland, 1967
Cleveland, Museum of Art, *Treasures from Medieval France*, 1967
Cologne, 1972
Cologne, Kunsthalle, *Rhein und Maas: Kunst und Kultur, 800–1400*, 1972
Copenhagen, 1981
The Vikings in England and their Danish Homeland, Copenhagen 1981, Århus 1981, York 1982

Edinburgh, 1982
Edinburgh, National Museum of Scotland, *Angels, Nobles and Unicorns*, 1982

London, 1930
London, Victoria and Albert Museum, *English Medieval Art*, 1930
London, 1939
London, Burlington Fine Arts Club, *British Medieval Art*, 1939

London, 1963
Great Britain, Arts Council: London, Victoria and Albert Museum, *Opus anglicanum: English Medieval Embroidery*, 1963
London, 1974
London, Victoria and Albert Museum, *Ivory Carvings in Early Medieval England, 700–1200*, 1974
London, 1975
Great Britain, Arts Council: London, Hayward Gallery, *Treasures from the Burrell Collection*, catalogue by W. Wells, 1975

Manchester, 1959
Manchester, City Art Gallery, *Romanesque Art c. 1050–1200 from Collections in Great Britain and Eire*, 1959, catalogue by C.M. Kauffmann, 1959

New York, 1970
New York, Metropolitan Museum of Art, *The Year 1200*, I, *The Exhibition*, ed. K. Hoffmann, II, *A Background Survey*, ed. F. Deuchler, 1970
New York, 1975
New York, Metropolitan Museum of Art, *The Year 1200*, III, *A Symposium*, 1975
New York, 1981
New York, Metropolitan Museum of Art, *The Royal Abbey of St-Denis*, 1981
New York, 1982
New York, Metropolitan Museum of Art, *Radiance and Reflection: Medieval Art from the Raymond Pitcairn Collection*, catalogue by J. Hayward and W. Cahn, 1982
Norwich, 1980
Norwich, University of East Anglia, Sainsbury Centre for the Visual Arts, *Medieval Sculpture from Norwich Cathedral*, catalogue by A. Borg, J. Franklin *et al.*, 1980

Oxford, 1975
Oxford, Bodleian Library, *The Survival of Ancient Literature*, 1975
Oxford, 1980
Oxford, Bodleian Library, *Manuscripts at Oxford: an Exhibition in Memory of Richard William Hunt, 1908–1979*, 1980, catalogue by W. Oakeshott, 1980

Paris, 1954
Paris, Bibliothèque nationale, *Manuscrits à peinture du VIIe au XIIe siècles*, catalogue by J. Porcher, 1954
Paris, 1965
Paris, Musée des Arts décoratifs, *Les Trésors des Églises de France*, 1965
Paris, 1968
Paris, Musée du Louvre, Douzième Exposition du Conseil de l'Europe *L'Europe Gothique XIIe–XIVe siècles*, 1968

Reims, 1967
Reims, Bibliothèque municipale, *Les plus beaux manuscrits de la bibliothèque de Reims*, 1967
Rouen, 1975
Rouen, Musée des Beaux-Arts, *Manuscrits normands, XI–XIIème siècles*, 1975
Rouen, Caen, 1979
Rouen, Caen, *Trésors des Abbayes normandes*, 1979

Stuttgart, 1977–79
Stuttgart, Württembergisches Landesmuseum, *Die Zeit der Staufer, Geschichte–Kunst–Kultur*, catalogue parts I–IV, 1977, V, 1979

Winchester, 1973
Winchester, Cathedral Treasury, *Saxon and Norman Art*, a revised exhibition, 1973

Chronology 1066–1200

by A.E. Reekes, M.A. Oxon

POLITICAL

William I 1066–1087

Halley's comet lit up the sky in the spring of 1066, an omen of future disasters: a series of battles for Edward the Confessor's legacy involving Harald of Norway, King Harold of England, and the man to whom he had allegedly promised the throne, William of Normandy, culminating on 14 October 1066 in the Battle of Hastings. William's victory over exhausted English infantrymen was followed by a circuitous march round southern England after an abortive assault on London Bridge, culminating in the surrender of the English nobility at Little Berkhamsted and in his coronation on Christmas Day in Westminster Abbey. The reign of this ruthless warrior was dominated by the need to suppress all challenges to his authority and by the elevation of the status of king. William crushed revolts in 1067 led by Edric the Wild in Herefordshire and by Eustace of Boulogne in Kent, and subjugated Exeter in 1068. From 1068 to 1070 he dealt with his greatest crisis when Edgar Aetheling of the old Wessex line of kings, took York with Danish support, while in collusion Wales, Chester, Dorset and Somerset rose and Hereward the Wake roused the Fens. His lieutenants dealt with the South and William personally 'harried' the North, laying it waste. Even this was not the end of the unrest: Malcolm of Scotland's raids over the border provoked typically forceful counters from William in 1072 and 1079 to bring him to make homage, and there was also a rebellion of William's eldest son Robert Curthose in Normandy in 1077, duly crushed. The Norman state of England that William so tenaciously initiated was secured by earth and timber fortifications, thrown up at strategic points, a means of holding down large areas of land from a central control. By 1100 there were about 5000 of these forts; in time they were made more permanent in stone. Loyalty was secured by the gradual transfer of land from English owners. In 1067–8 the south-eastern native aristocrats lost their land, to be followed by those on the Marches of Wales; by 1086 only two English magnates still held estates. But William built on the Anglo-Saxon obligation of large landowners to produce soldiers, and introduced from Normandy his native feudal system where the land of each vassal had a fixed quota of knights attached to it. He perpetuated the Anglo-Saxon fyrd, the army which in need could call on every able-bodied man. By his military success William had, when he died, secured Norman England from English rebels, Welsh and Scottish insurgents and Scandinavian rivals.

William II 1087–1100

William the Conqueror divided his inheritance, giving England to his second son, William Rufus, and Normandy to his eldest and less trusted, Robert. Rufus, a great knight, an indulgent and irreligious bachelor, was nevertheless conscious of his need to preserve his kingly powers. He had almost immediately to resist rebellion from barons sympathizing with his brother (Odo of Bayeux's revolt of 1088 in Kent), then later from over-mighty subjects such as Robert de Mowbray in Northumberland in 1095. He fought hard to enforce feudal rights, stop private war, and maintain royal control over the inheritance of vassals' fiefs. He had to deal with Welsh rebels from 1094, succeeding in 1096 in taming South Wales but failing by 1099 to subjugate Gwynedd and Powys. He forced first Malcolm (1091) then Edgar of Scotland to submit, and retook Cumberland and Westmorland in 1092. He eventually gained Normandy from his Crusading brother as surety for a loan in 1095. Like most Norman and Plantagenet kings, he spent his reign trying to unite, then keep together, England and the Continental possessions. He died in mysterious circumstances hunting in the New Forest in August 1100.

Henry I 1100–1135

Henry, third son of the Conqueror, used Robert's absence on Crusade to seize the throne in August 1100, being quickly crowned by the Bishop of London and promising in a coronation charter to renounce Rufus's 'unjust oppressions'. Anselm returned from exile, although relations between king and archbishop were stormy and the latter retreated abroad again in 1103. Henry's reign was dominated by the fight to secure the full Anglo-Norman Empire. First he had to resist brother Robert's invasion of England in 1101 – at Alton the two agreed that Henry should keep England but pay Robert an annual pension of £2000, and that Robert should hold Normandy. But then in 1106 at Tinchebrai in Normandy Henry went on the offensive, routed Robert's troops and re-established the Conqueror's empire. This was a good year for Henry: he also hammered out an agreement on investiture of bishops with Anselm at Le Bec. Henry now set about recovering what the weak Robert had lost on the Continent. After beating Louis VI of France at Brémule in 1119, by 1120 he had brought back the old border principalities of Boulogne, Bellême, Maine and Brittany under his control; but Vexin, so close and threatening to Paris, eluded him. The same year also saw disaster; his only son, William, was drowned in the White Ship in the Channel and the male line of Norman dynastic descent died with him. Now the succession was disputed: one party was that of his daughter Matilda, until 1125 prestigiously married to the Emperor Henry V and thence known as the Empress. Despite this in the 12th century it was well nigh impossible for a woman to rule. The other claimant was his nephew, Stephen of Blois, on whom he had lavished gifts of land. In 1127 Henry forced his court to swear an oath of allegiance to Matilda as his heiress, and Stephen complied too. She subsequently married Geoffrey Plantagenet of Anjou, whose father Fulk emigrated to Jerusalem to be its king in 1129. Henry died in 1135, having done much to secure his kingdom. He had tamed South Wales by raising the Clare family there and punitively raiding Gwynedd in 1121. He had also deterred the Scots from raiding by his presence on the borders in 1122. But on his death the dubious succession did much to undo the peace and security he had achieved.

Stephen 1135–1154

Supported by barons who respected his martial ability and exploits as well as his wealth, and by a Church grateful for his

reforming zeal, Stephen seized the throne on Henry's death. However, his troubles lay both in the expectations of easier times among his supporters – Henry had mulcted his barons – and in the existence of a rival party in Matilda, backed by her husband Geoffrey and son Henry. So, slowly, Stephen's reign subsided into anarchy. From 1136 Wales rebelled under first Gruffydd, then Owain. So did the Scots, though they were crushed at the Battle of the Standard near Northallerton in 1138. By then disappointed domestic barons allied with Matilda's party, who were regional landowners such as Henry's bastard Robert of Gloucester, Ranulf of Chester and later the constable Geoffrey de Mandeville. They effectively curtailed the king's rule in the West Country, in the North and in the Fens. Stephen also lost the support of many churchmen including his ambitious brother Henry of Blois, Bishop of Winchester, after Stephen had set out to break the power of the chief justiciar, the Bishop of Salisbury. The war became a series of sieges of stone castles and walled strongholds, at one of which, Lincoln, Stephen was captured in 1141, though he was later released. Matilda was near enough to success that year to occupy London and seek coronation; but residual support in the south-east and among London's citizens eventually gave the advantage to the King. By 1147, the main rebel barons were dead, others too old or drawn off to the Second Crusade, and the worst was over, Matilda left the West Country in 1148 never to return. All the while, in some places, the breakdown of law and order had seen individual barons securing their property and their vassals by peace treaties with neighbours, not trusting to the King's protection. Also by 1144, Stephen had lost Normandy to Geoffrey of Anjou, whose son Henry invaded England in 1149 and again, after inheriting the duchy, in 1153. He claimed England through Matilda his mother. At Wallingford in November 1153 Stephen surrendered the succession to Henry, bypassing his own son William, and the next year he died.

Henry II 1154–1189

Henry governed an empire which, at its furthest extent, included England, a large part of Ireland and all western France from Normandy through Anjou, Brittany, Poitou, Limousin and Périgord down to Gascony on the borders of the Pyrenees. This Angevin Empire passed to him from his succession to Stephen, from his father Geoffrey Plantagenet's inheritance and from his shrewd marriage in 1152 to Louis's divorcee, Eleanor of Aquitaine. The first part of his reign was spent recovering royal rights of taxation and justice, and to further this he resumed alienated Crown lands and tore down illegally-built castles. He had to subdue the Welsh Marches and York, and restore to his rule territories such as Berry, Auvergne and Toulouse, to which he had claim through the dowry of Eleanor. He also had to bring Malcolm of Scotland to surrender Westmorland, Cumberland and Northumberland and then submit in 1157, and Owain in North Wales and Rhys in South Wales to follow suit in 1158. Finally, he had to reconquer the strategically crucial Vexin from Louis VII in 1160. The 1160s were dominated by domestic reforms and the Becket controversy, but in the 1170s a political struggle for survival preoccupied him. He faced first Louis VII then Philip Augustus, kings of France who detested him for his control of much of France and especially the Vexin which pressed in sensitively on Paris; he alienated his powerful wife; and he failed to satisfy his four ambitious sons. True, the decade

opened well with the conquest of much of Ireland by 1172, and the submission of the Count of Toulouse in 1173. But that year his sons, backed by Louis, generated the 'Great Rebellion', uprisings in Gascony, Anjou, Normandy and Brittany, in concert with English earls, the Count of Flanders and the King of Scotland. The rebellions were smothered by autumn 1174 when Henry imposed the family peace of Montlouis on his sons, giving them castles and confirming young Henry as heir to England and Richard as regent in Aquitaine; although in truth he himself was the victor. He also imposed stringent terms on William, King of Scotland, at Falaise where William was effectively reduced to the status of an English earl. To maintain this vast empire he developed similar, independent governments for each unit and travelled round its entirety to hold it down. Yet some distant Angevin areas in France still recognized the king of France as their overlord and embarrassed Henry by appealing against him. His sons exploited this too: in 1183, and then in the last great revolt of his reign beginning in 1188 when Richard, now heir to England on the young Henry's death in 1183, allied with King Philip Augustus of France to ensure that he inherited all Henry's empire and that no land was split off for the favourite, John. Philip made severe inroads on Berry and Touraine, aiming to cut the empire in two. In 1189 at Colombières, Henry submitted to the allies and surrendered 20,000 marks to Philip, together with some Berry baronies, and recognized Richard as sole heir. He then died, it is said of a broken heart caused by his family's treachery.

Richard I 1189–1199

Richard was in England only rarely and briefly in his reign; in 1190 he set off on Crusade, *en passant* taking Sicily (punishing the ruler Tancred for his treatment of his sister Joanna), making the Treaty of Messina in March 1191 with his fellow, but much hated, Crusader Philip of France which made Richard a vassal for each piece of land he held in France, and then going on to conquer Cyprus from a Byzantine Christian. Eventually he arrived in the Holy Land where he dominated the fight against Saladin, finishing off the siege of Acre, brilliantly defeating the Moslems at Arsuf and Jaffa, and in 1192 negotiating a truce with Saladin whereby the Crusaders gained a new, slimmer Crusading state, and the right to visit Islamic Jerusalem. Richard never reached the Holy City, conscious of his inability to take, let alone hold, it. Returning home he was captured by a prince he had arrogantly insulted at Acre, Leopold IV of Austria, and was not ransomed until June 1193, at Worms, and released in February 1194 at Mainz. Meanwhile, in 1192, his brother John had set England in revolt, and Philip had taken lands in Normandy and Touraine: ironically Richard now found a former ally doing what he himself had done to Henry II. Richard returned to England, captured John's Nottingham Castle, raised money by the sale of charters and by the carucage tax, and sped off to tackle Philip. By 1198 only the great castle of Gisors on the Norman border remained in Philip's hands, and Richard countered this with the majestic stronghold of Château Gaillard and by new lands acquired in Berry near Bourges. However, the victories were temporary; the death of the great warrior who had won admiration from his Moslem enemies ushered in a period of imperial dissolution as a lesser king struggled with exhausted treasuries, ambitious nobles and the tenacious King of France.

RELIGIOUS AND SOCIAL

William I 1066–1087

Anglo-Saxon society was advanced and the Conqueror perpetuated many of its strengths: the coinage, the taxation system of Danegeld, the central machinery of Treasury and king's writ, the administrative divisions into shire and hundred. Slowly, though, the facts of Norman rule expressed themselves: in the relegation – albeit temporary – of the native English language to a subordinate place; physically in the Norman castles and equally formidable Romanesque parish churches; legally in the imported laws; ecclesiastically in the new Norman bishops remodelling the Church on Norman lines under Lanfranc, their Archbishop of Canterbury from 1070. He imposed a hierarchy on the Church's government, resited dioceses (Dorchester to Lincoln, Sherborne to Salisbury), encouraged the building of cathedrals (Lincoln from 1072, Rochester 1077, Winchester 1079, Worcester 1084) in Romanesque style, and elevated Canterbury over York in seniority. His King presided over the emergence of a strong Church in which new ecclesiastical courts, a drive to produce celibate clergy (largely unsuccessful) and a wider application of Church or canon law all pointed to a body developing its powers. Yet William still dominated his Church. He may have invaded in 1066 with the blessing of Pope Aexander II, promising to revive the lapsed tax of Peter's Pence and to reform the English Church; but after his coronation by legates in 1070 he pursued an independent policy, resisting Pope Gregory's pretensions. No appeals could be made to Rome, no bishops could visit it, no papal letters could be delivered to English bishops, and no new Pope could be recognized in England, without the Conqueror's consent. He knew little about his conquered country, who owned what parts of it, and what its taxable wealth was, and so he commissioned the Domesday Book, finished in 1086, to tell him. Its dry entries are an invaluable guide to ownership and use of land. This thoroughness, and the motivation for the survey, say much about the hard-headed practicality of William as King.

William II 1087–1100

His reign saw the growth of tension between monarch and Church in his battle against Anselm. William treated the Church as feudal vassal and financial resource, extracting revenue from monastic lands, keeping benefices vacant and taking the money accruing; he also attempted to control the English Church's contact with Rome, a policy rejected by Anselm, Archbishop of Canterbury from 1093, who exiled himself in Rufus's last three years. William employed Ranulf Flambard to control his legal and financial business, and the reign saw tighter government emerging with judicial visits to the shires 'on eyre' (on circuit), better administration of estates and of Danegeld, an improved supervision of the Treasury, and the innovative use of the abacus there. Rufus's control over the country is perhaps expressed in the building of the White Tower in London c. 1088. Flambard's influence can be seen in his reward of the bishopric of Durham, the commencement of Durham Cathedral in 1093, and the laying out of its Palace Green.

Henry I 1100–1135

Henry's 35-year reign saw the inexorable advance of the claims to papal supremacy in European principalities which had been begun by Gregory VII. Henry's promotion of reforming spirits, and the great expansion during his reign of the wealth and power of the new orders in England which looked to the Pope as their ultimate control, paradoxically only encouraged this. So, these years saw the establishment of Cistercian houses in remote regions of England: at Waverley in 1128, Tintern in 1131, Rievaulx in 1132 and Fountains the same year. There was also the rapid growth of an order patronized by Stephen of Blois, the Savignac, first at Tulketh in Furness in 1124, then at Neath in 1130 and at Quarr on the Isle of Wight in 1132. These primitivist houses sought to escape the world. On the other hand the Austin Canons, some 100 of whose houses were founded in Henry and Stephen's reigns, more actively ministered among the people, starting hospitals, hospices and almshouses. In 1131 a native English order for women was established by Gilbert of Sempringham. These years also saw the evolution of more sophisticated government; the Exchequer developed as a law court hearing land disputes, and its judges started to tour the country on eyre, dealing with the definition of royal rights and hearing common pleas. More ordered finances at the Exchequer can be seen in the Pipe Rolls made annually at Christmastide, the earliest extant example being 1129–30. Henry needed all the money he could get, rewarding friends too well, yet prosecuting wars continuously. So he actively encouraged the country's emergent boroughs, selling charters and the right to establish guilds (in Salisbury, York and Lincoln) and to hold fairs. And he extracted all the feudal dues he could from reluctant and resentful barons.

Stephen 1135–1154

Perhaps historians have overplayed the extent of the 'anarchy'. The coinage remained sound, the Exchequer system never collapsed, the king's writ continued to be transmitted to the shires, and justices and sheriffs continued with their work more or less well. The campaigns were confined in the main to the West Country, the Thames Valley, and a swathe of East Anglia. The dubious nature of Stephen's right to rule not only led ambitious barons to exploit his weakness; the Church also took advantage and consolidated its strength. The Conqueror's proprietary Church would not in any case have lasted long after his death. Under Archbishop Theobald ecclesiastical courts were more used to deal with delinquent priests and moral cases. Appeals increasingly passed out of the country to Rome. New religious houses proliferated, a sign that law and order had by no means completely broken down: by 1154 some 40 Cistercian houses had been built in England. It was clearly quiet enough for writers to work: Geoffrey of Monmouth, William of Malmesbury and Orderic Vitalis produced their works of national or ecclesiastical history in these years. Increasingly English churchmen went abroad. Nicholas Breakspear left Abbots' Langley and became Pope Adrian IV in 1154. John of Salisbury, after a 'modern' education at Paris, became Bishop of Chartres: this well illustrates the growing internationalism of the Church as well as how much England, with land on the Continent, was part of the mainstream there.

Henry II 1154–1189

Henry is popularly remembered for his struggle with Thomas Becket, who was raised by him first to Chancellor and then to Archbishop of Canterbury in 1162, but then profoundly differed from his monarch over the privileges of the Church. The King wished to preserve the Conqueror's 'English' customs of the Church, the subservience of churchmen to their feudal overlord, the monarch, and the right of secular, royal courts to deal with offending clerks. At Westminster in 1163, and at

Clarendon in 1164, Henry expounded his policy to the bishops. At Northampton in 1164 Henry, blocked by Becket, moved against him with charges of corruption as Chancellor, in which capacity he could be punished as vassal by his feudal overlord. Becket escaped abroad. Henry was trying to stem a long-term development of the Church's pretensions inspired by Gregory VII. Bishops could no longer accept the King barring them from appeals or visits to Rome, and they also objected to the double punishment of criminous clerks, first unfrocked then punished again in the King's courts for the same crime. Most bishops came around to the side of Henry, led by the Archbishop of York who saw Becket's embarrassment as a chance to recover York's lost ground *vis-à-vis* Canterbury; but none could condone the brutal murder of Becket in Canterbury Cathedral when he returned in 1170. Henry conveniently disappeared to Ireland until passions subsided, and at Avranches in 1172 he accepted Papal terms of penance. Subsequently he won many concessions over appointment of bishops in England and over the punishment of criminous clerks, and so the result was perhaps a draw. Henry's reign also saw great developments in royal government and powers, and foundations were laid for much of medieval England's administration. To ensure proper tax collection and justice, an Inquest of Sheriffs in 1170 purged delinquent officers. The Assize of Clarendon set out savage penalties for notorious robbers, and royal justices increasingly perambulated the shires on eyre. To deal with property disputes, the Exchequer expanded its legal side and developed the Common Bench. To strengthen his military side, Henry initiated the Assize of Arms, which acknowledged that the old knight service was a thing of the past, but now imposed new responsibilities on every freeman to fight for his king. England was more, and better, governed. Intellectually, too, it flourished with the foundation of Oxford University, with the writing of histories by Giraldus Cambrensis, John of Salisbury and Walter Map, and with the works of Glanville on the laws of the royal court and of Richard fitz Neal on the arcane machinery of the Exchequer.

Richard I 1189–1199

Richard sucked money from England to ransom himself and to fight for the preservation of his empire against Philip. Yet despite his absences and preoccupations, English government apparently continued to develop, with the first extant plea rolls recording the coroner's works in 1194. These years also saw the development of the wool and cloth trades with the Continent, in return for wine and salt from Gascony; and the rise of Southampton and London, facing the Continental ports and able to accommodate the new cogs, the large trading ships. The English took a more prominent part in Richard's Crusade than in any other, for he was their only king to go on Crusade. However, it seems that he was motivated less by piety than by desire for honour, military glory, and booty; and certainly in Sicily and Cyprus he made himself rich, albeit temporarily.

FOREIGN

William I 1066–1087

While William conquered England his fellow Normans, inspired by the same adventuring urge, completed the taking of southern Italy from the Byzantines (Bari, 1071) and went on, under Robert Guiscard, to secure Palermo and hence Sicily. Not content with this, Guiscard and his son Bohemund invaded the Byzantine mainland across the Adriatic at Durazzo, and besieged that port from 1081 to 1085. So important were the Normans that Pope Gregory VII, desperate for help against the Emperor, made the Treaty of Ceprano with Robert in 1080 and indeed died his guest at Salerno in 1085. Equally significant in European affairs of the period was the dispute of Pope and Emperor over the investiture of priests by lay patrons, specifically barred by Gregory VII (1073–1085) in a number of decrees. He provocatively outlined a new elevated role for St Peter's successor in *Dictatus Papae* (1075), but learned painfully that religious anathema has to bow to military force when the Emperor Henry IV, foiled in his desire to appoint the Archbishop of Milan in 1075, created an anti-Pope, opened up a schism in the Church, invaded Italy and took Rome in 1084, crowned his own Pope Clement III there, and exiled the hapless Gregory. This battle symbolized the greater issue of whether princes and nobles could control the fortunes of a powerful force such as the Church within their own territories, and was to be rejoined in decades to come. The weakness of Byzantium, the legatee of the Roman Empire based on Constantinople, reached crisis proportions in William's time: not only did it lose southern Italy, but at Manzikert in Asia Minor in 1071 its army was annihilated by the powerful Seljuk Turks. Their light, fast horsemen swept into Anatolia to within 100 miles of the Byzantine capital, and also penetrated Syria to wrest Jerusalem from the weak Fatimids of Egypt. The accession of Alexius I Comnenus as Byzantine Emperor in 1081 was the signal for a concerted effort to repel the Islamic invaders, culminating in the Crusades.

William II 1087–1100

His thirteen years were dominated by the Christian counter-attack: El Cid driving the Moors from Valencia in 1094; the pathetic endeavours of Peter the Hermit's People's Crusade of 1096 massacred at Civetot by the Turks; or more successfully the great Knights' Crusade of 1096–99 which saw the defeat of Kilij Arslan's Turks in Anatolia at Nicaea and Dorylaeum in 1097, the recapture of Antioch by the Norman Bohemund in 1098 and the reconquest of Jerusalem in 1099. Subsequently four Crusader states were initiated: Jerusalem, Edessa, Antioch and Tripoli. All this activity was inspired by Pope Urban II's call to arms, to a pilgrimage and holy war of vengeance in one, at Clermont in 1095. Urban had powerful motives for a Crusade which simultaneously channelled from Europe undesirable warring knights, elevated Roman Christianity in the Middle East where previously the Greek Church had ruled, and emphasized the Pope rather than his rival the Holy Roman Emperor as leader of Christendom.

Henry I 1100–1135

The Cistercian and Savignac orders expressed the ascetic, escapist, obedient strain in 12th-century religious life, but a contrary movement was growing up in the cathedral schools of Paris where thought was less stultified by authorities. Peter Abelard, a teacher of genius, personified the new rationalism of the Twelfth-century Renaissance in European thought. He

founded the new school of theology, rhetoric and philosophy in Paris in 1113. Symbolically, it was to be Bernard of Clairvaux, the Cistercian, who was to destroy Peter in Stephen's reign on the grounds of his unorthodoxy. Meanwhile the Church faced threats from without: in 1112 the Emperor Henry v reopened the investiture dispute with the Pope, Paschal II, leading in 1118 to Henry's creation of an anti-Pope, Gregory VIII. Only in 1122 was this conflict ended with the Concordat of Worms. Yet in the Holy Land the Church's appointed lieutenants, Baldwin I and II and then Fulk, proceeded apace to secure the new Crusader states' borders, taking Tripoli in 1109, then Tyre in 1124; building magnificent defensive castles; encouraging the new religious orders, the Knights Hospitaller and the Knights Templar; and succeeding at least until 1135 in keeping at bay the new Islamic leader from Mosul, Zengi.

Stephen 1135–1154

In France these years saw, under the tutelage of Abbot Suger at St Denis, the creation of the principles of Gothic architecture. Suger was to be regent of France while his king responded to Bernard of Clairvaux's calling at Vézelay in 1146 and went on Crusade; Pope Eugenius IV had announced the second Crusade after Zengi's capture of Edessa from the Christians in 1144. The Emperor Conrad III shared the leadership with Louis; his German army was shattered, being nine-tenths destroyed, at Dorylaeum in 1147. The expedition culminated in an abortive siege of Damascus, misconceived and mismanaged, in 1148. However, English and Flemish sailors independently attacked Moorish Lisbon and in taking it achieved the only success of the Crusade. And with Western Crusaders fuming at the unhelpfulness of the Byzantine Emperor Manuel it was, typically, a Norman, Roger II of Sicily, who showed the way for future Crusaders by attacking mainland Greece at Thessalonica in 1146-7.

Henry II 1154–1189

While Henry and successive kings of France disturbed the peace of Western Europe, and the German Emperor was preoccupied in conquering and holding down most of Italy in the 1150s and early 1160s, as well as in bringing an unbiddable vassal, Henry of Saxony, to heel from 1179 to 1181, the position of the Crusader states was deteriorating fast. From 1174 the Moslems were led by the inspired holy leader Saladin who held not only Syria but also Egypt and after 1185, Mesopotamia as well, and thus effectively surrounded the Crusaders. They were ruled in their last years by a leper; then by an infant; and finally by a woman, Sibylla, married to a weak consort, Guy. Debilitated by internal squabbles, poor leadership, manpower shortage, the ill-discipline of some of the holy orders and of the barons, the Crusader states slumped to crushing defeat by Saladin at Hattin in July 1187. After that, all that remained was Antioch, Tripoli, Tyre and a few castles. A new Crusade was preached and Barbarossa responded, only to drown in a river in Anatolia in the first months of Richard's reign. The Byzantines could not help: at Myriocephalum in 1176 their army had been smashed by the Turks, and this effectively destroyed their power east of Constantinople for ever. Another Crusade was launched in these years, showing the developing tendency to see other goals as equally important as the relief of Jerusalem: it was against the Albigensian heretics of Toulouse, and was authorized at the Third Lateran Council of 1179. It was to be a long and bloody enterprise.

Richard I 1189–1199

The period was dominated by the Third Crusade and the refounding of the Crusader states. Saladin's empire disintegrated on his death in 1193 among his warring sons and brother al-Adil, and the new State of Jerusalem, supported by Richard's Cyprus, established itself. Innocent announced a Fourth Crusade, which set off after Richard's death but was diverted by the Doge Dandolo of Venice into a successful assault on Constantinople in 1204. During the 1190s the German Emperor Henry VI had taken Sicily and had enlarged his pretensions to include the Near East, a vacuum created by the collapse of the Byzantine Empire. He made Cilicia, under King Leo of Roupenia, and Cyprus his vassals. However, he died in 1197, unable to complete his mission but bequeathing to his successors a dream of a German-dominated Italy and Middle East.

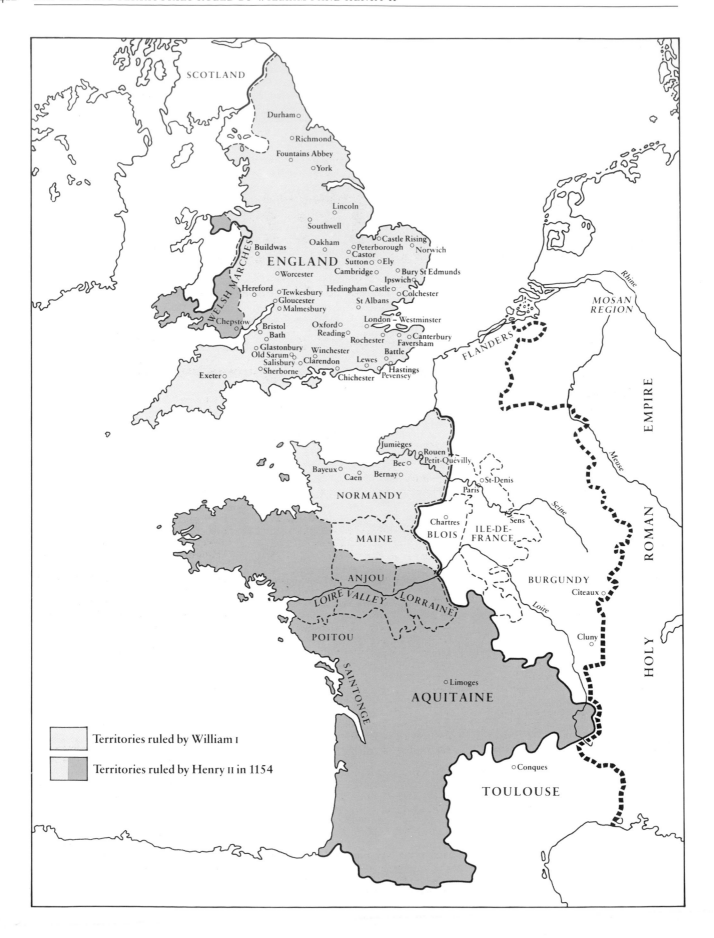

SCOTLAND

Durham

Richmond

Fountains Abbey

York

Lincoln

Southwell

Buildwas Oakham Castle Rising
WELSH MARCHES Peterborough Norwich
Castor
ENGLAND Sutton Ely
Worcester Cambridge Bury St Edmunds
Ipswich
Hereford Tewkesbury Hedingham Castle Colchester
Gloucester St Albans
Malmesbury
London – Westminster
Chepstow Oxford Rochester Canterbury
Bristol Reading Faversham
Bath Glastonbury Winchester Battle
Old Sarum Clarendon Lewes
Salisbury Hastings
Sherborne Chichester Pevensey
Exeter

Jumièges
Rouen
Bec Petit-Quévilly
Bayeux St-Denis
Caen Bernay Paris
NORMANDY
MAINE Chartres Sens
BLOIS ILE-DE-
FRANCE
ANJOU
LOIRE VALLEY LORRAINE BURGUNDY
Citeaux
POITOU Cluny
SAINTONGE
Cluny

Limoges

AQUITAINE

Conques

TOULOUSE

MOSAN
REGION

FLANDERS

Rhine

Meuse

Seine

Loire

EMPIRE

HOLY ROMAN

Territories ruled by William I

Territories ruled by Henry II in 1154

Glossary

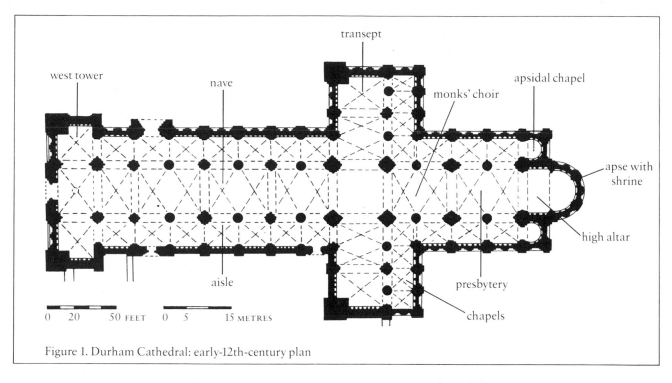

west tower
nave
transept
monks' choir
apsidal chapel
apse with shrine
high altar
presbytery
chapels
aisle

0 20 50 FEET 0 5 15 METRES

Figure 1. Durham Cathedral: early-12th-century plan

abacus The flat slab which forms the uppermost portion of the capital of a column.

addorsed Two human, animal or grotesque figures arranged symmetrically back to back.

affronted Two human, animal or grotesque figures arranged symmetrically facing each other.

affusion The pouring of water over the head in baptism.

alb An ankle-length, sleeved tunic, generally of white linen, worn by priests and others, often beneath other vestments.

alum-tawed (leather) Prepared by steeping the skin in a solution of alum and salt.

ambulatory A semicircular aisle at the east end of a church, round an **apse** or sanctuary.

amice A square of white linen worn by celebrant priests, formerly on the head, now on the neck and shoulders. In some religious orders, the amice has the form of a hood and is part of the habit.

amorini Winged cupids (putti).

aniconic Without portrait or animal figures.

antependium A panel of embroidery, goldsmithwork, carving or painting covering the front of an altar.

apse A vaulted semicircular or polygonal termination to the eastern end of the chancel, often housing an altar. In larger Romanesque churches there were additional apses in the eastern walls of the **transepts**.

aquamanile A metal ewer, for ablutions at altar or table.

archivolt The ornamentation or moulding on the face of an arch.

armature A supporting framework, usually of iron rods, for the construction of sculpture in wax, clay or plaster; or iron bars in a window opening to support stained glass.

ashlar Hewn or squared stone used in building.

aspergillum A long-handled rod with a brush or perforated globe at the end, used in the ceremony of sprinkling holy water over the altar and congregation.

Atlas (pl. Atlantes) Carved male figures used as supports for architectural features. In Classical art they were often used instead of columns; in Romanesque, they were usually carved on capitals or used to support columns, thrones, etc. Female figures (Caryatids) were seldom used in this way in Romanesque art.

beak-head An ornament in the form of a bird, animal or human head, whose beak, tongue or beard is superimposed on a **roll-moulding** of an arch, usually of a doorway.

'belle-verriere' Stained glass reset in a later opening in the Middle Ages (lit. 'beautiful stained glass panel').

bifolium Two folios (pages) made up of a single sheet of vellum.

billet An ornamental moulding formed of bands of raised short cylinders or square pieces placed at regular intervals. Of Roman origin, it was extremely popular during the Romanesque period.

blind tooling A decorative technique used especially in book binding. The design or letter is stamped on the leather and left without gold or other colouring.

bull (pl. bulla) A small metal disc with a design stamped on either side, used in the manner of a seal on documents. Also, by extension, the name given to the document itself.

burin A tool used for engraving coins.

buskins Stockings worn by bishops and some abbots.

'Byzantine blossom' An elaborate three-petalled flower design of Byzantine origin.

cabochon A round or oval convex polished stone or gem.

calendar Placed at the beginning of liturgical manuscripts to record, month by month, the feasts and saints' days celebrated locally.

came The soft metal strip used as the divider between adjacent pieces of glass in a stained or leaded glass window.

cameo A precious or semi-precious stone carved in relief, usually with more than one layer of colour, so that the figures will contrast in colour with backgrounds.

canon table A concordance table, usually arranged in columns under arches, showing parallel passages occurring in two or more of the four Gospels.

camelaucum A conical hat worn by the pope, the predecessor of the papal tiara.

capital The uppermost element of a column; **cubic** (or **cushion**) means a capital the upper part of which is a cube and the lower a sphere. Of Byzantine origin, they were extremely popular in Romanesque buildings in Italy, Germany and England. The semicircular faces or shields of such capitals are either painted or carved.

censer A metal vessel for the burning of incense during church services. It is usually suspended on chains, so that it can be swung for better burning.

chalice The cup or goblet used in church ceremony.

chamfer The edge of a corner that is bevelled or angled off, usually at 45° to the other two surfaces.

champlevé A type of enamel decoration, where the surface of a metal plaque has been cut out with an engraving tool to form shallow fields in which the powdered glasses are fired.

charger A large, usually wooden, plate or dish on which a joint of meat was served and cut.

châsse An enclosed vessel for sacred relics, shaped like a house with gabled ends and a pitched roof.

chasuble The principal vestment worn by the priest for the celebration of the Mass; medieval chasubles were originally of more or less conical form.

choir The eastern limb of a church; strictly, the part with stalls for singers.

chrism A mixture of olive oil and balsam used in the Sacraments.

Chrismon The pictorial invocation of Christ, in the form of a monogram, at the head of a few Anglo-Saxon charters.

ciborium A vessel designed to contain the reserved consecrated eucharistic hosts. A vault or dome suspended over a relic, altar, tomb or image.

cinquefoil A five-leaf clover shape: a motif in Gothic tracery.

clambering, or **inhabited**, **initial** or **scroll** An initial made up of foliate decorations, within which are small human, animal or grotesque figures.

clamp kiln The firing of pottery in a bonfire on the ground instead of a clay structure.

clerestory The upper story of a church, pierced by windows, usually above the aisles admitting light to the nave or main hall.

colonette A miniature column.

colophon The passage appearing at the end of a manuscript recording information comparable to that contained on the title-page of a book.

column-figure A human figure in high relief carved from the same block of stone as the column to which it is attached, used chiefly on doorways but also in cloisters and occasionally on windows. They originated at St-Denis Abbey, between 1137–40.

corbel table A row of projecting brackets (corbels) set in the wall, running just below the eaves of the roof.

corporal A square linen cloth on which the bread and wine are placed to be consecrated in the Eucharist.

costrel A bottle with one or more handles through which a cord may be passed so that it can be suspended from the waist of a traveller, especially a pilgrim.

crosier A Christian symbol of guidance, originating in the shepherd's crook: the pastoral staff of bishops, abbots, and abbesses.

crossing The space in a church where nave and **transepts** intersect.

cross-standard A long-handled cross with a flag attached – a symbol of Christian triumph, frequently carried in the Romanesque period by personifications, such as the lamb symbolizing Christ's passion.

dalmatic A shin-length, sleeved tunic worn mainly by deacons assisting the priest at High Mass.

damp-fold A style of representing draperies as if they were wet and clinging to the forms beneath.

diptych Paintings, carvings or writings on two hinged tablets, often used as portable altar-pieces.

dorter A dormitory.

dowel A headless pin used to hold two pieces of masonry or timber together; also used between stones to prevent shifting.

enamel Powdered glass, fired at very high temperatures so that it adheres to a metal surface and can then be polished. The metal surface preferred in the Romanesque period was virtually pure copper. See also *champlevé*.

end-leaf The blank leaf at the beginning or end of a book.

epigraphy The study of letter forms, or of inscriptions.

equestrian side That side of a two-sided seal showing a figure on horseback (cf. **majesty side**).

estoile The heraldic term for a star with six or more straight or wavy rays.

Evangelist symbols The four Evangelists were frequently represented symbolically by four winged creatures derived from Ezekiel's vision (Ezek.1.5–14; Rev. 4.6–8): the Lion (St Mark), the Winged Man (St Matthew), the Eagle (St John), and the Bull (St Luke).

ferrule A ring, usually of metal, put round a staff to prevent it splitting.

finial The terminating ornament on a post or intersection.

flabellum A liturgical fan used originally to keep the flies away at the Eucharist.

flan The disc of metal from which a coin is made.

frontal *see* **antependium**

Galilee A large porch or vestibule, usually at a church's west end, for use as a chapel by penitents.

garth The open space within cloisters.

gesso The plaster of Paris used as a ground for painting.

a globolo A gem-cutting technique, using a small round-headed drill.

gloss Commentary on the Scriptures or other texts.

grisaille Monochromatic painting in neutral greys or beiges only; in stained glass, a design in predominantly colourless glass.

guilloche An ornament formed by interlacing bands.

harpy A rapacious monster with a woman's face and body and a bird's wings and claws.

headband A narrow band serving as protection at the top and tail of the spine of a book.

hemicycle A semicircular structure.

historiated initial An initial letter enclosing a narrative scene.

impost The projecting member just below the springing line of an arch, on which it rests (*see* **springer**; and fig. 1).

inhabited initial or **scroll** *see* **clambering initial**

Insular Of the British Isles, but more specifically referring to the Anglo-Saxon style.

intaglio Designs cut out of a surface, leaving a relief in reverse, and below the plane which has been worked upon.

Jesse, Tree of A genealogical tree showing the ancestors of Christ ascending through Mary from the root of Jesse. It is often used in stained glass (hence Jesse window), for example at St-Denis, Canterbury and York.

knop A decorative knob, often spherical, usually a feature of the stem of, for example, candlesticks, chalices, crosiers and cups.

label The projecting moulding over a door or window arch, to throw the rain off from the wall. It is also called a dripstone, or hood-mould.

label-stop The ornamental knob usually in the form of a head, at either end of a **label**.

lampas A modern technical term for a type of weaving with two different textures, with the pattern raised in slight relief above the background.

lantern tower A tower open to view from the ground and lit by an upper tier of windows; often used over the **crossing** of a church.

lappets Two narrow strips of material which hang from the back of a bishop's or abbot's **mitre**.

lavabo A wash-basin.

lectern A reading desk in a church on which the Bible rests, and from which the lessons are read.

lip-lappet A ribbon-like extension from the upper or lower lip of human or animal figures, in the manner of a long beard or moustache.

lunette A semicircular, flat area in a building's elevation.

lute, luting The process of joining separate pieces of clay together with liquid slip, for example when applying clay decoration to a vessel.

Magus (pl. Magi) The three Kings of the Gospels (Matthew 2.1–12) who were venerated during the Middle Ages as saints. Their relics were removed from Milan to Cologne in 1162.

majesty side That side of a two-sided royal seal showing a figure enthroned (cf. **equestrian side**).

majuscule An upper-case letter, whether uncials, rustic or square capitals.

mandorla An almond-shaped line or series of lines surrounding the body of a person endowed with divine light, usually reserved for Christ or the Virgin.

maniple A narrow strip of material worn over the left forearm by a priest, deacon and sub-deacon.

martyrology An account or history of martyrs.

meander A decorative, geometric, repeating band.

minium An orange-red lead colour, common throughout medieval book illumination, from which the term 'miniature' is derived.

minuscule A lower-case letter.

mitre A cap with two points, or horns, worn by bishops and some abbots.

Mosan (art) Works produced in the region of the Meuse (Maas) river basin in the 11th, 12th and 13th centuries.

mullion A slender vertical or horizontal bar between windows or glass panels.

nail-head ornament An architectural enrichment consisting of small pyramids repeated as a band.

nasal The nose-piece on a helmet.

necking, or astragal A narrow ring of moulding between a capital and the shaft of its column. In Roman architecture necking was part of the column, in Romanesque it was actually part of the capital.

necrology An obituary notice.

nested V–fold A type of fold in which the cloth gathers into a series of diminishing, but similar, V shapes stacked inside one another.

niello A black substance composed of sulphides of silver and copper; from the Romanesque period onwards, lead sulphide was also added. Niello was used as an inlay for incised decorations, usually on silver or gold, and fixed by the application of heat.

nimbus A circle of light, or halo, surrounding the head in a representation of a divine or sacred figure.

nook-shaft A shaft set in the angle of a **pier**, a **respond**, a wall or the jamb of a window or doorway.

Octateuch A Byzantine manuscript containing the first eight books of the Bible. Several illustrated copies survive.

oculus A round window or opening.

ogee A line made up of a concave and a convex curve, forming an S shape. An ogee dome or arch is made up of two opposed ogee curves meeting in a point at the top.

olla A form of Roman cooking pot with a flat base, wider shoulders, and a turned-out rim.

orchid leaf A form of leaf in Romanesque art resembling the orchid flower; sometimes also called the 'octopus' leaf.

order In Classical architecture the order, or style of architecture, is determined by the form of the column, its base, capital and entablature. The term order in Romanesque architecture is applied to the recessions of a doorway.

Palladium Literally, the image of Pallas on which the safety of Troy was held to depend; generally, anything believed to provide protection or safety.

pallium A strip of woollen material worn round the shoulders of a bishop as a sign of his office.

palmette A stylized fan-like branch of the palm used as a decorative motif.

Pantocrator Christ, the ruler of all.

paste-down The blank, outer leaf of a book, pasted on the inside of the cover.

paten A shallow dish on which the bread is 'offered' at the Offertory of the Mass and on which the consecrated host is placed after the fraction. Invariably of gold or silver, it was usually made to match a **chalice**.

patristic texts The writings of the Church Fathers and the early Christian writers.

pectoral cross The cross worn on the chest by bishops and abbots.

pendilae Jewelled pendants usually hanging from the rim of a crown around the ears.

phylactery A miniature leather case for vellum strips with passages from the Old Testament, worn by Jews on the forehead and arm during prayers.

pier A pillar of masonry; a compound pier has attached shafts.

pile The lower of the two dies used to produce hammered coinage, ordinarily used for a coin's obverse.

plate-fold Cloth shown in Romanesque art as though it were a series of layers, superimposed at the edges.

polychromy The use of colours on walls, architectural enrichments and on sculpture.

porticus A room or porch leading off the central vessel of a church.

precentor One who leads a church choir or congregation in singing.

pricket An early form of candlestick with a spike projecting above the rim to hold the candle upright.

Psalter A service book containing the Psalms and a selection of prayers. Common in the Middle Ages both because Benedictine monks had to sing all the Psalms each week and because it was used for private devotion.

pulpitum A screen of stone or wood separating the **choir** from the nave.

pyx A small vessel in which the sacrament is reserved for later use, usually a round ivory or metal box.

quatrefoil A four-leaf clover shape.

quire Sheets of paper or vellum folded ready for binding, but unsewn.

rampant An heraldic term describing a lion or other animal standing on his hind-legs with his fore-paws in the air.

rebate (or rabbet) A continuous rectangular groove cut along the edge of a piece of wood or metal, usually to receive the edge of another piece.

recension The revision of a text. A revised text.

reduced Pottery fired in an atmosphere with little or no oxygen thus producing a fabric of dark grey colour.

reliquary A container for sacred relics.

repoussé work Relief work on metal, produced by hammering on the reverse side so that the design appears in relief on the front.

reredos A carved or otherwise ornamented screen behind the altar in a church.

reserved (enamelling) The raised area of polished copper, often gilded, dividing sections of enamel.

respond A half-column attached to a wall to support an arch.

retable A panel decorated with sculpture or paintings placed at the back of an altar.

rib Arched, moulded bands carrying the cells of vaulting.

rib-vault A framework of arched **ribs** which supports light masonry.

Ringerike A Scandinavian style (c. 980– c. 1090), taking its name from a district in Norway, employing animal forms with spiral 'hips' interlacing with lively foliage (see p. 18).

roll moulding A continuous convex moulding.

rood A cross, crucifix, or Christ figure, especially one which is placed above the screen (hence rood screen) at the entrance to the **choir** in medieval church architecture.

rove A small metal plate or ring through which a rivet or nail may be passed and secured.

rustic capitals A Roman alphabet whose distinctive form is a capital A without a cross-bar; it is generally characterized by a narrowness of letter, the contrast of thick and thin strokes and large serifs.

Sacramentary A liturgical book containing the prayers of the Mass; it was the fore-runner of the Missal.

saltire An heraldic term for a diagonal cross, often called a St Andrew's or St Patrick's cross.

scrip The wallet or satchel of a traveller, pilgrim or beggar.

scriptorium The place where manuscripts were written in a monastery, cathedral or secular workshop.

shelly Pottery made of clay with either naturally occurring or added shell.

soffit The under-side of any architectural feature.

spandrel The triangular space formed between two arches or between an arch and a wall.

spinario The antique figure of the sitting boy extracting a thorn from his foot.

springer In the construction of an arch, the stone supporting the beginning of the arc.

stole A narrow strip of material worn over the shoulders by priests and deacons, and falling to the knee or lower.

string-course A projecting band or moulding running horizontally along the face of a building.

tabby Plain weave: the simplest and commonest type of weave.

tablet-woven Woven not with a standard loom, but with perforated tablet or cards; used for the production of ribbons and bands.

tau-cross A T-shaped cross, the limbs often slightly splayed.

tenon In carpentry, the projection at the end of a piece of wood shaped to fit into a mortice (the socket).

thurible *see* **censer**

torque A gold collar-ornament, usually consisting of lines twisted together.

tourelle A turret projecting out from a wall and supported by stone blocks called corbels (*see* **corbel table**).

transennum An openwork screen or lattice, usually of marble.

transept The north and south arms of a cruciform church.

transom A horizontal cross-bar in a window.

trefoil A three-leaf clover shape.

trenail *see* **dowel**

triforium An arcaded passage within the thickness of the wall at the height of the aisle roof, below the **clerestory**.

triquetra A symmetrical ornament of three inter-laced arcs.

Troper A book containing texts with music to be sung in the liturgical services of the church.

trussell The upper of the two dies used to create hammered coinage, ordinarily used for a coin's reverse.

tympanum The field in the face of a pediment or in the head of an arch.

type The dominant design on each side of a coin or related object.

typology The interpretation of the Old in terms of the New Testament.

uncial A Roman alphabet with distinctive, generally rounded forms and a generous width of letter.

under side-couching A technique of embroidery in which gold, silver or silk threads laid on the face of the ground material are fixed at intervals by linen threads which are on the back of the material.

up-draught kiln A kiln in which the draught of air rises upwards from a stoke hole to a vent.

Urnes A Scandinavian style (*c.* 1050–*c.*1170), deriving its name from Urnes church in Norway, employing quadrupeds in combat with snake-like creatures, interlacing with thin, elegant foliage tendrils (*see* p. 22).

vervelle The metal ring attached to the leather strap round a hawk's leg, connecting it with the leash.

vermiculé The foliage scroll patterns (like worm patterns) engraved as backgrounds on certain Limoges enamels, and on masonry blocks.

vesica *see* **Mandorla**

volute A scroll or spiral used on some types of capitals.

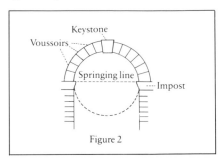

Figure 2

voussoir A wedge-shaped block used in arch construction; the central voussoir is the keystone. (*see* fig. 1)

zoomorphic The use of animal forms, real and fabulous, to compose symbolic or decorative devices.